敦煌藝術大展

荒漠傳奇・璀璨再現

From the Forgotten Deserts
Centuries of Dazzling Dunhuang Art

凡例

◆

本書為2005年3月25日—5月29日於國立歷史博物館、
2005年6月11日—8月27日於高雄市立美術館所舉辦
「荒漠傳奇‧璀璨再現—敦煌藝術大展」之共通圖錄。

◆

作品編號與展覽會場之展覽品陳列順序不盡相同。

◆

作品圖版由敦煌研究院、吉美博物館、台北國立故宮博物院、
台北國立歷史博物館與國立台南藝術大學提供。

◆

作品解說,敦煌研究院典藏品由簡佩琦執筆、潘亮文審訂;
吉美博物館典藏品由該館編寫;
國立故宮博物院與國立歷史博物館典藏品由巴東執筆;
樂器複製品由施德華執筆。

◆

翻譯編審分別註於文後。

◆

中文作者及內文人物之姓名依其慣用方式;
其餘中文拼音採漢語拼音系統。

◆

This catalogue is for the exhibition of
"From the Forgotten Deserts – Centuries of Dazzling Dunhuang Art,"
which being held at the National Museum of History,
Taipei (March 25, 2005 – May 29, 2005),
and the Kaohsiung Museum of Fine Arts
(June 11, 2005 – August 27, 2005).
The catalogue numbers are different from exhibit numbers.

◆

Descriptions of Dunhuang Academy exhibits are written by
JIANG Pei-chi, and checked and edited by PAN Liang-wen.
Description of Guimet exhibits are offered by Patricia de la Motte.
National Palace Museum, National Museum of History and
private collections are written by BA Dong.
Descriptions of musical instruments are written by SHI De-hua.

◆

Chinese writer's surnames are capitalized and put at the front;
figure's names in the text follow their normal usage.
Romanization in the catalogue content uses the pinyin system.

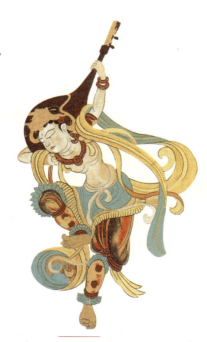

序文 Prefaces

國立台南藝術大學校長　黃碧端　　　　　　　　　　　　　　　　　　4
President of Tainan National University of the Arts　HUANG Pi-twan

國立歷史博物館代理館長　黃永川　　　　　　　　　　　　　　　　　6
The Acting Director of National Museum of History, Taipei　HUANG Yung-chuan

敦煌研究院院長　樊錦詩　　　　　　　　　　　　　　　　　　　　　8
Director of Dunhuang Academy, China　FAN Jinshi

法國國立亞洲藝術-吉美博物館館長　賈立基　　　　　　　　　　　　10
Director of Musée national des Arts asiatiques-Guimet, Paris　Jean-François Jarrige

高雄市立美術館館長　李俊賢　　　　　　　　　　　　　　　　　　　12
Director of Kaohsiung Museum of Fine Arts　LI Jun-shien

專文 Essays

《敦煌藝術大展》總論　樊錦詩　　　　　　　　　　　　　　　　　16
On the Exhibition of Dunhuang Art, 2005　FAN Jinshi

敦煌佛教藝術發展略述—以壁畫的內容為中心　潘亮文　　　　　　　28
An Introduction of the Development of the Dunhuang Buddhist Art:
On the Content of the Mural Paintings　PAN Liang-wen

敦煌石窟的建築藝術　孫毅華　　　　　　　　　　　　　　　　　　40
The Art of Architecture of the Dunhuang Grottoes　SUN Yihua

展現胡風的唐代時世裝　林春美　　　　　　　　　　　　　　　　　50
The Influence of Foreign Fashioins in Tan Dynasty Costume　LIN Chun-mei

敦煌音樂文化　鄭德淵　　　　　　　　　　　　　　　　　　　　　64
Dunhuang Music Culture　CHENG Te-yuan

伯希和收藏的禮拜儀式畫和許願畫：幾件重要經變作品與敦煌石窟藝術　傑克・吉埃　74
The Pelliot Collection of Liturgical and Votive Paintings:
Several Great "Images" of the Revered Ones, and the Art of Dunhuang Sanctuary　Jacques Giès

La Collection Pelliot de Peintures Liturgiques et Votives:
Quelques Grandes "Images" des Vénérés et L'art du Sanctuaire de Dunhuang　Jacques Giès

保羅・伯希和中亞使命之行　派翠西亞・莫特　　　　　　　　　　114
Paul Pelliot and the Expedition in Central Asia　Patricia de la Motte

Paul Pelliot et la Mission en Asie Centrale　Patricia de la Motte

張大千與敦煌石窟藝術之內在聯繫特質　巴東　　　　　　　　　　126
Traits of the Inner Connections between Chang Da-chien and Dunhuang Murals　BA Dong

敦煌地區的官民生活淺析　謝世英　　　　　　　　　　　　　　　140
Dunhuang Everyday Life at a Glance　HSIEH Shih-ying

敦煌莫高窟的保護　王旭東　　　　　　　　　　　　　　　　　　150
Preservation and Protection of Mogao Grottoes　WANG Xudong

回眸敦煌美術工作　李其瓊　　　　　　　　　　　　　　　　　　164
Artists Working in the Dunhuang Academy – A Recollection　LI Qiqiong

圖版 Plates

敦煌研究院典藏　　　　　　　　　　　　　　　　　　　　　　　175
Works from Dunhuang Academy, China

法國國立亞洲藝術－吉美博物館典藏　　　　　　　　　　　　　　313
Works from Musée national des Arts asiatiques-Guimet

國立故宮博物院、國立歷史博物館、私人典藏　　　　　　　　　　351
Works from National Palace Museum, Taipei; National Museum of History,
Taipei; Private Collections

國立臺南藝術大學典藏　　　　　　　　　　　　　　　　　　　　383
Reproduced Music Instruments, Tainan National University of the Arts

年表 Chronicle of Dunhuang Grottoes　　　　　　　　　　　　395

專有名詞對照表 Table of Term Comparison　　　　　　　　　410

序

黃碧端
國立台南藝術大學校長

開始籌辦「敦煌藝術大展」,是偶然,也是必然。

2001年深秋,我第一次踏上敦煌莫高窟現址,目的是去拜訪敦煌研究院的樊錦詩院長,和她洽商延長台南藝術大學(當時的台南藝術學院)古物維護研究所學生到敦煌的實習期限。南藝和敦煌研究院一直有相當密切的師生交流和研究合作,此時如衍伸進一步合作,自也不是意外;但第一次看到自小在地理歷史書上一再讀過的敦煌,驚詫於她的美麗、龐博與文化滄桑,興起了引入敦煌大展的念頭,這卻多少是個偶然。樊院長,這位畢生貢獻於敦煌的考古學者,在相談甚歡的情況下,愉快地承允了合作展出的提議。

2002年,我走訪典藏最多伯希和(Paul Pelliot 1878－1945)當年取自敦煌藏經洞之精品的法國國家吉美博物館(Musée Guimet),也很幸運地得到館長 Jean-François Jarrige 及東方部主任Jacques Giès 慷慨應允出借藏品。我們自吉美借到的敦煌文物,不管數量之多還是質量之精都是吉美外借所罕見。這要特別感謝好友,吉美資深研究員曹慧中女士。她的居中鼎力協助,功不可沒。2004年,我們向台北歷史博物館和高雄市美術館商借檔期,得到兩個館前後任四位館長的慨允和協助。史博的黃永川館長和他的高度專業的同仁並且熱心借出兩件館藏,又協助自台北故宮博物院借得十餘件二〇年代張大千先生的敦煌臨摹珍品。加上南藝的樂器重建項目,這個大展的規模和品質,至此已是各方矚目;首次把敦煌分散在世界各地的寶物薈萃於一展,意義尤其重大！

從開始提出,到大展終於實現的2005年,超過三年的時光已然過去。三年間,展出的構想在校內得到博物館學、古物維護、藝術史與藝術評論、音像紀錄、音像動畫、建築藝術等研究所在相關主題上的配合推動,民族音樂所和國樂系傾力重現敦煌樂器和演奏。在校外,對藝術文化活動始終懷著高度理想和熱忱的橘園國際藝術策展公司成為我們的合作單位。侯王淑昭董事長的經費挹注,簡丹總經理的擘劃推動,對我們真如及時雨和強心劑！

即使有了這許多協助,我仍必須說,這個大展的籌畫工作是艱辛的。然而,對敦煌石窟這樣一個蘊藏了近兩千年間宗教的虔敬、藝術才情的展露、官民生活的實錄、東西文化的薈萃……所聚集而成的浩瀚寶庫,能把它引介給台灣的文化藝術愛好者,再多的艱辛都是值得的。而若無前述的許多支持,再多的「艱辛」也不足以成事。放在最後,但也是我深切感激的,還有我在台南藝術大學幾位不辭辛勞的同事:博物館學者張譽騰教授主持整個策展工作;張教授和古物維護所林春美教授曾先後數度陪同我走訪敦煌和吉美,他為此案南來北往奔波更不計其數;研究佛教藝術史的潘亮文教授和史評所廖新田教授負責編輯圖錄;音樂學院院長鄭德淵教授費力重建敦煌樂器,並自2004年起數度推出敦煌樂展;還有許多無法一一列舉的工作伙伴和關心支持的朋友,都鏤心難忘。「敦煌藝術大展」是一次專業的文化盛宴,但背後我個人承領的無數友誼和協助,在這裡,致上最深摯的謝忱！

Preface

HUANG Pi-twan
President
Tainan National University of the Arts

The eventuation of the Dunhuang Art Exhibition was an accidental happenstance but, in retrospect, also a certainty.

In the late autumn of 2001 when I first set foot on the soil of Mogao Grottoes, Dunhuang, it was supposed to be a visit to Director Fan Jinshi of the Dunhuang Academy, China (DAC) to negotiate extension of the DAC internship program for students at our Graduate Institute of Conservation of Cultural Relics. Actually the DAC and the TNNUA had long had a cordial cooperative relationship with student and staff exchanges and collaborative research, and it was no surprise if we should extend the cooperation in other aspect. However, when I first saw the legendary Dunhuang that I'd read about so much since my childhood, I was bowled over by her beauty, splendor and her rich cultural heritage. It then dawned on me to introduce Dunhuang to Taiwan by way of a spectacular exhibition. This then, was more or less by accident. In our very cordial conversation Director Fan, an archaeologist who had devoted her life to the Dunhuang studies, happily agreed with my suggestion.

In 2002, I visited the Musée national des Arts asiatiques-Guimet which houses many valuable monuments taken from Dunhuang by Paul Pelliot (1878-1945) and also met its director, M. Jean-François Jarrige and M. Jacques Giès, Chief of the Oriental Department who generously agreed to lend us objects from their collections for the exhibition. The Guimet monuments are exceptional both in quality and in numbers and rarely seen in loan exhibitions. For this we owe a special thanks to Guimet research fellow, Mme. Tsao Huei-chung who worked hard to promote the success of the mission. When we were negotiating exhibition time-tables with the National Museum of History, Taipei and the Kaohsiung Museum of Fine Arts in 2004, we received magnanimous cooperation from both former and present directors of each institution, and to all four directors my heartfelt thanks for their unstinting cooperation and assistance. Director Huang Yung-chuan of the National Museum of History, Taipei and his professional colleagues have further lent us two valuable pieces from their collection, and helped us negotiate the loan of fourteen paintings copied from Dunhuang cave murals by the late master Chang Da-chien in the 1920s and since bequeathed to the National Palace Museum. Together with replicas of Dunhuang musical instruments in the collection of TNNUA, the scale and quality of the exhibition have received attention from many quarters. For the first time these monuments scattered across the world are gathered here in this same exhibition, making the event especially significant.

From its inception to its realization three years have already gone by. During this time, the idea of the exhibition has earned great support and cooperation from the graduate institutes of museology, art history and art criticism, conservation of cultural relics, sound and image studies in documentary, animation, and architecture. The graduate institute of ethnomusicology and the department of Chinese music spared no efforts in trying to reproduce Dunhuang musical instruments, as well as their performance. The art consulting firm, L'orangerie International Art Consultant Co.,Ltd. works on the project in tandem with us as our partner. Financial supported by Chairperson Hou-Wang Su-chao and planning by General Manager Chien Tan have been our timely help and positive reinforcement.

Although we have received so much support, I must say, preparing for such a large exhibition is exhausting. Nevertheless, to bring to Taiwan's art lovers something of this unfathomable treasure trove with its nigh two millennia of east-west cultural convergence, religious reverence and outpouring of artistic bounty, as well as records of lives of the people there–for this, any amount of hardship would have been worthwhile. But without the support of the above, all the "hardship" would have come to naught.

Last but also with deepest heartfelt gratitude, are my TNNUA colleagues who have tirelessly persevered throughout the preparations: museologist and Professor Chang Yu-teng who has been responsible for planning the entire exhibition project and who has accompanied me to visit Dunhuang and the Musée Guimet in Paris, as has Professor Lin Chun-mei of the Institute of Conservation of Cultural Relics on various occasions. For this project, Professor Chang has flown back and forth between northern and southern Taiwan for countless times, Professor Pan Liang-wen, an expert in Buddhist Art History, and Professor Liao Hsin-tien of the Graduate Institute of Art History and Art Criticism who edited the catalogue of the Exhibition; Dean Cheng Te-yuan of the School of Music who spent a lot of time on reconstructing those ancient instruments and who has organized Dunhuang Music concerts since 2004; and many other project partners and other friends who have given us their assistance and support.

The Dunhuang Art Exhibition is a professional cultural event. And I wish here to express my deepest appreciation to all those who have by their unstinting support, friendship and assistance made this challenging endeavor possible.

序

黃永川
國立歷史博物館代理館長

敦煌地處大陸西北，是古代中國通往西域的門戶，也是中西文化相通的著名要道－絲路的中繼站。西漢武帝元狩二年（西元前121）開始於敦煌設郡，隋唐時其地又稱沙洲，繁華盛況不減通都大邑，而一直至宋仁宗景佑三年（1036）西夏攻陷沙洲為止，敦煌共歷經了包括北涼、北魏、西魏、北周、隋、唐、五代、宋、西夏、元等十個朝代的統轄，千餘年來薈萃了包括了中國、印度、西亞、中亞（波斯、阿拉伯）等各種多元種族的文化特色，呈現了異彩繽紛的文化景觀。

佛教於東漢明帝時傳入中國，多有高僧東來傳法譯經，敦煌既居西域門戶的樞紐，故成為佛教東傳的的第一站。由於歷代長年爭戰動亂的痛苦，民間逐漸普及接受佛教的信仰觀念。西元366年由北涼早期開始，高僧樂僔於此鑿巖建造了第一龕佛窟，開啟締造了敦煌佛教藝術瑰麗的人類珍貴遺產。自此無數洞窟中結合建築、壁畫與彩塑等綜合的藝術表現，造就了龐大光輝燦爛的佛教藝術寶庫，成為照亮人類恆古文明中的一顆明珠。二十世紀初（1900年）敦煌藏經洞的考古發現，先震撼了西方漢學界，再次於中國文化界產生了重大影響，又是一頁令人滄桑遺憾的歷史。

藏經洞中出土的文物包括帛畫、絹畫、版畫、紙本畫、麻布畫、寫經卷等各類古代文獻，內容廣及建築、雕塑、繪畫、書法、文學、佛學、天文、醫藥、舞蹈、音樂、染織、刺繡等諸多領域，語文書體更遍及漢文、藏文、梵文、回紇文、于闐文、龜茲文、粟特文等。由此世人視敦煌石窟是中國文明千餘年來的一部真實具體的大百科全書，而國際漢學界乃確立了「敦煌學」的重要學術地位。迄今大致完好保存的四百九十二座石窟藝術，於1989年更為聯合國教科文組織列為世界文明遺產，自此成為世人爭相朝聖的藝術文化殿堂。

敦煌，原本是一個空間地理的位置，由此乃轉化成一個代表永恆不朽的人文歷史名詞。她是人類歷史文明中的光輝見證，更充滿著異域文化雄偉、浪漫、神秘、華麗，以及歷史承傳的多元意象。在國際化文化交流頻繁的今日，將地處偏僻的敦煌以及其豐富的文化內涵，對海角一嶼的國人作一精要的訊息傳達，自為文化社教推廣至為重要的一項工作。

國立台南藝術大學有鑑於此，特於兩年多前即開始聯繫籌畫此一深具意義的文化活動，並積極與本館洽商合作，共同策劃展出本次敦煌藝術大展。此次展出之主題單元共劃分為佛教藝術、敦煌舞樂、社會生活、建築藝術、服飾紋樣、壁畫摹本、文物原蹟等數單元；展品來源包括法國吉美美術館典藏敦煌絹畫真跡十餘件，大陸敦煌研究院提供敦煌出土之國家一、二級文物二十餘件、壁畫原蹟摹本三十餘件、敦煌實景模擬洞窟三座；另外尚有台北故宮博物院典藏張大千先生敦煌摹本精作十二件、台南藝術大學提供敦煌樂器展品二十餘件，以及本館典藏敦煌唐人寫經殘卷兩件、佛畫摹本二件等，共彙集五個文教機構之重要藏品達百餘件。其中法國吉美美術館所提供來台展出之敦煌絹畫真跡，更是自敦煌藏經洞現世，法國人伯希和（Paul Pelliot）於1908年攫取敦煌文物珍藏數千件回法國以後，首次赴國外展出。

本次敦煌藝術大展可說是國內外近數十年來，以敦煌為主題展出之內容最豐富、最多元、最精華的一次重要展覽。本館深感榮幸能共襄承辦這次盛會，在此除了感謝不吝共襄借展的各博物館機構外，更要特別向台南藝術大學的黃校長碧端致意；她率同校方多位同仁，兩年餘來為此次盛大之展出活動奔走策劃，付出無數心力，終能促成這次重要的國際交流展出。另外還要感謝同樣貢獻心力，協辦出資的橘園藝術公司、其他各公私立贊助單位，以及辛苦參與工作的同仁，由於他們無私的付出才有這次盛大的文化饗宴。在此預祝展出活動順利成功，並呼籲對敦煌珍貴的藝術文物有心認知學習的國人，千萬不可錯過這次在台展出的機會！

民國九十四年三月於台北南海學園

Preface

HUANG Yung-chuan
Acting Director
National Museum of History, Taipei

Dunhuang is situated in northwestern China, the gateway to the Western world in ancient China and the transit of the famous cultural exchange channel in history–the Silk Road. Emperor Wudi of the Western Han Dynasty (206 B.C.-A.D. 24) established the Dunhuang County in Yuansho Second Year (121 B.C.). It was known as the Shazhou during the Sui (581-618) and Tang (618-907) dynasties. The city was as flourishing as many big cities leading to the capital until it was seized by the Western Xia Regime (1038-1227) in Jingyiu Third Year (1036) of Emperor Renzong of the Song Dynasty (960-1279). Dunhuang has been ruled by ten different dynasties in ancient China, including the Kingdom of Northern Liang (401-439), the Northern Wei Dynasty (368-534), the Western Wei Dynasty (535-556), the Northern Zhou Dynasty (557-581), the Sui Dynasty (581-618), the Tang Dynasty (618-907), the Five Dynasties (707-960), the Song Dynasty (960-1279), the Western Xia regime (1038-1227) and the Yuan Dynasty (1271-1368). Over a thousand years, Dunhuang has become a melting pot of the Chinese, Indian, West Asian and Central Asian (Persian and Arabian) cultures that has represented a multicultural scene.

When Buddhism spread to China during the regime of Emperor Ming in the Eastern Han Dynasty (25-220), many eminent monks went to China to spread Buddhism and translated the sūtras. As the hub between the west and east, Dunhuang became the first stop for Buddhism to enter into China. Having suffered from the pain of the long warring period, Buddhism was immediately accepted by the Han people at that time. It was monk Yuezun who dug the first Buddhist grotto here in year 336 during the Kingdom of Northern Liang, initiating the flourishing Buddhist art of Dunhuang. Countless of grottoes combining architecture, murals and painted statues were built in this area in the following one thousand years and have created innumerable splendid Buddhist art treasures and the civilization that shines over human history. The discovery of Mogao Grottoes at the turn of the twentieth century (1900) first shocked Western sinologists and then started a new cultural influence on China which filled with vicissitudes and regrets.

The artwork unearthed from the Cave no.17, Mogao Grottoes include paintings on silk, woodblock paintings, paper paintings, paintings on linen, sūtras and all kinds of ancient documents with contents covering architecture, sculpture, painting, calligraphy, literature, Buddhism, astronomy, medicine, dance, music, dyeing and textile, embroidery etc. Languages used in these documents include Chinese, Tibetan, Sanskrit, Uigurisch, Khotan, Qiuci, Sogdian etc, suggesting that Dunhuang Grottoes are a walking encyclopedia of one thousand years of Chinese culture. Today, the Dunhuang Studies has become an important discipline in Sinology. The four hundred and ninety two well-preserved caves in Dunhuang were included by the United Nations Educational, Scientific and Cultural Organization (UNESCO) on the World Heritage List in 1989. Dunhuang has then become the "holy place" for art and culture pilgrims.

Dunhuang, originally is only a location in geography, but now has become a proper noun for immortal culture and history. She represents the brilliance of human history and civilization and fills with the splendor, romanticism, mystery, magnificence and heritage of exotic cultures. In a time when the exchange of international culture is getting increasingly vigorous, it is one of the important tasks in the cultural and social education promotion to introduce Dunhuang and her rich cultural contents to people in Taiwan.

Seeing the mission of cultural promotion, the Tainan National University of the Arts thus began to prepare such a meaningful cultural event two years ago through close cooperation with the National Museum of History in order to ensure the success of the Dunhuang Art Exhibition in Taiwan. The exhibition will be presented in terms of the following topics: Buddhism Art in Dunhuang, Dunhuang Dance and Music, Social Life in Dunhuang, Architectural Art in Dunhuang, Costumes and Tokens of Dunhuang, and Dunhuang Monuments and Relics. Over one hundred exhibits from five institutions will be displayed, including over ten genuine paintings on silk collected by the Musée national des Arts asiatiques-Guimet, France; over twenty Class 1 and Class 2 national treasures, over thirty genuine fresco copies, and three virtual reality grottoes from the Dunhuang Academy, China; twelve Tunhuang fresco replicas by Chang Dachien collected by the National Palace Museum; over twenty musical instruments from the Tainan National University of the Arts; and two sūtra manuscript fragments by Tang people and two Buddhist painting copies collected by the National Museum of History. The paintings on silk collected by the Musée national des Arts asiatiques-Guimet are displayed outside France for the first time since they were discovered in Dunhuang and seized by Paul Pelliot in 1908.

The Dunhuang Art Exhibition in Taiwan is the one with the richest, most comprehensive and most essential contents since the last few decades. It is our great honor to have the opportunity to sponsor this exhibition. In addition to expressing our gratitude to the museums and institutions for their generosity to lend us their valuable collections, special thanks should be given to President Huang Pi-twan of the Tainan National University of the Arts and to her colleagues who have spared no pain to plan and prepare the exhibition for the past two years to ensure the success of this international cultural exchange. We would also like to express our thanks to L'orangerie International Art Consultant Co., Ltd. and other public and private sectors that have sponsored the event and the colleagues who have participated in the planning and preparation of this exhibition. Without their devotion and support, this exhibition would not have been possible.

Wish this exhibition with big success and welcome everyone to this exceptional Dunhuang Art Exhibition.

March 2005 at the Nan-hai Cultivate Garden

序

樊錦詩
敦煌研究院院長

　　自1900年敦煌莫高窟藏經洞秘藏之文物被發現，世人開始了敦煌藏經洞文獻之研究，成為「此時代學術之新潮流」。其母體敦煌莫高窟之藝術也隨之被世人所重視。畫家韓樂然、李丁隴、王子雲、何正璜、張大千等先後來到敦煌，開始了他們個人對敦煌壁畫的臨摹和研究。至1944年著名油畫家常書鴻率領一批青年藝術家來到大漠戈壁，在莫高窟建立了國立敦煌藝術研究所（敦煌研究院前身）之後，敦煌壁畫和彩塑有計劃的臨摹由此開始，標誌著敦煌學已由敦煌文獻的研究拓展到包括臨摹在內敦煌石窟的研究，「敦煌學」這個新潮流也隨之得到發展壯大。

　　二十世紀四○至六○年代的敦煌研究院，不僅沒有現在的攝影設備和資訊設備，而且連城市中普遍使用的電燈都沒有。就是在這樣的條件下，敦煌研究院的藝術家們克服困難，埋頭苦幹，默默無聞地完成了近二千幅壁畫摹本和數十件彩塑摹本，與此同時，在國內外多次舉辦敦煌藝術展覽。這些摹本和展覽，使遠在西北戈壁沙漠中的敦煌藝術瑰寶向世人嶄露其卓絕風姿，敦煌藝術的珍貴價值和歷史地位也逐漸被人們重視，吸引了越來越多的敦煌藝術研究者。四○年代以前的中國美術史著作，幾乎沒有介紹過敦煌藝術，更談不上研究。到五○年代以後，凡研究中國傳統美術者，無不充分肯定敦煌藝術在中國美術史上的地位和價值。應該說，敦煌研究院從臨摹起家，世人認識和研究敦煌藝術發端於敦煌壁畫和彩塑的臨摹及展出。今天奉獻給敦煌藝術大展的原尺寸模型石窟以及壁畫和彩塑摹本，就是投身於敦煌研究院的幾代畫家在陰冷的洞窟中，以他們的執著、堅韌和心力澆灌而成的，凝聚著敦煌藝術之美和藝術家之愛。

　　國立台南藝術大學是以培養現代和古代各個藝術領域創作和研究高級人才著稱的高等學校，著名作家黃碧端校長為發揚和吸取傳統優秀文化藝術之精華，幾次組織師生來敦煌考察和交流，並與敦煌研究院建立了良好的合作關係。為加強交流與合作，黃校長提議在臺灣舉辦敦煌藝術大展，得到本院支援後，又為籌展的各項事宜奔忙，終於促成了展覽的如期舉辦，我們感謝黃校長和國立台南藝術大學的師生為舉辦大展所付出的努力，也要感謝素以展出精品著稱的臺北國立歷史博物館和高雄市立美術館為大展提供良好的場館。

　　祝敦煌藝術大展展出成功。

2004年12月12日于敦煌莫高窟

Preface

FAN Jinshi
Director
Dunhuang Academy, China

"A new academic trend of the epoch" started when people began to study the artistic and literary treasures found inside Mogao Grottoes in Dunhuang in 1900. Artworks unearthed from the Cave no.17, Magao Grottoes, the biggest of all Dunhuang caves, that has caught immediate global attention. Though artists like Han Leran, Li Dinglong, Wang Ziyun, He Zhenghuang and Chang Da-chien started the study and imitation of the Dunhuang frescoes after visiting the caves, it was not until a group of young artists headed by famous oil painter Chang Shuhong came to the great dessert of Gobi and founded the National Dunhuang Academy of Fine Arts (the forerunner of Dunhung Academy, China) in 1994 that a well-established imitation plan of the frescos and painted statutes in the caves began. This marked the transformation of the study of the artistic and literary treasures in these caves from literature study into a new discipline and promoted the burgeoning of the Dunhuang Studies.

There was neither video nor computer as we have today at the Dunhuang Academy, China back in the forties to sixties, not even the street lamp in the city. Though the condition was backward then, artists of the Dunhuang Academy overcame all difficulties and finished duplicating nearly two thousand paintings and tens of painted statutes found in the caves with unostentatious hard work. At the same time, many exhibitions on Dunhuang art were held home and abroad to display the unsurpassable charm and wonder of these artistic treasures in the Dunhuang Grottoes, at the edge of the Gobi desert in northwest China. The artistic and historical values of these unrivalled artworks gradually gained global attention and attracted more and more scholars devoting to the Dunhuang Studies. Though Dunhuang art was hardly mentioned in works on Chinese art history published before the forties, and the study Dunhuang art was never a focus then, people studying traditional Chinese art must assure the status and value of Dunhuang art in Chinese art history since the fifties. In fact, the Dunhuang Academy started the study of Dunhuang art from copying, and people began to recognize and study Dunhuang art from the replicas and exhibitions of the frescoes and painted statutes found inside the Dunhuang Grottoes. Today, duplications of the grottoes and painted murals in original size and shape displayed at the Dunhuang art exhibition are the results of the devotion, tenacity and diligence of artists working inside the cold and dim grottoes over generations. They are also the reincarnation of the beauty of Dunhuang art and the passion of artists.

The Tainan National University of the Arts aims at cultivating artists and scholars in modern and classical arts. President Huang Pi-twan, also a famous writer, has organized investigation teams with teachers and students to visit Dunhuang to absorb the essence of the excellent Dunhuang art and has established a good cooperation relationship with the Dunhuang Academy. President Huang also proposed the organization of the Dunhuang Art Exhibition in Taiwan to reinforce cultural exchange and cooperation. After receiving the support from the Dunhuang Academy, President Huang has spared no pain to ensure exhibition be held as scheduled. I would express my gratitude to President Huang, the staffs and teachers of the Tainan National University of the Arts for their efforts to make the Dunhuang Art Exhibition in Taiwan a reality. Special thanks should be given to the National Museum of History and the Kaohsiung Museum of Fine Arts for the provision of well-conditioned venues.

Wish the Dunhuang Art Exhibition in Taiwan a success.

12 December, 2004 at Mogao Grottoes, Dunhuang

序

賈立基
法國國立亞洲藝術-吉美博物館館長

時逢台灣首次大型敦煌展覽，吉美博物館很高興能參與其中。國立台南藝術大學是聞名的學術機構，吉美博物館能提供伯希和收藏之敦煌文物，並與中國的敦煌研究院等協辦機構共襄盛舉，實在深感榮幸。

伯希和於1906年遠赴中國西陲邊境展開其龐大的探險之行，雖然在他之前，俄國、英國、德國及日本已開始研究佛教如何從印度越過亞洲內陸，傳至遠東地區。但是伯希和這位偉大的法國學者精通多國語言，他回到法國後，畢生致力於研究他在敦煌第17窟密室發現的經卷及繪畫，成為一代大師。他的學術研究蔚然成風，諸多法國研究機構步其傳統，例如他任教多年的法蘭西學院、法國國家圖書館，特別是吉美博物館更在十年前出版伯希和收藏文物全集[1]。近年來，吉美博物館有幸參與安德魯‧梅隆基金會主持的一項大型計劃，與世界各大文化及學術機構合作-尤其是與中國的敦煌研究院，開建網站，首度匯集所有有關敦煌石窟的文獻圖像資料及原始內容。

二十世紀研究的重點之一一直都是嘗試重建當時位于中亞的諸宗教中心—尤其是敦煌，與中亞邊境以外的文明之關係。但是許多學術機構以及吉美博物館所耕耘的研究具有同樣的重要性，透過分析比較，確認了中亞文化對於整個亞洲佛教藝術之圖像主題、形式以及製作技巧的貢獻。國立台南藝術大學舉辦的敦煌展展出許多難得外借的古文物，對於想了解中亞璀璨佛教藝術的觀眾，實屬難能可貴的機會。

1. 吉埃，1996，《中亞藝術，法國國立亞洲藝術-吉美博物館之伯希和文物》，巴黎，國家博物館聯合會。

Preface

Jean-François Jarrige
Director
Musée national des Arts asiatiques-Guimet, Paris

Musée Guimet is greatly pleased to take part in the first major exhibition ever organized in Taiwan on Dunhuang. The Tainan National University of the Arts is a well-known artistic institution and we are happy that the loans from the Pelliot collection from Musée Guimet can contribute to the success of this exhibition along with several other major contributors such as the Dunhuang Academy in China.

Let us just recall that Russians, English, Germans and Japanese had already begun to study the diffusion on Buddhism from India to Far East through Inner Asia before 1906 when Paul Pelliot undertook his great expedition on the western borders of China. But the great French scholar with his exceptional command of many languages, after his return to France, played throughout his life a leading part in the studies of the manuscripts and painting that he had gathered during his visit to the hidden library kept in Cave no. 17 at Dunhuang. He has set a scholarly tradition followed by several French institutions such as College de France where he taught for many years, the National Library of France and in particular Musée Guimet where ten years ago a major publication of the Pelliot Collection was completed[1]. More recently Musée Guimet was happy to take part in the very large scale project led by the Andrew C. Mellon Foundation with many cultural and scientific institutions in the world and in particular with the Research Institute of Dunhuang in China to build a website bringing together for the first time all the data available on the caves of Dunhuang and their original contents.

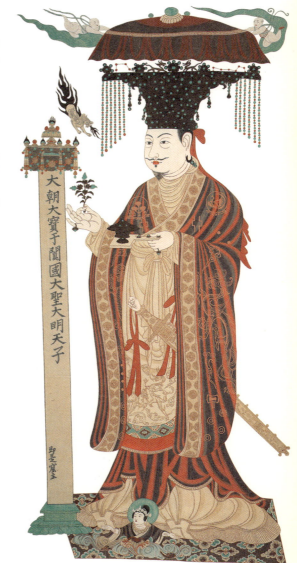

Tho reconstruct the links of the religious establishments of Central Asia and in particular of Dunhuang with the civilizations situated beyond the borders of Central Asia has always been an important aim of the research carried out all over the twentieth century. But it has also be very important through analytical studies which have been conducted in several institutions and in Musée Guimet to recognize the major contribution of the culture of Central Asia to the iconographic themes, forms and technical skill of the Buddhist art at the scale of the whole Asia. The exhibition on Dunhuang organized by the Tainan National University of the Arts is a great occasion to provide the visitors through this exceptional display of major original artworks, seldom travelling outside the places where they are kept today, with the opportunity to assess the outstanding quality of the Buddhist art of Central Asia.

1. Giès J., 1996. <u>Les art de l'Asie centrale, La collection Paul Pelliot du Musée national des Arts asiatiques-Guimet</u>. Paris. Réunion des Musées Nationaux.

序

李俊賢
高雄市立美術館館長

與洛陽龍門石窟、大同雲岡石窟並稱中國三大石窟的敦煌莫高窟，現存的洞窟是歷經了北涼、北魏、西魏、北周、隋、唐、五代、宋，直至西夏、元，在從五世紀到十四世紀的一千多年間漫漫塵煙中刻鑿而成。

敦煌藝術包含了繪畫、雕塑與建築，主要內容是以描寫形容佛教經典內文為主。從這些不同時代的風格與技巧中所呈現的，是對於宗教信仰的崇敬與感恩，也是對於現世生命與極樂世界的協調與想像。表現於壁畫中的菩薩、供養人、山川，或是擬態肖真的神佛、羅漢塑像，都在莊嚴與慈愛之中、溫恭與孺慕之間、寫實與幻想之外達到極高的藝術成就。而這些現存的古代珍貴資料，也成為一門包含了佛教史、繪畫史、雕塑史、社會史等研究的「敦煌學」。

敦煌位於絲路的必經要衝，漢元鼎六年（西元前111）設置了敦煌郡，與酒泉、張掖、武威相連並稱河西四郡，這一條絲路連接了古代中西文明，在文化交流的歷史意義上，輝煌而深遠。在《法顯傳》中提到：「沙河中多有惡鬼、熱風，遇則皆死，無一全者。上無飛鳥，下無走獸，遍望極目，欲求度處，則莫知所擬。唯以死人枯骨為標識耳。」對照於前人的艱辛苦難，我們非常感謝敦煌研究院與法國吉美博物館（Musée Guimet）千里迢迢帶來這一次精彩的展覽，從陸路與海上攜來敦煌千年的荏苒光陰，讓南部的民眾無須跋涉過散時如雨的驚風擁沙，無須渡過人鳥俱絕的四顧荒漠，就能親聆此瑰麗莊嚴的大千世界。

此次展出共有一百多件展品，其中包含了多件國家一、二級文物，並且將在現場重現莫高窟盛唐第45窟、晚唐第17窟、元代第3窟等，使觀眾能夠在不同時代的洞窟中所呈現出的殊異光景與風格中靜默懷想，感受其彈指剎那的流逝易變。在此並要特別感謝共同主辦單位國立台南藝術大學與國立歷史博物館為此展所付出的心力，特向他們表達由衷感謝之意。

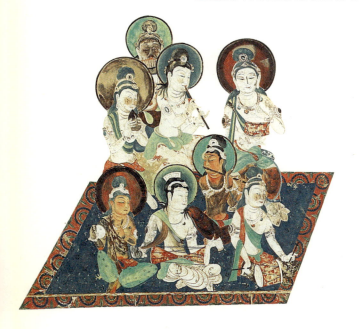

Preface

LI Jun-shien
Director
Kaohsiung Museum of Fine Arts

The Mogao Grottoes in Dunhuang, Lungmen Grottoes in Loyang, and Yungang Grottoes in Datong are known as the three great grottoes in China. The surviving caves in the grotto areas are built during the fifth century through to the fourteenth century, from the Kingdom of Northern Liang (401-439), through the Northern Wei Dynasty (368-534), the Western Wei Dynasty (535-556), the Northern Zhou Dynasty (557-581), the Sui Dynasty (581-618), the Tang Dynasty (618-907), the Five Dynasties (707-960), the Song Dynasty (960-1279), to the Western Xia regime (1038-1227) and the Yuan Dynasty (1271-1368), with a span of over a thousand years.

The Dunhuang Art covers painting and sculpture on topics in Buddhist sūtras and documents. These works of different styles and techniques from different periods of time express the artists' respect and appreciation toward religion and their harmony and imagination of the existing world and the Sukhāvatī (the Western Paradise). In addition to the solemnity and mercy, respect and admiration, realism and imagination as shown in the bodhisattvas, providers, mountains and rivers appeared in the murals or the vividly depicted portraits of gods, Buddha and Arhat, we can see superior art achievements. These surviving valuable ancient data also form a new discipline known as the Dunhuang Studies which covers the areas of Buddhism history, art history, sculpture history and social history.

Located at the hub of the Silk Road, the Han Court established four counties in Dunhuang in Yuanding sixth Year (111 B.C.). As these counties, Jiuquan, Tunhuang, Zangyi and Wuwei, were connected with one another, they were called the Hexi Szejun (the four counties of Hexi). As the Silk Road represented the meeting point of the Western and Eastern cultures in the past, it played a glorious and far-reaching role in the ancient time. According to a passage from the Story of Buddha Kingdom, "There were malicious ghosts and hot winds in the sand river that killed anybody who approached, and no one ever survived! There were neither birds in the sky nor animals on ground. There was nothing ahead, except the skull of the dead as sign of direction." Comparing with the hardships of our ancestors, we appreciate the courtesy of the Dunhuang Academy, China and the Musée national des Arts asiatiques-Guimet of France to bring us such a wonderful exhibition, so that people living in southern Taiwan can appreciate the splendor of the universe of Dunhuang in the distant past without traveling through the unexpected dangers in the desert or the deserted areas.

Among those hundred exhibits, there are first class national treasures and the reconstruction of Cave no. 45 built in the Great Tang High Dynasty, Cave no. 17 built in the Late Tang Dynasty and Cave no. 3 built in the Yuan Dynasty, so that audiences can experience the exotic atmosphere and style of the past and the transience of time. I would like to express my gratitude to the co-sponsors of the event, the Tainan National University of the Arts and the National Museum of History, Taipei for their efforts and devotion for the exhibition.

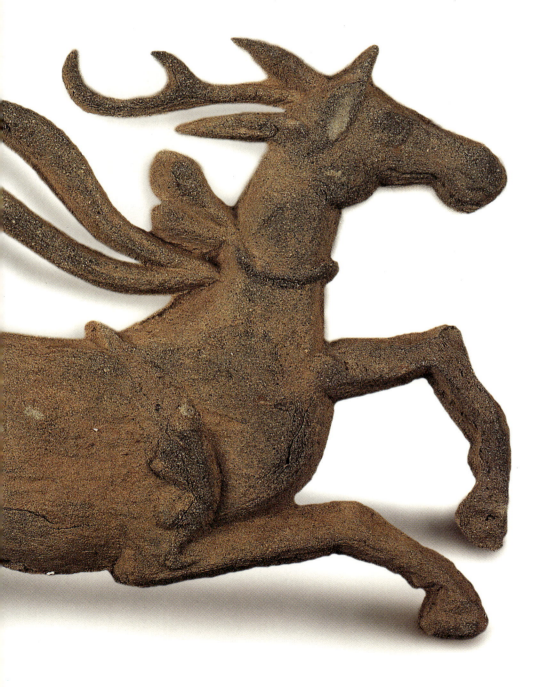

專文 Essays

《敦煌藝術大展》總論

樊錦詩　敦煌研究院

一、敦煌石窟是多種文化交匯的結晶

敦煌，位於我國甘肅省河西走廊西端，作為古代絲綢之路的重鎮，迄今有文字記載的歷史已有兩千多年。它總綰中西交通的咽喉之地，地當南北要衝。由敦煌出發，向東經過河西走廊，抵達漢唐古都長安、洛陽；向西通過西域，可進入中亞、西亞、南亞，乃至歐洲的羅馬；向北翻過馬崇山，可到北方草原絲綢之路；向南越過阿爾金山，可接唐蕃古道。敦煌在絲綢之路的關鍵性樞紐位置，使它占有重要的歷史地位。因此，它一直是東西之間的商品貿易中心，文化交流中心。

古敦煌郡區域開鑿的莫高窟、西千佛洞、榆林窟等石窟，都可歸入敦煌石窟的範疇。著名的世界文化遺產寶庫—敦煌莫高窟是其中最傑出的文化遺產，保存至今的七百三十五個洞窟，四萬五千平方公尺壁畫、兩千多身彩塑，及其藏經洞出土的五萬多件文物，不僅記錄了中古時期敦煌、河西走廊和西域的歷史，而且是中西文化交融的結晶。這些珍貴資料告訴我們：在中古時期，中國、印度、希臘、伊斯蘭文化在此匯流，羌戎、烏孫、月氏、匈奴、鮮卑、吐谷渾、吐蕃、回鶻、粟特、于闐、黨項羌、蒙古、漢等民族先後在敦煌聚居，創造了他們各自的文化。中原的儒教和道教、印度的佛教、波斯的摩尼教、粟特人的祆教（拜火教）以及西方早期基督教中的景教都先後傳入敦煌。敦煌莫高窟及其藏經洞內容浩繁的歷史遺存所蘊含的訊息是百科全書式的，具有豐富性、多元性、世界性。它形象地記載了歐亞文明互動、中原民族和少數民族文化交融；反映了五至十四世紀一千多年間佛教藝術的流傳及演變；保存了豐富生動的的中外藝術形象及藝術的源流傳承；展示了中古時期廣闊的經濟、文化、科技等社會生活場景。此次展覽展示了敦煌石窟的佛教藝術以及其中的音樂、舞蹈、建築、服飾藝術。

二、燦爛的佛教藝術

佛教藝術是敦煌石窟的主體。敦煌石窟藝術是集建築、彩塑、壁畫於一體的綜合藝術。石窟建築形制根據其內容、功能之不同而變化。彩塑是石窟藝術的主體，崇拜的主要偶像，置於石窟佛龕內外，或佛壇上最顯著的位置，並與周圍的壁畫內容相連。壁畫是敦煌石窟藝術的重要組成部分，適於表現複雜的場面和豐富的內容。石窟內的佛龕、四壁和窟頂佈滿色彩繽紛的壁畫，與居於主體位置的彩塑互相輝映，相得益彰，共同構成完整的石窟藝術。

敦煌早期佛教藝術是發展時期，包括北涼、北魏、西魏、北周四個時代。石窟建築形制有中心塔柱窟、禪窟、殿堂窟等。彩塑像有佛、菩薩、弟子，分別作一、三、五身組合。壁畫有表現佛教諸神的尊像畫、表現釋迦牟尼過去和現在世的本生、因緣和本行的故事畫、傳統神話人物畫、裝飾圖案與出資開窟造像的供養人畫像等。前期人物造型雄健，面相豐圓，身著袒裸式的衣冠服飾，壁畫採用表現明暗的凹凸法，表現人物面部和肌體的立體感，這是受西域佛教藝術影響的風格特徵。其後期人物身材修長，相貌清瘦，身穿漢式方領深衣大袍，面部以民族傳統暈染法在面部塗色，這種風格是傳自於中原的新風。

敦煌中期佛教藝術為隋唐時期，此時形成了中國式的佛教宗派、佛教思想、佛教信仰、佛教藝術。敦煌石窟進入鼎盛時期。石窟建築以窟內正壁或三壁開龕，或設中心佛壇的殿堂窟數量最多，還有窟內塑涅槃像的涅槃窟、塑大佛像的大像窟等。

彩塑像數量和內容都有較大發展，一般石窟佛龕的主佛兩側有弟子、菩薩，有的增加天王、力士或供養菩薩像，其數量少則三身，多則十一身。數量最多的為佛涅槃像及其舉哀者組成的群像。最引人注目的彩塑像為身高35.5公尺的北大像和身高27.3公尺的南大像。隋唐時期特別是盛唐的彩塑臻於嫻熟與完美。通過對人物形象、衣冠服飾、體態動作、面部表情細緻入微的刻畫，成功地塑造了許多比例準確、衣飾華麗、造型健美、神情鮮明的形象，成為具有永恆魅力、經久傳世的典範不朽之作。展品中，依原尺寸製作的莫高窟盛唐第45窟模型窟是唐代彩塑的代表作品【圖錄號1】。

壁畫出現了中國佛教藝術獨創的形象概括地表現大乘佛教思想的經變畫，及西域傳入和受西域影響而產生的中國佛教瑞像和感應故事畫等新的題材內容。經變畫有表現淨土思想的阿彌陀經變、無量壽經變、觀無量壽經變、彌勒經變、東方藥師經變等，如莫高窟第45【圖錄號1】、172【圖錄號17】窟、榆林窟第25窟的觀無量壽經變【圖錄號4】，榆林窟第25窟彌勒經變【圖錄號5】，都是極樂淨土經變的傑作；有表現天臺思想的法華經變，如莫高窟第217【圖錄號7】、103【圖錄號8】、23【圖錄號9】、156【圖錄號10】窟法華經變；以各種譬喻表現一切眾生都能成佛的思想，如莫高窟第335窟表現眾生都能成佛的維摩詰經變【圖錄號6】；有反映禪宗思想的天請問經變、金剛經變等；有表現持咒誦經、祈福禳災的密教畫，如第321窟十一面觀音經變【圖錄號12】、莫高窟第3窟原尺寸模型窟【圖錄號3】及其千手千眼觀音經變【圖錄號15】等。新興的經變畫通過雄偉壯觀的宮殿樓閣，綺麗多姿的山水景致創造遼闊的境界，運用豐富燦爛的色彩營造金碧輝煌的氛圍，並細膩地刻畫佛國世界的各類人物，形象生動地表現了不同佛國淨土的聖潔美妙。經變畫充分地展示了中國佛教繪畫藝術的構圖、敷色、透視、傳神等藝術的高度成就。瑞像和感應故事畫來自天竺（印度）、于闐（中國新疆和闐），如犍陀羅釋迦雙頭瑞像、于闐毗沙門天王與舍利弗決海，有中國本土的佛教傳說故事畫，如莫高窟第323窟的中國西晉淞吳淞江石佛浮江和迎佛的感應事蹟畫【圖錄號36】等。

除佛教藝術的題材外，還有展示了真實的歷史畫卷，在晚唐第156窟繪畫了收復河西失地建立功勛的首任歸義軍節度使張議潮【圖錄號34】及其宋國夫人出行圖【圖錄號35】。這個時期壁畫藝術經過隋代不同風格的探索，唐代臻於嫻熟精湛。唐前期繪畫色彩富麗，人物豐潤，肌勝於骨，呈現一派雄渾健美、生機勃勃的氣派。吐蕃時期構圖嚴謹、色彩明快，線描精細柔麗，人物刻畫細膩，形成精緻淡雅的風格。晚唐開始出現公式化趨向，已缺少意境和情趣。

敦煌晚期佛教藝術包括五代、宋、西夏、元代四個時代。此時的佛教藝術已呈衰退趨勢，石窟建築形式與彩塑藝術無甚創新。由於繼續受到中原繪畫藝術和藏傳佛教藝術影響，壁畫仍不乏精品佳作。五代至宋初開鑿一批大型石窟，其規模超過前代，經變畫內容大都一如前代，但在大型石窟中經變畫規模之大，入畫內容之多超過前代，而總的趨勢是經變種類逐漸減少，公式化現象日趨嚴重。圖錄號第19號的部分五臺山圖，原作繪於五代建造的大型石窟第61窟之後壁，畫面分三層：上層主要表現想像的天空幻化神變；中層表現神人交往的佛教活動場所，有大量寺院、樓閣蘭若、茅庵塔廟，有天空神變、佛像、修行的和尚，善男信女；下層表現五臺山區域內從山西太原到河北正定間的城市縣鎮、關隘道路、店鋪旅舍、名勝古蹟、送貢宗教活動等。五臺山傳說是文殊師利菩薩的道場，因為歷史悠久，信徒眾多，影響廣泛，至唐代已成佛教聖地，五臺山圖便應運而生，傳播各地；西域、東亞新羅、日本、吐蕃各地競相求取此圖。畫幅巨大，內容豐富，意境深遠，又是一幅難得的山水畫。展品展現的是五臺山圖右側之部分：上部書寫「東台之頂」，其左側和中部有若干

大寺院，如「大建安之寺」、「大佛光之寺」，下部右端是「河北道鎮州」（現河北省正定）及「鎮州城西大悲閣」，出鎮州城有「湖南送供使」、「高麗王使」正往五臺山巡禮，他們的前方是「石觜關鎮」和「石觜關門」，畫面左端是「河北道山門東南路」，此圖有重要的史料價值。

此外，五代至宋初在一些大型石窟內以大幅畫面表現久已不畫的釋迦牟尼本生、因緣和本行故事畫，護法題材四大天王等。以往高不及尺的供養人像，此時數量增加，形象更為高大，如莫高窟第98、61窟的于闐國王李聖天【圖錄號25】、于闐王后曹氏、回鶻公主供養像【圖錄號26】，都是高於真人，身份顯赫，服飾不一的大幅肖像畫，其中于闐國王像高達2.29公尺。上述壁畫是在畫院畫師或畫行畫匠帶領下繪製，形成了統一的風格。壁畫人物肌肉豐腴，設色熱烈，線描豪放，但失之粗糙簡率。

西夏、元代的佛教藝術也近尾聲，但仍佳作不斷。榆林窟第2窟西夏繪畫的兩幅風格迥異的水月觀音圖【圖錄號13、14】，觀音坐於水邊岩石上，有大如圓輪的白色身光，身後幾枝修竹，插著楊柳枝的淨水瓶置於一旁石桌上，天邊一彎新月，上空浮雲飄浮。其中一幅右下角還畫有迄今最早的唐僧取經圖。此畫無論人物造型、山石雲氣、線描敷色、結構佈局、意境神韻都是不可多得的作品。莫高窟第3窟元代繪畫的千手千眼觀音【圖錄號15】，是一幅採用多種線描造型的漢密風格的優秀作品。莫高窟第409窟回鶻國王供養像【圖錄號27】、榆林窟第29窟黨項羌女供養人像【圖錄號28】，反映了敦煌晚期少數民族的佛教活動。

三、佛國世界的仙樂曼舞

據佛教經典云，「伎樂供養」，即樂舞供養，是對佛的十種供養之一。出於禮佛、娛佛與弘揚佛法，每每佛教藝術中出現很多的樂舞形象。敦煌石窟保存了從十六國到元代極其豐富的樂舞形象，為我們展現了千年連續不斷的樂舞發展變化的面貌。這些樂舞形象可分為佛國世界的天樂舞和人間的俗樂舞兩大類。天樂舞，即我們常說的伎樂天，包括天宮伎樂、飛天伎樂、化生伎樂、護法伎樂、經變畫伎樂等等。人間俗樂舞，包括供養人樂伎、出行圖樂伎、宴飲圖樂伎等等。壁畫展現了吹奏樂器、拉弦樂器、彈撥樂器、打擊樂器，共四十四個品種的數千件樂器形象。每個洞窟無不是仙樂飄飄，舞姿婆娑的景象。早期的樂舞多為單身表演，人物形象多健壯而樸拙，樂器畫得較為簡略，樂舞帶有明顯的印度、西域及北方游牧民族的風格。中期唐代以繼承創新、兼收並蓄、融通中外、擷取精華的恢弘氣度，開創了中華民族樂舞的黃金時期，多民族交融的樂舞文化，各種舞蹈類型及河西地區的鄉土風情在壁畫中都得到了生動的反映。這時大鋪經變畫都繪有反映佛國世界的樂舞畫面，成為敦煌樂舞畫的主體，表現了樂隊合奏，各種不同風格的舞蹈，它是唐代宮廷樂舞曲折的生動再現。

唐代樂伎和舞伎體態豐腴，容貌端麗，衣飾華美。樂舞動作準確，姿態協調。樂器描繪精緻寫實，裝飾華麗。如著名的唐貞觀十六年（642）莫高窟第220窟樂舞圖【圖錄號29、30】，是不同巾舞的表現。南

壁的阿彌陀經變二舞伎作「吸腿」姿立於小圓毯上，雙手一上一下對稱揮巾起舞，兩側各有八個樂伎伴奏；北壁藥師經變在明亮的燈輪和燈樹照耀下，中間四個舞伎站在小圓毯上執巾翩翩起舞，左面一組身著似盔甲的軍裝，舞姿雄豪剛健，右面一組舞姿優美舒緩，從風格上看，前者爲「健舞」，後者爲「軟舞」，兩側分別有十五和十三個樂伎組成的樂隊坐在方毯上伴奏，演奏的樂器有豎笛（二）、橫笛（三）、篳篥（二）、海螺、排簫、箜篌、笙、箏、花邊阮、鐃、鑼（二）、拍板（三）、方響、腰鼓（三）、答臘鼓、雞婁鼓、羯鼓、都曇鼓。這是樂伎和舞伎最多、繪製最精緻寫實的樂舞圖。

　　莫高窟盛唐第320窟北壁樂舞【圖錄號32】則是又一種巾舞，在八人樂隊伴奏下，一個舞伎足踏方毯，左腿直立，右腿盤靠左膝，雙手抓巾作優美的「順風旗」舞姿。莫高窟中唐（吐蕃占領時期）第112窟繪製的反彈琵琶圖更是聞名於世，兩側六人樂隊伴奏，中央舞伎面部豐腴，表情溫婉，肩披長巾，左腿曲立，右腿提起，並腳部上勾，大拇指用力翹起，反背琵琶於腦後，兩手曲於身後，一手撥弦，一手按弦，舞姿獨特，造型俊美。有專家認爲是受吐蕃舞蹈的影響【圖錄號33】。榆林窟中唐第25窟觀無量壽經變中的腰鼓舞樂場面是在八個樂伎的伴奏下，手挽長巾、衣飾華麗的舞伎，在方形地毯上起舞，肩上掛腰鼓，伸展雙臂，張開五指，奮力擊鼓，腿部作跳騰之勢，長巾隨節奏回轉流動，舞姿矯捷健美，全身充滿力感【圖錄號4】。在唐代第445窟彌勒經變中嫁娶圖【圖錄號37】的婚禮場面右側，是盛裝站立的新娘與正在跪拜的新郎，左側是賓客圍坐宴飲，畫面上部是五個樂人正在吹簫、拍板，中央是舞伎，正合著音樂節拍揚袖抬足，舞姿優美，舞者的服飾和舞姿風格與南唐名畫韓熙載夜宴圖中舞伎的形態十分相似，說明這種舞姿來於現實生活。

四、記錄消失的古代建築

　　敦煌石窟包括數百個洞窟建築、古建築實物和壁畫中描繪的古代建築等三個方面豐富的建築史資料。（一）洞窟建築：有中心塔柱窟、殿堂窟（此類窟爲方形，覆斗頂，又可分爲壁面開龕，或窟中央設佛壇兩類）、大像窟、涅槃窟、禪窟、僧房窟、影窟與瘞窟等窟形。（二）古建築實物：根據敦煌文獻，唐代莫高窟窟前「前流長河，波映重閣」，根據石窟崖面遺跡和考古資料，古代莫高窟洞窟之間「悉有虛欄（棧道）通連」，每個洞窟外有窟檐，這些窟檐「上下雲矗，構以飛閣，南北霞連」。現在還保存唐宋窟檐五座，崖面上仍留有大量樑眼、椽眼等遺跡。此外，莫高窟前大泉河兩岸有五代、宋、西夏、元代舍利塔十多座。（三）壁畫中的古建築：壁畫中描繪了成千成萬座不同類型的群體和單體建築形象，記錄了自十六國至元代建築發展的軌跡，這些珍貴的建築形象資料可填補十六國至盛唐建築實物缺乏的空白。

　　十六國、北朝、隋代表現的建築畫比較簡單，缺乏體積感和幽深感。進入唐代建築畫才得到較大發展。初唐第431窟觀無量壽經變序品未生怨的內容，畫面中的城市、院落、房屋、廊廡等建築，開始採用透視法畫出建築的體積，表現建築環境的縱深感，甚至還畫出單體建築細部的台基、屋頂、脊飾、斗栱等構件，對前代的建築畫有較大的突破【圖錄號16】。盛唐時期的經變畫中表現許多傑出的建築畫作品，如莫高窟第172窟北壁的觀無量壽經變【圖錄號17】，以建築爲主構圖，形成有組織的建築群，高大的前殿爲建築群的構圖中心，其後有中殿、後殿，佛殿前爲佛、菩薩和伎樂從事佛事活動的平臺和水池，佛殿前的左右兩側爲配殿、樓閣，主要建築之間以低平的廊廡相接，迴

廊後部轉角處又有角樓。此畫建築群形成了很大的庭院，忠實地表現了現實生活中的佛寺，細緻地畫出單體建築各部位小構件的體積。此窟建築畫成功地採用中國特有的高遠（仰視）、深遠（俯視）、平遠（平視）相結合的透視畫法，處理建築群和單體建築的高大體量以及其環境的縱深空間，充分顯示中國建築群和建築之美，達到了建築畫前所未有的成就。

盛唐之後的建築沿襲唐制，如五代建造莫高窟第61窟的五臺山圖【圖錄號19】中的寺院為單院式，院落由迴廊圍成方形，繼承唐代院落的形制。在院落的正面中央設二層門樓，院落四角設二層角樓，院落中設一座兩層的樓閣式佛寺建築。「大佛光之寺」及其周圍的人物、山巒、河流、樹木呈圖案式，在透視上無遠近大小區別，人與景的處理採取深遠和平遠相結合的手法，使山前山後，建築內外的人物活動和環境一覽無餘。

五、琳琅滿目的民族服飾

敦煌壁畫是以人物為主的繪畫，其人物不是神就是人的形象，凡是神和人，皆著衣冠服飾。這些衣冠服飾又無不來源於現實的人間世界。敦煌自古是多民族往來聚居的都市，因此敦煌石窟不僅是十六國至元代人物畫的寶庫，而且也是這個時期各民族衣冠服飾的寶庫。十六國、北朝時期是胡裝漢服並存；隋唐帝國的統一，民族關係日益緊密，壁畫中各國各族的服裝更為豐富多彩；五代宋初偏隅瓜沙的曹氏歸義軍政權與周邊民族結成友好關係，曹氏政權之後的西夏黨項羌與元蒙統治時期，壁畫中還是中原漢裝和民族服裝繼續共存。供養人畫像和經變畫中的故事人物都是現實人物的寫照，這些人物的衣冠服飾也應是世俗人物的衣冠服飾，其衣冠服飾可分為漢服和胡服（少數民族服飾）兩大類。

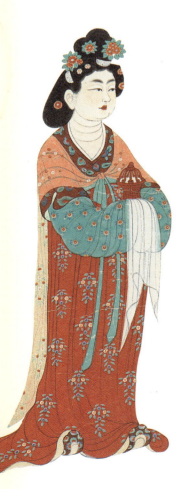

漢服有上自帝王、大臣，下至平民百姓不同的衣冠服飾；帝王身著袞冕，如莫高窟唐代第220【圖錄號20】、335【圖錄號6】、103【圖錄號22】窟維摩詰經變中的帝王圖，人數多，場面大，帝王戴冕旒，著深衣、青衣朱裳、曲領、白紗中單、蔽膝、大帶、大綬、舃。衣服上有日、月、星辰、山、川紋樣，大綬畫異龍之象，亦即帝王服飾上的所謂「十二章」之裝飾。與唐代閻立本的歷代帝王圖中的帝王袞冕相同。帝王兩側大臣身著深衣袍，戴委貌冠或進賢冠、笏頭履。帝王、大臣、貴族和百姓也穿大袖裙襦。女子也以大袖裙襦為貴族婦女的禮服。盛唐時期女子流行半臂衫裙，盛唐第130窟甬道的都督夫人太原王氏禮佛圖【圖錄號23】中的王氏及其女十一娘、十三娘，即著這種服飾；王氏碧羅花衫，袖大尺餘，外套絳地花半臂，紅裙、雲頭履、披白色羅花帔，捧香爐，頭梳拋家髻，插鮮花，飾小梳。身後九名侍女著男裝。五代第98窟于闐國王李聖天的供養像【圖錄號25】，榜題書寫「大朝大寶于闐國大聖大明天子…即是窟主」，他娶歸義軍節度使曹議金之女為皇后，曹氏政權將外戚于闐國王尊奉為窟主，是為了表示與于闐的友好。反映在衣冠服飾上，作為外族的于闐國王也穿中國帝王袞冕之服，頭戴冕旒，身著滾龍深衣袍，長裙蔽膝，大帶、分稍履，衣裳飾日月星辰十二章，腰佩長劍。

胡服，少數民族服飾，圖錄號第6、21號展品均是唐代維摩詰經變中維摩詰下部的各國王子聽法，展示了唐代各國各族的衣冠服飾。其中一類人物穿窄身小袖緣袍，腰束革帶，腳登烏皮長靴；有的剪髮，有的戴各式氈帽、繡帽、氈笠、渾脫帽，有的頭束繒彩，以此與梁元帝的職貢圖及唐代

出土石刻、文獻相比,他們是蔥嶺以東的疏勒、龜茲、吐谷渾、高昌等地民族的衣冠服飾。還有一類人物衣冠服飾與前一類大同小異,多著卷領窄袖長袍或披氈裘,穿豹皮鞋,戴卷檐氈帽,有的雙耳垂環、深目高鼻,濃眉虯髯,這些大約是中亞昭武九姓諸國的服飾。還有高鼻深目,虯髯捲髮,有的穿窄袖袍,有的穿貫頭衫、烏靴,這大約是中亞或西亞的服飾。還有一類是南亞的服飾,其人物膚色紫黑,捲髮、裸體,跣足,斜披錦巾,綾錦纏腰,項飾寶珠瓔珞,手腳佩鐲釧,穿短褲。各國王子中有的似穿漢裝,著深衣袍,束蔽膝,但頭戴蓮花冠,插二鳥羽為飾,這大約是東亞的服飾。

五代宋初曹氏政權繼續與于闐結好,流行回鶻裝,他們建造的第61窟壁畫曹氏女供養人像穿大袖裙襦漢裝,而于闐公主供養像身著回鶻裝,頭戴桃形鳳釵步搖冠,身穿窄袖翻領長袍,繡花鞋。十一世紀上葉繼曹氏歸義軍政權之後,沙州回鶻一度占領敦煌,壁畫中出現了回鶻國王和侍從供養像,他們都穿回鶻裝,國王戴白氈高帽,著圓領團龍袍,氈靴。侍從武士著皂衣白褲,束重帶,垂蹀躞,戴氈帽,垂紅結綬,持傘,執扇,背圓盾,持鐵爪籬。西夏黨項羌政權統治敦煌長達一百八十年,壁畫為我們留下了西夏的服飾。圖錄號第28號展品是西夏貴族婦女供養像,她們頭戴小冠,兩側插步搖,著交領窄袖衫,百褶裙,弓鞋。

六、薪火相傳保護敦煌石窟

1900年藏經洞文物的發現與被盜,使舉世無雙的敦煌石窟引起了國人的密切關注。經過朝野的共同努力,於1944年在敦煌莫高窟成立保護研究機構—敦煌藝術研究所(敦煌研究院的前身)。六十年來經過一代又一代有志者來到大漠深處,甘願過著清貧艱苦的生活,恪盡職守,不懈探索,為保護人類的珍貴遺產奉獻了自己所有的聰明才智。敦煌石窟的保護經歷了看守時期(1943~1950)、全面搶救加固修復時期(1950~1984)、科學保護時期(1984年以後)、主動的預防保護與科學管理時期(近年開始)幾個階段,使過去破敗不堪、病害頻生的莫高窟,重新煥發了昔日的光彩。

看守時期,常書鴻先生竭盡全力做了當時所能做的一切保護工作,如清除積沙、治理環境、保護洞窟、砌築圍牆、制定制度等。這就結束了敦煌石窟長期無人管理,任人破壞的歷史,開始有效保護的歷史。搶救時期,六○年代國家投入巨資,針對莫高窟崖體裂隙可能導致石窟坍塌和壁畫彩塑的嚴重病害,實施莫高窟崖體全面搶救加固和壁畫彩塑的修復,使莫高窟的文物得到及時保護,防止石窟的坍塌,瀕臨剝落的壁畫和糟朽傾倒的彩塑得到及時修復。

進入八○年代的科學保護時期,通過引進人才,充實保護儀器,與國內外科研機構合作,引進科學的保護技術和保護理念,採取自然科學領域多學科的結合,科技保護和科學管理結合,保護和利用結合的思路,對敦煌石窟本體的建築、壁畫、彩塑及其賦存的複雜環境實施宏觀、綜合、全面的科學保護,並強化科學管理,制定了莫高窟保護總體規劃,全面規劃保護、研究、展示開放各項工作。還協助立法機構制定並頒布《甘肅敦煌莫高窟保護體例》。上述各項措施極大地提升了敦煌研究院科學保護和管理的水平,使敦煌石窟得到了有效保護。

近年來,敦煌研究院越來越重視主動的預防性保護。實踐使我們深切地體會到要真正做到完整、真實地保護好文物,並使她完好永久地傳給子孫後代,應扭轉被動保護的局面,變被動為主動,向更為積極、全面、規範的預防性保護轉化,將預防文物病害的發生作為敦煌石窟保護的更高

目標。根據這一理念，建立了石窟本體及其環境的監測系統，全面做好日常的科學維護。針對文物的不可再生性和其本身不可抗拒的褪化，以及遊人逐漸增多兩種趨勢，開展了壁畫圖像數位化存貯與克服了再現技術的難關，以及洞窟遊客承載量研究的綜合研究專案。前者是採用高新技術，為世人永久保存珍貴的文化遺產資料，並為學術研究和展示開放提供準確、詳實的資訊資料；後者為正確處理保護和展示開放日益尖銳的矛盾，緩解遊人逐年增多，給石窟保護帶來的巨大壓力，確保石窟既得到有效保護，又能充分展示敦煌石窟蘊藏的豐富內涵及其珍貴的價值。

From the Forgotten Deserts :
Centuries of Dazzling Dunhuang Art

On the Exhibition of Dunhuang Art, 2005

FAN Jinshi
Dunhuang Academy, China

I. The Dunhuang Grottoes: A Multi-cultural Treasure

Dunhuang, located at the westernmost point of the Hexi Corridor, Gansu Province in China, has been a key point for communication between east and west ever since it was set up as a county in the Han Dynasty. East of Dunhuang the Hexi Corridor leads to the ancient cities – Changan and Luoyang of the Han and Tang dynasties. To the west passing through the Western Regions leads the route to Central Asia, Western Asia, Southern Asia and even to Rome in Europe. Beyond the Mazong range in the north lies the north grasslands of the Silk Road. To the south beyond the Aerjin range, Dunhuang is linked to the ancient route between China and Tibet.

Mogao Grottoes, the Caves of the Thousand Buddhas, and the Yulin Grottoes are all within the ancient Dunhuang county; collectively these sites are called the Dunhuang Grottoes. At the Mogao site, three hundred and seventy-five caves, 45,000 square meters of mural paintings, more than 2,000 sculptures, and more than 50,000 excavated relics record the history and culture of Dunhuang, the Hexi Corridor and the Western Regions in the Middle Ages. Furthermore, the treasures here are jewel-like–a fusion of eastern and western cultures.

II. Splendid Buddhist Art

Mogao is a comprehensive body of art comprising architecture, sculpture and mural paintings. The earlies Dunhuang Grottoes were created under four dynasties, the Northern Liang (397-439), Northern Wei (386-534), Western Wei (535-557) and Northern Zhou (557-581). The architectural types comprise central pillar caves, meditation caves and worship halls, and the polychrome clay stucco sculptures include Buddhas, bodhisattvas and disciples; besides individual statues, there are also triads and five-figured groups. The murals usually depict Buddhist deities, jātaka tales, narrative depictions of the historical Buddha Śākyamuni's past and present lives, traditional Chinese myths, donor figures and decorative motifs. In the very earliest caves, dating to the fifth century under the Northern Liang and Northern Wei dynasties, the figures on the murals are vigorous, the faces are plump and round and the garments worn leaving the upper bodies unclothed. At this time, artists used a painting technique incorporating an illusionistic method from the Western Regions, emphasizing the three-dimensional visual effect of the faces and bodies. In the sixth century under the Western Wei and Northern Zhou dynasties, the figures and the faces are slender, the figures wear ample robes of Chinese style and their faces resemble those of the Central Plains.

The medieval period of the Mogao Grottoes comprises the Sui and Tang dynasties, when the cave type was usually a single chamber. There is usually a niche in the western wall (main wall) or three niches in the western, southern and northern walls. Sometimes there is also an altar in the center. In addition, are caves with sculptures of the Buddha's nirvana and caves with colossal Buddhist images. Generally, disciples and bodhisattvas are beside the Buddha, and sometimes there are also heavenly kings, guardians or attendant offering bodhisattvas in a single niche. The total number of the statues in a single niche is at least three; the most is eleven.

In the murals of the Sui and Tang Dynasties (581-906), are sūtra illustrations explaining the Buddhist teaching, which have features that are unique to China. Many of them depict aspects of the Pure Land Doctrine, including the Amitābha Sūtra, Amitāyurdhyana Sūtra, Maitreya Sūtra, Bhaiṣajyaguru (Medicine Buddha) Sūtra, etc.; catalogue no. 1, 4, 5, and 17 are examples. There are also paintings of the Lotus Sūtra preaching the doctrine of the Tiantai School such as catalogue no. 7, 8, 9 and 10. Vimalakīrti-nirdeśa Sūtra expounding that every living being can become a Buddha, such as the catalogue no. 6. There are also Esoteric Buddhist paintings depicting scenes of chanting incantations, praying for good

fortune and release from calamity such as the Ekādaśhamukha Avalokiteśvara (Eleven-headed Guanyin) Sūtra painting in Cave no. 321 (Catal. no. 12). The various sūtra paintings vividly express the sacredness, purity and beauty of the Buddhist realm, and fully display the high artistic achievement of the composition, color, perspective and expressive spirit of Chinese Buddhist paintings.

Besides Buddhist subjects, the Procession of Zhang Yichao in Cave no. 156 (Catal. no. 34) and the Procession of Lady Song (Catal. no. 35) from the same cave, painted in the late Tang both represent the triumph of Zhang Yichao and his wife Lady Song after he expelled the Tibetans from Dunhuang in 848. They are paintings that depict actual historic themes.

In the first half of the Tang Dynasty, the color of the paintings is splendid and the figures are plump and smooth-skinned, vigorous, virile and thriving. In the Tibetan period (781-848), the composition was carefully arranged, the color is bright and sprightly, the lines were exquisite and tender and the figures are delicate. These formed a very sensitive and refined artistic style. From the Late Tang onward (848-906), it became more formulaic.

The late period at the Mogao Grottoes includes four periods, the Five Dynasties (907-960), Song Dynasties (960-1279), Western Xia (1032-1227) kingdom and Yuan Dynasty (1206-1368). In this period, Buddhist art at these sites declined, but with the influence from paintings of the Central Plains (i.e., metropolitan China) and from Tibetan Buddhist art, there are nevertheless some outstanding works, for example, the famous Panorama of Mt. Wutai in Cave no. 61(Catal. no. 19). It is not only an important historical document but also a distinctive landscape topographical painting.

From the the Five Dynasties to the early Song, in some large caves, there were large-scale pictures depicting the donors such as catalogue no. 25 and 26 of Caves no. 98 and 61, respectively, which represent King Li Shengtian of Khotan and a Uighur princess, which were all portraits larger than life-size. Catalogue no. 13 and 14 display two different styles of the Water Moon Avalokiteśvara (Guanyin) in Cave no. 2 of Yulin Grottoes in the Western Xia period of the twelfth century. All the objects such as figures, mountains, rocks, clouds and air, and the composition, spatial arrangement, and artistic conception are all distinguished. Catalogue no. 27 and 28 respectively present the patrons, the Uighur King in Mogao Cave no. 409 and the Western Xia Tangut lady of Yulin Cave no. 29, reflect the Buddhist activities of non-Han nationalities in the late period of Dunhuang.

III. Heavenly Music and Dance of the Buddhist Realm

There are two main types of the Dunhuang music and dance imagery: heavenly and secular music and dance. The former includes musicians in heavenly palaces, apsaras (flying heavenly beings), reborn souls, protectors of the dharma, and musical groups in sūtra narrative illustrations; the latter includes people offering music, processional bands, and musicians at feasts. Wind instruments, stringed instruments, and percussion instruments are depicted in the murals; altogether there are thousands of musical instruments comprising forty-four types. Early representation of music and dance usually were of a single performer, the figures are vigorous and the instruments were simply drawn. The music and dance were obviously influenced by India, the Western Regions and northern nomads. The murals of the Tang Dynasty show the music of many cultures, various kinds of dances and local customs and practices in the Hexi corridor.

The exhibits no. 29 and 30 are music and dance pictures depicting different "scarf dances" in the Mogao Cave no. 220 executed in the sixteenth year of Zhenguan reign of the Tang Dynasty (d. 642 C.E.). "Vigorous dance" is depicted in the

Amitābha Sūtra painting, two dancers perform on tiptoe and wave long scarves on a round carpet. In the Bhaiṣajyaguru Sūtra painting, next to the candelabras, four dancers are dancing on round carpets in the middle; those on the left are wearing military-like helmets and armor and the dance is grand and heroic; the dance of those on the right is elegant and graceful representing the "soft dance." In the Middle Tang period during Tibetan occupation (781-848), the famous Dancer Playing the Pipa behind Her Back in Cave no. 112 (catal. no. 33) was painted. The catalogue no. 37 is the Wedding Scene in the painting of the Maitreya Sūtra from the Cave no. 445. The garments and dancing style are very similar to those in the celebrated painting of the Southern Tang Dynasty The Night Banquet of Han Xicai, indicating that this dance here reflects daily life.

IV. A Record of Lost Monuments of Ancient Architecture

The Dunhuang Grottoes contain numerous historical materials of architecture, such as cave architecture, ancient architectural objects and the painted ancient architecture on the murals. In the Northern Dynasties and Sui (late fifth and early sixth century), the architectural representations were rather simple and undeveloped, lacking three-dimensional and spatial visual effect. After the beginning of Tang (618-906), architectural representation greatly developed. The exhibit no. 16 presents the content of the first chapter of the Amitāyurdhyana Sūtra in Cave no. 431 of the Early Tang Dynasty, in which the painters started to use perspective to depict the volume of architecture, cities, courtyards, houses and corridors. Catalogue no. 17 is the scene from the Amitāyurdhyana Sūtra on the northern wall of the Mogao Cave no. 172. It is mainly composed of architecture and forms of an architectural complex. At the center of the composition, is a magnificent front hall, with the middle and rear halls behind it. Moreover, there are platforms and pools in front of the halls for the Bodhisattvas and attendants to perform Buddhist activities.

V. Eye-catching Customs of Diverse Nationalities

From ancient times, Dunhuang was a town where many nationalities came and went, or took up residence. Thus Dunhuang is a treasury of the clothing and headdress of many nationalities. In the Northern Dynasties, Chinese and non-Chinese customs existed side by side; following the Sui unification and under the Tang empire, there were even more connections between peoples, and there are ever more splendid and colorful customs of different peoples. In the Five Dynasties and early Song Dynasty, good relations were established between the military government of the Chao clan and the peoples of the surrounding regions. After the Chao period, the area was governed by the Western Xia Tanguts and by the Mongols of the Yuan Dynasty, and Chinese costume from the central plains continued to be seen side by side with foreign clothing; there were the two principal categories of costume.

As to Chinese costume, it ranges from the clothing of emperors and high officials to the clothing and headgear of the ordinary people. Emperors wear a flat mortarboard crown, such as in catalogue no. 6, 20 and 22, from Mogao Caves no. 335, 220 and 103. In the High Tang, the entrance corridor of Cave no. 130 (cave of the Southern Great Buddha) features the portrait of Lady Wang of Taiyuan, Wife of the Commander (catal. no. 23). Lady Wang, as well as Eleventh Lady and Thirteenth Lady, all wear short jackets and skirts popular in the High Tang period (eighth century).

Foreign costumes, that is the costumes of all non-Han nationalities, can be seen in the groups of foreign rulers (catal. no. 6 and 21) in the Debate between Vimalakīrti and Mañjuśrī. They include local robes and headgear of peoples from Sule, Kizil, Toyok, Gaochang and the like, as well as those of the nine tribes of Zhaowu (the district of Zhangye in Gansu province), Central and Western Asia, South Asia and East Asia.

VI. Preservation for the Dunhuang Grottoes

The discovery and theft of the relics in the Library Cave in 1900 aroused great attention of the Dunhuang Grottoes in China. With the striving of the government and the public, an institute for preservation and research, the Institute of the Dunhuang Art was established in 1944 (the predecessor of the Dunhuang Academy)

During the Guardian Period (1943-1950), Chang Shuhong undertook all that could be done to preserve the caves at that time and put an end to the situation in which for many centuries there had been no-one taking care of the site. The Dunhuang Grottoes stared to be effectively protected.

During the Rescue Period (1950-1984), the government invested a great amount of funds, carried out comprehensive rescue and consolidation of the murals and sculpture, lest the cracks in the body of the cliff of Mogao Grottoes lead to the collapse of caves and to deterioration of the paintings and sculptures. The whole Mogao Grotto site was conserved and consolidated, with repairs to the sculptures and mural paintings, so that the cultural relics of the Mogao Grottoes received timely protection, damage to the caves was prevented, and conservation was carried out when needed.

During the Scientific Preservation Period (after 1984), through introducing professionals, enhancing conservation facilities, cooperating with international and domestic scientific research institutes, and introducing the techniques and ideas of scientific preservation, the architecture, mural paintings, sculptures and the environment of the caves have been integrally and comprehensively preserved.

In the prevention and scientific management (which began recently), the Dunhuang Academy has established a surveillance system of the caves and their environment in order to comprehensively implement daily scientific preservation. We have also begun the digital storage of the images of the murals, overcoming the difficulties of reproduction, and we have initiated a research project into the numbers of visitors that can be safely accommodated in the caves. The first project adopts up-to-date high-technology to provide accurate and practical data for research. The second project addresses the sharp contradiction between preservation and tourism. It ensures that the caves receive effective protection and also that the rich content and invaluable cultural worth of Mogao is properly revealed and displayed.

(Translation by CHIEN Li-kuei, revised and edited by Roderick Whitfield)

敦煌佛教藝術發展略述
─以壁畫的內容為中心

潘亮文　國立台南藝術大學

　　自1900年王圓籙道士發現位於第16窟甬道北壁、現編號第17窟的藏經洞後，洞內所藏大量的文物引起英、法、日、美、俄等國學者的注意，興起對敦煌考古、美術、史地等各領域的研究，形成敦煌學研究的風潮。除藏經洞出土有大量寫經與絹、麻、紙等材質的佛教繪畫外，敦煌莫高窟石窟整體就是佛教藝術的具體再現。其重要性可從四方面來看：一、結合建築、塑像與壁畫為一體─根據《敦煌石窟內容總錄》現有編號四百九十二個，另加北區發掘共有七百三十五個洞窟、兩千多尊的塑像與四萬五千多平方公尺的壁畫；二、延續的時間最長─根據武周聖歷元年（698）李懷讓的《重修莫高窟佛龕碑》，在前秦建元二年（366）時，有樂僔沙門到此開窟，同時從現有的研究成果顯示，元蒙時期在此仍有興建洞窟，之後明、清時期繼續進行重修或粧彩；三、結合多種民族─包括漢、藏（吐蕃）、黨項（西夏）、蒙古（元）、回鶻、于闐等各族共同努力造就而成的；四、單一石窟保存數量最多的壁畫─在四萬五千多平方公尺的壁畫上，雖然沒有包含所有佛教經典，但也涉及相當多部佛典的內容，尤其是表現經變畫的題材部分，其所涵蓋的經典數量、成就出風格多樣、千姿百態的藝術表現，是其他石窟藝術難以媲美的。因此，本文僅就壁畫的內容，來看敦煌佛教藝術的表現。

　　雖然政治史的發展並不等於藝術史的變化規則，但為方便考察各時期佛教藝術表現的異同，以下將依時代的順序，概觀其發展面貌。

一、北朝時期

　　這個時期壁畫的內容主要是與釋迦牟尼佛有關的題材，包括佛傳故事、本生故事、因緣故事與佛像畫四種。這些題材的出現，基本上也符合早期佛經的傳譯以部派的經典出現較早的史實。

1. 所謂佛傳故事，是指宣揚釋迦牟尼佛生平事蹟的故事，例如最早的第275窟南壁下的出遊四門或北魏第254窟南壁的降魔圖等，現存以北周第290窟窟頂前部東、西披的佛傳規模最大、情節最多。

2. 本生故事，是指佛降生以前之前世及種種世代教化眾生的諸多故事，如第275窟北壁下毗楞竭梨王、尸毗王、月光王等本生，又如第254窟南壁龕後部中層東端薩埵太子本生或北魏第257窟西壁中層九色鹿王本生等。

3. 因緣故事，是指宣揚佛教、化度眾生的故事，如第257窟西壁中層與北壁後部中層的須摩提女因緣、同窟南壁後部中層沙彌守戒自殺因緣，或西魏第285窟南壁上層的五百強盜成佛與北周第296窟窟頂西披北段至北披西段的微妙比丘尼品等。

4. 佛像畫，主要是以佛為主體的說法圖，如北魏第263窟北壁後部中層作品、北魏第435窟北壁前部的說法圖，或第263窟南壁後部中層的三世佛與千佛等。此外，聞佛說法的菩薩像與象徵兜率天宮的天宮伎樂，也是常見到的主題。在北周所出現的涅槃圖，是隋代涅槃經變的祖形，如第428窟西壁中層作品。

　　佛教藝術的表現乃根基於弘揚佛教思想的目的，因此不得不受限於佛經的特定內容，這是與一般藝術創作最大不同之處。然而隨著時代的不同，古代匠師注意到使用不同的手法，讓相同的主題展現不同的生命力，使得佛教藝術變得多采多姿。就整體造型而言，初期的菩薩臉圓、肩寬、胸厚實、臀約與肩同寬、下半身較上半身略長，因而造成略顯笨重的視覺效果，如第275窟南壁上層的菩

薩。在故事畫的構圖上,是以一、二個最富特點的情節作為表現的重點,如第275窟北壁下尸毗王本生,描繪割肉與過秤兩個相連的主要情節。

北魏時期,無論佛或菩薩的面相略作長圓狀,雖然是肩寬、胸厚實、臀約與肩同寬,但腰略細而下半身又較初期表現為長,使得整體形象較初期修長,而顯得身體輕盈。在故事畫的構圖上,出現凸顯主角的重要性,將其他情節散佈在周圍,如第254窟北壁後部中層東端的尸毗王本生,將被割肉的尸毗王置於正中,其左上是老鷹逐鴿、左下一人提秤。同時,故事情節又更為複雜,如第257窟西壁中層九色鹿王本生是由五個場面所組成,故事情節從畫面兩端向中央發展,讓觀者的視線最後集中在畫面的中心。

西魏時期的佛、菩薩,面部或呈長圓或上寬下略尖狀、或平肩或削肩、腰細,身修長是最大的特點,形成整體清秀的視覺效果。有關故事畫方面,出現在重要的壁面上,如第285窟南壁整個上半部,採橫幅連環形式,佔據相當大的空間,同時故事情節增多,而匠師又利用建築物或山體作為場面的區隔,維持畫面的統一性。另外,構圖形式增加了,除前者的橫幅連環形式之外,在同一洞窟內還有多情節單幅畫形式的婆羅門聞偈捨身本生,以及從上到下、又從下到上構圖的沙彌守戒自殺因緣[1]。

進入到北周時期,佛與菩薩的表現,出現了方而短的面部,肩寬、身稍短的形象,但身體各部位的銜接較自然,注意身體的結構,表現出體態豐腴的整體效果。在故事畫方面,無論是構圖形式或題材內容,大抵依循西魏時期的發展而來,同時更加重視細節的描繪,使得故事情節的數量增加,如位於第290窟人字披東披與西披的佛傳故事,就是由八十多個情節組成的。

二、 隋時期

僅維持三十七年國祚的隋代,卻在莫高窟留下八十一個石窟[2],由此可以推測當時佛教文化之興盛。此時期壁畫的內容大體可以分成三類。

1. **佛像畫**:基本上是延續前期的題材,主要是佛說法圖,同時也有少數其他菩薩像說法圖,如第390窟南、北壁中央戴化佛冠的菩薩說法圖或第405窟南壁中央的觀音說法圖。相較於前一時期的說法圖,除佛主尊外,聞法的弟子與菩薩有增加的趨勢,原屬於陪襯角色的飛天等,千姿百態,更增加洞窟內的律動感。同時說法圖的數量較前期大增,甚至整窟四壁都畫說法圖者,如第244、390窟等。此外,塑像與壁畫的結合更加密切,增添龕內佛、弟子、菩薩等群像規模,在龕壁上多描繪弟子、天王、力士與其他菩薩的形象,以營建熱鬧複雜的場景。

2. **故事畫**:現存作品不多,如第302(有婆羅門聞偈捨身、尸毗王、毗楞竭梨王、虔闍尼婆梨王、快目王、睒子本生、薩埵太子本生等)、419、423與427(三窟內皆有須達拏太子本生)等窟而已。其中,薩埵太子本生與須達拏太子本生是延續前期出現較多的題材,其構圖形式是根基於北周時期的基礎,如第419窟的須達拏太子本生分上、中、下三段,情節成S行發展,可以容納繁多的情節,但結構形式已經定型化了,同時其所在位置退居於窟頂人字披或中心柱腰沿上,正反映出故事畫在隋代衰落的事實。

3. **經變畫**:所謂的經變畫,是圖解佛典的內容,透過繪畫的形式表達經典教義與思想的作品。包括根據《無量壽經》的無量壽經變、《佛說彌勒上生兜率天經》的彌勒上生經變、《法華經》

的法華經變、《維摩詰所說經》的維摩詰經變、《涅槃經》的涅槃經變與《藥師如來本願功德經》的藥師經變，這些在隋代才開始出現的經變畫，正好取代故事畫的地位，奠定唐代出現大型經變的基礎。匠師擷取經典中特定的文字內容轉化成圖畫場面，形成構圖形式各不相同的經變畫，例如在第420窟中，以《維摩詰所說經》〈問疾品〉為中心，將文殊與維摩詰分置於西壁南、北側的上部凸顯其與他部經典不同之處。又如在第423窟窟頂西披以大殿內交腳菩薩和周圍諸菩薩、天人，象徵彌勒菩薩在兜率天宮說法情景，表現彌勒上生經變的內容。

隋代初期，雖然佛與菩薩的表現，是接續北周期的特點，如仍面方而短，存在腿短的缺點，但藉由出現重染兩頰、眉稜、突出額角、鼻梁與下頷的染色法，一改北朝以來在底色上預敷亮色的白鼻梁、白眼瞼與肉體突出部分加白光，使得面部的表現更加圓潤自然，同時重染的方法也運用到身體的他部位，使得人們視線的焦點不會只停留在身短的缺陷上，而能注意到形象整體的美感。而在後階段的發展，匠師注意到原屬神格的佛與菩薩頭、身的適度比例，加上對各部位的描繪更精緻，使之有接近人物形象寫實的趨勢。

三、唐時期

由於古代敦煌一直是東、西交通往來的中繼站，同時當地政權更迭的時間與中原地區也有不同，因此根據敦煌特殊的地理歷史環境因素，唐代又可分為初唐（西元618～704年）、盛唐（西元705～780年）、中唐（吐蕃佔領敦煌的西元781～847年）、晚唐（張議潮退吐蕃的西元848～906年）[3]。

1.初唐

此時期壁畫的內容基本上是延續隋代的發展，大體可以分三類。

第一類佛像畫：除配合西壁龕內塑像構成窟室主體所需的尊像外，以佛為主的說法圖仍占多數，同時說法圖中的聞法諸菩薩、天人等的群像趨向複雜組合。此外，雖有描繪於第287窟西壁龕內婆藪仙與鹿頭梵志，但此題材以後不多見。當然也發展出隋代未見的尊像題材，如第321窟東壁門北的十一面觀音【圖錄號12】。

第二類經變畫：自此以後，經變畫成為壁畫的主要表現內容。有些經變是繼續前期而來的，如彌勒經變、無量壽經變、法華經變、維摩詰經變與藥師經變等，但所在位置與構圖形式不同於前，例如隋第393窟的無量壽經變是位於西壁內，但受限於作畫空間，只表現了阿彌陀三尊像坐於蓮池與蓮池中有化生童子的簡單場景，但在第220窟南壁的無量壽經變是以通壁繪製一幅經變，阿彌陀三尊與寶池中的化生童子是全幅的重心，其上以各種樂器莊嚴的虛空段佔據畫面的五分之一，三尊段兩側的樓閣與置身樓閣中的諸菩薩活動皆面向三尊，三尊以下的寶地主要是樂舞，其兩側露臺各有一佛與眾菩薩的形式，成為以後無量壽經變的基本構圖。又如以法華經變為例，〈見寶塔品〉多描繪在西壁龕內是延續隋代之發展外，且多了〈從地涌出品〉，如第340、341窟的作品。在第331窟東壁門上有〈序品〉、〈從地涌出品〉、〈提婆達多品〉、〈妙音菩薩品〉與〈普賢菩薩勸發品〉的圖像內容。此外，出現了上生與下生合繪的彌勒經變，如第329窟北壁的構圖是以後彌勒經變圖的基本型。在維摩詰經變方面，如第203窟西壁龕外南、北側的作品是繼承隋代的佈局，但在第220窟東壁門南、北側的表現【圖錄號20、21】，是往後最

常見到的形式之一。另外，在第335窟西壁龕內南、北側的勞度叉鬥聖變則是一種新出現的題材。

第三類故事畫：此時期故事畫類的作品，與釋迦牟尼佛有關的佛傳故事，僅於第209窟窟頂有一鋪，可見此題材已逐漸地不受重視。同時也不見前一時期如須達拏太子本生等之本生故事，取而代之的是如繪製在第323窟南、北壁的西晉江南地區發生的石佛浮江【圖錄號36】等的佛教史蹟畫。這種故事畫包含許多在中國發生的神通感應故事，是一種形象化了的中國佛教史料。

初唐的佛與菩薩的造型，已經是以寫實為取向，使得形象整體比例適度，同時或許是因為匠師對各部經典內容有較深刻的認識，而能技巧性地將其內容圖像化，呈現出較複雜的畫面，如第331窟東壁門上有五品圖像內容的法華經變。

2.盛唐

此時期以經變畫的表現最為出色，而同時各種經變畫的構圖形式也建構完成。以觀無量壽經變為例，初唐時的第431窟北壁描繪出《觀無量壽經》〈序分〉的主要內容，描述未生怨的故事【圖錄號16】，西壁畫有《觀無量壽經》〈正宗分〉之十六觀的前十三觀，南壁畫後三觀之九品往生；而在第45窟北壁的作品則中央以淨土說法為重心，兩側分別繪製未生怨與十六觀的內容，這樣的形式成為以後觀無量壽經變的主要構圖形式，如中唐榆林窟第25窟南壁【圖錄號4】。又如第148窟東壁門北的藥師經變，正中央是藥師淨土說法的場面，於兩側分置十二大願與九橫死的內容，此形式常見於此後的藥師經變中。

在佛像畫方面，以觀音的造像為多，甚至從《法華經》中將〈觀世音普門品〉獨立出來，形成所謂的觀音經變，如第45窟南壁的作品【圖錄號1】。另外，密教觀音的出現，如初唐時已出現的十一面觀音，在第32窟東壁門北仍延續此一題材，另外尚有第113窟東壁門南的千手千眼觀音或第148窟東壁門上的千手千眼觀音等，顯示出此時期觀音信仰的重要性。

盛唐在初唐發展的基礎下，佛與菩薩的形象比例已趨完備，同時匠師「注意到主線與輔線關係。人物面部及形體的輪廓線為主線，粗而著實。衣紋鬢髮等則是輔線，較細而虛。由於主輔結合、虛實相生、輕重適宜，遂使形象結實而有立體感」[4]，如見於第103窟東壁的維摩詰經變【圖錄號22】。因此，畫面的內容雖複雜，但主、從角色清楚，且每個個體形象清晰，足能予觀者慢慢品味閱讀，由此可見匠師功力之所在。此外，各種經變的構圖形式，在此時期也大致都確定了。

3.中唐

在經變畫方面，題材大多是延續盛唐而來，如觀無量壽經變、阿彌陀經變、法華經變、彌勒經變、藥師經變、涅槃經變與維摩詰經變。另外，也出現較不見於前一期的題材，如第154窟東壁門南的天請問經變和金光明經變、北壁的報恩經變、第112窟南壁的金剛經變、第158窟東壁的思益梵天所問經變、第159窟北壁的華嚴經變與第236窟南壁的楞伽經變等，是宗派林立的一種反映。

有關佛像畫方面，此一時期的佛像畫最大特點是密教尊像的增加，如見於第176窟東壁門上的千手千眼觀音、第117窟東壁門北的不空羂索觀音、第129窟東壁門北的如意輪觀音與第361窟東壁南側的千手鉢文殊等。然而相同主題的圖像類型與構圖形式相近，似也反映出密教圖像較嚴格遵循經典

儀軌之規定。

其他，如初唐時曾出現一例，但在盛唐時銷聲匿跡，到了中唐的第231、237窟西壁龕頂四披又開始出現的佛教史蹟畫，其內容有源自天竺國白銀彌勒瑞像、中天竺摩伽陀國放光瑞像等印度的故事外，也有來自于闐國時瑞像、于闐故城瑞像等于闐國傳說，由此可見中唐時期的敦煌與于闐關係密切，同時還有如酒泉釋迦牟尼瑞像、張掖郡佛影月支國時現像等，這既可說與中國傳統的祥瑞讖緯思想有某些程度結合的結果，也可說是佛教中國化紮根的反映。此外，第159窟西壁龕外北側出現的五臺山圖，是一種新的題材，雖然畫面篇幅不大，但反映了文殊菩薩信仰已擴展到屬於吐蕃管轄範圍的敦煌。

整體而言，佛與菩薩的形象豐腴且有動感是共同點。經變畫的構圖大抵是繼承前期的形式，只增加了屏風畫之形式，與經變緊密結合，這種佈局一直延續到宋代[5]。無論是經變畫或佛像畫，兩者構圖皆運用各種形象將畫面填滿，是此時期的一大特點。由於構圖形式固定且形象繁多，同時人物又表現得圓潤豐滿，因此造成擁擠的視覺效果，可說是藝術表現形制化的開始。

4.晚唐

晚唐時期的經變畫發展是承接中唐而來，同時經變畫的內容增多，增加大量反映現實生活的場景，導致畫面龐雜、擁擠，反而不如前期主題明確、構圖清晰且結構完整。但其中，曾在北周出現一例（西千佛洞第12窟南壁）與初唐亦出現一窟（第335窟西壁龕內南、北側），以《賢愚經》中〈須達起精舍品〉為依據的勞度叉鬥聖變最具特色，如第9窟南壁東部的作品。巨幅畫面展現舍利弗與勞度叉種種神力之爭的過程，將其泰然自若與驚慌失措的神情鮮明呈現。

在佛像畫方面，仍是以千手千眼觀音、如意輪觀音、千手鉢文殊等之密教系統之尊像為主，但增加如出現在榆林窟第35窟前室西壁的熾盛光佛作品。隨著一行和尚的《宿曜儀軌》的問世，熾盛光佛漸為世人所重視，但現存作品以晚唐為最早。故事畫方面，在中唐出現於西壁龕頂的史蹟瑞像圖，進入晚唐則是置於如第85窟甬道頂的南、北披或第9、340窟甬道頂與南北披，形成以于闐牛頭山為中心構圖的瑞像圖。

雖然此時期的敦煌因為張議潮擊退吐蕃，又回復到漢人的統治，但如上淺析晚唐時期的壁畫內容，似乎沒有因為政權重新回歸漢民族管轄而有欣欣向榮的改變，仍然只是承續中唐的發展而來。因此，我們可以說敦煌傳統佛教文化思想的宗教信仰，很大程度地影響到畫師（匠）個人對佛教藝術創作的表現。

四、五代至元時期

歷代多可見的經變畫，如法華經變、觀無量壽經變等仍是此一時期壁畫中主要的題材，這些經變的表現除根據經典內容外，也多以變文為依據，甚至有時還直接以變文作榜題[6]。而於晚唐表現出色的勞度叉鬥聖變在此時仍保有相當精采的活潑度與豐富的情節，如第146窟西壁的作品。此外，以于闐牛頭山為主的瑞像圖出現甚至超過十個，其中尤以曹元忠時期的第126、454窟裝飾繁複、華麗為最。

此外，在朱景玄的《唐朝名畫錄》中提到「今上都有畫水月觀自在菩薩」，另在張彥遠的《歷代名畫記》中記載周昉妙創水月之體的水月觀音圖，其成立時間大約是八世紀後半到九世紀之間。但

在敦煌遲至五代時才有作品的出現，如吉美博物館藏天福八年（943）是現存最早有記年的一件作品【圖錄號71】，其發展一直延續到西夏，如榆林窟第2窟西壁門南、北的作品【圖錄號13、14】。而以十六羅漢作為單一洞窟壁畫的主題，始見於西夏第97窟。而在中唐業已出現的小幅五臺山圖，在五代則如第61窟西壁是宏幅巨製的畫面【圖錄號19】，圖上山巒起伏，五臺並峙，其間寺院佛塔遍佈，自然景色風土人情表露無遺，是一幅地理圖景，也是一幅歷史地圖。西夏與元代壁畫發展的共同點，是藏傳密教圖像的增加。洞窟雖小的元代第3窟中所見設色清淡典雅、線條自然流暢，有別於佛教藝術重色重彩的傳統，恰為敦煌佛教藝術劃下完美的句點【圖錄號3】。

五、小結

如上，概觀敦煌石窟壁畫的佛教藝術發展，大致可以歸納出以下幾個特點：

1. 北朝時期以佛傳、各種本生與因緣之故事畫為主，進入隋代後，經變畫與故事畫並存，初唐時經變畫成為主流；構圖上，盛唐時期主要的經變畫構圖形式已趨於完整，中唐至元代大抵是繼承盛唐的基礎而有所發展。

2. 各時期壁畫題材的出現與當時盛行的佛教文化有一定程度的關係，如北朝時期多見有楞竭梨王、尸毗王、月光王、快目王等本生以及薩埵太子本生、九色鹿王本生等，基本上符合早期佛經的傳譯以部派經典出現較早的史實。隋唐之際，宗派林立，如淨土宗等，反映在敦煌壁畫上就有無量壽經變等的繪製。金剛智、善無畏與不空在玄宗朝時來到中國，正式開啟密教在中國的流行，而敦煌也在中唐時出現大量的密教題材。

3. 在敷色的處理上，北朝多使用底色上預敷亮色的白鼻梁、白眼瞼與肉體突出部分加白光的方法，隋以來多用重染兩頰、眉稜、突出額角、鼻梁與下頷的染色法，使得面部的表現更加圓潤自然。

4. 對於佛、菩薩的形象處理上，初期表現為臉圓、肩寬、臀與肩約同寬等，因而略顯笨重；北魏時期，面相略作長圓狀，腰略細且下半身較長，整體顯得較修長。身修長是西魏時期最大的特點，形成清秀的視覺效果。北周時期，方短的面部及身軀短，體態豐腴。初唐以降，趨向於寫實，形象整體比例適度；至中唐，形象愈加豐腴，此後其表現的優劣與否和畫匠的技術水準有密切的關係。

5. 壁畫的目的是以宣揚佛教思想為主，是佛經內容圖像化的結果，除此之外，其描繪的形象如佛寺、宮殿、樓閣、城牆等，提供我們認識古代建築形制之美；出現在淨土世界中的笙、簫、琵琶等諸多樂器與多種舞蹈，提供我們瞭解古代舞樂之美；其繪製的風土民情與生活場景，成為我們體會古人社會風俗的重要實物。

1. 李永寧主編，《敦煌石窟全集 3 本生因緣故事畫卷》，2000年，香港商務印書館，頁85。
2. 李永寧主編，《敦煌石窟全集 3 本生因緣故事畫卷》，頁121。
3. 史葦湘，〈關於敦煌莫高窟內容總錄〉，敦煌研究院編《敦煌石窟內容總錄》，1996年，文物出版社，頁227。
4. 段文傑，〈唐代前期的莫高窟藝術〉，敦煌文物研究所編著，《中國石窟 敦煌莫高窟三》，1987年，文物出版社・平凡社，1987年，頁174。
5. 段文傑，〈唐代後期的莫高窟藝術〉，敦煌文物研究所編著，《中國石窟 敦煌莫高窟四》，1987年，文物出版社・平凡社，頁172。
6. 段文傑，〈莫高窟晚期的藝術〉，敦煌文物研究所編著，《中國石窟 敦煌莫高窟五》，1987年，文物出版社・平凡社，頁164。

An Introduction of the Development of the Dunhuang Buddhist Art: On the Content of the Mural Paintings

PAN Liang-wen
Tainan National University of the Arts

Besides the large number of Buddhist paintings on silk, hemp cloth and paper excavated from the Library Cave, the Mogao Grottoes constitute substantial presentation of Buddhist art. Their importance can be explained as followed: first, it combines architecture, sculptures and mural paintings. Secondly, the period of construction lasted the longest of all the grottoes; according to the inscriptions on Chongxiu Mogaoku fokanbei (The Stele Commemorating the Repair for the Mogao Shrines) written by Li Huairang in the first year of the Shengli reign of Wuzhou (698), Mogao Grottoes started to be cut in the second year of the Jianyuan reign of the Former Qin. According to present research, some caves were made in the Yuan Dynasty; later, the Ming and Qing Dynasties continued to repair and repaint. Thirdly, it combined the multiple cultures of various ethnic groups including the Han, Tibetans, Qiang, Mongolians, Uighurs and Khotanese. Fourth, it preserves the greatest number of mural paintings, 45,000 square meters all, far exceeding the total for any other grottoes. Therefore, this essay will focus on the contents of the mural paintings to discuss their artistic expression.

I. The Northern Dynasties

The subjects of the mural paintings in this period mainly include stories of Buddha's life, jatakas (stories of Buddha's previous lives), Stories of Cause and Effect and the Buddha figures.

1. Buddha's life stories:
 For example, the Four Encounters on the lower part of the southern wall in Cave no. 275, and the eastern and western sloping ceilings in Cave no. 290, which has the largest scale and most narratives and best preserved.

2. Jatakas:
 The various stories of Buddha's previous lives, such as the stories of the King Pilengjieli, King Sibi, King Moonlight and King Kuaimu on the lower part of the northern wall in Cave no. 275.

3. Stories of cause and effect:(hetu pratyaya)
 Preaching Buddhism and teaching people, for example, the story of Sumāgahā on on the middle part of the western and northern walls of Cave no. 257, and the story of the monk who committed suicide in order to keep his vows.

4. Buddha images:
 Mainly Buddha's preaching scenes, for instance, the scene of Buddha's first sermon on the middle part of the northern wall in Cave no. 263 of the Northern Wei period. In the Northern Zhou Dynasty, there appeared a depiction of the Buddha's nirvana on the northern wall of Cave no. 428, the precursor of Sui depiction of the nirvana.

As to the overall form, the visual effects are rather cumbersome like the composition of the Bodhisattvas at the upper part of the southern wall in Cave no. 275. There is a focus on one or two of the most characteristic actions as the primary scenes.

In the Northern Wei period (439-534), the figures are more slender than those in the initial stage and they give us an impression of lightness. The composition of the narrative scene tends to show the importance of the leading figures and arranges other scenes around them.

In the Western Wei Period (535-556), the slender body is the major feature, which makes the whole visual effect delicate and beautiful. About the narrative paintings, they appear on significant walls in the form of horizontal panels and occupy quite a large area, meanwhile, the number of episodes increase.

In the Northern Zhou Dynasty (557-588), Buddhas' and Bodhisattvas' facial figurations became short and square, but the joint of every part of the bodies became very natural and smooth, which expressed a plump visual effect. About the narrative paintings, no matter the composition, subject or content all proceed from the Western Wei, but with more emphasis on the details and a further increase in the number of episodes.

II. The Sui Dynasty

1. Buddha images:

 There basically inherited the subjects of the previous period. They are mainly pictures of Buddha preaching, but there are also a few pictures of the Bodhisattvas preaching, such as the Avalokiteśvara preaching in the middle of the southern wall in Cave no. 405. Besides, there were even closer connections between the sculptures and the paintings. In order to increase the number of images within the niches, additional figures of the disciples, heavenly kings, guardians and Bodhisattvas were painted on the walls of the niche, immediately behind the clay stucco images.

2. Narrative paintings:

 These are only preserved in four caves, but the compositions had been formalized, and there were relegated to the gable ceilings or the middle parts of the central pillar. This reflects a decline of the narrative paintings in the Sui Dynasty.

3. Sutra paintings:

 Including the Sukhāvatī-vyūha Sūtra, Maitreya Sūtra, Lotus Sūtra and Vimalakīrti-nirdeśa Sūtra. These sutra paintings started to appear in the Sui Dynasty and replaced the previous narrative paintings.

The artisans of the Sui Dynasty paid attention to the correct proportions of the head and body of Buddha and Bodhisattva and more carefully depict the details, which made the celestial figures tend to be as realistic as the secular figures.

III. The Tang Dynasty

1. Early Tang

At this time, the contents of the murals basically continued the development of the Sui Dynasty. They can approximately divided into three types:

(1) Buddha figure paintings:

 Apart from the images in the main niche of the western wall, which are the principal images of the caves, the majority are still pictures of Buddha preaching; meantime, new subjects occur, such as the Eleven-headed Avalokiteśhvara (Ekādaśhamukha Avalokiteśhvara) on the northern part of the eastern wall in Cave no. 321.

(2) Sutra paintings:

 Afterwards, sutra paintings became the main contents of the mural paintings. Some of them were inherited from the previous period, with subjects like Maitreya Sutra, Sukhāvatī-vyūha Sutra, Lotus Sutra, Vimalakīrti-nirdeśa Sutra and Bhaiṣajyaguru (Medicine Buddha) Sutra, but both the composition and the positions they occupy in the caves are different from those before. Take the Lotus Sutra for example; the pictures of the Treasure Stupa Chapter (one chapter of the Lotus Sutra) were mostly depicted in the niches on the western walls and this was a tradition of the Sui. Additionally, there is the chapter of Emerging from the Earth in Caves no. 340 and 341.

(3) Narrative paintings:
 There is only one Tang Dynasty narrative painting, on the ceiling in Cave no. 209. This kind of painting received very little attention at this time. It was replaced by the Buddhist historical story painting like the scenes of "the stone Buddha statue floating on the river" of an event that happened in Jiangnan in the Western Jin (265-314), which was depicted on the southern and northern walls in Cave no. 323. This is one of a series of illustrations of document of Chinese Buddhist history.

The form of Buddha and Bodhisattva in the Early Tang had become realistic and the proportions of the figures are very appropriate.

2. High Tang
In this period of time, the sutra painting was the most distinctive form of all the forms of the Buddhist art in Dunhuang, and this was also the time when the distinctive composition and form of each of the sutra illustrations were accomplished. For example, in the illustration of the Bhaiṣajyaguru (Medicine Buddha) Sutra on the northern part of the eastern wall in Cave no. 148, in the centre of the picture Bhaiṣajyaguru is preaching in his Pure Land, while the scenes of his Twelve Great Vows and of the Nine Unnatural Deaths from which Bhaiṣajyaguru will save people were depicted on either side.

Among the Buddhist images, the figures of Avalokiteśvara are in the majority. The Avalokiteśvara Pumenpin (chapter 25 of the Lotus Sutra) even illustrated independently from the Lotus Sutra as the so-called Avalokiteśvara Sutra illustration like the picture on the southern wall of Cave no. 45. Beside, there also appeared a few images of the Esoteric Buddhist Avalokiteśvara, showing the importance of the Avalokiteśvara belief.

In the High Tang, on the basis of the Early Tang the bodily proportion of Buddha and Bodhisattva figures were perfected. Although the contents of the composition are complicated, the positions of the leading and supporting roles are quite clear and every figure is very distinct. This offered the viewers the possibility of leisurely reading the pictures and revealed the competence of the artisans.

3. Middle Tang
About the sutra paintings, a great many of the subjects were inherited from the High Tang, but there were also new ones. New sutra paintings subjects including Tianqingwen Sutra (Devata Sutra, Sutra of Brahma's Questions), Baoen Sutra (Recompense Sutra), Jingang Sutra (Vajra-cchedikā Prajñāpāramitā Sutra, the Diamond Sutra), suvarṇaprabhāsottama-sutra (Golden Light Sutra), Siyifantiansuowen Sutra (Visesaciutabrahma-pariprccha Sutra), Avataṃsaka Sutra (Flower Garland Sutra) and Lengqie Sutra (Laṅkāvatāra Sutra), and these were reflections of various schools.

As to the paintings of Buddhist images, the most distinctive feature is the increase of the Esoteric deities.

Furthermore, there are paintings of Buddhist history. The subjects include the Auspicious Image of a Silver Maitreyan India and Images of Auspicious Paintings Khotan. Accordingly, we can imagine the close relationship between Dunhuang and Khotan in the Middle Tang period. Moreover, the small-scale Panorama of Mt. Wutai also reflects the fact that belief in Mañjuśrī Bodhisattva (Wenshu Bodhisattva) had extended to Dunhuang in the period of Tibetan rule.

Generally speaking, the common characteristic of the figures in the Tang period is plump and vivid, and the composition

of the sutra painting roughly inherited the previous ages. No matter whether in sutra paintings or Buddhist figures, the whole pictorial space is filled with varied images. Because of the unchangeable compositions and the full pictures, this is the beginning of formulaic artistic expression.

4. Late Tang

The sutra painting in the Late Tang continued the development of the Middle Tang; in the meantime, there was added a great number of scenes reflecting the secular life, which resulted in jumbled and crowded pictures. Therefore, the themes were not as clear as those in the previous periods. The Buddha and Bodhisattva figure paintings still focused on the Esoteric Buddhist system like Thousand-Handed, Thousand-Eyed Bodhisattva (Avalokiteśvara-sahasrabhuja-locana), but Tejaprabha Buddha (Chishengguang Buddha) also appeared. As to narrative paintings, the Buddhist historical and auspicious images found on the tented ceilings of the western niches in the Middle Tang began to be depicted on the southern and northern sloping ceiling of the entrance corridors in the Late Tang, like those in Cave no. 85, which has a auspicious painting with the Mt. Niutou (Mt. Bull Head) of Khotan in the centre of the picture.

Although Zhang Yichao fought off the Tibetans at this time and Dunhuang returned to Chinese rule, there was no corresponding change in the subjects and the contents of the mural paintings.

IV. Five Dynasties to the Yuan Dynasty

The sutra paintings that had been continually represented during many periods like the Lotus Sutra and Sukhāvatīvyūha Sutra were still the main subjects in this period. Besides, according to Record of Famous Painters of All the Dynasties (Lidai minghua ji) written by Zhang Yenyuan, the Water-Moon Avalokiteśvara icon appeared in the late eighth and early ninth century, and began to be depicted in the Five Dynasties (907-959) in Dunhuang. The earliest example is the one dated to the eighth year of the Tianfu reign (943) held by the Musée Guimet, and the development of this icon lasted to the Western Xia (1038-1227). As noted above, the small-scale Panorama of Mt. Wutai had appeared in the Middle Tang; the one found on the western wall of Cave no. 61 of the Five Dynasties is a very large-scale one, displaying the natural landscape and local customs. Thus, it is not only a geographical map but also a historical picture as well. The murals of the small cave cut in the Yuan Dynasty, Cave no. 3, using very light and delicate colours and natural and fluent lines, made a perfect final statement of Dunhuang Buddhist art.

V. Conclusions

We can conclude with the following points:

1. In the Northern Dynasties, narrative paintings comprised the majority of the murals. After the Sui, sutra paintings and narrative paintings coexisted. In the Tang Dynasty, sutra paintings became the dominant form; by the High Tang, the compositions of sutra paintings had become formulaic and complete. From the Middle Tang to the Yuan Dynasty, the mural painting inherited and developed the art of the High Tang.

2. The subjects and the contents of the mural paintings are related to contemporary Buddhist culture of each period. In the Northern Dynasties, the jatakas like the King Lengjieli jataka and the King Sivi jataka basically correspond to the early translations of the sutras and the appearance of different sects. In the Sui and the Tang dynasties, there were

many sects; for instance, the Pure Land School influenced the designs of the illustration of the Sukhāvatī-vyūha and other sutras in Dunhuang.

3. As to the colors, in the Northern Dynasties, people used to apply highlights on the noses and eyelids of the figures on the foundation layer, and also on the salient parts of the body. After the Sui Dynasty, they colored the cheeks, eyebrows and the bones, forehead, nose and chin with layers of colours making the facial expression more mellow and natural.

4. Regarding the expression of the Buddha and Bodhisattva figures, in the initial stage, the figures were more ponderous. In the Northern Wei Dynasty, the figures became more slender; in the Western Wei, the figures transmitted an impression of delicacy and beauty; in the Northern Zhou, the facial figuration was short and square and body was also short. In the Early Tang, the trend was realistic, so the proportions of the figures were correct. In the Middle Tang, the figures were more plump and full; after this time, the success or otherwise of the visual expression was closely related to the level of skill of the artisans.

5. The themes and subjects are the visualized icons contained in the sutras. Meanwhile, the representations of the temples, palaces, buildings and walls offer us the opportunity to understand the ancient architecture; the musical instrument like reed pipe, bamboo flute, pipa, and the dance depicted in the Pure Land paintings make us realize the ancient music and dance; the natural conditions, social customs and the views of daily life in the paintings are significant materials for us to experience the customs of ancient society.

(Translation by CHIEN Li-kuei, revised and edited by Prof. Roderick Whitfield)

敦煌石窟的建築藝術

孫毅華　敦煌研究院

　　敦煌石窟主要由莫高窟、榆林窟、西千佛洞三處規模較大，且保存較完整的石窟群組成，其中莫高窟的規模最大，榆林窟次之，西千佛洞最小。

　　敦煌石窟寺有著延綿千年的開鑿歷史，其間朝代更替、思想演變、內容出新、風格各異造就了石窟寺多樣的建造形式，使其成為我國石窟寺開鑿的一部首尾完整，最具代表性、系統性的石窟寺建築的編年史。在這部編年史中，保存大量的古代建築資料，它主要包括兩方面的內容：一是石窟寺本身的形制與裝飾；二是石窟內壁畫中所反映的大量的建築畫。

一、石窟形制與石窟裝飾

　　敦煌石窟形制從北涼到北魏、西魏、北周的二百年間，石窟形制有禪窟、中心塔柱窟、方形覆斗頂殿堂窟，其中禪窟僅存在於這時期，中心塔柱窟占莫高窟全部中心塔柱窟近一半，殿堂窟也形成於此時期，後來成為石窟形制的主流。

　　隋代開鑿有少量的中心塔柱窟、中心佛壇窟與大量的殿堂窟。殿堂窟包含了多種形式：有人字披與平頂式殿堂窟、三龕式殿堂窟、馬蹄形佛床式殿堂窟、覆斗頂殿堂窟。其中人字披與平頂式殿堂窟經隋代發展到一個高峰，以後幾乎絕跡。

　　唐代以後只有少數中心塔柱窟與人字披式殿堂窟，早期出現的覆斗形殿堂窟，則根據時代變化使內部也發生變化。隨著開窟技術的提高和發展，開大窟、造大像是唐代雄厚經濟基礎與輝煌藝術成就的反映。而中原地區大建佛寺，也影響到石窟形制的變化；大型殿堂窟內的中心佛壇，就受到木構佛寺影響，如僅存的唐代寺院佛光寺和南禪寺大殿內都保存有中心佛壇。

1.石窟形制

（1）**禪窟**：又稱僧房窟，為早期窟形之一。印度稱為毗訶羅（Vihara），是供僧侶們生活和坐禪修行的處所。於一窟之中開多個禪室的形式只在敦煌早期洞窟中出現過，而且在窟室中有精美繪畫的現在僅存兩座：一、是開鑿於十六國晚期的第267～271窟，是一組小型禪窟；二、是開鑿於西魏大統四、五年（538、539）的第285窟，為方形覆斗頂窟，後壁正中開一大龕，塑彌勒佛像，兩側各開一小龕，內塑一禪僧，南、北壁各開四個小禪室。石窟中心地面還有一小方台。它將禪修與殿堂及右旋禮佛的內容集於一窟之中，成為一多功能的石窟。窟形與印度阿旃陀第12窟形式接近【圖1】、【圖2】。窟室壁畫也與禪修相關：在覆斗形窟頂四披下部，繪出在山林中禪修的僧眾三十六身，四披上部繪滿了天空諸神靈與奇禽異獸。神靈的彩帶飄舞，攪動著祥雲翻卷，滿壁風動，體現了禪修靜思後達到「馳心八解脫，締想六神通」的虛幻精神境界。隋唐以後，淨土信仰的流行，使修行方式改變，禪窟形制基本消失。

圖1　印度阿旃陀第十二窟平面圖　　圖2　第285窟平面圖

（2）**中心塔柱窟**：來源於印度的支提（Chaitya）式石窟，又稱塔廟或塔堂窟，經過長途流傳到

敦煌時，其空間形式與印度的支提空間已相去甚遠，但它的功能依然存在，既可以禮佛，也可以圍繞中心塔柱進行右旋誦經。早期的中心柱窟，採取平棊頂與人字披頂相結合的形式，將講堂與右旋禮佛集於一堂，使一個完整的空間於無形中分為兩個空間單元【圖3】。

在莫高窟碑刻文獻中有「中浮寶刹，匝四面以環通」及「刹心內龕」的記述，說明敦煌石窟內的中心柱其本意就是塔。中心塔柱窟在莫高窟共二十九座，隋代以前有十四座，約近半數。以後開鑿的中心塔柱窟，除保留中心塔柱的基本形態外，塔柱的造型及窟室的空間也發生了很大的變化。

(3) **殿堂窟**：這類石窟因為中部沒有中心柱，空間尺度上比較靈活，可以大到幾十平方公尺，也可小至僅能容身，是敦煌石窟中最多且延續時間最長的一種石窟形式。

圖3 莫高窟北魏第254窟形制簡圖

北涼開鑿的第272窟，窟形介於穹窿頂與覆斗頂之間，有西域穹窿頂石窟的影響。西魏第249窟是殿堂窟的典型形制，方形窟室平面，佛龕開在西壁，覆斗頂，頂部正中向上凸起方形藻井，形式與敦煌及周邊地區魏晉墓中的覆斗形墓室相似。由於殿堂式石窟內部空間開敞明亮，適於信徒的瞻仰禮拜，因此覆斗頂殿堂窟成為敦煌石窟修建中的主流形式貫穿始終。除以上的三種基本形制外，還有少量其他類型的，但總體都在這些基礎上變化。

石窟形制在發展中，儘管早期受到較多的西域影響，但總是力求表現本民族的文化傳統，因而在石窟開鑿的各個時期，融合民族建築形式就成為石窟造型的主流，長期的開鑿過程就是石窟寺造型民族化的過程。

2.石窟內的裝飾變化

石窟開鑿中，每一個朝代既有繼承，又有發展。即使在相同的石窟形制下，也不只是簡單的重複。關注局部裝飾的變化，是石窟建築研究的又一個方面。在石窟空間內，窟頂、佛龕是裝飾的重點。

(1) **窟頂**：窟頂形式主要有人字披平棊窟頂和方形覆斗頂，少量有矩形盝頂等。人字披平棊窟頂前部的人字披源於對兩披屋頂的模仿，時代越早，模仿越具體。北魏的人字披頂上，在塑繪出的橡檁之間又彩繪橡間望板圖案。北魏第251、254窟的檁端，還保存著彩繪的木斗栱和替木，在相應的牆壁上繪出大斗和柱子。北周開始漸變成用土紅色繪出橡檁或由佛經故事或千佛取代，逐漸擺脫了對木構屋頂的模仿。

方形覆斗形窟頂多用垂帳圖案裝飾。帳是我國古代的一種大型家具，古文獻中多有記載，《西京雜記》中記漢武帝雜錯天下珍寶造甲乙二帳，用甲帳居神，乙帳自用。用豪華的帳供佛是表示對佛的尊崇。莫高窟表現帳形裝飾最早是西魏第285窟，在覆斗頂中心繪華蓋藻井，井心為斗四蓮花紋，華蓋一周由三角垂帳組成，四角有饕餮紋樣的獸頭飾物，從獸頭口中垂下長大的環佩流蘇。窟室四壁上部又繪一周弧形帳幃，將整座石窟置於一個佛帳中。

隋與初唐時，在藻井三角垂帳形的四角增加了連珠紋帳杆，通過四壁直到地面，帳杆的轉角處用蓮花做節點裝飾。初唐第320窟四壁拐角則直接用木棍做帳杆。盛唐以後，窟頂藻井依然是帳形垂

幔,隨著時代的推移,窟頂藻井帳幔中的裝飾圖案增加,使帳幃的垂幔披於四披,延伸至四壁上部,使窟室又置於一座大帳中。

(2) **佛龕**:在敦煌石窟中出現的佛龕形式,主要有闕形龕、尖拱券淺龕、重層龕、敞口龕(平頂敞口龕和斜頂敞口龕)、帳形龕。

闕形龕:其形式是在龕外塑出殿屋,兩邊各有一高低錯落的子母闕,殿中間安坐彌勒菩薩,表現彌勒菩薩所居住的兜率天宮,是最早的一種佛龕形式,將西來的佛教內容包容在中國傳統建築中。闕形龕只存在於北涼和北魏時期。

尖拱券淺龕:是在早期淺佛龕前裝飾尖拱券形龕楣,淺佛龕中只容納一佛或一佛二菩薩。尖拱券龕楣形式起源於印度,據宿白先生研究,龕楣本是對在山中禪修的草廬的模仿。北涼的龕楣還沒擺脫對草廬的模仿,形象簡單。早期龕楣多用浮塑與繪畫相結合形式。西魏第285窟內有大小十一個龕楣,圖案繁複華麗,使龕楣裝飾達到高峰。隋代的佛龕形式發生改變,出現了重層佛龕,龕楣在加深的佛龕前逐漸消失,尖拱券淺龕也被重層龕所取代。

重層龕:隨著佛教經典的大量翻譯和佛教的世俗化,淺佛龕已不能滿足造像數量增多的現象,於是隋代出現了重層龕,大致是內龕塑佛與二弟子,外龕塑二菩薩。龕前用繪畫的龕楣延伸到外龕頂上。發展到初唐,僅少數石窟延用了重層佛龕,以後敞口龕的優勢取代了重層龕。

尖拱券形淺龕　　重層佛龕　　梯形敞口龕

圖4　三種佛龕示意圖

敞口龕:初唐的佛龕形式以半圓敞口龕為主,龕內更利於造像的佈置。佛正面向前,兩旁的弟子與菩薩沿著半圓形龕舒展排開,以半側身扭腰轉頭的S形姿態向著參拜的芸芸眾生。優美的佈局和姿態,充滿了世俗的人情味。菩薩身上華麗的衣飾與壁畫中彩飾的佛國世界相呼應【圖4】。第45窟是一座殿堂窟,西壁佛龕為半圓敞口平頂龕【圖錄號1】。

帳形龕:將整座石窟裝飾為帳形窟的同時,從盛唐開始,除窟頂的帳形藻井外,又將佛龕裝飾成帳形龕,最初只將敞口龕頂繪出帳柱與帳幔,以後發展成盝頂帳形龕。中唐是帳形龕的鼎盛期。中唐的帳形龕內,頂上是色澤豔麗,排列有序的平棊圖案,龕外繪出鑲板木格式的仰陽版,兩端飛翹出帳外,端頭伸出龍頭,口銜環佩組成的花飾,頂上裝飾山花蕉葉,龕兩邊有束蓮帳柱,完全模仿木構的佛道帳形式。

石窟中大量採用帳形龕形式,是寺院裏大造木構佛道帳的反映,宋代將這一形式編入《營造法式》中。這種纖巧的小木建築,在唐代曾盛行於各大小寺院內,隨著寺院的興衰,保存下來的唐宋實物極少,而石窟中大量的帳形龕形象,再現了唐宋時的佛道帳形式。

(3) **地面**:在石窟空間內,除了用塑繪方式裝飾空間四壁和窟頂外,還用花磚作為地面鋪裝。用花磚鋪地曾廣泛應用於宮廷、寺觀、陵墓建築中。在唐代壁畫中有很多露臺地面表示有花磚鋪地。敦煌唐代墓葬內使用的花磚紋樣與石窟地面所見大致相同。石窟內外用花磚鋪地,最早見於隋代的八瓣蓮花紋磚,現在莫高窟保存有隋至元各時代的花磚紋樣達幾十

種，以蓮花紋為主要樣式。用蓮花紋樣裝飾地面，象徵著清淨和吉祥，行走在蓮花鋪設的地面上，是否也有步步生蓮的喻意？石窟本身就是色彩和紋樣的海洋，地面上再鋪墁花磚，更增加了室內的華貴之感。

莫高窟保存的花磚還有一種用於建築下部的踢腳線部位，這類花磚數量不多，但很有特色。如慈氏塔基座上鑲嵌的龍、鳳花磚，龍飛鳳舞，造型生動。此外有麒麟磚、獅子磚、天馬磚等，其他還有馴馬磚和牽駱駝磚，馴馬人和牽駝人都著少數民族服裝，形象生動，充分反映絲綢之路上民族風情。

二、形象的建築歷史畫卷—石窟壁畫中的建築畫

建築是人類文明的綜合成果，與人們的生產和生活息息相關。在繪畫中反映建築之美，古已有之。在石窟寺內反映建築形象，始終伴隨在石窟的開鑿過程中。從印度經中亞再到新疆的各處石窟中，反映眾多的建築形象。敦煌石窟以繪畫形式保存了大量的建築形象，成為當今研究中國古代建築史的一個重要資料庫。

敦煌石窟裏的建築畫展現了從北涼到元代很多類型的建築形式，既有建築群體組合—寺院建築群，又有建築群中的各單體建築，還有許多世俗建築及建築細部技法描繪。由於石窟開鑿年代久遠，這些建築形象反映了中古時期建築歷史的發展軌跡，展現了一部形象的建築歷史畫卷。

1. 寺院建築群

組合的寺院建築群從隋代開始出現，唐代表現大型寺院建築群，場面開闊。第172窟南、北壁經變畫中的兩組建築群，在中軸線前面有大小幾座出於水中的露臺，是佛與眾菩薩觀看天人伎樂歌舞表演的看臺。露臺後的軸線正中是一座大佛殿，之後有後殿，兩側用迴廊相連，組成凹形廊院佈局。通過迴廊與臺階，組成庭院的內在交通要道。畫面中使用不同組合的殿、堂、樓、閣、台、廊等多種建築單體作為建築元素，形成各自錯落優美的建築天際線【圖錄號17、18】。

唐代的大型經變畫有莫高窟第329、217、172、148、159窟及榆林窟第25窟【圖錄號4、5】等。在這些畫面裏，表現的寺院群落都自成特點，同時又呈現了宏大的群落之美的共性。

五代第61、98、100窟窟內的大幅經變畫，反映大型寺院建築形象，沿軸線佈置有三門、殿堂、配殿、迴廊、角樓等種類繁多的單體建築，形成氣勢恢弘，波瀾壯闊的建築群體。受當時以建高樓競相誇耀的時尚影響，壁畫中的寺院裏，樓閣充斥過多，有失於龐雜壅塞，失去了唐代寺院中的疏朗之美。

榆林窟西夏第3窟南、北兩壁各一幅大型經變，運用不同的單體建築，形成不同的寺院群。該窟的建築畫形式與以往各朝代的風格截然不同，卻與中原宋、遼、金時期流行的建築形式相近，是西夏與中原加強文化交流與聯繫，在建築形式與繪畫上受中原影響的反映。人們甚至懷疑這些壁畫當出自中原畫師之手。

2. 佛塔

佛塔的形式是伴隨著佛教的傳播與發展而產生的，是壁畫中變化最多的一種建築類型。在印度「塔」的作用原本是埋藏屍骨的墳塚，於地面上起一個大覆鉢是其基本形式，梵文稱為「窣堵坡」。

壁畫中從北魏開始繪製塔的形象，直到元代，塔的造型各不相同。早期壁畫中，既有埋藏屍骨

的窣堵坡，也有中國傳統的高樓式塔，如北魏第254窟南壁和北周第428窟東壁同樣都表現薩埵本生故事中的舍利塔，卻有窣堵坡和高樓塔兩種形式。隋唐以後，塔的形象逐漸趨於華麗，如第23窟南壁〈見寶塔品〉中的大塔，由於畫幅大，所以精細的描繪了塔的整體形象及細部，該塔與陝西扶風法門寺塔地宮中出土的一件銅塔模型極為相似。榆林窟第36窟開鑿於五代，在前室有一座托在天王手中的小塔，於美麗的蓮花中間有一小覆缽塔，在覆缽形的塔身上加蓋了具有中國傳統的四角攢尖的大屋頂，好像一頂大草帽蓋在覆缽上。屋頂上有相輪塔剎，塔剎兩邊懸掛鏈與鐸，整體造型好似一個精巧的工藝品。

3. 世俗建築

世俗建築主要有宮城、民居、城門、城樓、角樓、茅庵、草棚、小橋、墳墓、烽燧等不同用途的建築形象。儘管壁畫內容反映的是佛國世界，但壁畫的製作者卻無法擺脫世俗的影響，將中古時期人們生活中常見的建築形式描繪在壁畫中。

北涼反映了早期的闕形宮城形象，如第275窟南壁「太子出遊四門」故事中的城闕。北周和隋代的世俗建築裏，繪製了大量的院落民居建築。隋代開鑿的第431窟，至初唐將下部改繪；展品中一幅宮廷院落圖就臨摹於北壁【圖錄號16】。這是一座宮城，以橫向構圖方式表示，用圍牆分隔出宮廷中前朝、後寢及御苑的三個組成部分。

唐代的彌勒經變畫裏，為了表現彌勒佛世界裏，人們豐衣足食的美好生活，繪出很多城，帳幕、蘆棚、小橋、墳墓等眾多的世俗生活建築場景。

榆林窟西夏第3窟的普賢變與文殊變中，有仙山瓊閣隱現在深山峽谷中。建築摒棄了城市宮廷寺觀嚴格的軸線對稱，使殿閣隨山勢自由組合，構成一幅優美的山水景觀圖畫。

建築畫中除表現建築主體外，常常在建築內外畫有遠山近樹、小橋流水、紅花綠草，反映出濃郁的生活情趣和優美的建築環境。

4. 建築細部技法特徵

建築細部主要有台基、欄杆、地面鋪裝、牆、窗、柱、斗栱、屋面、屋脊等，通過細部技法的表現，分別組成一幅幅不同構件和部位的發展史。這裏主要介紹台基、欄杆與地面鋪裝和斗栱。

（1）**台基、欄杆與地面**：早期的房屋多為素平台基，表面砌磚，前有臺階。佛塔的台基受佛教的影響，出現簡單的疊澀須彌座形式，邊沿的欄杆形式較簡單，主要有直欞又稱直棱欄杆和勾片欄杆。台基與欄杆的組合形成虛實對比，豐富了建築的立面形象。隋代的台基已逐漸華麗。自唐代出現大幅經變畫後，台基、欄杆與地面就在畫面

圖5 莫高窟北魏第257窟斗栱

中起著連通、分隔和裝飾的作用。建築之間的通道，佛、菩薩講經說法的平臺，伎樂表演的舞臺都由台基承載。台基有出水平座式和實心砌築式，一幅畫中有虛有實，如第172窟中的台基【圖錄號17、18】。台基的立面裝飾各種圖案，台基上面邊沿多用勾片欄杆，欄杆的節點用金屬包鑲，形成華麗的建築形象。有的台基地面上繪出方格與蓮花圖案，表示花磚墁地。石窟中保存了大量的花磚與壁畫形成呼應。可見壁畫中表現的各種裝飾與圖案均來自於現實生活，壁畫裏只是將人間美好的建築形象都融匯進去，進一步美化了經變中的淨土形象，感染虔誠的信眾。

（2）斗栱：是斗與栱的總稱，用於屋檐下，是屋身與屋頂之間的連接與過渡，它是中國傳統建築最重要的特徵之一。有關記錄建築工程的典籍中，都對斗栱的製作記述十分詳盡，而在實際建造中，對斗栱的運用技術如何，直接關係到整座建築的造型和建築的穩定性。

斗栱的起源很早，經過長期的不斷改進、演變，逐漸趨於完善。早期斗栱處於不斷發展變化之中，北涼第275窟中所畫的斗栱圖像清晰，結構特殊，為以後所不見。北魏第257窟有一組斗栱，形成了一枝樹杈的形象【圖5】。

在隋代的斗栱形式中看出，它是斗栱發展的關鍵和過渡時期，出現了多種斗栱形式共存的特徵：有柱頭上直接用一斗三升斗栱（第433、419窟），之上再用欄額連接，欄額上承托人字栱；柱頭之間用

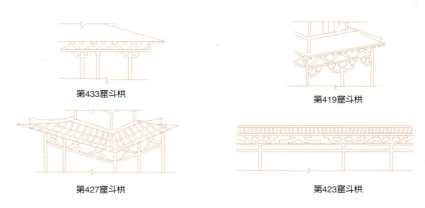

圖6 莫高窟隋代斗栱的變化

欄額連接，欄額上承托人字栱（第427窟）這是一種比較古老的結構方式；柱頭之間用雙欄額連接，柱頭上有一斗三升斗栱，中間有人字栱（第423窟）【圖6】。在柱子之間用額枋加強聯繫，斗栱放在柱頭上，這是結構上的重大變革，加強了柱網的穩定性，為唐代建築走向成熟奠定了基礎。

唐代趨於寫實的繪畫風格，更清楚的刻畫了建築構件細部。第172窟（西元705—781年）北壁寺院建築上【圖錄號17】，繁簡不一的斗栱分別用於不同等級的建築上，出一跳四鋪作斗栱用在迴廊上，出兩跳五鋪作斗栱用在角樓及後佛殿夾屋上，出三跳六鋪作斗栱用於後佛殿的上層，位於正中的大佛殿，其轉角鋪作採用七鋪作雙抄雙下昂重栱計心造斗栱。這種斗栱形式是盛唐及以後壁畫中所見最複雜，高規格的斗栱，而且畫得精確合理。現存五臺山唐代佛光寺大殿（西元857年）的斗栱即為七鋪作斗栱。

榆林窟西夏第3窟南、北壁大幅經變中的建築簷下，繪製的斗栱遠不如唐代斗栱粗大雄壯，遠看細小密集成一片，是明清時期斗栱的結構作用減弱，裝飾作用增強的開端。

此外壁畫中還保留有一些小型建築和裝修，這些小型物件或已失傳，或有少量保存，如平閣、障日版等，在古籍文獻中曾有文字記載，但實物稀少，石窟中保留的形象更顯彌足珍貴。歷史學家翦伯贊先生曾說：「我以為除了古人的遺物外，再沒有一種史料比繪畫雕刻更能反映出歷史上社會之具體的形象」。敦煌石窟中反映了中古時期延續近一千年的建築形象，從中可以窺見中國古代建築的發展變化過程，是一部形象的建築歷史長卷畫。敦煌石窟中無論是石窟形制和裝飾，以及壁畫中大量的建築畫，共同構成了一部完整的敦煌石窟建築藝術。

The Art of Architecture of the Dunhuang Grottoes

SUN Yihua
Dunhuang Academy, China

The Dunhuang Grottoes consist mainly of three extensive and well-preserved Grotto complexes – Mogao, Yulin and the Western Thousand-Buddha Grottoes. Among them, Mogao is the largest site, next is Yulin and the Western Thousand-Buddha site is the smallest. The period during which Mogao Grottoes were hollowed out extended for a thousand years and they preserve an enormous quantity of ancient architectural materials. These include two main parts: the first being the types and decorations of the caves themselves; the second being the numerous representations of architecture in the mural paintings.

I. Types and Decoration of the Caves

In the two centuries (early fifth to late sixth century) from the Northern Liang, Northern Wei, Western Wei to Northern Zhou, the cave types of Dunhuang consisted of vihāras (meditation caves), caityagṛha (central pillar caves) and māṇḍapa (worship halls). Meditation caves are found only during this period, central pillar caves were in the majority and the halls for worship began to appear in this era and were the most common type later.

1. Types of the Caves

Vihāra (Meditation Cave):
"Vihāra" is a Sanskrit word. It was also called "monk-room cave" in Chinese and was one of the earliest cave types. It was a place in which monks could meditate and practice Buddhist teachings. Caves with several cells are found only in the Dunhuang Grottoes, and only two still preserve exquisite paintings: the first is a set of four small-scale cells, Caves no. 267 to 271, cut in the late Sixteen Kingdoms Period; the other is Cave no. 285 built in the fourth or fifth years of the Datong reign of the Western Wei dynasty (538-539), which has a total of eight cells.

After the Sui and Tang, with the rise of the Pure Land belief, there were changes in religious practice, and the vihara type of the meditation cave practically disappeared.

Chaityagṛiha (Central Pillar Cave):
Chaityagṛiha came from India and was also called "stūpa temple" or "stūpa hall." After this type had spread to Dunhuang from such a long distance, the spatial arrangement was quite different from how it had been in India, but the function remained the same. People could still worship Buddha at front of the caves, and they could also process clockwise around the central pillar and intone the sutras. The new space combined two functions of lecture hall and the ritual of clockwise circumambulation around the central pillar. This new type divided the whole space into two units. (Fig.1)

The inscriptions on the stelae of Mogao Grottoes show that the basic idea of the central pillar was a "pagoda." There are twenty-nine central pillar caves in the Mogao Grottoes and fourteen of them were constructed before the Sui Dynasty, almost half of the total. Those built later only preserved the basic shape but changed greatly in both the form of the central pillar and the spatial arrangement.

Māṇḍapa (Worship Hall):
There was no central pillar in this type of cave. Therefore, it was more flexible in spatial arrangement and was the most long-lasting type. Cave no. 249 of the Western Wei is a typical example with a square plan, a niche in the western wall and a ceiling in the shape of an inverted rice-measure "dou" (truncated pyramid), the same as many of the tomb chambers of the Southern and Northern Dynasties (fourth to sixth centuries) within and nearby Dunhuang. The interior

space of such caves was open and bright and suitable for believers to worship in. Thus, this cave type became the dominant one throughout the remainder of the period during which caves were actively created at Dunhuang.

Besides the above three types, there are a small number of caves of other types, but the designs are single variations based on these three. In the development of the cave types, despite the influence from the Western Regions in the earlier days, people always tried to express their own cultural tradition. Consequently, in every period of cave construction, types that integrated different peoples' architectural features would become the mainstream types. The long history of cave temple construction is the process by which the form of the cave temples became assimilated to the people.

2. The Transformation of the Interior

In the construction of the cave temples, every dynasty inherited a certain amount and developed new forms. Even when people were constructing the same cave type, they never treated it like a repetitive work. Therefore, observing changes in the detail of the decoration is another way of studying the cave architecture, and the key points in the cave interior are: the ceiling and the niches for Buddha images.

Ceiling:
The main type of the ceilings are gable ceilings, truncated pyramidal ceilings and a few caves in which this square pyramid ceiling was extended into a rectangle. The gable ceiling in the caves was a mimic of a gabled roof. The earlier the date, the more faithful the imitation.

The decoration in the square pyramidal ceiling cave was usually in the form of a hanging tent and the earliest example is in Cave no. 285 of the Western Wei Dynasty.

Niche:
The niche types in Dunhuang are a niche in the form of a gateway, shallow niche with a pointed arch, two-stepped niche, open niche and a tented niche。

Gateway Niche:
This type of niche is modeled in the form of a hall flanked by taller and shorter towers. Maitreya Bodhisattva is seated in the centre of the niche, which symbolizes the palace of Tushita Heaven in which he dwells. This was the earliest type of niche and embraced the Buddhist content from the Western Regions in the traditional Chinese architecture. However, this type only existed in the Northern Liang and Northern Wei dynasties (fifth to early sixth centuries).

Shallow Niche with A Pointed Arch:
This was an early type of shallow niche decorated with pointed arch lintel. In this shallow niche, there would only be one Buddha or one Buddha with two bodhisattvas.

Two-stepped Niche:
The two-stepped niche appeared in the Sui Dynasty. There were usually one Buddha and two disciples in the inner part of the niche and two bodhisattvas in the outer part with a painted lintel stretching to the top of the niche. By the Early Tang, there are a few caves of this type, which was replaced by the open niche.

Open Niche:
This was the dominant type of niche in the Early Tang. This hemispherical plan made it earlier to arrange the images. The Buddha was in the exact centre facing the front and the disciples and bodhisattvas were positioned along either side of the hemispherical plan (Fig. 2). Cave no. 45 in this exhibition is a mandapa worship hall and the niche in the western wall is of exactly this type.

Tented Niche:
From the High Tang, people started to cut the main niche in the form of a tent. At the beginning, people only painted the pillars and canopies on the upper part of the niche. Gradually, the form developed and became a tented niche with sloping sides. In the Mid-Tang, this tented form of the niche reached its peak.

Floor:
Within a cave, besides the painted and modeled decoration of the walls and ceilings, there were also patterned tiles to adorn the floors. In the murals of the Tang Dynasty, the surface of many terraces is shown as being decorated with patterned tiles. The patterned tiles used for the cave floors were mostly the same as those used in the Tang tombs at Dunhuang. The earliest such pavement of patterned tiles dated from the Sui Dynasty (late sixth to early seventh century). Dunhuang now preserves ten kinds of patterned tiles dating from the Sui to the Yuan Dynasties. The lotus was the main pattern and symbolized purity and auspiciousness.

An Illustrated Architectural History–Representations of Architecture in the Mural Paintings:
The representations of architecture in Mogao Grottoes reveal many types of architecture from the Northern Liang to the Yuan dynasties. There were architectural complexes: temple complexes, individual buildings of architectural complexes and many examples of secular architecture and details of architectural techniques. Those architectural images reflect the historical development of the architecture of medieval China and together form an illustrated architectural history.

Temple complex:
The temple complexes began to appear in the Sui Dynasty. In the Tang Dynasty, there are magnificent scenes of the large-scale temple complexes, spaciously laid out.

Pagoda:
The occurrence of pagodas called "stūpa" in Sanskrit, used to enshrine the relics of the Buddha, followed the spread and development of Buddhism and they had the most diverse images of all architectural representations. The function of the stūpa in India was originally as a tomb and its basic form was like a huge inverted bowl on the ground. The first pagoda depicted in the murals was in the Northern Wei Dynasty (fifth century) and until the Yuan Dynasty forms of pagoda continued to appear.

Secular Architecture:
Secular architecture mainly included the palaces, dwellings, gates, castles, watchtowers, cottages, thatched sheds, bridges, tombs and beacons, and buildings created for various purposes. In spite of the fact that the murals were to reflect the Buddhist domain, there was inevitably a secular influence and the artists depicted the familiar architectural images of their daily life in medieval China.

In the architectural representations, besides the architectural subjects, ancient painters also depicted distant mountains,

the trees nearby, bridges, rivers, colorful flowers and green meadows, which expressed the rich living temperament and the interest and graceful environment of the buildings.

Techniques of the Construction and Characteristics:
The architectural details in the murals included platforms, balustrades, tiles, walls, windows, pillars, brackets, façade and ridges. Through their display of detailed constructional techniques, they present a history of the development of the foundations, galleries and bracket systems of the buildings.

Platforms, Balustrades and Floor:
The platforms of the earlier buildings were mostly undecorated. They were usually tiled with bricks and there were steps in front. The platforms of the pagodas were influenced by Buddhism and took the form of corbelled pedestals, known as Sumeru pedestals. The combination of the platforms and balustrades offered a beautiful contrast of solid and void, enriching the appearance of the architectural façade. From the Sui Dynasty onwards, the platforms became splendid. From the Tang, there appeared large-scale stūpa illustrations, in which the platforms, balustrades and floors communicated with each other, having separate functions of use and decoration. We can see that the various ornaments and patterns all came from people's real life.

Bracket System (Dougong):
The bracket system supporting the roof is called "dougong" in Chinese. It is a compound appellation of "dou" (literally: rice measurement) and "gong" (bracket arm). It is used beneath the eaves as the transition between the walls and the roofs and is one of the most important characteristics of Chinese architecture. The relevant construction writings all had exhaustive accounts of the bracket system. In actual construction, these techniques directly determined the form and stability of the building.

Early bracket systems were always changing and developing. The bracket representation depicted in Cave no. 275 of the Northern Liang (first half of the fifth century) is very clear, and the construction was distinctive. This bracket has never been seen in later ages. The bracket system in Cave no. 257 took the form of branches (Fig.3). From the bracket constructions seen in the murals of the Sui Dynasty (late sixth to early seventh century), this was a critical transitional period because there coexisted many different bracket systems. The realistic painting style of the Tang Dynasty (618-706) more clearly depicted the details of the architectural components. The temple architecture from the northern wall of Cave no. 172 from the High Tang period (705-781) in the exhibition displays various kinds of complicated and simple bracket systems used on diverse levels of architecture.

Besides, the Dunhuang mural paintings also preserved some small-scale buildings and assemblages. Unfortunately, these items didn't successfully pass to the later generations. Although some of them might be recorded in documents, actual examples are too few. This circumstance makes images preserved in the grottoes even more precious. The historian Jian Bozan once said, "Except for actual remains, I think there are no documents more capable to reflect the reality of the society in the past than painting and sculpture." Dunhuang Grottoes revealed the representations of the architecture over a period of almost a thousand years in the medieval age. We can see the transformation and evolution of ancient Chinese architecture. It is an illustrated history of architecture. The cave types, their decoration and the numerous representations of architecture on the murals constitute the art of architecture of the Dunhuang Grottoes.

(Translation by CHIEN Li-kuei, revised and edited by Roderick Whitfield)

展現胡風的唐代時世裝

林春美　國立台南藝術大學

家戶喻曉北魏孝文帝推行漢化運動，令鮮卑族人著寬衣博帶的漢裝，但卻少有人知道，漢族統治者常因實用的因素，令國人著輕便的外國服。最早的像趙國的武靈王（執政於西元前325-298年）見騎射輕捷靈活，改穿胡服：褲褶、靴與附加銅勾的腰帶，即後來所謂的蹀躞帶；最近的是創建民國的孫中山（1866-1924年）仿照英、美適合野外鍛鍊的童子軍裝，制定衣、褲給公務人員取代長袍、馬褂，因而稱中山裝。唐代（618-907年）結束近近四百年的胡、漢爭戰結束之後，選賢與能、休養生息，使經濟得以發展，文化趨向繁榮。在服飾文化方面，由於對外交流頻繁、態度開放，呈現多元風貌。本文針對敦煌莫高窟壁畫中各族群交會的盛況，探討西域流行風對唐人時尚的影響。

莫高窟壁畫中呈現各族群大會合的場面以維摩詰經為題材的畫面最壯觀，且歷代各有變化。就以紀有貞觀十六年（642年）的第220窟為例【圖錄號20、21】，觀察圍繞在文殊菩薩與維摩詰居士之間問疾，或聆聽兩者辯論所激發出智慧之語的云云眾生，他們各自穿戴的服飾即反映出當時的多元文化。除了中原的帝王服袞冕：冕旒、飾有日月龍山等紋的玄衣、纁裳、韍（蔽膝）與舄[1]，從臣著朝服：介幘、滾飾青色邊的絳紗單衣與白裙、蔽膝與舄，以及掌扇人穿著引進將近千年並已成為軍服的騎射褲褶裝、戴裲襠（護胸、背）之外，還有異國裝扮，如袒胸披帔帛、赤腳穿短褲或著圓領與靴的外國王子和武將，以及維摩詰右邊著大袖衫、裙與半臂的天女等。下面將從這些異國王子與天女的裝扮開始，盡量羅列敦煌壁畫中漢民族以外的異族、即當時所謂胡人的服飾，分三項探討：一、服裝形制的探討與變遷，二、相關的佩飾（首飾），三、服裝紋樣的轉變。

一、服裝

1. 圓領袍、靴

第220窟黑卷短髮、赤腳、穿短褲的非洲王子右旁兩位異國王子各穿圓領赭色與石綠窄袖袍服，搭配棕色與黑色有筒能護小腿的勒靴，他們穿的袍採取前、後身均直裁，直裾袍的領座、袖口、衣裾邊沿滾飾花邊，看不出是否繫蹀躞革帶。這種遊牧騎射的裝扮通行於北朝，按《夢溪筆談》記載，北齊（550-577年）以來全用窄袖、紅（緋）、綠、紫或五色胡服[2]。窄袖利於馳射，短衣長勒便於涉草，蹀躞帶好佩掛刀、磨石、契苾真、針筒、火鐮袋、噦厥、算袋等七件日常必需品，高氏諸帝則常穿緋[3]袍。這種以五色或素色為衣身，以雜色鑲滾沿邊的袍服，下著小口褲，可作為北朝朝會之服，還在北周時，於前後襟下沿各以一幅布橫接成橫襴，稍做改變，歷經隋進入唐代，也成為皇族、官吏下至廝役均可穿著的常服。其尊貴品第主要以顏色、紋飾和革帶的裝飾材質[4]來區分：三品官以上服紫色大團花（大窠）綾羅，配玉帶鉤腰帶；五品以上服紅色小團花（小窠）綾羅，配金鉤腰帶；六品以上服黃色雜花絲、布，配銀環扣帶；八、九品服青色雜花紬、布，配瑜石腰帶。直到高宗總章元年（668年）才禁止官民穿黃，赭黃成為象徵皇帝的顏色。

另外，還有一種圓領袍變化式樣，即袍下左、右開衩，稱缺胯袍，也是唐代男子的主要服裝。這些圓領袍、革帶和長勒靴與漢族的幞頭配成套，一直流行到明代才被滿族人的騎射服裝取代。莫高窟晚唐第17窟洪辯塑像右後側壁畫上繪樹下仕女【圖錄號2】也著此袍；西夏第409窟【圖錄號27】的供養人回紇王著深色地淺色團龍紋的缺胯袍，腰繫蹀躞革帶佩劍、刀等必需品。

唐代女子也喜歡穿這種圓領袍衫，太平公主[5]著紫衫玉帶、裹黑色折上巾（幞頭），歌舞於高宗

帝前。從第七世紀下半葉墓葬出土的俑與壁畫仕女形象來看，著圓領袍衫的女子都以尖頭履或線鞋取代靴，頭上裹幞頭，戴尖頂搭耳的蕃帽、卷簷虛帽或用羊皮做的渾脫帽，如第159窟壁畫維摩詰經變中各國王子群的穿戴【圖1】。他們還經常把領扣解開，轉變成翻領袍的樣子，如第445窟彌勒經變女剃度畫面【圖錄號37】中有一穿深棕色小團花，手捧剃度工具的女侍形象。這些領子實際上並非翻領式樣，領襟部分真正裁、縫製成的翻領袍呈現在圖一各國王子群中，走在前頭的吐蕃贊普及其隨從身上穿翻領袍：後翻領部份裁剪成如意雲頭，前領與斜裾衣襟相連至左腰際。

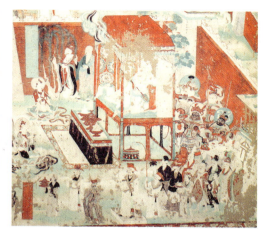

圖1 莫高窟第159窟維摩詰經變中各國王子

2.半臂

　　半臂也稱半袖，也就是袖子只遮住半個手臂。西漢馬王堆一號墓（西元前第二世紀）出土穿半臂的侍女俑是目前最早的實例，高春明引用唐人注釋，說明兩漢交替時期（西元前後）加罩繡花半臂的多半是女子，男子穿了要遭訕笑[6]。但從四川漢墓出土的樂舞俑多處可見男俑也穿交領斜裾的半袖，袖口還飾以細摺邊（折襴）[7]。類似的半袖實物在新疆尼雅東漢（25-220年）[8]墓出土一件：深黃交領衣的短袖口綴飾縐褶荷葉邊，下半截寬鬆斜裁，腰部左右各飾五條綠色窄帶，作為腰帶又富裝飾【圖2】。

　　雖然魏明帝（227-233年）著遊牧民族常穿的青白（縹）色半袖衫與臣屬相見時，遭斥為『服妖』[9]，但歷經北朝（386-581年）之後，隋大業年間（605-617年）內官已多服半臂。從此，半臂與圓領袍一樣成為正式場合的服裝，普及全民。

　　常見的騎射半袖衫樣式多是圓領袍身，或無袖或配上寬的短袖，衣身長短依搭配的下裳是裙或褲而定。新疆克孜爾石窟六世紀第205窟壁畫龜茲國王及王后各穿合身的半臂裝【圖3】，半袖綴折襴呈小喇叭狀。國王穿襯綠裏的棕黑色半臂缺胯衫於窄長袖的綠色長袍與深色小口褲上，袍沿滾飾深藍地白點三角形紋樣。王后穿襯深藍裏的綠色細腰半臂短衫於白色龜背形藍花的燈籠長裙上，棕、藍條紋相間的長袖緊身衣的胸領開得很低，隱約現出緊身胸衣（訶子），袖口滾棕、藍條紋邊再綴繐。兩件半臂衣領應屬扣在中間的圓領款式，解開領扣便成對稱式翻領。有些衣領襟開在頸邊的，領扣解開後，僅見一邊三角形樣的翻領。這種男女皆著的外衣，在莫高窟壁畫人物中處處可見。

　　唐代女子穿的半臂除了上述半袖的圓領衫袍之外，還有無領與曲領的低胸緊身短衣和對襟短衫，但袖口的裝飾方式相仿。唐初女子的常服沿襲隋代裝扮，穿窄袖、緊身交領短上衣（襦）或窄袖或大袖，繫高腰長裙於胸下，著高頭鞋。裙腰束在衣裏、衣外皆可，也有所謂的壓腰[10]穿法，即先將裙腰束在衣外，再將衣下擺朝上翻出，複壓在裙腰上。

　　唐初女子半臂衫多見無領低胸[11]、紮在間色條紋長裙的裙腰內。從長樂公主墓室壁畫（西元643年）昆侖女奴著V字形領的半臂開始，胸領越來越低、越大，像莫高窟初唐第329窟東壁南側說法圖下的女供養人【圖4】所披透明橘色帔帛下，透出鵝黃色露胸緊身半臂一般。新疆吐魯番阿斯塔納第

230號墓（約702年）【圖5】出土的絹畫女子半臂領胸更低，是穿在高腰裙外的對襟短衫。從那沒完全被遮住的左襟部份[12]和衣身上的對稱纏枝花葉紋樣可推測，半臂可能由當時流行織成的半臂錦縫製的。

半臂的樣式跟隨穿衣人豐滿的身軀而加寬衣袖，約繪於753年禮佛的都督夫人王氏【圖錄號23】所著的半臂是V字形領的花色衫，材質柔軟的袖口寬比襦袖許多，還見疊出的褶來。新疆阿斯塔納第187號墓（約744年）出土弈棋仕女著的上衣袖比王氏一行人的更加寬，或因此不再罩半袖衫，只披透明的帔帛。莫高窟第156窟宋國夫人出行圖（約861年）【圖錄號35】中：夫人著襦裙騎在馬上，高腰所束的交領斜襟衣有四層之多，寬袖越到袖口越寬大，呈喇叭狀，也沒見再穿半袖衫。稍晚三十多年的第9窟（約893年）[13]女供養人【圖錄號24】所穿的襦裙在胸領上稍有變化：領呈U字形，裙腰裝飾花葉。這種強調裙腰花飾並穿到胸上的流行風，傳到五代（907-960年），更凸顯胸前裙腰部份的裝飾，但卻在胸裙外穿大袖衫，如千手千眼觀世音菩薩圖（943年）下的女供養人還穿了兩件【圖錄號71】。胸前裙腰還凸顯成弧形的，如王處直墓（924年）室內的婦女形象。從此可確定，傳周昉（約766-796年）繪簪花仕女透肌膚的薄羅衫子[14]形制與弧形胸裙的裝扮屬於五代的流行風，該畫的原跡或因此是這時代的作品。

圖2 尼雅出土東漢半臂裝（摹本）

二、佩飾

1. 帔帛

帔帛是披在肩背上的長方形巾，即現代所稱的披肩或披巾。第220窟的非洲王子裸露上身，披紅地聯珠圈長帛，裏襯石綠色，十分豔麗。帔帛從背後往胸前交叉後，兩端各拋往肩後顯出石綠，繞過胳肢回纏到肘臂上轉垂下來。這種裝飾兼保暖的帔帛在同一幅畫面上還可找到不同的變化：文殊菩薩右邊兩個菩薩肩上綠色的帛配合肩背的需要，裁剪得較寬。同樣形式也搭在第321窟的十一面觀音身上【圖錄號12】，但這些披在菩薩和天人身上的卻稱為天衣。帔帛是從絲綢之路傳進中國的，舊唐書上記載波斯人男女均有巾帔[15]。但這種長方形、披在衣服之上的巾帔，依其厚、薄、長、短，或當大衣裹身，或當裝飾點綴，是古希臘男女[16]西元前六世紀以來流行服飾的特色，透過波斯、粟特人在北魏[17]時期傳到東亞絲綢之國，在唐代卻只成了婦女服飾的獨寵。開元時期（713-741）詔令三妃以下參加宴會時都得服彩繪帔帛[18]，因此，柔軟、輕飄搭配服裝的帔帛在唐代

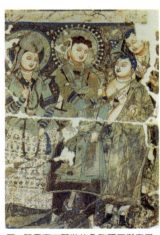

圖3 壁畫穿半臂裝的龜茲國王與皇后

圖4 穿圓領低胸半臂裝的女供養人

便更加講究。原來披帶樣式也多：有一端束在高腰裙內、一端手捏握著，有兩臂夾住的，以及中段掛在胸前兩端往肩後拋的，應有盡有。其長短還跟著服裝的窄、寬起變化：從初唐短垂到腰膝發展到晚唐、五代，帛長到得在腹前兜半圈之後，再繞從手臂飄及地【圖錄號24】。

2. 冪䍦與帷帽

冪䍦原是西北、北方多風沙，行騎時需掩蔽頭面障風沙，戴在頭上的遮蔽物，盛唐第217窟法華經變之化城喻品部分【圖錄號7】，可見在山澗之間行騎的男、女有戴此頭飾者。

源自戎夷的冪䍦與圓領袍和半袖跟進唐代。唐初期宮人、王公之家行騎時，為了不想讓人看見，多罩蔽障面積長而多的冪䍦[19]【圖6】。永徽（650-655年）時改戴帷帽，即在帽檐施裙到頸邊【圖7】，露出無領半臂袒現的胸口和一點肩、背。這種款式曾被認為過於輕率、深失禮容，而遭禁兩次。在武周（684-705年）時卻更盛行，到了中宗(705-710年)後，便完全取代了冪䍦。開元初，隨侍玄宗的宮人騎馬、戴胡帽，士庶之家又相仿效。一陣子後，連帽也不帶，流行露髮髻。

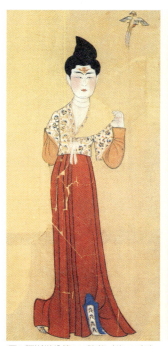

圖5 阿斯塔納第230號墓（約702年）出土穿對襟半臂裝的仕女

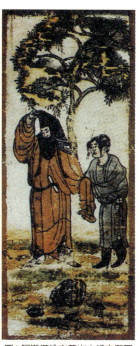

圖6 阿斯塔納古墓出土紙本戴冪䍦的人物畫

3. 貼花黃與點面靨

唐代女子面部化妝也深受胡風影響，爭相把顏色添加到臉上的額、眉、臉旁和頰上的酒窩處，貼花黃、點面靨與描斜紅在當時變化最多。花黃的花樣很豐富，從留下的繪畫資料看，北朝以黃色材料剪成薄片，用時蘸膠水貼於雙眉之間的。到了唐代原來黃色的花黃被紅、綠兩色凌駕；樣式從簡單的珠形和其組合形變化成花、葉的變形（參考【圖5】），從眉間一點到半個額綴滿花樣，或單色點染或多色相配，視衣裝而定，也因此稱花鈿。

花鈿的形式與顏色也裝飾到兩頰，合稱花靨【圖錄號26】，再加上眼尾鬢邊施一條紅彩斜線，確是滿面縱橫、熱鬧非凡。就像莫高窟第61窟東壁北側下，戴綠色寶珠鳳冠、著大袖衫襦裙的于闐公主和其女眷屬盛裝花靨，提供一個有趣、值得深入探討的問題：富藝術的花靨由來與象徵佛悟道的白毫或黥面習俗較有關？

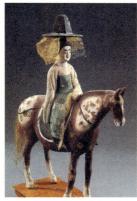

圖7 阿斯塔納第187號墓（約744年）出土戴帷帽的泥俑

三、紋樣

西方傳來的[20]、富有彈性、不規則的波浪形纏連式椰子葉、半椰葉與蓮花紋樣，在唐代包容中、外多元文化的開放風氣之下，得以自在發展、欣欣向榮。多元思潮中，以擺脫天命的無神論者最突出。他們相信自身的努力是成敗關鍵，連太宗皇帝也提出「無道則人棄而不用」的觀點，認為他的祥瑞是得賢臣[21]。神權、皇權不再至高無上，人提升到扮演歷史發展的腳色。這種人事為本的風尚促使裝飾藝術設計不斷推陳出新。

團花紋，纏枝紋，以及稍晚的雁銜綬帶等紋樣均被列為異文袍[22]中的幾個紋樣，而纏枝紋傳到日本還被稱為唐草紋。下面簡介圈似的團花與連綿不絕半椰葉似的忍冬紋在唐代的變遷。

1. 團花

團意指紋樣安排設計的外觀以圓為目標，唐代把這種圓如鳥巢的紋樣稱窠，因此有大窠（科）、小窠或小團窠之紋飾名[23]。這種外觀成圓的花樣源自波斯薩珊王朝（224-651年）流行的聯珠圈紋，從莫高窟壁畫的人物服裝可以觀察早期直接接受的狀況：如隋代（528-618年）第420窟西龕最外側兩位菩薩裙子上的紋樣就是典型的聯珠紋[24]【圖8】之一：以聯珠為圈，圈內裝飾飛馬或馴虎的圖式；圈與圈之間裝飾放射性十字形花。聯珠在祆教的信仰中象徵神明居住、光明所在並能賜福的天空與光明、華麗又具神性的珍珠。聯珠圈內所呈現的神人屬性，仍待研究，但常見的聖物則是阿呼拉馬茲達神所授的王權之環──靈光（Khvarenah）或勝利之神的化身，有：野豬、犬、神馬、鷹、和羚羊等[25]；另外，還有有翅的神穆聖獸（senmurv）、頸繫飄帶的瑞鳥以及代表戰爭與性愛女神的放射形多瓣花[26]。這些聖物在唐代初期多半被漢文化的符瑞所取代，如彎卷成團的盤龍[27]（參考第409窟供養像【圖錄號27】）或對龍【圖9】，以及鳳凰等。初唐晚期，聯珠圈漸被花環或纏枝蔓草紋所取代，如出土於吐魯番的團花（約680年，【圖10】）：大、小各六朵的側視花環圈中立著一隻鳥。而青海都蘭出土圈住對獅、立鳳的花環圈[28]則分別為大、小各有八朵，以及十六朵大小相當的側視花組合成；前者顯得豐滿，後者腫脹。另外，還有正倉院收藏的枕頭花樣又是另種變化：立鳳外的環是纏枝蔓草。這類花環圈的形式本質上與圖案式的放射狀瓣花周邊那豐滿的多重瓣或多朵花組合成的花團雷同，像莫高窟出土一件纈染成的綠地團花殘幅【圖錄號57】，放射性六瓣花周邊的花環是由十二個弧形連綴成的，弧的連接處點綴以花瓣：環外是十二朵由花蒂托住的三瓣花，環內則是兩弧相連後各自卷成渦形，再現環外的三瓣花，形成雙重的豐厚感。

上述對龍、對鳳、或對獅等的設計，在道家哲理「太極生兩儀」[29]的影響下，改變對立形態並捨棄聯珠與花環圈。對禽或對獸，採順時針、順向追逐、咬合成圓的新形式，稍晚或只用兩朵花佈置成圓。唐朝中、晚期的金銀器與紡織品上常出現這種樣式，莫高窟直到宋代（960-1036年）第55窟窟頂才有雙龍呈團狀表現戲珠的圖式。

而滾邊的條帶則常以半個團花為邊、上下或左右交錯來裝飾，如盛唐第45窟西龕內主佛的袈裟襟領滾邊紋飾及佛的背光呈現的紋樣【圖錄號1】。這種壯麗的、每個花瓣又自成一朵小

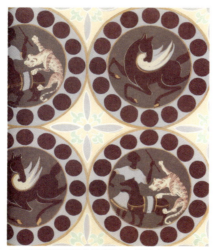

圖8 隋代菩薩裙子上的聯珠紋（摹本）

圖9 吐魯番出土的雙珠對龍紋（約711年）

花似的紋樣，特別強調深度感，是典型的盛唐風格，到了中唐開始圖案化：以不同顏色塗飾花瓣來取代深度而保有原來豐碩的面積。晚唐則葉瓣更簡，或改變以花葉-花-葉花等的結合方式來變化，常佈置成長形、菱形或橢圓形的樣式。

2.忍冬草紋

忍冬草紋的特點多是以三瓣或四瓣葉的形象，依其正、反、側的變化，相背、或同向組成連綿不絕的波浪形紋。波浪形纏連式草紋勁健的相貌呈現於盛唐早期第328窟西龕主佛與阿難的衣襟領的滾邊條上【圖11】。阿難的金地衣襟上各有一枝浪型的蔓草或稱纏枝紋花：綻放的三瓣花朵與單葉均翻動呈現背面，致力表現深度的三度空間感。稍晚的第45窟西龕內阿難身上斜襟袍所滾飾的纏枝花邊【圖錄號1】同主佛襟上的半團花一樣，增加了花瓣與葉子的數量，彎轉呈現背面的弧度更大，有的還轉成渦形而失去花葉向背的邏輯。

圖10 吐魯番阿斯塔納第191號墓（約689年）出土的團窠鳥紋

圖11 莫高窟第328窟阿難的織錦衣紋（摹本）

按常沙娜摹的服飾圖案，初唐第334窟的纏枝紋樣之間就有禽、獸，如鳳、雁、獅、鹿等穿梭自如[30]。而盛唐第130窟，繪於753年間的供養像都督夫人王氏的帔帛表現紅、白與藍、綠葉相間的折枝花，石榴紅裙上也飾折枝，變化以藍、橘相間的花朵【圖錄號23】。

另外，波斯神穆聖獸銜瑞草與瑞鳥頸上的飄帶圖式，啟發了中唐時期朝廷設計禽銜綬帶的新紋樣。波斯瑞鳥、聖獸所繫的飄帶源自兩河流域皇帝皇冠從腦後垂下來的帶子，帶子便成了皇族的象徵[31]。中國秦漢以來自公主封君也有帶綬的習俗，唐代皇族與百官皆佩綬於腰間，因地位不同而顏色、長度有別，如皇帝的玄組雙大綬六彩、二丈四尺長，五品官的黑綬二彩、一丈二尺長[32]。綬帶在波斯與唐代不謀而合象徵尊貴，於是貞元七年（791年）賜節度使新制時服，便以鶻銜綬帶為紋，取其武毅，以靖封內；觀察使以雁銜儀委為紋，取其行列有序、人人有威儀。太和六年（832年）准許三品以上官員穿鶻銜瑞草、雁銜綬帶服裝，晚唐第138窟女供養人穿著此類紋樣[33]的服裝，依封建時代婦女服飾的顏色、紋樣從夫的規定，她們都是三品官員以上的家屬。（參看【圖錄號26】）

四、小結

唐代時世裝吸取異族時尚的狀況說明了一個事實：外國裝要根深蒂固在一個國家，需美觀兼實用之外，還得符合民情。如圓領袍衫、半臂（背心）、靴與帔帛等至少都沿用到明代，歷代僅在流行款式上稍作改變。忍冬紋樣寓意連綿不絕，動物或植物團花呈現圓滿且運而無窮，均表現生生不息的吉祥含意；這兩種形式仍流行於目前的裝飾藝術中，反映國人依舊希冀瑞物帶來好運道的心態。

1. 此帝王冕服形象是目前最早的資料。
2. 沈括,《夢溪筆談》,1968年,臺灣商務印書館有限公司,頁3;周錫保,《中國古代服飾史》,1984年,丹青出版社,頁136。
3. 劉昫等,《舊唐書》〈輿服志〉,1995年,中華書局,頁1951。
4. 劉昫等,《舊唐書》〈輿服志〉,頁1952。唐代衣服令雖有改變,但都更改綠、青等下品官服色的規定。
5. 歐陽修、宋祁,《新唐書》〈五行志〉,1995年,中華書局,頁878。
6. 高春明,《中國服飾名物考》,2001年,上海文化出版社,頁558。
7. 高春明,《中國服飾名物考》,頁558;嚴福昌,《巴蜀古代樂舞戰曲圖像》,1999年,西南師範大學出版,圖25、26、30、33。
8. 李肖冰,《中國西域民族服飾研究》,1995年,新疆人民出版社,頁76;該書第75頁介紹尼雅遺址也出土同樣的腰帶綴飾衿對襟窄袖襦腰際。
9. 黃能馥、陳娟娟,《中國服裝史》,頁128。
10. 高春明,《中國服飾名物考》,頁617。但此詮釋內容並不像李壽墓槨上舞伎的穿著形象:從裙腰垂下兩片「衣擺」到腰際,交領上衣的下擺不可能如此分片垂下;因此,這種穿法仍待進一步探討。
11. 按武德(618-626)令,後宮的女書記(女史)著半臂裙襦,劉昫等,《舊唐書》〈輿服志〉,頁1956。
12. 畫面上的女子手捏一片土黃色的不明物,並非對襟單翻如李肖冰的復原圖,參見《中國西域民族服飾研究》,頁152;陳夏生主編,《中華五千年文物集刊 服飾篇 下》,1986年,中華五千年文物集刊編輯委員會,178圖說。
13. 榮新江,《歸義軍史研究》,1996年,上海古籍出版社,頁89-91。
14. 李煜(936-978)《長相思》詩句:淡淡衫兒薄薄羅,於張淑瓊《唐宋詞新賞(2)》,1992年,錦繡出版社有限公司,頁63;高春明,《中國服飾名物考》,頁546。
15. 劉昫等,《舊唐書》〈波斯國〉,頁5311;黃能馥、陳娟娟,《中國服裝史》,1995年,中國旅游出版社,頁162。
16. Loschek, Ingrid, Reclams Mode- & Kostüm Lexikon. Stuttgart, 1999, p. 13。希臘人的這種穿著深受更早的巴比倫與亞述文明的影響,參考Peacock, John, The Chronicle of Western Costume. London, 1991, p.17
17. 莫高窟北魏第228窟壁畫女供養人已著帔帛,黃能馥、陳娟娟,《中國服裝史》,頁162。
18. 黃能馥、陳娟娟,《中國服裝史》,頁162。
19. 歐陽修、宋祁,《新唐書》,頁1957。該書記載著冪羅而全身蔽障,常被誤會以為冪羅為全身裝。
20. 貢布裏希在論述〈圖式的根源〉時,雖然批評李格爾舉例說明希臘椰葉卷紋受埃及蓮花紋影響、以及阿拉伯的花草紋由希臘椰葉、蓮花卷紋而轉變成的研究成果,說李格爾把時、空拉得太遠,方式太草率,又忽略另一種新圖式老鼠勒屬(acanthus)卷葉的產生。但是,他還是同意波浪似的纏連蓮花與椰葉紋是希臘人的創作,Gombrich, E. H., The Sense of Order. A Study in the Psychology of Decorative Art. New York, first published 1979, reprinted 2002, pp.180-190。
21. 王溥,《唐會要》〈祥瑞上〉,1990年,中華書局出版,頁531-535。
22. 王溥,《唐會要》〈輿服下〉,頁581-583。
23. 目前學者常稱此類紋樣為寶相花,但是此名稱起源於宋代,使用於服飾見於《元史》〈輿服志〉。
24. 常沙娜,《敦煌歷代服飾圖案》,1986年,萬里書店有限公司、輕工業出版社,頁35;中國境內出土北齊時期與祆教有關的文物或佛教造像上就常見有聯珠紋,姜伯勤,《中國粟特祆教藝術史研究》,2004年,三聯書店,頁33-62。
25. 王怡璇,《聯珠紋樣與唐代紡織紋飾研究》,2002年,國立台南藝術大學碩士論文,頁24-30。
26. 見Ishtar(Inana),於 Bienkowski, Piotr and Millard, Alan, Dictionary of the Ancient Near East. London: British Museum Press, 2000, p.156;有關此女神與素特女神娜娜的關係,見姜伯勤,《中國粟特祆教藝術史研究》,頁249-270。
27. 武周延載元年(694)賜諸王繡盤龍及鹿的袍,見《唐會要》,頁582。
28. 趙豐,《織繡珍品》,1999年,藝紗堂,頁142-143。
29. 黑白彎曲各佔一半分享一圓、的太極圖是否受此圖式影響才形成,及兩朵花組成圓的時間仍待探討。
30. 常沙娜,《敦煌歷代服飾圖案》,頁62-65。
31. Bienkowski and Millard, p. 84; 瑞草或源自漢代祥瑞之一的嘉示。
32. 劉昫等,《舊唐書》〈輿服志〉,頁1936-1945。
33. 常沙娜,《敦煌歷代服飾圖案》,頁128-133。

圖1 段文傑主編,《中國美術全集繪畫編 15 敦煌壁畫 下》,1988年,上海人民美術出版社,圖109部分。
圖2 李肖冰,《中國西域民族服飾研究》,1995年,新疆人民出版社,圖127。
圖3 李肖冰,《中國西域民族服飾研究》,1995年,新疆人民出版社,圖227。
圖4 段文傑主編,《中國美術全集繪畫編 15 敦煌壁畫 下》,1988年,上海人民美術出版社,圖34。
圖5 新疆維吾爾自治博物館編,《中國博物館叢書 第九卷 新疆維吾爾自治博物館》,1991年,文物出版社,圖146。
圖6 穆舜英主編,《西域藝術》,1994年,淑馨出版社,圖239。
圖7 新疆維吾爾自治博物館編,《中國博物館叢書 第九卷 新疆維吾爾自治博物館》,1991年,文物出版社,圖127。
圖8 常沙娜,《敦煌歷代服飾圖案》,1986年,萬里書店有限公司、輕工業出版社,圖32。
圖9 趙豐,《織繡珍品》,1999年,藝紗堂,圖04.06b
圖10 新疆維吾爾自治博物館編,《中國博物館叢書 第九卷 新疆維吾爾自治博物館》,1991年,文物出版社,圖63。
圖11 常沙娜,《敦煌歷代服飾圖案》,1986年,萬里書店有限公司、輕工業出版社,圖120。

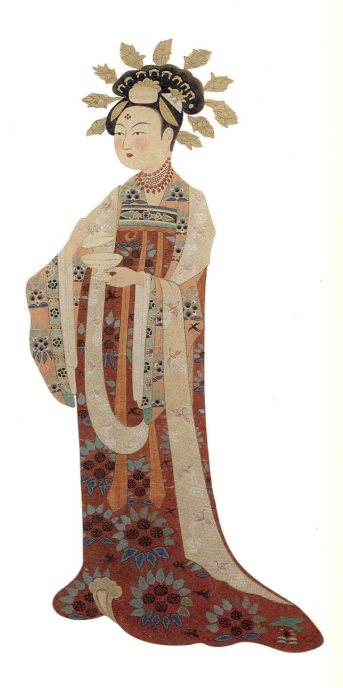

The Influence of Foreign Fashions in Tang Dynasty Costume

LIN Chun-mei
Tainan National University of the Arts

In terms of fashion, there was a great deal of cultural exchange between the Chinese and the so called "barbarians" in neighboring countries, in particular the nomadic people from the north and the northwest. The Chinese had adopted the practical aspects of nomadic clothing since the fourth century B.C., such as the well adapted shirt, tight fitting trousers and leather boots worn for riding. After ending almost four hundred years of fighting and the usual ensuing chaos, the emperors of the Tang Dynasty (618-907) tended to coexist peacefully. During this period of relative peacefulness government officials and individuals of talent and ability were able to get support and opportunities to develop their ideas. The stimulation of a developing and diverse economy and greater opened-mindedness led to the adoption of many different styles of dress from different countries. What follows is a discussion of foreign influences on Tang fashion, as demonstrated in the assembly scenes in the wall paintings from the Mogao Grottoes in Dunhuang.

The greatest diversity of individuals and groups of peoples, Chinese and foreigners, seen in the wall paintings based on descriptions in sūtras, found in the Vimalakīrtinirdeśa sūtra. The Mogao Grotto no. 220, which contains a date inscription from 642, is a model example, as it presents the Bodhisattva Mañjuśrī visiting the sick Vimalakīrti; many people from around the city also wanted to see Vimalakirtī and listen to the wise conversation between the two deities. In the illustration, on the one side is the Chinese emperor with his officers and guards, on the other, foreign princes and kings with their servants. They are wearing their own traditional costume, e.g. the young princes from Africa wearing short trousers and long scarf (stole), wrapped around their bare chests. Even an Apsara deity next to Vimalakirtī wears a close-fitting shirt with short sleeves, of the type worn by nomadic tribes in Central Asia. The following discussion begins with costumes from the depicted figures in the wall painting sūtra Vimalakīrti, and is structured in three parts: I. The Origin and the Development of Costume, II. Related Accessories, and III. The Development of the Style of Patterns on Clothing.

I. The Origin and the Development of Costume

There were two kinds of foreign clothing that came into fashion in the Tang Dynasty: long tunic with boots and dress with short sleeves. They were combined with Chinese traditional clothing in interesting ways.

1. Tunic with boots

Next to the African princes in the illustration on sutra Vimalakīrti in the Mogao Grotto no. 220 there are two young men in long tunic with decorative coloured borders. The one in malachite green tunic wears a black overcoat and boots, the other has a red tunic and wears brown boots. Such tunics with round necklines were straight cut on both sides, sometimes varied with side-slits, and were worn with close-fitting trousers underneath. Tunics at that time were worn belted, usually with a belt that had seven hooks for carrying items such as knives, needles, grindstones, lighters, measuring tape. Everyday practical tools as used by the nomadic people whose dress these fashions were based on (Cat. no. 27).

Since the Tang Dynasty the Emperors and their officials, even the commoners had worn such kinds of garment. Color, pattern and the decorative material on the belt, all denoted rank or status: the officials from the first to the third rank wore purple silk tunics patterned with a motif of only one large roundel, the fourth to the fifth rank wore red patterned tunics with motif in small roundel, and the sixth rank in yellow tunics patterned with small mixed motifs, the seventh to the ninth ranking in blue and made of flax. The ranks of belt were, in descending order, with decoration made of jade, gold, silver and lower quality jade (yu-stone). With this costume governors did not wear nomadic-inspired hats, but traditional Chinese putou, which was a square cloth folded and tied around the topknot.

In the first year of the Zongzhang era (668), a new law was introduced to forbid wearing yellow hues. The color

reddish yellow began to symbolize the Emperor. The tradition of wearing these tunics continued up until the beginning of the Ming Dynasty (1644-1911), when they were replaced by the riding costume of the Manzu People.

Women in the Tang Dynasty also wore these tunics. Even the Princess Taiping danced and sang in a purple tunic with a black headdress (putou) before the Emperor Gaozong (650-683). Archaeology findings dating from the second half of the seventh century also show women in tunics, but instead of boots they wore low-heeled cloth shoes or string-plaited shoes without high-curled toe-caps. Cossack caps with ear flaps, bowler hats or pointed caps were also worn. They often undid the top collar button at the neck (Cat. no. 37), so that it looked like a lapel. Not to be confused as is often the case with the wide lapel of the garments with large volute shapes on the back part, which the Tibetan king (Fig. 1) and his companions wore.

2. Clothes with short sleeves

The earliest historical appearance of short-sleeved clothing is evidenced by a wooden female servant figure from the tomb M1 at Mawandui from the end of the second century B.C.. Such short sleeved jackets or shirts were often embroidered or decorated with frills around the sleeve above or below the elbow (Fig. 2). They are often seen on both the male and female musician figures excavated from Eastern Han (25-220), but the Wei Emperor Ming (227-233) was still heavily criticized for wearing this short-sleeved "barbarian" blue garment when giving audience to his officials. Following the period of nomadic government from the late fourth century to the late sixth century in North China, short-sleeved clothing gained acceptance parallel to tunics and became popular.

In fact, the cut of both forms of clothing was the same but distinguished via the length of the sleeves. The length of such short-sleeved clothing depends upon the trousers or skirts underneath. An example from the sixth century wall painting in Kyzil, which depicts the religious benefactors, the Kyzil king and queen, demonstrates the period's fashion (Fig. 3): close-fitting jacket or caftan (tunic) in blue and malachite green, short sleeves with frills. The low-cut décolletage of the jacket worn by queen indicates in particular the influence on female clothing in the Tang Dynasty.

Women in the beginning of the Tang Dynasty continued wearing long narrow-sleeved shirts and high-waisted skirts gathered under the bust. After contact with the costume culture from Central Asia, Tang women developed a new short-sleeved bodice worn over much closer-fitting shirt than before, but the skirt retained the traditional A-shape.

A black female servant depicted in the wall paintings in the tomb of the Princes Changle (643) wears a bodice with a low v-shaped neckline. From that time onward the neckline became increasingly wide and low (Fig. 4), until the wide-sleeved shirt came into fashion at the end of the eighth century and began to replace the over short-sleeved bodice. Such developments can be observed in the depiction in the cats. no. 23, no. 24, no. 35, and no. 72: The Madame governor from the family Wang, painted about in the year 753, is wearing a patterned, short-sleeved clothing over a shirt with wide-sleeves, and the stole is wrapped around her; the benefactor depicted in the Grotto no. 9 dated about 893 wears traditional shirts, one on top of the other, folded over on the right and forming a v-shape neckline, but the high-waisted skirt stands out due to the widened decoration on the front waistband. Accentuating this front part of skirt led to its being tied above the bust and was very popular in the Five Dynasties (907-960). But women wore extra coats over this renovated costume, as the depicted benefactor, dated 943, from the painting "Thousand Armed Avalokiteśvra" (Cat. no. 72) shows. But this thick material depicted (Cat. no.26) does not match the descriptions of the quality of gauze silks jacket in Li Yu's poetry of the same period (936-978): light, soft and transparent. It may be that it was for religious reasons this female benefactor's clothing was not as transparent as the women depicted in the same

style of costume in the painting "Women wearing flowers headdress", attributed to Zhou Fang (about 766-796). The analysis of costume development suggests the date of this painting may not have been the Middle Tang but the Five Dynasties.

II. Related Accessories

In this section three kinds of popular accessories will be introduced: stoles, headdress mili and facial adornments in different kinds of shapes. Only stoles remained in fashion after the Tang Dynasty.

1. Stoles

A stole is a length or square of fabric worn around the neck or over the shoulder. The red stole wrapped around the chest of the young princes from Africa in the Mogao Grotto no. 220 is lined with malachite green and patterned with pearls in roundels. Similar pieces for warmth or ornament found in Boddhisattvas near Mañjuśrī vary in shape. They are wider around the shoulder (Cat. no.8) than at the end and in Buddhism are usually called "heaven dress".

Such stoles came into China with the Persians and Sogdians during the fourth Century A.D. Their origins may date back to Greek fashion in the sixth century B.C. or five hundred years earlier in Babylonia and Assyria, where both men and women wore them. But in the Tang Dynasty they were only worn by women, following an edict by the Emperor Xuanzong (713-756) that second ranking concubines (fei) should wear painted stoles to society events, the stoles became more popular and developed variations, not only from short to long (Cat. no. 24), but also from roundel to cut flowers in the patterns.

2. Headdresses mili and weimao

Headdress mili came from nomadic people who wore them as protection against sand when riding in the desert. This large head kerchief would be wrapped around the head and fell down to the shoulder (Cat. no.7). Only the eyes were kept free. Such protective clothing also fit in with the Chinese traditions of women covering themselves from view when going out (or being outdoors). But the accepted mili soon changed to an airy style in the Yonghui Era (650-655) and was named weimao: The kerchief would be attached around the hat edge except for the front part. In the meantime the weimao was twice forbidden because it revealed the neck area and some parts of the shoulder. After 50 years weimao lost popularity as a substitute, and women at the beginning of the Kaiyuan Era (713-741) no longer wore headdresses, but rather competed with each other in tying their hair knots into varied artificial shapes.

3. Facial decoration

Women in the Tang Dynasty also adopted the Central Asians' habit of putting on make-up. Instead of dotting yellow or sticking a tiny yellow shape between eyebrows they now used more varied coloured shapes on the face. Red and green colors became increasingly popular. The shapes varied from the simple dot and its diverse arrangements to the other forms as hearts, leaves or flowers.

In the Five Dynasties such kinds of female facial decoration reached its peak in terms of make-up history. The female benefactors in the Mogao Grotto no. 61 (Cat. no. 26) demonstrate this trend. They adorned their faces as if they were painting a landscape: Birds or wild ducks are seen flying between green shapes on the forehead and the cheeks, under each eye are painted mini hills with green pieces.

Such fantastic make-up prompt us to speculate on its origins: Is the White curl between the eyebrows, the symbol of the Buddha inspiration, more related to facial decoration or to tattooing traditions?

III. Pattern

The flexible adaptable wavy scrolls with leaf-palmette, half leaf-palmette, lotus blossom or their combinations from the West were well developed in the free multi-cultural atmosphere of the great Tang. Many of the Tang people denied the notion of a fixed destiny, but rather believed in the effect of their own efforts; even the Emperor Taizong (627-649) maintained that the talented officials were really lucky omens for him. Such trends in attending to human agency promoted the renovation and design of those plants motifs. What follows is an introduction to the development of wavy scrolls with plants and motifs in roundel.

1. Motifs in roundel

Motifs in pearl roundel characterize the Sasanian (224-651) clothing pattern. Typical motifs were the wild pig, dog, bull, horse with wings, eagle and rosette etc. These animals were usually the embodiment of Khvarenah, which appeared in a ring-shape being full of light and derived from the Zoroastrian God Ahuramazda. The rosette was an old motif, an attribute of the war and sex goddess Ishitar in ancient Mesopotamia. Precious pearls also with deity characters symbolized auspicious heaven, where goddesses were living and the realm of light. These patterns full of auspicious senses soon found resonance in China, where a circle shape was interpreted as a symbol of eternity.

Chinese auspicious animals replaced the Persian holy animals as the first stage in renovation, while a pair of facing dragons (Fig. 9) and dancing phoenixes had been represented. The continuing development accentuated the transformation of the roundel contents: the wavy scroll of flowers and leaves in roundel appeared parallel to the flower wreath (Fig. 10). The pattern of the catalogue no. 57 shows a small rosette in the middle, around which twelve contiguous curves revolve. At their touching points, the flowers in profile are decorated: inside the circle there are six flowers in double layers, outside the circle there are twelve in a single layer. All together this pattern forms a full shapely figure and represents the style of the High Tang period.

The final innovation was the integration with the Chinese sense of order, putting a pair of living organisms, especially animals running after one another clockwise in a circle. Now the ring-shape was removed and the pair of creatures itself formed the roundel. Such pattern alterations to an unmistakable Chinese style may have been influenced from the Taoist center philosophy: the highest nature creates the both poles yin and yang or the opposites of earth and sky. The principle of this circle-pattern was then followed by the illustration of the Yin Yang symbol, a pair of asymmetrical halves which fit together to form to perfect circle.

2. Wavy scrolls with plants

What remains from the wavy scrolls with plants, which date back to before the beginning of the Tang, is the motif of the half leaf-palmette, named in Chinese rendong-pattern, whose basic elements are three or four curled-leaves. We can see such kinds of curled-leaves forming lotus blossom in the wall paintings from the fifth and sixth century, but at the end of the seventh century the alternation of leaves and flowers appeared between the undulatory lines. The similar depiction on the front border from the Monk Ānanda (Cat. no.1) is renovated through flourishing flowers and leaves in a three-dimensional style, while the underside of plants was carefully formed.

According to the copies taken from the patterns on the costumes depicted in the wall paintings, in the seventh century animals in flying or fixed positions are found between the wavy scrolls with plants. In the middle of the eighth century one part of the scrolls flowers with leaves prompted a new pattern for clothes (Cat. no. 23), similar to branching flowers.

This branching flower motif would later be combined with wild duck as pattern. Its variation showed a bird putting a sash in its beak. Flourishing cereals were a lucky omen and in China a sash around the waist had symbolized rank since the third century B.C. A parallel can be drawn with the sash or ribbon at the neck or feet of the Persian holy animals that symbolized royalty. The auspicious meaning of both coincided and the new arrangements were created in 791 in China: the pattern of a hawk holding a sash was designed for governors and the pattern of wild duck for inspectors. In 832 officials and their womenfolk of first to third rank were allowed to use the decoration of a duck holding a branch. The fantastic make-up on the benefactors (Cat. no. 26) demonstrates this clothing pattern.

IV. Conclusions

The analysis above demonstrates the facts that foreign products should be beautiful, practical and particularly in accordance with the customs of the land in which they take root. What has been completely integrated existed longest, as the roundel pattern is still found, with interesting variations, in the arrangement of diverse motifs today.

(Translation by LIN Chun-mei, Jayne Pilling)

From the Forgotten Deserts:
Centuries of Dazzling Dunhuang Art

敦煌音樂文化

鄭德淵　國立台南藝術大學

　　音樂是文化的一種重要表現層面，它的發展呈現了人類文明的足跡，作為禮樂之邦的中華民族，在音樂上更有豐富而延續的發展。古代的文獻中雖以樂志、律志等方式大量的記載音樂歷史，但由於缺乏系統的分析、調查，每每是偏向帝王將相的上層社會音樂歷史，且缺乏圖像的收集，對於音樂史的研究，對於樂響、樂譜、樂器、樂典、樂像、樂俗未能全面調查，呈現的當然是片面甚至是錯誤的樂史。敦煌地處絲路咽喉，是中西交通的要道，東西音樂文明的交流，在文獻中皆有圖像文字記錄。而敦煌所在的古河西隴右之地，是中國音樂文明的源頭之一，是楚漢音樂的傳存重鎮，是華夏之聲西進的前沿，是西域文明東漸的窗口，在敦煌文獻中亦有忠實的反映。敦煌石窟始建於北朝時期，歷經北涼、北魏、西魏、北周、隋、唐、五代、宋、西夏、元等十朝，長達千餘年，在莫高窟、千佛洞、榆林窟…等等石窟中，大量的壁畫描繪了各個時期的樂器圖像，以莫高窟為例，有二百四十個洞窟的壁畫繪有音樂題材，包括四十四種共四千五百件的樂器、五百組的樂隊、三千三百四十六身的樂伎，以及四百舖的樂隊經變，其連續千年繪製的樂器圖形，以及藏經洞文獻的音樂資料，可以說是中國古代音樂史研究的一個重要的資料，因為「敦煌音樂文化呈現了中國千年的音樂文化面貌」。

　　縱觀整個中國音樂歷史的發展：具有先民原始宗教祭祀色彩的樂舞到了周代，進入了禮樂制度，編鐘樂舞呈現了王權威勢；漢代以來雅樂衰微，民間音樂興起，中原與西域開始了音樂的交流；魏晉以降，則中原地區樂風舒緩的清商樂與北方游牧民族的粗獷豪放音樂並行；隋唐時期，宮廷與民間音樂皆有輝煌成就，東西音樂交流更達到高峰。敦煌跨越十朝的音樂壁畫記載了千年的音樂文化，其本身與中國古代音樂相互激盪，在封建禮樂文化背景下形成特定寓意與理性內蘊，成為中國古代宗法觀念、等級制度、禮樂思想的歷史見証[1]。

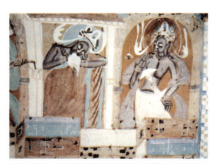
圖1 印度、西域風格的天宮樂伎　北魏　莫高窟第435窟北壁

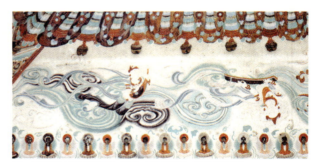
圖2 飛天樂伎彈鳳首彎琴　晚唐　莫高窟第12窟窟頂西披

一、敦煌音樂壁畫的特色

　　敦煌音樂壁畫早期模仿自印度、西域之風格【圖1】，到隋唐以後乃形成中國民族音樂畫的特色，從跨越十朝的圖像中可以看出其反映出東西文化藝術融合的歷程，以及中國民族音樂與繪畫藝術的發展軌跡。根據鄭汝中的研究[2]，敦煌音樂壁畫呈現了幾項藝術特色：

1. 寫實與虛構並舉，樂器的繪製時而精確具體，時而簡略寫意。如以一個黑色長框作為古琴，或畫一塊三角形為排簫，也有幾條弦、幾個吹孔都精細繪出者。畫工將琵琶與箜篌嫁接在一起而形成「鳳首彎琴」，是出現在唐代中後期的想像虛構樂器【圖2】。

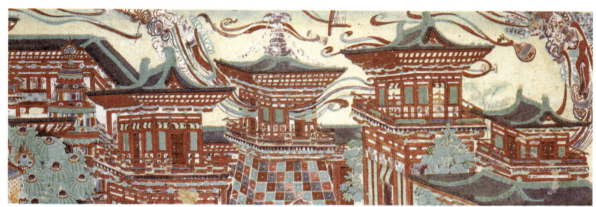

圖3 不鼓自鳴的笙、阮、羯鼓等 盛唐 莫高窟第217窟北壁

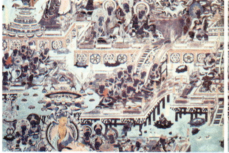

圖4 繪於龕頂的飛天奏樂器 中唐 榆林窟第15窟前室頂南端　　圖5、圖5-1 觀無量壽經變吹打彈俱全的大型樂隊（局部） 盛唐 莫高窟第148窟東壁南側

2. 象徵手法之運用，充份運用象徵手法，使人通過音樂圖像產生音樂美感，例如不鼓自鳴樂器寓意仙樂自鳴於天宮【圖3】、天王所持琵琶象徵佛法威力、繪於華嚴經變「華嚴海」內的諸多小樂器，則代表大千世界的萬千景象；象徵圖形具有特定的符號意義，例如飛天伎樂首尾相接，表示天界浩瀚。

3. 音樂畫的裝飾，為了美化洞窟，畫工將各種動物、花卉、飛天、樂舞等經過處理，繪製於洞窟不同位置，如天宮伎樂、飛天、壺門中的仕生伎樂等等【圖4】。

4. 構圖中「滿」的特點，中國傳統民間繪畫，將畫面填得滿滿的，例如在經變畫安排了多層音樂，每組樂隊數十人，極具節奏感【圖5】。

二、敦煌壁畫的樂器文化

作為音樂史研究的六大項內容中，樂器是其中重要的一個部份，特別是當無法獲得實際演奏的音樂時，或者樂器實物也無法獲得時，對於壁畫上所呈現的樂器描繪，是作為研究古代的音樂文化極為重要的考據資料。敦煌壁畫延續千年，在四十四種共六千件的樂器圖像中，展現了中國樂器的發展演變過程。

就壁畫樂器的構圖來看，它反映了古代西北地區的音樂生活，例如北涼第275窟北壁下方，即有一隊吹管樂器的人物，開頭兩人以大角引路。西涼即西北地區，在這些樂舞圖像，從其形式、人物

外貌、服飾等等，可以了解西北地區的風俗習慣。敦煌壁畫的音樂圖像是漢代畫像石刻的延續，但漢代畫像石刻表現的是以粗獷的描繪當時的雅樂內容，而敦煌壁畫音樂圖像則是以較寫實與具體的手法，反映出各時期的音樂面貌，包括世俗歌舞、音樂場面、威武的軍樂儀仗等等，具有創造性。敦煌壁畫構圖，在早期保持著西方佛教畫的原始面貌，樂舞場面窄小，樂器少，沒有大型活動，樂器繪得比較簡單。由隋至唐，則由小型合奏的形式到大型的經變畫樂隊，以當時隋唐燕樂的坐部伎為摹繪依據，在畫面空間有限的情況下，以每種樂器一件，對稱而象徵性的縮小了宮廷樂隊。即使如此，也可自這些樂隊圖像中了解隋唐時期的樂隊面貌。

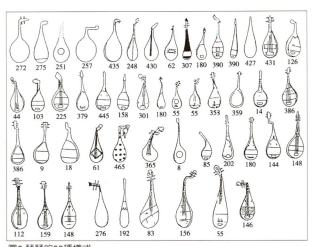
圖6 琵琶的50種樣式

壁畫所繪樂器呈現出幾個特點：它首先表現了禮儀性的作用，在周代的禮樂制度下，音樂是教化人民最重要的手段，各種政權設立音樂機構，收集樂器，組成樂隊，先是打擊樂器為主，用於宗廟典禮等場合，到了漢代改以吹打樂為主的俗樂引進宮廷，壁畫所呈現的音樂內容，即是這種音樂制度變化後的跡象。壁畫所繪的四十四種六千件樂器，形式多樣，色彩

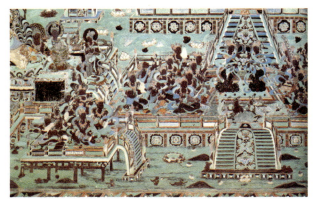
圖7 藥師經變氣勢宏偉的大樂隊（局部） 盛唐 莫高窟第148窟東壁北側

豐富，具有濃厚的民族與民間特色，由這些多樣的樂器來看，各不同時期不同地域的音樂生活必定是多彩多姿的。壁畫所繪樂器所呈現的另一個特點，是樂器形制的多變性及樂器組合的系列性，每一個時期，樂器的變化都是形態各異，卻又游離在一種基本模式周圍，它應是處於一種樂器的發展和變革的過程中。從五十種不同樣式的琵琶圖形，可以說是千年來琵琶流傳的形態演變【圖6】。在壁畫上，每一種樂器都是多種多樣、互相關聯，具有群體、族類及派生的特徵，例如以琵琶類為例，就有琵琶、五弦、葫蘆琴、阮的系列。從壁畫中可以看出，中國樂器已經系列化了，這些同類的樂器，因具獨特之音質與相融的特性，產生了系列化，而形成既對稱又相互依存的組合特點。

樂器在壁畫中，其表現形式與出現的位置：樂器可以是作為一種壁畫的構圖形式而呈現，例如「不鼓自鳴」的樂器圖案畫面，繫著彩帶的樂器寓示天界無人演奏自會發出仙樂，增加了天宮虛幻飄渺之意境，所以將樂器作為圖案，是一種文化意識，一種圖騰，象徵祥瑞之意。樂器也可作為法器而出現，在壁畫某些場合出現的鐘鼓、琵琶等，即象徵著佛法神權，具有威懾鎮邪之功能。當然，樂器是作為伎樂天、伎樂人的音樂表演場面中出現的，在天宮職司樂器的樂伎，或世俗音樂場面的伎樂人，都持有樂器表演的場合，呈現了人間社會的音樂生活或極樂世界中歌舞昇平的虛幻境界。

壁畫中呈現的樂器演變，在整個壁畫歷史過程中，有以下的特點：樂器的品種，從最早的北涼第272窟的四種樂器（琵琶、橫笛、貝、橫鼓）到初唐發展到三十餘種，包括了敦煌地區獨創的葫蘆琴、花邊阮、彎頸琴、鳳首箜篌、扁鼓、銅角等。樂器的形態則是逐步在演變發展著。例如莫高窟的六百八十五件琵琶，在五十種形制上呈現其發展狀況，而其派生的葫蘆琴、花邊阮、彎頸琴的形態亦呈現了同類樂器的演變現象。隨著樂器本身的發展變革，在壁畫的樂器圖像中也可看出樂伎演奏技巧的相應變化。樂器的演奏，從壁畫的先後來看，其演奏形式是由個別到集體的，從早期洞窟到的單個天宮或飛天的獨奏，到小型樂隊的隋代，以至唐代則有三十二人的大型樂隊出現【圖7】。

作為圖像學的研究，敦煌壁畫中的樂器固然提供了重要的參考依據，但由於敦煌壁畫中具有很多非寫實的部分，其虛或實應予分辨。作為寫實的部分，敦煌壁畫反應了各種時期的社會面貌；而當畫工在宣揚宗教的題材上，由於音樂知識之局限、藝術手段之不同，可能出現偏離真實的現象，鄭汝中提出了樂器描繪中虛的部份：在樂器形態上，所繪樂器大小比例、造型的準確度有出入、細部結構不嚴謹、演奏姿勢錯誤、虛擬樂器。鄭汝中認為由琵琶與鳳首箜篌混合嫁接而成的「鳳首彎頸琴」是一種子虛烏有的樂器，因為張弦不能貼及琴面，不符發音原理，不可能成為樂器。即使在莫高窟出現二十餘幅，這是因造型華麗，裝飾性強，具有觀賞效果，不能視為實物與信証[3]。

三、敦煌壁畫樂器分類

樂器在中國歷史中的發展，隨著政治、文化、經濟、地理環境等等，不同條件而有所變化，從歷代的樂志文獻中固然有部份文獻的記載，畢竟是以樂律或宮廷為主，橫跨千年的敦煌壁畫音樂圖像則提供了重要的資料。莫高窟的四千多件樂器類，反映了各個時期、各種樂器的形制與演變、演奏方法、組合形式，以及當時的社會音樂活動，可以作為研究樂器史極為重要的參考。

若依現代習慣的方式加以分類，大致上可分為吹奏樂器、彈拉樂器以及打擊樂器三種。在吹奏樂器上，壁畫上出現最多的是橫笛，為吹管樂器中主要的

圖8 飛天吹銅角　隋　莫高窟第302窟東壁

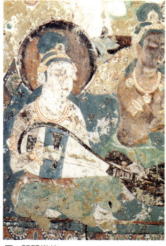
圖9 琵琶樂伎
　　初唐　莫高窟第220窟南壁

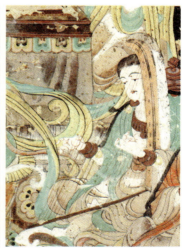
圖10 演奏大箜篌
　　　中唐　莫高窟第112窟南壁

樂器，從形制挖孔及演奏方法來看，都與今日的橫笛差異不大；一種哨管的樂器稱為篳篥，出現在壁畫的中期以後，類似今日的管子；排簫，在壁畫中以造形華麗，極富仙樂幻覺的意境呈現在顯著的位置，在莫高窟壁畫中即有三百餘只，具有音樂的象徵意識；同樣出現有三百多次的笙，自北魏一直延續至最後，在壁畫上從早期只具輪廓到唐以後逐漸具體；作為古代軍營使用的角，在壁畫中，形成了角—畫角—銅角的演變過程。以銅角而言，其出現在壁畫之後期，早於西方數個世紀，從世界銅管樂器歷史來看，具有重要意義【圖8】；其他的吹奏樂器還有豎笛、塤、貝等等。今日在管弦樂團或現代國樂團主要的聲部—擦弦樂器，在歷史上是最晚出現的，在敦煌壁畫中直至西夏才有類似胡琴的擦弦樂器出現，而唐代最燦爛輝煌的則是彈撥類樂器，這現象同樣出現在壁畫的樂器中。在彈弦類樂器中，主要為頸箱型的琵琶族樂器（或謂魯特琴族），以及板箱型的琴箏族樂器（齊特琴族），以及框箱型的箜篌（豎琴族）。琵琶是壁畫中最重要的彈弦樂器，在莫高窟中即繪有七百餘只，居所繪樂器之首，具有音樂的象徵意義。在壁畫中，琵琶的形式並不規範，其處於持續發展、相對穩定的特點【圖9】。早期繪製較小而狹長，到了唐代呈現寬圓形式，在演奏形式上，除少數作為舞蹈造型的反彈琵琶外，大部份是橫抱踞坐的形式。壁畫中另有四十餘只的五弦琵琶，形制與四弦琵琶類似，只多一軸一弦。敦煌特有的一種可能由琵琶演變而來的，稱為葫蘆琴，只出現在莫高窟五處及榆林窟一處；具有正圓共鳴箱的阮在壁畫中始自北魏，莫高窟共繪近百只，見於天宮伎及不鼓自鳴中；另有花邊阮

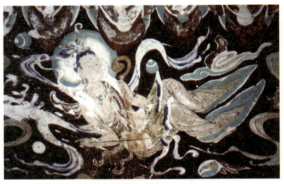

圖11 拉胡琴飛天 西夏 榆林窟第10窟

圖12 《敦煌曲譜》第十二曲《傾杯樂》

則極具特色，為阮與琵琶造形合成的樂器；琵琶與箜篌相結合的彎頸琴，可能是畫家的一種藝術構思，屬於想像中的樂器；在文獻中出現最多的古琴，在壁畫中為數甚少，可能是敦煌壁畫樂隊主流是俗樂，多見的為箏，在經變樂隊中，箏描繪得十分具體；壁畫中的箜篌數量僅次於琵琶，莫高窟有二百餘只，顯現了在中國由興至衰的歷史【圖10】。莫高窟未見擦弦樂器的胡琴，在安西榆林窟元第10窟及西夏第3窟繪有大小共四支之類似今日墜胡胡琴，為壁畫中胡琴之最早者【圖11】。

敦煌壁畫中的打擊樂器種類繁多，可分為鼓類（膜鳴）及鐘鑼鼓（體鳴），前者包括了各種形狀

不同的鼓。敦煌壁畫中，腰鼓從早期的北涼至末期的元代從未間斷；作為唐代樂隊首席指揮地位的羯鼓，在壁畫中出現甚多，一般置於樂隊前列或居於高處；其他的鼓類樂器尚有毛員鼓、都曇鼓、答臘鼓、節鼓、雞婁鼓、齊鼓、大鼓、手鼓、軍鼓以及圍成圈的多個鼓的雷公鼓等等。在體鳴樂器方面，類似編磬的方向，在壁畫中見於隋代大型樂隊中，而隨佛教自西方傳入的則有鈴、鐃、鈸等銅製樂器；敦煌壁畫中的鼓帶有濃郁的西域風格，反映出河西地區在古代中西音樂交流中的重要地位。

四、敦煌曲譜

敦煌壁畫音樂畫所呈現的中國歷史千年的社會音樂文化是以圖像的形式展現的，另外在莫高窟第17窟的石室藏經洞中並藏有從晉到宋近十個朝代的各種寫本與文物數萬件，其中有一卷曲譜是五代後唐明宗（西元933年）抄寫的唐曲，這僅存的一套唐代曲譜被稱為《敦煌曲譜》。林謙三、楊蔭瀏、葉棟等學者進行了曲譜的解釋，希望藉由這套由二十五首分曲所組成的唐「大曲」音樂，再現唐代音樂【圖12】。《敦煌曲譜》不僅為音樂學者研究古代音樂的珍貴文獻，並對古代社會、歷史和文藝的研究，也有重要的價值。

敦煌音樂，並非是敦煌地區的音樂，而是敦煌壁畫中音樂圖像與藏經洞出土的「敦煌曲譜」所記載繪製的十個朝代、近千年的音樂文化，它反映了各個時期的音樂社會生活，從生動鮮明的音樂圖像與曲譜中，我們彷彿進入了隋唐的時空隧道，享受著金壁輝煌的音樂生活。

1. 鄭汝中，《敦煌壁畫樂舞研究》，2002年，甘肅教育出版社，頁12。
2. 鄭汝中，《敦煌壁畫樂舞研究》，頁25。
3. 鄭汝中，《敦煌石窟全集 16 音樂畫卷》，2002年，香港商務印書館，頁91。
4. 牛龍菲，《敦煌壁畫樂史資料總錄與研究》，1991年，敦煌文藝出版社。
5. 葉棟，《唐樂古譜譯讀》，2001年，上海音樂出版社。
6. 姜伯勤，《敦煌藝術宗教與禮樂文明》，1996年，中國社會科學出版社。

圖1 鄭汝中，《敦煌石窟全集 16 音樂畫卷》，2002年，香港商務印書館，頁17，圖1。
圖2 鄭汝中，《敦煌石窟全集 16 音樂畫卷》，2002年，香港商務印書館，頁79，圖57。
圖3 鄭汝中，《敦煌石窟全集 16 音樂畫卷》，2002年，香港商務印書館，頁47，圖25。
圖4 鄭汝中，《敦煌石窟全集 16 音樂畫卷》，2002年，香港商務印書館，頁77，圖55。
圖5、圖5-1鄭汝中，《敦煌石窟全集 16 音樂畫卷》，2002年，香港商務印書館，頁97，圖70。
圖6 鄭汝中，《敦煌壁畫樂舞研究》，2002年，甘肅教育出版社，頁83，圖5-2。
圖7 鄭汝中，《敦煌石窟全集16 音樂畫卷》，2002年，香港商務印書館，頁94，圖68。
圖8 鄭汝中，《敦煌石窟全集 16 音樂畫卷》，2002年，香港商務印書館，頁183，圖160。
圖9 鄭汝中，《敦煌石窟全集 16 音樂畫卷》，2002年，香港商務印書館，頁198，圖169。
圖10 鄭汝中，《敦煌石窟全集 16 音樂畫卷》，2002年，香港商務印書館，頁218，圖196。
圖11 鄭汝中，《敦煌石窟全集 16 音樂畫卷》，2002年，香港商務印書館，頁193。
圖12 葉棟，《唐樂古譜譯讀》，2001年，上海音樂出版社，圖7。

Dunhuang Music Culture

CHENG Te-yuan
Tainan National University of the Arts

Dunhuang is located at the right side of long of the ancient Hexi; it serves as, an origin of Chinese music, the musical center in the Western Zhou and Western Han dynasties, the frontier of Huaxia (Chinese) music going westward, and the gateway to China of Western civilization. All these are faithfully recorded in ancient documents found at Dunhuang. The construction of the Dunghuang grottoes started in the Northern Dynasties (386-581) and spanned over one thousand years; there are many frescoes depicting musical instruments in different periods. Take the Mogao Grottoes for example, there are two hundred and forty grottoes featuring dance and music scenes, including four thounsand instruments in forty-four groups, five hundred groups of bands of all types, three thounsand three hundred forty-four performers, and four hundred sūtra illustrations with orchestras. The musical instrument drawings and data recorded in the documents found inside the grottoes built over one thousand years are important resources for the study of ancient Chinese music.

I. Characteristics of Dunhuang Music Frescoes

The style of early Dunhuang music frescoes is in imitation of Indian and Western paintings (Fig. 1). Characteristics of Chinese music paintings were not formed until the Sui and Tang dynasties. The Dunhuang music frescoes from ten dynasties reflected the process of fusion between the Western and Chinese cultures. According the Cheng Ru-chung, the characteristics of Dunhuang music frescoes include:

1. Realistic and fictitious at the same time: instruments are sometimes accurately depicted and sometimes in a freehand style. For example, we can see the exact number of strings of the guqin (a seven-string plucked instrument resembling the zither) and the exact number of holes on the panpipe in some paintings, while a black rectangle is supposed to be the guqin or a triangle to be the panpipe in other paintings. Or, in an extreme example, painters combined the pipa to the konghou, an ancient plucked instrument, to create the "conceptual" (imaginative) instrument called fengshouwan qin of the mid- and late Tang Dynasty (Fig. 2).

2. Use of symbolism: Painters exploited symbolism to present musical esthetics through pictures. For example, hanging idiophones symbolize music in the heaven (Fig. 3), and the small instruments in "huayanhei" of the Avataṃsaka Sūtra (Flower Garland) symbolize the multivalent scenes in the universe.

3. Decoration: Painters drew animals, flowers, flying fairies and dancers in different locations to embellish the grottoes, such as the heaven performers, flying fairies and singers and performers in the teapot gate (Fig. 4).

4. "Fullness" in the layout: Traditionally, ancient people would draw as many objects as possible in a painting to express the sense of "fullness." For example, there are multiple music paintings in sūtra illustrations presenting the sense of rhythm (Fig. 5).

II. Instrumental Culture in Dunhuang Frescoes

The instrument layout in Dunhuang frescoes reflects the musical life in ancient northwestern China. For example, there is a wind band headed by two horn players at the lower part of the mural in the north of Grotto 275 built during the Kingdom of Northern Liang Dynasty. The style, appearance and costume of these performers tell us about the customs in ancient northwestern China. In fact, the aspects of music in different periods are manifested in Dunhuang music frescoes are articulated in a rather realistic and representational style. These include the secular music and dances, musical scenes, and the powerful military bands. They are rather creative. As the music scene was rather small, there were not many instruments and no big musical events in earlier periods, instruments were depicted without much detail. From the Sui

Dynasty to the Tang Dynasty, however, painters drew music scenes with reference to the sitting band performing court table music in all kinds of musical events, including small ensembles to large-scale bands for the large sūtra illustration performances. When the space was limited, they drew one instrument for each kind in parallel to symbolize a reduced court band.

The characteristics of instruments depicted in the frescoes include, first, instruments used to represent the nature of music, the wind- and percussion-based secular music was introduced to the court in the Han Dynasty, and signs of the system change were presented in the frescoes. Second, the diversity of instrument construction and the scheme of instrument grouping, though the shape or construction of musical instruments changes over time, such changes will never turn an instrument from one genre into another. In fact, such changes should be considered as the development or evolution of the instrument itself. The fifty pipa patterns found in the frescoes should thus be considered as the development or evolution of the instrument over 1,000 years (Fig. 6). Take the pipa family for example; there are the pipa, five-stringed pipa, the huluqin and the ruan.

We can trace the evolution of instruments from the frescoes. The characteristics of the fresco history in general includes the following. The variety of instruments, from four types of instruments (pipa, transverse flute, bei and chest drum) found in the Grotto no. 272 built during the Kingdom of Northen Liang to over thirty types of instruments in murals made during the Early Tang Dynasty, including the huluqin, huabian yuan, wantou qin, fengshou, konghou, biangu and tongjiao uniquely found in Dunhuang area. For example, there are six hundred eighty five pipa drawings in fifty groups found in frescoes in the Mogao Grottoes. Drawings of its derivatives like huluqin, huabien ruan and wantou qin also present the evolution of types. As for the playing of the instrument, solo to ensemble is the general trend as presented in the frescoes in chronological order. That is, the depictions shift from solo instruments in the earlier periods, to the ensemble in the Sui Dynasty, and finally to the thirty-two-player orchestra in the Tang Dynasty (Fig. 7).

III. Instrument Classification in Dunhuang Frescoes

From over 4,000 instruments found in the frescoes in the Mogao Grottoes, we can see the construction and evolution of instruments, playing methods, grouping of instruments and the musical events in different periods. Therefore, these frescoes are important resources for instrument study.

According to modern instrument classification, these instruments fall into wind instruments, strings (bowed and plucked) and percussive instruments. The transverse flute is the most common wind instrument found in the frescoes. From the viewpoint of the construction, hole location and playing methods, they are similar to the modern transverse flute. A pipe instrument called the biliappeared after the middle period of the frescoes and it looks like the modern guanzi. The panpipe in a gorgeous appearance and dreamy style and is often found in a prominent position in the frescoes. There are over three hundred panpipe drawings in the Mogao frescoes, suggesting that it is a symbol for music. The sheng is another instrument that appears over three hundred times in the frescoes since the Northern Wei Dynasty until the Yuan Dynasty. It first appeared in frescoes in outline, but was finally illustrated in detail since the Tang Dynasty. The horn which was a military instrument in ancient times became the brass horn-fresco horn-in the frescoes. From the history of horn development, though it did not appear until the later fresco period, it still appeared a few centuries earlier than in western culture, suggesting a significant status in the world's brass instrument development (Fig. 8).

There were other winds instruments including the bamboo flute, jun and bei. The bowed instrument playing the leading

role in modern orchestras or Chinese orchestras appeared the latest amongst all instrument types. Bowed instruments resembling the huqin did not appear in frescoes before the Western Xia regime (1038-1227), while the plucked instrument enjoyed its heyday in the Tang Dynasty. The same phenomenon is found in the frescoes. Amongst all plucked instruments, the neck-box type pipa (in the lute family), the board-box type qin and the zheng (in the zither family), and the frame-box-type konghou (in the harp family) were the most popular. The pipa was the most depicted plucked instrument in the frescoes, and there are over seven hundred pipa drawings in the Mogao frescoes, suggesting that it was the symbol of music in those days. The form of pipa was not specified in the frescoes. In fact, it was a developing instrument in some relatively regular properties (Fig. 9). It began with a smaller and narrower shape, and evolved into a broad and rounded shape in the Tang Dynasty. In terms of the playing manner, in addition playing as accompaniment for dances occasionally held in the opposite manner, most players held the instrument horizontally in a sitting position while playing. Some forty five-string pipa are found in the frescoes. They look similar to the four-stringed pipa, with only one extra peg and string. The instrument unique to Dunhuang the huluqin, believed to be a derivative of the pipa, is only found in five frescoes in the Mogao Grottoes and in one fresco in the Yulin Grottoes.

The ruan with a round resonator did not appear in the frescoes before the Northern Wei Dynasty (368-534). There are about one hundred ruan drawings found in the Mogao frescoes, mostly in the heavenly bands. The huabian ruan is a special instrument combining the ruan and the pipa. The combination of the pipa and the konghou is called the wantouqin. May be created out of the artistic project of painters, the wantouqin is simply a conceptual (imaginative) instrument. Though the guqin is a common instrument in many grotto documents, it is rarely seen in the frescoes. The reason may be that secular music was the musical mainstream of the murals, so we see the zheng, instead of guqin, depicted in detail in many paintings. The konghou is the second most depicted instrument next to the pipa. There are some two hundred konghou depictions in the Mogao frescoes, indicating the rise and fall of the instrument in China (Fig. 10). The bowed instrument huqin is not found in any Mogao frescoes, though there are four drawings resembling today's zihu found in Grotto no. 10 (built in the Yuan Dynasty) and Grotto no. 3 (built in the Western Xia regime) in the Yulin Caves. They are the earliest painting of the huqin in Dunhuang frescoes (Fig. 11).

There are many percussion instruments in the Dunhuang murals, dividing into drums (membranophone) and the bells and cymbals (idiophones). The former includes drums of different shapes. The waist drum is a long-lasting percussive instrument in the Dunhuang frescoes made from the Kingdom of Northern Liang to the Yuan Dynasty. The jiegu (lamp-skin drum) is a common percussion in frescoes made in the Tang Dynasty as it played a major role in the concert orchestra. It is often found in front of the band or in a higher position. Other drums include the maoyuan drum, dutan drum, dala drum, jie drum, jilou drum, zi drum, bass drum, tabor, military drum, and the circular leigong drums. The pianxing (chime stone or inverted bell) is the most common idiophone. It is found in big orchestras of the Sui Dynasty. The Western brass percussive instruments that passed to China together with Buddhism included the bell, big cymbal and cymbal.

IV. The Dunhuang Scores

Dunhuang music and dance frescoes represented an illustrated history of Chinese music for over one thousand years. Yet, in no. 17 of the Mogao Grottoes, a cave known for its document (sūtra) storage, over ten thousand musical manuscripts and relics from nearly ten dynasties, from the Jin Dynasty (265-420) to the Song Dynasty (960-1279), were unearthed. One of them is the pipa music manuscript of Emperor Mingzong, Li Ziyuan, (933) of the Later Tang Dynasty (923-936). This is the only surviving musical manuscript of the Tang Dynasty and is known as the "Dunhuang Scores."

Musicologists Lin Qiansan, Yang Yinliu and Yeh Dong are attempting to reconstruct the music of the Tang Dynasty with this daqu (suite) containing twenty five pieces (Fig. 12). The "Dunhuang Scores" is not only a valuable resource for ethnomusicology but also an important reference for social studies, cultural studies and history of ancient China.

Instead of the music in Dunhuang area, Dunhuang music refers to the musical culture from ten dynasties and over one thousand years in ancient China as depicted in the music and dance frescoes found in Dunhuang and the Dunhuang Scores unearthed from the sūtra cave. It reflects the music, social context and everyday life of the respective periods. From the vividly painted musical drawings and musical notations, we are enjoying the magnificent and splendid musical life as if it were the Sui and Tang dynasties.

伯希和收藏的禮拜儀式畫和許願畫[1]：
幾件重要經變作品與敦煌石窟藝術

傑克・吉埃
法國國立亞洲藝術-吉美博物館

 針對廿世紀初在莫高窟發現的宗教作品，不同的新研究方向能夠促進對這批佛教繪畫的認知。因此，我們在此配合經文，提出伯希和收藏中一些重要的圖像主題。佛經是這些題材主要的來源：記載佛陀講道的內容，透過許多的寓言方式來表達，而這些故事引發起圖像學家，繼而畫家們的靈感。還有其他的經文，就如供禮儀式般，明確地設定雕像及繪畫法相的條規。我們在此將特別討論伯希和的收藏中一再出現的幾個重要主題。這些作品參與了當時的宗教禮拜儀式，極具有代表性，我們希望在本文中探討這些圖像的存在，盡量回溯至最古老的源頭，以便能更佳地掌握其宗教意義。

 在伯希和收藏的研究進展中最重要的發現之一是：這些變像並非單獨存在的，而是彼此有配合的關係，以至形成大套的「圖像」組群。同樣的情形可見於石窟內的壁畫結構，雖然儀式的目的各自不同，每一鋪畫皆具一個浩大的圖像組織。伯希和收藏中最具說服力的證明為兩幅組織龐大的繪畫（其尺寸，也是「藏經洞」中所發現最大的作品），反映在當時與經同名的華嚴宗之興盛。第一件作品為「華嚴經變七處九會變像」[2]，完整地圖繪出經書中全部的卅九品；第二件有關十地經[3]，明顯地將前者中之一章節（品）加以發展鋪陳。

 這兩種圖像深具重要性，反映出華嚴宗之傳教方式，它們之間密切的關係為以下的推論提供首項實際有力的證明：敦煌石窟中的大型經變像組群是依據藏經洞中所發現此類的禮拜畫而發展出來的。這個例子值得我們注意，因為它引發我們以新的眼光去看許多其他作品，目前後者純粹以其本身的價值被當作個體研究。當然，採取此種方法學表示藝術史家必須冒險地踏入了奧妙的佛教教義與其哲學理論的領域中。

一、騎獅的文殊菩薩

 伯希和收藏中的一件幡畫 EO. 1399 [P. 129] 主題為被稱做「莊嚴且溫柔」的文殊菩薩（中文音譯為文殊師利）或文殊，祂在大乘佛教眾多的菩薩中占極特別與優越的地位，甚至成為眾菩薩之首。從其造像來看，對祂的崇拜流行似乎相對地出現較晚，約在七世紀。至少依據我們目前所擁有的考古知識，在中國印度間一片廣大、偶有綠洲的沙漠地帶（SERINDE）首次出現了佛教眾神圖像，文殊菩薩在釋迦佛尼三尊像中占脇侍菩薩的位置，與普賢菩薩相對。祂們經常在佛兩旁以對稱的方式成雙出現，特別是在中國。

 文殊的名字中帶「莊嚴」之意已顯示其優越的地位，祂不同的稱號更明顯地表現出，特別是「妙音文殊菩薩」一詞，暗示祂說法者的角色。其他的稱法在經中時常提到，均係別名，這些別名的涵意隨著其以上的稱號而顯得明白化，例如「童子」或「法王子」。在這些頭銜中，我們特別記取「說法者」，這與佛陀是相近的。名歸其實，文殊菩薩具此稟賦，能透過說法同時教化無數的眾生。祂的說法神力可從佛經中所舉出神奇的創造物為例，如具超自然能力的龍，深洋中的神，宮中護法的門神。

 文殊辯才無礙的主題即是《妙法蓮華經》第十二品的內容（大正藏[4]，第262號，頁35b-c），其中敘述文殊從大海中涌出，之後發展出祂在眾生前說法。在《華嚴經》最後一章〈入法界品〉中重新採用極類似的故事，當文殊菩薩對福城的居民說法之際，無量百千億諸龍離開大海來聽佛法（大正藏，第279號，頁331c - 332a）。在《法華經》中或是鮮為人知的《普照法界經》中，菩薩所傳的教

義是「一乘」法，即「佛陀的乘」，能廣泛地導引眾生並"令速成菩提 [覺醒]"（大正藏, 第262號，頁35b）。

妙言菩薩因賦智慧的完美（般若波羅蜜多），值得擁有「王子」的頭銜；般若波羅蜜多為諸佛神聖的知識，無所不知的智慧，也稱做「摩訶佛母」。因身份認同之故，妙言菩薩與文殊菩薩常被混淆。根據大乘空無（舜若多：空性）的教義，般若波羅蜜多是一種至高無上的智慧，就如覺醒所顯示的真理，用來啓發世人。這也就是說，超越二元性（不二成），解放無所不知（一切智）－這世界不具備任何特性（無相，無想），不在乎任何人或事（無生死的現象），而其真正的本質是一種空無的過程。科學或智慧，不論如何，縱使缺乏認知物的思考，屬於只有完全覺醒者的領域。歸依到這佛法中，就如《法華經》中婆竭羅龍王的女兒，要信仰文殊菩薩，今後不可能後退（不退），同時確信可迅速達到「菩提」的境界。

因此之故，隨著源自印度的中觀派發展，菩薩似乎根據這項大乘教義而獲得此一卓越的身份，甚至確切地「成形」。因此，《維摩詰所說經》成為遠東佛教中空無「哲學」最具代表性的典籍。經文中最有名的故事為文殊菩薩與維摩居士的對談之景（MA.6277，圖錄81號），特殊的是，這經變圖在敦煌六世紀的壁畫中出現，但是要到稍晚的唐代（七－八世紀）才有佛與文殊普賢三尊的造像。在中國，維摩的知名度及其圖像可推至更早的時期，例如東晉名畫家顧愷之（345-407）的畫作中提及過。

文殊菩薩由其坐騎的雄獅子區別：獅子是象徵王權的動物，表示文殊說法的權威性，明顯地類比佛陀之口才，猶如獅吼，能傳到很遠的地方。一件八世紀末風格的幡畫上文殊菩薩即以騎獅的造像出現（伯希和收藏，EO. 1399 [P. 120]）。祂手無持物，施說法印，與其使命有關。值得注意的是，敦煌大部份此種造像的文殊菩薩皆極為類似（例如，大英博物館的斯坦因收藏，斯坦因繪畫 34），即從不具任何持物或特徵，它們似乎稍晚在中日佛教中才出現。這文殊新像中祂首戴五葉冠（或五髻冠），右手持能斷無知的利劍，左手執含有佛智慧（般若波羅蜜多）的經卷。本菩薩另一種造像的出現就是上面所提的「維摩詰經變」圖，畫中文殊坐在帶華蓋的床榻上，如其對話者維摩居士，手中僅持代表辯才的「言杖」。

最後，在一幅也來自敦煌罕有的禮拜儀式佛畫中（伯希和收藏，EO. 3588），文殊騎獅，背景為祂化現的五臺山。五臺山位於中國北方山西省，長久以來朝聖者雲集於此崇拜文殊。在流行文殊菩薩信仰的國家中（中亞、西藏、中國），其道場始終如一，皆處山脈中，就如位喜馬拉雅山中的神秘香山，頂有五峰。

佛教轉移到遠東之特點就是在佛教新聖地的中國選擇了文殊菩薩化現的地方，採用中亞古老的信仰，特別是根據于闐的傳說，其中預言佛涅槃後四百五十年，大乘佛教將廣為流行，同時選擇牛頭山為佛教的中心。中國高僧玄奘以宗教的虔誠心提及牛詰山，矗立在于闐的西南部。

二、藥師如來

所有有關「藥師如來」信仰崇拜的證據（許願幡畫，伯希和收藏，EO. 1178）均呈現一個獨特性：即皆透過目前最早有關藥師如來的中文佛經，雖然它於四世紀初才傳入中國。這仍是至今研究藥師如來的現狀。

在此，就如探討有關如來某些其他的問題，敦煌石窟為中亞地區中保藏這些佛教聖像特殊的例子，在敦煌不僅存有某些圖像唯一的證明，同時這些作品可與一些經典聯起關係，這是佛教世界中的孤例。對藥師如來的信仰在其他的綠洲中並不明顯，大家期待一些證據的出現－如在庫車發現了一塊木製許願板，上繪有一托鉢的佛立像（柏林博物館，A.格蘭威德爾探險隊）；相反地，在敦煌大量出現了有關藥師如來的圖像與經典。有關前者，將近八十五個洞窟中有其造像，同時藏經洞中也發現相當數量的禮拜儀式畫作，其中一些為絹畫中最大幅且精美的作品，此外尚須加上反映信仰虔誠的見證，例如以「千佛」作重複性圖案的木版印刷卷軸中，藥師佛的身份可從祂膝上所托的認出（大英博物館收藏）。至於經典，敦煌則出現數十卷《藥師經》的寫本，主要為四世紀至七世紀中葉所翻譯的三種歷史性的版本。其中以高僧玄奘在公元650年所翻譯的《藥師琉璃光如來本願功德經》（大正藏，第450號）在中國及遠東最具權威性。

　　這些不同的翻譯彼此有聯帶關係，包括707年義淨所翻的第四版（大正藏，第451號），誠如伯希和所指出，「前後時間非常接近」。因此，大家期待著應該是梵文原版的出現，但至今未發現。唯一的梵文寫本，在靠近吉爾紀（喀什米爾）的一佛塔中出現，因為接近玄奘的翻譯，而被認為不早於七世紀之前。此外，值得注意的是，此經文也存於其他中亞的語文中，但僅是粟特文及于闐文的殘片。

　　中國大藏經在此再度地保存了最令人崇敬的版本。縱使本佛擁有複雜的梵文名稱，但必須透過咒語來召喚其神力，同時替祂正名，中文為「藥師琉璃光」，所以梵文應是 Bhaiṣajyaguru-vaiḍūrya-pratha，祂的圖像就是依據這長稱號而建立起來的。

三、東方淨土淨琉璃世界

　　上面所提到的幡畫中（伯希和收藏，EO. 1178），藥師佛造像單純，除此之外，還存有其他的圖像，但規模宏偉，特別是引入神秘的範疇，為前一例所無法想像的。畫面環繞著藥師而形成的東方佛土，稱作「淨琉璃世界」（伯希和收藏，EO. 1135），是一個完美及幸福的世界，其中佛法大興，類似西方阿彌陀淨土的極樂世界。這也就是釋迦牟尼在藥師經中的預言。

　　此種東方淨土與其相對的西方淨土類似，除了反映出理想化的對稱性外，甚至描述出更古老的極樂世界的模式，在大乘佛教神秘主義的眼中，絕非一種獨特孤立的現象。這些類似的佛界，位於四方、十方及無止境的方向；如空間中的佛般是不可數的，所在之距離是難以估量的。根據信仰，在這些淨土上的所有佛完成一項同樣的救世工作，佛性如同佛法是唯一的。

　　有關上面所提諸佛及樂土的平等性，表面上會遭到邏輯上的矛盾，然而大乘佛教的教義輕易地就可消除此種矛盾，採用古老的諸世佛之觀念。誠如釋迦牟尼在廣嚴城眾會說法時所言，藥師佛仍是菩薩時，為解脫世人存在的痛苦，發十二大願，淨琉璃世界乃是十二願實行之後所成真的佛土：其自身發出的琉璃淨光照明世界，驅逐幽冥，這是頭二願；其他願則確保眾生免除苦難，重生於淨土，享受平等的至福。如來希望世人「聞我名」、「專念授記」（大正藏，第450號，頁405b）；此意味著，只要思如來的名，就可以擁有治癒疾病、消災免難、拯救世人等所有的能力。最後，如果人們在終死之際想到祂的名字，會有一個由八位菩薩所組成的龐大行列出現，其中包括文殊菩薩、觀音、大勢至及彌勒等，將指引死者朝向東方樂土，往生者並將於一朵蓮花中化生。

本經集及其主題－如來身散發光明及念其名即能獲得解救，非常忠實地與大乘佛教重要的經書內容相對應，亦即《妙法蓮華經》－特別是第25章的〈普門品〉，和《無量壽經》。這情形決非偶然的。例如九橫死的主題取自《妙法蓮華經》（大英博物館畫中之橫條幅），而對淨土的描述則來自《無量壽經》，非常類似：「清淨無有女人[輪迴]，亦無惡趣及苦音聲。琉璃為地。金繩界道。城闕宮閣軒窗羅網皆七寶成」。

　　東方淨土的藥師佛坐於蓮花座上，沉思狀，手捧藥鉢，兩位脇侍為日光菩薩及月光菩薩，取代阿彌陀佛兩旁的觀音和大勢至菩薩。祂們的名字及祂們的出現代表藥師如來的心願之一：其軀體放出光明，莊嚴過於日月的光芒，同時如這兩座大乘佛教中象徵性的星宿，照亮眾生。

四、觀音經

　　敦煌藏經洞中出現多件與觀音菩薩信仰有關的禮拜儀式及許願繪畫作品，反映出歷史上對這位最能代表佛教慈悲心的菩薩信仰之熱烈。來自敦煌最古老以觀音作主題的繪畫可回溯至八世紀，雖然大部份的見證－包括石窟中的壁畫，屬第十世紀。透過這些作品以及經文手抄本，可以確定觀音圖像所依據的經典皆來自中國新校的《妙法蓮華經》，此經係由原籍龜茲的僧人鳩摩羅什（344 - 413）作第二版的翻譯，竺法護的首版譯本較鳩摩羅什早了一個多世紀。在中國的佛教中，〈普門品〉經文有效的救難價值極被重視，以至手抄本以《觀音經》的名稱單獨存在[5]。

　　事實上，誠如這些作品所示，經文內容提供畫家相當大的自由，而不至於改變其字義。這是很明顯的，佛陀於耆闍崛山的說法會中，透過其當時的對話者無盡意菩薩而言。一尊救苦者出現在被一些困障所驚嚇的人或受難者之前－無論這些考驗是自然、超自然或人為的（隨著經文中以詩詞或散文的形式，個別地或平行地描述詳細的內容）。例如，人為的考驗包括世俗法律所施加的苦刑（一位犯罪者的懲罰），世法其上則是佛法。這位尊者就是觀世音菩薩，意為「將其目光轉向世人之音」。此一名稱透露祂所賦有被祈求的能力。如果佛教用唯名法來顯示難以表達的事物，而《觀音經》則佔有一特殊的地位，只要用這唯一菩薩之名進行祈禱最有效：「獨一及光榮的，有能力提供一個避難場所，提供一種支援」，根據中國僧人道生（355-434）所著的《法華經疏》。

　　因此，如果提及此一名號就有大功效的話，這是因為這名號能獲取功德，透過不同的方式：觀想、心念或一心稱。因此之故，我們所謂的名之稟賦，形成一種獨一無二及宇宙性的範疇。對我們言，這也是〈普門品〉(梵文samantamukha)名稱的意義，好像一種「巧方便」，就如佛與菩薩，配合眾生之差別，採取不同的方式以得度他們。

　　我們再回來討論這個具有如此能力的名稱。「無量百千萬億的眾生」，當遭受諸痛苦及考驗之際，聽到稱頌觀音菩薩之名的同時，馬上（速）能夠被拯救。梵文的經文原意彷彿為「… [眾生]聞稱觀世音菩薩名者」，然而中國經文決定採用所有詞的「其」字：「聞其稱觀世音菩薩名者」，「其」代表觀音，祂解救世人。

　　上面所提及的曖昧是相當極端的，同時創造出許多奇蹟。因為，佛接著說明，也就是由於這些能力，菩薩帶「觀世音」的名號，意指「將其目光朝向世人的呼喚」。較聲音更佳的是，它指從世間傳上來的「音」，並非像有時有人所稱的「呼喚」，而是由稱頌菩薩名所形成的「音聲」。

　　對中國的譯者，在這曖昧的句子中，「其」字意指誰的－世人的或菩薩的？毫無疑問地是兩者

的。只要菩薩觀視眾生以其名號呼喚祂,這名號具體的實現化就能解救世人。辯證法的循環性也同樣地形成:「若有持是觀世音菩薩名者,設入大火,火不能燒」。相同地,所有的苦難都自然地消失。最後,「觀」這個詞指「注視」、「察看」此一音聲。將這些彼此無關的詞彙湊和起來:「注視所有的呼喚」,翻譯出無法表達的,其中語言已失去它的功能,目的為顯出菩薩非常重視祂所聽到的呼救;以其慈悲心,祂能隨意到處顯現其超自然的能力(自在神力)－也就是說不用離開其沉思的地方,就能替受驚的世人消除懼怕、甚至苦難。

在梵文及中文的校訂本中,《觀音經》提及佛在凡間帶有一個外號,也被稱做「施無畏者」,能提供安全(大正藏,第262號,頁57b)。顯而易見地,在畫作中,菩薩就是以此種造型出現(伯希和收藏 MG. 17665,圖錄76號,及斯坦因繪畫〔大英博物館〕,東方藝術 1919.1-1.028)。經中繼續神秘鏡子的反照遊戲,將念菩薩名號的人之功德反射到菩薩的顯現:「聞是觀世音菩薩,一心稱名,觀世音菩薩即時觀,其音聲皆得解脫」。

注視、觀想的對象,當然是指觀音菩薩的軀體,而《觀音經》明言祂能依據世人的特性以不同的「三十三身」表現,也就是祂靈巧地使用所有的方式。因此,觀音能以佛身、菩薩身、聲聞身、天王身－特別是毘沙門身、婆羅門身、執金剛神、甚至女身等各種形體顯現;其目的是為了說法。

說法中最後的階段為聽法,從此以後,所謂的佛法之言,皆與眾生所聽到觀音菩薩的聲音有關。這些音以氣魄宏大的暗喻表現,完全不亞於佛陀本身的特徵:「妙音觀世音,梵音海潮音,勝彼世間音」。

五、十一面觀音菩薩

在伯希和收藏中,有數幅作品為十一面觀音菩薩的造像,為絹本(伯希和收藏 MG. 17778)[6]或苧麻本(伯希和收藏 EO. 3587)的許願畫[7]。如果祂的稱呼明顯地表示其特徵,這個頭銜也為兩部中文經書所採用,而且似乎只有中文才存在(大正藏,第1069號及1070號)。反之,此種稱法會造成對菩薩像意義上的混淆,至少會轉移真正的本旨。這十一面是否係同一尊者所具的多寵臉孔,表達其無所不在,根據有些人,甚至能朝向四方,看到一切?很明顯地,如此的詮釋將冒著把這聖像轉移納入印度教的領域中之風險,這些外道諸神祇具多頭及多手,象徵其具有超能力,而這正是佛教教義所排斥的。任何具何種神通力的諸天都無法超越覺醒的尊者(佛或菩薩)。因此,十一面觀音的造像雖與被排斥的異教神祇有類似之處,祂在此存在的意義就是要更清楚地表達出它們彼此之間的分野處。

十一面觀音的造像起源自印度,年代為笈多王朝之後(約七世紀),當時佛教在印度已經勢微,在印度馬哈拉斯特拉石窟的浮雕上出現,特別是在坎哈瑞(21洞),可能為最早的圖像。除了十一個頭外,這尊菩薩已有四隻手臂。但是除了這些作品外,並未發現任何印度文的原始經籍,只存有根據原本所衍生出三部有關十一面觀音的經文(大正藏,第1069,1070及1071號)。最早的翻譯要溯至北周(六世紀),為耶舍崛多(561-578)所翻,第二本譯文與第一本極為相似,由玄奘(602-664)所譯,最後一部則由不空(705-770)所譯,內容較著重密教的儀軌。這三部中文校訂本為我們基本資料的來源,要透過它們,以瞭解觀音的造像。如果經文中有關「十一面」一詞的意義極為重要,同樣地,有關一尊「宗教禮拜造像」的製作也是重點－經中提到須用旃檀作觀世音像,及對這位菩薩的

崇拜禮儀。

然而，這三卷經文皆先明確地提到這些「面」是指陀羅尼及神咒（或心咒），經文文中稍後，十一面才具體地出現於菩薩的造像中。三經中觀音菩薩向佛致言－第一本修訂經文中，此景在耆闍崛山中發生的，而在二譯版中，是在羅筏竹笻的道場進行，只有第三譯本提及在觀音菩薩所居住補陀落山的南面道場舉行，祂說：「世尊，我有心咒（神咒），名十一面，此心咒十一億諸佛所說。我今說之為一切眾生故」（大正藏，第1070號，頁149a；第1071號，頁152a；第1069號，頁140a）。念這些具大威力的神咒（又稱十一面）同時，菩薩繼續言：「欲令一切眾生念善法故，欲令一切眾生無憂惱故，欲除一切眾生病故，為一切障難災怪惡夢欲除滅故…欲除一切諸魔鬼神障難不起故」（大正藏，第1070號，頁149a）。這兒說出了「十一面」的真正意義，並非如印度教中象徵「至高無上的神」，權威無比，同時也非我們意欲加諸於祂身上的意義：「面對四方」至高無上的菩薩；此一稱號令人混淆。

此外，經文中也清楚地表明菩薩的造像。這件虔誠的作品是由依附在觀音所教佛法中的「善男子善女子」所供奉，這舉動當然也歸功於佛。經文接下來列舉造像的特徵規格，其手持物－左手持一支蓮花莖，右手則施無畏印，特別敘述代表神咒的十一面。我們在此引用三種經文中有關十一面之「特點」，均如出一轍，對畫中的觀音形像不解自明：「其像作十一面：當前三面作慈悲相。左邊三面作瞋怒相。右邊三面作白牙上出相。當後一面作暴惡大笑相。頂上一面作佛面像」（大正藏，第1070號，頁150c-151a；第1070號，頁154a）。這些兇惡的面孔在慈悲者中出現代表何種意義？正確而言，這些神咒對抗由惡魔所設的障礙、消除痛苦及所有惡夢。這是藏傳密教的曖昧性：「善」同時匹配上它所毀壞的「惡」。具大威力的神咒保證安全，推除所有的侵害，消滅所有的毒藥，並保護佛法的代言人。

六、千手千眼觀音菩薩

觀音菩薩表現大慈悲的另一種神奇造像，是以千手千眼的形式出現，闡明救世尊者的力量無所不在（伯希和收藏 MG.17775，圖錄71號）。根據經文所註釋的內容（大正藏，第1060號，頁108a；第1064號，頁115b），此一無所不在必須具備兩種條件，分別是：「千眼照見」-這些眼睛可以看，因為眼睛是亮的，可以發出光芒；另一為「千手護持」佛法。解救世人的菩薩具憐憫心及目光無所不在的特性（見《觀音經》）。在此，造相莊嚴，具密教色彩，為其造像所發展出最極終的的形式。觀音菩薩原有的造形包括救苦（伯希和收藏 EO.1137，圖錄72號）、不空羂索（伯希和收藏 MG.23076，圖錄69號）、十一面、或不空羂索與十一面的合成像，此種千手千眼的新像盡量力求比以前的造型更具效力。

這種令人暈眩的形象，畫家僅能採取一小規模的構圖方法並且付出圖像混亂的代價：千眼固定在同樣數量的打開的手掌心中，諸手各結施予印、無畏印及說法印；群手環繞於尊者的背後，形成橢圓形光圈外，並以淺淺的月光為底－月亮為另一種慈悲的象徵，因為溫柔的月光普照世人。唐朝不空（705-774）所翻譯的《千手千眼觀世音菩薩大悲心陀羅尼》中，內有敘述並圖繪專門禮拜此觀音之密教儀式。四十餘件「主要的」手中各執特別的持物，每一件物均代表菩薩救度的使命：勝利的寶弓、治病的藥鉢、降伏魔鬼的利劍；青蓮花、紫蓮花、紅蓮花，皆為如願以償的標誌，分別

是：重生十方空間的淨土中、面見一切十方諸佛、在諸天宮中重生。另外還有代表保護、安慰、無所不在等的象徵（大正藏，第1064號，頁117-119）。舉起的諸手抬得很高：右邊為化宮殿，引喻佛界的宮殿建築，在此顯然是指阿彌陀佛的西方淨土；在左邊，一位化佛，象徵「生生之處不離諸佛邊」；更上面則是日月兩星宿，散發光芒－根據此一文章的註釋－太陽是抗無知，而月亮則是抗毒藥與惡行。

顯而易見地，這種大組織冗長繁瑣，年代比前面所介紹的諸圖像稍晚。第一本中文《陀羅尼神咒經》修訂本的序是由智通所翻譯的（627-653），（大正藏，第1057號，頁83b-c），序文指出，千手千眼觀音菩薩的圖像及其禮拜儀式直到唐初才傳入中國，尤其經過太宗的支持後，才開始傳開，在太宗之前，所有推廣的企圖均未成功。

我們在此可以建立出觀音形象的演變年代：千手千眼觀音在十一面觀音之後，稍後，在十至十一世紀，出現一種混合兩種造像的型式，即同時擁有千手及十一頭的菩薩。千手千眼觀音的形式比十一面觀音更明顯地模仿密教圖像，但同時又不願沉迷其中，這在文後所討論的兩件大曼荼羅中可見。尊者的曖昧性為來自密教辯證法的雙重特性，在頭正前面繪出一位馴服惡利者之凶狠的面貌（見下面）－此種面貌曾在前述的儀式中提及（大正藏，第1057號，頁83b），亦表現「大慈悲」的本質。經文除了十一面的造像（見其憤怒的頭，大正藏，第268號），同時也強調菩薩保證會實現佛說的神秘咒語；透過大悲陀羅尼的顯露，所有這些經文及圖像的魔力才得以開始運作。千手千眼觀音許大願，欲消除十五種惡死，為壞的重生之來源，並將它們轉化成十五種善生；只要信者虔誠地詠誦一遍就夠了：「親承受持是陀羅尼…便得超越無數億劫微細生死…由持此咒故，所生之處恆在佛前。」（大正藏，第1060號，頁106c）

千手千眼為觀音衍生形象之一，祂體現咒語，並身為傳佛法的大魔術師，受到信者崇拜的主要對象。與其之前的十一面觀音比較，我們可以衡量出或許是歷史性的差別。只要以十一面觀音為拯救世人所發的十願為例，其法儀保留了最初的顯現，咒語和神力之精神；這從十一面的形容詞彙就可看出來。雖然有關千手千眼觀音的經文主要抄襲前者的主題，反之，所使用的語言卻失去了力量，不僅被扭曲，十一面觀音中令人驚訝的善惡面之對比變得軟弱無力，甚至包括這菩薩的造像。對「旃檀作觀世音像」之描述是忠實的，根據精確的儀式，只要去製作，去安置，去崇拜祂就夠了；依照佛的指示，提及這雕像作為經文的結論。

有的人可能認為我們太以美學觀來評斷；但是我們應記得唐高祖（618-626）當時難以接受觀音這種新的造型之事實。千手千眼觀音的造像和法儀在中國的佛教中獲得極大的迴響，這是中亞領域中唯一的孤例，之後才在朝鮮及日本找到有利發展的地方。

七、華嚴經及十地品

在中亞東方的藝術見證中，尤其在敦煌繪畫中，佛教文學大作《華嚴經》以一種特別而連續不斷的方式出現在我們面前，特別要指出，這些敦煌繪畫採用經文中不同的章節而發展出經變複雜的型式。以此經作主題的作品可從眾多的題材中識出，這些構圖宏偉的壁畫經常位於某些洞窟的牆壁或窟頂上。飾有此主題的洞窟超過廿九座（敦煌洞窟總數超過四百）。

這些大型組織作品的特性就是畫面上眾多的佛說法會，它們皆類似，同時排置的方法覆蓋整個

畫面空間，接近壁毯的感覺。整體的效果仿佛一再重覆同一景象，有若同一佛說法會的反射作用。以棋格狀作嚴謹的排置方式可解釋從中央向外呈放射形的次序。「華嚴經變七處九會」（插圖1）要不是具有一項較神秘而哲理化的意義，而非法力秘傳的工具，它的構圖特點會令人聯想到密教的曼荼羅，也就是說整個畫面凝縮出經文全部的內容。

八、伯希和收藏中有關華嚴經變的作品

伯希和收藏中兩件大幅作品為至今掛幅畫中唯一存在的例子（它們十餘年前在收藏中被發現並被識認出），絹本，作《華嚴經》龐大組織的經變。特別要強調的是其中一件的形式極為罕見，另一件則在舉世所知的作品中，獨具特色。首件主題為「華嚴經變七處九會」（伯希和收藏 MG. 26462），插圖1，類似敦煌洞窟的壁畫；第二幅畫獨一無二，即是根據《十地經》－亦即《華嚴經》中第廿六章〈十地品〉，所發展出的景像（伯希和收藏 MG. 26465），插圖2。

《華嚴經》及其教義在中國影響廣大深遠，但目前除了毗鄰中亞的敦煌外，有關此經的圖像極為稀有，甚至可說是不存在的，反映出「考古」方面與資料不完整的現狀。事實上，本經文僅被保存在中國的藏經中－這並非獨特的例子，因為許多其他經文的印度原本皆同樣地已消失。另一種假設，則是透過由諸「品」所組成的經文之修訂歷史，這些「品」文當時是由中國宮庭派遣特使在于闐所獲得，所以我們可以假設中文版就是以文集的方式構成的。事實上，我們可以說《華嚴經》引用了兩本真正獨立的經《十地經》及《入法界》作為其中的兩品。而這兩者皆以梵文的獨立型式為人所知。鑑於這兩件經文教義的重要性，令人傾向於《華嚴經》全套經文是以它們為主要來源而發展出來的假設。

九、華嚴經與七處九會的畫作

《華嚴經》的兩種歷史性的翻譯本均保留在中日的藏經典中。第一版稱作「東晉」本或「六十卷」本（大正藏，第278號）由佛陀跋陀羅（418-420）所翻－同樣也出現在敦煌藏經洞的一黃絹寫本上（法國國家圖書館：伯希和 中國 2144），第二本稱做「周朝」譯本（武則天女皇之朝代，684-705），由實叉難陀（695-704）翻譯，為較長的修訂本，亦稱「新譯」本或「八十卷」本（大正藏，第279號）。我們這兒所討論的一幅構圖龐大的圖畫即根據後者而成。我們在此不考慮般若（756-758）所翻譯也帶有「經」名稱的「三譯本」，（大正藏，第293號）。所以會引起混淆，因為事實上第三版僅與前二本經文的最後一章〈入法界品〉有關，經文長篇大論。第三本翻譯與前二者毫不相關，係根據西印度烏荼王送給中國宮廷的一本經文所建立。

「六十卷」或「八十卷」兩種翻譯本的出現並不是為追求語言學上的完美，建立正確的佛教術語（這些術語似乎一開始就找到了），而是為探尋經文本身真正的起源。章節數目明顯的差異似乎在追尋每種所翻譯的梵文原始版本。兩種譯本之間相隔大約三個世紀，但皆以由中亞于闐國所取回的經文為基礎；這就是為什麼大家認為此一王國在華嚴宗的推廣中扮演重要的角色，隨而產生了對至高無上的毗盧遮那佛信仰的流行。來自這中亞王國當地出土（同時已消失）的大型諸作品之中，有一件約可斷代為六世紀的彩繪木板，上繪有一軀如來像，來自達瑪溝地區（奧雷爾・斯坦因探險

隊，大英博物館，東方藝術MAS. 459[F. II. iii. 2]），另有一塊壁畫殘片，亦由斯坦因在巴拉瓦斯特發現的（新德里，亞洲考古中央博物館，Har. D.）。然而，這兩種修訂本最大的差異在於佛「說法會」的數目，在「舊本」的譯文中爲八次，而在「新本」中卻是九次。但如果不談及說法會實際上及精神上舉行的地方－「處」，此一名詞將是不完整的。而兩種版本都談到共有七處。此種數字的區別（是形式上的，而非經義的闡明）也左右了圖像的構圖。這些圖像依其說法「會」的數目而出現在歷史的短暫敘述中，但是經常因過於簡潔而無法令人想像這些作品。特殊的是，在敦煌所有我們所知的〈華嚴經變〉圖均作「九會七處」像，因此可以說皆取自「八十卷」或「新譯本」的修訂本。

就如其他重要的經文，新翻的《華嚴經》剛引入中國就迅速地遇上熱忱的信眾，他們主張研究及對經文的崇拜，並成立華嚴宗，加入複雜的諸教派行列之中，宗派眾多是中國佛教具有的特色。但是華嚴宗的歷史（也就是它的推廣）與其他教派之差別－特別是與其類似的天臺宗，在於其基本上爲沉思與「哲理」的教義，竟然有一天替帝王的意識型態服務。我們不會因爲此種宗教目的的轉移而感到驚訝，這是中國任何佛教宗派所無法避免的情形。對於外來宗教而言，帝王的支持恩澤一向是使其能保久的條件之一。事實上，華嚴宗一開始就遭到反對的力量。在此所要談的並非這項歷史，而是在武則天統治下，皇帝的保護對《華嚴經》經變的發展所產生重大的影響。在此必須指出，本幅作品的造像，以我們所知，並無其他前例。至於稍晚的壁畫中，其數目不斷增加，甚至與本絹畫同時代的唐末（九世紀後半）五代（十世紀）洞窟中已出現類似的圖像。最後，一些宋代（十至十一世紀）的洞窟中也出現相同的主題，可以說是我們所知最宏偉的構圖。

因此之故，所有有關《華嚴經》八十卷「長」本，亦即「武周新譯」本之修訂歷史的資料，均能幫忙了解圖畫形式與其製作。派人到于闐國尋求《華嚴經》的梵文原本，同時於695年邀請原籍于闐的實叉難陀來中國，居留在洛陽的寺院，主持新本的翻譯工作，這項大工程似乎是武則天皇帝在華嚴宗三祖法藏（名譽頭銜爲「賢首」）[8] 的建議下而開始進行的。總之，我們認爲這重要的取經和翻經工程主要歸功於皇家的贊助，武則天親自題著新譯本的序中也提到（大正藏，第279號，頁1a-b）；同樣地，在武則天的統治下，華嚴宗特別受到她的支持。同時在此出現另一大事件，主宰了華嚴宗在唐朝的發展歷史。

就如《般若波羅蜜多經》（智慧的完美）所講授及發展的，華嚴宗屬於大乘佛教思想的潮流之一。這個新的教派，透過其主張的哲學，特別是藉著華嚴宗尊崇的集法身、報身和化身於一身的宇宙佛毗盧遮那，足以說服和吸引一位自以爲生來注定爲王的女皇；但是對正史家而言，她僅僅是個粗魯的僭位者。大家將她這種宗教狂熱解釋爲她一心一意想建立及穩固其權力的合法化。至少這是一般的意見。此一毫不留情的「黑色傳奇」圍繞著這位女皇帝，繼續爲復朝後的唐代官方歷史所記載，並不斷地被後世各代的史書所採用。更嚴重的是這觀點利用大乘佛教所發展出最龐大廣泛的理論「毗盧遮那佛華嚴世界」替女皇帝的意識型態服務－她自以爲並意欲欺騙她的人民相信她是「金輪聖王」及彌勒菩薩的化身。因此之故，正史家也以同樣方式指責對經文作如此詮釋的華嚴宗。然而如果此一教派在武則天統治下透過華嚴宗三祖而得到一些重要的的特權，武則天之子中宗對發揚此一教派的熱衷較武氏有過之而無不及。之後在德宗（779-805）統治時間，他允許印度僧般若進行《華嚴經》〈入法界品〉的翻譯，那我們又能以什麼理由說明此種熱衷？

在此，我們所要討論的並非華嚴宗的歷史，而是透過對前者的了解來闡釋敦煌的繪畫作及其年代。藉著這個機會能同時提出幾項重點：皇家的贊助對華嚴宗的發展扮演啓先及重要的角色（不論

從連續翻譯經文的工作，及在三祖法藏僧的推動下而建立新教派，獨立自成一宗的方面來看）；此種原先皇室支持的烙印明顯深入，甚至影響到教派的命運。然而華嚴宗的信眾並不只限制於宮廷內。在其較不抽象及理論化的宗教儀軌之中，隨著禪法的出現，華嚴宗很快地就推廣到文武精英之間。從法藏的繼承人澄觀起，已經產生一種轉變，以一種更直接、直覺的方式來了解佛法，這是禪宗的特色。在五祖時宗密（780-841）時更明顯，甚至禪宗的諸世祖表中也將宗密算入。

華嚴宗以「精英」宗派的形象為顯，組織嚴謹，特別是靠著註釋經書這重要的傳統來承傳，在唐帝國衰微之時，華嚴教派的存在大受影響，以至其傳統完全消失。由武宗（840-846）下令滅佛（845）所採取的措施，其巔峰之際大量焚經，隨後在黃巢（876-884）之亂的年代中，消滅了仍保留在寺廟中的經典，對教派帶來致命的打擊。

華嚴宗並非唯一遭遇此種運命的教派，還有其他名聲顯赫的宗派，如天臺宗及法相宗，它們對大乘佛教的理解類似，為唐代佛教的精華，在上亞洲的所有佛教國家中領風騷。

十、圖像的規劃及簡介

《華嚴經》為大乘佛教所發展出最龐大的富想像力之理論，此文學經典來源自佛教的解脫道，如同《法華經》，它們有許多共同的教義，皆是佛所揭示的「圓滿的說法」，亦即佛法的精髓，以及揭開經文題目所指的「毗廬遮那佛華嚴藏世界」神秘的面紗。要如何使兩座山峰彼此不遮掩到對方？只能讓他們各負清楚的使命。信仰《法華經》的天臺宗信徒描繪歷史性的佛說法會，他們的經文中以尊者在樂土使命中最尾端的高峰為主，而將《華嚴經》安排到最初的高峰－但《華嚴經》似乎是更晚才編纂的。因為這是涉及神秘及教義的真理。重要的是彼此的接近性與類似性。這就說明了在諸多洞窟繪畫的結構中，以此兩種經變作主題的壁畫互相呼應。有關窟頂的經變，我們可以舉出第9號窟（伯希和107號）及第55號窟（伯希和 118F號），壁畫則有第6號窟（伯希和168號）及第61號窟（伯希和117號），均為五代至宋初（十世紀）的作品。

《華嚴經》透露佛陀在離優留毘村不遠之處剛覺醒時的舉動，也就是說祂在菩提伽耶得解脫與在波羅奈城初次說法之間的的數週期間，大部份古經典對這段時期所發生的事保持沉默。這插入的神秘之舉，小乘佛教文學暗示佛在正要開始祂為眾生造福的使命之際，頓然升起猶豫之心。此種心理上的標誌勾劃出歷史上現世佛的人性，《華嚴經》則以佛性中至福的超越時間性來取代，而沒有覺者面對義務時的退卻。其中傳奇的神秘面就是透過絕對佛「大光明毗廬遮那佛」之圖像代表佛性的本質，而非帶神性。因此，在樹下沉思的如來，未離開樹，卻神奇地在七地的說法會中同時出現，其中三次大會是在菩提（覺醒）道場。

敦煌洞窟中有關《華嚴經》的經變圖，就如同吉美博物館所收藏舉世唯一的禮拜儀式畫，內容皆敘述如來說法時能在欲界以上的諸天化現的神蹟：首先在覺醒的地，通過宇宙山頂須彌山，然後垂直升上三十三天，以達到最高天國。如此經變圖造像的傑出處，如果以哲理觀點來看，也就是說其詮釋經文及道德的影響，在於構圖依循由下往上升的次序，最後高潮的說法會發生在佛對世人歷史上傳道的地方，也就是祂在逝多林首次傳揚解脫道。在此被描述成廣大的宇宙天體中，教訓是顯而易見的：就如經中影射佛陀在波羅奈城的說法，《華嚴經》與正統的教規及傳統的佛陀傳記重新建立起關係。

（中文翻譯：曹慧中）

1. 「許願畫」是指由供養人所訂製的虔誠作品，為供養物。因此它們在特別場合中「應景」來當作宗教的用途（就如畫中許願文所述）─不論以其所施的願，所期待的償願，或為葬禮、紀念亡者所舉辦的法會時使用的角度來看。第17號窟所發現大部份的繪畫很可能屬於這種性質，因為無法毀滅，所以人們將其藏在洞內。「禮拜儀式畫」與前者分別處，作為持久的禮拜儀式所使用，內容為經變圖，取自數本重要經典：特別是法華經，阿彌陀經，華嚴經等。以當時代所遺留的見證中，這些經變圖也經常當作莫高諸窟內的壁畫主題，同時也裝飾甘肅和中國北方的諸洞窟。
2. 伯希和收藏MG.26462。參見：《中亞藝術，吉美博物館之伯希和收藏》，吉埃主編，第一冊，東京，巴黎，倫敦，1994-1996，圖版 I，頁51-62。
3. 伯希和收藏MG. 26465. 如上，圖版II，頁 63-72。
4. 日本版的大藏經：《大正新修大藏經》，大正年間（1912-1925）所編；在此以《大正藏》簡寫。1924至1935年在東京出版，高楠順次郎、渡邊海旭及小野玄妙主編。
5. 法國國家圖書館：伯希和中國3932；吉美博物館：伯希和收藏 MG. 17665。
6. 《中亞藝術，吉美博物館之伯希和收藏》，巴黎，1996, 國家博物館聯合會，第一冊，頁92。
7. 同上，第一冊，頁92。
8. 唐皇室對法藏的器重從未中斷過，甚至在705年武則天皇后遭罷黜後；他仍保持了高官位置，甚而被隨後兩位皇帝施與最高尊敬的頭銜：也就是重新掌權的中宗（705-710）及其繼承者璿宗（710-712）。

圖1. 華嚴七處九會變像圖
　　　五代（10世紀初），絹本設色 194×179 厘米
　　　伯希和收藏，吉美博物館 MG. 26462
圖2. 華嚴經之十地品變像圖
　　　五代（10世紀初），絹本設色 286×189 厘米
　　　伯希和收藏，吉美博物館 MG. 26465

The Pelliot Collection of Liturgical and Votive Paintings:[1]
Several Great "Images" of the Revered Ones, and the Art of Dunhuang Sanctuary

Jacques Giès
Musée national des Arts asiatiques-Guimet

New lines of research able to add a contribution to the knowledge of Buddhist paintings – pious works discovered at the beginning of the twentieth century in the Mogao grottoes in Dunhuang – are still open. This is why we propose several major iconographic subjects, as they appear in the study of the Pelliot Collection, viewed here with the insight of pertinent texts. Among these sources, the sūtras occupy a place of primary significance. These collections of the Buddha's teachings, in the form of apologues, recount a great number of stories that inspired iconographers, and in their wake, painters. The same is true for many other texts, like the rituals that gave precise directions for the making of pious Images (statues and paintings). Several great "images" (bianxiang 變相) of the Revered ones, whose presence is very apparent among the works of the Pelliot Collection, are displayed here. As they represent the great liturgies that they are part of, we have been careful to go back, as far as is possible within the framework of this article, to the most ancient, pertinent sources to better seize their religious impact.

One of the most important discoveries revealed by the Pelliot Collection is that some of these works, far from being isolated "images", should be matched up among themselves, thereby composing important "iconic monuments"; following, but distinctly as far as ritual finality is concerned, the example of mural compositions of caves directed by a vast iconographical program. The eloquent proof, revealed in the Collection, is offered by two great compositions (amongst the most important paintings, not only by their size, ever found in the "Sealed Cave", the so-called Pelliot's Cave of the Manuscripts). Such a monument refers to the widespread influence, at a certain era, of the School of Flower Ornament (Huayan zong 華嚴宗), founded upon the scriptures, the sūtras, of the same name. The first of these works, identified as the Buddha's "Nine Assemblies of the Seven Places" (Qichu jiuhui bianxiang 七處九會變相)[2] illustrates in the whole of the thirty-nine chapters the plenitude of this preaching; the second, dedicated to the figuration (in the same sūtra) of the Ten stages [of the bodhisattva's career] (Daśabhūmika-sūtra, Shidi jing 十地經)[3], is distinctly from former a developed illustration of one of the Flower Ornament's chapters (pin 品).

This intimate relation between two iconographies whose importance reflects the pedagogy of the Doctrine of the School of Huayan, is the first supporting evidence that vast monuments were conceived from liturgical paintings found in the "Sealed Cave". The example deserves to be briefly developed here because it invites us to consider, in a new light, many other works that today are studied for their own aesthetic value. Indeed, such an undertaking supposes that the Art Historian ventures in the subtleties of the Buddhist Doctrine and its philosophical foundations.

I. The Bodhisattva Mañjuśrī (Wenshu 文殊菩薩) on the Lion

The Enlightenment-Being (bodhisattva, pusa 菩薩) – illustrated among other paintings by the Pelliot Collection EO. 1399 [P. 129] banner – Mañjuśrī "agreeable majesty" (transliterated in Chinese Wenshushili 文殊師利) or Mañju (Wenshu 文殊), occupies a particular and prominent place among the many revered Bodhisattva(s) of the Great Vehicle, to the point that he could appear as their chief. His cult, as far as we can judge from the icons (paintings and sculptures), seems to have developed only relatively late, towards the seventh century. In any case it is the knowledge that we have garnered from archaeology that attests once again to Central Asia as the first pantheon where he occupies this place: that of the Buddha's assistant in the Blessed Śākyamuni triad, to whom answers facing him the Bodhisattva, Samantabhadra (Puxian pusa 普賢菩薩). Indeed, these two great figures are often paired as icons in a symmetric presentation of the Buddha's acolytes, particularly in China.

The superior position denoted by his name "Majesty" is clarified further on in the given epithets naming him, and particularly in that of Mañjughoṣa (Miaoyin Wenshu pusa 妙音文殊菩薩) "With the soft voice", "Wonderful", an allusion to his role as predicant: other names as well, often mentioned in scriptures, have the value of a nickname, and

their meanings consecutively shed light upon the first epithets, such as Kumārabhūta "Young Man" (tongzi 童子) or "Royal Prince of the Law" (Fawangzi 法王子). We will remember from the lesson of these titles, the "Predicant" who, is this case, is kin to the Buddha himself. In this title, Mañjuśrī is the one who has the gift of converting millions of creatures at the same time through his teachings. His preaching, in this field, is particularly exemplified in proportion of the fabulous creatures that are the nāga (snakes) whose powers are supernatural, divinities from the abyssal depths of the ocean, guardians in their palace of the Buddhist sūtras.

This eloquent theme which prefigures his work in favour sentient beings is the one developed by Chapter 12 of the Sūtra of the Lotus Flower of the Wonderful Law, or Lotus Sūtra (Taishō [4], n° 262, p. 35b-c), where the Bodhisattva emerges from the Ocean. It is taken up again in a similar fashion in the last chapter of the Gaṇḍavyūha (Rufajie pin 入法界品), from the sūtra of the Flower Ornament (Avataṃsaka-sūtra, Huayan jing 華嚴經) where Mañjuśrī's preaching made to the inhabitants of the city of Dhanyākara (Fucheng 福城) incites millions of nāga to come out of the waters to listen (Taishō, n° 279, p. 331c-332a). In the case of the Lotus Sūtra itself, and in that of a sūtra called "Universal Illumination of the World of Law" (Puzhaofajie 普照法界), whose name is by the way unknown, the doctrine exposed by the Bodhisattva is that of the Unique Vehicle (yicheng 一乘), the "Vehicle of the Buddhas" which has the power to largely guide beings and to enable them "to obtain rapid Enlightenment today (bodhi)" (Taishō, n°262, p. 35b).

The Bodhisattva "with the marvellous voice" (Miaoyan pusa 妙言菩薩) deserves the title of "Royal Prince" (wangzi 王子) in his capacity as the all-knowning depository of the "Perfection of Wisdom" (Prajñāpāramitā, panruo poluomiduo 般若波羅蜜多), the sacred, omniscient knowledge of the Buddhas; also said to be "Mother of the Buddhas" (Mahe Fomu 摩訶佛母) — with which Mañjuśrī is often confused in respect of this identity. Under the term of Prajñāpāramitā must be understood a Superior Knowledge that initiates to the world of the Truth such the very Enlightenment unveils, according to the Great Vehicule's lesson of the doctrine of "emptiness" (śūnyatā, shunruoduo 舜若多: kongxing 空性). That is an "overstepping of the dualities" (advaya, bu ercheng 不二成) freeing "omniscience" (yiqiezhi 一切智): this very world being void of all determining signs, signless (ānimitta, wuxiang 無相, 無想), offering no consideration for either beings or things (on the principle of absence of production and destruction of the phenomena), and whose true nature is nothing but a process of emptiness : "void of a self or anyting belonging to a self". Science or sapience, deprived in whatever manner possible of the reflection of objects of knowledge — such is contemplated the Prajñāpāramitā —, which, we will agree, could only come within the scope of beings perfectly, completely "awakened". "To take refuge" in this doctrine of the Buddhas, is to be like the daughter of the snake king Sāgara (Sāgara-nāgarāja, Suojieluo longwang 娑竭羅龍王) mentionned in the Lotus Sūtra – converted by Mañjuśrī – incapable from then on of regression (avaivartika, butui 不退) and insured a prompt attainment of the state of bodhi (pudi 菩提).

It seems thus that it is in light of this Mahāyāna doctrine, development of the Mādhyamika (Zhongguan pai 中觀派), originally Indian, that the Bodhisattva acquired, or took the "form" of this eminent stature, as it take shape in the Sūtra of Teachings of Vimalakīrti (Vimalakīrtinirdeśa-sūtra, Weimojie jing 維摩詰經 or Weimo jing 維摩經), one of the most well-known expressions in Far-Eastern Buddhism of the "philosophy" of emptiness.

Singularly, if the illustrations of the famous scene of this Sūtra, where Mañjuśrī has for his interlocutor, in this "pure conversation" the secular saint Vimalakīrti (Weimo 維摩) "UnstainedGlory" (MA6277 Cat. 81), go back to the Dunhuang caves paintings of the sixth century, it is only later apparently, under the Tang (seventh – eighth centuries) that the Buddha triad with its two great acolytes is envisioned. In China itself the fortune of the Vimalakīrti-nirdeśa Sūtra and its representation is said to go back to an even earlier period, as it has been mentioned among the works of the great painter Gu Kaizhi 顧愷之 (345-407), of the Eastern Jin 東晉 Dynasty .

The appearances of the Bodhisattva distinguish themselves by the presence of a lion (siṃha, shizi 獅子) which he mounts. This emblematic animal of royalty, royalty as linked to the authority of his teachings, the preaching of Law (Dharma) – is an obvious analogy with the eloquence of the Buddha who, like the roaring of a lion, is heard far away. Mañjuśrī appears thus on his mount in the banner (Pelliot Collection EO. 1399 [P.120]), which we stylistically date towards the end of the eighth century. His hands empty of any attribute form together the gesture of Preaching (vitarka-mudrā, shuofa yin 說法印) in relation with his vocation. It should be noted that most of the Dunhuang paintings that represent him in this manner follow a very close iconography (for instance, in the Stein Collection in London, the double composition in form of spectacles. Stein Painting 34), that does not include the signs and attributes that seem to have appeared later on in Sino-Japanese Buddhism: the wearing of a tiara with five spikes (or the hairstyle with five locks), the sword in his right hand that slices ignorance and, in the other, the book containing the Prajñāpāramitā ("Sacred Science of the Buddhas"). The other iconic apparition, from Central Asia, of the Bodhisattva is apparent in the illustration of the Sūtra of Teachings of Vimalakīrti, as has been noted, and in which Mañjuśrī has taken his place, like his partner, the secular saint, under a canopy presenting as sole attribute the "conversation stick" of direct eloquence.

A rare liturgical painting also from Dunhuang (Pelliot Collection EO. 3588), represents him associated with the feline with a mountain in the background, the way he was revered in China, in the chosen place of his appearances, at Wutaishan 五臺山 (The Five Terrace Mountain), a very real location in Northern China, in the Shanxi Province, towards which crowds of pilgrims flocked throughout the centuries. A constant element in the Mañjuśrī cult was that it was always situated in the countries of its influence (in Central Asia, Tibet and China) on a chain of mountains comparable to the mythic Mount Gandhamādana (Xianghsan 香山) in the Himalayas, which is said to be crowned by five summits. The remarkable feature of the translation of Buddhism towards the Far East was the selection of a place in Chinese territory – new holy ground of Buddhism – for its appearance, a replica of the most ancient Central Asia beliefs, and particularly of a Khotan legend where the "mid-millennium" prophecy announcing 450 years after the Buddha's nirvāṇa, the success of the Great Vehicle, the election of a Buddhist omphalos, Mount Gośṛṅga (Niujia shan 牛角山) "The Mountain of the Bull Horn" are intermingled. The great Chinese monk Xuanzang mentions with religious reverence that it rises up in the South-Western part of Khotan (Yutian 于闐).
*

II. The Buddha Bhaiṣajyaguru 藥師如來

The testimonies concerning the cult of the Buddha Bhaiṣajyaguru "Master of Healing" (Yaoshi rulai 藥師如來) (Votive Banner, Pelliot Collection EO. 1178) present the singularity of appearing only through the initial transmission in China of the sūtra dedicated to this Tathāgata 如來", that is at the beginning of the fourth century only. Such is, still today, the state of the question related to the transcendent Buddha.

Here, like for certain other aspects of the Tathāgata, the Dunhuang sanctuaries represent an exceptional conservatory in Central Asia, not only for the unique iconography that can be seen there, but also, because of the fact, without equivalent in the Buddhist world, that these works are exposed in relation to documentation.
Although it is diffused and apparent in other oases – thus in Kucha, a wooden votive tablet (Berlin Museum, Mission A. Grünwedel) painted in the effigy of a Buddha holding a bowl – the cult of the "Medecine Buddha" occurs in Dunhuang, with a luxury of iconographic as well as scriptural sources. Among the iconographical sources, there are nearly eighty-five caves dedicated to its representation and a respectable number of liturgical paintings emerging from the "Sealed Cave", some of them among the most imposing and most beautiful works executed on silk, to which must be added testimonies of more direct piety in the manner of printed scrolls with a plethora of images, said to be "of the Thousand Buddha(s)", where Bhaiṣajyaguru can be recognized by the bowl in his lap (British Museum). The scriptural

sources are illustrated by several dozen copies of the Sūtras said of Bhaiṣajyaguru (Yaoshi jing 藥師經), particularly in the three historical translations, which were spaced out from the fourth century to the middle of the seventh century. This last translation (650 A.D.), authored by the great monk Xuanzang, was authoritative in China and in the Far East, under the title developed from the Sūtra of the Fundamental Wishes of the Radiant Lapis-lazuli Master of Healing Buddha (Yaoshi liuliguang rulai benyuan gongde jing 藥師琉璃光如來本願功德經), (Taishō, n° 450).

These translations were related to one another, like the fourth one by Yijing 義淨, in 707 (Taishō n° 451) and "follow each other closely", as Pelliot emphasized and, consequently, keep us waiting for a first text supposed to be in Sanskrit. This text has not been found. The only manuscript in this language, discovered in a stūpa near Gilgit (Kashmir) cannot be dated back to before the seventh century, based on the argument that it is close to Xuanzang's translation. An important fact is that the Sūtra exists, moreover, in other Central Asian languages, but in a fragmented state in Sogdian and Khotan languages.

The Chinese Tripiṭaka (the Threefold collection of autoritative texts in Buddhism), here again, guards the memory of the most venerable versions. So much so that even in the Sanskrit name of this Buddha, the good fortune of the dhāranī, "charm-formula", was necessary to call its powers, to restore it, as it should be: Bhaiṣajyaguru-vaiḍūrya-pratha, corresponding to the Chinese terms Yaoshiliuliguang 藥師琉璃光 "Radiant lapis-lazuli Master of Healing". A long epithet in the background of which its icon is drawn.

III. The Land of Pure [Radiant] Lapis Lazuli, Jingliuli shijie 淨琉璃世界, of the East

Besides the simple icon of the Buddha Bhaiṣajyaguru on the votive banner which has been just mentioned (Pelliot Collection EO. 1178), there are other liturgical images of the Same, but of a completely different scope and introducing a particularly mystical dimension, that the previous one did not anticipate. That is, the outline of a "Buddha-field" (Buddha-kṣetra, Fotu 佛土), (Pelliot Collection EO. 1135), situated in the East and called "Field of Pure Lapis Lazuli" (Jingliuli shijie 淨琉璃世界), a perfect and happy realm where the unadulterated Law (Dharma, fa 法) reigns – a domain comparable to the "Place of Happiness" (Sukhāvatī, Jile shijie 極樂世界) of Amitābha Buddha (Mituo jingtu 彌陀淨土), in the West,. Such is the preaching delivered by the Buddha Śākyamuni in the sūtra of Bhaiṣajyaguru (Taishō, n° 450).

This similarity between the Buddha-field of the East with its Western counterpart, besides the ideal symmetry that it indicates, or even the more ancient pattern of the Sukhāvatī that it describes, in the eyes of the mystic of the Great Vehicle is in no way unique. These are comparable Domains of the Buddha that once again are drawn in four, in ten, in an infinite number of directions: countless like the Buddhas of space, and situated at immeasurable distances. This, by virtue of the belief that the Buddha(s) of these fields accomplish the same Work of Salvation, that "Buddhahood" is Unique, the same way the Law (Dharma) is.

But this would be a far too apparent dead-end logic, coming after the profession of faith that we have just seen concerning the equality of these Buddha(s) and their fields, a dead-end that the Doctrine of the Great Vehicle easily lifts nevertheless by resorting, precisely, to the ancient notion of successive Buddha(s). Thus the Fields of Pure lapis-lazuli Radiance is the fulfilment, as Śākyamuni teaches to the people gathered in Vaiśālī, of the Twelve wishes that the Buddha Bhaiṣajyaguru articulated in the past, when he was a Bodhisattva, to save sentient beings from the pain of existence: the pure Radiance of lapis lazuli that his body reflects, illuminating the worlds to chase away darkness, accomplishes the first two; from the others, assurances to be released from the hardships of this world and to be born again in his Buddha-field to stay there in equal bliss. The Buddha wishes : "that my invoked name be heard" (wen worning 聞我名), "that it may be remembered with consistency" (zhuannian shouchi 專念授記), (Taishō, n° 450, p. 405 b): which means that the

virtue to think his name has all the powers: to cure diseases, to protect against perils and to lead to salvation. Finally, if one thinks of his name at the time of death, a great procession composed of eight Bodhisattvas, among whom Mañjuśrī, Avalokiteśvara, Mahāsthāmaprāpta, ... and Maitreya are found, will guide the deceased towards the Field of the East where he will be born again in a Lotus flower.

This book and its theme – the Buddha sparkling with radiant light and the salvational powers of his name – are a faithful echo to the main Mahāyāna texts that are the Lotus Sūtra of Wonderful Law (Miaofa lianhua jing 妙法蓮華經) and particularly its chapter 25, entitled the "Universal Doors" (Pumen pin 普門品), on the one hand, and the Sūtra about the Place of Happiness of the West (Sukhāvatī-vyūha 無量壽經), on the other hand; this could be a coincidence. The first indicates, for instance, the protection that saves from nine violent endings (illustrated in the predella of the British Museum painting), the second, of course, describes the Pure Land (jingtu 淨土) — latter common name for the "Place of Happiness of Buddha Amitābha " —, of which it is said: "There are no temptations, no bad ways (to be reborn), nor can be heard cries of pain there; the ground is made of pure lapis lazuli, roads are ropes of gold; walls, doors and palaces, … the draperies are made of seven jewels."

As for the two main assistants of the Buddha of this Radiant lapis-lazuli Field, represented sitting in meditation on a lotus holding the bowl of remedies, in place of the great acolytes of Buddha Amitābha , Avalokiteśvara and Mahāsthāmaprāpta of just previous mentioned Pure Land, we find here the Bodhisattva(s) "Solar Sparkle" (Suryaprabha, Riguang pusa 日光菩薩) and "Lunar Sparkle" (Candraprabha, Yueguang pusa 月光菩薩). Their name and their presence evoke as much one of Bhaiṣajyaguru's wishes – that his body radiates with a sparkle that overtakes the two luminaries – as the Mahāyāna symbolism of stars that also shed light on all beings.
*

IV. The Sūtra of Avalokiteśvara, Guanyin jing 觀音經

Numerous votive or liturgical paintings, dedicated to the cult of the Bodhisattva Avalokiteśvara (Guanyin pusa 觀音菩薩), have been provided by the walled cave of Dunhuang, thus establishing the great historic fervour of the cult to this Bodhisattva who is the ultimate figuration-incarnation of Buddhist Compassion (kāruṇā, cibei 慈悲).
The most ancient illustrations from Dunhuang go back to the eighth century, even though the main body of testimonies, including the many wall-paintings in the caves, dates from the tenth century. Judging from these masterpieces, a certainty backed by manuscripts is that the textual source of the images is founded uniformly on the Chinese reviewing of the Lotus Sūtra (Saddharma-puṇḍarīka-sūtra, Miaofalianhua jing 妙法蓮華經) by the monk of Kuchean origin Kumārajīva (Jiumoluoshi 鳩摩羅什, 344-413 A.D.), which was the second translation more than a century after the first undertaken by Dharmarakṣa (Zhoufahu 竺法護). The efficient, propriatiatory value of this text was held in such consideration that the chapter deserved, in Chinese Buddhism, independent copies under the title of Sūtra of Guanyin [bodhisattva] (Guanyin jing 觀音經) [5].

In truth, as refered to by these varied illustrations, the text offered to painters a relatively free field without incurring a great risk of upsetting the literality of meaning. This is almost too apparent. A great helpful figure stands up – exposes the Buddha of the Four Assemblies gathered on Vulture Mount (Gṛdhrakūṭa-parvata, Qidujue shan 耆闍崛山), through his great attendants of the moment, the Bodhisattva of Infinite intelligence, Akṣyamati (Wijinyi pusa 無盡意菩薩) – in front of all those who are either frightened by a hardship or the victim of one; these hardships (they are evoked in detail, distinct or in parallel whether they are mentioned in verse or in prose) may be of natural, supernatural or human causes. The latter, for instance, comprise those that dictate secular laws (the punishment of a guilty person), above which the Buddhist Dharma (the Law) is situated. This figure is that of the Bodhisattva Avalokiteśvara, Guanshiyin 觀世音 "Who

turns his Gaze towards the Sounds of the World". This name holds within all the powers invoked by Him.

If nominalism is common in Buddhism to show what is inexpressible, the Sūtra of Guanyin holds a particular position since his whole message lies on the efficiency of a prayer formulated with only the name of the Bodhisattva: "unique and glorified, with the power of offering a refuge within himself, a support", according to the Commentary of the Lotus Sūtra, by the Chinese monk Daosheng (道生 (355-434A.D)).

Moreover, if there is great efficiency in invoking this Name (minghao 名號), according to the credo that: "His image comes to mind" or " is remembered" (xinnian 心念), "He is praised from a sincere heart" (yixincheng 一心稱), it is that its very Name provides merits (puṇya, gongde 功德). What we call this "gift of the Name" thus forms a unique and universal field. This is, it seems the meaning of the Pumen 普門 (Sanskrit: samantamukha) chapter (pin 品), that can appear like a "clever recourse to the means [of salvation]" (upāya-kauśalya 巧方便), that both the Buddha and the Bodhisattva deploy to be in harmony with the different dispositions of the sentient beings.

This brings us to this name that has such a beneficial power. Perils and hardships are met and endured, as it is professed, by all in this "World of hundreds of thousands of myriads of sentient beings"; the latter experience immediate (su 速) salvation aided upon hearing the Bodhisattva Guanshiyin being praised. The Sanskrit text seems to indicate "… (the creatures) hear the name (of the Bodhisattva) being praised"; whereas the Chinese, apparently, opt for a possessive (qi 其): "hearing his name being praised" which refers to Guanyin himself, he saves them.

The ambiguity that has just been mentioned is extreme and exceptionally productive of the prodigy. Because, the Buddha reveals afterwards that it is because of these powers that the Bodhisattva carries the name Guanshiyin "The One who turns his eyes towards the calls of the world". More than sounds, ordinary sounds (yin 音) rising from the world, less even than cries, as is sometimes said, it is the sound of incantation (yinsheng 音聲) formed by the glorified name of the Bodhisattva.

Who, between the sentient beings or the Bodhisattva, is alluded to in this sentence that is apparently ambiguous even for the Chinese translator? Both, without any doubt. The realization, in its proper meaning, of the name has the power to save with respect to the former, in measure that the latter considers the call thrown his way by his name being pronounced. The dialectic circularity is thus formulated: "those who possess (chi 持) this name of the Guanshiyin (Bodhisattva), as it is exposed, if they come to fall in a big fire, will undoubtedly come out unharmed", and, in the same way, all perils disappear with this measure. Finally, this term guan 觀 that "looks", "considers", as understood, this incantation. Bringing together these terms that are foreign one another, "look at the prayers" translates the inexpressible where language loses its faculty to say how much the Bodhisattva takes into consideration the call that rises up to him and, from his compassion, displays great supernatural powers wherever they are requested – as he wishes, (zizai shenli 自在神力), thus, without leaving his place of meditation – who alleviates the very peril for those in fright and fear.

The Sūtra of Guanyin, in Sanskrit and Chinese reviewing, mentions an epithet of the Buddha, given to him in this lower world, where he is also called Abhayaṃdada (Shiwuwei 施無畏), "The one who gives security" (Taishō, n°262, p. 57b). It is under this guise that he appears, obviously, in paintings (Pelliot Collection MG 17655, cat. no. 76 and Stein Painting [British Museum], Oriental Art 1919. 1-1.028). And this mystical play upon mirrors, sending back the merits of the one who pronounces the praise of the name when the Bodhisattva shows himself, is ongoing: "the audition of the name, the contemplation of (Guanyin's) body, the regular remembering are not in vain: their certain result is to abolish all the pains of existence".

The contemplation, the vision, is indeed that of the body of the Bodhisattva Guanshiyin, whose Sūtra professes that he may manifest himself under "Thirty-three forms", all different depending upon the disposition and the nature of sentient beings. And this, by virtue of the ability in the means that he displays. Thus, he may appear in the shape of a Buddha, a Bodhisattva, a disciple (śrāvaka, shengwen 身聞), a Celestial-King (Lokapāla, tianwang 天王), particularly Vaiśravana (Pishamen 毘沙門) a Brahman, a genie carrying the lightening-diamond (Vajrapāṇi, Zhijin'gang shen 執金剛神), even a woman, and this to teach the Law.

The word that lets itself be heard, this audition written in the conclusion of the preaching, contrary to what has been exhibited up to now, is henceforth carried over to the one that the sentient beings have of Bodhisattva Guyanshiyin's voice. This voice is evoked by magnificent metaphors that nearly match the attributes of the Buddha himself: "It is like the sound of a cloud, like the roaring of the ocean, like the voice of Brahmā (Fantian 梵天) who overtakes the limit of space where sound reigns."

V. Guanyin "With Eleven Faces" Ekadaśamukhāvalokiteśvara 十一面觀音菩薩

The Bodhisattva Avalokiteśvara, with the epithet "With Eleven Faces", Ekādaśa-mukha (shiyimian Guanyin 十一面 [觀音]) is illustrated in the Pelliot Collection by several votive masterworks, made primarily on silk (Pelliot Collection MG. 17778)[6] and on hemp (Pelliot Collection EO. 3587)[7]. If the Bodhisattva's expression clearly shows the titles thus given to two sūtra in Chinese, and only in this language apparently (Taishō, n° 1069 and 1070), it also induces, however, if not a confusion in the meaning of this representation of the Great Enlightenment-Being, at least it draws well away from the subject itself. Are these Eleven Faces the numerous faces of a revered being, expressing his omniscience and as one who, according to some, can "face everything" (samantamukha)? The risk in such an interpretation is obviously to remove the figure to the field of imagery of the divinities of Hinduism, a figure of their omnipotence signified by their numerous heads and arms, which Buddhism challenges in the name of its principles. What "divine" substance could draw itself above the revered beings, examples of Enlightenment, whether Buddha or Bodhisattva? In the same manner, such an image where certain similarities with the divinities of rejected beliefs show on the surface, has obviously its place here only to mark more acutely the distance that opposes them.

The iconographic source of the Bodhisattva Avalokiteśvara with Eleven Faces is Indian. It may be situated in the post-Gupta period (circa seventh century), already the decline of Buddhism in this country, manifested in the reliefs of the Maharashtra caves, and particularly in Kanheri (cave 21) where one of its very first representations existed. In addition to his Eleven heads, the Bodhisattva of this effigy already has four arms. But, besides these images, none of the scriptural sources kept in the Indian language deal with the three sūtras speaking of Ekadaśamukhāvalokiteśvara (Taishō, n° 1069, 1070 and 1071). The most ancient translation by Yaśogupta Yeshejueduo 耶舍崛多 (561-578) dates back to the Northern Zhou (sixth century), the second, closely linked to the previous one, is by the great monk Xuanzang 玄奘 (602-664), and finally the last one, more developed with regards to Tantric rituals, by Amoghavajra (Bukong 不空 ; 705-770). These three Chinese reviews are thus our essential sources, and they may be used to understand Guanyin's image. Because if there is the question of the meaning to give to the expression "Eleven Faces", there is also that of the making of the " worship Image" – a sandalwood statue of the Bodhisattva, and the particular cult to be given to it.

What is exceptional in this case is this appearance of the Bodhisattva. The three texts are explicit and, moreover, all agree on the fact that these "faces" (mukha, mian 面), before being literally figured in the image of Guanyin, designate the "charm-holding formulas", dhāraṇī (Tuoluoni 陀羅尼) and "new formulas" mantra (shenzhou 神咒 or xinzhou 心咒), from the mouth of the Guanyin Bodhisattva's address to the Buddha – the scene takes place, in the first reviewing, on

Mount Vulture (Gṛdhrakūṭa-parvata), in the second, in the Karaṇḍakanivāpa park, also near Rājagṛha (Wangshecheng 王舍城); only the third one mentions the Southern site of Mount Potalaka (Putuoluo shan 補陀落山), "place" of sojourn of the Bodhisattva Avalokiteśvara: "Bhagavat, I own today the mantras (shenzhou 神咒) that are called the Eleven Faces (shiyimian 十一面), the mantras that eleven koṭī (one million and a hundred thousand) of Buddhas have pronounced […]. I will pronounce them in my turn today, and this in the interest and for the well-being of all creatures" (Taishō, n° 1070, p. 149 a; n° 1071, p. 152 a; n°1069, p. 140a). Pronouncing these mantras, said of the Eleven Faces, that have great powers, the Bodhisattva pursues: "I want for all beings to keep them in memory and recite the Good Law (shanfa 善法) so that they do not suffer from diseases, in order to destroy all obstacles (that they might encounter), all calamities, all bad dreams, to counter evil and demonic spirits". (Taishō, n° 1070, p. 149 a).

The matter is clear. We are far from evoking a "sovereign god", in the manner of Hinduism, who would be omnipotent, just as far from the meaning that some wanted to give to it: the sovereign Bodhisattva "Who faces everything", an epithet that creates confusion.

The link with the Image of the Bodhisattva is, furthermore, clearly underlined in the sūtra. A pious work that suggests an act of grace that could only come from the Buddha, testimony from the "good disciples" that they should take refuge (yi 依) within the breast of Guanyin teaching the Law. Instructions touching to the particular marks of the icon, to the attributes presented by his hands, follow: the left hand must hold the Lotus stem; the right one must form the gesture of Reassurance (abhaya-mudrā, wuwei yin 無畏印). But, such instructions concern above all these heads or faces, images of mantras in the number of eleven. The explanation which is the same in the three texts concerning the "features" of these faces is an exceptional revelation of the intelligence of the form figured in the painting: "Eleven heads will be made: the three facing will have an expression marked with the Bodhisattva's compassion; on the left-hand side, three faces with irritated features (chen 瞋); on the right-hand side, three faces in the Bodhisattva's aspect, but with fangs coming out of their mouths; behind, a face bursting with an evil, bad laughter (baoe daxiao xiang 暴惡大笑相); above, finally, a Buddha head" (Taishō, n° 1070, p. 150c-151a; n°1071, p. 154a).

What can be said about these malicious faces in the Being of Compassion? Precisely these mantras that counter the obstacles created by malicious spirits, that destroy pain and bad dreams. This ambiguity of esoteric characters is revealed more surely by images than by texts: benevolence ornamented with the aspect of the malicious vehemence it destroys. The great power (daweili 大威力) of magical charms that guarantee security pushes away attacks, destroys poisons: finally, it protects the interpreters of Law.

VI. Avalokiteśvara "with a Thousand Hands and a Thousand Eyes", Qianshouqianyan Guanyin 千手千眼觀音菩薩

Another magical apparition of the Same, the Bodhisattva Avalokiteśvara, in his works of great compassion, here under the form said to be "with a Thousand Hands and a Thousand Eyes", Sashasra-bhuja-sahasra-netra (qianshouqianyan 千手千眼) explains the ubiquity of the Saviour's powers (C. Pelliot MG17775, Cat. no. 71). This ubiquity, according to the gloss of the texts that are dedicated to it (Taishō, n° 1060, p. 108a; n°1064, p. 115b), must be understood under the double meaning, respectively of these eyes "that see and give light [everywhere]" (zhaojian 照見) – according to the idea that the eye sees because it is luminous and gives light – and of these hands that hold and protect (huchi 護持) the Buddhist Law (fa 法): the universal feature of the Bodhisattva's look and compassion, the Bodhisattva who saves the beings (see the sūtra of Guanyin). Here we have the ultimate form of sovereign, colourful, Tantric esotericism, tending if it were still possible towards a greater efficiency than previous works: "helpful to pain, Jiuku 救苦…(C. Pelliot EO.1137,

Cat. no. 72)", to the infallible Lasso, Bukongjuansuo 不空羂索"(C. Pelliot MG.23076, Cat. no.69), "with the Eleven Faces, Shiyimian 十一面)", or simultaneously with the last two.

This is a dizzying vision that the illustrator can render only partially and at the price of an image that is confusing to the viewer: one thousand fixed eyes in as many open palms, forming the seal of the Gift of Wish (*varada-mudrā*), of Reassurance (*abhaya*) and of Preaching (*vitarka*). In addition to the orb of emptied hands that composes an almond-shaped crown for the Revered, the pale disk of the moon serves as background – another symbol of Compassion, because of its soft light that is spreads equally for all beings. Specific attributes, each worthy of the salvation work of the Great Enlightenment-Being, come into the "main" hands, about forty privileged arms: the arc of victory, the medicinal bowl of cure, the sword of the the demons' submission; the blue (qinglianhua 青蓮花·), crimson (zilianhua 紫蓮花·), red Lotuses (honglianhua 紅蓮花·), emblems of granting of wishes (respectively, to be born again in the Pure Lands of the ten directions of space, to look upon the Buddhas, to be reborn in celestial palaces…); other symbols of protection, of appeasement, of infinite knowledge, such as they are described and illustrated in the Tantric ritual dedicated to this form of the Bodhisattva, the "Dhāraṇī of Great Compassion of the Guanshiyin Bodhisattva with the Thousand Hands and Thousand Eyes" (Taishō, n° 1064, p. 117-119), translated by Amoghavajra (Bukong 不空) (705-774), under the Tang. The hands are raised high: to the right, the pavilion of metamorphosis (huagongdian 化宮殿), that evokes the palace architecture of the Buddha Fields, here, obviously, the western Pure Land of the Amitābha Buddha; to the left, a transformation Buddha huafo 化佛, who symbolizes the "reassurance to be born again in a world where the Blessed One manifests itself" ; presented even higher are the two luminaries, the Sun and the Moon, so that light may spread – according to the many texts – the first against ignorance, the second against poisons and evil spells.

This great machine, as it were, is, obviously, a redundant representation that certainly appeared later than the previous ones. The preface to the first Chinese reviewing of the dhāraṇī sūtra, translated by Zhitong 智通 (active 627-653), (Taishō, n°1057, p. 83b-c), specifies that the image of the Revered one and this Guanyin ritual were only known in China at the beginning of the Tang, and only once the Emperor Taizong gave his agreement. A previous attempt, under the reign of his predecessor, had failed.

A chronology of Guanyin's forms could be imagined in the following manner. This would follow the Same with the Eleven Faces – later in the eleventh and the twelfth centuries, a form where two images are intertwined will be observed: the Bodhisattva, with his Thousand Hands and Eleven Heads – would testify to an even bigger harnessing of the salvation figure towards Tantric esotericism, all the while refusing, in the images, to totally abandon earlier iconography, as it will be seen in the two great maṇḍala. An ambiguity of the Great Revered, double character of esoteric maieutics, draws up-front a terrible aspect of tamer of a demon-god, evoked in the mentioned ritual (Taishō, n°1057, p. 83b), and its essence of the "Great Benevolent". And in parallel to Ekādaśa-mukha (see, his heads with angry features, n° 268) is underlined the engagement that the Bodhisattva takes to pronounce secret formulas of the Buddha: here the divulgation of the dhāraṇī of Great Compassion (Dabeituoluoni 大悲陀羅尼) is the event by which all the magic of these sūtra and of these images begins. Guanyin "with the Thousand Hands and Thousand Eyes" promises – such is the great wish he has formed – to lift the bad conditions (fifteen are listed), sources of bad rebirths, and to transmute them in as many good rebirths. The faithful just need to pronounce in pure faith the revealed dhāraṇī: "To those who carry it (within themselves) and recite it" (shouchi 受持), it enables to overcome (yue 越) an infinite number of reincarnations… It is because they possess the dhāraṇī (of Great Compassion) that the place of their rebirth is in front of the Buddha" (Taishō, n° 1060, p. 106 c).

We will measure the distance, perhaps historic, of this imitator of Guanyin that reveals magic formulas – and "in his own

person," the principal object of devotion, in his quality as great magician of the preaching of law – with the previous form "With Eleven faces", and this, only in compensation with the Ten Wishes (Shiyuan 十願) formed by Ekādaśa-mukha for the salvation of beings, of which the ritual retains all the savour of the first revelations, of the first formulas and their powers. Just examining the expressions of the faces is sufficient proof. Even though the texts concerning the last one seem to be, essentially, a simple repetition of the themes of the first, the language, however, has lost some of its strength. It is tortuous, it blunts the counterpoints that were previously so striking, and it is the same with the Bodhisattva icon. Its description is faithful to the "sandalwood statue" that has to be sculpted, erected and revered according to a precise ritual; a statue that is suggested at the conclusion of these texts, upon Buddha's recommendation.

But we judge too much in aesthetics terms if we keep in mind Emperor Gaozu's 高祖 reticence (618-626) to accept the new form. The image and the pertaining rituals found an echo in Chinese Buddhism, in Central Asia alone, before they found other favourable lands in Korea and Japan later on.
*

VII. The Sūtra of Flower Ornament (Avataṃsaka-sūtra, Huayan jing 華嚴經) and the Chapter of the Ten Stages [of the Bodhisattva's Career] (Daśabhūmika, Shidi [pin] 十地 [品])

The monument of Buddhist literature that is the Sūtra of Flower Ornament, also known as "Sūtra of the Garland or Buddhas", comes to us with particular insistence through the testimonies of Eastern Central Asia and, particularly – should we say, exclusively in the matching of texts and images – in the paintings of Dunhuang. The works that were inspired by this sÈtra are above all recognizable, in this place, by magnificent compositions painted on the walls or the ceilings of certain caves. No less than twenty-nine (admittedly out of a total of over four hundred) are decorated with these images.

The particularity of these vast compositions is to illustrate a great number of the Buddha's Assemblies of Preaching, all comparable and laid-out in such a way that the pictorial surface is entirely covered, giving an impression closely resembling that of a tapestry. The dominant effect is reiteration it seems of a same scene, as if their own images were reflected upon themselves. A rigorous disposition following a grid pattern suggests an influent order starting from the center. All this would evoke a maṇḍala from Tantric Buddhism, if did not appear to be a more philosophical and mystical project than a magical and esoteric one, to illustrate the said "Nine Assemblies in Seven Places" (Qichujiuhui bianxiang 七處九會變相圖). That is, in the plenary image of the collection of texts. (Fig. 1)

VIII. The Works of the Pelliot Collection

Only two masterly works from the Pelliot Collection (discovered in this collection and identified about ten years ago), testify to this day of the unique, mobile paintings, made on silk, illustrating the vast iconographic program of the sūtra. We must specify, however, the extreme rarity of one of them, and the exceptional character, among all the paintings known in the world, of the other. The first is similar to the cave paintings, figuring the said "Nine Assemblies in Seven Places" (Pelliot Collection MG 26462), Fig. 1; the second is absolutely unique to this day, giving the developed image of the sūtra of the Ten stages (Daśabhūmika-sūtra, Shidi jing 十地經), incorporated in a sub-form of a chapter of the Huayan jing 華嚴經, chapter 26 entitled "Section of the Ten stages", Shidi pin 十地品 (Pelliot Collection MG. 26465), Fig. 2.

The rarity, even the non-existence to this day of these images outside the sanctuary of Gansu Province bordering Central

Asia, only refers to an "archaeological" and very imperfect state of what might be expected to be the great influence of the texts and their doctrine in China. The sūtra, indeed, has only been kept in the Chinese Canon – which is not unique in itself, since such a disappearance from the sources in Indian languages is the case of many other texts. Another hypothesis, suggested in light of the history of reviewing of the parts composed in "chapters", obtained in Khotan by the Chinese Court emissaries, would be that the collection of texts was composed as such in its Chinese version. We will remember, indeed, that it contains two chapters (pin) borrowed from independent sūtra: the Daśabhūmika (Shidi jing 十地經) and the Gaṇḍavyūha (Rufajie 入法界), only part of the collection known in Sanskrit. The doctrinal importance of these latter texts inclines us to see in them the vivid sources of the entire work.

IX. The Sūtra of the Flower Ornament and the Painting of the "Nine Assemblies of the Seven Places" (Qichu jiuhui bianxiang 七處九會變像)

Two historic translations of the Avataṃska-sūtra are maintained in the Sino-Japanese Canon. The first, said to be of the "Eastern Jin" or in "60 scrolls" (Taishō, n° 278) is by Buddhabhadra (Fotuobatuoluo 佛陀跋陀羅, 418-420) – illustrated by the scroll manuscript on silk dyed in yellow also found in the sealed cave of Dunhuang (Bibliothèque nationale de France: Chinese Pelliot 2144). The second is by Śikṣānanda (Shichanantuo 實叉難陀 ; 695-704), said to be the " translation of the Zhou dynasty 周朝 (Empress Wu Zetian's reign 武則天, 684-705), a long reviewing also called "new translation" or in "80 scrolls" (Taishō, n° 279). The latter concerns the great pictorial compositions discussed here. We will put aside a said "third translation" attributed to the monk Banrou 般若, (756-758), with the title of sūtra (Taishō, n° 293). This ultimate version causes some confusion because it only concerns, in fact, the concluding chapter of the former two collections of texts: the said Gaṇḍavyūha, given in a considerably spread out narrative. This translation, distinctively from the other two, would have been established according to a text offered to the Court of China by the sovereign of Odra, in Western India.

These two translations, in "60 or 80 chapters" bring to light, not so much a perfecting of the language towards a more accurate terminology, (apparent from the outset), but of a real genesis of the text itself. The notable differences in the number of chapters might be due to the search of the roots of each translation of the original versions from Sanskrit language. Three centuries apart, both of them are founded upon texts obtained in Khotan, in Central Asia. These works attest to the important role credited to this kingdom in the influence of the Flower Ornament sect 華嚴宗, and consequently, in the cult given to the Supreme Buddha, Vairocana (Piluzhenei fo 毗盧遮那佛). From the Central Asian kingdom come, among other monumental testimonies revealed *in-situ* (and disappeared), a wooden panel painted in the effigy of the Cosmic Buddha, circa the sixth century, and originating from the Domoko region (Aurel Stein Mission, British Museum, Oriental Art MAS. 459 [F. ll.iii. 2]), and a fragment of a wall-painting, discovered in Balawaste by the same scientist (New Delhi, Museum of Central Asian Antiquities, Hard. D). The main difference, however, between these reviews concerns the number of "Assemblies" (hui 會) of Buddha preaching, which number eight in the "ancient tradition" and nine in the "new." But this would be incomplete without the mention of the "Places" (chu 處) real and spiritual where these assemblies took place. And the latter, which number Seven, remain the same from one review to the other. This distinction (more than formal with regards to the Sūtra doctrine) has ordered the composition of iconic representations. Thus, they are mentioned according to the number of their "assemblies" in brief historic relation often too concise to enable one to visualize these works. Singularly, the images of the Sūtra of the Flower Ornament that are known in Dunhuang are illustrations of the "Nine Assemblies in the Seven Places", thus inspired from the reviewing in "eighty chapters" or the "new translation."

Like many other major sūtras, the Avataṃsaka, once translated into Chinese, quickly aroused zealots that extoled the

study and the central veneration of the text and instituted the "sect" of Huayan, adding to the complex landscape of doctrinal schools, so characteristic of Chinese Buddhism. The history, however, of the sect (and thus of the influence of the Avataṃsaka-sūtra) distinguishes itself from other such sects – particularly of the Tiantai sect, with which it shared roots – by the fact that its doctrine, essentially contemplative and "philosophical", served for a brief historical moment of its history for the purposes of Imperial ideology. We must not be surprised by such diversions which spared no current, no school of Buddhism in China. Imperial benevolence has always been for this imported religion one of the conditions of its sustainability since it was from the outset exposed to contending forces. The subject, here, is not this story, but the particular perspective that the imperial sponsorship under the reign of Empress Wu played in the fixation of the image of the "Flower Ornament". Because this image, it must be emphasized, has no precedent. As to the mural compositions that came a bit later on, their number increases, as do the representations that are related to the present painting on silk in contemporary caves of the end of the Tang (second half of the ninth century) and of the Five Dynasties (tenth century). Finally, several sanctuaries of the Song (tenth, eleventh centuries) testify to the later fortunes of the subject, and equal even the most magnificent known compositions.

From then on, everything that is related to the history of the reviewing said to be the "long" or "new translation of the Zhou Dynasty 周朝" of the sūtra is interesting in the understanding that we must have of pictorial formalism and its elaboration. The enterprise – by meaning the quest of the original Sanskrit coming from Khotan, and the new translation of the sūtra under the direction of the monk Śikṣānanda of same origin, invited to stay in a monastery in Luoyang for this task in 695 – seems to have been dominated by the figure of Empress Wu, who would have sponsored it at the instigation of the third patriarch of the School, Fazang 法藏 (honorific name, Xianshou[8] 賢首). We will thus attach the importance it deserves to the fact of imperial sponsorship, consecrated by the preface to the new translation written by Empress Wu herself (Taishō, n° 279, p. 1 a-b); and, in the same manner, to the special support which the Huayan sect benefited from during her reign. This introduces another important factor of the School's history during the Tang dynasty.

The new School, not only by the philosophy that it advocated – which, within the scope of the current of Mahayanist thought, as professed in the texts of Prajñāpāramitā (Perfection of Sapience) and its developments – but also by the opportunity that it offered in its system of universal representation converging towards the tropism of a center: the cosmic Buddha Vairocana had in him what was needed to convince and seduce a sovereign who also saw herself as pre-destined, rather than a brutal usurper. This purpose of her religious fervour was to demonstrate the legitimacy of her power. This is in any case the general opinion. The uncompromising "black legend" that surrounds the person of the sovereign, recorded in the official historiography of the restored Tang Dynasty, is incessantly taken up again by all the dynastic Histories. Graver still is that this opinion would tend to serve to the ideological designs of a sovereign – who believed herself to be, and wanted to make her people believe, that she was in this Buddhist perspective of the "Universal Sovereign (s. Cakravartin) with the Golden Wheel" (ch. Jinlun shengwang 金輪聖王) and an incarnation of Bodhisattva Maitreya (Mile pusa) – the greatest, the most vast visionary theory that Mahāyāna Buddhism contains: this "World of Flower Ornament of the Buddha Vairocana", Piluzhenei Fo Huayan shijie 毗盧遮那佛 華嚴世界. And, by way of consequence, to accuse in the same manner the sect that dedicated itself to her praise. Yet, if the latter, in the person of the third patriarch benefited from several substantial privileges under the reign of Empress Wu, even greater favours were given by her son, Zhongzong to the prestige and influence of the sect. But what led to the comparable imperial favour under the reign of Emperor Dezong (779-805), that enabled Indian monk Prajñā to undertake the translation of the Gaṇḍavyūha?

Once again, the intention here is not the story of this School of thought, but the light it can cast on the Dunhuang

painting and its date. This digression enables us to specify a few important points: the initial and later preponderant role of imperial patronage (as much in the successive translations of the sūtra, as in the constitution of a new sect, that distinguished and affirmed itself under the guidance of the third patriarch, the monk Fazang 法藏), even though this original imprint has revealed itself influencial upon the destiny of the sect. The audience of the Huayan Zong, however, was not exclusively confined to Court circle. Rapidly, it spread to the civilian and military elites, as a strong influence of the Chan 禪宗 appeared to inspire, by its less abstract and theoretical, religious practices. This turn, marking a more direct and intuitive approach, characteristic of the latter, began under the patriarchy of Chengguan 澄觀, Fazang's successor. It became even more apparent under the fifth patriarch of the school, Zongmi 宗密 (780-841), to the point that he was also mentioned as one of the great historic patriarchs of the Chan.

Finally, stamped in a way by this profile of an "elitist" sect, heavily institutionalized, and above all dependent for its transmission of a very important scriptural heritage, the existence of the School was profoundly affected by the declining years of the Tang Dynasty, to the point that its tradition completely disappeared. The measures against Buddhism (845) ordered by Emperor Wuzong (840-846), brought a fatal blow that culminated in a large auto-da-fé, followed by the loss of priceless works of scholarship hidden inside monasteries, in the tormented years of insurrection of Huang Chao (876-884). The School of Huayan is not the only one to have known such a fate. This also happened to the Tiantai (天臺宗) and Faxiang Schools (法相宗), similarly prestigious in their approaches to the Doctrine of the Great Vehicle that made Tang Buddhism the glory for all the communities in High Asia.

X. Iconographical Argument and Programme

This literary monument inspired by the Path of Buddhist Deliverance – the largest visionary theory produced by the Mahāyāna – is, in many ways, like the Lotus Sūtra, with which it shares many doctrinal points, a "preaching of the crowning" delivered by the Buddha; in other words the pure quintessence of Law, as it is expressed by the formula of the title of this unveiling of the "World of Flower Ornament of the absolute Buddha Vairocana" Piluzhenei Fo Huazang shije 毗盧遮那佛華藏世界. How can one such pinnacle of Buddhist art not overshadow the other, but find its distinct place in history? It is this tendentious historic outline of the Buddha's preaching that the zealots of the Lotus Sūtra, belonging to the Tiantai School, have drawn. Reserving for their Sūtra the summit of the "End" of the mission on earth of the Blessed One, they credit the Flower Ornament predication of that of the "Beginning" – even though it seems that the latter may have been of later writing. This is a question of mystical and doctrinal truth. What is important here is this relationship, this kinship. It would explain why in numerous painted compositions in caves, the illustrations of both Sūtra dialogue with one another from one wall to the next. We will cite for the compositions on the ceiling panels, caves 9 (Pelliot 107) and 55 (Pelliot 118 F), and for those that ornament the walls, caves 6 (Pelliot 168) and 61 (Pelliot 117), given in the periods of the Five Dynasties – beginning of the Song (tenth century).

The Flower Ornament scripture reveals the gesture of the Buddha soon after his Enlightenment not far from the village of Uruvilvā, during this period of many weeks that separates the beatitude of the Deliverance obtained in Bodh-gayā, from the first Sermon delivered to his first disciples in Banaras (Kāśi); a period on which the ancient texts are usually silent. A collection of epic, mystical events have been inserted in its place, where the literature of the Small Vehicle (xiaocheng 小乘) suggested a hesitation that seized the Blessed One on the eve of undertaking his mission for the liberation of all sentient beings. In place of a psychological profile where the human stature of the historic Buddha outlined itself, our Sūtra substitutes the timelessness of beatitude, but without any distance from the duty of a Perfectly Enlightened. It is the mystical side of a legend where the figure of the so-called cosmic Buddha, the "Great Illuminator" Vairocana, displays itself, in a principled manifestation, much more than substantial and divine. It is thus that the

Tathāgata, without leaving his meditation under the Enlightenment-Tree, magically manifests himself within his great preaching assembly in Seven Places, three times that of the Enlightenment, the bodhimaṇḍa in Bodh-gayā.

The cave paintings dedicated to the Flower Ornament Sūtra, like the unique existing copy of a liturgical painting, are all devoted to describe this magic of simultaneous apparitions of Tathāgata preaching the Dharma in all the superior places of the World of desire (Kāma-dhātu, Yujie 欲界): first in the terrestrial place of Enlightenment, then in the verticality of heavens rising above the summit of the cosmic mountain, Mount Sumeru (Xumi shan 須彌山), to reach the superior heavenly strata of this World. But the genius of this invention, its exegetic and moral impact, if we place ourselves from a philosophical point of view, is the conclusion of this ascending movement, or more exactly its resolution in the fact that this last audience takes place in the very historic place of the foremost Preaching made for humanity, the first Sermon of Deliverance pronounced in the Jetavana Woods. The lesson is obvious in this orb described in celestial amplitude: in the same way that in the evocation of the Benares preaching, the Sūtra resumes, beyond, with canonical orthodoxy and classical hagiography.

(Translation by Jennie Dorny and Susan H. Perry)

1. By the term "votive paintings" one must understand the pious works; that is, in a literal meaning, *meritorious offerings* ordered by nominal donors. These works, in consequence, were made up for occasional religious ceremonies/uses (as it is attested by the inscriptions), concerning both the clear utterance of the vows and their awaited realization alike — in funerary and commemorative ceremonial purpose. It is likely that the paintings found in the Grotto 17 (Pelliot) were, for a large number, of this nature; and, being excluded of any destruction without proper rituals, one had kept them in the hidden store-grotto. In the distinction of the former, the term "liturgical paintings" must be understood for compositions and images which appear as *illustrations (bianxiang)* of great doctrinal texts: for instance The Lotus Sûtra, "Amitâbha" Sûtra, The Flower Ornament Sûtra…, and whose the very purpose was of perennial liturgical uses. The same compositions often illustrate the walls of Mogao grottoes, as well as many other rupestral sanctuaries along the Gansu province and in Northern China — for the survived testimonies of these periods.
2. Pelliot Collection MG. 26462. In Les Arts de l'Asie Centrale ; la collection Pelliot du Musée Guimet, (Giès, Jacques, dir.), vol. I, Tokyo, Paris, Londres, 1994-1996, pl. I, pp. 51-62.
3. Pelliot Collection MG. 26465. Ibid. pl. II, pp. 63-72.
4. Japanese Edition of the Buddhist Canon: the Taishō shinshū Daizōkyō 大正新修大藏經 "Buddhist Canon newly compiled during the Taishō era (1912-1925)"; here mentioned as Taishō. Published in Tokyo from 1924 to 1935, under the direction of Takakusu Junjirō 高楠, Watanabe Kaigyoku 渡邊海旭 and Ono Gemmyō 小野玄妙.
5. Bibliothèque nationale de France: Chinese Pelliot 3932; Guimet Museum: Pelliot Collection MG. 17665.
6. Les Arts de l'Asie centrale. La collection Pelliot du Musée Guimet, vol. 1, pl. 92.
7. Ibid. vol. 1, pl. 91.
8. The imperial favor of which Fazang was honoured remained unchallenged, even after Empress Wu Zetian's deposing in 705; he was thus kept in his high functions close to the Throne, and even raised to higher honorific titles by the following two sovereigns: Zhong Zhong (705-710), for whom this was a return to power, and his successor Emperor Rui Zhong (710-712).

1. The "Nine Assemblies of the Seven Places" of the Flower Ornament Sūtra (s. *Avataṃsaka-sūtra*, ch. *Huayan jing*)
 Five Dynasties (Early Xth century)
 Ink and colours on silk, 194×179 cm
 Pelliot Collection, Musée Guimet MG. 26462
2. "The Ten Stages [of the Bodhisattva's Career]" (s. *Daśabhūmi*, ch. *Shidi [ping]*), chapter of the Flower Ornament Sūtra
 Five Dynasties (Early Xth century)
 Ink and colors on silk, 286×189 cm
 Pelliot Collection, Musée Guimet MG. 26465

La Collection Pelliot de Peintures Liturgiques et Votives[1] :
Quelques Grandes "Images" des Vénérés et L'art du Sanctuaire de Dunhuang

Jacques Giès
Musée national des Arts asiatiques-Guimet

Ouvertes sont encore les lignes de la recherche susceptible d'apporter une pierre à la connaissance des peintures bouddhiques, œuvres pies révélées au début du XXe siècle dans les grottes Mogao à Dunhuang. Aussi proposons-nous ici, tels qu'ils se font jour dans l'étude la Collection Pelliot, quelques sujets iconographiques majeurs envisagés ici à la lumière des textes. Ces sources que sont, au premier chef, les sūtra : recueils des paroles d'enseignement du Buddha, où sont contées, sous forme d'apologues, tant d'histoires qui inspirèrent les iconographes et, à leur suite, les peintres. De même en est-il que bien d'autres textes : tels que les rituels donnant des prescriptions précises pour la réalisation des Images pies (statues et peintures). Quelques grandes "images" (bianxiang 變相) de Vénérés, dont la présence est fort insistante parmi les œuvres de la collection Pelliot, sont ici retenues. Représentatives des grandes liturgies auxquelles elles participaient, on a veillé à remonter, autant qu'il est possible dans les limites de cet article, aux sources pertinentes les plus lointaines pour mieux en saisir la portée religieuse.

L'une des plus importantes découvertes venue au fil de l'étude de la Collection Pelliot est que certaines de ces œuvres, loin d'être des "images" isolées, doivent être appareillées entre elles, de telle sorte qu'elles composaient d'importants "monuments iconiques" — à l'exemple, mais distinctement quant aux fins rituelles, des compositions murales des grottes, commandées chacune par un vaste programme iconographique. La preuve la plus éloquente révélée dans la Collection est offerte par deux grandes compositions (les plus importantes peintures, par leurs dimensions, jamais trouvées dans la "grotte scellée") renvoyant à la fortune, à certaine époque, de l'école de l'Ornementation fleurie (Huayan zong 華嚴宗), fondée sur le Sūtra de même nom. La première de ces œuvres, dite des "Neuf Assemblées des Sept Lieux" (Qichu jiuhui bianxiang 七處九會變相)[2], illustre dans l'intégralité des 39 chapitres la plénitude du recueil ; la seconde consacrée à la manifestation (du Sūtra) des Dix Terres, (Daśabhūmika-sūtra, Shidi jing 十地經)[3], est clairement l'illustration développée d'un chapitre (pin 品) du précédent.

Cette relation intime de deux iconographies dont l'importance reflète la pédagogie de la Doctrine de l'école du Huayan, est la première preuve tangible apportée à la thèse de ces vastes monuments conçus à partir des peintures liturgiques trouvées dans la cachette. L'exemple méritait que l'on s'étende un peu ici, car il invite, en conclusion à considérer, sous ce jour, bien d'autres œuvres, aujourd'hui étudiées pour elles-mêmes. Certes, telle démarche suppose que l'historien d'Art s'aventure dans les subtilités de la Doctrine bouddhique et ses fondements philosophiques.

I. Le Bodhisattva Mañjuśrī (*Wenshu* 文殊菩薩) sur le Lion

L'Être d'Éveil (pusa 菩薩) — illustré entre autres peintures par la bannière C. Pelliot EO. 1399 [P. 129] — nommé Mañjuśrī "douce majesté" (translitéré en chinois Wenshushili 文殊師利) ou Mañju (Wenshu 文殊), occupe une place particulière et prééminente parmi les nombreux bodhisattva(s) vénérés du Grand Véhicule ; c'est au point qu'il fait figure de chef de ces derniers. Son culte, autant qu'on puisse en juger par les icônes, ne semble s'être dessiné que relativement tard, vers le VIIe siècle. Du moins est-ce la connaissance que nous avons à la lumière de l'archéologie, où la Sérinde, à nouveau, atteste le premier panthéon au sein duquel il occupe cette place ; soit, comme l'assistant du Buddha, dans la triade du Bienheureux śākyamuni, auquel répond, lui faisant face, cet autre grand bodhisattva, Samantabhadra (Puxian pusa 普賢菩薩). Car telles, le plus souvent et comme il est advenu en Chine même, ces deux grandes figures sont comme couplées, dans ces icônes qui appellent la symétrie des acolytes du Buddha.

La position supérieure inscrite dans son nom "majesté", s'explicite plus avant dans les épithètes qui lui sont données, et particulièrement dans celle de Mañjughoṣa (Miaoyin Wenshu pusa 妙音文殊菩薩) "à la voix douce", "merveilleuse", allusion à son rôle de prédicateur ; d'autres encore, souvent mentionnées dans les textes, ont valeur de surnom, et leur sens s'éclairent consécutivement aux premières épithètes, ainsi de Kumārabhūta "Jeune homme" (tongzi 童子) ou

"Prince royal de la Loi" (Fawangzi 法王子). On retiendra de la leçon de ces titres le "Prédicateur", qui, sous ce jour, s'apparente au Buddha lui-même. À ce titre, Mañjuśrī est celui qui a don de convertir par son enseignement des millions de créatures à la fois. Son œuvre, dans ce domaine, est particulièrement exemplifiée auprès des créatures fabuleuses que sont les serpents nāga aux pouvoirs surnaturels, divinités des profondeurs abyssales de l'océan, gardiens, dans leur palais, des sūtras bouddhiques.

Ce thème éloquent, qui préfigure sa geste à l'endroit des êtres, est celui que développe le chapitre 12 du Sūtra du Lotus de la Bonne Loi (Taishō [3], 大正藏, n° 262, p. 35b-c.), où le Bodhisattva sort de l'Océan ; il est repris avec grande similitude dans le dernier chapitre qui forme le Gaṇḍavyūha (Rufajie pin 入法界品), du Sūtra de l'Ornementation fleurie (Avataṃsaka-sūtra, Huayan jing 華嚴經), où la prédication de Mañjuśrī, faite à l'adresse des habitants de la ville de Dhanyākara (Fucheng 福城), suscite des millions de nāga à sortir des eaux pour l'écouter (Taishō, n° 279, p. 331c-332a). S'il est question de l'enseignement, dans le premier cas, du Sūtra du Lotus lui-même, dans le second, d'un sūtra appelé "Universel illumination du Monde de la Loi" (Puzhaofajie 普照法界) dont le nom est ailleurs inconnu, la doctrine qu'expose le bodhisattva est celle de l'Unique Véhicule (yicheng 一乘), le "Véhicule des Buddha" qui a pouvoir de guider largement les êtres et de leur permettre "d'obtenir, aujourd'hui, rapidement l'Éveil (bodhi)" (Taishō, n° 262, p. 35 b).

Le bodhisattva "à la voix merveilleuse" (Miaoyan pusa 妙言菩薩) mérite le titre de "prince royal" (wangzi 王子) en qualité de dépositaire de la "Perfection de sagesse" (prajñāpāramitā, panruo poluomiduo 般若波羅蜜多), connaissance sacrée des Buddha, omnisciente, dite aussi "Mère des Buddha" (Mahe Fomu 摩訶佛母) ; avec laquelle Mañjuśrī se voit confondu, par un effet d'identité. Sous ce terme il faut entendre une connaissance supérieure qui initie au monde tel que l'Éveil le dévoile, selon la leçon de la doctrine de la vacuité (śūnyatā, shunruoduo 舜若多 : kongxing 空性) du Grand Véhicule ; c'est-à-dire, dans un dépassement des dualités (advaya, bu ercheng 不二成), libérant l'omniscience (yiqiezhi 一切智) — ce monde-ci étant vide de caractéristiques propres (ānimitta, wuxiang 無相，無想), n'offrant aucune prise en considération, pas plus des êtres que des choses (absence de production et de destruction des phénomènes), et dont la nature réelle n'est qu'un procès de vacuité. Science ou sapience, privée de la réflexion, en quelque manière que ce soit, d'objet de connaissance, telle est envisagée la prajñāpāramitā, qui, on en conviendra, ne peut être que du ressort des êtres parfaitement, totalement éveillés. "Prendre refuge" dans cette doctrine des Buddha, c'est être, comme la fille du roi serpent Sāgara (Sāgara-nāgarāja, Suojieluo longwang 裟竭羅龍王) du Sūtra du Lotus — convertie par Mañjuśrī —, incapable désormais de régression (avaivartika, butui 不退) et assurée d'obtenir rapidement l'état de bodhi, pudi 菩提). Il semble, par conséquent, que ce soit à la lumière de cette doctrine mahâyânique, développement du Mādhyamika (Zhongguan pai 中觀派), indien à l'origine, que le bodhisattva acquit cette stature éminente, sinon même prit "forme". Ainsi qu'il se dessine dans le Sūtra de l'enseignement de Vimalakīrti (Vimalakīrtinirdeśa-sūtra, Weima jing 維摩經), l'une des expressions les mieux connues dans le bouddhisme extrême-oriental de la "philosophie" de la vacuité. Singulièrement, si les illustrations de la célèbre scène de ce Sūtra, où Mañjuśrī a pour interlocuteur, dans cette "pure conversation", le saint laïc Vimalakīrti (Weimo 維摩詰) "Gloire pure" (MA. 6277, Cat. n° 81), remontent à Dunhuang aux peintures des grottes du VIe siècle, ce n'est que plus tard et, semble-t-il, sous les Tang (VIIe - VIIIe siècle) qu'est attestée la triade du Buddha avec ses deux grands acolytes. En Chine même la fortune du Vimalakīrti-nirdeśa et de sa représentation remonterait à une époque plus haute encore, ainsi qu'elle est mentionnée, au nombre des œuvres du grand peintre Gu Kaizhi 顧愷之 (345-407), sous la dynastie des Jin Orientaux 東晉朝.

Les manifestations du Bodhisattva se distinguent par la présence du lion (siṃha, shizi 獅子) qu'il a pour monture : animal emblématique de la royauté, s'entendant ici de celle qui a trait à l'autorité de son enseignement, la prédication de la Loi — et dans une analogie évidente avec l'éloquence du Buddha, qui, comme le rugissement du lion, porte loin. Tel

apparaît Mañjuśrī sur sa monture dans la bannière (C. Pelliot EO. 1399 [P. 120]), que nous donnons stylistiquement à la fin du VIIIe s. Les mains vides d'attributs, forment ensemble le sceau de la Prédication (vitarka-mudrā, shuofa yin 說法印), en rapport avec sa vocation. Il est à noter que la plupart des peintures de Dunhuang qui le représentent ainsi, suivent une très voisine iconographie (par exemple, dans la collection Stein de Londres, la double composition en forme de lunette, Stein Painting 34), soit, jamais avec les signes et attributs qui semblent être apparus plus tard dans le bouddhisme sino-japonais. À savoir, coiffé de la tiare à cinq pointes (ou la coiffure à cinq mèches de cheveux), tenant, dans la main droite, le glaive qui tranche l'ignorance, et, dans l'autre, le livre recelant la Prajñāpāramitā ("Science sacrée des Buddha"). L'autre apparition iconique sérindienne du Bodhisattva est celle qu'en donne l'illustration du Sūtra de Vimalakīrti (Weimaji jing 維摩結經), ainsi qu'il a été noté, et dans laquelle Mañjuśrī a pris place, comme son interlocuteur, le saint laïc, sous un baldaquin, présentant pour tout attribut le "bâton de conversation" de l'éloquence directe.

Une rare peinture liturgique, enfin, provenant également de Dunhuang (C. Pelliot, EO. 3588), le représente associé au félin sur fond de montagne, tel qu'il a été vénéré en Chine, en son lieu d'élection de ses manifestations, au Wutaishan 五臺山, (la Montagne aux Cinq terrases) ; lieu bien réel de la Chine du Nord, dans la province du Shanxi, vers lequel convergèrent pendant des siècles des foules de pèlerins. Une constance du culte de Mañjuśrī, est qu'il fut toujours localisé dans les pays de son rayonnement (en Sérinde, au Tibet et en Chine) sur une chaîne de montagne comparable au mont mythique Gandhamādana (Xiangshan 香山) situé dans l'Himâlaya, dont on dit qu'il est couronné par cinq pics. Le trait remarquable de la translation du bouddhisme vers l'Extrême-Orient, fut l'élection d'un lieu en terre chinoise — nouvelle terre sainte du bouddhisme — de sa manifestation, réplique de plus anciennes croyances sérindiennes, et notamment d'une légende khotanaise, où se mêle à la prophétie "mi-millénariste", annonçant 450 ans après le Nirvāṇa du Buddha les succès remportés par le Grand Véhicule, l'élection d'un omphalos bouddhique, le mont Gośṛṅga (Niujia shan 牛角山) "la Montagne de la Corne de bœuf". Le grand moine chinois Xuanzang la mentionne avec une révérence religieuse comme se dressant au Sud-Ouest de Khotan (Yutian 于闐).

II. Le Buddha Bhaiṣajyaguru 藥師如來

Les témoignages touchant au culte du Buddha Bhaiṣajyaguru, "Maître des remèdes" (Yaoshi rulai 藥師如來), (bannière votive, C. Pelliot EO. 1178), présentent cette singularité de n'apparaître que via la transmission initiale en Chine du Sūtra consacré à ce Tathāgata 如來, soit, au début du IVe siècle seulement. Tel est, encore aujourd'hui l'état de la question qui s'attache au Buddha transcendant.

Ici, comme pour certains autres aspects du Tathāgata, les sanctuaires de Dunhuang font figure d'un conservatoire d'exception en Sérinde, non seulement, pour l'unique attestation de certaines icônes qui s'y montrent, mais encore, en raison du fait, sans équivalent dans le monde bouddhique, que ces œuvres s'y trouvent mises en relation avec des documents.

Diffus et attendu en d'autres oasis — ainsi à Kucha, une tablette votive en bois (Musée de Berlin, Mission A. Grünwedel) peinte à l'effigie d'un Buddha debout tenant le bol —, le culte du Buddha de Médecine survient, en revanche, à Dunhuang avec un luxe de sources tant iconographiques que scripturaires. Des premières, ce sont près de quatre-vingt-cinq grottes qui lui consacrent une représentation et un nombre respectable de peintures liturgiques, provenant de la cachette, certaines parmi les plus imposantes et les plus belles exécutées sur soie, auxquelles il faut ajouter ces témoignages de la piété plus directe, en des rouleaux imprimés de litanies d'images, dits "aux Mille Buddha(s)", où Bhaiṣajyaguru est reconnaissable au bol reposant dans le giron (British Museum). Les secondes s'illustrent par plusieurs dizaines de copies de sūtras dits de Bhaiṣajyaguru (藥師經), particulièrement dans les trois tra-

ductions historiques, qui se sont échelonnées du IVe siècle au milieu du VIIe siècle. Cette dernière (650), due au grand moine Xuanzang 玄奘, fit autorité en Chine et en Extrême-Orient, sous le titre développé de Sūtra des Vœux fondamentaux du Tathāgata Maître des remèdes à l'Éclat de lazurite (Yaoshi liuliguang rulai benyuan gongde jing 藥師琉璃光如來本願功德經), (Taishō, n° 450).

Ces traductions apparentées les unes aux autres, tout comme la quatrième de Yijing 義淨, en 707 (Taishō, n° 451), "se suivent d'assez près" comme le souligne Pelliot et font attendre, en conséquence, un texte princeps supposé en sanscrit. Il n'a pas été retrouvé. Le seul manuscrit dans cette langue, mis au jour dans un stūpa près de Gilgit (Cachemire), ne remonterait pas avant le VIIe siècle, sur l'argument qu'il est proche de la traduction de Xuanzang. Fait d'importance, le sūtra est attesté, en outre, dans d'autres langues d'Asie centrale, mais à l'état de fragments en sogdien et en khotanais. Le Canon chinois, ici à nouveau, conserverait la mémoire des versions les plus vénérables. À tel enseigne, que jusqu'au nom sanscrit développé de ce Buddha, il fallut la providence de la "formule-charme", dhāraṇī, d'appel à ses pouvoirs, pour le restituer, et serait : Bhaiṣajyaguru-vaiḍūrya-pratha, correspondant au chinois Yaoshiliuliguang 藥師琉璃光· "Le Maître des remèdes à l'Éclat de lazurite" ; longue épithète sur fond de laquelle se dessine son icône.

III. La Terre de Pure de Lapis Lazuli, Jingliuli Shijie 淨琉璃世界, de l'Est

Outre l'icône simple du Buddha Bhaiṣajyaguru sur une bannière votive dont il vient d'être question (EO. 1178), il est cependant d'autres images liturgiques du Même, mais de tout autre ampleur et ouvrant surtout sur une dimension mystique que la précédente ne laissait pas présager. Soit, l'esquisse, à partir de lui, d'une Terre de Buddha, Buddha-kṣetra (Fotu 佛土), (EO. 1135), située à l'Orient et nommée "(Champ) de Pure Lapis lazuli" (Jingliuli shijie 淨琉璃世界), monde parfait et heureux où règne sans mélange la Loi (Dharma, fa 法) — domaine comparable à la Sukhāvatī (Jile shijie 極樂世界) de l'Ouest, Terre heureuse d'Amitābha (Mituo jingtu 彌陀淨土). Telle est la prédication que le Buddha śākyamuni délivre dans le Sūtra de Bhaiṣajyaguru. (Taishō, no. 450).

Cette similitude de la Terre de l'Est avec son pendant occidental, outre la symétrie idéale qu'elle indique, voire le modèle plus ancien de la Sukhāvatī qu'elle décline, n'est aux yeux de la mystique du Grand Véhicule en rien une singularité. Ce sont des Champs de Buddha comparables qui à nouveau se dessinent dans les quatre, les dix, une infinité de directions ; innombrables autant que sont les Buddha de l'espace, et situées à des distances incommensurables. Ceci en vertu de la croyance que les Buddha(s) de ces Terres accomplissent la même Œuvre de Salut, que la "bouddhéité" est Une, de même que la Loi.

Mais il y aurait là, par trop, une impasse logique en apparence d'après la profession de foi que l'on vient de voir concernant l'égalité des Buddha(s) et de leurs Terres, impasse que la doctrine du Grand Véhicule lève néanmoins aisément en recourant, précisément, à la notion ancienne des Buddha(s) successifs. Ainsi la Terre de Pure Lazulite est-elle la réalisation, comme l'enseigne śākyamuni à son assemblée réunie à Vaiśālī, des Douze vœux que le Buddha Bhaiṣajyaguru forma jadis, alors qu'il était bodhisattva, pour sauver les êtres de la douleur de l'existence : l'éclat pur de lapis lazuli que renvoie son corps, illuminant les mondes pour en chasser les ténèbres, accomplit les deux premiers ; des autres, l'assurance d'être ravi aux épreuves de ce monde et de renaître en sa Terre pour y demeurer dans une félicité égale. Le Buddha souhaite "que mon nom invoqué soit entendu" (wen woming 聞我名), "qu'on se le remémore avec constance" (zhuannian shouchi 專念授記 ; Taishō, n° 450, p. 405 b) ; ce qui signifie que la vertu de penser à son nom a tous les pouvoirs de guérison des maladies, de protection contre les périls, de salvation. Enfin, si l'on pense à son nom au moment de la mort un grand cortège composé de huit bodhisattva(s), parmi lesquels se comptent Mañjuśrī, Avalokiteśvara, Mahāsthāmaprāpta, ... et Maitreya, guidera le défunt vers la terre de l'Est où il renaîtra dans une fleur de

lotus.

Ce recueil et sa thématique : le Buddha irradiant de lumière et les pouvoirs salvifiques de son nom, fait si fidèlement écho aux grands textes mahâyâniques que sont le Sūtra du Lotus de la Bonne Loi (Miaofa lianhua jing 妙法蓮華經) et tout particulièrement son chapitre 25, intitulé les "Portes Universelles" (Pumen pin 普門品), d'une part, et les Sūtra sur la Terre Heureuse de l'Ouest (Sukhāvatī-vyūha 無量壽經), de l'autre, pour qu'il s'agisse ici de coïncidence. Au premier est empruntée, par exemple, la protection qui sauve de neuf fins violentes (illustrée dans la prédelle de la peinture du British Museum), au second, bien sûr, la description de la Terre Pure, dont il est dit qu'elle est toute semblable : "Il n'y a pas de tentations, pas de mauvaises voies (de renaissance), non plus que s'y font entendre de cris de douleur ; le sol y est de pur lapis lazuli, les routes sont des cordes d'or ; les murs, les portes, les palais… les draperies sont faites des sept joyaux".

Quant aux deux principaux assistants du Buddha de cette Terre, ce dernier étant représenté assis en méditation sur un lotus tenant le bol aux remèdes, en place des grands acolytes d'Amitābha, Avalokiteśvara et Mahāsthāmaprāpta, sont les bodhisattva(s) "Éclat solaire", Suryaprabha (Riguang 日光菩薩) et "Éclat lunaire", Candraprabha (Yueguang 月光菩薩). Leur nom et leur présence évoquent, tant l'un des vœux de Bhaiṣajyaguru : que son corps rayonne d'un éclat qui surpasse les deux luminaires, que la symbolique mahāyāniste des astres qui éclairent également tous les êtres.

IV. Le Sūtra d'Avalokiteśvara, *Guanyin jing* 觀音經

Un grand nombre de peintures liturgiques et d'origine votive, consacrées au culte du bodhisattva Guanyin a été livré par la grotte murée de Dunhuang, établissant ainsi la grande ferveur historique du culte adressé au Bodhisattva qui, par excellence, Incarne la Compassion bouddhique. (kāruṇā, cibei 慈悲)

Les plus anciennes illustrations issues de Dunhuang remontent au VIIIe siècle, bien que le gros des témoignages, au nombre desquels se comptent des peintures murales de grottes, date du Xe siècle. Jugeant à partir de ces œuvres une certitude, confortée par les manuscrits, est que la source textuelle des images, uniformément, se fonde sur la recension chinoise du Sūtra du Lotus (Saddharma-puṇḍarīka-sūtra, Miaofalianhua jing 妙法蓮華經) faite par le moine d'origine koutchéenne, Kumārajīva (Jiumoluoshi 鳩摩羅什, 344 - 413), deuxième traduction après celle de Dharmarakṣa (Zhoufahu 竺法護), antérieure de plus d'un siècle. La valeur propitiatoire efficace de ce texte fut tant considérée que le chapitre mérita, dans le bouddhisme chinois, des copies indépendantes sous le titre de Sūtra de Guanyin (Guanyin jing 觀音經)[4].

Au vrai, comme le renvoient ces diverses illustrations, le texte offrait aux peintres un champ relativement libre sans grand risque de tourner la littéralité du sens. Celui-ci est par trop clair. Une grande figure secourable se dresse — expose le Buddha aux Quatre assemblées réunies sur le Pic du Vautour (Gṛdhrakūta-parvata, Qidujue shan 耆闍崛山), via son interlocuteur du moment, le Bodhisattva Intelligence infinie, Akṣyamati (Wujinyi pusa 無盡意菩薩) — devant tous ceux qu'une épreuve effraie ou qu'ils en soient victimes ; que ces épreuves (elles y sont évoquées avec force détails, distinctes ou parallèles selon qu'elles sont mentionnées dans les passages en vers ou en prose) soient causes naturelles, surnaturelles ou humaines. Ces dernières, par exemple, comprenant celles que dictent les lois séculières (châtiment d'un coupable), au-dessus desquelles se place le Dharma (la Loi) bouddhique. Cette figure est celle du bodhisattva Avalokiteśvara, Guanshiyin (觀世音) "Qui tourne son regard vers les sons du mondes". Ce nom recèle tous les pouvoirs en lui invoqués.

Si le nominalisme est chose commune au bouddhisme pour pointer l'inexprimable, le Sūtra du Guanyin a cependant une place particulière en ce que tout son message repose sur l'efficace d'une prière formée avec ce nom seul du Bodhisattva :

"unique et glorifié, avec pouvoir d'offrir un refuge en lui, un appui", selon le Commentaire au Sūtra du Lotus, dû au moine chinois Daosheng (VIe siècle 道生).

De plus, s'il y a grande efficacité à invoquer ce Nom (minghao 名號), suivant le credo : que sa pensée vienne à l'esprit, qu'on se le remémore, (xinnian 心念), "qu'on le loue d'un cœur sincère" (yixincheng 心稱), c'est qu'il procure des mérites, puṇya (gongde 功德). Ce que nous appellerons ce don du nom, forme, par conséquent, un champ unique et universel. C'est, nous semble-t-il, le sens du titre du chapitre Pumen [pin] 普門 [品], [sanscrit : samantamukha]), qui peut apparaître comme un "habile recours aux moyens (salvifiques)", upāya-kauśalya, que déploient le Buddha comme le bodhisattva, pour s'accorder aux dispositions différentes des êtres.

Venons-en à ce nom qui a tel pouvoir de fruition. Des périls et épreuves appréhendés, rencontrés et endurés, est-il professé, par tous les êtres qui existent en ce "monde de centaines de milliers de myriades de créatures", celles-ci se voient immédiatement (su 速) secourues en entendant louer le bodhisattva Guanshiyin. Le texte sanscrit semble indiquer "... (les créatures) entendent louer le nom (du bodhisattva)" ; tandis que le chinois, apparemment, tranche pour un possessif (qi 其) : "entendant louer son nom", qui renvoie à Guanyin lui-même, celui-ci les sauve.
L'ambiguïté, qui vient d'être mentionnée, est extrême et supérieurement productive du prodige. Car, le Buddha expose ensuite que c'est à raison de ces pouvoirs que le bodhisattva porte ce nom Guanshiyin "Celui qui tourne son regard vers les appels du monde". Il s'agit, mieux que des sons, de bruits quelconques (yin 音) montant du monde, moins encore de cris, comme on l'a dit parfois, que du son de l'incantation (yinsheng 音聲) formé par le nom glorifié du bodhisattva. De qui, des êtres ou du Bodhisattva est-il fait allusion dans cette sentence apparemment ambiguë pour le traducteur chinois? Des deux, sans nul doute. La réalisation, au sens propre, du nom a pouvoir de sauver les premiers à la mesure que le second considère l'appel vers lui lancé par son nom prononcé. La circularité dialectique est aussi formulée : "ceux qui possèdent (chi 持) ce nom du bodhisattva Guanshiyin, est-il exposé, s'ils viennent à tomber dans un grand feu, en sortiront assurément indemnes", et, de même, tous les périls s'abolissent à cette mesure.
Enfin, ce terme, guan 觀 qui "regarde", "considère", il s'entend, cette incantation. Le rapprochement de ces termes étrangers l'un à l'autre : "regarder les appels", traduit l'inexprimable où la langue perd sa faculté, pour dire combien le bodhisattva prend en considération l'appel qui monte à lui et, de sa compassion, manifeste partout où ils sont requis des grands pouvoirs surnaturels, à sa guise (zizai shenli 自在神力) — soit, sans quitter le lieu de sa méditation — qui lèvent pour les êtres dans la frayeur, la crainte, le péril même.

Le Sūtra de Guanyin, dans les recensions sanscrite et chinoise, mentionne une épithète du Buddha à lui donné dans ce bas monde, où il est également nommé Abhayaṃdada (Shiwuwei 施無畏) "celui qui donne la sécurité" (Taishō, n° 262, p. 57b). C'est sous cette forme qu'il apparaît, à l'évidence, dans les peintures (C. Pelliot MG. 17665, cat. n° 76 et Stein Painting [British Museum], Oriental Art 1919.1-1.028). Et le jeu de miroir mystique, renvoyant les mérites de celui qui prononce la louange du nom à la manifestation du bodhisattva, se prolonge : "l'audition du nom, la contemplation du corps (de Guanyin), la remémoration régulière ne sont pas vaines ; elles ont pour résultat certain d'anéantir toutes les douleurs de l'existence".

La contemplation, la vision, est bien celle du corps du bodhisattva Guanshiyin, dont le Sūtra professe qu'il peut se manifester sous "Trente-trois formes" différentes, fonction des dispositions et de la nature des êtres. Et ce, en vertu de l'habileté dans les moyens qu'il déploie. Ainsi peut-il apparaître sous la forme d'un Buddha, d'un bodhisattva..., d'un disciple (śrāvaka, Shengwen 身聞)..., d'un Roi-céleste (Lokapāla, tianwang 天王), notamment Vaiśravana (Pishamen 毘沙門), d'un brahmane, du génie porteur du foudre-diamant (Vajrapāṇi, Zhijingangshen 執金剛神), même d'une femme ; et ce pour enseigner la Loi.

La parole qui se fait entendre, cette audition inscrite dans la conclusion de la prédication, contrairement à tout ce qui a été exposé jusque là, est désormais rapportée à celle qu'ont les êtres de la voix du bodhisattva Guanshiyin. Cette voix est évoquée par de grandioses métaphores qui n'ont rien à envier aux attributs du Buddha lui-même : "Elle est comme le bruit du nuage, comme le rugissement de l'océan, comme la voix de Brahmā (Fantian 梵天) qui franchit la limite de l'espace où règne le son".

V. Guanyin "aux Onze Faces" *Ekadaśamukhāvalokiteśvara* 十一面觀音菩薩

Le bodhisattva Avalokiteśvara à l'épithète dite " aux Onze faces", Ekādaśa-mukha (shiyimian Guanyin 十一面觀音) est illustré dans la collection Pelliot par plusieurs œuvres votives, réalisées sur soie (C. Pelliot MG. 17778)[5] et sur chanvre (C. Pelliot EO. 3587)[6] , entre autres exemples. Si l'expression du bodhisattva prend raison des titres ainsi donnés à deux sūtra conservés en chinois, et uniquement dans cette langue semble-t-il (Taishō, n° 1069 et 1070), elle induit en revanche, sinon à une confusion du sens à donner à cette image du Grand Être, du moins à détourner sensiblement du sujet proprement dit. Ces Onze faces sont-elles les visages multiples d'un être vénéré, manifestant ainsi son omniscience et qui, selon certains, ferait "face-à-tout" (samantamukha) ? Le risque en telle interprétation est à l'évidence de déporter la figure dans le champ de ces images des divinités de l'hindouisme, figure de leur toute puissance signifiée par leurs têtes et bras multiples, que précisément le buddhisme récuse au nom de ses principes. Quelle hypostase "divine" saurait se dessiner au-dessus des êtres vénérés exemplaires de l'Éveil, qu'ils soient Buddha ou bodhisattva? Aussi bien, telle image où affleure certaine ressemblance avec les divinités de croyances repoussées, n'a de toute évidence sa place ici, que pour en marquer plus nettement le départ qui les oppose.

La source iconographique du bodhisattva Avalokiteśvara aux Onze faces est indienne, on la situe à l'époque post-gupta (circa VIIe siècle), déjà dans le déclin du bouddhisme dans ce pays, telle qu'elle est manifestée dans les reliefs des grottes du Maharashtra, et notamment à Kanheri (grotte 21) où serait l'une des toutes premières représentations. Outre les Onze têtes, le bodhisattva de cette effigie se voit déjà pourvu de quatre bras. Mais, hors ces images, il n'est aucune des source scripturaires conservées en langue indienne qui fondent les trois sūtra traitant d'Ekadaśamukhāvalokiteśvara (Taishō, n° 1069, 1070 et 1071). La plus ancienne traduction remontant à l'époque des Zhou du Nord (VIe siècle), est due à Yaśogupta (561-578), la seconde, fort apparentée à la précédente, au grand moine Xuanzang (602-664), enfin, la dernière, plus développée sur les aspects du rituel tantrique, à Amoghavajra (705-770). Ces trois recensions chinoises sont donc nos sources essentielles, et l'on jugera de leur utilité pour comprendre l'image de Guanyin. Car s'il y est question du sens à donner à l'expression "Onze faces", il y est également de la confection de l' "Image cultuelle" : une statue en bois de santal du bodhisattva, et du culte particulier à lui rendre.

Or, ce qui est particulier ici, est cette manifestation du bodhisattva. Les trois textes sont explicites, et, de plus, s'accordent tous sur le fait que ces "faces" (mukha, mian 面), avant que d'être figurées littéralement dans l'image de Guanyin, désignent les "formules porte-charmes", dhāraṇī (Tuoluoni 陀羅尼) et "formules germes" mantra (shenzhou 神咒 ou xinzhou 心咒, ainsi qu'il est mis dans la bouche du bodhisattva Guanyin s'adressant au Buddha — la scène se passe, dans la première recension, au Pic du Vautour (Gṛdhrakūṭa-parvata), dans la seconde, au parc Karaṇḍakanivāpa, également près de Rājagṛha, seule la troisième fait mention du site méridional du mont Potalaka, Putuoluo shan 鋪陀落山, "lieu" de séjour du bodhisattva Avalokiteśvara — : "Bhagavat, je possède aujourd'hui les mantra (shenzhou 神咒) qui se nomment les Onze faces (shiyimian 十一面), les mantra que onze koṭī (un million cent mille) de Buddha ont prononcés [...] Je les prononcerai à mon tour aujourd'hui, et ce dans l'intérêt et pour le bien de toutes les créatures" (Taishō, n° 1070, p. 149 a ; n° 1071, p. 152 a ; n° 1069, p. 140 a). Prononçant ces mantra, dits des Onze faces qui ont grands pouvoirs, le bodhisattva poursuit : "je désire faire en sorte que tous les êtres les gardent en mémoire et récitent la

Bonne Loi (shanfa 善法), pour qu'ils ne souffrent pas de maladies, pour anéantir tous les obstacles (qu'ils viendraient à rencontrer), toutes les calamités, tous les mauvais rêves, pour contrer les esprits malfaisants et démoniaques". (Taishō, n° 1070, p. 149 a).

La chose est donc entendue. Elle est loin d'évoquer un "dieu souverain" à la manière de l'hindouisme, omnipotent sur le monde, loin aussi du sens qu'on a voulu lui donner : le bodhisattva souverain "Qui-fait-face-à-tout" ; épithète qui entretient la confusion.

Le lien avec l'Image du bodhisattva est, d'ailleurs, clairement souligné dans le sūtra. Œuvre pieuse que prédispose une action de grâce qui n'était due qu'au Buddha, en ce qu'elle témoigne de la part des "bons disciples" qu'ils prennent refuge (yi 依) dans le sein de Guanyin enseignant la Loi. Suit une prescription touchant aux marques particulières de l'icône, aux attributs que ses mains présentent : la gauche doit tenir une tige de lotus, la droite formant le sceau de Rassurance (abhaya-mudrā, wuwei yin 無畏印), mais surtout au sujet de ces têtes ou faces, images des mantra au nombre de onze. Nous reproduisons ici la prescription qui est la même dans les trois textes concernant les "caractères" de ces faces, tant elle est édifiante pour l'intelligence de la forme figurée dans la peinture : "On fera onze têtes : trois, de face, auront une expression empreinte de la compassion du bodhisattva ; sur le côté gauche, trois faces aux traits irrités (chen 瞋) ; sur le côté droit, trois à l'aspect de bodhisattva mais sur la bouche desquels feront saillie des crocs ; à l'arrière, une face éclatant d'un rire malin, mauvais, (baoe daxiao xiang 暴惡大笑相) ; au sommet, enfin, une tête de Buddha" (Taishō, n° 1070, p. 150c - 151a ; n° 1071, p.154 a).

Qu'est-ce à dire de ces faces malignes dans l'être de compassion? Précisément ces mantra qui contrent les obstacles dressés par les esprits malins, anéantissent les douleurs, les mauvais rêves. Ambiguïté des caractères de l'ésotérisme, renvoyée plus sûrement par les images que par les textes : la bonté parée de l'aspect de la véhémence maligne qu'elle détruit. La grande puissance (daweili 大威力) des charmes magiques qui garantissent la sécurité, repoussent les atteintes, détruisent les poisons ; enfin, qui protègent les interprètes de la Loi.

VI. Avalokiteśvara "aux Mille Mains et Mille Yeux", *qianshouqianyan Guanyin* 千手千眼觀音菩薩

Autre magie d'apparition du Même, le bodhisattva Avalokiteśvara dans ses œuvres de grande compassion, ici sous la forme dite "aux Mille mains et Mille yeux", Sahasra-bhuja-sahasra-netra, (qianshouqianyan 千手千眼), explicite de l'ubiquité des pouvoirs du Sauveur (C. Pelliot MG. 17775, cat. n° 71). Celle-ci, selon la glose des textes qui lui sont consacrés (Taishō, n° 1060, p. 108a ; n° 1064, p. 115b), doit s'entendre sous le double sens, respectivement : de ces yeux "qui voient et éclairent [partout]" (zhaojian 照見) — selon l'idée que l'œil voit parce qu'il est lumineux et émet de la lumière — , et de ces mains qui tiennent et protègent (huchi 護持) la Loi bouddhique (fa 法). Caractère universel du regard et de la compassion du bodhisattva qui sauve les êtres (voir, Sūtra de Guanyin). Ici, en une ultime forme créée, colorée d'ésotérisme tantrique, souveraine. Tendant encore, s'il était possible, à une plus grande efficacité que celles qui étaient jusque là connues : "Secourable aux douleurs, Jiuku 救苦 (C. Pelliot EO.1137, cat. n° 72)",… "au Lasso infaillible, Bukongjuansuo 不空羂索 (C. Pelliot MG.23076, cat. n° 69)", "aux Onze faces, Shiyimian 十一面"), ou simultanément avec ces deux dernières.

Vertigineuse vision que l'illustrateur ne peut rendre qu'à une faible mesure et au prix d'une image qui se trouble : mille yeux fixes dans autant de paumes de mains ouvertes, formant les sceau du Don de vœu (varada-mudrā), de Rassurance (abhaya) et de Prédication (vitarka) ; outre l'orbe des mains nues qui compose comme une mandorle au Vénéré, sur fond du disque pâle de la lune — autre symbole de la Compassion, à raison de la douce lumière égale pour tous les êtres

qu'elle répand. Des attributs spécifiques, chacun digne de l'œuvre salvifique du Grand Être, viennent aux mains " principales", une quarantaine de bras privilégiés : arc de la victoire, bol à médecine de la guérison, glaive de la soumission des démons ; lotus bleu (qinglianhua 青蓮花), lotus pourpre (zilianhua 紫蓮花), lotus rouge (honglianhua 紅蓮花), emblèmes d'exaucement des souhaits, respectivement : de renaître dans les Terres pures des dix directions de l'espace, de contempler les Buddhas, et de renaître dans des palais célestes... ; d'autres symboles de protection, d'apaisement, d'omniscience, tels qu'ils sont décrits et illustrés dans le rituel tantrique voué à cette forme du bodhisattva, la "Dhāraṇī de Grande Compassion du bodhisattva Guanshiyin aux Mille Mains et Mille Yeux" (Taishō, n° 1064, p. 117-119), traduit par Amoghavajra (Bukong 不空) (705-774), sous les Tang. Les mains levées dressent haut : à droite, le pavillon de métamorphose (huagongdian 化宮殿), qui évoque ces architectures de palais des Champs de Buddha, ici, manifestement, la Terre pure de l'Ouest du Buddha Amitābha ; à gauche, un Buddha de transformation (huafo 化佛), dont la symbolique est la "rassurance de renaître dans un monde où le Bienheureux se manifeste" ; présentés plus haut encore sont les deux luminaires, Soleil et Lune, pour que se répandent la lumière — selon la glose de ce texte,— du premier, contre l'ignorance, de la seconde, contre les poisons et les maléfices.

Tout ce grand appareil est, à l'évidence, une figure redondante certainement plus tardive que les précédentes. La préface à la première recension chinoise du Sūtra de la dhāraṇī traduit par Zhitong 智通 (actif 627-653), (Taishō, n° 1057, p. 83b-c) précise que l'image du Vénéré et ce rituel de Guanyin ne furent connus en Chine qu'au début des Tang, et dès lors que l'empereur Taizong donna son accord. Une précédente tentative, sous le règne de son prédécesseur, avait échoué.

Une chronologie des formes de Guanyin se devinerait ainsi. Celle-ci à la suite du Même à Onze faces — on observera, plus tard aux XIe-XIIe siècle, une forme où se mêlent les deux images : le bodhisattva, muni de ses Mille mains et de Onze têtes — témoignerait d'une captation plus grande encore de la figure salvifique du côté de l'ésotérisme tantrique, tout en refusant, dans les images, de s'y abandonner totalement, comme on le verra dans les deux grands maṇḍala. Une ambiguïté du Grand vénéré, caractère double de la maïeutique ésotérique, dessine, de front, un aspect terrible de dompteur d'un dieu-démon (voir ci-dessous), évoqué dans le rituel mentionné (Taishō, n° 1057, p. 83b), et son essence de "Grand Compatissant". Et parallèlement à Ekādaśa-mukha (voir, ses têtes aux traits courroucés, n° 268), est souligné l'engagement que prend le bodhisattva de prononcer les formules secrètes des Buddha ; ici la divulgation de la dhāraṇī de Grande Compassion (Dabeituoluoni 大悲陀羅尼), est l'événement par lequel toute la magie de ces sūtra et de ces images commence. Guanyin "aux Mille mains et Mille yeux" promet — tel est le grand vœu qu'il a formé — de lever les mauvaises conditions (quinze sont énumérées) sources de mauvaises renaissances et de les transmuer en autant de bonnes renaissances ; il suffit que le fidèle prononce d'une foi pure la Dhāraṇī révélée: "A ceux qui la portent (en eux) et la récitent" (shouchi 受持), elle fait franchir (yue 越) un nombre infini de réincarnations… C'est parce qu'ils possèdent la Dhāraṇī (de Grande Compassion) que le lieu de leur renaissance est devant le Buddha" (Taishō, n° 1060, p. 106 c.)

On mesurera la distance, peut être historique, de cet épigone de Guanyin révélateur des formules magiques — et "en sa personne", si nous osons dire, principal objet de dévotion, en qualité de grand magicien de la prédication de la loi — avec la forme précédente "aux Onze faces", et ceci, ne serait-ce que par la confrontation des Dix Vœux (Shiyuan 十願) formés par Ekādaśa-mukha pour le salut des êtres, dont le rituel conserve toute la saveur des premières révélations, des premières formules et de leurs pouvoirs ; il suffit, pour cela, de se reporter aux expressions des faces. Bien que les textes concernant le dernier paraissent, pour l'essentiel, un simple démarquage des thèmes du premier, la langue, en revanche, y a perdu en force. Elle se fait contournée, émousse les contrepoints précédemment si frappants, et il en est de même de l'icône du Bodhisattva. Sa description est fidèle à la "statue en bois de santal", qu'il convient de confectionner, de dresser et de vénérer. selon un rituel précis ; statue qui advient en conclusion de ces recueils, sur recommandation du Buddha.

Mais nous jugeons par trop, dira-t-on, en terme d'esthétique ; encore que l'on puisse rappeler la réticence de l'empereur

Gaozu (618-626) pour accepter la forme nouvelle. L'image et les rituels afférents rencontrèrent ensuite un large écho dans le bouddhisme chinois, et lui seul semble-t-il en Sérinde, avant qu'ils ne trouvent d'autres terres favorables en Corée et au Japon, par la suite.

VII. Le Sūtra de l'Ornementation Fleurie (Avataṃsaka-sūtra, Huayan jing 華嚴經) et le Chapitre des Dix Terres (Daśabhūmika, Shidi [pin] 十地 [品])

Ce monument de la littérature bouddhique qu'est le Sūtra de l'Ornementation fleurie vient à nous avec une particulière insistance dans les témoignages artistiques de la Sérinde orientale, et singulièrement — il faudrait dire, exclusivement sous la forme développée épousant les chapitres du recueil — dans les peintures de Dunhuang. Les œuvres qu'il a inspiré se reconnaissent, entre toutes, dans ce lieu par de grandioses compositions peintes sur les parois ou les plafonds de certaines grottes. Pas moins de vingt-neuf d'entre elles (certes, sur un total supérieur à quatre cents), en sont ornées.

La particularité de ces vastes compositions est de figurer un grand nombre d'assemblées de prédication du Buddha, toutes comparables et agencées de telle sorte que la surface picturale s'en trouve couverte, renvoyant une impression proche de celle d'une tapisserie. L'effet qui domine est la réitération, semble-t-il, d'une même scène, comme des reflets de leur image renvoyés. Une rigoureuse dispositions selon un quadrillage suggère un ordre rayonnant à partir d'un centre. Tout ceci évoquerait un maṇḍala du bouddhisme tantrique, si ne se faisait jour un projet plus mystique et philosophique, que magique et ésotérique, en l'illustration des dites "Neuf Assemblées des Sept Lieux" (Qichujiuhui bianxiang 七處九會變相圖). Soit, en l'image plénière du recueil (Fig. 1).

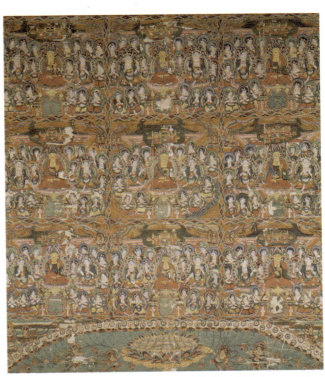

Fig.1 Les "Neuf Assemblées des Sept Lieux" du Sūtra de l'"Ornementation fleurie" (s. Avataṃsaka-sūtra, ch. Huayan jing)
Cinq Dynasties (début du Xe siècle)
Peinture sur soie, 194 x 179 cm
Collection Pelliot MG. 26462

VIII. Les œuvres de la Collection Pelliot

Seules, deux œuvres magistrales de la Collection Pelliot (découvertes dans ce fonds et identifiées voici une dizaine d'années), témoignent à ce jour des uniques peintures mobiles, réalisées sur soie, illustrant le vaste programme iconographique du Sūtra. En précisant toutefois l'extrême rareté de l'une, sous cette forme, et le caractère exceptionnel, parmi toutes les œuvres connues au monde, de l'autre. C'est à savoir, la première, parente des peintures des grottes, figurant lesdites "Neuf Assemblées des Sept Lieux" (C. Pelliot MG. 26462), Fig. 1 ; la seconde, absolument unique à ce jour, donnant l'image développée du Sūtra des Dix terres (Daśabhūmika-sūtra), incorporée dans sous forme d'un chapitre du Huayan jing 華嚴經, chapitre 26 intitulé "Section des Dix terres", Shidi pin 十地品 (C. Pelliot MG. 26465), Fig. 2.

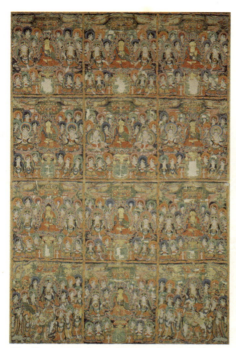

Chapitre des "Dix degrés [de la carrière du bodhisattva]" (s. *Daśabhūmi*, ch. *Shidi [ping]*) du Sūtra de l'Ornementation fleurie
Cinq Dynasties (début du X° siècle)
Encre et couleurs sur soie, 286 x 189 cm
Collection Pelliot, Musée Guimet MG. 26465

La rareté, voire l'inexistence à ce jour de ces images en dehors du sanctuaire de la province du Gansu confinant à l'Asie centrale, ne renvoie qu'un état "archéologique" et très imparfait de ce que ferait attendre le grand rayonnement du texte et de sa doctrine en Chine. Le Sūtra, en effet, n'a été conservé que dans le Canon chinois — ce qui, en soi, n'en fait pas une singularité, puisque telle disparition des sources en langues indiennes est le lot de bien d'autres textes. Une autre hypothèse, suggérée à la lumière de l'histoire des recensions des parties composées en "chapitres", obtenus à Khotan par des envoyés Chinois de la Cour de Chine, serait que le Recueil fut composé comme tel dans sa version chinoise. On retiendra, en effet, qu'il comprend deux chapitres (pin 品) empruntés à de véritables sūtra indépendants, le Daśabhūmika (Shidi jing 十地經) et le Gaṇḍavyūha (Rufajie 入法界), connus pour leur part, et sous cette forme, en sanscrit. L'importance doctrinale de ces derniers, incline a voir en eux les sources vives de l'Œuvre toute entière.

IX. Les Sūtra de l'Ornementation Fleurie et la Peinture des Neuf Assemblées de Sept Lieux

Deux traductions historiques de l'Avatauska-sūtra sont conservées dans le Canon sino-japonais. La première dite des "Jin de l'Est" ou en "60 rouleaux" (Taishō, n° 278) est due à Buddhabhadra (418-420) — illustrée par le rouleau manuscrit sur soie tenté en jaune également trouvée dans la grotte scellée de (Bibliothèque nationale de France : Pelliot chinois 2144) —, la seconde, à Śikṣānanda (695-704), dite "traduction de la dynastie Zhou 周朝" (règne de l'impératrice Wu Zetian 武則天, 684-705), recension longue également appelée "nouvelle traduction" ou en "80 rouleaux" (Taishō, n° 279). C'est sur cette dernière que se fondent les grandes compositions picturales dont il est ici question. On mettra de côté une dite "troisième traduction" donnée au moine Prajñā (756-758), et portant le titre du Sūtra (Taishō, n° 293),. D'où la confusion. Car cette ultime version ne concerne, en fait, que le chapitre conclusif des deux recueils précédents : ledit Gaṇḍavyūha, donné en un récit considérablement étendu. Laquelle traduction, distinctement des deux autres, aurait été établie d'après un texte offert à la Cour de Chine par le souverain d'Odra, dans l'Inde occidentale.

Ces deux traductions, en "60 ou 80 chapitres", font jour, non pas tant d'un perfectionnement de la langue vers une plus juste terminologie (celle-ci semble avoir été trouvée, dès l'abord), mais d'une véritable genèse du texte lui-même. Les différences notables du nombre des chapitres semblent avoir eu pour cause le ressourcement opéré pour chacune des traductions aux versions originales en langue sanscrite. À plus de trois siècles d'intervalle, toutes deux sont données pour s'être fondées sur des textes obtenus à Khotan, en Sérinde ; d'où le rôle important dont on crédite ce royaume dans le rayonnement de l'Ornementation fleurie 華嚴宗 et, par voie de conséquence, dans le culte rendu au Buddha suprême, Vairocana, Piluzhenei fo 毗盧遮那佛. — Du royaume sérindien proviennent, entre autres témoignages monumentaux révélés in-situ (et disparus), un panneau en bois peint à l'effigie du Buddha cosmique donnée au environ du VIe siècle, provenant de la région de Domoko (Mission Aurel Stein, British Museum, Oriental Art MAS. 459 [F. II.iii. 2]), et un fragment de peinture murale, mis au jour à Balawaste par le même savant (New Delhi, Museum of Central Asian

Antiquities. Har. D.) —. La principale différence, cependant, entre ces recensions concerne le nombre des "Assemblées" (hui 會) de prédication du Buddha, qui sont huit dans la "traduction ancienne" et neuf dans la "nouvelle". Mais ce terme serait incomplet sans la mention des "Lieux" (chu 處) réels et spirituels où celles-ci prennent place. Et ces derniers, qui sont Sept, demeurent tels d'une recension à l'autre. Cette distinction (plus que formelle quant à l'exposition de la doctrine du Sūtra) a commandé la composition des représentations iconiques. Ainsi sont-elles mentionnées d'après le nombre de leurs "assemblées" dans les brèves relations historiques ; trop laconiques, souvent, pour permettre de se figurer ces œuvres. Singulièrement, les images du Sūtra de l'Ornementation fleurie qui nous sont connues à Dunhuang, sont des illustrations des "Neuf Assemblées des Sept Lieux", inspirées par conséquent de la recension en "quatre-vingt chapitres" ou "nouvelle traduction".

Comme nombre d'autres sūtras majeurs, l'Avataṃsaka, fraîchement connu en Chine par sa traduction, a rapidement suscité des zélateurs qui prôneront l'étude et la vénération centrale du texte et institueront une "secte" dite Huayan, ajoutant au paysage complexe des courants doctrinaux, si caractéristique du bouddhisme chinois. L'histoire, toutefois, de la secte (et donc du rayonnement de l'Avataṃsaka-sūtra) se distingue de ses semblables — notamment de celle dite du Tiantai, avec laquelle la parenté est proche — en ce que sa doctrine, essentiellement contemplative et "philosophique", se vit cependant servir, un moment de son histoire, aux fins de l'idéologie impériale. On ne s'étonnera pas de ce détournement qui n'a épargné aucun courant, aucune école du bouddhisme en terre chinoise. La bienveillance impériale a toujours été pour la religion importée une des conditions de sa pérennité, sinon de son simple maintien. Celle-ci, en effet, était en butte dès l'origine à des forces contraires. Le propos, ici, n'est pas cette histoire, mais la perspective toute particulière que joua dans la fixation de l'image de l' "Ornementation fleurie" le parrainage impérial sous le règne de l'impératrice Wu. Car cette image, il convient de le souligner, n'a pas, à notre connaissance, d'antériorité autre. Quant aux compositions murales un peu plus tardives, leur nombre s'accroît, de même celui des représentations qui s'apparentent à la présente peinture sur soie dans les grottes contemporaines de la fin des Tang (deuxième moitié du IXe siècle) et des Cinq Dynasties (Xe siècle). Enfin quelques sanctuaires des Song (Xe- XIe siècle) témoignent de la fortune tardive du sujet, et vaut même les plus grandioses compositions connues.

Dès lors, tout ce qui à trait à l'histoire de la recension dite "longue" ou "nouvelle traduction de la dynastie Zhou" du sūtra intéresse la compréhension que l'on doit avoir du formalisme pictural et de son élaboration. L'entreprise — entendons la quête de l'original sanscrit provenant de Khotan et la nouvelle traduction du sūtra sous la direction du moine Śikṣānanda de même origine, alors invité à séjourner dans un monastère de Luoyang pour cette tâche, en 695 — paraît avoir été dominée par la figure de l'impératrice Wu, qui l'aurait commanditée sur l'instigation du troisième patriarche de l'école, Fazang (nom honorifique Xianshou). On attachera, par conséquent, l'importance qu'elle mérite au fait du parrainage impérial, consacré d'ailleurs par la préface à la nouvelle traduction écrite par l'impératrice Wu, elle-même (Taishō, vol. 10, n° 279, p.1a-b.) ; et, de même, au soutien tout particulier dont a joui la secte Huayan sous son règne. C'est ici que s'annonce l'autre contingence qui a présidé à l'histoire de l'école sous la dynastie Tang.

La nouvelle école, non seulement par la philosophie qu'elle prônait - qui s'inscrit d'ailleurs dans le courant de la pensée mahâyâniste, tel qu'il est professé dans les textes de Prajñāpāramitā (Perfection de Sapience) et ses développements - , mais surtout par l'occasion que celle-ci offrait de par son système de représentation universelle convergeant vers le tropisme d'un centre : le Buddha cosmique Vairocana, avait de quoi convaincre et séduire une souveraine qui se voyait de même prédestinée ; tandis qu'elle n'était, pour les légitimistes, qu'une brutale usurpatrice. Et l'on met au compte de cette ferveur religieuse le seul souci de fonder, d'asseoir la légitimité de son pouvoir. Tout au moins est-ce là l'opinion répandue. Cette "légende noire" sans nuances qui entoure la personne de la souveraine, entretenue par l'historiographie

officielle de la dynastie Tang restaurée, et reprise incessamment par toutes les Histoires dynastiques. Plus grave est que cette opinion tendrait à faire servir aux desseins idéologiques d'une souveraine — qui effectivement se crut et voulut faire accroire à son peuple qu'elle était dans cette perspective bouddhique le "Souverain universel (s. Cakravartin) à la Roue d'or" (ch. Jinlun shengwang 金輪聖王) et une incarnation du bodhisattva Maitreya (Mile pusa) —, la grande, la plus vaste théorie visionnaire que le bouddhisme du Mahāyāna se soit donné : ce "Monde de l'Ornementation fleurie du Buddha Vairocana", Piluzhenei Fo Huayan shijie. Et, par voie de conséquence, de taxer de même la secte qui se vouait à son exégèse. Or si celle-ci, par la personne du troisième patriarche bénéficia de quelques privilèges substantiels sous le règne de l'impératrice Wu, des faveurs plus grandes encore pour le prestige et le rayonnement de la secte furent accordées par son fils, Zhongzong. Et quelle raison invoquera-t-on pour qualifier la comparable faveur impériale sous le règne de l'empereur Dezong (779-805), qui permit au moine indien Prajñā d'entreprendre la traduction du Gaṇḍavyūha?

A nouveau, le propos n'est pas ici l'histoire de l'école, mais l'éclairage que celle-ci peut apporter relativement à la peinture de Dunhuang et sa date. Cette digression permet de préciser quelques points importants allant dans ce sens : le rôle initial et prépondérant également par la suite du patronage impérial, (autant dans les entreprises de traductions successives du sūtra, que dans la constitution de la nouvelle secte, qui s'est distinguée et affirmée comme telle sous l'impulsion et grâce à la personnalité du troisième patriarche, le moine Fazang 法藏); bien que cette empreinte d'origine se soit révélée prégnante jusque sur la destinée de la secte. L'audience du Huayan zong, toutefois, ne s'est pas trouvée confinée au seul milieu de la Cour. Rapidement, elle s'élargit à l'élite civile et militaire, à mesure que se fit jour, au sein de ses pratiques religieuses, moins abstraites et théoriques, une forte influence du Chan. Ce tournant, marquant une approche plus directe, plus intuitive, caractéristique de ce dernier, s'est opéré dès le patriarcat de Chengguan, le successeur de Fazang. Il s'accusa plus encore sous le 5ème patriarche de l'école, Zongmi (780-841), au point que celui-ci est également mentionné au nombre des grands patriarches historiques du Chan.

Enfin, marquée en quelque sorte par ce profil d'une secte "élitiste", lourdement institutionnalisée et surtout dépendante pour sa transmission d'un héritage scripturaire exégétique très important, l'existence de l'école fut profondément affectée dans l'Empire, dans les années de déclin de la dynastie Tang, au point que sa tradition disparut complètement. Les mesures à l'encontre du bouddhisme (845), ordonnées par l'empereur Wuzong (840-846), qui culminèrent dans un vaste autodafé, puis la perte des trésors d'érudition encore conservés au sein des monastères, dans la tourmente des années de l'insurrection de Huang Chao (876-884), lui ont porté un coup fatal.

L'école Huayan n'est pas la seule à avoir eu ce sort, il fut celui aussi des écoles Tiantai et Faxiang, semblablement prestigieuses en leurs approches de la Doctrine du Grand Véhicule, et qui faisaient la gloire du bouddhisme Tang pour toutes les communautés de la Haute Asie.

X. Argument et Programme Iconographiques

Ce monument littéraire inspiré par le Chemin de la Délivrance bouddhique — la plus vaste théorie visionnaire que le Mahāyāna a produit — est, à bien des égards comme le Sūtra du Lotus, avec lequel il partage de nombreux points doctrinaux, une "prédication de couronnement" délivrée par le Buddha. Soit de pure quintessence de la Loi, ainsi qu'il y est question sous la formule du titre de ce dévoilement du "Monde de l'Ornementation fleurie du Buddha absolu Vairocana". Que faire de deux sommets pour que l'un ne porte pas d'ombre à l'autre? Sinon de leur trouver des vocations distinctes. C'est cette esquisse historique de la prédication du Buddha qu'ont dessinée les zélateurs du Lotus appartenant à l'école Tiantai. Réservant à leur Sūtra le sommet de la fin de la mission sur terre du Bienheureux, il crédite l'Ornementation fleurie de celui du début — bien qu'il semble que celui-ci ait été de rédaction plus tardive. Mais il s'agit de vérité mystique et doctrinale! L'important est ce voisinage, cette parenté. Elle expliquerait que dans nombre de compositions peintes des grottes, les illustrations des deux Sūtra se répondent d'une paroi à l'autre. On citera, pour les

compositions figurant sur les panneaux des plafonds, les grottes 9 (Pelliot 107) et 55 (Pelliot 118F), et pour celles qui ornent les parois, les grottes 6 (Pelliot 168) et 61 (Pelliot 117), données aux périodes des Cinq Dynasties - début des Song (Xe siècle).

L'Ornementation fleurie révèle la geste du Buddha dès après son Éveil non loin du village d'Uruvilvā, soit pendant cette période de plusieurs semaines qui sépare la béatitude de la Délivrance Bodh-gayā à du premier Sermon prononcés à Bénarès (kāśi), et sur laquelle règne le plus grand silence des textes anciens. Geste mystique insérée là, où la littérature du Petit Véhicule laissait à entendre une hésitation qui aurait saisi Bienheureux au seuil d'entreprendre sa mission pour le bien de tous les êtres. À cette remarque psychologique où s'esquissait la stature humaine du Buddha historique, notre Sūtra substitue une intemporalité de la béatitude, mais sans ce recul face au devoir d'un Parfait éveillé. Versant mystique de la légende où se dessine en une hypostase principielle, bien plutôt que divine, la figure du Buddha absolu, le "Grand Illuminateur" Vairocana . C'est ainsi que le Tathāgata, sans quitter sa méditation sous l'arbre, se manifeste magiquement au sein de sa grande assemblée de prédication en Sept lieux, dont trois fois sur celui de l'Éveil, le bodhimaṇḍa.

Les peintures des grottes consacrées à l'Ornementation fleurie, tout comme l'unique exemplaire existant d'une peinture liturgique, sont toutes consacrées à décrire cette magie d'apparitions simultanées du Tathāgata prêchant le Dharma dans tous les lieux supérieurs du Monde du désir (Kāma-dhātu) : d'abord sur le lieu terrestre de l'Éveil, puis sur la verticalité des ciels s'élevant par-dessus le sommet de la montagne cosmique, le mont Sumeru, pour atteindre le ciel supérieur de ce Monde. Mais le génie de cette invention, sa portée exégétique et morale, si l'on se place du point de vue philosophique, est la conclusion de ce mouvement ascensionnel, ou plutôt sa résolution en ce que la dernière audience prend place au lieu historique même de la Prédication faite pour l'humanité, le premier Sermon de la Délivrance prononcé au Bois du Jetavana. La leçon est évidente dans cet orbe décrit à l'amplitude céleste : de même que par l'évocation de la prédication à Bénarès, le Sūtra renoue, au-delà, avec l'orthodoxie canonique et l'hagiographie classique.

1. Par "peintures votives", il faut ici entendre des *œuvres pies*, au sens littéral : d'"Offrandes méritoires", commanditées, nommément, par des "donateurs". Elles étaient, par conséquent, d'un "usage" religieux circonstanciel (comme le précisent les dédicaces inscrites) : tant à l'égard des vœux formés et leur exaucement attendu, que du temps dévolu à leur "usage rituel" — funéraire et commémoratif. Il est vraisemblable que les peintures retrouvées dans la grotte 17, aient été, pour un grand nombre, de cette nature, et, ne pouvant être détruites, on les ait reléguées dans cette cachette.
Par peintures *liturgiques*, nous entendons — dans la distinction des précédentes — des compositions et des images qui apparaissent comme des illustrations (bianxiang), à usage liturgique pérenne, de grands textes doctrinaux : notamment les Sûtra du Lotus, d'Amitâbha, de l'Ornementation fleurie, etc.)... Souvent, ces mêmes illustrations ornent les parois des grottes Mogao, ainsi que de bien d'autres sanctuaires rupestres du Gansu et de la Chine septentrionale — pour les témoignages connus de ces époques.
2. Collection Pelliot MG. 26462. In Les Arts de l'Asie centrale ; la collection Pelliot du Musée guimet, (Giès, Jacques, dir.),, vol. I, Tokyo, Paris, Londres, 1994-1996, pl. I, pp. 51-62.
3. Collection Pelliot MG. 26465. Ibidem., pl. II, pp. 63-72.
4. Édition japonaise du Canon bouddhique : le Taishō shinshū Daizōkyō 大正新修大藏經 "Canon bouddhique nouvellement compilé en l'ère Taishō (1912-1925) ; ici mentionné Taishō. Publié à Tôkyô de 1924 à 1935, sous la direction de Takakusu Junjirō 高楠順次郎, Watanabe Kaigyoku 渡邊海旭 et Ono Gemmyō 小野玄妙.
5. Bibliothèque nationale de France : Pelliot chinois 3932 ; Musée Guimet : C. Pelliot MG. 17665.
6. Les Arts de l'Asie centrale. La collection Pelliot du Musée Guimet, vol. 1, pl. 92.
7. Ibidem. vol. 1, pl. 91.
8. La faveur impériale dont fut honoré Fazang ne se démentit pas, même après la déposition de l'impératrice Wu Zetian en 705 ; il fut ainsi conservé dans ses hautes fonctions auprès du Trône, et même élevé à de plus hauts titres honorifiques par les deux souverains suivants : Zhong Zong (705-710), dont ce fut le retour au pouvoir, et son successeur l'empereur Rui Zong (710-712).

保羅・伯希和中亞使命之行

派翠西亞・莫特
法國國立亞洲藝術-吉美博物館

十九世紀末，歐洲在精神及知識領域中遭逢熱烈的動盪。科學、地理和考古的使命團如雨後春筍般大增，對神秘的絲路透露出某種迷惑力。這條道路從古代就由沙漠商隊與朝聖的僧侶所採用，特具重要性，長久以來就連接了歐洲及近東與遠東的文化。一些重大的發現—例如在庫車（Kutcha）附近發現的包爾（Bower）手抄本，或於1892年由杜特也・德漢斯（Dutreuil de Rhins）所發現的手抄本，均反映出當時對絲路之興趣日益增加。

法國漢學家保羅・伯希和（Paul Pelliot）就是在此種特殊的時代環境中於1878年5月28日誕生。身為巴黎工業家之子的伯希和在巴黎最頂尖的中學之一，史塔尼斯拉中學（collège Stanislas）就讀。他是優秀的學生，透過學習拉丁與希臘文而獲取古典文化的基礎。年輕的伯希和最初的志願是準備成為一位外交官，獲得英文的學士學位和政治學院的文憑，同時也在東方語言學校學習中文。另一位漢學家艾德華・沙畹（Edouard Chavannes）任教於法蘭西學院，成為伯希和的導師，並指引他朝向研究和語言學的道路。

伯希和廿一歲時受聘為位於西貢的法蘭西遠東學院（Ecole française d'Extrême-Orient (E.F.E.O.)）的領薪特派員，並啓程前往河內，展開他在中南半島第一次的使命。1900年初，他被學院派到北京採購中文圖書與文物，作為遠東學院圖書館的研究資料。此一時期對年輕漢學家的事業而言係極為重要的一個里程，特別是當時發生了義和團對駐北京的外國使節團的暴亂事件。這些暴動從五月起就癱瘓了整個城市，而伯希和穿越所有的路障，與叛亂者進行交涉，同時一起「吃茶點」。事件結束後，由於他英勇的行為而獲頒法國榮譽勛位團的十字勛章。伯希和在遠東學院任職期間，蒐集了一大批重要的中文、藏文與蒙古文書籍，同時也收藏了極精美的佛、道繪畫及藝術品。

1904年七月返回法國後，伯希和專攻中亞文化的研究，學習俄羅斯、蒙古、伊朗、西藏、維吾爾與梵語等六種語言。由於他初期研究工作的卓越表現，特別是針對六至十三世紀中國旅人敘述的研究，法國中亞考察國際協會擬聘請他率領一支龐大的考古遠征隊前往中國的土耳基斯坦。當時世界各處—歐洲、俄羅斯與日本—正積極地組織各國考古探險隊，所以使命團的任務也是要在諸隊中取得一席之地。

伯希和8月2日的手稿中寫明探險隊的角色與任務。此一科學探險隊係由法國中亞與遠東考察國際協會所籌組。而探險隊的基金則獲得國民教育部、法蘭西科學院、法蘭西文學院、自然歷史博物館、法國主要的地理學會及一些名人的資助，其中包括羅蘭・波那帕特（Roland Bonaparte）。年青的伯希和被任命為探險隊的領隊，由於是遠東學院的中文教授，所以負責考古、語言學與歷史的任務。他的兩位同伴一為路易・瓦揚（Louis Vaillant），是伯希和的童年友人與殖民軍隊的二等軍醫，負責描繪所有的地形與天文圖，並研究所有的自然生物；另一位則是查理・努埃特（Charles Nouette），負責攝影。除了上述三人外，尚須加上在俄羅斯與中國土耳基斯坦當地所招募的人員。在最初計劃的行程中，探考主要的遺址要經過亞歷桑德洛夫（Alessandrovo）、莫斯科（Moscow）、奧倫堡（Orenburg）、塔什干（Tashkent）、喀什市（Kashgar）、庫車（Kutcha）、羅布泊（the Lob Nor）、沙州（Cha-tcheou）、西安（Si-ngan-fou）、山西的大同（Ta-t'ong-fou of Chan-si）及北京。而探險隊的主要任務則係研究與尋找在被回教征服前佛教在中亞所遺留的古遺跡。在一封致給國民教育部的信中，伯希和甚至提出蒐集土耳基斯坦古老民謠的意見。由於缺乏經費，此一計劃最後被退回。

在經過一年多的準備工作後，探險隊於1906年6月15日由巴黎出發 (圖1)。6月25日抵達塔什干，之前搭乘了十一小時的火車，但不幸的是行李卻未到達。一個月後，探險隊才再度出發，伯希和也利用這段時間學習東土耳其語，抵達位於俄羅斯及中國分界嶺山腳下的烏什市（Ville d'Och）。他們在烏什組織了一支卅餘匹馬的龐大旅隊，由兩位俄羅斯哥薩克人—波科夫（Bokov）及伊利亞佐夫（Iliazov）—所率領。而另一位曾經伴隨探險隊一段時間的人士則是芬蘭共和國未來的元帥總統—曼那海姆（Mannerheim）男爵，當時任職俄羅斯衛隊的軍官。稍後，探險隊所雇用的中國年輕助理丁某也加入同列。在越過高度約四千公尺的阿賴嶺（Altai）及進入克孜爾（Kyzilsu）河山谷後，探險隊臨喀什噶爾（Kashgar），並於1906年10月2日抵達圖木舒克（Toumchouq）。伯希和於一偶然的機運之下，在離開主要道路沒多少公尺的地方挖了一下土面，就有首次的發現：土中埋藏著一個希臘式佛教風格泥製的頭。於是展開六週詳細地挖掘，在這段期間探險隊發現了多件泥製的小雕像及一些說明佛本生故事的淺浮雕組群（今日保存在吉美博物館）。可惜的是，由於缺乏時間，挖掘工作並未完成，探險隊必須再度啟程，由於一項更重要的命運在等待著他們…

　　伯希和不僅運氣高照，加上精通中文及具豐富的歷史知識使得他在中國土耳基斯坦以超不尋常的條件被接待。雖然伯希和為外國人，當地的中國官員均視他如一位才學高超的文人。因此，每到一處，探險隊經常受到禮貌性的訪問和請客。

　　探險隊從1907年1月2日起逗留在庫車（Kutcha）大綠洲將近八個月。在那兒，德國的格蘭威德爾（Grünwedel）與馮勒柯克（Von Lecoq）探險隊以及俄羅斯的別列佐夫斯基（Berezovski）探險隊已在當地，先佔領了地盤。但附近充滿了佛教的遺跡，伯希和著手研究庫木土拉（Kumtura）、蘇巴什（Subashi）及都勒都爾阿護爾（Duldur-Aqur）等地帶壁畫的洞窟及古老廟宇。從7月起，探險隊為了能考察更多的地方而分開，並於10月9日在烏魯木齊的俄羅斯領事館碰頭。他們在中國土耳基斯坦的首都逗留至1907年12月25日，此城由於是諸多涉及1898-1900年事件的中國名人流放的地點而顯得十分熱鬧。伯希和再次碰到了蘭親王，他是已故光緒皇帝的嫡親兄弟及1900年義和團的領袖端親王的兄弟。在與中國文人聊天的機會中，伯希和獲知在甘肅邊界的敦煌附近，一位道士在一座十一世紀起即被封壁的洞窟內發現一批重要的手卷窟藏，從未遭竊盜過。在法國人來到之前，英國人歐雷爾·斯坦因（Aurel Stein），也適聞此一發現，特別搶先一步。然而，伯希和立刻就瞭解到，千佛洞將成為其探險之行的主要階段。為了到達敦煌，路途將是遙遠的，因為必須在極艱難甚至是險惡的狀況下穿過沙漠及高山峻嶺，加上溫度極端化和有時食物不足的情況。

　　1908年2月12日，終於抵達原為絲路古站的敦煌綠洲。離城不遠處有一座峭壁，其上被鑿出將近五百個洞窟，神奇地保留著，其內充滿壁畫及雕刻。普爾熱瓦爾斯基（Prjevalski）及博寧（Bonin）的敘述中，以及洛克濟教授（professeur de Loczy）所率領的匈牙利探險隊皆已提及莫高窟遺址的存在，但是遺址從未被好好地研究過。而遺跡係由一位名叫王道士的道人所看管。斯坦因已成功地說服王道士，向其展示著名的第17窟，內藏有上萬件的寫本、卷軸、印刷品、冊書和各式繪畫，避過了改朝換代的征服者，跨越數世紀而保存下來。但斯坦因超前伯希和只是暫時性的，由於伯希和博學多聞，記憶力強與精通十三種語文最後終究能成就一個瘋狂的計劃：第17窟收藏品的詳細清單。對年輕的天才而言的他必須待在洞穴窟約三週的時間，每天必須審閱近一千冊的文件，以能記錄及區分從六世紀至十世紀間所有的文字與著作。在這一段期間，努埃特負責記錄遺址的平面圖及拍攝

數百張相片（圖2），伯希和於1920至1940年間公開這些相片。靜坐在塵埃中使用一支蠟燭照明（圖3）的伯希和毫不鬆懈地在其之筆記中寫下：「1908年3月3日。我在此渡過了星期二的狂歡節，整整花了十小時蹲在長寬各十尺的藏經洞中，三面環繞著深度兩三層的書籍；除了在地上之外無法攤開這些手抄卷，然後再將它們捲起來；雖然我極度地疲勞，但我對這一天的辛苦不感遺憾。這些數千件的卷軸由王道士於1900年發現，其中還有尺寸極大開的藏文頁式寫本。以中文與西藏文占了大部份，由玄奘所翻譯的《大般若波羅蜜多經》高達六百餘冊的數量，占了令人難以置信的地位」。伯希和在敦煌慶祝他卅歲的生日。

1908年5月，探險隊離開敦煌，於10月初抵北京。當伯希和一抵達北京就告知中國的學者尚存留在第17窟中那批古書的重要性。由於這些中國學者反應熱烈，伯希和決定多留一年在中國，而努埃特及瓦揚則啟程返回法國。伯希和在上海和北京購買了約三萬冊書，以期能好好研究及瞭解他驚人的敦煌發現。

1909年10月伯希和返回法國，將其所攜回的物品分置於國家圖書館及羅浮宮博物館，後者並特設一展覽專室，他同時寄放一些作品在吉美博物館。這位年青漢學家的重大發現不只引起了一些競爭對手，甚至有人懷疑在敦煌所發現文獻的真實性。儘管遭到這些攻擊，伯希和仍受到學術界的支持，收到數百封的支持信，有些係由斯坦因、馮勒柯克或奧登堡（Oldenburg）所寫的。

1911年，為了獎勵其所有的研究成果，法蘭西學院為伯希和成立了一個講座，當時他年僅卅三歲。他被任命為中亞考古及歷史教授。伯希和終生保留此一職位直至1945年逝世。

伯希和在其有生之年一直與中國維持著關係：第一次大戰中，他被任命為駐北京武官，1920年成為《通報》（T'oung Pao）雜誌的聯合社長，1939年獲選為中央研究院的永久院士。伯希和在其個人文件中保存著大量的中文書信，同樣地也見證他與中國的特殊關係。

伯希和一生發表了無數的專文和博學的研究結果，但從未有多餘時間的出版有關其旅游及中亞的大著作，使得大眾對他並不熟悉。他的旅途筆記本以及大量的信件為其探險期間所有的情況提供了珍貴的資料。透過他豐富的見證，伯希和至今仍為研究東方學中最傑出的代表人物之一。伯希和不僅是早熟的天才、理性的漢學家、熱情的發掘者，亦是一位老練的「冒險家」，他嘗試尋找出曾經跨越中亞和及當今中國領域的豐富文化之見證。他所攜回的「寶物」今日收藏在法國國家圖書館及吉美博物館，這些文獻提供我們有關中亞東部佛教區（"SERINDE"印度與中國之間一片廣大、偶有綠洲的沙漠地帶）的語言、藝術、風土、傳統等的歷史資料，其重要性無以倫比。這些文獻的研究離結束尚有一段距離，但同時隨著時間而有所進展。以伯希和中亞行攜回文物為主題所辦的展覽 — 其中亦包括敦煌文物，同樣地也加入了此研究風潮的行列中。敦煌莫高窟被聯合國文教科學組織指定為世界文化遺產，愈來愈吸引國際學術界的注意，而諸項保護遺址及建立資料庫的計劃也開啟了一個新的紀元。伯希和參與了開啟東方研究的新道路，基於此，伯希和的遺產應該繼續被研究，出版及開放給大眾知曉。

H. 瓦瑞文斯，《H. 保羅・伯希和 (1878-1945)，他的生平和著作—傳記》，2001年，印第安那大學東方研究第九輯，布魯明頓。
莫妮克・瑪雅爾，《敦煌石窟，保羅・伯希和使記，題記和壁畫》，1992年，XI-1至XI-6卷，巴黎，法蘭西學院。
蘿荷・斐爵，《亞洲的歲月及面孔》，迪炯美術館，展覽目錄，1996，頁115-124。
《中國及上亞洲的寶藏，保羅・伯希和百年誕辰》，1979年，展覽目錄，法國國家圖書館。
《保羅・伯希和旅途筆記，1906-1908中亞使命行》，目前正由吉美博物館準備出版中。
傑克・吉埃，《中亞藝術》，1996年，RMN，巴黎。

Paul Pelliot and the Expedition in Central Asia

Patricia de la Motte
Musée national des Arts asiatiques-Guimet

At the end of the 19th century, Europe underwent a period of intellectual and spiritual excitement. Scientific, geographic and archaeological expeditions increased and revealed a certain fascination for the legendary Silk Road. This route, used since Antiquity by merchant caravans and pilgrim monks, was, for a long time, the favored link road between European, Eastern and Far-Eastern cultures. The discovery of exceptional documents such as the Bower manuscript, near to Kutcha or the one found nearby by Dutreuil de Rhins in 1892, fed this growing interest.

Into this particular climate, the French sinologist Paul Pelliot was born on 28th May 1878. Son of a Parisian industrial figure, he studied at one of the best institutions in Paris, Stanislas College. Brilliant student, he acquired a knowledge of classical culture, learning both Latin and Greek. With the intention of following a career in the diplomatic service, the young Pelliot secured a degree in English, a diploma from the Institut des Sciences Politiques, and studied Chinese at the Ecole des langues Orientales. Another great sinologist, Edouard Chavannes, Professor at the Collège de France, became his mentor and led Pelliot on the path of research and linguistic studies.

At the age of twenty-one, Pelliot was made a fellow of the Ecole Française d'Extrême-Orient (EFEO), based in Saigon and undertook his first expedition to Hanoi in Indochina. Then, at the beginning of 1900, he was sent to Beijing by the library of the EFEO to acquire Chinese books and works of art for study. This period was to leave a deep impact on the career of the young sinologist, particularly the episode of the Boxers revolt against the installation of the Foreign Legations at Beijing. As fights were paralysing the town since May, Paul Pelliot broke through the barricades and began discussions with the insurgents, while "having some tea." Following these events, he was rewarded for this act of bravery and received the Croix de la Légion d'Honneur. During his commission at the EFEO, Pelliot gathered a significant collection of Chinese, Tibetan and Mongolian works, including works of art and remarkable Buddhist and Taoist paintings.

When he returned to France in July 1904, Pelliot specialised in the study of Central Asian civilizations and learned six languages: Russian, Mongolian, Persian, Tibetan, Ouigour and Sanskrit. He was already known for his first works, in particular for his studies on Chinese travellers of the VI and XIII centuries, and was approached by the French Committee of the International Association for the Exploration of Central Asia to head a major archaeological expedition to Chinese Turkestan. He was also expected to take part in archaeological expeditions organized all over Europe, Russia and Japan.

A Pelliot's letter dated 2nd August precises the content and purpose of the mission. This scientific expedition was organized on the initiative of the French Committee of the International Association for the Exploration of Central Asia and the Far East. The funding for the expedition was provided by the Ministère de l'Education, the Académie des Sciences, the Académie des Inscriptions et Belles Lettres, the Musée d'Histoires Naturelles, leading geographical societies and some private individuals, notably prince Roland Bonaparte. Young Pelliot was appointed to head the expedition. As Professor of Chinese at the EFEO, he was also responsible specifically for the archaeology, linguistics and history. His two companions on this journey were Louis Vaillant, Pelliot's childhood friend and Major-Doctor, 2nd Class in the Colonial Army. He was responsible for topographical and astronomical plans and for studying native species. Pelliot's other companion was Charles Nouette who was in charge of photographical documentation. Other personnel were recruited in Russian and Chinese Turkestan. In planning the journey, the route envisaged passed through Alessandrovo, Moscow, Orenburg, Tashkent, Kashgar, Kutcha, the Lob Nor, Cha-tcheou, Si-ngan-fou, Ta-t'ong-fou of Chan-si and Beijing, to name the main sites. The principal aim of the expedition was the research and study of the archaeological vestiges left in Central Asia by Buddhism, prior to the Islamic conquest. In a letter addressed to the Minsitère de l'Education, Pelliot even suggests that the old folk songs of Turkestan should also be collected. But this idea was rejected due to a lack of funding.

After more than a year of preparation, the expedition left Paris on 15th June 1906 (see photograph 1). They arrived in Tashkent on 25th June, after eleven days of travelling by train, only to discover that their baggage had failed to arrive. One month later, time for Pelliot to improve his Oriental Turkish, the expedition left for the town of Och, situated at the foot of the mountainous barrier separating Russia and China. At Och, a caravan of around thirty horses was organized, lead by two Russian Cossacks named Bokov and Iliazov. One other person accompanied the expedition for a while. He was the future Marshall-President of the Finnish Republic, the Baron de Mannerheim, who was then an officer in the Russian Guards. Later on, a young Chinese named Ting joined the expedition as an assistant. After crossing the Altai at an altitude of nearly 4,000 m, and descending via the Kyzilsu valley to reach Kashgar, the expedition arrived at Tumchuk on 2nd October 1906. By good luck, Pelliot made his first discovery after scraping the ground a few meters from the main road. Buried in the soil was a head made from sun-dried clay, in a clearly Greco Buddhist style. Over the following six weeks, a more detailed excavation revealed a significant number of figurines made from sun-dried clay and groups of bas-relief depicting the jataka (now housed in the Musée Guimet). Unfortunately, due to a lack of time, the excavations were not completed and the expedition was once again underway, to fulfil even greater plans.

It was due partly to chance, but above all to his perfect mastery of the Chinese language and historical knowledge that Pelliot received an exceptionally warm welcome in Chinese Turkestan. Although he was a foreigner, Chinese civil servants ranked Pelliot as a highly qualified, literate man. He was so well regarded that every time they stopped, courtesy was frequently expressed in terms of visits and dinners invitations.

From 2nd January 1907, the expedition stopped for nearly eight months at the large oasis of Kutcha. Here, the area was already occupied by the German expedition of Grünwedel and Von Lecoq, and Berezovski's russian expedition. However, the surrounding area was particularly rich in Buddhist relics and Pelliot examined the painted caves and ancient temples of Kumtura, Subashi and Duldur-Aqur. In July, the team separated in order to cover a wider area and regrouped at the Russian consulate at Urumchi on 9th October. The capital of Chinese Turkestan, where they stayed until 25th December 1907, was at that time a very busy place. It served as a place of exile for numerous Chinese personalities who had been compromised in the events of 1898-1900. Pelliot found himself in the company of Duke Lan, German cousin of the deceased emperor Guangxu and brother of prince Duan, head of the Boxers of 1900. Whilst in discussion with these gentlemen, Pelliot learnt that a Taoist monk had discovered a cache of manuscripts in a cave that had been walled up since the XI century, and which had been spared by the plunders. This cave was near Dunhuang, in Gansu province. Englishman Aurel Stein had also heard of the discovery before the French expedition reached the area and had taken care to be the first on the scene. In spite of this, Pelliot understood immediately that the Caves of the Thousand Buddha would constitute the fundamental stage of his journey. The route was long and fraught with difficult and sometimes dangerous conditions. It crossed deserts and mountains, and exposed them to extreme temperatures and scant food supplies.

Notwithstanding, they finally reached the oasis of Dunhuang, a former stopping point on the Silk Road, on 12th February 1908. Close to the town was a cliff into which had been carved some five hundred caves, painted and sculpted, which were miraculously well-preserved. As can be read in the accounts of Prjevalski, Bonin and Professor Loczy's Hungarian expedition, the caves of Mogao had not yet been excavated thoroughly. The site was guarded by a Taoist monk named Wang. Stein had succeeded in persuading the monk to show him the famous Cave no. 17 which contained tens of thousands of manuscripts, scrolls and paintings, folded up together for centuries to keep them safe from plunderers. Stein's advantage over Pelliot was only temporary since Pelliot, thanks to his erudite knowledge, prodigious memory and mastery of thirteen languages, was eventually going to be able to carry out an amazing feat, namely the detailed

inventory of all the material contained in Cave no. 17. The young genius spent almost three weeks frantically examining and documenting one thousand documents per day. The inscriptions and other works dated to the VI and X centuries. During this time, Charles Nouette was given the task of making a plan of the site and taking hundreds of photographs (photograph 2), published by Pelliot between 1920 and 1924. Sitting in the dust, with only a candle for light (photograph 3), Pelliot was constantly deciphering and conscientiously writing in his notebooks. "*3rd March 1908. I spent all of Shrove Tuesday for ten hours in a row, crouched in a niche ten feet by ten feet with manuscripts and books lining three of the walls, two or three books deep. There was no other way of unrolling and rolling them except on the ground. I am aching terribly, but I do not regret spending my day in this manner. These are thousands of scrolls that Wang-tao found in 1900, with enormous Tibetan leafed manuscripts. They are mostly in Chinese and Tibetan, and the translation of the Mahāprajñāpāramitā-sūtra by Hiuan-tsang holds an incredible place with its six hundred or more volumes.*" Paul Pelliot celebrated his thirtieth birthday at Dunhuang.

In May 1908, the expedition left Dunhuang to reach Beijing towards the beginning of October. As soon as he arrived, Pelliot alerted Chinese scholars of the significance of the texts still contained in Cave no.17. The enthusiasm of these scholars was such that Pelliot decided to stay in China for another year. Nouette and Vaillant, however, returned to France. In Shanghai and Beijing, Pelliot bought nearly 30,000 manuscripts in order to understand more fully and study the amazing discoveries made at Dunhuang.

On his return to France in October 1909, Paul Pelliot shared the items collected during his travels between the Bibliohtèque nationale de France and the Musée du Louvre, where a room is dedicated to him, as well as leaving some items at the Guimet Museum. The wealth of discoveries made by the young sinologist gave him not only followers, but some people went so far as to question the authenticity of the documents found at Dunhuang. In spite of these attacks, Pelliot found support in the scientific community and in the hundreds of letters he received, some written by Stein, von Lecoq and Oldenburg.

In 1911, in recognition of his works, he obtained a Chair at the Collège de France, although he was only thirty-three years old. He was appointed Professor of Central Asian History and Archaeology. He maintained this responsibility until his death in 1945.

During his life, Paul Pelliot maintained his links with China. He was appointed military attaché to Beijing and in 1920 he became the co-director of the Tun'g Pao review and was elected permanent member of the Academia Sinica in 1939. The significance of correspondence in Chinese kept by Pelliot in his personal papers bears witness to this special relationship.

Author of many articles and academic studies, Pelliot never had the time on his travels and in Central Asia to give talks, which would have made him better known to the general public. His notebooks, as well as his abundant correspondence, offer a valuable insight into the travelling conditions of the expedition. Through his many accounts and writtings, Paul Pelliot remains one of the more outstanding figures in Orientalism. A precocious genius, sinologist by study and explorer by passion, he was also a seasoned "adventurer," in search of testaments to the richness of the civilizations that populated Central Asia and that is now China. The "treasures" he brought back and kept at the Bibliothèque nationale de France and the Musée des Arts Asiatiques-Guimet are counted among the most significant documents with regard to the linguistic and artistic history, traditions and folklore of Indochina. Study of these documents is far from finished and continues day after day. Exhibitions organised for the material brought back from Dunhuang among other places, also contribute to this ever-increasing knowledge. Recognized as a United Nations World Heritage site, Dunhuang is becoming more and more open to the international scientific community and conservation projects and databases are paving the way forward. Paul Pelliot participated in broadening the horizon with regard to oriental studies and, because of this, his legacy continues to be studied, published and exhibited to the public.

H. Walravens, H. Paul Pelliot (1878-1945). His Life and Works - a Bibliography, Indiana University Oriental Studies IX, Bloomington, 2001.

Monique Maillard, Grottes de Touen-Houang, Carnets de Notes de Paul Pelliot, Inscriptions et Peintures Murales. XI-1 to XI-6. Paris. Collège de France. 1992.

Laure Feugère, Ages et Visages de l'Asie, catalogue d'exposition, Beaux-Arts de Dijon, 1996. pp. 115-124.

Trésors de Chine et de Haute Asie, centième anniversaire de Paul Pelliot. Exhibition catalogue. Bibliothèque Nationale, 1979.

Paul Pelliot's note books, under publication, Musée des Arts asiatiques-Guimet.

J. Giès, Les Arts de l'Asia Centrale. RMN Paris, 1996

Paul Pelliot et la Mission en Asie Centrale

Patricia de la Motte
Musée national des Arts asiatiques-Guimet

A la fin du XIXe, l'Europe connaît une véritable effervescence intellectuelle et spirituelle. Les missions scientifiques, géographiques et archéologiques se multiplient et révèlent une certaine fascination pour la mythique Route de la Soie. Cette route, pratiquée depuis l'Antiquité par les caravanes marchandes et les moines pèlerins, présente une voie privilégiée, reliant depuis longtemps les cultures européennes aux cultures orientales et Extrême-orientales. La découverte de documents exceptionnels, tels que le manuscrit Bower près de Koutcha ou celui trouvé par Dutreuil de Rhins en 1892, participent à cette intérêt grandissant.

C'est dans ce climat particulier que naît le sinologue français Paul Pelliot, le 28 mai 1878. Fils d'un industriel parisien, il fait ses études dans un des meilleurs établissements parisiens : le collège Stanislas. Elève brillant, il acquiert une culture classique, apprenant le latin et le grec. Se destinant au début à une carrière de diplomate, le jeune Pelliot obtient une licence d'anglais, ainsi que le diplôme de l'Institut des Sciences Politiques tout en apprenant le chinois à l'Ecole des langues orientales. Un autre grand sinologue, Edouard Chavannes, professeur au Collège de France, devient son maître et conduit alors Pelliot sur la voie de la recherche et des études en linguistique.

A 21 ans, Pelliot est nommé comme pensionnaire à l'Ecole française d'Extrême-Orient (E.F.E.O.) située à Saïgon et part pour sa première mission en Indochine, à Hanoï. Dans ce cadre au début de l'année 1900, il est envoyé à Pékin afin d'acquérir des livres chinois et des œuvres d'art à étudier pour la bibliothèque de l'Œ.F.E.O. Cette période va marquer profondément la carrière du jeune sinologue, en particulier l'épisode de la révolte des Boxers contre les légations étrangères installées à Pékin. Alors que les luttes paralysent la ville depuis le mois de mai, Paul Pelliot franchit les barricades et entame les discussions avec les insurgés, tout « en prenant le thé ». A la fin des événements, il est récompensé pour son acte de bravoure et reçoit la croix de la légion d'honneur. Au cours de son mandat pour l'E.F.E.O. il rassemble un corpus important d'ouvrages chinois, tibétains et mongols, mais également des collections d'objets d'art et de peintures bouddhiques et taoïstes remarquables.

De retour en France en juillet 1904, Pelliot se spécialise dans l'étude des civilisations d'Asie centrale tout en apprenant 6 langues dont le russe, le mongol, l'iranien, le tibétain, le ouïgour et le sanscrit. Remarqué pour ses premiers travaux, notamment sur les récits des voyageurs chinois du VIe au XIIIe siècle, il est pressenti par le Comité français de l'Association internationale pour l'exploration de l'Asie centrale pour diriger une grande expédition archéologique dans le Türkestan chinois. Il s'agit également de prendre place parmi les missions archéologiques qui s'organisent de toutes parts en Europe, en Russie et au Japon.

Un manuscrit écrit de la main de Pelliot et daté du 2 août précise le contenu et le rôle de la mission. Cette expédition scientifique est organisée sur l'initiative du Comité français de l'Association Internationale pour l'exploration de l'Asie Centrale et de l'Extrême-Orient. Les fonds de la mission sont souscrits par le Ministère de l'Instruction publique, l'Académie des Sciences, l'Académie des Inscriptions et Belles Lettres, le Museum d'Histoire naturelle, les principales sociétés de géographie et par quelques particuliers dont Roland Bonaparte. Le jeune Pelliot est tout désigné pour prendre la tête de la mission. Professeur de chinois à l'EFEO, il est ainsi chargé plus spécialement de l'archéologie, de la linguistique et de l'histoire. Ses deux compagnons de route sont Louis Vaillant, ami d'enfance de Pelliot et médecin-major de 2e classe de l'armée coloniale, chargé d'établir les relevés topographiques, astronomiques et d'étudier les espèces naturelles ; et Charles Nouette, chargé de la documentation photographique. A ce trio s'ajoute le personnel recruté sur place au Turkestan russe et au Turkestan chinois. L'itinéraire prévu dans le projet de départ passe par Alessandrovo, Moscou, Orenburg, Tachkent, Kachgar, Koutcha, le Lob Nor, Cha-tcheou, Si-ngan-fou, Ta-t'ong-fou au Chan-si et Pékin pour les principaux sites. L'objectif principal de la mission est la recherche et l'étude des vestiges

archéologiques laissés en Asie centrale par le Bouddhisme, antérieurement à la conquête islamique. Dans une lettre adressée au Ministère de l'Instruction Publique, Pelliot lance même l'idée de recueillir les vieux airs populaires du Turkestan. Faute de moyens, le projet est finalement rejeté.

Après plus d'un an de préparatifs, le départ de l'expédition a lieu à Paris le 15 juin 1906 (illustration1). Arrivés à Tachkent le 25 juin après onze jours de chemin de fer, une mauvaise surprise attend les voyageurs car les bagages ne sont pas encore arrivés. Après un mois, le temps pour Pelliot de perfectionner le turc oriental, la mission repart pour gagner la ville d'Och, située au pied de la barrière montagneuse qui sépare la Russie et la Chine. A Och, est organisée une importante caravane d'une trentaine de chevaux menée par deux cosaques russes, Bokov et Iliazov. Une autre personne accompagne la mission pendant un temps, il s'agit du futur Maréchal-Président de la République Finlandaise, le baron de Mannerheim, alors officier de la garde russe. Plus tard encore, se joint à la mission le jeune chinois Ting, alors engagé comme aide. Après avoir franchi l'Alaï à près de 4000 m d'altitude et descendu la vallée du Kyzil-sou pour atteindre Kachgar, la mission parvient à Toumchouq le 2 Octobre 1906. Par le plus heureux des hasards, en grattant le sol à quelques mètres de la grande route, Pelliot fait sa première découverte :

Illustration1. « Le Jour du Départ , 15 juin 1906», Au centre, Paul Pelliot, à droite Charles Nouette, à gauche, le Docteur Louis Vaillant. La photographie est adressée « A mon cher papa. Paul Pelliot » (Photographic Musée des Arts Asiatiques-Guimet)

enfouie dans le sol, une tête en terre séchée arborant un style nettement gréco-bouddhique. Commence alors une fouille plus étudiée de six semaines pendant lesquelles se révèle un nombre conséquent de figurines en terre séchées et des groupes de bas-reliefs illustrant les jataka (aujourd'hui conservés au Musée des Arts Asiatiques-Guimet). Malheureusement, faute de temps, les fouilles restent inachevées et la mission doit à nouveau repartir car un dessein encore plus grand l'attend…

La chance mais surtout sa parfaite maîtrise de la langue chinoise et ses connaissances historiques vont permettre à Pelliot d'être accueilli dans le Turkestan chinois dans des conditions exceptionnelles. Les fonctionnaires chinois assimilèrent Pelliot à un lettré des plus qualifiés, bien qu'étranger. Si bien qu'à chaque arrêt, les visites et les repas de courtoisie étaient fréquents.

C'est autour de la grande oasis de Koutcha que la mission va séjourner pendant près de huit mois, à partir du 2 janvier 1907. Là, le terrain est déjà occupé par les missions allemandes de Grünwedel et Von Lecoq, et russe de Berezovski. Mais les environs sont particulièrement riches en vestiges bouddhiques et Pelliot étudie les grottes peintes et les anciens temples de Qoum-Toura, Soubachi et Douldour-Aqour. A partir de juillet, l'équipe se sépare pour couvrir plus de terrain et se retrouve le 9 octobre au consulat russe d'Ouroumtchi. La capitale du Turkestan chinois où ils séjournent jusqu'au 25 décembre 1907 est alors très animée car elle sert de lieu d'exil à de nombreuses personnalités chinoises compromises dans les évènements de 1898-1900. Ainsi Pelliot retrouve-t-il le Duc Lan, cousin germain de l'empereur défunt Guangxu et frère du prince Duan, grand chef des Boxers de 1900. A l'occasion de discussions avec les lettrés chinois, Pelliot apprend qu'un moine taoïste aurait découvert près de Dunhuang, aux confins du Kan-Sou, un extraordinaire dépôt de manuscrits dans une grotte murée depuis le XIe siècle et épargnée par les pillages. L'Anglais Aurel Stein a eu aussi vent

de la découverte avant le passage des Français et il a pris soin de prendre de l'avance. Cependant Pelliot comprend immédiatement que les Grottes aux Mille Bouddha vont constituer l'étape capitale de son voyage. Pour y parvenir, la route est longue car il faut traverser dans des conditions difficiles et parfois périlleuses, déserts et montagnes, avec des températures souvent excessives et une alimentation parfois précaire.

Illustration2. Photographie prise par Charles Nouette.
« Douen-Houang, intérieur de la grotte P 63 ».
Photographie Musée des Arts-asiatiques Guimet.

Mais le 12 février 1908, l'Oasis de Dunhuang, ancienne étape sur la route de la Soie est enfin atteinte. Tout près de la ville se trouve une falaise dans laquelle sont creusées près de 500 grottes, peintes et sculptées, miraculeusement conservées. Signalé par les récits de Prjevalski, Bonin, et la mission hongroise du professeur de Loczy, le site des grottes de Mogao n'a encore jamais été étudié sérieusement. Le site est gardé par un moine taoïste répondant au nom de Wang. Stein avait réussi à persuader le moine de lui montrer la fameuse grotte n°17 qui renfermait, repliés sur eux-mêmes après des siècles de conservation à l'abri des conquêtes, des dizaines de milliers de manuscrits, rouleaux, imprimés, carnets et peintures divers. Mais l'avantage de Stein sur Pelliot n'est que temporaire car ce dernier, par sa connaissance érudite, sa prodigieuse mémoire et les treize langues qu'il maîtrise, va finalement réaliser un projet fou : un inventaire détaillé du matériel de la grotte 17. Il faut près de trois semaines au jeune génie pour relever et distinguer, à un rythme effréné de 1000 documents par jour, les inscriptions et les œuvres datant du VIe au Xe siècle. Pendant ce temps, Charles Nouette est chargé de relever le plan du site et effectue des centaines de clichés (illustration 2) qui seront publiés par Pelliot entre 1920 et 1924. Assis dans la poussière, éclairé à la seule lueur d'une bougie (illustration 3), Pelliot lit sans relâche et écrit dans ses carnets : « *3 mars 1908. J'ai passé le mardi gras entier, dix heures de rang, accroupi dans la niche aux manuscrits, 10 pieds sur 10 pieds, avec deux et trois profondeurs de livres sur trois côtés ; impossible de déliasser et reliasser autrement que par terre ; je suis terriblement courbaturé, mais je ne regrette par ma journée. Ce sont des milliers de rouleaux qu'a trouvés le Wang-tao en 1900, avec d'énormes manuscrits tibétains en feuilles. Le chinois et le tibétain font la grosse masse, et la traduction du Mahāprajñāpāramita-sūtra par Hiuan-tsang tient avec ses 600 et quelques volumes une place incroyable.* » Paul Pelliot fête son trentième anniversaire à Touen-Houang.

Illustration 3. « Paul Pelliot dans la grotte aux manuscrits»
Photographie Musée national des Arts-Asiatiques-Guimet

En mai 1908, la mission repart de Dunhuang pour rejoindre Pékin vers le début du mois d'octobre. Dès son arrivée, Pelliot alerte les érudits chinois sur l'importance des textes encore en place dans la grotte 17. L'enthousiasme de ces derniers est tel que Pelliot décide de rester un an de plus en Chine, alors que Nouette et Vaillant repartent pour la France.

Il achète ainsi à Shanghaï et à Pékin près de 30,000 ouverages afin de mieux étudier et comprendre les fabuleuses découvertes de Dunhuang.

A son retour en France en octobre 1909, Paul Pelliot répartit ses caisses de voyages entre la Bibliothèque Nationale et le Musée du Louvre où une salle lui est dédiée, avec quelques dépôts au Musée Guimet. L'ampleur des découvertes du jeune sinologue ne fait pas que des émules, certains vont même jusqu'à dénoncer l'authenticité des documents trouvés à Dunhuang. Malgré ces attaques, Pelliot est soutenu par la communauté scientifique et des centaines de lettres lui sont envoyées, écrites pour certaines par Stein, von Lecoq ou Oldenburg.

En 1911, en récompense de tous ses travaux, une Chaire au Collège de France est créée alors que Pelliot n'a que 33 ans. Il est nommé professeur d'histoire et d'archéologie de l'Asie centrale. Il conservera cette fonction jusqu'à sa mort en 1945.

Paul Pelliot ne cesse durant sa vie d'entretenir des liens avec la Chine : il est ainsi nommé comme attaché militaire à Pékin, en 1920 il devient co-directeur de la revue Toun'g Pao et est élu en 1939 comme membre permanent à l'Academia Sinica. L'importance de la correspondance en chinois gardée par Pelliot dans ses papiers personnels témoigne également de cette relation privilégiée.

Auteur de très nombreux articles et d'études érudites, Pelliot n'a jamais eu le loisir de donner sur ses voyages et sur l'Asie centrale les grands ouvrages de synthèse qui l'auraient mieux fait connaître du grand public. Ses carnets de notes ainsi que sa correspondance abondante offrent de précieux renseignements sur les circonstances de voyage de la mission. Par ses nombreux témoignages, Paul Pelliot demeure une des plus brillantes figures de l'Orientalisme. Génie précoce, sinologue par raison, découvreur par passion, il fut aussi un « aventurier » chevronné, en quête de témoignages de la richesse des civilisations qui ont peuplé l'Asie Centrale et la Chine actuelle. Ses « trésors » rapportés et conservés à la Bibliothèque nationale de France et au Musée Guimet comptent parmi les documents les plus importants qui nous renseignent sur l'histoire linguistique et artistique, traditionnelle et folklorique de la Sérinde. Les études de ces documents sont loin d'être terminées et se développent de jours en jours. Les expositions organisées sur les matériaux rapportés entre autres sites de Dunhuang participent également à cette mouvance. Reconnu comme patrimoine mondial de l'UNESCO, le site de Dunhuang s'ouvre de plus en plus à une communauté scientifique internationale et les projets de conservation et de bases de données amorcent une ère nouvelle. Paul Pelliot a participé à ouvrir de nouvelles perspectives aux études orientales, et pour cela son héritage doit continuer à être étudié, publié, et exposé au public.

H. Walravens, H. Paul Pelliot (1878-1945). His Life and Works-a Bibliography, Indiana University Oriental Studies IX, Bloomington, 2001.

Monique Maillard, Grottes de Touen-Houang, Carnets de Notes de Paul Pelliot, Inscriptions et Peintures Murales. XI-1 à XI-6. Paris. Collège de France. 1992.

Laure Feugère, Ages et Visages de l'Asie, catalogue d'exposition, Beaux-Arts de Dijon, 1996. pp. 115-124.

Trésors de Chine et de Haute Asie, centième anniversaire de Paul Pelliot. Catalogue d'exposition. Bibliothèque Nationale, 1979.

Carnets de voyages de Paul Pelliot, publication en préparation, Musée Guimet.

J. Giès, Les Arts de l'Asia Centrale. RMN Paris, 1996.

張大千與敦煌石窟藝術之內在聯繫特質

巴東　國立歷史博物館

一、導言

圖1 張大千，〈倣石濤山水軸〉，水墨設色紙本，1934，私人收藏（圖版說明請見文後）

圖2 張大千在敦煌洞窟中描摹壁畫的情形，1942年

敦煌，一個充滿著歷史、神秘、浪漫、古遠以及幽渺意象的名詞。

就人文地理而言，敦煌是中國古代來往於西域的門戶，也是連貫中西著名交通要道「絲路」的中繼站，因此薈萃了中國、印度、西亞、中亞（波斯、阿拉伯）等各種多元種族的文化特色，呈現了異彩繽紛的文化景觀。

就文化資源而言，敦煌石窟的藝術寶藏舉世聞名，不但是中華文物的瑰寶，更是屬於全體人類的世界文明遺產。敦煌歷經了包括北涼、北魏、西魏、北周、隋、唐、五代、宋、西夏，以及元等十個朝代共千餘年的文化累積，其於歷史考古的重要文化價值固無論矣，而其在藝術方面的燦爛瑰麗更是令人嘆為觀止[1]。

對藝術家來說，敦煌是用之不盡，取之不絕的靈感泉源，也是創作學習取法的對象。最早遠赴敦煌臨摹壁畫，取法古人苦心孤詣的藝術偉業，且規模成就最高也最大的畫家首推張大千（1899-1983），大致已是公認的事實。然而其成就究竟為何，恐怕也有必要再作深一層的釐清，否則致力於敦煌壁畫臨摹之成就者亦大有人在，而張大千與他人相異的特殊成就何在？

在當今研究藝術史的領域中，嘗有謂論明末書畫大家石濤（1642-1707）之藝事成就而不知有張大千其人其藝者，則不足以深論石濤[2]。就筆者個人的觀點而言，研究敦煌彩繪之精麗偉構，倘若不探究張大千與敦煌藝術息息相關的藝術創作內涵，恐怕在某種程度上來說，亦難充分體認敦煌藝術其表現特質之精微所在。這裡並非指研究敦煌學的豐富內涵非涉及張大千不可，但至少藝術這個區塊，通過張大千對敦煌石窟藝術的創作表現，可以帶給世人不同啟發的新視野。

但實際上張大千與敦煌在相當程度上也有著密不可分的關係，就敦煌石窟而言，張大千對石窟藝術的保存宣揚功不可滅，他的壁畫臨摹成就讓國人矚目，亦引起當道重視，而成立了敦煌藝術研究所。對張大千個人而言，他閉關三年於敦煌研摹古人壁畫，上探北魏隋唐之精麗高古，使他由一個「文人畫家」的風格取向，邁入了「職業畫家」的藝術創作領域。由此張大千掌握了敦煌彩繪上千年以來最重要的藝術表現特質，而開創他本人的藝術大業。本文於此嘗試將張大千藝術創作與敦煌石窟之內在深層聯繫作一分析說明，庶幾供世人作若干認知之參考。

二、敦煌之行的源起

張大千在三○年代間已經在國內畫壇頗有名氣，常往來於北京上海兩地。當時這兩處是中國南

北兩大文藝薈萃中心,而他已在兩地闖出字號,受到國內畫壇相當的矚目。四〇年代初他步入中年,在內涵修養方面已進入到成熟穩定的境地;在此之前,他的藝術創作風格主要多在文人水墨寫意的畫風範疇。張大千性好旅遊,喜歡看雲觀海,常不惜跋涉千里增廣見聞;僅黃山一處他便攀登過三次,而當時黃山人煙荒蕪,入山途徑極艱困,而未嘗令之卻步。

論及大千當初赴敦煌面壁之緣起,他自述說:「最早我是聽曾、李二師談起敦煌的佛經、唐像等,不知有壁畫,抗戰後回到四川曾聽見原在監察院任職的馬文彥到過敦煌,他極力形容偉大,我一生好遊覽追古蹟自然動念,決束裝前往,這是民國二十九年間的事。」[3] 其後又加上藝友葉公綽(1881-1968)多次鼓勵他專攻人物畫,以振明清人物畫日趨衰頹之弊,遂決定西去敦煌看個究竟[4]。但不料大千最尊敬的二長兄張善子(1882-1940)卻於1940年底病逝重慶,大千乃倉促回奔辦理後事,傷心之餘返回青城山,敦煌之行遂延至次年三月間方始成行[5]。

張大千遠赴敦煌,在其地生活達二年七個月,自籌一切龐大開支,集結門人、子姪、喇嘛多人之力,臨摹壁畫大小共二百七十六件,其間過程之艱苦遠非一般人所能想像,而他所表現出來的勇氣、毅力及對藝術的虔誠,則堪稱「偉大」二字;作家高陽即曾說,「他在敦煌兩年有餘的生活之本身,便是一大成就。」[6] 但實際上,當初張大千遠赴敦煌之初,也沒有想到他後來會耗費如許大的精力、時間、資源於該地[7]。

張大千第一次去敦煌是在1941年3月,帶著三夫人楊宛君,門人子姪以及五百公斤的行李,由成都飛往蘭州。當時的蘭州市長蔡孟堅很幫張大千的忙,很清楚張大千敦煌之行的艱苦。他說大千在蘭州準備赴敦煌時,「其籌備工作一如遠征作戰。自蘭州出發,雇用卡車數輛,有時車輛發生故障,改乘『拉拉車』或駱駝代步跋涉,加之敦煌缺乏飲水及肉食蔬菜,多需自蘭州購運,且土匪出沒無常,人人危懼,他偕同家人冒險犯難到達目的地後,竟敢深入那幾十個暗藏『牛鬼蛇神』的洞中,依次考證,探尋古蹟壁畫、立架樹梯,艱苦臨摹,預定三個月,竟及二年零七個月之久。」[8],再加上氣候之嚴寒酷暑、風沙蟲螫、缺柴缺水,工作環境之惡劣可想見一般。

當大千抵達千佛洞的那天清晨,天色未亮就迫不及待的提燈入洞探視;這一看發現不知較原先想像中偉大多少倍,原訂計劃是來此觀摩三個月,但在第一天粗略地看過一些洞後,他就對他的太太子姪們說恐怕留下來半年都還不夠[9]。激勵張大千留下來痛下苦功的原因頗多,一方面是他深受敦煌藝術的偉大而感動啟發,另一方面則來自於他對藝術創作執著堅毅的抱負;尤其在工作過程中,他深深體驗到古人為藝術奉獻犧牲的精神。他說:

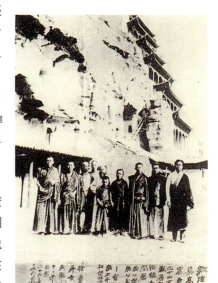

圖3 張大千與子姪心智、心玉、喇嘛等人攝於敦煌莫高窟第44窟前,1943年

> 我在敦煌工作,多方面幫忙,都感覺非常困難,揣想起來古人比我們更困難。我們在敦煌時還有玉門油礦供給我們洋臘,雖然不太好,總比油燈好得多。古人在洞中繪畫,由於光線不夠,其困難是可想而知的。

大千描述「白天,午前八九點鐘,敦煌的太陽射進洞子,一刻過午之後,太陽往南走,光線就暗

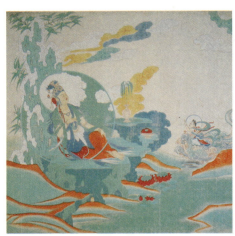
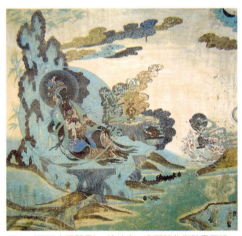

圖4 張大千，〈西夏水月觀音〉，水墨設色布本，140.8 × 144.5cm，ca.1942，成都四川省博物館

圖5 〈西夏水月觀音〉，榆林窟二窟西壁北側壁畫原蹟，西夏

了，不方便；下午是背光的。因為洞門很小，要光線只有點火，點著火作畫，牆又高又大，搭起架子，人站著還可以，最困難的就是天花板上的高處和接近地面的低處，一高一低，畫起來都很困難。天花板往往幾丈高，要畫屋頂一定要睡著、躺著才能夠畫，但是古人的畫，雖然在天花板頂上，也沒有一筆是軟弱的，一如他們畫在牆上同樣的好。可見他們的功力技巧，遠在我們現代人之上。」

　　張大千一來感慨今不如古，二來也十分痛惜「古人把一生的精力都犧牲在藝術上，在敦煌洞裡就埋沒了不少有功夫的畫家，連姓名都沒留下來。」[10] 由是大千深受古人的精神感召，閉關面壁痛下臨摹功夫近三年，鑽研古代畫家的描繪技法。自此大千乃上溯隋唐北魏的精麗高古，使他由原本清新秀逸的文人畫風邁入了「職業畫家」的藝術創作領域；畫風一轉而為精密雄渾之體，對其一生的藝術發展產生了無與倫比的深遠影響，其盛年「集中國古典畫學傳統大成」[11] 的藝術創作性格肇因於此，而其晚年開創潑墨潑彩之時代新畫風亦與敦煌藝術風格脫不了干係。

　　然而在世態人情間，敦煌之行卻帶給張大千一生之際極不愉快的困擾與經驗，那就是使他蒙上了「敦煌盜寶，毀壞古蹟」的惡名，使得以迄於晚年的張大千都深感遺憾，而深具憂讒畏譏之忌[12]。

三、敦煌石窟藝術的內在表現特質

　　敦煌在漢武帝時開始設郡（公元前121年），唐代其地又稱沙州，距今一千五、六百年前是東西文明交通要道「絲路」的中繼站，也是中西文化薈萃交流之所。由魏晉南北朝以迄隋唐是中國佛教（文化）最昌盛的時代，而敦煌莫高窟等地層樓疊殿的四百多座洞窟中所蘊藏的壁繪彩塑，則是從北朝迄元八百多年漫長歲月中僧侶、信士、藝術家以及鑿洞工匠等無數人的心血結晶，這其中的血汗、信仰，要比財力物力更為重要；這些不但是先民集體藝術的寶藏，亦是他們奉獻心靈的聖地。

　　敦煌的彩塑、壁畫、建築、絹畫等藝術結晶，都是當時所留下的人類文明瑰寶與光輝。其優美莊嚴的造型，妍麗生動的色彩，不但統合了東西千餘年的繪畫彩塑的精華，也超出其他任何時空地域的佛教藝術成就。其內容表現雖起自宗教卻直逼人生；處處透顯出人世間善惡嗔癡、煩惱歡喜等眾生實相，洋溢著生命的律動與力量。壁窟內莊嚴寧靜的佛像菩薩、健美優雅的飛天、儀態威猛的

天王力士，以及虔誠的信徒男女，將佛經說法、本生、地獄等各種經變故事的龐大場面，襯著鮮豔的色彩、富麗堂皇的藻飾、典雅莊穆的建築，交織成一空前金碧輝煌與生動緊湊的視覺景觀，呈現出撼人的氣勢，令觀者深受感動。

歸納以上所述，可知敦煌佛教藝術最特殊而重要的表現特徵，即在於視覺精奇效果所呈現的「裝飾性」。所謂「人要衣裝，佛要金裝」，即使是濟世度人的菩薩，假如未繼以寶冠、珠玉、瓔珞、法器、霞光、瑞彩、華飾，協侍等五光十色的裝飾形式，恐怕諸佛菩薩的說法也難以呈現那「法相莊嚴」的意境。所謂「莊嚴」者，裝飾也。實際上，宗教儀式都十分講求藝術形式的運用，例如佛教的法器鐘鼓、梵音梵唱都具有氣勢龐大的莊嚴效果，這都是音效形式的高度掌握；再加上前述空間藝術之燦爛表現，可使任何經過這樣視覺(繪畫)、觸覺(建築雕塑)、聽覺（梵音梵唱）、嗅覺（檀香）接觸的對象，立即承受無比的感動與震撼，在佛光普照之下產生虔誠的宗教情感，從而使生命得以淨化。

就這點而言，西方基督教的宗教儀式亦是如此，例如哥德式教堂向上升起的建築空間、室內玻璃花窗所透進的光量、聖母耶穌的聖潔與受難形象、基督教的圖繪故事（猶如敦煌的「經變」）；禮拜儀式的聖歌、唱詩、燭光，以及風琴鳴奏的回音等，都交織成一片神聖莊嚴的氛圍，實際上都是藝術形式的運用。就此而言，信徒與其說是被宗教內容所感動，倒不如說是先被藝術形式所打動。

因此換句話說，「裝飾」的效果與「形式」運用的掌握，即是敦煌石窟藝術最重要的創作表現特質。一般而言，在藝術上假如過於強調「裝飾性」的風格，往往是偏重經營外表華飾唯美的傾向，通常缺乏生命內涵的深度，因而藝術評價通常並不高。然而敦煌石窟藝術的裝飾效果，卻是來自於整個時代的生命整體對宗教信仰所產生的虔敬情感，其璀璨的藝術成就中包含著雄偉的生命莊嚴力量，這其中有著高度的藝術境界，因此不能僅以外表的華麗精美來評價。這裏所顯示的裝飾意義，實際上是一種「精采感動」，也就是前述所說的「法相莊嚴」，並非一般所認知的「美麗漂亮」。

這裡必須要再進一步說明的是，藝術之美感形式與宗教之生命內涵必須互為表裏，方是佛教「法相莊嚴」的精義，否則徒落於外表的華飾，那麼這種裝飾的境界就很低了，也談不上是所謂「莊嚴」。本文只是強調佛家內涵的精微意境若要普遍的宣揚，仍必須借重於外在的形式包裝，也就是現代所謂「行銷推廣」的方法。於是敦煌整體的藝術風格色彩繽麗濃艷、描繪精緻繁複，而呈現金碧輝煌的高度裝飾效果，則是一件可充分理解的事。換言之，唯有如此燦爛瑰麗之表現方能激發宗教熱力之感動，此絕非文人寫意書畫風格恬雅清逸的境界所能達到。

張大千後來的藝術發展，即是他掌握了敦煌石窟藝術這項的內在深層特質，而逐漸建立了其個人龐大的藝術創作體系。這其中他不但承續敦煌佛教藝術高度裝飾性之表現，更進一步將之作結合時代氛圍的現代發揮—青綠潑彩畫風的產生。敦煌石窟藝術與張大千晚年所開創的青綠潑彩畫風，都具有高度裝飾性的造型特質，而其中關鍵即在於「色彩」方面的使用。張大千對色彩原

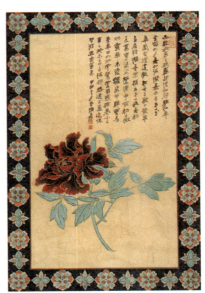

圖6 張大千，〈潑墨紫〉，水墨設色紙本，66 × 41 cm，1944，私人收藏

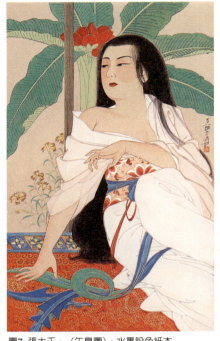

圖7 張大千，〈午息圖〉，水墨設色紙本
46 × 29 cm，1951，台北私人收藏

本就具有極敏銳的天分，敦煌道釋人物畫的專業繪畫風格表現，除了線條勾勒精擅以外，特別注重妍麗精美的設色；石青、石綠、硃砂都是古人慣常使用濃彩顏料，張大千由此深入研摹這種繪畫風格，使他恢復了中國畫家在唐宋以前用重色重彩的傳統，再現了自元代以後逐漸失去的色彩生命。

張大千晚年的青綠潑彩畫風，則更能將色彩鮮麗的高彩度質感發揮到極致，實際上仍是基因於敦煌石窟藝術之影響。因此張大千在色彩方面的成就，可說後世文人畫風興起以來，最能掌握色彩特質的中國畫家；故筆者曾特為指出，張大千是中國藝術史上最注重「裝飾性」表現，以及掌握「形式」能力最強的畫家[13]。由是可知，張大千與敦煌石窟藝術的互動發展關係；張大千的藝術創作受到敦煌佛教藝術極深鉅之影響，而敦煌高度裝飾性的藝術表現，也因為通過張大千而達到更徹底地發揮。

四、張大千的敦煌壁畫摹本

臨摹壁畫大致有兩種方式：一種是「現狀式」的臨摹，亦即按壁畫之現狀描摹，因此其線條色澤、造型肌理經過時間而氧化變質的斑剝痕跡都按原蹟畫出；因此畫面色澤比較黝暗，而造型輪廓亦不明顯，特能呈現一種蒼古歲月的面目。另一種則是「復原式」的臨摹，臨摹者需深入觀察壁畫的底層，揣摩原蹟用筆用色的本意，並據以再生壁畫的原貌；因此往往輪廓清晰，色澤鮮麗如新。張大千的敦煌壁畫摹本都是以「復原式」的臨摹方式為主，而大千以後赴敦煌臨摹的畫家則多是以「現狀式」的臨摹方式為主。以上兩種臨摹方式都必須有高度的藝術表現能力，而各有其重要的價值；前者著重於原蹟現貌的資料保存，偏向於歷史考古的內涵意義；而後者則著重於復興古人的繪畫面目，偏向於藝術創作的內涵意義。

由於古代壁畫之原貌後世畢竟難以作完全的確認，是以後世之臨摹觀念多偏向於原蹟保存的現狀描摹。然而張大千本人的創作經驗豐富，加上其精深的畫學修養，因此雖似個人創作的主觀臨摹方式，但亦有其客觀依據之相當考證，他說：「壁畫色多斑斕，尚須秉燈靜視良久才能依稀看出線條，我主要在觀摹揣測上下功夫，往往數十次觀研之後才能下筆。」[14] 同時他也再三強調「臨摹的原則，是完全要一絲不扣的描，絕對不能參加己意，這是我一再告訴門生子姪們的工作信條，若稍有誤，我就要重摹，由此令他們叫苦不已。」[15] 故大千摹本之藝術成就可觀，而考古意義亦不容小覷。

張大千於敦煌面壁，總共完成大小壁畫摹本共二百七十六幅；這些摹本主要收藏在成都四川省博物館(約二百餘件)，以及台北的故宮博物院 (六十二件)，以及少部分散落於私人藏家之手。張大千本人也曾將他在敦煌長時間的實地觀察，加以深入分析，發表了一篇共一萬一千餘字的長文〈談敦煌壁畫〉[16]，其中論述了許多他對敦煌壁畫的研究心得，是一份研究「敦煌學」極有價值的文獻。

由這篇專文以及這批壁畫摹本的綜合觀察,可以了解張大千在畫風的轉變上,實際受敦煌壁畫之影響所在。

其一是「線條」用筆,大千自此盡去文人畫風筆墨纖弱之病,此實得力於敦煌佛像人物畫之線條表現。魏晉隋唐古人特重線描用筆,所謂「曹衣出水,吳帶當風」;宋李公麟(1049-1106)更創所謂「白描法」,不賦色彩,專門以線條用筆來表現作畫之特殊風格。後世文人畫興起,這種風格逐漸失傳。然而這種變化多端,精當準確的線條卻在敦煌的古代壁畫中比比皆是;張大千在感動之餘大受啟發,乃著力痛下苦功勤練線條,終能掌握古人用筆的作畫關鍵。因此,張大千的線條筆法,可謂復興了隋唐高古的用筆傳統。

他指出線條的運用主要在人物畫方面的表現,畫人物線條尤其要有剛勁的筆力才能勝任;敦煌佛畫線條之勁秀絕倫直如鐵劃銀鉤一般,只可惜後代人物畫式微連帶減低了對線條的重視[17]。試觀張大千在敦煌所畫的諸多摹本,無論菩薩頭像、羅漢表情、象奴體態,鬼怪造型以及諸菩薩之輪廓五官、衣飾飄帶、身軀手足等,其線條無不流暢生動,精練有力。影響所及,大千畢生論畫藝,首重線條鉤勒,認為是一切作畫的基礎,足見其重視線條的程度[18]。

其二是為「色彩」。繪畫在西方素有「色彩的音樂」之稱,意謂畫面的視覺意象主要是源自於色彩搭配調和所形成的韻律效果。假如抽離色彩的表現元素,繪畫即無法達到其為視覺藝術的理想境地,可見色彩之造型因素在繪畫上的重要。中國自元代以後文人畫水墨畫風興起,畫家們雖時時刻刻不忘以自然為師,於造化氤氳中追求筆墨造境的真實基礎,超脫了炫目喧麗的色相,但卻漸離「畫是眼睛的藝術」之原始意義。

然而中國繪畫風格在唐宋以前皆由職業畫家所主導,他們卻極重視精豔色彩的運用。張大千在看到敦煌精工富麗,金碧輝煌的色彩表現後,促使他深下功夫精研古人之設色方法,並向喇嘛學習石青、石綠等礦物顏料的調製方法[19],他說敦煌自北魏至西夏八百多年間,「不管是那一個朝代,那一派作風,但他們總是用重顏料,即礦物顏料,而不用植物性的顏料,他們以為這是垂之久遠要經若干年的東西,所以對於設色絕不草率。而且上色不只一次,必定二三次以上,這才使畫的顏色,厚上加厚,美上加美。」[20] 他在敦煌所畫的大批摹本,無不色澤鮮明穠艷,敷染純厚,將高彩度的色質發揮盡致,呈現高明視度的視覺效果。自此,敦煌壁畫所經常使用的石青、石綠、硃砂等重色,都成為張大千其後在繪畫創作上所經常使用的主要色彩。

其三則是敦煌「鉤勒」之技法。大千指出古人畫壁畫「是先在壁上起稿時描一道,到全部畫好了,這初時所描線條,已被顏色所掩蓋看不見,必須再在

圖8 張大千,〈山雨欲來〉,水墨設色紙本,93 × 116 cm,1967,私人收藏

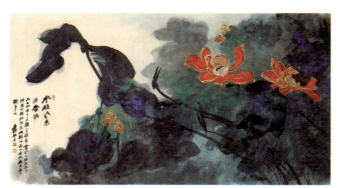

圖9 張大千，〈潑墨鈎金紅蓮〉，水墨設色紙本，94 × 175 cm，1975，私人收藏

顏色上描一道，也就是完成工作最後一道描。唐畫起首一道描，往往有草率的，第二道描將一切部位改正，但是最後一道描，卻都很精妙的將全神點出。且在部位等方面，與第二道描，有時不免有出入。壁畫是集體的製作，在這裡看出，高手的作家，經常作決定性最後一描，有了這種鈎染方法，所以才會發生這敦煌崇高的藝術。」[21]

由上述可知，這種勾勒的程序是敦煌畫壁畫的特殊技法。畫壁畫初稿時，通常是由首席畫師審驗定稿，交由初級的助理畫師在經過打底並處理好的畫壁上放大起稿，資深畫師核定修正過初稿後，再分交各人分多次敷染設色，每畫一種色彩都必須先經過底色打底，使色彩看來沉凝古艷，資深畫師則在旁隨時督導。待壁畫接近完成時，輪廓線的第一道與第二道描多已掩蓋或模糊不清，此時則交由功力最高深的首席畫師，加以全面的審核潤飾，並勾勒出最後一道精準的線描，這道手續則是全部壁畫製作過程的成敗關鍵。

是故張大千在敦煌所臨摹的壁畫，皆經過喇嘛、門人、子姪等多人合力完成；有些壁畫摹本或未及完成，或未經張大千本人作最後一道勾勒之潤飾處理，因此大千傳世敦煌壁畫之摹本，品質高下的水準有時相差頗大。這種集體繪製的作業方式，與西方古典傳統的油畫工作室(Atelier)頗有相通之處[22]。這種勾寫技法對張大千影響很大，他後來畫山水、人物、花鳥、走獸皆從此法，先以淡墨起稿佈局，再以主輪廓線重新勾摹定位，使畫面呈現多元之層次變化，所作無不精美豐厚，此實為敦煌描繪技法之延伸。

其四則是格局氣魄的增大。近代中國畫家中，張大千特別有一項他人所難以比擬的能耐，那就是他擅於經營尺幅碩大的畫作。畫大畫是畫家最艱難的挑戰，也是畢生藝術修養與功力的嚴格考驗。假如畫家胸中丘壑不足，不是落於大而無當的空洞，便是落於局部填塞的瑣碎，因此畫大畫至難。張大千之所以能構築大畫，主要仍是受到敦煌之行的歷練與啟發。敦煌壁畫場面盛大，面積往往有高達數丈，長逾十數丈的規模；其精麗繁複的彩繪，人物眾多與氣勢磅礴的宏偉景象給予張大千極大的震撼，他說：

畫家也必要有幾幅偉大的畫，才能夠在畫壇立足。所謂大者，一方面是面積上講，一方面卻在題材上講。必定要能在尋丈絹素之上，畫出繁複的畫，這才見本領，才見魄力。如果沒有大的氣慨、大的心胸，那裡可以畫出偉大場面的畫？我們得著敦煌壁畫的啟示，我們一方面敬佩先民精神的偉大，卻也要從畫壇狹隘局面挽救擴大起來，這才夠得上談畫，夠得上學畫。[23]

由於張大千在敦煌臨了許多巨幅的壁畫摹本，掌握了古人繪製巨幅大畫的技法，大幅增強了他在藝術創作上的氣魄格局。自此他雄心展現，一生勇於面對巨幅大畫作之挑戰。大千由敦煌返回四川以後，更自運構思佈局，籌作大畫；一九四五年其於成都畫展展出〈西園雅集〉八屏及〈大墨荷通屏〉四幀轟動國內藝壇，皆是受到敦煌大壁畫場面的啟發而作。張大千晚年開創潑墨潑彩之時代新風格後，再繪製了多件大幅鉅製，其中〈長江萬里圖畫〉與〈廬山圖〉二作，更是蒼鬱清潤，氣

勢磅礡，代表著張氏一生藝術成就之總結。巨幅大畫也成為張大千在近代中國藝術家中，他人所難比擬的重要藝術成就[24]。

五、結語

由以上之敘述可知，張大千藝術創作發展與敦煌石窟藝術實有緊密而不可分的內在聯繫關係。張大千赴敦煌苦修三年，就比較於其後一生奉獻於敦煌研究或壁畫臨摹二、三十年的人士而言，或許並不算夠久；但是張大千畢竟是早期藝術家披荊斬棘的第一人，且以當時敦煌其地工作環境之惡劣條件下，他堅苦卓絕的精神毅力著實令人動容。何況以其功力才情之高，自不能以一般之臨摹表現等閒視之；他乃是憑藉其精深之畫學修養與經驗判斷，通過敦煌壁畫來上溯元魏隋唐技法的精神理念，回歸古人的風格面貌。這使他深入掌握了敦煌石窟藝術最重要的藝術創作特質—「法相莊嚴」之視覺裝飾效果。

實際上這是一種「再生的創造」，而不是照本宣科地著重於表相。故早在一九四四年，史學家陳寅恪(1890-1969)曾特別評述張大千的壁畫摹本說：

> 敦煌學，今日文化學術研究之主流也。大千先生臨摹北朝唐五代之壁畫，介紹於世人，使得窺見此國寶之一斑，其成績固已超出以前研究之範圍。何況其天才特具，雖是臨摹之本，兼有創造之功，實能於吾民族藝術上，另闢一新境界。其為敦煌學領域中不朽之盛事，更無論矣。[25]

「敦煌學」不但蔚為漢學界之學術研究主流，也由於張大千連續在重慶、成都等地，開了大規模的敦煌壁畫摹本展覽造成國內轟動，世人矚目；教育部乃在國內藝學界之呼籲下，成立了國立敦煌藝術研究所[26]；就此而言，張大千其於古蹟國寶之維護與宣揚功不可沒。

另一方面張大千晚年開創的青綠潑彩畫風，可謂將敦煌石窟藝術的表現特質，結合時代的新氣象而作了更進一步地詮釋與發展。由此可知，大千的藝術創作與敦煌石窟藝術之間，是一種互動延續的

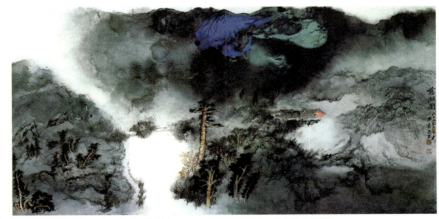

圖10 張大千〈慈湖圖〉，水墨設色紙本，90×180 cm，1976，台北私人收藏

發展關係而並非是一種單方面的影響承受。經過時間的累積醞釀，敦煌佛教藝術之影響特質在大千筆端，或為花卉、或為仕女、或為山水，變化萬千，令人炫目。其於發揮敦煌藝術風格的成就之所以難為後人企及，蓋以其深厚之文化底蘊超越皮相，直入「般若智」之無礙藝術境地，是之謂「大千」。大千者，「大千世界」也。

二〇〇五年嘉平月冬日於台北南海學園

1. 關於這一點，實在不需要筆者再加以贅述，介紹或研究敦煌藝術的專書、專文可謂不計其數。
2. 請參閱：傅申，〈大千與石濤〉，《張大千紀念文集》，1988年，台北國立歷史博物館，頁99。
3. 謝家孝，《張大千的世界》，1982年，台北時報出版公司，頁116。
4. 樂恕人編纂，《張大千詩文集》，1984年，台北黎明書局，頁124-127。
5. 有關張大千的敦煌之行，可另參閱：〈張大千敦煌壁畫摹本之創作發展析論〉，台北《典藏》月刊（古美術）112、114期，2002年，頁34、90；或巴東，《潑彩敦煌：張大千的藝術與生活》，台北典藏藝術家庭公司，2005年。
6. 高陽，《梅丘生死摩耶夢》，1984年，台北《民生報》，頁187。
7. 此處值得一提的是，大千敦煌之行有兩位好友鼎力支持，一位是為人「四海」的蕭翼之，大千尊之為「蕭二哥」；另一位叫楊孝慈，是成都中央銀行的經理。兩人多次幫張大千在成都張羅畫展籌措經費，以支應大千在敦煌及四川家裡兩邊的龐大開銷。大千敦煌之行三年，其經濟開銷頗仰賴於楊、蕭二人支持；說來大千敦煌之行的成就，兩人厥功至偉。
8. 高陽，《梅丘生死摩耶夢》，頁187。
9. 謝家孝，《張大千的世界》，頁118。
10. 劉震慰，〈大千居士再談敦煌〉，香港《大成雜誌》，34期，1976年，頁33。
11. 巴東，《台灣近現代水墨畫大系——張大千》，2004年，台北藝術家出版社，頁11-16。
12. 請參閱：張心智，〈憶隨侍我父敦煌行〉，五六卷第5、7期，1990年；李永翹，〈張大千敦煌冤案—揭毀壁畫情事真相大白〉，台北《雄獅美術月刊》，247期，1991年；巴東，〈張大千的人品究竟如何〉，《張大千研究》，1996年，台北國立歷史博物館，頁362。
13. 巴東，〈裝飾與形式〉，《張大千研究》，頁157。
14. 謝家孝，《張大千的世界》，頁127。
15. 謝家孝，《張大千的世界》，頁126。
16. 張大千口述，曾克耑整理，〈談敦煌壁畫〉，《張大千紀念文集》，1988年，台北國立歷史博物館，頁6-14。
17. 張大千口述，曾克耑整理，〈談敦煌壁畫〉，《張大千紀念文集》，頁11。
18. 張大千，〈畫說〉，《張大千畫》，頁16、17。
19. 張心智，〈憶隨侍我父敦煌行〉。
20. 張大千口述，曾克耑整理，〈談敦煌壁畫〉，《張大千紀念文集》，頁11。
21. 同前註。
22. 黃才郎主編，《西洋美術辭典》，1984年，台北雄獅圖書公司，頁754。
23. 張大千口述，曾克耑整理，〈談敦煌壁畫〉，《張大千紀念文集》，頁12。
24. 有關張大千的巨幅大畫，請參閱：巴東，〈張大千傳世的三幅山水鉅作〉，台北《美育月刊》102期，1998年，國立台灣藝術教育館，頁15-28。
25. 陳寅恪，〈觀張大千臨摹敦煌壁畫之所感〉，李永翹，《張大千年譜》，1987年，成都四川省社會科學院，頁191。
26. 最早是肇因於于右任（1878-1969）赴敦煌探看張大千的工作情形而決心發動此議；見《張大千的世界》，頁129。

圖1 張大千早期之文人書畫風格，筆墨清潤，意境逸雅。
圖4 此作色澤明艷，敷染醇厚，用筆細勻，意境優雅，是一件「復原式」的壁畫摹本，與原蹟面貌相差頗大。
圖5 此舖壁畫原蹟經歷歲月的痕跡，所見色彩多已氧化而呈黝黑色，可與大千摹本以及敦煌研究院史葦湘所臨的「現狀式」摹本，三者作一對照。
圖6 畫家自敦煌面壁以後，作花卉多見精麗穠艷的工筆風格，此作邊框的描繪十分具裝飾意味，明顯地是受到敦煌藻飾圖案的影響。
圖7 此作無論用筆、設色、構圖、造境，處處嚴謹，無一筆閃失。裝飾繪畫風格能入此一境地，實將敦煌佛教藝術「法相莊嚴」之精神理念融會貫通，盡收其手底。按此華麗精美之意象，不落一絲低俗意味，仕女衣衫半掩之性感造型，卻難令觀者生半分輕慢之心；石綠朱紅之對比配色大方明艷，尤見畫家恢弘不凡的氣度。
圖8 畫面上之青綠潑彩深邃濃艷，接近西方抽象現代藝術的風格表現；但其背後深層的內涵特質卻是遠承敦煌佛教藝術之影響。敦煌彩繪除了使用青綠等重彩外，也常用炫目的金色來強化視覺效果的華麗莊嚴；此作右下角的落款即用金粉來書寫，呈現了光彩奪目的意象，顯示畫家將來自於敦煌的影響作了更徹底的發揮。
圖9 這幅精麗絕倫的紅蓮，用彩度極高的硃砂來敷染荷花，色澤已十分豔麗；又用金線來勾寫花瓣，更顯得光彩奪目，華麗異常。其氣勢雄匹，筆墨老辣，是畫家的得意之作。這種瑰麗璀璨的裝飾效果，開前人所未有之境地，顯然也出於敦煌佛教藝術的影響。
圖10 為了突顯主題的神聖意象，畫家在潑墨暈染的山頭上施用了兩處妍麗純淨的青綠色彩，彩度極高，有如藍綠寶石般地光彩奪目，在畫面上特別提神搶眼。其造型上的象徵意義，即有如佛相菩薩項後的圓光，呈現一種意境莊嚴的神聖象徵，明顯地看出也是敦煌佛教藝術的深刻影響。

From the Forgotten Deserts:
Centuries of Dazzling Dunhuang Art 135

Traits of the Inner Connections between Chang Da-chien and Dunhuang Murals

BA Dong
National Museum of History, Taipei

I. Introduction

Treasures in the Dunhuang Grottoes are an endless source of literary and artistic creation and an irreplaceable resource for learning styles and techniques for artists. Chang Da-chien (1899-1983) was the first contemporary artist who made copies of and learned from the greatest achievements of the Dunhuang murals. While there are good many great artists devoting to copying Dunhuang murals, it is necessary to further investigate the differences between Chang and other artists. If we simply marvel at the splendor and craftsmanship of the murals without investigating the correlation between the artistic contents of Dunhuang art and Chang, it may be difficult to realize the sublime and subtlety of the artistic characteristics represented in the murals.

To Chang, after studying the murals for three years in isolation, he finally transformed from a "scholar artist" into a "professional artist" who really creates after investigating the essence of paintings made since the Northern Wei Dynasty through to the Sui and Tang dynasties. By capturing the most important traits of artistic creation of Dunhuang murals developed over the years, he finally initiated his own career in art. This article thus attempts to investigate in depth the correlation between the artistic creation of Chang and the Dunhuang Grottoes.

II. Origins of the Trip to Dunhuang

Chang had established a reputation in China in the 1930s and often traveled between Shanghai and Beijing, the art centers of southern and northern China. Chang had already developed a mature mastery of art in the 1940s when he was in his midlife. Before this period, he was still a "scholar artist" focusing on freehand brushing. He liked travel and loved watching nature, so he would travel a thousand miles to broaden his view. It explained the reason why he visited Huangshan thrice when it was almost uninhabited at that time. Though the road to the peak was long and winding, it never frustrated his strong determination.

Regarding the reason why Chang wanted to visit Dunhuang, he said,

> I heard of the Buddhist sūtras and figures of the Tang Dynasty in Dunhuang for the first time from masters Tseng and Li, but I didn't know there were murals. It was not until Ma Wenyian, a former official of the Investigation-Censor Bureau, told me how magnificent the Dunhuang murals were when I returned to Sichuan after the outbreak of the Second Sino-Japanese War (1937-45) that I was motivated to take a good look at those historical monuments. It was in 1940 then.

It was also due to the advice of an artist friend called Yeh Gongchang (1881-1968) who encouraged him to revive the declined tradition of figure painting since the Ming and Qing dynasties that he decided to take a look of the murals in Dunhuang. Unfortunately, Chang was forced to return to take care of the funeral of his beloved older second brother Chang Shanzi (1882-1940) who died in Chongqing of illness in 1940. He was so sad that he returned to Qingshan City and the trip to Dunhuang was postponed to the following March.

Chang stayed in Dunhuang for two years and seven months. With funds he raised for himself and for the support of his students, nephews and lama painters, he copied a total of two hundred and seventy-six works from the Dunhuang murals, and what he had suffered is beyond our imagination.

Chang came to Dunhuang for the first time in March 1941 by plane from Chengdu to Lanzhou with his third wife Yang Wanchun, students and nephews, and five hundred kilograms of luggage. It was early morning when Chang arrived at

the Cave of the Thousand Buddhas, and he could not wait for daylight and rushed into the caves immediately with a torch. Amazed by the splendor of the murals, he told his wife and nephews that he would stay there for over six months instead of the original plan to stay three months. There were many reasons making Chang stay there to learn from the murals. On the one hand, he was deeply motivated and inspired by the greatness of Dunhuang art; on the other hand, it was due to the perseverance and aspiration of a true artist, especially the devotion of ancient artists he felt during the copying work.

Being called by the spirit of ancient artists, Chang spent about three years' time on studying the techniques and styles of the murals in isolation. This allowed him to transform from a "scholar artist" looking for being elegant into a "professional artist" who really creates after capturing the essence from the paintings made since the Northern Wei Dynasty through to the Sui and Tang dynasties. His turn toward accuracy and power had by far changed his career for the rest of his life and had initiated his style that "combines the achievements of classical Chinese painting" in his great years. Moreover, his invention of the splash-ink and splash-paint techniques in his late years was an effect of his trip to Dunhuang.

Yet, the trip also brought him unhappy experience and troubles for the rest of his life. He was accused of "stealing from Dunhuang and damaging historical monuments." This explained why Chang felt regret in his late years and had troubles to live up to that gossip.

III. Internal Characteristics of Dunhuang Art

The painted statues, murals, architecture and paintings on silk found in Dunhuang are the treasures and glory of human civilization that passed down by our ancestors. The elegant and solemn styles and attractive and vivid colors of these works not only have integrated the essence of paintings and painted statues of both Asian and western cultures over a thousand years, but also have surpassed the achievement of Buddhist art anywhere at any point. Though subjects in the works are religious, they represented the seven emotions and six desires in reality, such as good and evil; greed, anger and confusion; vexation and pleasure, and brim over with the rhythm and strength of life. Inside the caves, the solemnity and quietude of the Buddha and bodhisattva statues, the proportional shape and elegance of flying apsaras, the bravery and power of the maharajas, and the devout believers are the elements that weave forever the magnificent, vivid and well-knitted visual effects of the vast scenes in Buddhist parables, human nature and inferno in glamorous colors, majestic decorations and classical architecture. They are sensational and inspiring.

Concluding the above descriptions, the "decorativeness" presented in the peculiar visual effects is the extraordinary, key feature of Dunhuang art; the effect of "decoration" and mastery of "form" are the most striking features of artistic creation of Dunhuang art. In general, bias on external beauty is the result of over emphasis on "decorativeness"; and works of such kind are often soulless and have little artistic value. In the decoration in the murals of Dunhuang however, the representation of total devotion to religion of all men of all periods is so complete, so the murals are splendid because they are filled with the dignity and strength of the religious spirit. They encompass high levels of art and cannot be justified simply by their brilliant appearance. The decoration presented in the murals is, in fact, the "wonder of emotions," that is, the "dignity of dharma" instead of just "beauty and splendor."

In fact, the "dignity of dharma" in the murals is the combination of the esthetic form and religious spirit. Otherwise, it is simply florid decoration without a soul, and the artistic value of murals is degraded, and "dignity" is never found. That is

to say, "packaging" can help promote a refined doctrine of Buddhism like the "marketing technique" in modern times. In this case, the magnificent and splendid decorations of murals in the brilliant colors and detailed brushing are reasonable and acceptable. In other words, it was such kind of splendid and gorgeous expression that the passion of religion could be stimulated, and none of them can be achieved by freehand brushing or the elegant and pure state of scholars.

After learning the inner purposes of the Dunhuang murals, Chang finally developed his own creative system that inherited the decorativeness of the Buddhist art in Dunhuang and combined the spirit of modern times-the indigo splash-paint style. Both the Dunhuang art and Chang's indigo splash-paint works in later years are highly decorative, and the "color" scheme is the key. Chang was sensitive to color, as for the Dunhuang murals, in addition to the special treatment of lines, color contrast is another focus in Daoist and Buddhist figures. Lapis lazuli, malachite, and cinnabar were the common heavy pigments that were used by ancient artists, and when Chang studied the murals during copying them, he successfully revived the saturated color tradition before the Tang and Song dynasties and the life of colors that faded since the Yuan Dynasty. Dunhuang art has cast a big influence on Chang's works, and the decorativeness of Dunhuang art was fully demonstrated in modern times because of Chang.

IV. Copies of Dunhuang Murals by Chang

Considering the features of Dunhuang murals, two copy methods were developed: the objective copy and restoration copy. The "objective copy" refers to copying the original work according to its present status. In this case, the line, color, texture and tone, and even the marks of deterioration and damage over time are faithfully recorded in the copy. Copies of such kind often look paler in tone and unclear in shape, suggesting a strong sense of antiquity. In the "restoration copy," artists need to study the background of the work and endeavor to capture the brushing and coloring schemes of the original work before restoring it. Therefore, works of such kind often have a clearer outlook and brighter tone. Copies made by Chang are mostly "restorations," while those made by later artists are "objective." Both methods require perfect artistic techniques, each of which has different values and features. The former stressing the preservation "as is print" of works is a history- and archaeology-oriented approach; while the latter emphasizing on restoring the "original print" of works is an art- and creation-focus approach.

Chang made the total of two seventy-six copies of Dunhuang murals. Most of them are collected by the Sichuan Museum (over two hundred works) and the National Palace Museum of Taiwan (sixty-two works), and a few of them are in the hands of private collectors. Chang also wrote an article called "Discussing Dunhuang Murals" of about 11,000 words on the murals according to his findings during his stay in Dunhuang. As it represented a report of his investigation of the murals, it has since become an important literature for Dunhuang Studies. From this article and the copies made by Chang, we can see his style change and the strong influence of the murals.

First, it is the style of line. After visiting Dunhuang, Chang gave up on the slim and powerless style of line as found in most scholar artists, which is the influence of the Buddha figures in Dunhuang. According to Chang, line is very important in figure painting, and powerful lines are the key to a successful figure painting. Lines that were used on Buddha figures in the murals were as powerful as steel, though such style was gradually neglected by later artists.

Second, it is the style of color. Artists before the Tang and Song dynasties were professional painters who had a strong preference for sharp and heavy colors. After seeing the brilliance and splendor of colors in the Dunhuang murals, Chang decided to study the color scheme of ancient artists in order to invent his own. He also learned the making of lapis lazuli, malachite, and other mineral pigments from Tibetan lama painters. All his copies have sharp colors, which exploit hue to

present a sharp visual effect.

Third, is the drawing technique. The drawing process is a special technique of Dunhuang murals and cast a great influence on Chang. After learning it from the murals, he applied the technique to his landscape, figure, flower and bird, and even animal paintings. In fact, he started the work with a light ink draft and outlined the object with lines in order to make changes on different levels. All works are accurately shaped and brilliantly colored, expressing the heritage of Dunhuang murals.

Fourth, it is layout. After making copies of many huge murals, Chang captured the compositional technique of huge works from ancient artists, which improved his competence in making large-scale works. Since then, he began to make huge works. After returning to Sichuan, he started to develop his own layout method for bigger works. At the Chengdu Exhibition held in 1945, his eight screens of The Elegant Gathering in the West Garden and four scrolls of Screens of Ink Lotuses shocked the domestic art circle at that time. Both works were inspired by the Dunhuang murals. After inventing the splash-ink and splash-paint style in his later years, Chang made many huge works. The Ten Thousand Miles of Yangze River and Lushan are verdant, luxuriant, refreshing, grand, and magnificent, representing the conclusion of his artistic life. In fact, large-scaled works have made Chang incomparable amongst contemporary Chinese artists.

V. Conclusions

Chang and Dunhuang art are inseparable from each other. With his comprehensive and profound artistic achievements and expertise, Chang acquired the spirit and key of the techniques and styles of artists since the Northern Wei Dynasty through to the Sui and Tang dynasties and revived the style and print of Dunhuang art from the murals. Furthermore, he captured the decorativeness and visual effect of the "dignity of dharma"-the most important artistic feature of Dunhuang art.

In fact, it is a form of "re-creation" instead of simply modeling. Therefore, historian Chen Yinke (1890-1969) wrote in 1944,

> *Dunhuang Studies have become a major trend of cultural and academic studies. Chang Da-chien's replicas of the Dunhuang murals not only presented the art of the Buddhist paintings made in the Northern Dynasties, Tang Dynasty and the Five Dynasties in ancient China, but also surpassed the scope of previous research. Though they are replicas, Chang's artistry is expressed in these works. Therefore, his attempt has broken a new horizon in the domain of cultural arts. His achievement is a landmark in Dunhuang Studies and his replicas are immortal.*

In this case, Chang's contribution to the preservation and promotion of historical monuments and national treasure is undeniable.

On the other hand, the dark blue splash-paint style he invented in his later years is a new interpretation and development of the artistic features of Dunhuang art in modern times. Therefore, instead of a type of one-way influence, Chang and Dunhuang art are mutually affected, and the former is the continuation of the heritage of the latter.

敦煌地區的官民生活淺析

謝世英　國立歷史博物館

　　敦煌壁畫的內容，大都根據佛經，主要是佛像、菩薩像、本生故事等為主題，其目的是宣揚佛法，但同時也有庶民生活的描述附屬其中，以及對當時政治、社會盛事的描繪。這些內容提供我們對當時不論是豪門貴族或一般庶民的生活面上的瞭解。敦煌當地豪門貴族的生活，以第156窟中張議潮出行圖【圖錄號34】及宋國夫人出行圖【圖錄號35】最著名。張議潮（798-872），沙州敦煌人，世代為州將，父張謙逸官至工部尚書；宋國夫人則是唐朝賜予他夫人的封號，描繪出豪門貴族出行時壯觀的行列隊伍，尤其作為前導的百戲、樂舞場面，是當時官民皆欣賞的流行活動之一。

　　除此之外，《法華經》中的各種譬喻品亦是研究生活百態的重要資料。六譯三存的《法華經》最常見的是《妙法蓮華經》本，其共分為二十八品，亦即二十八章。每品以不同的比喻故事來宣揚佛法，因此故事情節中，穿插著描繪一般人民生活的畫面：如〈藥草喻品〉中農田中工作的農夫、婦人田邊席地進餐等……，這些畫面的處理都非常真實而有趣。

　　在古代，河西走廊是中西絲綢之路的重要交通要道。在七至十世紀的中亞地區，是政治、文化交流的中心，在這裏主要是吐蕃（藏Tibetan）及漢人、回鶻或回紇人—即今日的新疆維吾爾族（Uighurs）雜處共居。這些部族，各自擁有不同的語言、文字、風俗與宗教，相互之間，曾以結親通好、進奉納貢、和平通使等方式，來換取短暫的和平[1]。一個地區經歷不同民族政治、軍事上的統治，通常隨之而來的是文化交融。敦煌是佛教名城，自唐朝到宋朝，先後經吐蕃、漢族、回鶻等族所統治，因此在敦煌壁畫中，不論是豪門貴族或庶民的生活，都可見多元文化交流及多民族雜居的場面，而其中胡舞與胡樂的流行乃是最佳的例證。同時，在日常生活及婚葬禮俗中，也有文化相融的痕跡。例如壁畫上就記載了吐蕃族婚禮的形象，在中唐榆林窟第25窟北壁上【圖錄號5】，可看到新郎及新娘的服裝與漢人款式並不相同：禮席上男子透額羅帽上的小禮帽，以及婦女的多辮髮式。此外，榆林窟中也有漢族與回鶻通婚的形象。另外，壁畫中還可見有高鼻深目，髭髯捲髮，牽駱駝的僧人或胡商，服裝上更是胡、漢服都有[2]。經由此城來往絲路的商客，不論來自中原或胡商，有許多信奉佛教者。以當時文化多元的的狀況推測，其實際情況應是比壁畫上所見，還要複雜許多。以下，僅從四方面淺析敦煌地區的官民生活狀況。

一、多民族的歷史

　　在七至十世紀（唐高祖至唐亡西元623-907）的二百多年間，唐朝為爭取西域的控制權，與吐蕃進行長期作戰。然而因內部的問題，如安史之亂（755-763）等，以致無力繼續經營西域，導致與中亞的交通幾乎中斷。因此河西敦煌地區，於781年左右為吐蕃所統制[3]。除了這兩大勢力之外，居住在中亞地區的還有回紇人。西元788年改稱回鶻，也就是維吾爾族，主要居住在今日的新疆。在西元840年左右，回鶻建立已百年的漠北回鶻汗國，被北部的部族所併，引起回鶻人遷移。其中有的南下依附唐朝，但大部分是遷到當時吐蕃統治下的甘州，也就是河西走廊。到西元851左右，敦煌地區為張議潮所掌握，因此回鶻人又依附漢族的張議潮。在西元900年，回鶻攻占甘州城，建立了甘州回鶻汗國。漠北回鶻國一直與中原保持良好的關係。中國歷史記載，回鶻世以中國為舅，與中國以甥舅相稱。十世紀，張承奉政權被回鶻所敗，稱回鶻可汗為父，成為附庸。兩者到了十一世紀初，被西夏所滅[4]。

吐蕃，就是現在的西藏，藏為漢語發音，有學者認為吐蕃一詞，第二字古音是「播」，也就是今日Tibet的發音。唐朝自始至終都未獲得西藏的主權，漢族與西藏之間，從唐朝迄今，仍為主權問題發生爭執。因此在維吾爾族的歷史中認為，有百年的時間，中國是在回族的保護中[5]。唐朝與吐蕃為西北疆域相戰近兩世紀，其間，吐蕃曾聯合回紇、南詔攻唐，唐也曾聯合回紇、南詔、大食、天竺等合擊吐蕃，直至唐末之際，唐朝內部藩鎮割據，國力已弱。另一方面，吐蕃也是歷經內部混亂，無力再攻唐。故唐末（821-907），唐朝與吐蕃之間已沒有大的戰事發生。

二、敦煌社會階層

西元847年，敦煌地區的漢人張議潮，率眾驅除吐蕃的統治，同時得到當地僧團的支持，獲得了地方掌控權。張議潮事件基本上是個獨立事件，並不出於唐朝與吐蕃競爭間的戰略規劃。張議潮將在吐蕃統治下的沙州河西十一州，歸到漢人的統治之下，因此被漢族視為功臣。唐朝則封張議潮為河西十一州節度使兼節御史大夫河西萬戶侯，其夫人也被封為宋國夫人。為紀念此事，其侄子張淮深於西元867年左右，開鑿第156窟並作壁畫。咸通八年（867），張議潮決定留居長安，河西地區的政務則委交張淮深。到了五代時期，敦煌地區落入張議潮的親戚曹議金之手，地方豪族的統治，直至十一世紀北宋初年被西夏消滅為止[6]。

九至十一世紀之間，沙州敦煌在歸義軍，也就是張議潮及曹議金的統治之下。經過二百年的經營，當時人口大約是三萬人左右，有五千餘戶，建有十七所寺院，約有二千名的僧人居住在當地，此外還有廣大的在家信徒。敦煌社會分為三個階層：一是由世家豪族與寺院高級僧侶集團所組成的上層階級。這個階層主要是張、索、李、曹、陰等世代為官的家族，也包括部分大姓及寺院都僧、大德高級僧侶，他們掌握著政、經、軍大權。中等階層是一般大姓、地主及一般寺院僧侶，和軍隊的中級官員。最下一層是一般的城鄉百姓，如壁畫中的奴婢、舞伎、樂工、各種手藝人等，都是庶民階級[7]。

收復敦煌自然是當時一大盛事，為了贊頌張議潮的功績，於是開鑿了敦煌莫高窟第156窟。洞中南、東、北壁的下半部，出現有張議潮出行圖【圖錄號34】與宋國夫人出行圖【圖錄號35】，兩幅皆高約一百零八公分，長約八百八十八公分。張議潮出行圖的榜題全文是：「河西節度使檢校司空兼御史大夫張議潮統軍□除吐蕃收復河西一行圖」。兩幅出行圖都是以樂舞場面為前導。張議潮出行圖中，是以軍隊輕騎為前導，旌旗招展，有舞伎八人，排成兩行，一邊四人，一行為戴襆頭，另一行束雙髻，繪彩絡額，垂於背後，著花衫、白褲，揮舞長袖。另有樂隊十人，演奏琵琶、箜篌、橫笛、篳篥、腰鼓等。張議潮出現在壁畫的中段，由文武百官簇擁著，騎在馬上，即將跨越短橋。後面有隨從官員、武士、輕騎及駝重的駱駝，壁畫後段的上方，可見兩名騎手，奔馳射獵，四隻獵犬尾隨左右。

在宋國夫人出行圖中，以百戲、歌舞為前導。在頂竿的後面是樂舞，舞伎四人，長袖飄飄，繞圓而舞，以敦煌地區的多元文化背景來看，這類歌舞可能是類似藏族民間歌舞的圓圈舞，稱之為「康諧」。康諧即康巴人跳的舞，又稱為巴塘弦子。另一旁則有樂隊四人，演奏橫笛、擊拍板，一人背大鼓、一人擊鼓。後接樂舞七人，演奏豎笛、笙、琵琶、腰鼓等。樂舞、衛隊的後方，緊接著的

是幾輛行李車。一輛是馬車,有人字形的車頂,車前有榜文:「司空夫人宋氏行李車馬」,後面另有馬車四輛[8]。宋國夫人圖中,後段騎馬的那位貴婦,著衫裙,帔帛,高髻,頭飾九樹釵,被一群女官及侍女、隨從簇擁著,正行過一棵大樹,侍女及隨從手中各捧著物件。在壁畫的中後段,後面跟著駱駝。此部分壁畫已損壞不全,但仍可見兩隻背負著酒甕等用品的駱駝隊。壁畫後段有騎手奔馳射獵,並有獵犬尾隨。兩幅作品都表彰了張議潮此時期在敦煌地區的重要性。

出行圖中,比較特殊的是宋國夫人出行圖中前導的百戲。在壁畫的左端,戴竿指的是那五人表演爬竿。最下方的一人,身著連身衣,外套半臂,白褲黑靴,頭頂長竿。竿上有四少年。一攀緣竿上作戲,一單手掛在一端,另一人倒掛在竿的另一端,竿頂還有一人懸垂水平。另有一人持長竿一旁站立。爬竿,也稱之為橦伎[9]或都盧,是「百戲」中的一種,除在宋國夫人出行圖中所見的五人一組的表演外,大都是一人在下,以手、頭、肩、肚、額頭、鼻子來頂一根竿,竿上有小孩,人數不等,在上面作懸垂、倒立、翻轉等各種表演[10]。

百戲是古代樂舞、雜技表演的總稱,中國在秦漢之時就有百戲,許多的活動中,都有舞樂。隋朝設有太常寺機構,唐朝則在長安及洛陽兩地,設立了左右教坊,作為專門管理百戲雜藝及各種俗樂的機構。當時有散樂數萬人,皇帝常在宮內設宴,伴以各種百戲舞樂的表演。作這些表演的人,許多是官廷藝人,其中也有西域人士。百戲的「百」指的是多樣,項目頗多,包括有走索、倒立、舉重物、繩索、高蹻及人上疊人,甚至吞刀吐火等,與今日的馬戲團相當。不難想像,百戲這樣的表演,並不限於宮廷所專有,民間也有同樣喜好。因此達官貴人的出行圖中,往往以百戲作為前導。所以,敦煌壁畫中,除了角抵(摔交及相撲)之外,也有疊羅漢、倒植(倒立)、橦技(爬竿)、翻觔斗、弄丸、樂舞等各項雜耍[11]。

三、敦煌庶民生活

敦煌壁畫農作圖的出現,在於宣揚不同的經文,但是也可藉此略窺庶民的生活。如《法華經》第五品的〈藥草喻品〉,其經文中提到:「一雲所雨,稱起種性而得生長,…其雨普等,四方俱下。雨之所潤,無不豐足。干地普濕,藥木并茂。…佛也如是,出現於世,譬如大雲,普覆一切」,解釋一切眾生聞佛法,但個人的種性不同,如一大地都為一雨所潤,而諸草木所獲滋潤各有差別[12]。因此在〈藥草喻品〉中,有農作圖的出現。如第23窟是一個法華窟,建於天寶年間,全窟的東、南、北壁以及窟頂的東、南二披,畫的都是法華經變的內容。北壁中間是靈鷲會,南壁中間是虛空會,在北壁西側是〈藥草喻品〉,下方是〈方便品〉、〈信解品〉、〈化城喻品〉與〈觀世音菩薩普門品〉。藥草喻品圖【圖錄號9】中之主題可分上下兩部分,以山水相隔。上部為農作圖,天上烏雲滿佈,大小雨滴落下來。經文云,「慧雲含潤,電光顯耀,雷聲遠震,令眾悅豫」。在圖上,可見烏雲滿佈,下起傾盆大雨。一農夫正在耕地,在圖的右方,有另一人,被三塊方形的經文所隔,右方農夫,肩挑著一根桿,頭戴蒻帽,向著左方走來。由圖中的犁田挑莊稼的景象觀察,推測敦煌地區仍用牛耕。一個農夫,以一牛拉犁。在圖中央,可見三人在田間席地進食[13],之間放置一大瓦盆,三人圍坐,其中一人頭戴帽,雙手持著食物,正在進食。一人紮著雙髻,手捧之物應為食物。

在農夫耕作圖的下部,即圖的左方,有一人正在跳舞,一人跪地膜拜佛塔,中間則有樂舞及小孩遊戲的景象。樂舞者,有六位坐在花氈上,各持不同樂器演奏樂曲;有吹笛者,其右邊則有四

位童子在田間玩堆沙的遊戲，沙堆堆得頗高。在法華經變中，常描繪有童子堆沙的景象。在《法華經》〈方便品〉中，有所謂：「乃至童子戲，聚沙為佛塔，如是諸人等，皆已成佛道」之語。宣傳得到佛法的途徑很簡單，童子也可做到，就算是在遊戲中堆佛塔，也可達到成佛之道。

另外，農作圖也出現在彌勒淨土變中，彌勒淨土變內容描述的是，當彌勒佛出世之時世上會出現「雨隨時，穀稼滋茂，不生草穢，一種七穫，樹上生衣，用功甚少，所收甚多」的理想世界。其所描寫彌勒出世的理想世界，是個不花勞力，就能「一種七穫」，樹上也長出衣服來的世界，因此在敦煌的壁畫上，也以農人耕作來表現這個理想的圖像。

此外，如佛本生故事的壁畫情節中，亦出現有農作圖。第290窟及第296窟中的農作圖，是依佛傳故事而畫的。其太子樹下觀耕的景象是根據佛傳中的記載：「太子出游，複次前行，到王田所，即便止息，閻浮樹下，看諸耕人。爾時，淨居天化作傷蟲，鳥隨啄之，太子見之，起慈悲心，眾生可愍，互相吞食。即便思惟，離欲愛界」。這個故事情節是發生在農田中，描繪悉達多太子，看到農夫耕田，而田中的牛踏過長蛇及孔雀，見此景，太子發慈悲心。第296窟中的農作圖，正是描繪佛傳故事中的太子觀耕，不同之處為中間的動物，太子看見一農夫正在耕田，而耕過的土地上，一隻蛤蟆正要吃小蟲，蛇要吃蛤蟆，而天上的孔雀要吃掉蛇[14]。

壁畫上雖看不出耕作農作物的種類，但是根據其他文獻記載來看，敦煌食物已是非常多樣化。在《俗務要名林》一書中，記載唐代人的主食，不只是麥，也有米，浙江大米是唐人的主食；同書另有記載，唐朝食用的肉類中，羊、豬、牛都有，而以羊肉為首。而在米麥上，除了拌蜜或是包熟餡的煎餅，也炊米為飯，或吃糯米飯及稀飯，以及作糯米餅包生肉煎熟。此外，還有蕎麥餅，或上有灑糖或果絲蒸的米糕，在敦煌變文集的資料中記載有飯、粥、餅、羹等主食[15]。在敦煌以旱田為主，因此小麥是主食。敦煌在唐朝時，糧食不但可自給，也可作為拓邊軍糧的儲備基地，天寶年間，在河西收購的糧食達三十七萬一千餘石，約佔全國總收量的三分之一[16]。

四、其他的生活場景

在敦煌的壁畫中，描繪了西域或中土來往求經、譯經的僧侶，也記載了僧人個人的生活面貌，如衛生清潔習慣等。清潔沐浴是必要的，因為在《佛說溫室洗浴眾僧經》中記載：入溫室洗浴後，能讓眾生長夜清淨，積垢消除，不遭眾患，其福無量[17]。寺僧一早起來，要刷牙，稱之為淨齒，通常拿來做為牙刷的是楊、柳、槐、楮之樹枝，沒有牙膏，因此選擇樹枝味道辛辣者為佳，以扁或是圓的小樹枝，使用時將一端做成纖維狀（砸爛或放入口中嚼）。在第146窟及第159窟中可見數幅僧侶梳洗、刷牙的圖像。第146窟中的僧侶，坐在地上，背對觀者，上身裸露，兩臂手上戴有手環，下身著袈裟及長褲。濃眉、蓄有鬍鬚，似非中土人士。他左手所執似為淨瓶，可能是正仰頭刷牙、漱口[18]。另一幅刷牙圖在第159窟的南壁，一僧人在畫面的右邊，正蹲在地上刷牙，有一沙彌站立在旁邊侍候。其他盥洗的景象還包括以圓盆盛水以洗臉、洗頭與沐浴淨身。這些圖像是伴隨在勞度叉鬥聖變中，是講訴洗心革面皈依佛教的景象。另外還有更多包括洗頭、洗浴、刮臉等個人清潔習慣的圖像。在第302窟西披及中唐第159窟壁上有洗澡圖，第146窟壁上有洗頭圖[19]，都是以一大圓盆盛水，一僧人正彎下身去洗頭，有的揩身。此外，敦煌也有以木樹圍起的露天浴池。

五、小結

　　敦煌地區是佛教中心，位於漢、藏、回等多民族聚居之地，政治上彼此之間為爭統治權而互相衝突，文化上則有不同文化的混合。出行圖展現了敦煌豪族的殷富盛況，而圖中馬車及駱駝隊等的場面，更是敦煌交通運輸工具的真實寫照。百戲樂舞則是當時民間歌舞、雜技的寫照。法華經變壁畫的目的，雖是為宣揚佛教，引導人皈依佛教，但是在這些教義之外，許多壁畫的內容，也紀錄了日常生活兒童玩的遊戲，以及日常飲食等各方面的面貌。

　　敦煌壁畫亦顯示出當時社會階層相差懸殊的狀況，揭示了當時在敦煌擁有政治、軍事權力的僧侶，他們的個人衛生習慣等細節的寫照，也使我們研究的範圍擴及了當時現實生活的層面。

1. Richard M. Heli,"Timeline of Central Asia during the Tang Dynasty" Retrieved January 4, 2005 from http:www.spotlightongames.com/background/emw.html,.
2. 段文傑，〈敦煌壁畫中的衣冠服飾〉，《敦煌民俗研究》，1995年，甘肅人民出版社，頁183-205。
3. 唐朝（641年）將文成公主嫁到吐蕃，取得了三十年的和平。中國只有在元朝及清朝之時，才統治西藏，而這兩個王朝都不是漢族建立的王朝。1959建立西藏自治區。
4. T.T. Moh, "A Short History of Tibetan," Retrieved January 4, 2005 from http://omni.cc.purdue.edu/-wtv/tibet/history.html.
5. 維吾爾的歷史中，認為唐朝視其為蕃，並不重視回族對唐朝西北疆域守護的貢獻。Erkin Alptekin, "The Uighurs" Journal Institute of Muslim Minority Affairs, vol. 8:2, July 1987, Retrieved January 4, 2005 from http: www.taklamakan.org/erkin/aliptekin.html,.
6. 中國佛教學術論典 （50），Retrieved January 8, 2005.from http://www.ebud.net/book/readari.asp。
7. 郭鋒，〈敦煌的社及其活動〉，《敦煌民俗研究》，1995年，甘肅人民出版社，頁70。
8. 王進玉，〈敦煌壁畫中的交通工具〉，《敦煌民俗研究》，1995年，甘肅人民出版社，頁264。
9. 橦是指体輕捷，善緣竿而上。李重生，《敦煌古代體育文化》，2001年，甘肅人民出版社，頁35-45。
10. 易紹武，〈敦煌壁畫中的所見的古代體育〉，《敦煌民俗研究》，1995年，甘肅人民出版社，頁278-305。
11. 李重申，《敦煌古代體育文化》，頁29-45。
12. 《大正新修大藏經》，第50冊，《釋迦譜》卷一，頁18；《釋迦氏譜》〈觀耕生厭相〉，頁90；《敦煌民俗研究》，1995年，甘肅人民出版社，頁236。
13. 段文傑主編，《敦煌石窟全集25　民俗畫卷》一書中，記載為四人，但實為三人。
14. 王進玉，〈敦煌壁畫中的《農作圖》，《敦煌民俗研究》，1995年，甘肅人民出版社，頁236-254。
15. 高國藩，中國民俗文化研究叢書《敦煌民俗學》，1989年，上海文藝出版社，頁393-401。
16. 段文傑主編，《敦煌石窟全集25　民俗畫卷》，頁13-15。
17. 該文獻是漢文在前，回鶻文譯文在後。大約是成於十一世紀，見李重生，頁166。
18. 段文傑主編，《敦煌石窟全集25　民俗畫卷》，頁76-77。
19. 李重申，《敦煌古代體育文化》，頁165-167。

Dunhuang Everyday Life at a Glance

HSIEH Shih-ying
National Museum of History, Taipei

The content of the mural paintings in Dunhuang is mainly based on Buddhist sūtras. It depicts images of Buddha, Bodhisattva or scenes from the Jātaka fables, which tell of the Buddha's previous incarnations in various human and animal forms. The wall paintings were to convey the principal ideas of a sūtra in order to assist the seeker's discovery of the truth. At the same time, the pictures give clues to the nature of daily life, labor and farming in Dunhuang.

Two mural paintings in Cave no. 156, record the historical events of the Zhang Yichao era. Zhang Yichao (789-872) was born in Shazhou, Dunhuang. His wife received the title "Lady of the Song State" from the Tang court. The two mural paintings in Cave no. 156, Processions of Zhang Yichao and Processions of the Lady of the Song State, show a bustling scene of processions such as acrobatics, dancing and singing, reflecting the popular activities of the people of Dunhuang. There are also paintings which tell stories based on the Fahua Jing (Lotus Sūtra), which also provide important information about everyday life in Dunhuang. The Lotus Sūtra is comprised of twenty-eighty chapters. Each chapter contains vivid metaphors and imaginary plots with far-reaching moral messages. Popular themes, such as a farmer plowing the fields, a family having meals in the fields and dances to worship the Buddha were all treated vividly and interestingly.

The Silk Road was the route along which the great caravans carried goods between east and west from the seventh to the eleventh century. Inevitably also these cities were channels for the communication of ideas, beliefs, and artistic styles. Dunhuang, located at the western end of the Silk Road, and as people traveled that route, developed into a cultural and political center. Over the centuries, this city has been occupied by three different peoples, Tibetans, Han Chinese and Uighurs. The Dunhuang region was a cosmopolitan, multi-lingual one and many cultures blended to create a cultural syncretism along the Silk Road.

Dunhuang is an important place because its wall paintings provide an invaluable source of information on historical events, foreign contacts, Buddhist stories and the everyday life of Chinese society. There were conflicts between the city's different ethnic groups. However, the wall paintings reflect the city's cultural amalgamation in terms of artistic style, music, and literature. For example, foreign music and dance was popular during the Tang Dynasty. It was not rare to see a mixture of Tibetan, Han and Muslim customs in funeral and marriage ceremonies; Cave no. 25, shows a foreign wedding with the bride and groom dressed in foreign costumes. One of the guests at the wedding banquet is wearing a high hat, which was not the Han custom. The wall paintings depict mixed-race weddings of Han Chinese and Muslim couples. Foreign merchants with camel troops are also seen in the wall paintings. Many of these people were Buddhists. The full extent of cultural interaction was much greater than we might easily imagine today.

I. Political History

The Tang people, Tibetan and Uighurs fought over the control of Dunhuang and its regions from the seventh to the eleventh century. In the late eighth century, Dunhuang surrendered to the Tibetans internal political reasons related to the rebellion of An Lu Shan. Tang power was thus cut off from the Silk Road. In 847, the Zhang family defeated the Tibetans and brought Dunhuang back to Tang rule. The Dunhuang regions maintained independence and were controlled by local families until the Song period (the eleventh century).

The Tang people enjoyed more cordial relations with the Uighurs than with the Tibetans. The Uighur had traditionally respected the Tang court as their "uncle." The Uighur people were Muslims and were known as Huihe. Today, Chinese people called the Uighurs as Wei Wu Er. The first Uighur Empire fell around 840 A.D. and many Uighur people emigrated to the west banks of the Yellow River. A second group moved to the south and a third to live under Tang rule.

In the tenth century, however, the local branch of the Zhang family was overthrown by the Uighurs, who became the protectors of the Tang people in the Dunhuang regions. They served this role for a hundred years. During two centuries, the Tibetans joined with the Uighurs against their common enemy, the Tang. Tang also had invited the Uighurs to work with them against the Tibetans. To the late Tang, both the Tang court and Tibetan had not made many battles toward each other.

II. The Social Spectrum in Dunhuang

Zhang Yichao's achievement in bringing Dunhuang under Tang rule was a great event for the Tang people. Zhang was appointed as the commander-in-chief by the Tang court. His wife was also given the official title, "Lady of the Song State." To mark this event, his nephew, Zhang Huisheng, commissioned to cut Cave no. 156. In 867, Zhang Yichao decided to move to Changan and left power in the hands of Zhang Huisheng. The Dunhuang regions fell into the hands of the Chao family, where they were to remain for the next Five Dynasties. In the eleventh century, control by local families finally came to an end.

When the Dunhuang regions were ruled by the Zhang families, there were around 30,000 persons and 5,000 households. In the regions, there were seventeen monasteries and 2,000 monks. These people can be divided into three levels on the social spectrum. The upper class was aristocracy, such as the Zhang, Suo, Li, Chao and Ying and eminent monks who had power over monasteries. The middle class were landlords, monks of general rank and court officials. The laborers, servants, musicians and dancers and who performed in the processions were on the bottom of the social spectrum.

Cave no. 156 was commissioned to eulogize the great event of Zhang Yichao. Pictures of Zhang's story were painted on the south, east and north walls of the cave. Processions of Zhang Yichao and Processions of the Lady of the Song State are both large, around 108×888 cm. The picture Processions of Zhang Yichao starts from cavalry riders. The inscription in the picture states "the Governor of Hexi of the rank of Minister of Justice, General Zhang Yichao, on his journey to assume governorship of the territory, recovered from Tibetan occupation." Following the cavalry riders is a band of ten musicians playing the lute, harp, flute and drum. There are eight dancers in two rows wearing costumes. They perform the sleeve dance. This dance has its origins in Tibet. The figure in the center of the picture is Zhang Yichao riding on a horse, about to cross the bridge.

In the other picture Processions of the Lady of the Song State, the processions are led by an acrobatic show. The performance involved by five people with long poles, followed by dancers and musicians. The dance was similar to the Tibetan folk dance called Batang Xuanzi in which four dancers form a square and dance with their sleeves. There is a four-musician band, playing a flute, clapping bamboo pieces, one person carrying a big drum on his back and the other person beating the drum. Following them is a white horse drawing a cart with a v-shape roof. The inscription reads "Luggage cart of Lady Song." In the center of the painting is Lady Song, riding a white horse. She wears a long-sleeved skirt. Her hair is decorated with jewels. Behind her comes a group of rider-attendants holding a vase, a fan, a musical instrument, and a mirror. At the rear, there are hunters with their hounds, and camels carrying wine jars. Both paintings illustrated the importance of Zhang Yichao in the Dunhuang regions.

The acrobatic scene of Processions of Lady Song was quite unusual. The acrobatic acts have an ancient name, Daigan, which meant "holding the pole." Climbing the pole was called Chuanggan. In the picture, five members performed the climbing of the pole. The man on the bottom wearing a garment and coat, white trousers and black boots, balances a long pole on his forehead. Another three boys then gracefully climb the pole, and perform a series of intricate acrobatic acts.

On the pole, one boy climbs with one hand and the second boy hangs by his feet, the third boy hanging on the other side with one hand, the fourth balancing himself on the top of the pole. One person stands aside. The acrobatics shown in this picture were preformed by five persons. Usually, one person held the pole with the shoulder, forehead, hand, nose or belly while several others performing acrobatic acts with one hand, while upside down or turning.

Baixi means one hundred kinds of circus acts. Circus had very early origins in China, dating back to the Qing and Han dynasties. In many processions and parades, music bands, dancing, and acrobatic acts were important circus performances. In the Tang Dynasty, the court set up an official organization for these performances. There were over 100,000 members, some of whom were foreigners. The acrobatic acts included balancing, tumbling, juggling, walking on the hands and weight lifting, etc. Many of these acts can still be seen in circus performances. Today performances were enjoyed by the officials as well as the common people. Many processions therefore started with circus performances, which lent them a certain zest. In the wall paintings in Dunhuang, we also see other activities such as wrestling.

III. Everyday Life in Dunhuang

The theme of plowing the fields in the wall paintings gives us a glance at everyday life in Dunhuang, although its original purpose was to promote Buddhist doctrines. The theme appears in the Maitreya Sūtra, the Jātaka stories and Lotus Sūtra. In the wall paintings, it was seen most in illustration of the Maitreya Sūtra. It was said that when Maitreya Buddha reborn to the world. In this ideal world clothes grow from the trees. Farmers grow one crop will get for seven times harvest, and no weed and no draught and rain spreads over the crop.

On the wall paintings in Caves no. 290 and 296, a Jātaka story tells of a prince who rested under a tree and saw a farmer plowing his field. The prince sees a worm get eaten by a peacock, who them gets eaten by an ox. The prince witnesses these creatures killing each other and is moved to save all lives. In Cave no. 296 is a variation on the story with a farmer plowing, and the prince seeing a snake catching a toad but then being caught by a peacock.

In Lotus Sūtra, the theme of plowing the fields is often used to illustrate the Chapter Five Parable of the Medicinal Herbs (yiaochao yuping). The scripture of the Parable of the Medicinal Herbs reads:"...He (Buddha) appears in the world like a great cloud rising up. With a loud voice he penetrates to all the heavenly and human beings and the asuras of the entire world. Like a great cloud spreading over the thousand-million fold land..." This explains Buddha preaches to everyone equally although the nature of each person is different, some diligent for example and others lazy. Thus, Buddha's preaching was like a rain spread over the plants, trees, thickets, herbs and groves. The rain is uniform in nature, each person's response to it is different.

In the wall paintings in Dunhuang, plowing in the fields is usually associated with other stories in the Lotus Sūtra. In a cave, we can see not only the pictures of The Chapter Five Parable of the Medicinal Herbs but also other pictures. For example, Cave no. 23, constructed during the Tienbao Era wall paintings illustrating the Lotus Sūtra were painted on three walls and two ceilings: the east, south and north walls and the east and south ceilings. The scene of plowing in the fields which illustrates Chapter Five, is on the west side of the north wall. Beneath the picture are Chapter Two "Expedient Means", Chapter Four "Belief and Understanding", Chapter Seven "The Parable of the Phantom City," and Chapter Twenty-five "The Universal Gate of Bodhisattva Kanzeon."

In the field plowing field scene in Cave no. 23, the composition of the picture can be divided into two parts: a scene of plowing in the fields and one of people having meals in the field. Each part is separated by a landscape painting. On the top of the picture, there are clouds in the sky and it is raining. A farmer follows a plow in the field. Another farmer on the right-hand side is separated by three panels of cartouche. He wears a straw hat and carries a pole as he walks toward the left-hand side. In the middle of the picture, there are three people enjoying a meal in the field. They sit together around a large round bowl. One person is wearing a hat and holding some food as she eats. The second person faces the viewer and holds a bowl, while a third person, wearing red trousers also enjoys the meal.

On the lower left side of the picture is a scene of worshipping, with one person dancing and another kneeling in front of a pagoda. There is a band of six musicians sitting on a mat, each playing different music instruments. On the right-hand side of the picture are four children building sand hills. According to the Lotus Sūtra, to enter Buddha's paradise can be as easy as it is for children to play at building a Buddhist pagoda.

The economy of Dunhuang was largely based on agriculture, with wheat apparently the dominant crop. Animal husbandry was less important. There are sources that mention some of the standard domestic animals, such as goats and sheep. The Tang people ate lamb, pork, and beef and made pies with honey or meat and flour. They also cooked rice, sticky rice or porridge.

There are several pictures which give us a glance of a monk's daily life. According to Buddhist doctrine, the maintenance of good personal hygiene habits was a virtue that could help one to enter the Buddha's paradise. Caves no. 146 and 159 show scenes of teeth brushing and cleaning up. It was called jinshi meaning teeth cleaning. Small twigs crushed or chewed at the end were used as toothbrushes. There was no toothpaste but the twigs were selected from the willow, aspen and locust trees which had a strong taste. In Cave no. 146, a monk sits on the ground, with his back to the viewers. He is topless and wears a pair of trousers, and bracelets on both arms. He has thick eyebrows. In the picture, he holds a bottle in his left hand, is brushing his teeth. In Cave no. 159, a monk is brushing his teeth with twigs. A young monk standing beside him might be his servant.

Dunhuang was a cultural center and a meeting point for the Tibetan, the Uighur and Tang cultures. The region is the site of very important Buddhist wall paintings, in which today one can see a treasure trove of Buddhist art. These wall paintings not only enable the people of the world to experience artistic excellence but also to glance at the daily life of the people of Dunhuang centuries ago.

敦煌莫高窟的保護

王旭東　敦煌研究院

前言

　　莫高窟是現今世界上規模最宏大、歷史最久長、內容最豐富、保存最良好的佛教遺址。莫高窟各窟均由洞窟建築、彩塑和壁畫綜合構成。壁畫內容豐富博大，分為佛教尊像畫、佛經故事畫、佛教史故事畫、經變畫、神怪畫、供養人畫像、裝飾圖案等七類，是古代社會歷史形象的反映。精美的彩塑與壁畫系統地反映了各個時代的藝術風格及其傳承演變，具有珍貴的歷史、藝術、科技價值。

　　敦煌莫高窟以其博大精深的藝術、文化、科技內涵聞名於世。由於其特殊的地理環境，使它能比較完整地被保存下來，但歷經一千多年的自然和人為破壞，莫高窟仍然受到各種病害的困擾。自1944年成立敦煌藝術研究所至今，我國政府和一大批有識之士對其給予了極大的關注。敦煌研究院的三代人在不同時代對其進行了力所能及的保護與修復工作。從最初的防止人為破壞到石窟加固，發展到今天已進入全面的科學保護階段[1]。

一、莫高窟的自然環境特徵

　　敦煌地處河西走廊西端的戈壁荒漠腹地，地理座標為北緯40°，東經94°49´。莫高窟位於敦煌盆地南緣的三危山與鳴沙山相間的大泉河西崖上，海拔在1330公尺～1380公尺之間【圖1】。

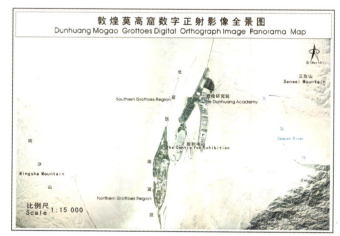

圖1　莫高窟地貌景觀圖

　　由於常年受蒙古高壓的影響，具有氣候極端乾旱，降水量少，氣溫變化大，日照時間長以及風沙活動頻繁的沙漠氣候特點，年平均氣溫為11℃，年平均相對濕度為23%。月平均最高氣溫最高在八月份，為25.86℃，最低在一月，為-22.23℃。月平均相對濕度最高在一月，為45.4%，最低在三月，為22.4%，本區降水稀少，年平均降水量23.2mm，而且主要集中在六、七、八三個月，約占全年降水的58%【圖2】。但年蒸發量則高達4347.9mm，年蒸發量是降水量的一百八十七倍。

　　本區是一個多風且多風向地區，偏西風是該區風沙活動的主害風，將鳴沙山沙物質搬運到窟區，偏東風則對洞窟崖面產生了強烈風蝕[2]【圖3】。

圖2　莫高窟全年降水分布圖

　　莫高窟所處的岩體屬第四紀酒泉礫岩，以鈣質膠結和鈣泥質膠結。岩性乾燥孔隙大、鬆散、力學強度較低。莫高窟崖體地層可分四個工程地質岩組[3]【圖4、圖5】。由表1、表2可以說明莫高窟洞窟圍岩的物理力學特徵。

圖3 莫高窟風向極點圖（1999.11-2000.6）

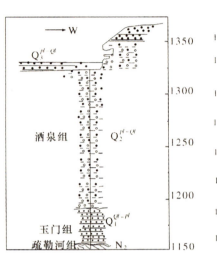

圖4 莫高窟前地層剖面圖

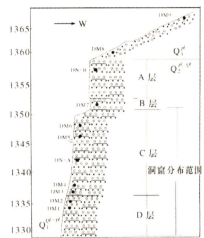

圖5 莫高窟崖體實測地層剖面圖

工程地質岩組	A組	B組	C組	D組
岩 性	厚層礫岩夾細礫岩	含礫石英砂岩	厚層細礫岩夾礫岩	厚層細礫岩夾礫岩
礫石含量（%）	81	16	74~79	50~60
砂含量（%）	16	79	19~24	35~45
粉土含量（%）	3	5	2	5
中值粒徑（mm）	15.7	0.16	5.2~12.2	2.0~3.3
膠結物	鈣質泥質	泥質鈣質	泥質鈣質	鈣質
膠結方式	孔隙—接觸式	孔隙式	孔隙、接觸式	孔隙、接觸式
岩體質量	中等	差	中等	優

表1 莫高窟地層工程地質岩組劃分及其組成特徵

工程地質岩組	平均峰值抗壓強度（Mpa）		平均峰值抗拉強度		順層縱波波速Vp（m/s）
	垂直層面	平行層面	垂直層面	平行層面	
A	10.6	9.5	0.36	0.36	—
B	16.3	12.6	0.47	0.62	1200
C	12.4	8.6	0.33	0.47	1500-1930
D	19.4	15.8	0.60	0.74	2100-2300

表2 各岩組力學性質及縱波波速統計結果

二、莫高窟存在的主要保護問題

敦煌莫高窟已經歷了千百年漫長歲月，由於受到自然營力和人類活動的長期作用，使石窟崖體及壁畫和彩塑遭到了不同程度的破壞。特別是明朝與十五世紀封閉嘉峪關後，敦煌便成為邊荒之地。遂使千年佛教重地敦煌石窟為人遺忘，長達五百年之久無人問津。任憑自然坍塌、風沙侵蝕、降水入滲、偷盜破壞和烟熏火燎。截至本世紀四〇年代初，敦煌莫高窟已是一派荒涼破敗、病害累累，其主要病害可概括為五類：

1. 岩體崩塌
石窟所在崖體結構不穩定，產生的橫向崖邊裂隙和縱向垂直裂隙，造成石窟崖體錯落失穩，裂隙還為水分入滲與鹽份運移提供通道，危及文物。

2. 風蝕破壞
莫高窟位於鳴沙山東麓的崖壁上，由於西北、東北、西南多風向的作用，鳴沙山大量的沙物質進入窟區，造成每年近達三千立方公尺積沙，污染環境，影響景觀；風沙掏蝕崖壁，造成崖壁危石，威脅洞窟安全；污染磨蝕壁畫和彩塑，使表面顏料脫落，失去光彩，影響視覺效果。

3. 降水入滲
雨水沖刷崖壁，形成沖溝；大氣降水從石窟上層薄頂洞窟裂隙入滲；在本世紀四〇年代以前，由於長期無人管理，莫高窟大部份下層洞窟埋在沙中，上面的雨水和對面河水灌入積沙的洞內，使下層洞窟長期處於飽水沙的浸泡之中；水的滲入，導致岩體中可溶鹽類運移，危及壁畫。

4. 壁畫退化
各種原因使壁畫和彩塑產生病害，造成其退化。主要有：
（1）裂隙或其他原因使壁畫地仗層與崖壁失去黏接，導致壁畫局部空鼓，有的造成大面積脫落，甚至墜毀。
（2）水分入滲，造成岩體中可溶性鹽類的運移，使壁畫地仗層酥鹼，嚴重者壁畫完全毀壞。
（3）顏料用膠不當，導致壁畫顏料層龜裂，狀似鱗甲，甚至起片卷翅脫落，畫面成了空白。
（4）光照潮濕或顏料間的相互作用，致使壁畫某些顏料變色，影響藝術魅力。
（5）壁畫顏料層的顏料顆粒逐漸脫落減少，造成畫面色調晦暗，形象模糊，一些壁畫作品失去了藝術魅力。
（6）壁畫生長霉菌，昆蟲碰撞和遺留在壁畫表面的排泄物，污染壁畫顏料層，改變了壁畫的原有面貌。
（7）彩塑木質骨架的變質或者糟朽，導致四肢斷折，肢體鬆動、傾斜甚至解體、嚴重者墜毀。

5. 人為破壞
（1）烟火熏燎形成的烟炱，污染畫面甚至使畫面完全變黑，無法辨認。
（2）塗寫刻劃，損傷畫面，破壞了壁畫藝術的完整性。
（3）遊客人數逐年增加，但洞窟空間很小，遊客對洞窟小環境的影響越來越大，其中包括相對濕度增高、二氧化碳濃度急劇升高，遊人引起的振動，以及開放洞窟的壓力逐年在增大等。

三、主要的保護對策

1. 加大基礎研究力度，尤其是莫高窟的環境研究

　　風沙、降水、地震等自然因素以及遊客的日益增加將繼續影響莫高窟的保護。如何扼止或減緩這些因素的影響是必須面對和急需著手解決的問題。在解決自然環境因素給莫高窟帶來的威脅方面，我們正一如既往的開展環境監測、防沙治沙、莫高窟地質環境、水環境調查研究、風化和裂隙岩體的加固技術與材料的研究等。

（1）環境監測

　　　　早在二十世紀六〇年代，莫高窟就開始氣象監測，主要監測窟區的氣溫、相對濕度、降水量、蒸發量、日照、風速、風向和風沙活動，但因當時條件有限，未能長期堅持下來，僅進行了近三年的觀測工作。而且觀測數據的間距很大，不能準確地揭示莫高窟的氣象環境特徵。

　　　　從八〇年代開始，觀測工作又向前推進了一步，從單純的窟區大環境監測擴大到窟內小環境的監測。尤其是八〇年代末，我們與美國蓋蒂保護所、日本東京文化財研究所合作，對莫高窟窟區大環境與洞窟小環境進行系統的監測研究[4-8]。

　　　　與此同時，我們還開展了遊客對洞窟小環境影響的監測研究。研究表明，大量的遊客進入空間狹小的洞窟，會使洞窟內的相對濕度、溫度以及二氧化碳的濃度顯著提高，破壞了洞窟小環境的原有平衡，將對十分脆弱的壁畫長期保存構成潛在的威脅[9]。

（2）洞窟遊客承載量研究

　　　　近年來，我們又開展了洞窟遊客承載量實驗研究[10]。實驗模擬製作莫高窟壁畫地仗試塊，然後在高低溫濕度條件下循環老化，以觀察模擬試塊的老化狀況和嚴重程度。部分試塊放置在實驗洞窟中自然老化，以作對比分析。實驗還選擇莫高窟第25、26、29和35窟四個洞窟進行拍照、紀錄、監測及開放對病害壁畫的影響，其中第26窟和第29窟開放供遊客參觀，第25窟和第35窟關閉。

　　　　模擬實驗結果表明：模擬試塊在經過高低溫循環試驗後，其變化趨勢是顏料層裂縫逐漸加寬，顏料翹起翹現象逐漸加重，試塊逐漸鬆軟，趨於膨脹。模擬試驗最終產生了與壁畫地仗極為相似的棉絮狀酥鹼病害現象。

　　　　現場試驗結果表明：第25窟和第26窟變化明顯，酥鹼病害有發展，第29窟、第35窟沒有明顯變化。

（3）崖體抗震穩定性研究

　　　　九〇年代與蘭州大學地質系、蘭州地震研究所一同開展敦煌莫高窟崖體及附加構築物抗震穩定性研究和敦煌莫高窟地震防災文物保護研究。通過這些研究，我們得出莫高窟的地震烈度為Ⅶ度，未來地震仍然威脅著莫高窟的保存，必須採取一些切實可行的工程措施對莫高窟進行加固保護。

（4）風沙防治研究

　　　　早在二十世紀六〇年代，敦煌研究院就嘗試莫高窟的風沙防治試驗研究。在鳴沙山腳下

利用防沙柵欄阻止鳴沙山的流沙向洞窟方向移動，在石窟崖頂修建防沙牆、開挖防沙溝阻止流沙滑入窟區。但因當時對風沙活動規律認識不足，且經費有限，試驗規模小而未能取得理想的結果。1989年以來，我們與美國蓋蒂保護研究所、中科院寒區旱區環境與工程研究所合作開展了莫高窟風沙活動規律與風沙防治研究，基本弄清了莫高窟的風沙活動特徵，並進行了化學固沙，三角形尼侖沙障阻沙、生物固沙的試驗研究，提出固阻結合，以固為主的風沙防治原則[11]。

(5) 壁畫製作材料分析研究

從八○年代開始，我們逐步開始了對敦煌莫高窟壁畫製作材料的系統分析研究。結果表明，莫高窟壁畫地仗層一般為二到三層，自下而上為草泥層、麻泥層、棉花泥層。草泥層用土一般為窟前砂質土，而麻泥層、棉花泥層的用土則為大泉河河床沈積的澄板土[12]。

莫高窟壁畫顏料主要為天然礦物顏料，分白色顏料、紅色顏料、藍色顏料、綠色顏料、黑色顏料，此外還有人造顏料銀朱、鉛白、鉛丹[13]（表3）。

壁畫顏料的膠結材料主要為動物膠，動物膠的最大可能種類為牛皮膠[14]。

白色顏料		紅色顏料		藍色顏料	
顏料名	分子式	顏料名	分子式	顏料名	分子式
白堊	$CaCO_3$	朱砂	HgS	石青	$2CuCO_3Cu(OH)_2$
高嶺土	$Al_2Si_2O_5(OH)_4$	土紅	Fe_2O_3	青金石	$(Na,Ca)_8(AlSiO_4)_6(SO_4S，S,Cl)_2$
滑石	$Mg_3Si_4O_{10}(OH)_2$	雄黃	AsS		
石膏	$CaSO_4 2H_2O$				
雲母	$KAl_2AlO_{10}(OH)_2$				
綠色顏料		黑色顏料		人造顏料	
顏料名	分子式	顏料名	分子式	顏料名	分子式
石綠	$CuCO_3Cu(OH)_2$	墨	C	銀朱	HgS
氯銅礦	$Cu_2(OH)_3Cl$	鐵黑	Fe_3O_4	鉛白	$2PbCO_3Pb(OH)_2$
				鉛丹	PbO_4

表3 莫高窟壁畫用顏料一覽表

(6) 水環境研究

與蘭州大學、日本大阪大學等大學院校合作開展大泉河流域水環境和莫高窟區水分運移規律研究，基本弄清了大泉河的水量、水質特徵，而莫高窟的水分運移規律研究則因難度大，水分來源複雜，目前仍在進一步研究之中[15]。

(7) 壁畫病害機理研究

千百年來，敦煌莫高窟的壁畫由於受所處環境諸因素、壁畫製作材料及結構等的影響，使壁畫產生許多病害，弄清這些病害的產生機理，將為防止其發生以及尋找科學的修復方法

（包括修復材料與工藝）提供依據。二十多年來，我們在壁畫顏料的變、褪色、壁畫的酥鹼、起甲等方面做了大量的工作[16-20]。尤其是在壁畫酥鹼病害產生機理方面進行了深入的探討，取得了一系列的成果。

（8）敦煌壁畫、彩塑的電腦存貯與再現研究

從九〇年代初，我們開始利用近景攝影測量與電腦存貯技術進行敦煌壁畫的數位化存貯研究。隨著近年來數位攝影技術的迅猛發展，目前數位敦煌專案已取得突破性進展。通過這些技術能夠實現敦煌莫高窟藝術的永久保存[21]。

2. 莫高窟崖體的加固

（1）崖體穩定性加固

二十世紀六〇年代和八〇年代，國家投入了大量資金採用支頂、擋、刷的綜合工程措施分四期對莫高窟崖體進行加固。整個加固工程基本上體現修舊如舊、有若無的不改變石窟原貌的原則。該工程有效地防止莫高窟崖體的坍塌破壞，但限於當時的技術條件，這次加固工程仍然過大地改變了莫高窟岩體的原貌。

（2）崖面防風化加固

如前所述，崖面的風化也是影響莫高窟保存的一大危害。我們獨立開發研製一套利用PS材料進行防風化加固的技術，利用這套技術，對莫高窟南區中段和莫高窟第3窟的崖面進行了防風化加固，取得良好的效果。

（3）裂隙灌漿加固

利用我們獨自研製的砂礫岩石窟裂隙灌漿材料PS-F對莫高窟南區中段和莫高窟第3窟的裂隙進行了灌漿加固，防止大氣降水沿這些裂隙進入洞窟破壞壁畫現象的發生。

（4）薄頂洞窟加固

與美國蓋蒂保護研究所合作，通過模擬試驗驗證，最終利用土工薄膜等輕質防滲加固材料對第460窟薄頂進行加固[22]。結果表明，防滲加固效果明顯，且不改變崖體的原貌，不會過大地增加其對洞窟的荷載。

3. 壁畫、彩塑修復

（1）起甲壁畫修復

自上世紀六〇年代起，敦煌研究院便與中國文物研究所合作開展起甲壁畫的修復實驗，修復加固材料採用聚醋酸乙烯乳液和聚乙烯醇。在幾十年的修復實踐中，創造出一套完整的修復工藝[23]。上述材料在莫高窟這種乾燥環境下應用已達三十年，其修復效果良好。但這些材料也還存在一定的缺陷；如果曾修復過的位置再次發生顏料層起甲，修復材料無法再次滲入。目前，我們採用明膠（一種用動

圖6 起甲壁畫修復前後對比

物膠製成的黏結劑）替代聚醋酸乙烯乳液和聚乙烯醇，效果也不錯，它所具有的最大特點是性質與壁畫顏料的膠結材料相同，及材料的相容性好，而且其他修復材料還可多次滲透。當然這種修復材料的加固效果還需時間來檢驗[24]【圖6】。

（2）空鼓壁畫的修復加固

空鼓壁畫分兩類，一類是已有部分壁畫脫落，另一類為壁畫僅與崖體分離但還未脫落。對第一類採用邊緣加固的辦法進行修復加固，第二類過去採用錨固與注漿相結合的辦法實施加固，敦煌研究院採用這種方法搶救了大量瀕臨剝落的壁畫。目前，敦煌研究院與美國蓋蒂保護研究所合作完成的莫高窟第85窟壁畫保護專案，在最小干預和最大相容的原則指導下，成功地篩選出適合莫高窟空鼓壁畫灌漿材料和灌漿工藝，將空鼓壁畫的修復加固向前推進一大步[25]【圖7】。

圖7 空鼓壁畫灌漿加固（與美國蓋蒂保護研究所合作第85窟壁畫保護專案）

（3）酥鹼壁畫的修復

酥鹼病害是影響莫高窟壁畫保護的癌症，長期以來尚未能得到有效的治理。七〇年代修復過的壁畫在八〇年代又產生同樣的問題，而八〇年代再次加固後在九〇年代又同樣出現相同的問題。為此，敦煌研究院與美國蓋蒂保護所合作，篩選出了修復加固此類壁畫病害的材料和工藝，尤其是在壁畫脫鹽技術方面取得一些令人振奮的成果[26]【圖8】。

圖8 壁畫脫鹽處理（與美國蓋蒂保護研究所合作第85窟壁畫保護專案）

（4）塑像修復

對一些骨架糟朽和面臨傾倒的塑像，採用「脫胎換骨」、局部補強和扶正的方法實施修復加固，盡可能不改變其保存現狀，除非保持其穩定的需要，不做任何添補和復原[26]。多年來，採用這些方法修復加固了一大批塑像【圖9】。

4. 開放管理

莫高窟自1979年正式對外開放以來，特別是九〇年代後期，隨著我國經濟的持續增長和人們生活水平的提高，至莫高窟的遊客大幅度增加。1984年遊客人數突破十萬人次，1998年突破二十萬人次，2001年突破三十萬人次。預計2004年莫高窟的遊客人數將達到四十二萬人次。莫高窟過去二十五年遊客流量年平均增長率為13%、近十年為12.2 %、近五年為14.7 %，遊客數量長期保持穩定快速

增長的態勢。根據市場調查分析預測,未來五至十五年,莫高窟的年遊客流量將達到六十四至一百六十四萬人次,日遊客流量峰值將達到八千至一萬六千人次,遊客流量將比現在增長一至四倍,莫高窟文物保護與利用之間的矛盾更加突出[27]。

為了最大限度地降低遊客帶來的破壞,敦煌研究院採取多種方法予以解決;如複製藝術價值極高的洞窟,不僅在陳列館中供遊客參觀,同時開闢多個參觀景點、將遊客分成二十至二十五人一組由講解員帶領有序地參觀等。但無論採取上述何種措施,都不能減少遊客在洞窟內的滯留時間。為了徹底解決這個問題,敦煌研究院正積極開展數位展示中心專案的前期研究工作。根據設計概念,遊客將在數位展示中心最大限度地汲取敦煌莫高窟的自然、歷史及藝術方面豐富而又博大精深的內容,然後到洞窟做一般遊覽,這樣就可以大大壓縮遊客在洞窟內滯留的時間,保證洞窟小環境的變化在一個壁畫保護可以接受的幅度內。

圖9 塑像修復

四、結語

經過幾代人六〇年的艱苦努力和探索,莫高窟得到了卓越有成效的保護,無論是石窟保護研究、崖體加固、壁畫彩塑修復,還是旅遊開放管理,都取得了大量的成果,具體表現為以下幾個方面:

1. 對莫高窟的自然環境進行系統研究,初步掌握自然環境與石窟保存的依賴關係。
2. 開展窟區環境與洞窟小環境的監測;崖體抗震穩定性研究,風沙治理研究,壁畫製作材料及病害機理研究,取得一系列重要成果。
3. 對莫高窟崖體進行大規模的穩定性加固,防止崖體和洞窟的坍塌及崖面的風化。
4. 開展崖體裂隙灌漿與薄頂洞窟加固,防止大氣降水對窟內文物的破壞。
5. 對起甲壁畫進行成功的修復空鼓壁畫,對空鼓壁畫和酥鹼壁畫的修復取得實質性的突破。
6. 開展敦煌壁畫圖像的電腦存貯與再現研究,完成二十多個洞窟的數位化保存,為敦煌文物的永久保存開闢新的途徑。
7. 旅遊開放思路進一步開闊,從被動的接納到有組織、有計劃地疏導遊客;從簡單的講解參觀發展到提出建立數位展示中心的構想,將會有效地解決旅遊開放和文物保護的矛盾。

1. 樊錦詩，〈敦煌莫高窟的保護與管理〉，《敦煌研究》2000：1，頁1-4。
2. 淩裕泉等，〈敦煌莫高窟崖頂風沙危害的研究〉，《敦煌研究文集 石窟保護篇（上）》，1993年，甘肅民族出版社。
3. 王旭東等，《敦煌莫高窟洞窟圍岩的工程特性岩石力學與工程學報》2000：6，頁756-761。
4. 唐玉民、孫儒僩，〈莫高窟小氣候的初步觀測〉，《敦煌研究文集 石窟保護篇（上）》，1993年，甘肅民族出版社。
5. 付文麗、張擁軍等，〈敦煌莫高窟的氣象（1962-1992）〉，《敦煌研究文集 石窟保護篇（上）》，1993年，甘肅民族出版社。
6. 王寶義、張擁軍等，〈莫高窟窟內溫濕度的觀測與分析〉，《敦煌研究文集 石窟保護篇（上）》，1993年，甘肅民族出版社。
7. 李實、張擁軍、三浦定俊、西浦忠輝，〈敦煌莫高窟的氣象觀測〉，《敦煌研究文集 石窟保護篇（上）》，1993年，甘肅民族出版社。
8. 三浦定俊、西浦忠輝、張擁軍、王寶義，〈敦煌莫高窟的氣候（1989-1991）〉，《敦煌研究文集 石窟保護篇（上）》，1993年，甘肅民族出版社。
9. 張擁軍、王寶義、付文麗、[美]前川信，〈觀眾對洞窟環境影響的實驗分析〉，《敦煌研究文集 石窟保護篇（上）》，1993年，甘肅民族出版社。
10. Demas, M. Nevill, A. Bell, J. Zaixuan, F. Gangquan, CH. Jinyu, W. "A Methodology for Determining the Visitor Carrying Capscity of the Mogao Grottoes,"in The Second International Conference on the Conservation of Grotto Sites, Dunhuang, 2004.
11. 汪萬福等，〈敦煌莫高窟的風沙危害與防治研究〉，《敦煌研究》2000：1，頁42-48。
12. 段修業，〈對莫高窟壁畫製作材料的認識〉，《敦煌研究》，1988：3，頁41-59。
13. 樊錦詩，〈敦煌莫高窟的保存、維修和展望〉，《敦煌研究文集 石窟保護篇（上）》，1993年，甘肅民族出版社。
14. 李實，〈對敦煌壁畫中交結材料的初步認識〉，《敦煌研究文集 石窟保護篇（下）》，1993年，甘肅民族出版社。
15. Chikaosa TANIMOTO, Chunze PIAO, Keigo KOIZUMI, Syuichi IWATA, Tadashi MASUYA, Zuixiong LI, Xudong WANG and Qinglin GUO, "Geology and Hydrogeology of Mogao, Dunhuany, China -Application of Satellite Remote Sensing to Fault Distribution," Original Paper, Vol.52 No.5 pp.523-528.
16. 李最雄，〈光和濕度對土紅、朱砂和鉛丹變色的影響〉，《敦煌研究》1989：3，頁80-93。
17. 段修業，〈莫高窟第3窟泡疹狀病害的研究〉，《敦煌研究文集 石窟保護篇（上）》，1993年，甘肅民族出版社。
18. 張明泉等，〈敦煌壁畫鹽害及其地質背景〉，《敦煌研究文集 石窟保護篇（上）》，1993年，甘肅民族出版社。
19. 朽津信明等，〈敦煌莫高窟的鹽類風化〉，《敦煌研究文集 石窟保護篇（上）》，1993年，甘肅民族出版社。
20. Agnew, N. Pique, F. Schilling, M. Shuya, W."Causes and Mechannisms of Deterioration and Damage in Cave no. 85,"in The Second Conference on the Conservation of Grotto Sites, Dunhuang, 2004.
21. 劉剛等，〈敦煌壁畫電腦存貯與再現系統的目標與再現〉，《敦煌研究》2000：1，頁95-99。
22. Agnew, N. Lin, P. M. Li, Z.X. and Wang, X.D. "A lightweight composite panel for the repair of cave roofs at the Mogao grottoes, China," in Conservation and Management of Archaeological Sites, 3 (1999):135-144.
23. 李雲鶴，〈莫高窟壁畫修復初探〉，《敦煌研究文集 石窟保護篇（下）》，1993年，甘肅民族出版社。
24. Fan Zaixuan, Qiao Hai,Tang Wei, Stephen rickerby Lisa shekede,"Implementation of the Remedial Treatments of Cave no. 85,"in The Second International Conference on the Conservation of Grotto Sites, Dunhuang, 2004.
25. Stephen rickerby Lisa Shekede Fan Zaixuan etl,"Devolepment and Testing of the principal Remedial Treatments of Cave no. 85: injection Grouting and Solublesalt Reduction,"in The Second International Conference on the Conservation of Grotto Sites, Dunhuang, 2004.
26. 李雲鶴，〈莫高窟彩塑修復技術〉，《敦煌研究文集 石窟保護篇（下）》，1993年，甘肅民族出版社。
27. 敦煌研究院、北京中房億融投資諮詢有限公司，《莫高窟遊客承載量測定與研究報告》，2004年。

Preservation and Protection of Mogao Grottoes

WANG Xudong
Dunhuang Academy, China

I. Introduction

The Mogao Grottoes are the world's largest, oldest and best-preserved Buddhist relics with the richest contents ever discovered. Major components of the caves of the Mogao Grottoes include architecture, painted statues and murals. Thanks to the special geographic conditions of the site, these caves have been preserved in fine condition, encompassing early prevention of damage to grotto reinforcement to today's fully scientific protection.

II. Natural Environmental Features of Mogao Grottoes

Dunhuang is situated in the interior of the Gobi Desert, on the western border of the Hexi (Gansu) Corridor, 40°N and 49°49'E. Due to the high pressure from the Mongolian Plateau, Dunhuang experiences typical desert climate, including dry weather, little precipitation, extreme temperature changes, long sunshine duration, and frequent sandstorm activity. The average annual temperature and relative humidity in Dunhuang is 11°C and 23%, respectively. It is a windy area with winds coming from all directions. The major source of sandstorm activity comes from the west and winds carry sand substances from the Mingsha Hill to the grotto area; while easterly promotes strong weathering effect on the cliff surface of the caves.

III. Potential Preservation Problems at the Mogao Grottoes

These caves were built over a thousand years ago. The physical and human systems over time have deteriorated the cave walls, murals and painted statues in various degrees. By the beginning of the 1940s, the site had become a deserted area suffering all kinds of natural or artificial damage which basically falls into the following five categories.

1. Sloughing
The grottoes are located on unstable cave walls where sloughing occurs easily as cracks run horizontally and vertically. These cracks also provide channels for water to carry away the minerals inside the rock and thus endanger the monument.

2. Weathering
Winds in Dunhuang come from all directions, and continual physical weathering takes place when northwest, northeast and southwest winds carry sand substances from the Mingsha Hill into the grotto area. Every year nearly 3,000m of sand deposits in the area. Besides polluting the environment, this spoils the outlook of the natural landscape. Furthermore, the potential of peeling arises when the cave walls is seriously weathered.

3. Infiltration of precipitation
Gullies are formed on the cave wall due to spouts of rain water. When atmospheric precipitation infiltrates the cave wall from the cracks on top, soluble minerals inside the rock are carried away. This endangers the murals.

4. Mural deterioration
Diseases occur to the murals and painted statues for various reasons. As a result, deterioration takes place. These reasons include:
(1) The bonding effect between the land-supporting layer and the cave wall of murals disappears due to cracks or other factors. As a result, negative spacing takes place in some regions of the murals, and some murals even collapse.
(2) When water infiltrates the rock, soluble minerals inside the rock are carried away and salt damage and efflorescence

occurs on the land-supporting layer. More severely, an entire mural can be damaged.
(3) The bonding agent for pigments was improperly processed and the cracks like the symptoms of psoriasis on the human skin. As a result, pigments either roll up or peel off.
(4) Pigments on the murals change color because of long exposure to sunshine, moisture and chemical changes among the pigments. As a result, murals look less attractive and beautiful.
(5) Particles of the pigments on murals peel. As a result, the image looks dimmer and unclear. Some murals even lose their original charm and attraction.
(6) The mural surface is contaminated by penicillium, insect disruption and excretions. As a result, the appearance of the murals is changed.
(7) The wooden framework of painted statues becomes rotten or deteriorated and finally loosens.

5. Man-induced damage
(1) The mural surface is contaminated or even darkened by the soot that is caused by burning incense. As a result, the design of the murals is unidentified.
(2) The mural surface is damaged by graffiti, and the artistic integrity of murals is thus ruined.
(3) The annual increase of tourists causes a rise of relative humidity, an increase of carbon dioxide concentration, and vibration.

IV. Major Preservation Policies

1. Reinforcement of foundational research: focus on environment study of the Mogao Grottoes
In eliminating threats from physical systems, on a regular basis we conduct studies on environmental measurement, engage in sandstorm prevention and control, conduct geological and hydrological surveys, and engaging in reinforcement technology and materials of weathered and cracked rocks.

(1) Environmental monitoring and analysis
 Though meteorological monitoring of the Mogao Grottoes started as early as in the 1960s, it was ended three years later. Furthermore, as the monitoring interval was quite long, the results were unable to indicate accurately the meteorological properties of the grotto area.
 Therefore, closer environment monitoring started in the grotto area in the 1980s in addition to the greater area monitoring. In the end of the 1980s, cooperation with the Global Commons Institute (GCI) of the USA and the National Research Institute for Cultural Properties, Tokyo, Japan, was launched to conduct systematic environmental monitoring and analysis in the cave area.
(2) Cave visitor load study
 The cave visitor load study was stared in recent years. The high/low temperature and humidity aging treatment was performed on a simulated land-supporting layer specimen to observe the aging condition and severity, and part of the specimen was placed inside the cave for natural aging as the control.
(3) Cliff anti-quake reliability study
 Cooperation with the Department of Geology, Lanzhou University, and the Lanzhou Earthquake Institute, GSSB, was launched to study the anti-quake reliability of the Mogao Grottoes and its additional constructions; we also study historical monument protection in earthquake mitigation.
(4) Sandstorm prevention and control study
 A sandstorm prevention and control experimental project was conducted by the Dunhuang Academy as early as in the

1960's. Furthermore, the study on the pattern and prevention of sandstorm activity in the grotto area in collaboration with the GCI and the Cold and Arid Regions Environmental and Engineering Research Institute, Chinese Academy of Sciences (CAREERI, CAS) was started in 1989.

(5) Mural material analysis and study

The analysis and study on mural materials started in the 1980s. Results indicated that Mogao murals have two to three land-supporting layers, including the grass and mud layer, hemp and mud layer, and cotton- and mud layer. The grass and mud layer was made with a sandy clay (or mud) from near the grotto and the other two layers were made with the sedimentary clay found in the Daquan River.

Mural pigments are basically natural minerals, including white, red, blue, green and black hues. There are also artificial pigments, such as vermillion, white lead and red lead. Animal glue or gelatin is the most common agent for bonding pigments, and bovine-skin material was the most probable bonding agent.

(6) Water environment study

The study on the Daquan river water environment and on the water transportation patterns of the Mogao Grottoes area has started in cooperation with the Lanzhou University and the Osaka University of Japan.

(7) Mural hazards study

Over the last twenty years or so, lots of projects have been carried out to investigate the changes and fading of mural pigments; and the efflorescence, salt damage and peeling of murals. So far, good results have been obtained in the efflorescence and salt damage management after an in-depth study.

(8) Digital storage and retrieval of murals and painted statutes

The study on the digital storage of murals using close-range photogrammetry and IT started in the beginning of 1990s. Currently, an important breakthrough in mural digital storage has been made to ensure the permanent retention of the Dunhuang art in the Mogao Grottoes.

2. Reinforcement of the cliff structure of the Mogao Grottoes

(1) Reinforcement of cliff stability

Work in four phases was carried out in the 1960s and 1980s according to the following principle: to repair as if it was never repaired, in order not to change the original appearance of the grottoes.

(2) Reinforcement of the cliff against weathering

An exclusive anti-weathering technology using PS materials has been developed to reinforce the anti-weathering structure of the cliff located in the middle section, south region and in Grotto no. 3. The results are quite good.

(3) Reinforcement of cracks with grouting

An exclusive grouting material, PS-F, using gravel and sand, has been used as grout in the cracks located in the middle section of the south region of the Mogao Grottoes and Cave no. 3.

(4) Reinforcement of caves with thin roofs

After collaborative study with the GCI, a geomembrane has been chosen as anti-leaking agent applied to the thin roof of grotto no. 460.

3. Restoration of murals and painted statues

(1) Restoration of psoriatic murals

An experiment on restoring flaking murals with EVA emulsion and PVA started in the 1960s is being done in cooperation with the Chinese Cultural Heritage Research Institute. Currently, gelatin (a bonding agent produced with animal glue) has replaced EVA and PVA in the restoration, and the results are quite good.

(2) Restoration and reinforcement of Flaking murals

Flaking murals fall into two categories: peeling and cracking murals. Lateral reinforcement has been applied to restoring peeling murals and anchoring and grouting to buckling murals.

(3) Restoration of murals suffering salt damage and efflorescence

Materials and techniques for restoring murals suffering salt damage and efflorescence have been selected in cooperation with the GCI. The result of the desalination technology developed has been encouraging.

(4) Restoration of painted statues

"Framework replacement," local reinforcement and support have been applied to restoring would-be falling painted statues in order not to change the original appearance of the statues. No repair and restoration is applied except for ensuring the stability of statues.

4. Visitor management

Since the Mogao Grottoes was opened to visitors in 1979, a host of policies for eliminating visitor-induced damage has been implemented, especially in the late 1990s, such as reproducing caves of priceless art value and displaying them in the exhibition areas. Different spots are opened for visitors, and guides bring groups of twenty to twenty-five visitors at a time to visit these spots. Moreover, the preparation work of the virtual museum project is under progress in order to minimize the time visitors staying inside the caves to ensure that the environmental changes of each cave is within the minimum acceptable range for protection.

V. Conclusions

The arduous efforts and explorations of scholars and crews over the past sixty years or so have resulted in admiring achievements in Mogao Grottoes protection. Whether it is the study on grotto protection, cliff reinforcement, mural and painted statue restoration, or visitor management, the results are encouraging. Here is a description of the physical achievements.

1. The correlations between the physical environment and grotto preservation have been confirmed through systematic study of the natural system of the Mogao Grottoes.
2. Important results regarding studies on the anti-quake reliability of cliff, sandstorm prevention and control, and mural materials and hazards are obtained through the monitoring of the grotto area and the nearby environment.
3. A scaled grotto cliff reinforcement project has been carried out to prevent cliff and cave flaking and cliff wall weathering.
4. Crack grouting and thin roof reinforcement have started to prevent damage of monuments by atmospheric precipitation.
5. Restoration of drying murals has been a success; and physical breakthroughs in buckling murals and mural salt damage and efflorescence have been made.
6. Stuies on digital storage and retrieval of the murals is under progress, and the digitization of monuments in over twenty caves has completed, marking a new chapter in the permanent preservation of Dunhuang relics.
7. A big step forward has been made in visitor management from passive acceptance to organized and planned visitor distribution, from simple oral-briefings to a digital display booth. All these can help to maintain a balance between tourism and monument protection.

回眸敦煌美術工作

李其瓊　敦煌研究院

　　1943年常書鴻所長領著第一批自願者來敦煌創業時看見的莫高窟，僅是一背依鳴沙山面對三危山的斷壁殘垣，許多洞窟崖壁坍塌，繪塑裸露，高處難於攀登。窟前是清代修建的上、中、下三寺，僅上寺還有兩位喇嘛，是當時唯一的居民。初建的國立敦煌藝術研究所所長址，就選在中寺（原皇慶寺），大家清除古廟塵土，因陋就簡，略加改造，放幾張桌椅就成了國立敦煌藝術研究所的辦公地。修建的員工宿舍更簡單，撤除寺側一排牲口糟，將原夯土墻利用起來，用土塊分隔成小間，上面蓋頂，前面開門，內置土塊壘成的土桌、土凳、土炕、土書架、白灰飾面，一排整齊的職工宿舍就成功了。上至所長下至員工一律土房、土家具，這種房舍一直沿用到六○年代才稍有改善，一個省錢省時，與環境協調一致的國家級機關就算建成了。

　　考古組是藝術研究所內唯一的業務組，集中領導石窟調查、壁畫臨摹等工作。第一批隨常書鴻所長來敦煌的考古人員僅蘇瑩輝、李浴、史岩三人，來敦煌學習的青年美術工作者有龔祥禮、董希文、張琳英、張民權、邵芳、周紹淼、吳密風、趙冠洲、潘潔茲等九人。

　　1945年抗日戰爭勝利後，由於國民政府忙於南遷復原，無暇關注偏遠的敦煌，而給國立敦煌藝術研究所送來一紙撤消令，使得創建不易的研究機構又陷入困境。有賴所長常書鴻先生奔赴當時的陪都—重慶，聯合學術界人士奔走呼籲，於1946年又恢復了國立敦煌藝術研究所。機構恢復後，藝術研究所招聘自願來敦煌的郭世清、淩春德、范文藻、段文傑、霍熙亮、張定南、鍾貽秋、沈福文；1947年又從四川招聘了孫儒僩、歐陽琳、黃文馥、薛德嘉、李承仙、肖克儉；1948年周星翔自費來敦煌臨摹，同年史葦湘從四川來敦煌，這時考古所人員奇缺，新來的青年中除了學建築的孫儒僩之外，全是一批藝術家。

　　六○年代的敦煌藝術研究所建立在交通不便、消息閉塞、經濟落後的邊陲農業小縣，冬季只有蘿蔔、白菜、土豆加大蔥，陽曆五、六月才有少量韭菜的生活確實是艱苦的，可是在那些敢於來敦煌的美術工作者看來，生活中的苦不算苦，只有創造條件工作才是真正的挑戰。聽從藝術研究院所走過來的前輩畫家潘潔茲先生回憶當年開展工作的困難，他說在敦煌幾乎買不到繪畫材料，畫紙是四川帶來的質次連史紙，吸水性太強，不能著重色，工作前人人要學會礬紙、裱背，將一張普通的川紙加工成適宜臨摹的繪畫用紙才具備工作條件。敦煌也買不到合格的毛筆，舊筆用到無鋒時想方設法剝去表層，令筆鋒再現又繼續使用，甚至一管硬化變質的馬利牌顏料也視為至寶，加水軟化磨細，又成上等顏料使用，最困難時用染料代色作復原畫。為表現歷史沈澱後的壁畫古舊效果，就地取點黃土加工也可代色。他們尋找的代用色白灰、紅土還真是敦煌壁畫原用色之一。尤其是紅土，就地取材，永不變色，在敦煌是歷代沿用不衰的基本色種之一。紙、筆、色的困難克服後，唯有窟內光源不足最難辦。許多保存好，色彩鮮麗的壁畫往往隱藏在日光照射不到的洞窟深處，或中心柱背面。為一睹廬山真面目，或用一面鏡子將洞窟外面日光反射到洞窟內（用鏡面反射日光一直沿用到六○年代，嚴格的說反射日光進洞不利壁畫保護，可是在那條件困難的年月裏，卻是唯一能解決光源不足的辦法之一）。只要能將壁畫臨摹出來，不惜採用各種簡陋、原始的手段，苦中尋樂，這就是第一代敦煌美術創業者的風采。

　　1951年國立敦煌藝術研究所更名敦煌文物研究所，常書鴻先生繼任敦煌文物研究所所長。一批堅守工作崗位的藝術研究所業務人員也留了下來，包括霍熙亮、段文傑、孫儒僩、歐陽琳、黃文馥、李承仙、史葦湘等，他們都是隨常書鴻所長開拓敦煌文物研究所事業的先軀。1951年在敦煌工

作的業務人員中除了學建築的孫儒僩一人，其餘都是青一色的美術工作者。此外，敦煌文物研究所亦將前考古組一分為二，設保管組（今保護研究所前身）、美術組兩個專業組。

1951年文化部調集敦煌壁畫臨本至北京舉辦敦煌文物展，敦煌藝術深厚的文化內涵在首都引起廣泛關注。於是，文化界紛紛根據敦煌壁畫臨本提供的資料各抒己見，1951年的《文物參考資料》為此專門出了一期《敦煌文物展覽特刊》上下兩冊，刊載各家論文。論及藝術方面的有常書鴻所長《敦煌藝術的源流與內容》、向達《敦煌藝術概論》、王遜《敦煌壁畫的臨摹工作》、陰法魯《從敦煌壁畫論唐代的音樂和舞蹈》、梁思成《敦煌壁畫中所見的中國古代建築》、宿白《敦煌莫高窟中"五臺山圖"》等，都是對敦煌文物展的積極迴響。其盛況應了宗白華先生的一句話—「我們的藝術史可以重新寫了！」

從1952年開始，臨摹工作由單幅臨摹轉向整窟臨摹，也是敦煌文物研究所在新的歷史條件下制定工作計劃最主要的一年。根據文化部「…臨摹是研究工作的基礎，也是研究所的基本工作…臨摹的過程就是鍛煉的過程…」的指示，美術工作者一致投入以臨摹為工作核心的任務中。同時，敦煌的美術工作也從藝術研究所單兵作戰的個人臨摹變成為集體合作；從只臨摹畫一角為臨摹整幅乃至複製整窟的原大洞窟模型；要求臨摹效果達到與現存洞窟色彩、破損同步的亂真程度，方便不能來敦煌的專家學者借助臨本進行研究。於是，西魏時期保存較好、有造窟紀年的第285窟，就定為1952年整窟臨摹的試點。

臨摹整窟原大壁畫是敦煌美術工作的一次創舉。沒有經驗，沒有借鑒，更不允許直接從壁畫摹印畫稿，怎麼辦？幾個年青人自己動手測量畫面，憑藉對敦煌藝術的一腔熱情面壁起稿。起稿完成後，支起比原壁略大的畫板，一窟之內最多容納二至三人，就採用你出我進、著色起稿、參差進行的方法爭取時間。兩年左右五六個人全力合作，第一次畫成總面積百餘平方公尺的第285窟原大洞窟模型一座，以及部分壁畫代表作。

1953年至1954年又集中力量臨摹以敦煌藻井為主的圖案專題。敦煌裝飾圖案內容豐富，遍佈洞窟各處，其中尤以藻井、邊飾圖案最多姿多彩，是敦煌裝飾藝術的精華所在。若採用忠於現狀的客觀臨摹方法，必然達不到將精美的敦煌圖案介紹出去的目的。因此臨摹圖案專題時，又採用了能顯示敦煌圖案變化規律、色彩組織規律的整體臨摹。

五○年代以臨摹為主，研究也緊隨其後，臨摹、研究結合進行。1955年常所長下達編寫《敦煌藝術小叢書》一套十二冊，是敦煌文物研究所第一次以通俗讀物的形式介紹敦煌藝術。1952年至1957年是敦煌美術工作安定的幾年，是敦煌美術工作自覺追求質量、數量的幾年。這時臨摹認真，一致追求高質量臨摹，形成一個老帶新、學線描、傳經驗的集體，還制定評比制度，促進臨摹質量不斷提升。短短五、六年間，美術組靠十一、二人完成莫高窟第285窟、榆林窟第25窟兩座整窟的臨摹，以及一批壁畫代表作的臨摹複製；並補充了榆林窟西夏、元代壁畫大型圖案代表作。

臨摹與研究總是相輔相成。莫高窟內容、石窟分期斷代，六○年代已初具規模。我們在臨摹中難免產生對前人判斷的質疑，在考古人員缺乏的年代，解決的路只能在自己腳下。例如，五○年代認為莫高窟沒有北周朝的石窟，而是從北魏、西魏直接過渡到隋。可是，在臨摹實踐中，根據壁畫彩塑造型、表現規律，美術工作者產生了疑問。帶著這些不解之謎，史葦湘終於在第442窟找到一條「第…主簿鳴沙縣丞張恩供養佛時」的北周供養人畫像題記，後來萬庚育復查莫高窟供養人畫像題記

時，又在第428窟發現「普昌郡沙門比丘慶仙供養時」的題名。在不同的洞窟找到兩處北周供養人畫像，說明北周確實在莫高窟修建了一批洞窟。另外，五〇年代到文革前，美術工作人員在日積月累的臨摹中，相繼發現不少新內容、新題材，如睒子本生故事畫、微妙比丘尼因緣故事、福田經變、賢愚經諸品連屏畫、佛教史蹟畫、瑞像畫等。此外，如對中晚唐時的屏風畫與經變畫的構圖關係，第285、249窟窟頂壁畫中佛教內容與民族傳統神話並存的新認識，都是石窟內容研究的新成果。

1958年所長常書鴻、李承仙夫婦攜帶敦煌壁畫臨本至日本，在東京舉辦敦煌藝術展，這是第一次將敦煌藝術介紹給日本觀眾。這時，美術組臨摹了敦煌盛唐壁畫中的傑作第217、172窟觀無量壽經變；為中國歷史博物館臨摹第159窟西壁帶佛龕的模型一座，第156窟長卷畫張議潮出行圖、宋夫人出行圖各一幅。另外還進行敦煌服飾、供養人、飛天三大專題的臨摹工作。隨著臨摹任務的增加，人力不足的矛盾十分突出。當時常書鴻所長已兼任甘肅省蘭州藝術學院院長，為此特調藝術系畢業班同學至敦煌實習，協助美術組臨摹第156、159窟，同時調藝術系的雕塑教師何鄂至敦煌工作，加強敦煌的雕塑力量。1959年劉玉權、何治趙兩人大學畢業後，來到敦煌加入美術組，充實了美術研究的力量。

1959年敦煌文物研究所與甘肅省博物館共同承擔武威天梯山石窟的搶救搬遷任務，由常書鴻所長親自帶隊，除保護組全力以赴外，美術組也抽調李承仙、段文傑、萬庚育、馮仲年、李復等人去天梯山，協助進行石窟內容調查、壁畫臨摹、搬遷等工作，這項工作於1960年結束。1962年秋，敦煌飛天、圖案專題藝術赴上海展出。1963年起敦煌的美術工作又恢復為以臨摹為中心的工作了。

自1952年改用礦物臨摹已有十餘年，壁畫臨本的效果自有公論，按「忠於現狀的客觀臨摹」標準要求，在社會上也有良好反應。但是紙本是否就是臨摹敦煌壁畫藝術的唯一途徑？為什麼不可以像臨摹彩塑一樣按原作的規律，用同樣的材料臨摹，恰巧研究所正在籌劃莫高窟建窟1600年紀念活動，要製作一座洞窟模型，半是創作畫，半是臨摹，為仿製畫壁提供了機會。限於時間不可能按部就班製作，臨時採用在纖維板上刷泥漿做成畫壁表面效果，兩三個人先在簡易的泥壁上試臨第323窟南壁，臨完後果然效果不錯。因此促成美術組人人研究壁畫地杖製作規律的熱情，很快地一批大小不等的試驗泥壁畫臨摹出來了。

1964、1965年常所長又從中央工藝美院壁畫系爭取到李振甫、何山、樊興剛三人來敦煌。他們都是學習壁畫的，是文革前敦煌文物研究所最後吸收的三位專業人員。1964年以後階級鬥爭的弦一天緊似一天，莫高窟創建一千六百年紀念活動無疾而終，敦煌美術工作也由於文化大革命的開始而陷入停頓狀態。

1984年敦煌文物研究所擴建為敦煌研究院，原來的美術組升格為美術研究所，業務範圍由臨摹為主拓展為「臨摹、研究、創新」的六字方針，它是敦煌美術工作數十年夢寐以求的願望，標誌著敦煌美術工作從此邁上了一個新的臺階。

1982年中央決定在東京舉辦敦煌壁畫展，鑒於1958年已在日本舉辦過大型敦煌藝術展，1982年是文革後敦煌藝術第一次辦出國展，應該有較多的新作品介紹出去，而出版《敦煌莫高窟》五卷本的工作也不能放鬆。於是，研究所組織孫紀元、關友惠、李其瓊三人籌備展覽，同時，為解決臨摹缺人的矛盾，從西北師大美術系借調王洪恩、東北魯迅藝術學院借調王占鰲、西安美院借調陳之林、四川美院借來杜顯清、楊鱗翼、施肇祖六位教師，於1981年全年在莫高窟臨摹，解決了人員短

缺的燃眉之急。1982年在日本舉辦的敦煌壁畫展相當成功，法國人在日本看過敦煌壁畫展後，立即洽談於1983年將同樣的內容移至法國巴黎展出。敦煌壁畫在日本展出時，日本創價學會提出收藏敦煌藝術研究所創始人、敦煌研究院名譽院長常書鴻先生臨摹的第217窟化城喻品、敦煌研究院首任院長段文杰復原臨摹的第130窟都督夫人太原王氏供養像，以及李其瓊臨摹的第220窟帝王圖、第98窟于闐王后曹氏供養像四幅參展壁畫臨本，四幅臨本包括忠於現狀的客觀臨摹、舊色整理臨摹、復原臨摹三種臨摹方法。三代美術工作者的臨摹作品在展出時被觀眾提出收藏，這種巧合說明敦煌的美術工作者充滿熱情、激情的臨摹能如實地反映敦煌藝術精神，研究性的復原、整體臨摹是對敦煌藝術的再創作，均為社會認可。

　　1982年展覽取得成功的同時，美術工作呼喚人才已成燃眉之急。1982年敦煌文物研究所委託甘肅省藝術學校為敦煌招收一期美術班，並出資送中央美術學院附中系統培訓三年，成為具有中等美術專業的人才。為了吸收學有專長，經驗豐富，能勝任研究工作的高素質人材，1982年研究所向全國公開招聘專業人員，1984年相繼有一批藝術院校的畢業生、研究生以及在美術崗位已工作多年的學者，這批受過高等專業訓練的美術工作者，已成為繼承敦煌美術工作的骨幹，一支包括不同專長的美術隊伍正在敦煌研究院茁壯成長。

　　使用人、培養人、知識更新是適應事業發展的必由之路，是美術研究所始終不渝的目標。在培養高素質人才方面，敦煌研究院更是不遺餘力，對已經是學有專長的美術工作者，毫無例外地為他們創造繼續深造的機會。自段文杰先生擔任敦煌研究院院長開始，就先後請國內藝術院校為敦煌培養美術人材，繼而創造機會送已有工作經驗的美術工作者至外國深造。他們學成歸來，已成為敦煌美術工作的骨幹。敦煌美術研究所已初步越過斷層，進入不斷提高素質的時代。

　　二十世紀八〇年代以來，敦煌研究院的工作進入了以研究為主的時期。敦煌美術工作在六字方針的指導下，研究敦煌藝術理論義不容辭，配合展覽提供展品責無旁貸。研究、臨摹的雙重任務同時落在美術所的頭上，其困難可想而知。儘管已有兩位從臨摹走向研究的段文杰先生、史葦湘先生擔任研究任務的主將，但也還需要合作者與助手。這時，面對剛提出的六字方針，有人說今後不斷有敦煌藝術的出版物，介紹宣傳敦煌藝術不發愁，美術所老人們的眼也花了，應全部轉入研究；還有一種意見認為敦煌已有不少臨本可供展覽，創新剛納入規劃，今後的美術工作應以創新為主要。事實上，敦煌美術研究所既不是單純的理論研究所，也不是畫院式的創作單位。從研究、繼承、發揚敦煌藝術的實際出發，美術所制定了以臨摹為基礎、臨摹與研究相結合、臨摹與創新相結合的工作原則。

　　基於需求，萬庚育第一個全面轉入研究，參加《中國石窟　敦煌莫高窟》、《中國石窟　安西榆林窟》、《中國美術全集　敦煌彩塑》中部分圖片說明的撰寫工作，編撰《中國壁畫全集》十卷中的五代、宋分冊，並參加撰寫《敦煌學大辭典》部分辭條，還發表了不少敦煌藝術研究的論文。歐陽琳、關友惠、李其瓊則游移於研究、臨摹之間，都是《中國石窟　敦煌莫高窟》、《中國石窟　安西榆林窟》圖片說明、《敦煌學大辭典》辭條的撰稿之一，李其瓊為《敦煌莫高窟》五卷本撰寫《隋代的莫高窟藝術》，李其瓊、關友惠分別是《中國壁畫全集　敦煌》十卷中的中唐卷、晚唐卷的編撰人。

　　美術研究所的同仁在敦煌研究院時期，工作之餘個人發表研究文章亦成風氣，如關友惠有《敦

煌莫高窟早期圖案紋飾》、《莫高窟隋代圖案初探》、《敦煌壁畫中的供養畫像》等；萬庚育有《談談莫高窟的早期壁畫及其裝飾性》、《敦煌壁畫中的技法之一——暈染》、《珍貴的歷史資料—莫高窟供養人畫像題識》等；歐陽琳有《談談隋唐時代的敦煌圖案》、《敦煌壁畫中的蓮圖案》、《敦煌圖案簡論》等；李振甫有《敦煌花磚藝術》、《敦煌的手》、《敦煌佛像畫造型藝術初探》等，都是他們個人近年研究成果之一。值得慶幸的是，今日美術研究所已走出人才斷層的艱難時期，美術研究的年青人不僅成了臨摹敦煌藝術的主力軍，敦煌藝術研究也嶄露頭角，發表了不少文章與專著。如謝成水《看敦煌壁畫—也談中國繪畫透視》、《敦煌藝術美學巡禮》、《莫高窟第296窟的藝術》、《謝成水敦煌壁畫線描集》；侯黎明《新的超越—寫在"敦煌研究院成立五十周年美術作品展"之際》、婁婕《試論敦煌藝術的空間構成》、李月伯《莫高窟第305窟的內容和藝術》、《敦煌莫高窟第一五六窟附第一六一窟的內容及其藝術價值》、霍秀峰《敦煌唐代壁畫中的卷草紋飾》、《敦煌覓珍—李月伯、霍秀峰敦煌壁畫臨本集》、杜永衛《莫高窟彩塑藝術》等，另外，吳榮鑒、馬玉華、關友惠、關晉文、趙俊榮等五人的敦煌飛天、伎樂、供養人、圖案、菩薩白描集五種，獲甘肅省第六屆優秀圖書獎。一個能畫會寫的年輕化的敦煌美術隊伍正在成長。

（本文內容由敦煌研究院楊秀清依《敦煌研究》2004年第3期〈回眸敦煌美術工作〉一文做部分刪減而成。）

Artists Working in the Dunhuang Academy – A Recollection

LI Qiqiong
Dunhuang Academy, China

In 1943, when Director Chang Shuhong led the first volunteers to Dunhuang, the Mogao Grottoes they saw were just ruins leaning against the Mt. Mingsha and facing the Mt. Sanwei. In many of the caves, the murals were collapsing, the statues were broken, and it was almost impossible to climb up to the higher parts of the cliff. The National Dunhuang Art Institute was established and was locatedby the Huangqing Temple. They cleaned up the dust in the ancient temple, fixed up the space, put in some desks and chairs, and the temple became the office of the National Dunhuang Art Institute of Dunhuang.

In 1945, after the victory in the war against Japan, when the government was busy in the affairs of recovery, an order rescinded this National Art Institute, which it had taken so much trouble to set up. The institute immediately fell into difficulties. Director Chang Shuhong rushed to the capital Chongqing and together with the scholars appealed to the government for the preservation of the Institute. In 1946, the authorities finally reinstated it.

In the 1940s, Dunhuang was still a small town with poor communications, cut off from news, and lagging far behind economically. It was almost impossible to obtain any painting materials in Dunhuang at that time. The painting paper was brought from Sichuan and was low-quality material, which always absorbed too much water and could not hold strong colors. Thus, every staff member had to learn mounting and how to apply preparatory alum on ordinary Sichuan paper in order to turn it into proper material for copying the murals. Suitable brushes were lacking as well. The solution was to peel off the outer layers of the old brushes to make new tips and go on using them. A hardened colour tube was also regarded as a treasure: they would add some water to soften the hardened pigment, pound it so that it once more became a high-class painting pigment. Besides all this, the painters used the local yellow earth as a substitute to mimic the aged colors of the wall paintings. After conquering the difficulties with the paper, brushes and pigments, the only problem was the lack of light in the caves. Many well-preserved and bright-colored murals were hidden deep in the caves or behind the central pillars, where the sunlight could not reach. However, without light, the painters could not see and copy the paintings. The answer was to use mirrors to reflect the sunlight into the caves and this method was used until the 1960s. Strictly speaking, it was disadvantageous to preservation. Nevertheless, it was the only way given the difficulties of the time. As long as they could copy the paintings, they would use any method however primitive or clumsy.

In 1949, the People Republic of China was established. In 1951, the National Dunhuang Art Institute was renamed the Research Institute of Dunhuang Culture; Chang Shuhong continued to serve as director. A number of other staff members who firmly stuck to their positions also retained. They were all Chang Shuhong's followers and founding members of the Research Institute of Dunhuang Culture. In 1951, except for Sun Rujian who had an architectural background, the rest of the members were all artists.

In 1951, the Cultural Ministry requisitioned copies of the Dunhuang mural paintings to Beijing and held an exhibition of Dunhuang heritage. For the duration of the exhibition, it was the time of supporting Korea in her war against the US. The exquisite art and the sorrowful history of Dunhuang aroused widespread patriotism, and the profound cultural meaning of Dunhuang art also stimulated extensive attention within the capital city. Accordingly, people in the cultural field started to write essays expressing their feelings towards Dunhuang mural copies. In the same year, the periodical Cultural Heritage Reference, later to be known as Wenwu (Cultural Relics), published essays in two volumes of Special Issue of Dunhuang Cultural Heritage Exhibition.

From 1952, the copying task turned from copying a single picture to whole caves. This was also the year when The

Research Institute of Dunhuang Culture worked according to a new scheme under new historical conditions. Based on the Cultural Ministry's instruction "Copying the paintings is the foundation of the research and is also a basic work of the academy. The process of copying is also a process of training," the staff members all devoted themselves to the core work of copying. Meanwhile, artwork production in the Dunhuang Institute turned from working individually to teamwork and from copying a certain picture to copying the entire cave and even to modelling the cave in its original size. In order to provide the researchers who were not able to investigate the caves in person, the demand of the copying task was to precisely mimic the original murals using the same colors and even copying the damaged parts. Therefore, the well-preserved cave with the precisely dated inscription of 538-539 of the Western Wei Dynasty, Cave no. 285, was assigned as a trial cave for the entire copying of the year 1952. From 1953 to 1954, the Academy focused their efforts on copying the ceiling designs of the caves.

The main task of the 1950s was copying, but research followed. Copying and research complemented each other. In 1955, Director Chang Shuhong planned to publish twelve volumes of A Small Series of Dunhuang Art, and this was the first time that the Research Institute of Dunhuang Culture ever published popular works to introduce the art of Dunhuang. In only five or six years with just eleven or twelve members of staff, the Art Department of the Research Institute of Dunhuang Culture accomplished the entire copying of the Mogao Cave no. 285, Cave no. 25 of Yulin and a batch of representative murals. Besides, they also supplemented these with the large-scale decorative motifs of the Western Xia and the Yuan Dynasties at the Yulin Grottoes.

Copying and research always complemented each other. The contents of the Mogao Grottoes and the periodization of the grottoes began to take shape in the 1940s. In the 1950s, it was commonly thought that there were no Northern Zhou caves. The cave building from Northern Wei and Western Wei directly jumped to Sui Dynasty. Nevertheless, in the copying practice, according to the forms and expressions of the murals and statues, Shi Weixiang finally found a donor inscription of the Northern Zhou. Afterward, when Wan Yugeng reexamined the donor inscriptions, he found another Northern Zhou inscription in Cave no. 428. The discovery of the Northern Zhou figure paintings from different caves illustrated that the Northern Zhou indeed built some caves here. Moreover, in the 1950s before the Cultural Revolution, the art workers learned new contents and themes in the daily copying work. Additionally, there were new research achievements such as the compositional relationship between narrative panels and the sutra paintings in the Middle and Late Tang Dynasty, and a new comprehension of the coexistence of Buddhist themes with traditional motifs from Chinese mythology in Caves no. 249 and 285 of the Western Wei Dynasty.

In 1958, Director Chang Shuhong and his spouse Li Chengxian brought the mural copies to Japan and held a Dunhuang exhibition in Tokyo. This was the first introduction of Dunhuang art to the Japanese audience. In the meantime, the art department copied the Amitayārdhyana Sūtra Panels in Caves no. 217 and 172 of the High Tang period. They also simultaneously undertook the copy work on three main subjects of costume, donors and apsaras. With the increasing tasks of copying, the young age of personnel became a serious problem. At that time, Director Chang Shuhong had become Dean of the Lanzhou College of Art of Gansu province. He thus assigned the graduates to the Dunhuang Institute for practice training and assisting the art department with the copying work in Caves no. 156 and 159. Furthermore, Chang also drafted He E, a sculpture teacher in the art department, to work in Dunhuang to enhance the reproduction of Dunhuang stucco images.

In 1959, the Research Institute of Dunhuang Culture and the Gansu Museum both shouldered the task of rescuing and urgently investigating the cave contents, copying the murals, and moving the contents of Tiantishan Grottoes in Wuwei.

This work was completed in 1962. In the autumn of 1962, the Dunhuang apsaras and decorative motifs were exhibited in Shanghai. From 1963, the primary work of the Research Institute of Dunhuang Culture returned to copying.

It was over ten years since the adoption of mineral pigments for copying. There was public discussion of the result, and very positive responses to the principle of copying objectively. However, was the paper the only material for copying the murals? Was it not possible to use the same material as the original as was being done in copying the sculptures? Meanwhile, it was coincidently the time of the preparation for the anniversary celebration of the one thousand and six hundred years of the Mogao Grottoes. There was a demand for a full-scale cave model and this offered the opportunity for duplicating the murals with the same materials as the original, i.e. the clay wall. Many copies in different scales were thus produced on trial clay wall.

After 1964, class struggle had become more and more severe. The one thousand and six hundred years anniversary celebration for the Mogao Grottoes was abandoned. The work in Dunhuang also halted because of the beginning of the Cultural Revolution.

In 1984, the Research Institute of Dunhuang Culture was upgraded to become the Dunhuang Academy. The task for the former Art Department was also widened from copying to the guiding principles of "copying, study and innovation." It was a coveted aspiration of the Dunhuang artists for several decades and also a landmark for the beginning of a new stage in Dunhuang artwork.

In 1982 the tenth anniversary the normalization of diplomatic relations with Japan took place. The authorities decided to hold an exhibition of Dunhuang paintings in Tokyo and this was the first Dunhuang exhibition after the Cultural Revolution. Because of its the success in Japan, where the French authorities had seen the copies, there was an immediate invitation to hold the exhibition in Paris, France. While this exhibition was on display in Japan, the Soka Gakkai of Japan proposed to collect four of the copies in the exhibition: the copy of "Parable of the Illusory City" in Cave no. 217 by Chang Shuhong, the founder of the Research Institute of Dunhuang Culture and Honorary Director of the Dunhuang Academy; the copy of the Donor Portrait of Lady Wang of Taiyuan in Cave no. 130 by Duan Wenjie, the first Director of the Dunhuang Research Academy; the painting of the Chinese Emperor in Cave no. 220 and the Donor Queen of Khotan from the Cao family in Cave no. 98 by Li Qiqiong. The four copies included three copying methods: a precise copy of the original, copying using ancient colors, and a full reconstruction.

While the exhibition succeeded in 1982, the lack of personnel had become an urgent concern. Therefore, the Dunhuang Research Academy commissioned the Gansu Art College to recruit new members and sent them to the affiliated college of the Central Institute of Fine Arts for three years with financial support. The purpose was to train them to an average standard of skill in artwork. Additionally, in consideration of absorbing professional, experienced and competent members, the Academy recruited nationally in 1982. From 1984, many graduates from art colleges and scholars within this field continually joined the work in Dunhuang. These staff members who received their professional education and training at Dunhuang have become the backbone of those who transmit the tradition of Dunhuang artwork. An art cohort with different professional backgrounds is now growing in the Dunhuang Academy.

Since the 1980s, the task of the Dunhuang Academy has entered a new epoch with research as the primary assignment. The Art Department confronted the double tasks of both copy and research. Although two leading members, Duan Wenjie and the late Shi Weixiang switched from copying to research, there was still a need for collaborators and

assistants. The Dunhuang Academy is not simply a research institute, neither is it an institute for artistic creation. From the standpoint of researching, inheriting and exalting Dunhuang art, it has set up its own working principles: on the basis of the copying work, it will integrate copying and research and also combine copying and innovation.

(Translated by CHIEN Li-kuei, revised and edited by Prof. Roderick Whitfield)

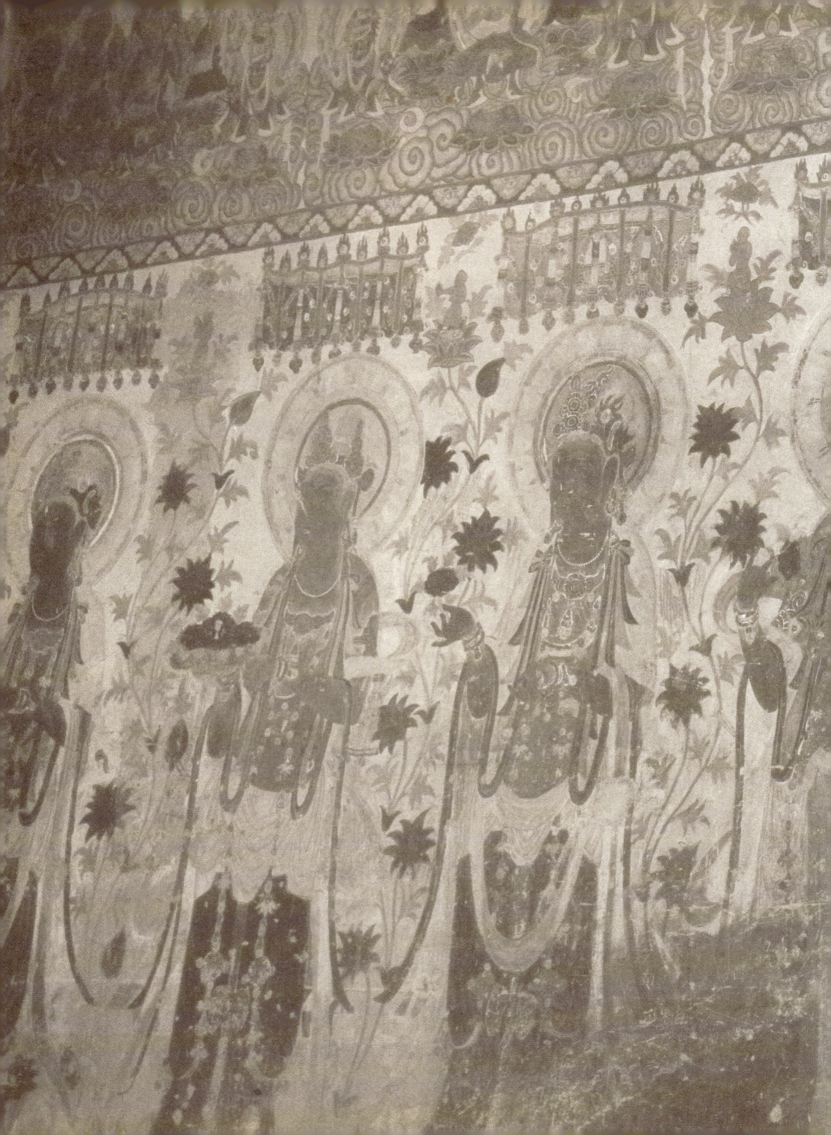

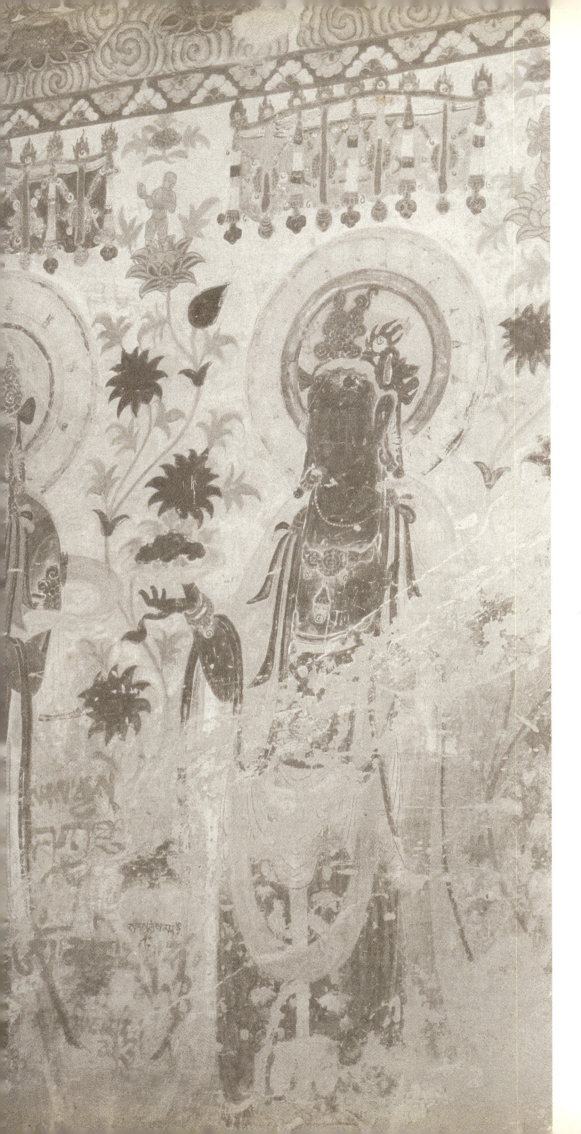

敦煌研究院 典藏
Works from Dunhuang Academy, China

1
莫高窟盛唐第45窟
盛唐
439.0×471.0×503.0 公分

第45窟位於莫高窟南區崖面中段底層，是盛唐所建的中型窟，窟內部分經中唐、五代重新修繪。主室為覆斗形頂，西壁開一龕，窟頂藻井繪團龍井心，四披繪佈千佛。西壁龕頂為表現二佛並坐之《法華經》〈見寶塔品〉內容；東壁畫地藏、觀音等。南壁為觀音居中，兩側分別為觀音三十三種化身及神變救助諸苦難的觀音經變；北壁則為觀無量壽經變，皆通壁繪製。可惜兩壁經變的下部由於曾遭流沙掩埋因而殘損，且由於經後代重新描繪，拙劣的技法破壞原有的表現。

第45窟的彩塑表現技巧高超，被認為是莫高窟盛唐的代表作品，塑像主要有兩個特色，一是高度結合繪與塑的表現手法。西壁至今良好保存一佛、二弟子、二菩薩、二天王，共七身像。主尊為結跏趺坐，面形豐滿圓潤，內著僧祇支，外穿通肩式袈裟，衣紋流暢自如，色彩渾厚深沉。主尊身後的頭光和身光以繪畫的方式表現，而其中一道道突起的金條為泥塑，塑繪相間層次更顯分明；另外，在七尊造像間穿插繪畫的菩薩，亦將塑繪融合的淋漓盡致。

塑像的另一個特色是充分展現出人間性格。主尊兩側的阿難與迦葉，一老一少，老者持重而練達，少者灑脫而童稚，除了對比鮮明之外，也呈現出唐代僧侶寫真形象。兩脇侍菩薩頭梳高髻、姣好如宮娃的面容中有一抹溫婉的微笑，S形一波三折阿娜多姿的形體，配合天衣斜披、長裙束腰、以及袒露上身所顯出的冰肌，充分顯現出唐代佳人顧盼生姿的風采。而位於南北相對的天王，瞪目張口，鎧甲嚴身，一手在腰，另手揮拳，腳踩地神，威風凜凜，實為唐代武將的翻版；而天王腳下的地神則塑造成外族的模樣，無疑為唐將士俘虜的寫照。

Cave No.45, Mogao Grottoes
High Tang Dynasty
439.0×471.0×503.0 cm

Located at the bottom of the middle section on the cliff façade in the southern section of the Mogao Grottoes, Cave no. 45 is a medium-size grotto built during the high Tang Dynasty. Part of the interior was repaired later in the Mid-Tang Dynasty and in the Five Dynasties. The alcove has a double-bracket roof, and there is a niche on the west wall. Dragon patterns are found at the apex (cavern ceiling) and images of the Thousand Buddhas are painted on all four sides. The roof of the niche on the west wall depicts the story of Buddha Śākyamuni and Prabhūtaratna as described in The Bejeweled Pagoda, Chapter 11, Saddharma-puṇḍarika-sūtra (Lotus Sūtra). The Avalokiteśvara image at the center of the south wall is surrounded by the thirty-three nirmāṇakāya (transformations) adapted from stories of the Avalokiteśvara's salvation. The story of Buddha Amitayus is depicted on the north wall. Though both walls were all painted, the bottom section was damaged by shifting sand and "reconstructed" by later painters. As the reconstruction technique was deficient, the original artistic quality was spoiled.

The perfectly crafted painted statues in Cave no. 45 are considered masterpieces of High Tang. Characteristics of these painted statues are a perfect fusion of the painting and sculptural arts and a physical realism. As examples of the perfect fusion of painting and sculptural arts, on the west wall there are seven well-preserved statutes, including one Buddha, two disciples, two Bodhisattvas, two Devarājas. The Buddha's full face is serene and he sits cross-legged wearing a sankaksikā inside and a cross-shoulder kasaya. The patterns of the clothing is smoothly painted in a thick and powerful tone. The nimbus and mandorla behind the head and the body are articulated in paint. The golden haloes are made of clay to bring a sharp contrast between painting and scuplture. Moreover, the bodhisattva paintings connecting the seven statutes are vividly portrayed with delicate lines and beautiful form.

In terms of realism, Ānanda and Mahā Kasyapa, the young and the old close disciples of Śākyamuni, flank the main deity. The older one looks dignified and experienced, while the younger one expresses a free and easy character, with a little bit of childishness. In addition to the sharp contrast of the characters, these figures reflect the condition of monks and nuns in the Tang Dynasty. The two attendant bodhisattvas each dressed with a tall bun look like the smiling maids in the Tang Court. The unclothed upper body of their attractive tripanga (s-shaped) figures are covered with a lace gown over a high-waisted skirt ; this is the stereotype of beauty in the Tang Dynasty. The two Devarājas in amour located in the north and south are staring at each other with mouths agape. They make a fist in one hand and put another at the waist and step on an earth deity expressing their majesty. These physical attributes are stereotypical of military officers of the Tang Dynasty. The earth deity that looks alien under the foot of the Devarajas is analogous the prisoner of war captured by Tang troops.

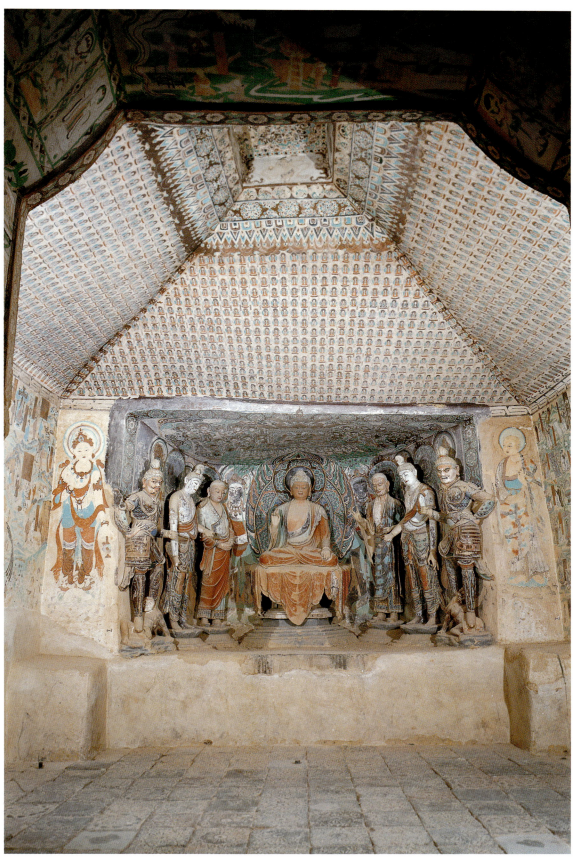

西壁　West Wall

178 敦煌藝術大展
荒漠傳奇・璀璨再現

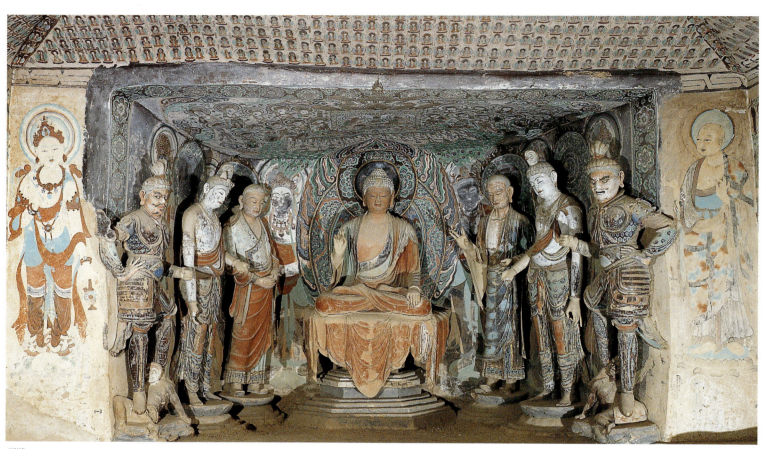

西壁　West Wall

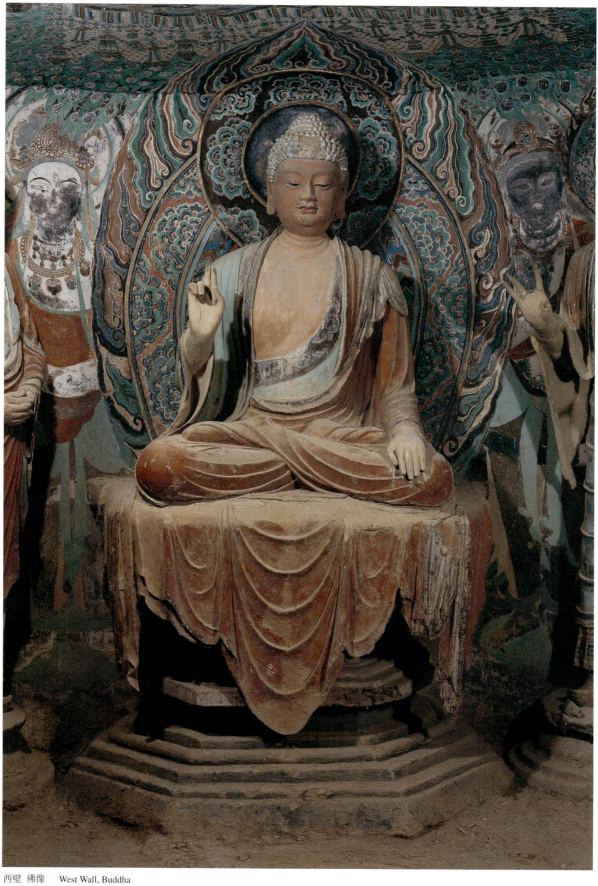

西壁 佛像　West Wall, Buddha

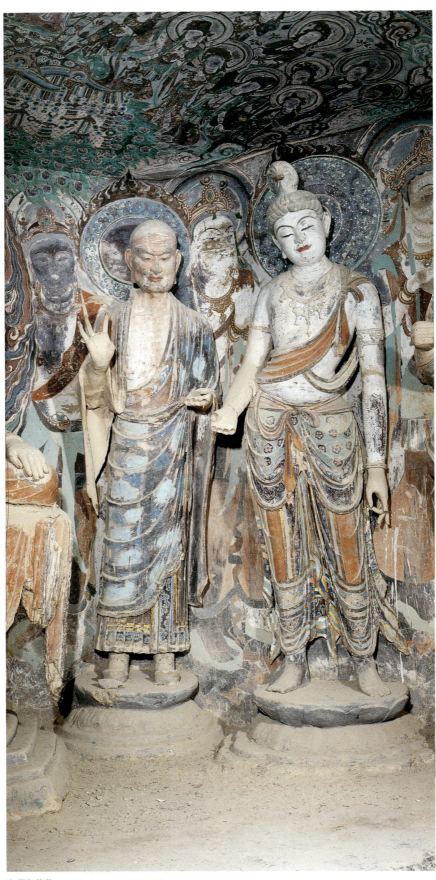

迦葉與菩薩　Mahā-kāśyapa and Bodhi-sattva

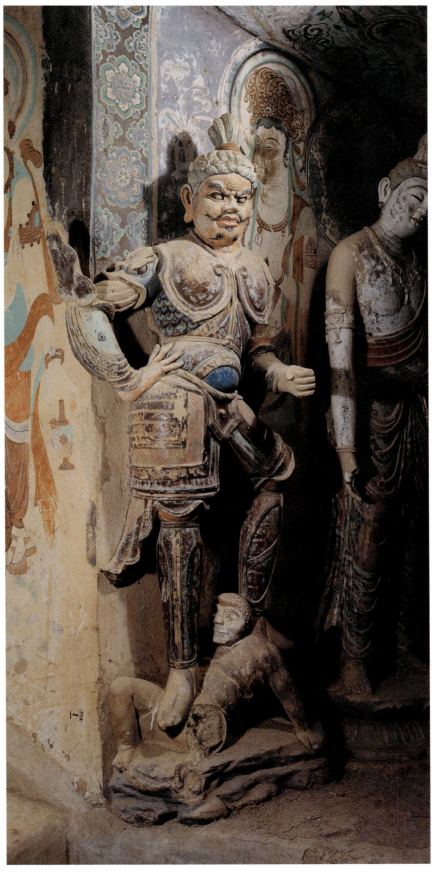

天王（南）　Devarajas (South)

南壁觀音經變　Avalokiteśvara Sūtra, South Wall

南壁觀音—水難（局部） Calamity of Shipwreck, South Wall (part)

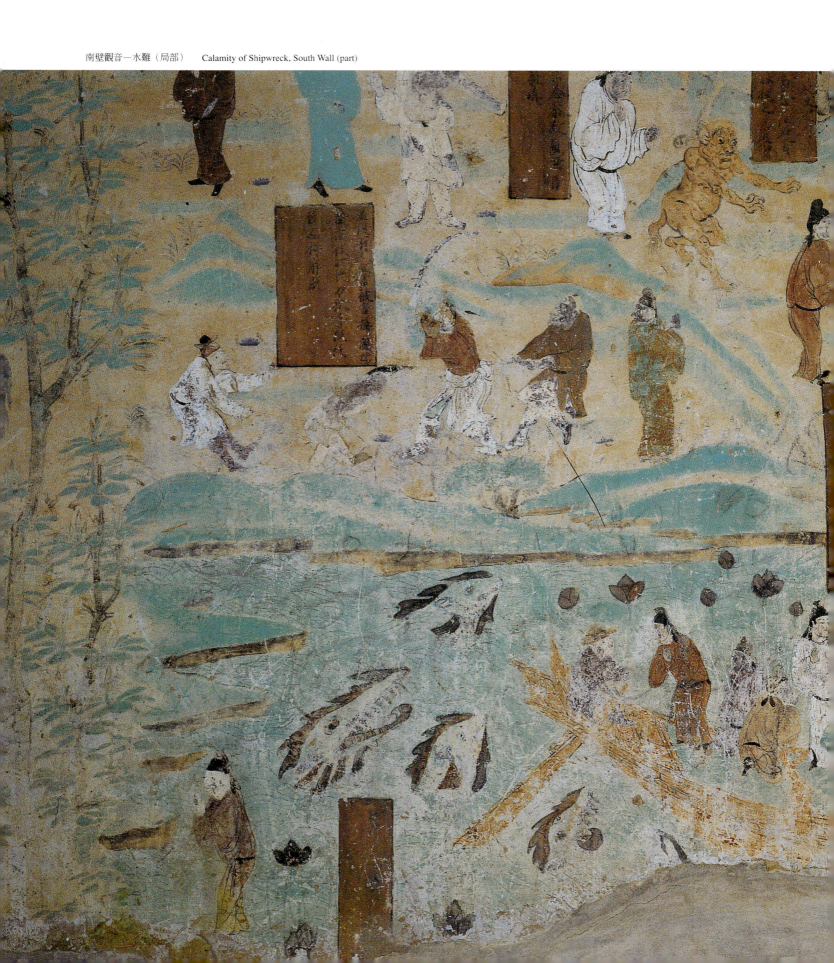

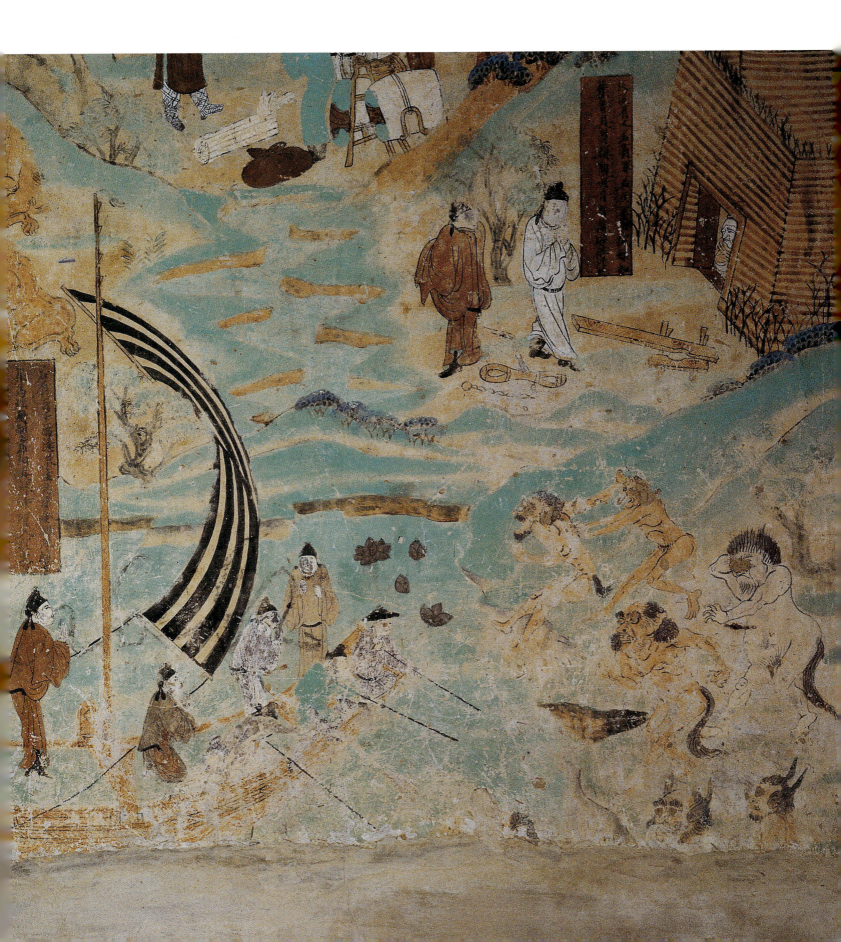

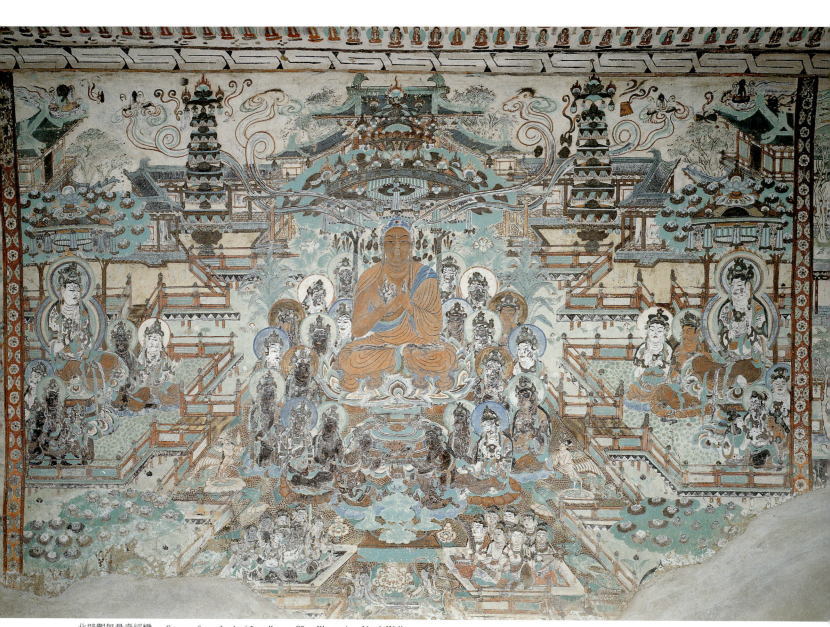

北壁觀無量壽經變　Sermon from the Amitāyurdhyana Sūtra Illustration, North Wall

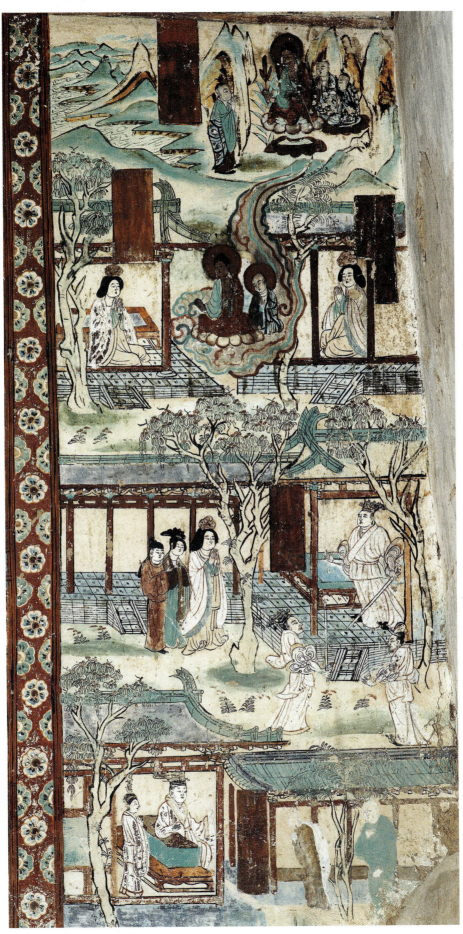

未生怨　Ajātaśtru

2
莫高窟晚唐第17窟(藏經洞)
晚唐
275.0×412.0×310.0 公分

第17窟為素負盛名的藏經洞，位於莫高窟南區崖面北端底層大窟（第16窟）內的甬道北壁，為覆斗形方形窟。由於開鑿於第16窟甬道側，因此並非如一般莫高窟坐西朝東，而是坐北朝南的方向，北壁貼壁處建有長方形禪床式低壇泥床，其正面可見彩繪的痕跡；其上泥塑一僧人像，為晚唐河西僧人領袖洪䛒的影窟。西壁嵌有大中五年（851）「洪䛒告身碑」，根據碑文記載，洪䛒俗姓吳，由於悉心研讀漢經梵典、兼習番文藏語，成為出色的翻譯僧侶，更因為積極參與推翻佔領敦煌的吐蕃，因而在宗教與政治上擁有舉足輕重的地位。在二十世紀六十年代，於塑像背後發現一袋骨灰，考證後始知為洪䛒真容塑像，才又搬回第17窟中。

洪䛒塑像，其珍貴之處在於面容上寫實的處理方式，內斂下視的眼神、厚實穩扺的雙唇，以及眼角的皺紋、鼻翼至唇角的法令紋痕，皆十分細膩，顯得真實而自然；而在身形衣著上幾道泥塑衣紋、以及相配合的袈裟彩繪，形擬出高僧禪坐的定靜姿態，展現出當時形塑人物上高超的藝術水準。正壁上除了洪䛒塑像外，壁面尚繪有雙樹，枝葉相連，畫面右方樹下為一比丘尼，雙手捧對鳳團扇，樹枝內側上掛一長頸水瓶，下半部有些殘損；左方樹下所繪的近侍女則大致保存良好，線條與色彩清晰可辨，一手持杖、一手捧巾，樹枝內側上掛一布包。近侍女是指在家受五戒的女子，畫面上的裝扮乃是典型的唐代風格。此外，西壁牆上還有張大千在此臨摹壁畫後，讚嘆洞窟藝術成就所提寫的字跡。

第17窟存藏文物後封洞，並上泥、及重繪壁畫掩蓋表面，直至1900年道士王圓籙發現此窟為止。洞內存藏大量文物，包括數萬卷寫經文書及幡、幢、絹、麻、紙畫等文物，目前分藏中國、英國、法國、日本、俄國和美國等地，因為這批文物價值彌足珍貴，因而掀起敦煌學研究的風潮。

Cave No.17, Mogao Grottoes
Late Tang Dynasty
275.0×412.0×310.0 cm

Commonly known around the world as the Sūtra Cave (or sūtra-storage cave), Cave no. 16, a double-bracketed square cave, is located within the bottom level off the north wall of the corridor of the large Cave no. 17 which is in the southern section of Mogao's cliff façade. In front of the rectangular, low clay bed in the shape of a meditation dais located towards the side closest to the north wall, there are remnants of a mural and a clay sculpture of a monk seated on top. It is the relic-keeping cave of Abbot Hong Bian, a monastic leader in the Late Tang Dynasty. According to the Hong Bian Biographic Tablet dated to the fifth year of Dazhong (851 A.D.) embedded in the west wall, Hong's surname name was Wu. He became a brilliant sūtra translator - because he devoted himself to the study of classics and sūtras written in Chinese and Sanskrit and various other foreign languages. As he was also an activist in overthrowing the Tibetans occupying Dunhuang, he enjoyed a decisive position in both religion and politics. A bag of ashes was discovered behind the statue in the 1960s. The status was put back in Cave no. 17 when further investigations indicated that this was Hong's portrait statue.

Realism is the most valuable quality about the statute. The facial expression of Hong was captured naturally and in detail, such as the reserved and lowered eyes, the thick and smooth lips, the cross-feet, and the dharma folds; all are minutely depicted in a real and natural manner. In the clay sculpture with features of his kasaya (monastic clothing) marked pictorially (the artist has) captured the serenity of an eminent mediating monk. All these qualities suggest a sculptural art at its peak. In addition to Hong's statute, two trees with branches and leaves linked together were drawn as a mural on the central wall. A bhiksun holding a fan with phoenix patterns in her hands is standing beneath the tree on the right side. A long-neck bottle (damaged, bottom) is hung in the branch. The maid on the left hand side holding a stick in one hand and a towel in another, beneath the tree is preserved quite well with clearly identifiable lines and colors. A garment is hung in the branch. Up āsikā refers to women who practice the five prohibitions panca-veramani at home. The style of the upasikas in the mural is typical in the Tang Dynasty. Further, writing remarking on the wonder of the Dunhuang art by Chang Da-chien are found on the west wall after he copied the mural here.

After the paintings and manuscripts were stored inside, the cave was sealed with a clay wall and murals were painted on top as kind of camouflage. It was not until 1900 that the cave was discovered by the Taoist priest Wang Yuanlu. There are large amount of manuscripts inside the cave, including over ten thousand rolls of sutras and documents and bannersand pennants on silk, linen, and paper. Currently, these treasures are in the collections of China, Great Britain, France, Japan, Russia and the USA. As these are invaluable Buddhist, literary and artistic treasures, Dunhuang Studies were initiated with their discovery.

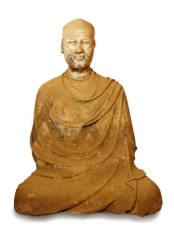

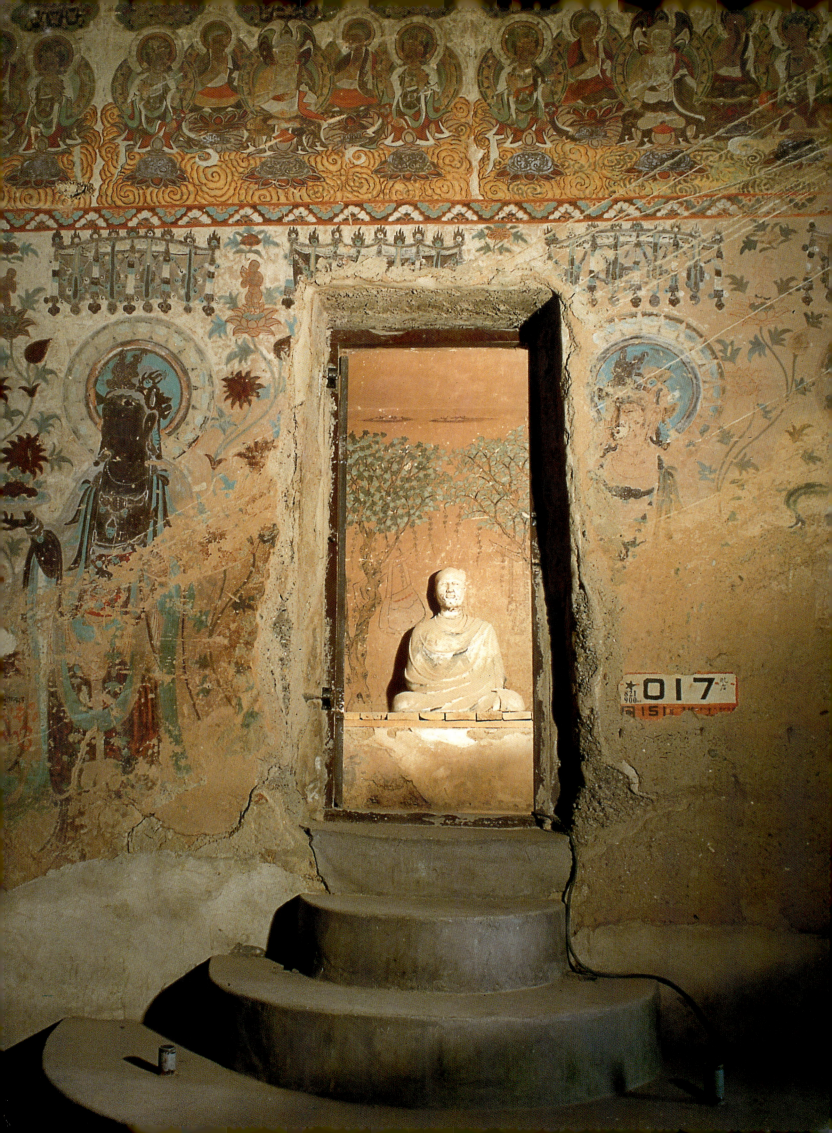

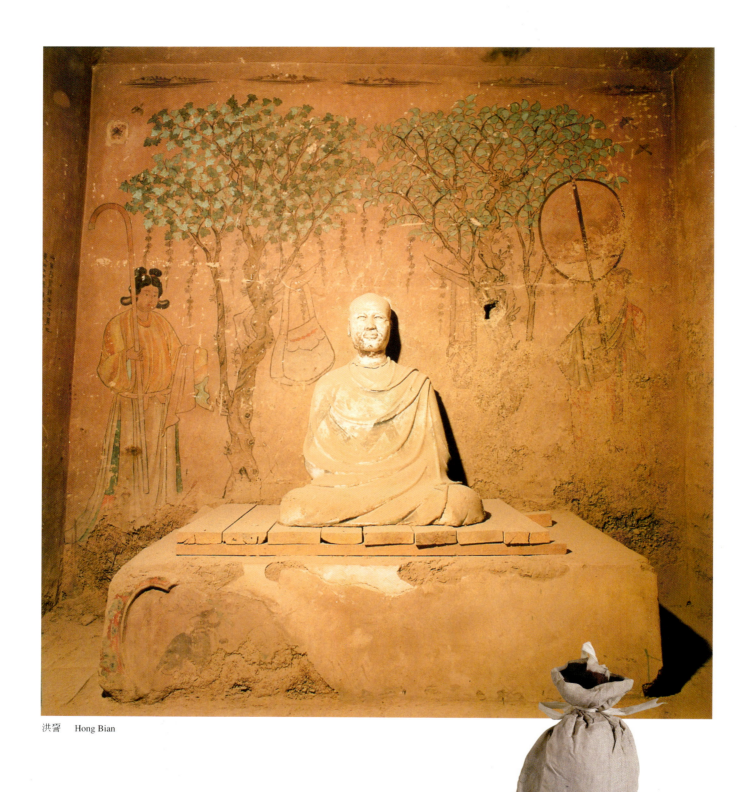

洪誓　Hong Bian

骨灰袋　A Bag of Ashes

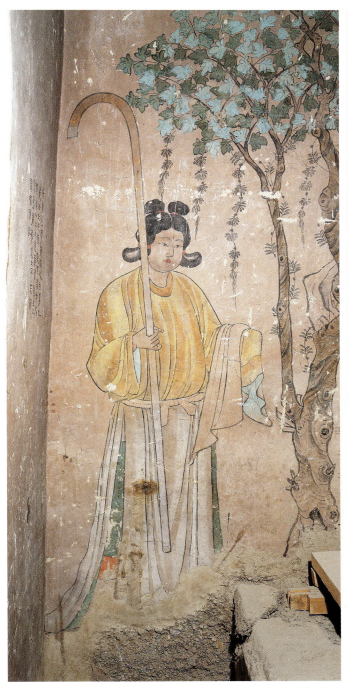

北壁西側　近侍女　Upāsikā, West Section of North Wall

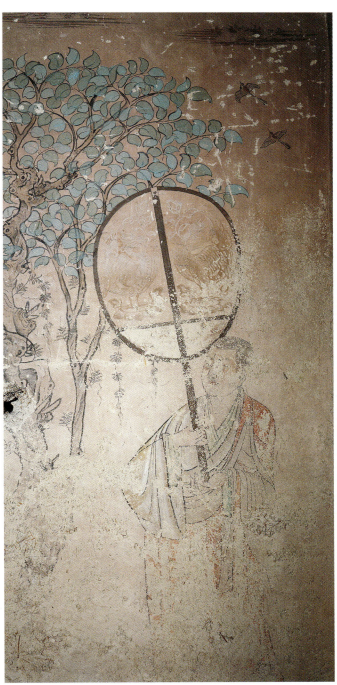

北壁東側　女尼　Bhikṣunī, East Section of North Wall

3
莫高窟元代第3窟
元代
320.0×256.0×315.0 公分

第3窟位於莫高窟南區崖面北側、沙坡與崖立面的交接處，崖體低矮，為元代所建的小型洞窟。主室頂部呈覆斗形，西壁開龕，門道很淺，窟頂藻井浮塑四龍井心，唯中心殘毀，四披畫聯珠紋圖案，其中東披殘，南、北披模糊；西龕外南、北兩側為持淨瓶的菩薩與披帽菩薩等；南壁繪十一面千手千眼觀音經變一鋪，觀音位居中央，兩側上角各一身飛天，東側為帝釋天、西側為梵天女，東下角為跏趺坐的梵天女，西下角為跏趺坐之婆羅門，可說以觀音之圓為中心，兩兩相對；北壁亦繪十一面千手千眼觀音經變一鋪，型態相仿，也是以觀音為中心兩相排列分佈，但所繪人物內容與位置則有所出入，例如於西側為吉祥天、東側為婆藪仙，西下角為三頭八臂金剛與象頭神、東下角為三頭六臂金剛與豬頭神；東壁門上畫跏趺坐佛五身、門南為將甘露施餓鬼的持淨瓶之觀音、門北為將七寶施予貧兒散財的觀音。

第3窟兩鋪千手千眼觀音經變皆顯示出精湛的描繪技法，人物面部五官以及裸露的胸臂多用秀勁圓潤的鐵線描，火焰形髮絲與蓬鬆飛揚的鬍鬚採游絲描，菩薩、天人等厚重的衣裙則以蘭葉描描繪，可說融合了多種線描技巧；特別是千手千眼勾勒得一絲不苟，如此畫功著實令人好奇畫家的身份。一般敦煌的畫作是沒有留下提名的，而此窟卻在西壁外北側觀音左下方有畫家題記：「甘州史小玉筆」，雖為一無可考之畫家，但卻創造出令後世嘆為觀上的畫作。

此窟南、北壁描繪的十一面千手千眼觀音，是屬於密教的觀音圖像；而西壁龕外、與東壁窟門持淨瓶或散財的觀音，則為顯教的觀音造型，體現出蒙元時期顯密融合的歷史實況。

Cave No.3, Mogao Grottoes
Yuan Dynasty
320.0×256.0×315.0 cm

Located at the intersection of the sand enbankment and the cliff façade in the northern edge of the southern portion of the Mogao cliff, Cave no. 3 is a small-scale cave built in the Yuan Dynasty. It has a truncated pyramidal-shaped ceiling, a niche on the west wall and a shallow entrance. Four carved dragons are found in the damaged caisson ceiling. Though there are continuous bead patterns on four sides, the eastern side is damaged, and patterns on the southern and northern sides are unclear. Paintings of bodhisattvas holding a holy bottle and wearing a hat are found in the south and north outside of the western niche. The story of Avalokiteśvara with eleven faces, 1,000 hands and eyes is painted on the south wall. In each of the two upper corners of the Avalokiteśvara painting, are flying Apsaras. Avalokiteśvara is flanked by standing Śakra Devānmindra and a seated Brahmī (left), and standing Brahmī and a seated Brahmā (right), as if the couple are worshipping Avalokiteśvara at the center. The scene of Avalokiteśvara with eleven heads and 1,000 hands and eyes on the northern wall has a similar layout. Two rows flank the Avalokiteśvara icon, though the characters and their locations are different. For example, on the left (west) is the standing Goddess Śrīmāha-devī, who is above a Three-headed, Eight-armed Vajrapāṇibalin, and to the right by a standing ascetic Vasu-deva, above a Three-headed Six-armed Vajrapāṇibalin (holding a vajra, dharma, sword, bell, sūtra scroll and a magical object). Below Avalokiteśvara on north wall, are two creatures, one in an elephant-headdress, the other in a pig-headdress. Apsaras occupy the upper corners of both murals. On the east wall, above the entrance, are five seated Buddhas. Left of the entrance (north) is Avalokiteśvara who distributes wealth among the people. scatters seven jewels (such as coral, ivory tusk, money, pearls) into a bucket hoisted by a man; another arm reaches towards the jewels from the right. Small pagoda on lotus appear at the bottom of painting. Right of the entrance, Avalokiteśvara holds a nectar flask containing sweet dew to feed hungry ghosts.

The two murals depicting the scenes of Avalokiteśvara with eleven faces and 1,000 hands and eyes in Cave no. 3 are virtuously crafted. Iron-wire line was used to draw facial features and the exposed chest achieving an elegant, but powerful, smooth style. Gossamer - thin lines (like long, waving loose strands of a spider's web), were employed to outline the flame - like hair and fluffy, flying whiskers. What is noteworthy is that the eleven-headed, one thousand hands and eyes Avalokiteśvara was carefully sketched in every detail. Though the name of the artist, Shi Xiaoyu of Ganzhou prefecture, which appears in an inscription on the right (north) side of west wall, was unknown, the painting is forever formidable.

The icons of the Eleven-headed, 1,000 Hands and Eyes Avalokiteśvara on the south and north walls are Tantra; the Mahāsthāmaprāpta bodhisattva and the fortune-giving Avalokiteśvara icons found outside the niche on the west wall and the east wall are in the Dhyana (Mahayana) tradition, suggesting the fusion of both sects in the Yuan Dynasty.

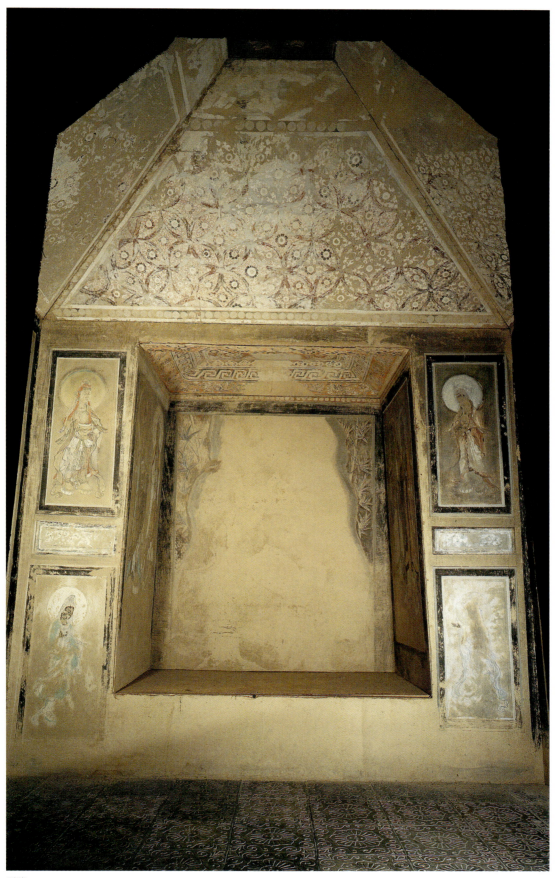

西壁　West Wall

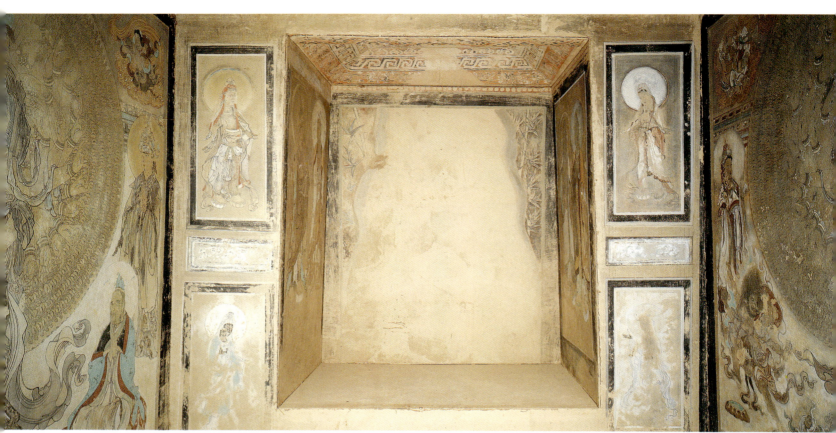

西壁　West Wall

東壁　East Wall

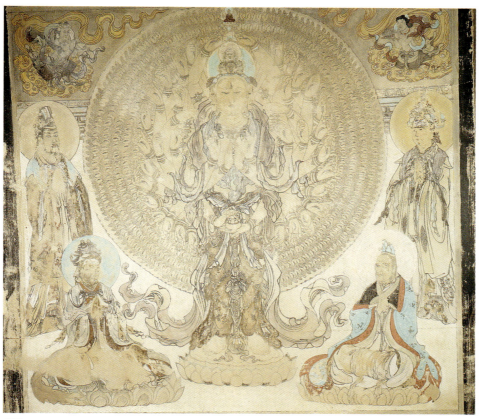

南壁　South Wall

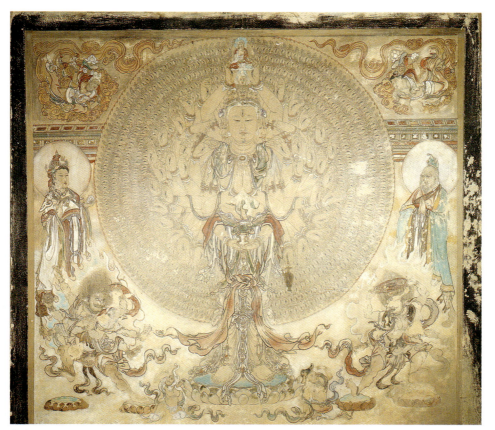

北壁　North Wall

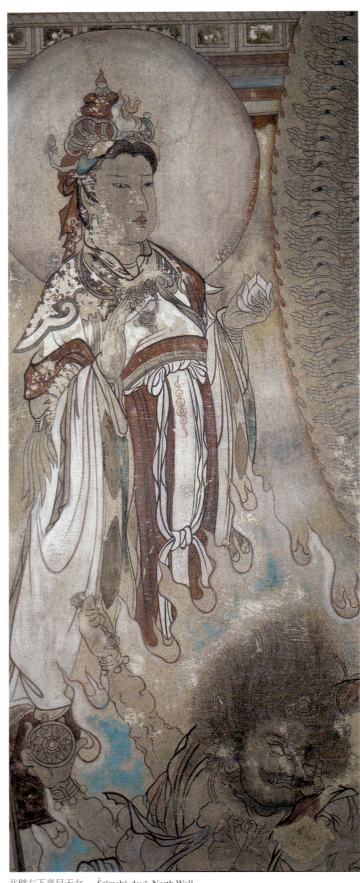

北壁左下童目天女　　Śrīmahā-devī, North Wall

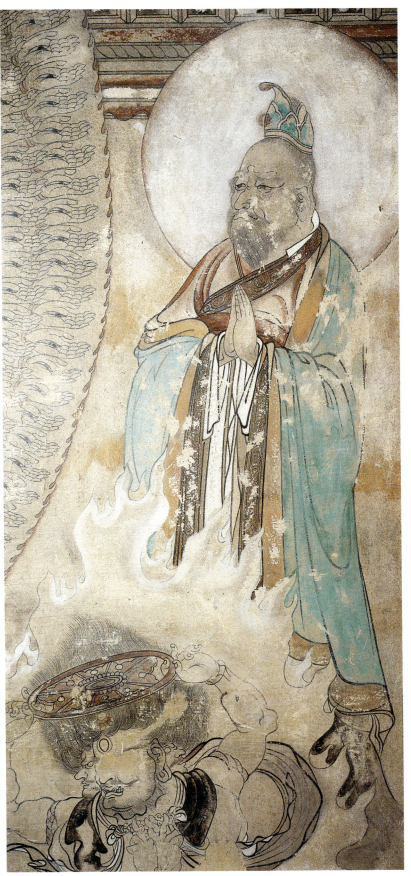

北壁婆藪仙　　Vasu-deva, North Wall

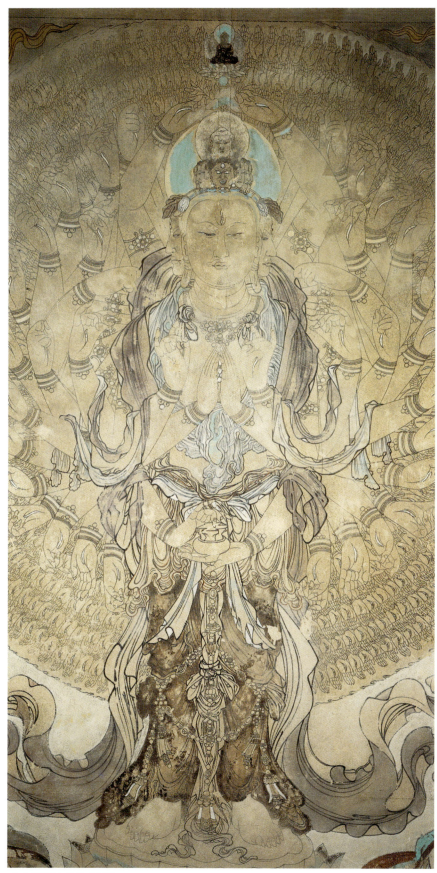

千手千眼觀音菩薩（局部）
Thounsand-handed and Thousand-eyed Avalokiteśvara (Avalokiteśvara-sahasrabhuja-locana) (part)

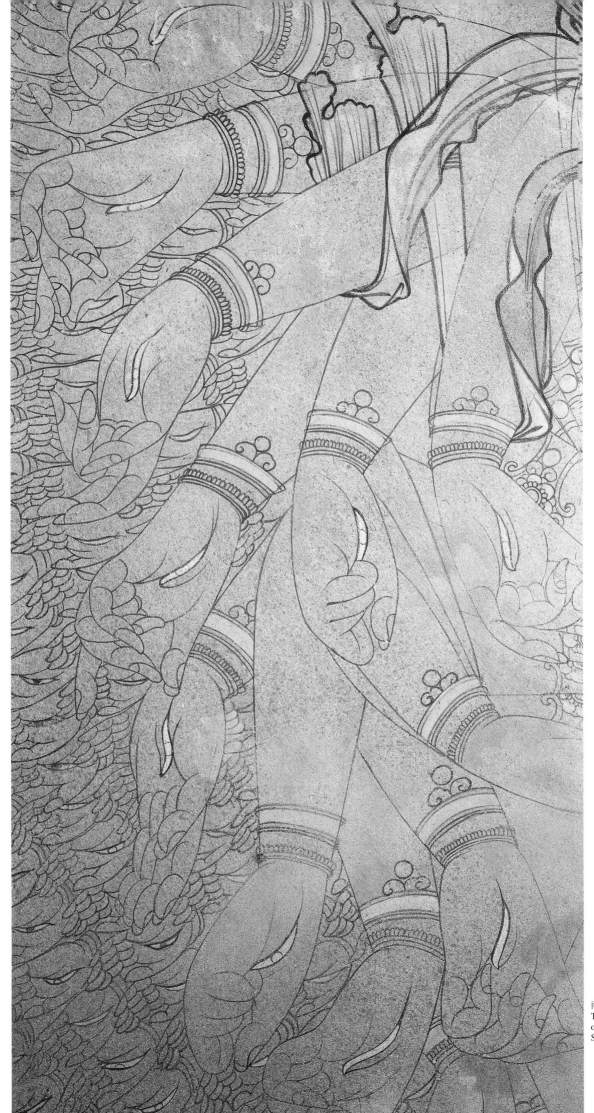

南壁觀音手部特寫
The Feature of Hand of Avalokiteśvara, South Wall

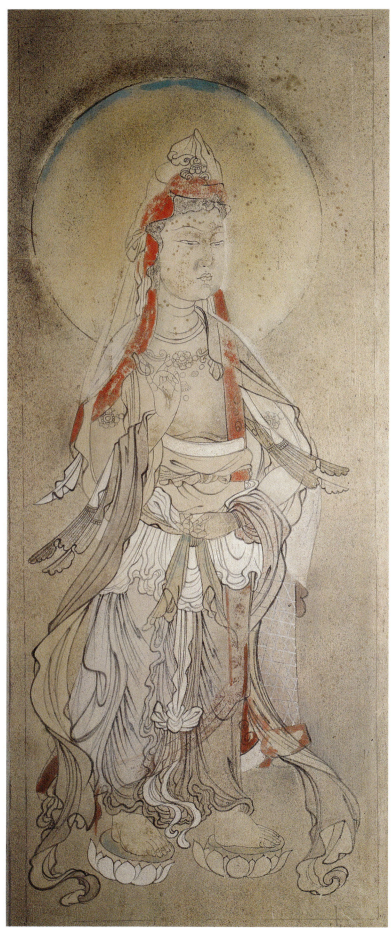

西壁南側菩薩　　Bodhisattva, South Section of West Wall

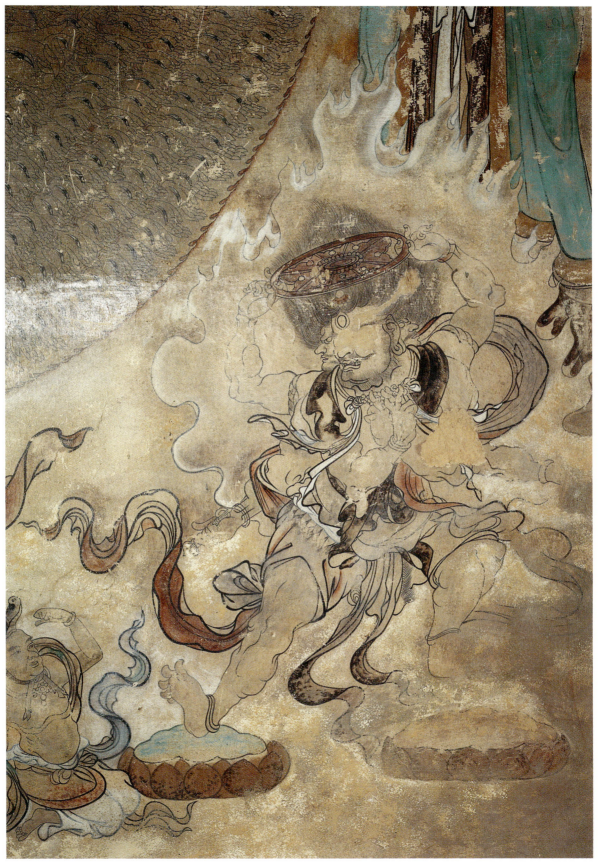

北壁三頭六臂金剛　　The Wrathful Vajrapāṇibalin(Nārāyaṇa) with Three Heads and Eight Arms

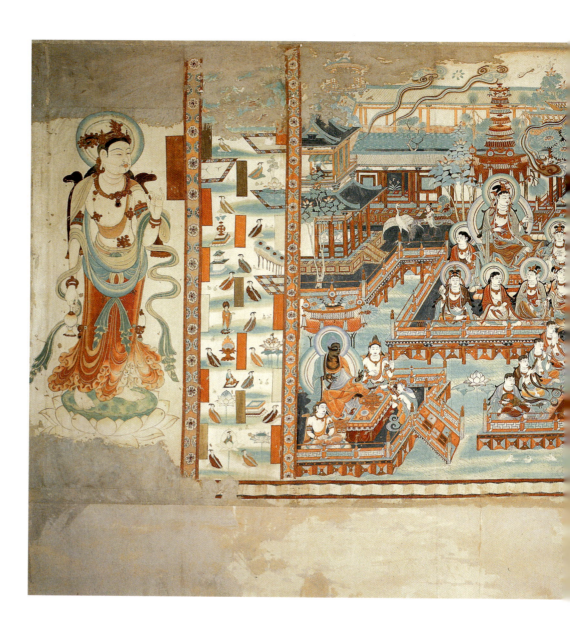

4
觀無量壽經變
榆林窟第25窟 南壁
中唐
壁畫臨本
328.0×625.0 公分
臨摹者：段文傑、關友惠、李其瓊、李復、
　　　　馮仲年、霍熙亮、何治趙、
　　　　歐陽琳、李承仙、史葦湘

Scenes from Amitāyurdhyana Sūtra Illustration
South Wall, Cave No.25, Yulin Grottoes
Mid Tang Dynasty
Copy, Wall Painting
328.0×625.0 cm
Copied by：Duan Wenjie, Guan Youhui,
　　　　　Li Qichiong, Li Fu, Feng Zhongnian,
　　　　　Huo Xiliang, He Zhizhao, Ou Yanglin,
　　　　　Li Chengxian and Shi Weixiang

　　本作品堪稱是中唐時繪製精美且保存良好的觀無量壽經變的代表，依據宣說西方阿彌陀佛極樂淨土世界的《觀無量壽佛經》繪製而成。由於有足夠空間，將阿彌陀說法的場景置中，兩側描繪有阿闍世太子囚禁父王、並欲殺害母后的未生怨與韋提希夫人發願至極樂世界、佛陀應現、教導其觀想修行的十六觀，採橫長方形的構圖。前景左右兩側是在露臺的一佛二菩薩與一供養菩薩，中間為舞樂的場面，畫面的正中是阿彌陀三尊與諸菩薩，通過迴廊、臺階與水池等串連樓閣建築，形成有深度空間的統一畫面。此圖相較於其他同時期的淨土畫描繪眾多人物，在此則是按畫面大小安排適當數量，因此顯得疏朗、卻不失於冷清。

　　中唐的繪畫風格發展至此，人物形體已闊然呈現福態，例如諸菩薩眾的身形、中央亭臺上的舞者；然而仍可以從舞者的動作，包括背腰鼓扭腰舞動的身軀、雙手張開準備擊鼓的動作、以及單腿支撐，皆可看出舞者靈活的身段；特別是指尖翹起呈五爪狀，左腳不單前曲、大拇指還勾起來，表現舞者所散發的力度，而同時也體現了畫者的觀察仔細。

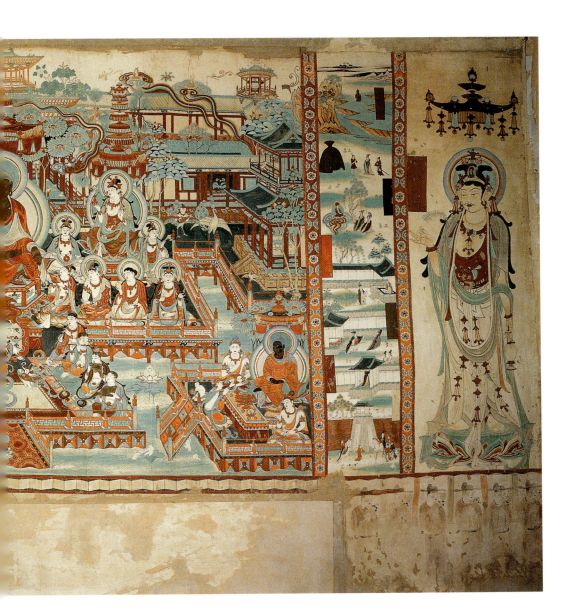

The original mural may be considered the finest and well-preserved mid-Tang dynasty, Pure Land Buddhistpaintings of the Buddha Amitayus based on The Amitāyurdhyana Sūtra (The Sutra of the Buddha of Everlasting Life). Due to the copious space, scenes regarding the origins of Amitābha are concentrated at the center, and the sixteen meditations are depicted in narrative frames. They are: depicting Prince Ajātaśatru capturing and imprisoning his father; Bimbisāra becoming furious with his mother Vaidehi and trying to kill her; the Queen prostrating and asking the Buddha to show a land of no sorrow and no affliction where she could be reborn; the Buddha demonstrating to the Queen the many Buddha-lands and teaching her the method of visualizing the Pure Land, etc. The Buddha, two Bodhisattvas and donor Bodhisattvas are positioned on the left and right sides of the platform in the foregroundand a dance stage occupies the middle section The Three Holy Onesand other Bodhisattvas occupy the front center of the painting, which spatially recedes to a series of buildings connected to winding corridors, platforms and a pond. Compared to other Pure Land paintings of the same period, objects and characters in this painting are well-scaled and well-arranged, that are arrayed in a pleasing manner.

Though the Mid-Tang Dynasty figures are plump, such as the center stage Bodhisattvas and dancers, they are still dexterous and quick in action. This is evident in the dancers' movements, in carrying a waist drum and twisting at the waist, simultaneously beating the drum, and balancing on single foot. Of particular note is the case of the extended toes and the bending left foot, where the big toe even points up, demonstrating the dancer's extraordinary strength and the artist's careful observation.

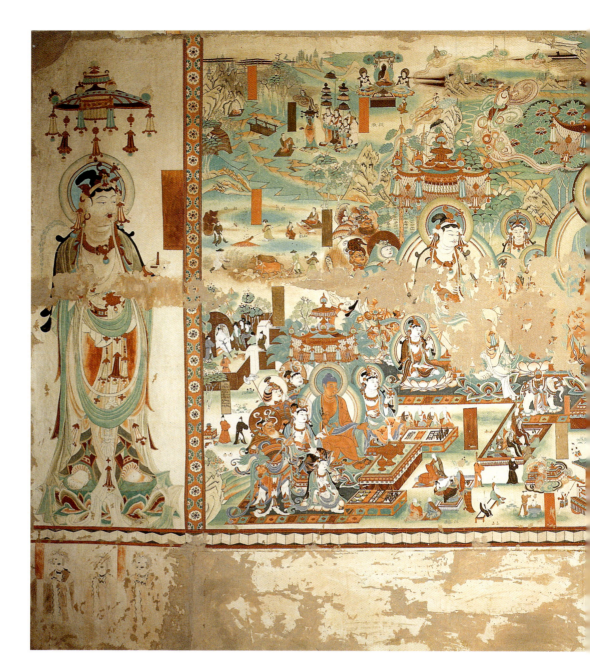

5
彌勒經變
榆林窟第25窟 北壁
中唐
壁畫臨本
328.0×625.0公分
臨摹者：段文傑、關友惠、李其瓊、
　　　　李復、馮仲年、霍熙亮、何治趙
　　　　、歐陽琳、李承仙、史葦湘

Scenes from Maitreya Sūtra Illustration
North Wall, Cave No.25, Yulin Grottoes
Mid Tang Dynasty
Copy, Wall Painting
328.0×625.0 cm
Copied by：Duan Wenjie, Guan Youhui,
　　　　　　Li Qichiong, Li Fu, Feng Zhongnian,
　　　　　　Huo Xiliang, He Zhizhao, Ou Yanglin,
　　　　　　Li Chengxian, Shi Weixiang

　　本作品是以《彌勒下生成佛經》為依據，畫面主體是彌勒三會，彌勒初會居中，未來佛彌勒在龍華樹下倚坐說法，菩薩左右脇侍，諸聽法聖眾、天龍八部圍繞；第三會和第二會分別置於畫面左、右下角，與初會組成「品」字型的整體結構。畫面其餘空間則表現彌勒菩薩從兜率天宮下降到翅頭末城閻浮提世界的景象，如龍王夜雨、羅剎掃地（右上角）；樹上生衣、五百歲行嫁（右下角）；迦葉傳袈裟、一種七收（左上角）；人壽綿長、見寶生厭（左下角）；七寶供養、觀拆幢悟出家、為眾剃度（中央下方）等，錯落穿插在彌勒三會說法場面中，形成內容詳盡而又主次分明的宏偉構圖。此圖畫風細膩、色彩絢麗，為敦煌石窟中不可多得的傑作之一。

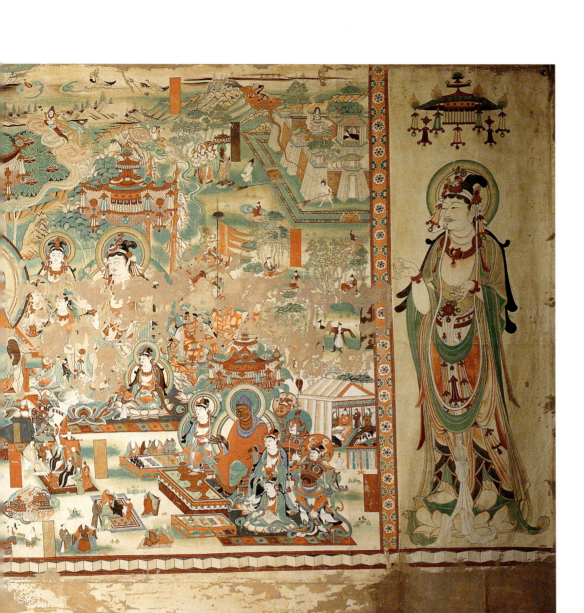

The work was based on The Sūtra of Maitreya's Descent from Heaven. The three sermons of Maitreya are the primary subject matter. The scene of first sermon is at the center, depicting how Maitreya explains the dharma to the gathering under the nāga-puṣpa tree. Flanking Bodhisattvas attend, the Eight Classes of Beings gathers around. The scenes of the third and the second sermons are drawn at the lower corners on the left and right hand sides respectively, forming a triangular shape with the first sermon. The rest of painting depicts the scenes of the Jambu-dvipa world after Maitreya's descent from Palace Tuṣita to the to the world below. The Seven Treasures (goddess, wheel, elephant, pearl, box, horse, and general) surround the altar at Maitreya's feet. Directly beneath the altar, the destruction of the pillar represents end of the law. On the left (and right) side of the composition are vignettes of preparation for Maitreya's coming, including an older disciple going willingly to his grave and farmers reaping abundant crops. Above, Buddha transmits the kaṣāya (monastic robe) to Mahā-Kāśyapa. On the right side of the composition, a groom bows to parents of 500-year-old bride. Tonsuring scenes divided between men and women at either side of the pillar appear at the bottom center. Scenes from the sermons are depicted in detail in the mural in a splendid composition. The detailed painting and brilliant colors of the work is one of the best amongst the Dunhuang murals.

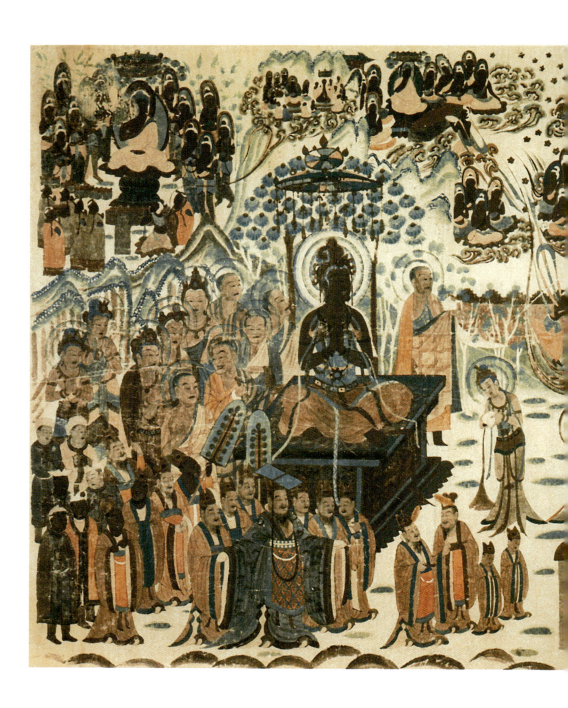

6
維摩詰經變
莫高窟第335窟 北壁
初唐
壁畫臨本
144.1×258.5 公分
臨摹者：段文傑

Story from the Vimalakīrtinirdeśa Sūtra Illustration
North Wall, Cave No.335, Mogao Grottoes
Early Tang Dynasty
Copy, Wall Painting
144.1×258.5 cm
Copied by：Duan Wenjie

　　維摩詰經變乃根據《維摩詰所說經》繪製，本幅作品位於北壁，通壁繪製，是唐代規模最大的一鋪維摩詰經變。

　　畫面上文殊、維摩詰分坐左右兩側，代表著文殊率眾問疾與維摩詰相對辯法的情形（〈問疾品〉）；下方左右分別為國王與王子等（〈方便品〉）。此外，還有許多情節，如維摩以神通力遣三萬兩千獅子座入室，但唯有文殊菩薩道行高深而得座，圖中維摩詰上方繪有數個獅子座自天飛來（〈不思議品〉）；維摩以神力遣化菩薩至香積國請施飯，後覆地而成山，飯香遍三千大千世界，圖中文殊、維摩間除化菩薩外，可見九百萬菩薩乘彩雲自香積國飛降而下（〈香積佛品〉）；畫面右上角是維摩應聽眾要求，現身於妙喜國大海中由阿修羅守護的須彌山世界的神變場景（〈阿閦佛品〉）；左上角則是釋迦長子以七寶做成的寶蓋供養之景（〈佛國品〉）等。可說在宏大的場面中，以文殊、維摩詰為主體，將其他品的內容穿插期間，形成一協調的構圖。

　　由於壁畫變色嚴重，本圖臨摹時試圖復原一定程度的變色，也可看出臨摹者的用心。

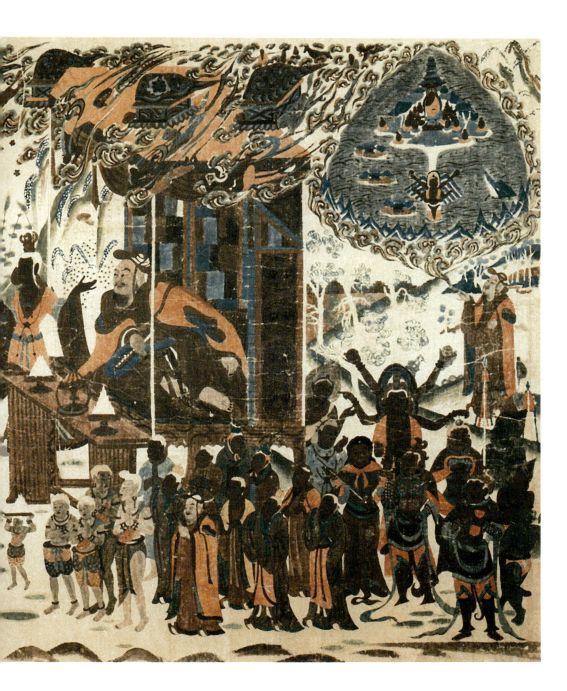

Occupying the entire north wall, the mural based on The Vimalakīrtinirdeśa Sūtra is largest work made in the Early Tang Dynasty.

Mañjuśrī and Vimalakīrti are sitting on the left and right sides, respectively; the scene depicts their dharma debateafter Mañjuśrī calls on Vimalakīrtī due to the latter's illness. A king and prince from the Chapter on Expedient Means flank the debate in the lower section. Many other episodes appear from the story, such as Vimalakīrti summoning 32,000 lions with supernatural powers to sit in the chamber and Bodhisattvas Mañjuśrī alone among the Bodhisattvas appearing on a dais due to his superior practice. A number of lions over the image of Vimalakīrti are approaching with flying Apsaras. With his supernatural power Vimalakīrti sends Bodhisattvas to the Land of Fragrant Rice and later turns the land upside down to form hills; the smell of the rice spreads three thousand boundless universes. In addition to the Bodhisattvas between Mañjuśrī and Vimalakīrti, nine million Bodhisattvas ride on colorful clouds descending from the Land of the Fragrant Rice. At the right top corner is the scene of Vimalakīrti's appearance on Mt. Sumeru located on the sea of Akṣobhya, guarded by Asura. The episode on the left top corner describes how the first son of Sakyamuni offers a jeweled dais with the Seven Treasures. This extensive mural puts Mañjuśrī and Vimalakīrti at the center relegating the other objects and scenes to positions between them creating an elegant tableau.

While colors of the mural have greatly darkened, the artist has endeavored to "restore" the original colors in order to "restore" the painting.

7
法華經變之化城喻品
莫高窟第217窟 南壁西側
盛唐
壁畫臨本
172.7×159.5 公分
臨摹者：常書鴻

　　〈化城喻品〉為法華經變的一部分，譬喻五百由旬外藏有珍寶，有一導師領眾尋寶，夜長路險，導師在半路化作一城（畫面右方）令眾歇息，待休憩足即滅化之，告知城乃幻化，珍寶已近；用以說明導師好比佛陀，領眾出險，當眾心退轉時，權設方便救拔，作為止息。畫面表現與經文記載不同的是，畫面上由流暢線條所構成的層巒疊嶂、青綠山水所渲染出的鮮活景致，一掃經文所形容的荒險景色，展現出春和景明的氛圍，形成一幅優美的山水畫。左下方為畫家進一步融合〈提婆達多品〉，佛陀過去常為國王，為求《法華經》而捨國位；描繪出巍巍宮城內，國王頭帶冕旒、身著華服、臣眾圍繞的場景。此與〈化城喻品〉的畫面聯繫起來，似乎上方為取寶的旅程，下方宮城為取寶眾到達目的地的意味，而達到一氣呵成的鋪排效果。

"Parable of the Illusory City," Lotus Sūtra Illustration
West Section of South Wall, Cave No.217, Mogao Grottoes
High Tang Dynasty
Copy, Wall Painting
172.7×159.5 cm
Copied by：Chang Shuhong

"The Parable of the Phantom City" (*Purva-yoga-parivartah*) is a chapter of the Lotus Sūtra (Saddharmapuṇḍarīka-sūtra). In the parable the Buddha said that there was treasure hidden five hundred yojanas away, and a mentor led the gathering to search for the treasure. As it was dangerous to walk at night, with his magic the mentor conjured a city (pictured on the right hand side of the painting) during the middle of the trip for the group to rest. After the gathering was rested, the city vanished. The mentor told them that the city was merely an illusion, and they were getting close to the treasure. According to the parable, the mentor is a symbolic figure of the Buddha who brings all people out of danger; when the people change their mind, he rescues them as kind of relief.

The difference between the sūtra and the painting is that the vivid scenes presented in terms of peaks on top of each other and the great green landscapes depicted in smooth lines are quite different from the deserted and dangerous situations described in the sutra. In fact, the painting is in an elegant landscape filled with the beauty of spring. At the bottom on the left hand side of the painting, the artist further describes the plot of Devadatta (Chapter 12 of the Lotus Sūtra. According to this chapter, the Buddha used to be a king who gave up his throne for the pursuit of The Lotus Sūtra. In this part of the painting, we can see a king wearing his crown and robe standing in front of his people in front of a towering palace. When compared to the Parable of the Phantom City above it, it seems that the artist attempted to express the archetype of the Buddha-the quest and the triumph of the leader in front of the people.

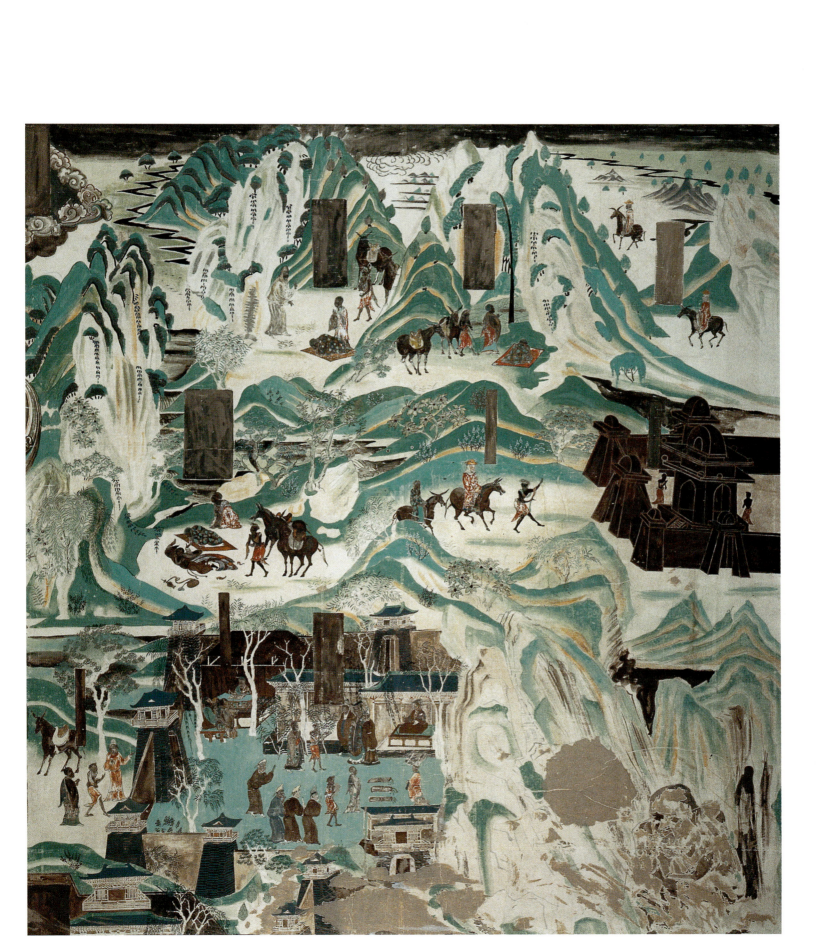

8
法華經變之化城喻品
莫高窟第103窟 南壁西側
盛唐
壁畫臨本
97.0×99.0 公分
臨摹者：樊興剛

第103窟的〈化城喻品〉和第217窟同為盛唐時代的作品（圖錄號7），都是表現法華七喻中的「化城喻」，但更強調細節內容。

此鋪壁畫下方已多殘損，本件臨摹作品乃擷取縱長方形壁畫之部份。畫面上右邊的建築物為經文中所幻化的城垣，但較第217窟的作品更突出城中塔的表現，使得建築更加宏偉。北朝至隋代的作品多借山體或樹林區隔出不同的場景，而此鋪作品，例如左下方一行尋寶眾到達河邊，身後被巍巍的山勢完整地區隔出來，這是和第217窟由低緩的山形所營造出來的空間感不同，使各情節更具獨立性。同時，場景的描繪也較為細膩，如河邊深淺河岸的落差、河畔山谷上涓絲垂幕的瀑布，與第217窟較抽象的筆法不同，呈現出高度的寫實性。

"Parable of the Illusory City", Lotus Sūtra Illustration
West Section of South Wall, Cave No.103, Mogao Grottoes
High Tang Dynasty
Copy, Wall Painting
97.0×99.0 cm
Copied by：Fan xigang

Both this painting in Cave no. 103 and the painting found in Cave no. 217 (Cat. no. 7) depict the plot of "The Parable of the Phantom City" (Purva-yoga-parivartah), from the Lotus Sūtra and were made in the High Tang Dynasty. They are different because this one contains more details.

The lower part of the painting was damaged, so Fan simply copied the rectangular framed section of the painting. The buildings on the right hand side represent the Phantom City, focusing more on the tower section compared with that of the Cave no. 217. In this case, the entire view looks more splendid. Works made during the Northern Dynasties to the Sui Dynasty, often use the mountain or the forest as the means to divide scenes. For example, we can see that the group who searches for the treasure is separated from the rear scene by the towering mountains behind them at the bottom on the left hand side. This is quite different from the gentle mountain slopes in the Cave no. 217 mural. Additionally, in this painting scenes are depicted in greater detail. Conveying the various depths of the river and the waterfall at the valley, which are quite different from the abstract style as found in the painting of Cave no. 217, suggests that the Cave no.103 mural has more elements of realism.

From the Forgotten Deserts :
Centuries of Dazzling Dunhuang Art

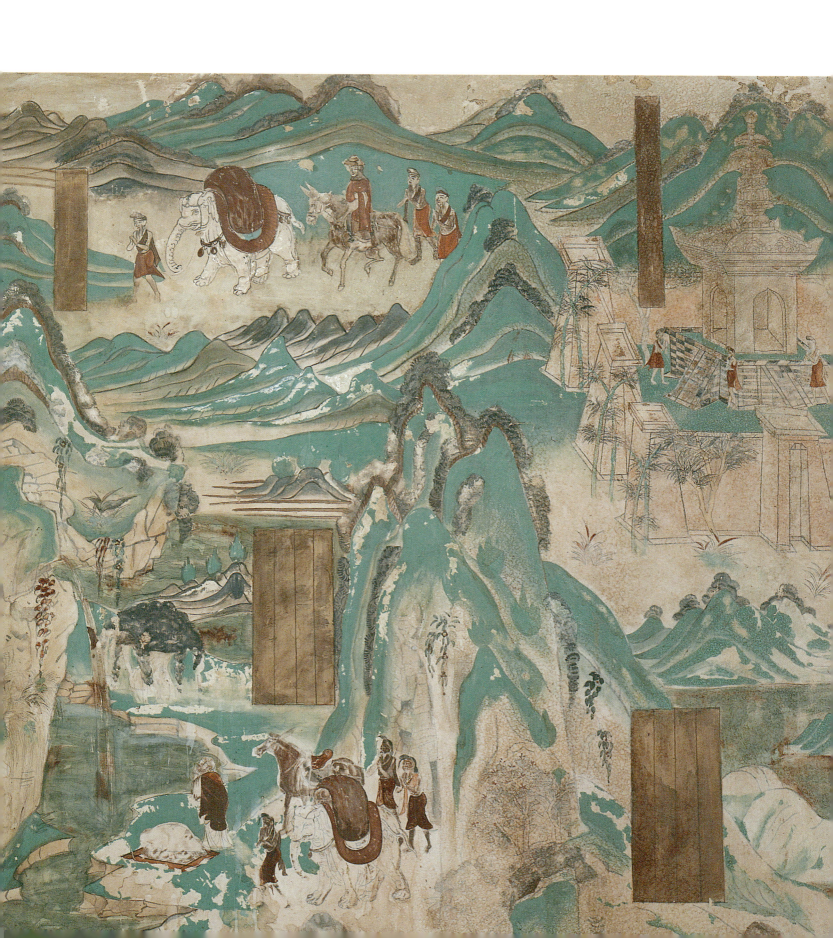

9
法華經變之藥草喻品
莫高窟第23窟 北壁
盛唐
壁畫臨本
78.5×82.0 公分
臨摹者：邵宏江

"The Parable of the Medicinal Herbs," Lotus Sūtra Illustration
North Wall, Cave No.23, Mogao Grottoes
High Tang Dynasty
Copy, Wall Painting
78.5×82.0 cm
Copied by：Shao Hongjiang

　　《法華經》〈藥草喻品〉以小中大三種藥草，比喻為人天、聲聞與緣覺二乘，以大小兩種樹，比喻中根與上根之菩薩；而佛陀平等施予慈悲，如同一雨普潤大地。經文中的寓意表現在壁畫上，則以雨中躬耕作的景像呈現。畫面上一農夫使牛犁地耕作，另一農夫冒雨擔肩挑物；其間穿插農婦送飯的場面，農婦看著父子倆捧飯而食，描繪親切而生動。而畫面上方大片烏雲密佈，並落下斗大的雨滴，正呼應經文中「密雲彌布，遍覆三千大千世界，…卉木…藥草，…一雨所潤，而諸草木各有差別」，乃將抽象譬喻的佛理，成功地以圖繪的方式來表達。

　　畫面下方左側繪有一塔，塔前一人跪拜、一人起舞，此外還有六人席地而坐，各持樂器伴奏；右側繪四個胖娃娃，在沙堆前忘情玩耍。這些生動活潑的畫面，是另一〈方便品〉的內容，表現出榜題所言「若於曠野中／積土成佛廟／乃至童子戲／聚沙為佛塔／如是諸人等／皆已成佛道」的概念，提示即使微小的行為都能具足成佛的因緣。藉由我們熟悉的生活場景，如實地闡明《法華經》的思想，由此可見畫者的智慧。

In this parable, three medicinal herbs are used to represent the men and devas and śrāvaka and pratyeka Buddhas; tall and short trees refer to Buddha at different ranks; and the Buddha shows mercy to all kinds like rain falls on ground and nourishes all creatures. In the mural, the connotation of the sūtra in terms of cultivation and rain. In the painting, we can see one farmer ploughing the land with a cow, and another farmer is carrying things in a rainfall. A scene depicting a woman sending food to the farmers is in between. In this scene, we can see the warmth of family ties presented through the happy expressions on the father's and son's faces as they enjoying their meals. There is a dense cloud and a heavy rain, exactly the same as described in the sūtra: "*Dense clouds spread over them, covering the entire thousand-million fold world and in one moment saturating it all...plants, trees, thickets and groves, and medicinal herbs equally...each has its differences and particular features.*" It is a successful attempt to illustrate the abstract Buddhist idea.

A tower is found at the lower part of the mural on the left hand side. In front of the tower, one person is worshipping on his knees, one is dancing, and six more are sitting on the ground each carrying a musical instrument. On the right hand side there are four fat babies playing in front of the sand. These are episodes from another chapter, "Expedient Means" (Upāya-kausalya-parivartah, chapter 2, the Lotus Sūtra), and the artists have fully captured the idea of the topical sentences, "...*if in the midst of the broad fields, they pile up earth to make a mortuary temple for the Buddhas, or even if little boys at play should collect sand to make a Buddha tower, then persons such as these have all attained the Buddha way.*" That is to say, even tiny acts of good faith can help one to become a Buddha. This painting, which faithfully presents the ideas of the sūtra with scenes we see in everyday life, expresses the wisdom of the artist.

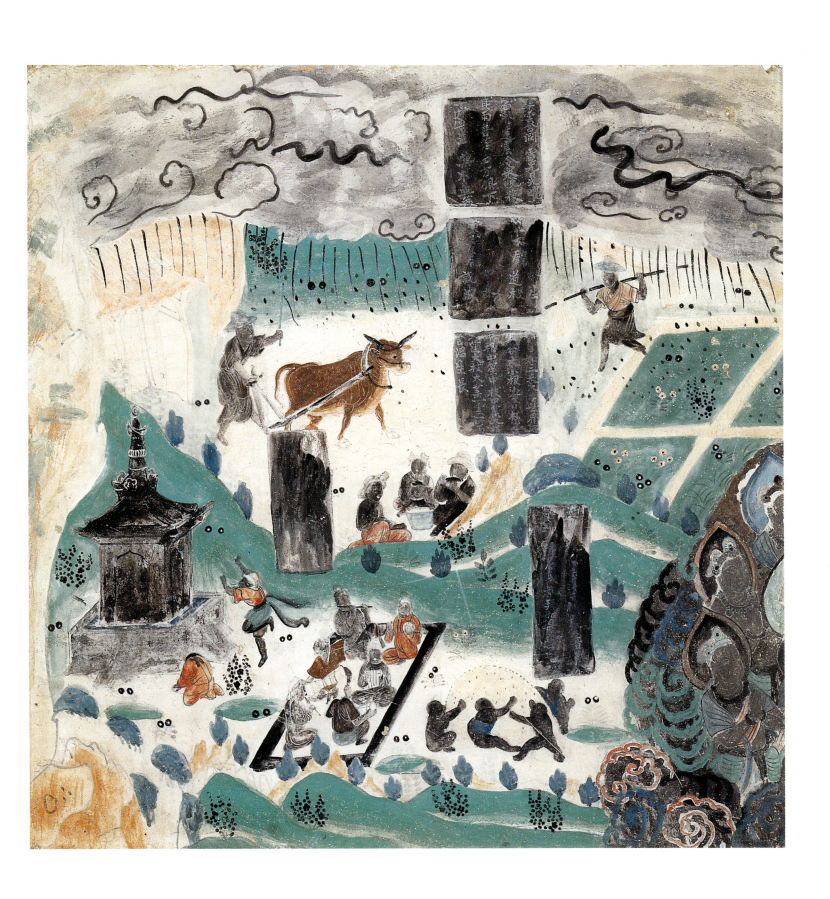

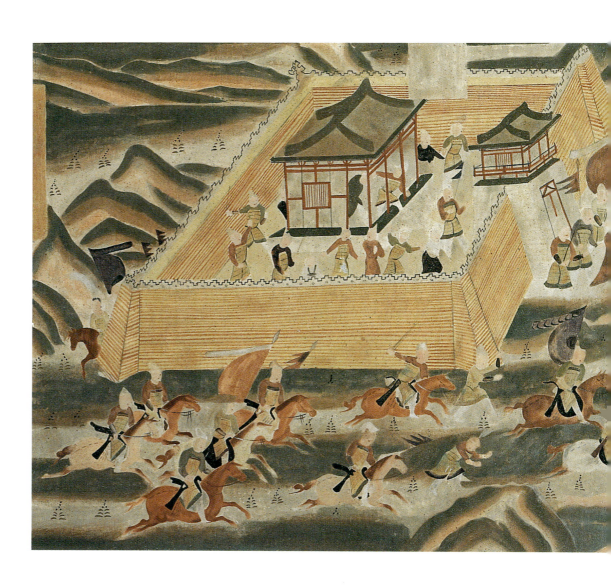

10
法華經變之安樂行品
莫高窟第156窟 窟頂南披
晚唐
壁畫臨本
67.0×166.0 公分
臨摹者：關友惠、徐淑青

"Peaceful Practices," Lotus Sūtra Illustration
South Wall, Ceiling Apex, Cave No.156, Mogao Grottoes
Late Tang Dynasty
Copy, Wall Painting
67.0×166.0 cm
Copied by：Guan Youhui, Xu Shuqing

　　法華經變之〈安樂行品〉為中唐新出現的題材，大意為轉輪聖王一心以威勢討伐不順服抵抗的諸小國，而後轉輪聖王論功行賞，賞賜種種田宅、城邑、珍寶等，唯獨髻中明珠因為十分珍貴，不以予之；然而對於特殊功勳者，心甚歡喜，最後還是將髻中明珠賜與。在此轉輪聖王即意指佛陀，髻珠則比喻法華經，為諸經中最珍貴的一部，因此不輕易宣講；但當佛陀看到弘傳、護持佛法有大功者，則會宣講此經。

　　此作品為〈安樂行品〉中「髻珠喻」的場景。畫面中大批兵馬奔馳，來勢洶洶，為轉輪聖王討伐小國的情形；而小國面對大批人馬來襲亦有背水一戰之勢。中央河水區隔兩方城郭，右城外持旌旗出城，左城內有論功行賞拜謝的場景，使畫面表現愈見豐富。

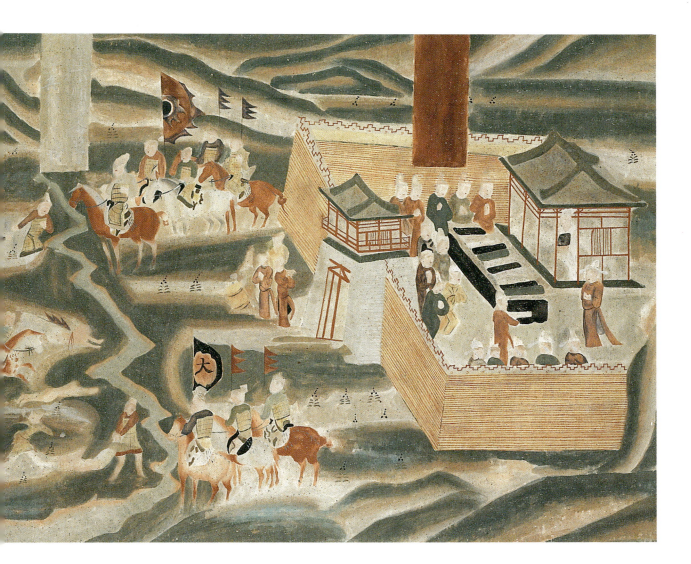

Murals using materials from the "Peaceful Practices" chapter of the Lotus Sūtra, were not found until the middle Tang Dynasty. The parable is about how the king cakravartin-rājan wants to conquer small kingdoms which do not obey his throne. Later, the king rewards those who have earned merits from battles with houses, lands and treasures-except the bright jewel that is in his topknot because it is very precious. Yet, when he sees someone among his soldiers who has gained truly great distinction, he is so delighted in heart that he takes the unbelievably fine jewel that has been in his topknot for so long and has never been recklessly given away, and now gives it to this man.

In fact, the cakravartin-rājan is the Buddha, and the "bright jewel in the topknot" represents the Lotus Sūtra, which is the most precious among the sūtras. Therefore, it is less preached. Yet, when the Buddha sees someone who has great performance in spreading and defending the dharma, he will teach him the Lotus Sūtra.

The mural depicts the "bright jewel in the topknot" scene of the "Peaceful Practices." Many horses and troops conquering smaller kingdoms for the the cakravartin-rājan, as these kingdoms are prepare for winning or dying. The river in the middle separates both camps. On the right hand side, troops gallop off the city; on the left hand side, we see the king giving rewards to his troops. The entire work is very interesting with these contrasts.

11
法華經變之部分
莫高窟第61窟 南壁
五代
壁畫臨本
70.5×258.0 公分
臨摹者：關友惠

Episodes of the Lotus Sūtra (Saddharmapuṇḍarīka-Sūtra)
South Wall, Cave No.61, Mogao Grottoes
Five Dynasties
Copy, Wall Painting
70.5×258.0 cm
Copied by：Guan Youhui

　　第61窟是敦煌第四任歸義軍節度使曹元忠及其夫人的功德窟，約建於西元951-957年間。此鋪壁畫鴻幅巨製地將《法華經》二十三品的故事內容巧妙配置於一長方形內，既符合義理又兼顧藝術表現。

　　此作品臨摹自主尊下方的部分。畫面中央為一城，城內外火苗燃燒、鬼遍四佈，卻有三孩童不知禍之將至地玩耍，是表現「火宅喻」中長者之子面臨危難的場景。中央城垣下方至左方另一城之間，有鹿車、羊車與牛車，是長者為誘其子出火宅給予的玩具；長者喻佛陀，稚子喻眾生，意味著佛陀以三乘誘導眾生遠離三界火宅的權宜之計，即「三車喻」，這兩個比喻皆出於〈譬喻品〉。左方為〈信解品〉「窮子喻」，富有的長者見年幼離家的窮子回來，設法取信於窮子，後宣布實為其子，比喻佛陀如長者循循善誘；最左城內為窮子拜見貌，下方為雇用窮子清掃馬廄的畫面。至於右方城外兵馬爭逐即〈安樂行品〉「髻珠喻」中轉輪聖王率軍攻佔之景。

　　畫師必須在有限空間內繪出眾多經文情節，便不得不設計出固定格式；而格式一經確立，也就隨之形式化了。因此，此鋪可說是式微前的佳作。

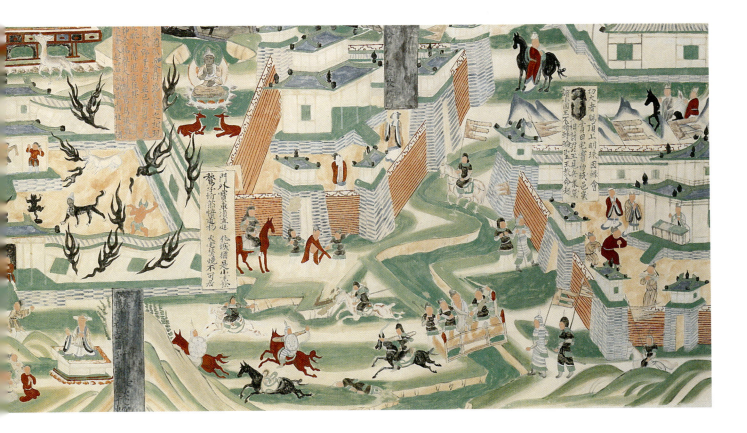

Cave no. 61 was built ca. 951-957 to accrue merit by Cao Yuanzhong, the fourth Military Commissioner of the Returning Commandery Government, and his wife. The artist skillfully blended episodes from all twenty-three chapters of The Lotus Sūtra (Saddharmapuṇḍarīka-sūtra) in a rectangular format with the necessary symbolic ingredients.

The copy was made from section under the main deity. At the center of the mural, a city burns and ghosts are everywhere. Yet, a child is playing without recognizing the impending doom. A father's sons are in danger scene in the "Parable of the Burning House." There are deer carts, sheep carts and cow carts below the city, which are the toys that the man uses to attract his sons to come out of the burning house. The man (or sage) is a representation of the Buddha, and the sons are all kinds of people's offspring. It suggests that the Buddha tries to save everyone from the burning house of trilokaṃ (the three realms) with the triyāna (the three vehicles), i.e., the "Parable of the Three Vehicles." Both parables are from the Aupamya-parivartah ("Simile and Parable" Chapter). On the left hand side it is the parable of the poor from the Adhimukti-parivartah ("Belief and Understanding"). The story is about how the rich and old sage convinces his poor son who has returned from afar, representing how the Buddha tries every means to save all kinds like the rich and old sage in the story. The meeting with the poor scene is on the far left, and the sable cleaning scene is under it. The scene of running horses outside the city is taken from the "Bright Jewel in the Topknot" parable from the Sukha-vihara-parivartah ("Peaceful Practices" Chapter), when the troop of the wheel-turning king is in a battle.

The artist must draw many scenes from the sūtra within a limited space. Therefore, he must plan well before drawing. After the form is established, it is formalized. Therefore, it is one of the finest work before artistic form declined; i.e., painting was at its peak.

12
十一面觀音像
莫高窟321窟 東壁北側
初唐
壁畫臨本
233.0×191.0 公分
臨摹者：邵宏江

此鋪十一面觀音位於初唐武周時期所建的第321窟東壁北側，由此可知在初唐時已有密教流傳。

畫面中央觀音站立於雙樹寶蓋之下、蓮花臺上，兩側有脇侍菩薩，下方則繪有兩隻迦陵頻伽鳥，四周綴以藤蔓花草，圖案豐富而曼妙。主尊的十一種面像，以四個層次表現，且每個面部表情十分清楚，由於所佔空間尚未壓縮，因此頭部以上的比例顯得龐然，由此可看出畫家欲求面面俱到、如實呈現的企圖。

根據唐不空法師所譯《十一面觀自在菩薩心密言念誦儀軌經》，形容面部是：「前三面作寂靜相，左三面威怒相，右三面利牙出現相，後一面作笑怒容，最上一面作如來相，頭冠中各有化佛」，與此對照，大致符合；但是手的部分則不同，畫面上所描繪的「六臂」，是左、右上手上舉，左二手胸前捻指、右二手下垂捻指，左下手提淨瓶、右下手持楊柳，並不見諸經典記載。因此，可以瞭解圖文間的關係與圖像本身的變化。

Eleven-Headed Avalokiteśvara (Ekādaśamukha)
North Section of East wall, Cave No.321, Mogao Grottoes
Early Tang Dynasty
Copy, Wall Painting
233.0×191.0 cm
Copied by : Shao Hongjiang

The mural is located on the northern side of the east wall in Cave no. 321, built during the reign of Wu Zitian, in the Early Tang Dynasty, indicating that the Tantrayāna sect has spread to the Central Plains by that period.

In the painting of the eleven-headed Avalokiteśvara, the deity stands on a lotus dais under the shade formed by two trees. There are two Bodhisattvas on either sides and two kalaviṅka birds beneath, and decorative vines running through. The eleven-headed Avalokitesvara is presented in four levels, each of which is depicted in detail without compression. Therefore, the head is huge in proportion, indicating the artist's intention to present the deity in true form.

According to The Sūtra of the Eleven-headed Avalokiteśvara Bodhisattva translated by monk Amoghavajra of the Tang Dynasty, "...*the three faces in the front are peaceful, the three on the left hand side are angry, the three on the right hand side are wrathful with spikes, the one at the back is laughing with anger, and the one on top is in a Buddha image; every face has a Buddha image.*" In this case, the artist has followed the description faithfully, except the hands. In the mural, the Avalokiteśvara has "six arms." The upper left and right hands are rising; the second left hand is making a mudrā with the fingers in front of the chest; the second right hand is pointing down in a mudrā; the lower left hand is holding a holy bottle and the lower right hand is grasping willows. None of these is mentioned in the Sūtra. Therefore, we can find the difference between the two and the changes in the painting.

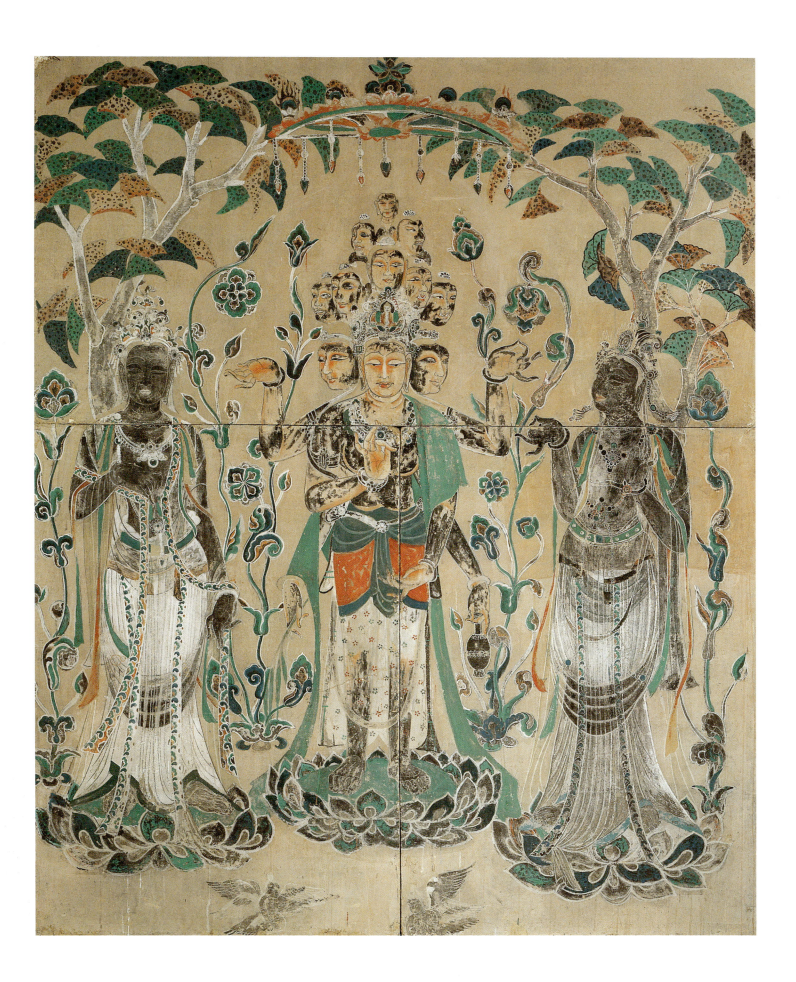

From the Forgotten Deserts: Centuries of Dazzling Dunhuang Art

13
水月觀音像
榆林窟第2窟 西壁北側
西夏
壁畫臨本
147.8×146.3 公分
臨摹者：史葦湘

水月觀音為三十三觀音之一，是較晚出現的形式。根據文獻記載，最早的水月觀音約出現於唐代；然五代始見於敦煌石窟的壁畫上，開始多為小幅，西夏時則為大型畫作。

此幅臨摹自榆林窟西夏第2窟西壁北側之作。觀音處於巨大的圓光中，左手置於膝上，右手置於胸前數珠，偏頭凝視左前方的一彎新月，倚石而坐，水中有一對蓮花承接菩薩雙足。而在水的對岸，一童子正乘雲而來，合掌高舉遙向觀音行禮。《華嚴經》〈入法界品〉曾提到善財童子五十三參，觀音正是善財童子所參訪的第二十七位善知識，觀音為其解說大悲行法門，畫面上所表現即此一典故。而右前方可見一僧人雙手合十高舉，身後有一牽著馬匹的猴樣形貌者，符合《西遊記》唐僧取經途中路遇危難求拜觀音的景象。畫家描繪水月觀音時，結合種種相關故事，表現於同一畫面上，更顯得饒富趣味。

Avalokiteśvara, Known as Water Moon Guanyin
North Section of West Wall, Cave No.2, Yulin Grottoes
Western Xia Dynasty
Copy, Wall Painting
147.8×146.3 cm
Copied by：Shi Weixiang

The Water Moon Guanyin is one of the thirty-three images of Avalokiteśvara in a later Buddhist art. Literature indicates that this form first appeared in the Tang Dynasty. Yet, it was not found in the Dunhuang murals even in small scale until the Five Dynasties. Big-scaled paintings of the Water Moon Kuanyin began in the Western Xia period.

The painting is in north sectopm of the west wall in Cave no. 2 of the Yulin Grottoes. Behind the icon is a nimbus. The left hand is placed on the knee and the right hand is counting a rosary in front of the chest. The head look left at the moon; the body leans against a rock. A pair of lotus flowers are positioned beneath the feet rising from the water. A boy (Sudhana-śreṣṭhi-dāraka) flying in a cloud is approaching from the other side of the water saluting to deity. According to "Entry into the Dharma Realm," in The Flower Garland Sūtra (Buddhāvataṃsaka-māhavaipulya Sūtra), the good, prosperous disciple bows fifty-three times, and Avalokiteśvara is the twenty-seventh sage that to which the disciple bows. Avalokiteśvara explains to him the initial approach to the gateway of great compassionate practice (mahākaruṇā). This is the episode which appears in the mural. In the foreground on the right hand side, we can see a monk in prayer, and behind him there is a monkey-like creature riding on a horse. This is an episode from The Journey to the West. In the mural, we see the artist has combined stories or episodes related to Avalokiteśvara, making the work more interesting.

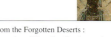
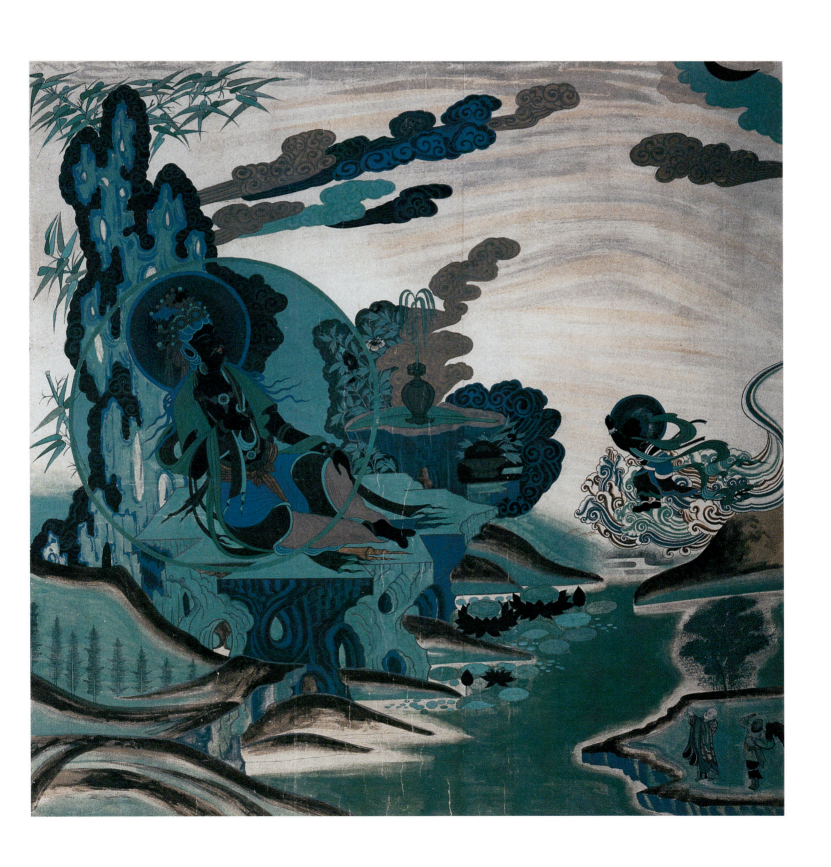

14
水月觀音像
榆林窟第2窟 西壁南側
西夏
壁畫臨本
147.5×152.5公分
臨摹者：李承仙

　　本幅臨摹作品，主體同為倚石而坐的水月觀音，但此觀音上半身非以飄帶為主而是綴以瓔珞嚴身的描繪，另外菩薩所對應的人物也有所不同—此觀音在相同一水之隔的對岸安排了一慈目的女子，長袖衣襦，雲肩披垂，面帶微笑，合掌恭敬地凝視觀音，成功地避免落入畫面角色相同之俗套，也突顯觀音普濟不同眾生的性格。

　　此幅繪畫以石青色為主，與北側的水月觀音相同，是西夏時的特殊用色。但是在處理菩薩的用色則各有不同，此幅以金色描繪菩薩身，呈現出高貴莊嚴的效果。而在用筆上，明顯不同於北側在處理岩石等物象的堅硬折轉，乃以柔和的線條將觀音描繪於綾羅綢緞的軟墊上，配合著身後的雲氣，觀音柔美的意象不言可喻。兩相對照之下，可以見出此鋪屬於寫意的風格，並突顯出北側水月觀音之花鳥派的嚴謹工筆，畫家同中求異，顯得既對稱又別具風采。

Avalokitesvara, Known as Water Moon Guanyin
South Section of West Wall, Cave No.2, Yulin Grottoes
Western Xia Dynasty
Copy, Wall Painting
147.5×152.5 cm
Copied by：Li Chengxian

The Water Moon Guanyin sitting on a rock is the subject of this copy. Instead of the flying silk scarf, the deity in the painting wears a jade jeweled necklace. Moreover, the traditional attending figures accompanying Avalokiteśvara are different – on the other side of the water there is a girl with a pair of compassionate eyes, smiling wearing a long robe with a scarf, looking at Avalokiteśvara with great respect. The artist has successfully eliminated any repetition in the figure painting as in other Avalokiteśvara paintings and depicted them with the salvation of Avalokiteśvara.

The painting is mainly malachite green in hue a special feature of the Western Xia paintings of the Water Moon Guanyin and the same as the painting across from it. Yet, for the upper body the coloring scheme is different. For example, the body is golden expressing a sense of opulence. In terms of brushwork, we can see more delicate and subtle application here, especially in the silken cushions and the nimbus behind the deity, conveying the tenderness and beauty of the icon. When compared to the one in the northern side, this painting is rather spontaneous in style and contrasts sharply with the detailed, technical drawing of the bird and flowers in the one on the north. The artis's attempt to be different and unique here is evident.

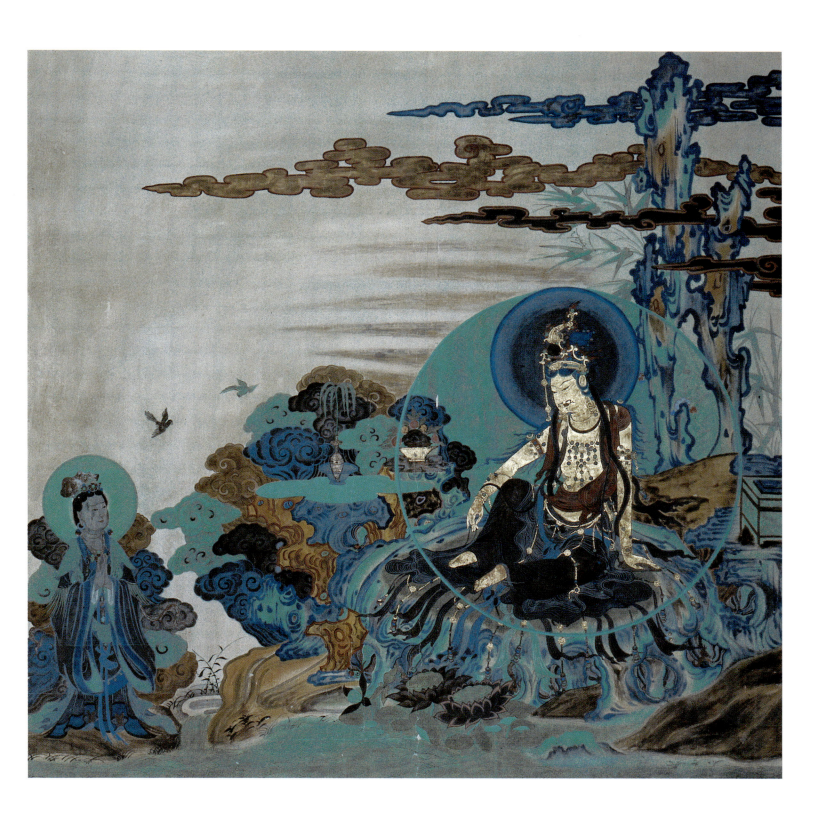

15
千手千眼觀音像
莫高窟第3窟 北壁
元
壁畫臨本
206.2×223.0 公分
臨摹者：李其瓊、杜顯清、楊麟翼

觀音往昔聽聞廣大圓滿無礙大悲心陀羅尼（即大悲咒），發願若能利益一切眾生，身上立刻生出千手千眼，願畢，旋即具足。所謂千眼，意指能觀眾生之苦；千手，意味能救拔眾生之難。

觀音的千手，除表現於胸前合掌、撐舉化佛、頭上頂戴外，其餘千手密疊繪於四周、環成一圓；而千眼，則於每一手中繪以一眼，使千手千眼的意象具足飽滿。千手千眼並配合觀音大圓身光，呈現出近大遠小的分明層次，佈局高妙；勾勒千手千眼細膩準確，乞畫菩薩衣紋飄帶則猶勁流暢，筆法運用行雲流水。

菩薩四周的人物皆以墨線勾勒而成，包括飛天、畫面左之吉祥天女、右之婆藪仙、下方左、右面目猙獰的三頭八臂金剛與三頭六臂金剛、金剛之下左、右兩側的象頭神與豬頭神，不同的人物形象，由多變的線描勾繪，營造出生動豐富的樣貌。

Thousand-armed, Thousand-eyed Avalokiteśvara
North Wall, Cave No.3, Mogao Grottoes
Yuan Dynasty
Copy, Wall Painting
206.2×223.0 cm
Copied by：Li Qiqiong, Du Xianqing, Yang Linyi

On hearing the Mahākāruṇikacitta-dhāraṇi, Avalokiteśvara prayed to the heaven that in order to benefit all sentient beings, hewould would need 1,000 hands come out of his body. The wish was granted and so he began works of salvation. Avalokiteśvara has 1,000 eyes in order to see the suffering of all; there are 1,000 hands in order to save all kinds from mishaps.

Expect for the the two mudrās at the chest and above, all the other hands are drawn around in a circle; the deity wears a crown. As for the 1,000 eyes, there is an eye in every hand to fully capture the sense of 1,000 hands and 1,000 eyes. Together with the halo or nimbus around Avalokiteśvara, we can see different layers in the background and the foreground. The eyes and hands are accurately depicted with much detail, and the scarfs of Avalokiteśvara flying naturally, as if they were flying clouds and running water.

Figures around Avalokiteśvara are drawn with a ink-line technique including the f ying Apsaras, Śrimahā-devī (goddess of wealth and beauty in Indian mythology) on the left hand side; Vasudeva on the right hand side; the wrathful vajrapāṇibalin with three heads and eight arms and vajrapāṇibalin with three heads and six arms on the left and right hand lower sections; Gaṇeśa (elephant-head god, in Hindu mythology); avajrapani with three heads and six arms and a pig-head god beneath the vajrapāṇibalin. Different brush techniques are used to depict each of the figure types capturing their vivid expressions.

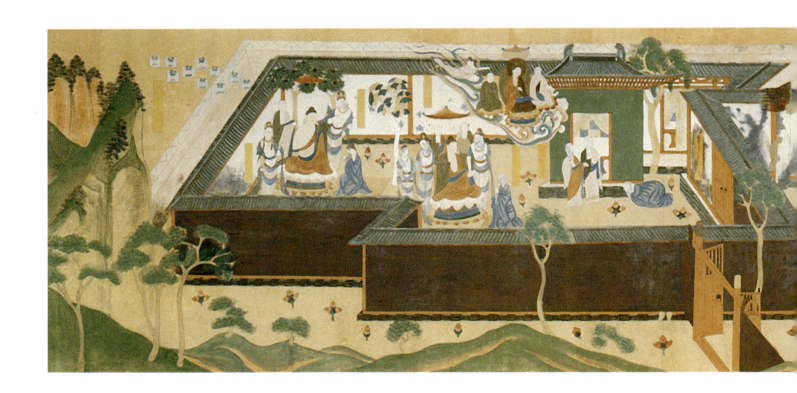

16
觀無量壽經變之序品
莫高窟第431窟 北壁
初唐
壁畫臨本
56.9×253.2 公分
臨摹者：孫儒僩

Foreword to the Amitāyurdhyana Sūtra Illustration
North Wall, Cave No. 431, Mogao Grottoes
Early Tang Dynasty
Copy, Wall Painting
56.9×253.2 cm
Copied by：Sun Rujian

　　第431窟為北魏開鑿、初唐改建之窟。觀無量壽經變中常見的內容，如未生怨與十六觀分別繪於北、西、南壁，是一橫卷式構圖。

　　此作品以《觀無量壽經》〈序分〉為臨摹，表現未生怨與十六觀的內容。畫面中的宮城上建城樓，圍成封閉的院落，分成三部分：前部表示宮中的前朝，正面有門，旁立守衛，院內有堂，堂中再一建築即為幽禁頻婆娑羅王之所在；有一女正欲進入半開的堂門，為韋提希夫人前往探望之景。中部為宮中的後寢，有殿三間，歇山屋頂，殿前欄額掛盝帷，空間全敞，無牆與門窗、僅有殿柱；殿中為阿闍世太子得知母后借探監暗中送食，大怒提劍欲殺之，幸經大臣勸阻方得不死之景。後部表現宮中的御苑，院落中有一堂，花木扶疏，為幽閉王后的後花園；身繫囹圄的韋提希夫人發願至極樂世界，以解脫痛苦，佛陀因此應現，教導其觀想修行方法，畫面中佛陀乘彩雲自空而降，為其說法。作品雖說是有佛教的教化意義，但同時也展現出宮廷之前朝、後寢、及御院三部分的建築樣貌。

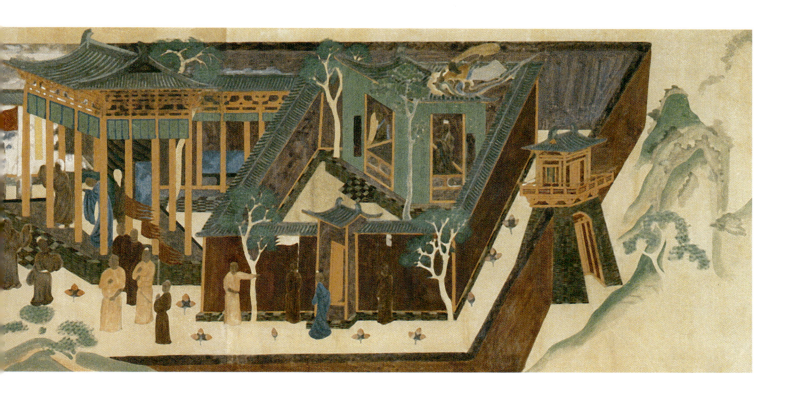

The cave was excavated in the North Wei Dynasty and renovated in the Early Tang. The common episodes of Buddha Amitāyus are drawn on the north, west, and south walls in a horizontal compositional formal. These episodes include the sixteen meditations including how Prince Ajātaśatru captured and imprisoned his father and how he became furious with his mother and tried to kill her, etc.

The work is based on the foreword to The Amitāyurdhyana Sūtra (The Sūtra Everlasting Life), depicting the story of the sixteen views covering how Prince Ajātaśatru captured and imprisoned his father and how he became furious with his mother and tried to kill her, etc. In the painting a pavilion is built on a palatial structure becoming an closed environment divided into three sections: the first section indicates the front court of the palace; there is a door in the front, guards on both sides, a hall inside, and the prison of King Bimbisāra. The woman entering the half-opened door of the hall depicts the scene when the queen Vaidehi visits the king. The middle section is the resting palace with three buildings constructed with a gable and hip roof. There is a curtain over the palace's eaves, and there is no partition or door inside, except the column. Prince Ajātaśatru is very angry when he knows the queen has sent food to the king secretly; he is so furious with his mother that he tries to kill her with his sword. Fortunately, she is saved by ministers. The third section is the royal garden. There is a hall, flowers and trees; the queen is captured here. The queen who is imprisoned wishes to go to the land of no sorrow and no affliction where she can be reborn. Therefore, the Buddha shows her many Buddha-lands and teaches her the method of visualizing the Pure Land. In the painting, the Buddha arrives colorful clouds. Though the work is didactic, it also captures medieval palatial architecture.

17
觀無量壽經變

莫高窟第172窟 北壁
盛唐
壁畫臨本
269.2×419.6 公分
臨摹者：史葦湘、李其瓊、萬庚育、歐陽琳、
　　　　馮仲年、關友惠

Scenes from Amitāyurdhyana Sūtra Illustration

North Wall, Cave No.172, Mogao Grottoes
High Tang Dynasty
Copy, Wall Painting
269.2×419.6 cm
Copied by：Shi Weixiang, Li Qiqiong, Wan Gengyu,
　　　　　 Ou Yanglin, Feng Zhongnian, Guan Youhui

　　中間佛說法圖、兩側繪有未生怨與十六觀的形式，是典型的唐代觀無量壽經變的構圖，值得注意的是表現大型寺院多種單體建築元素組合的形象。

　　此圖中全部建築都架設在浮出水面的高度，畫面最前方橫向有五個露臺，中臺上有仙鶴、迦陵頻伽等，左、右露臺上有佛與菩薩眾，為觀看樂舞之處；水池中橫向第二層有三個露臺，中央為舞者，左、右兩側為樂眾；其後畫面的中心為一大露臺，為佛說法的隆盛場面。露臺後方中央為三座大佛殿，畫面上沿著中軸線大致相疊、前低後高、層次分明。而佛殿兩側則以迴廊圍成ㄇ字形，建築群中除了以迴廊相連外，藉由小橋斜道相通。此外，視覺上大殿、配殿、樓閣分採仰視、俯視、平視，多點透視強化了宏偉壯觀的場面。

The center is occupied by the Buddha's preaching sceneflanked by the sixteen meditations including Prince Ajātaśatru's capturing and imprisoning his father, his anger towards his mother and attempt to kill her, etc. Though it is the typical layout of Amitāyurdhyana sūtra in the Tang Dynasty, the work captures the many different types of monastic buildings typical of period temples.

All buildings in the painting are above water level. There are five platforms above it with cranes and kalaviṅka birds center stage. The Buddha and Bodhisattvas are on the left and right platforms watch the performances of music and dance. There are three stages on the second level above the pond, dancers are in the middle and performers on both sides, and the big stage at the center of the painting is the place where the Buddhist doctrines are manifested. There are three temples behind the stage, and objects are laid on both sides in parallel; those on the foreground are at a lower level, and those in the background are at a higher level. The corridors surround the temples in a "n-shape." In addition to the corridors, different groups of buildings are linked together by means of bridges and spurs. From the perspective of visual design, the main hall, side halls and pavilions are drawn in terms of a view from below, an aerial view and a frontal view, respectively, in order to enhance perspectival views of the magnificent scene.

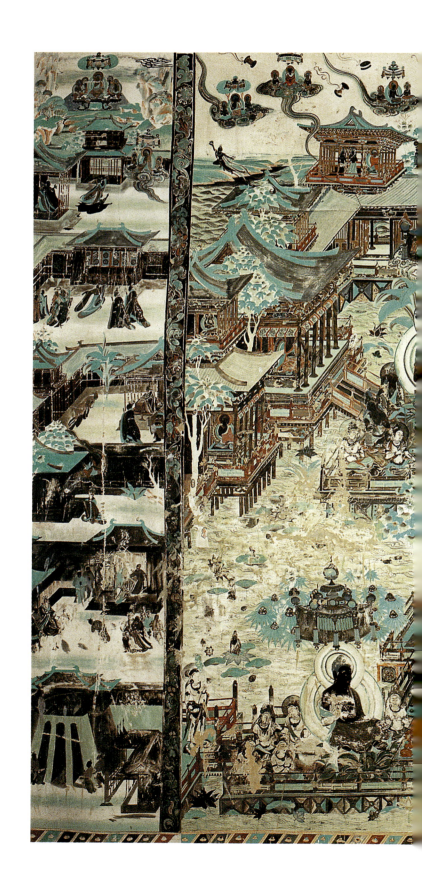

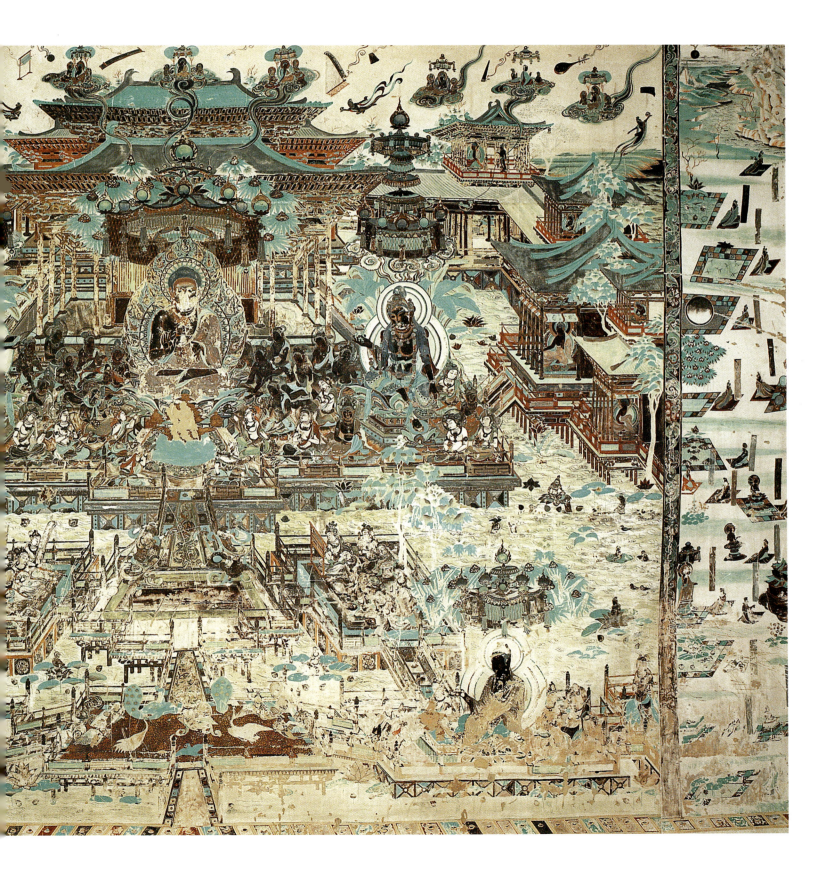

18
觀無量壽經變之部分
莫高窟第172窟 南壁
盛唐
壁畫臨本
248.0×110.5 公分
臨摹者：邵芳

本圖臨摹自第172窟南壁觀無量壽經變說法圖右側，特別能突出建築型態。畫面上方大佛殿連接迴廊的ㄇ字形轉角，前後三座大佛殿在此圖範圍中僅見部分檐下的斗拱，第二層佛殿可見屋頂上正脊右端的鴟尾；迴廊轉角處為兩層五間的樓閣，樓閣上下層間有可資通行的平座，下層的屋檐又稱腰檐，可保護下層牆面；樓閣外側是一座攢尖頂圓亭，造形優美；迴廊往前延伸至菩薩旁的建築是兩層五間歇山頂的配殿，可以看見唐代此時的屋頂坡度比起後代甚為平緩舒展，屋角起翹亦未甚明顯；至於菩薩與佛所坐之處，為一露臺，露臺邊緣的欄杆寬度工整，木面繪朱紅色，欄面以藍色深淺交錯配置，效果華麗而和諧。可以說，不但注重建築整體造形，對於細部的描繪也十分細膩。

Episodes from the Amitāyurdhyana Sūtra Illustration
South Wall, Cave No.172, Mogao Grottoes
High Tang Dynasty
Copy, Wall Painting
248.0×110.5 cm
Copied by：Shao Fang

This is a copy of a mural of the Amitābha's preaching the dharma from the right side of the south wall in Cave no. 172; it the architectural style of the buildings. The main temple connected by a "n-shaped" corridor is in the upper section; only the brackets of the three temples can be seen. The swallow-tail akroteria on the right hand side of the temple's main ridge on the second level is visible. A two-storied pavilion with five doors is at the corner of the corridor, platforms connecting both stories are in the middle, and at the lower level of the eaves is the "architraves" designed for protecting the walls beneath. Outside the pavilion there stands an elegantly-built kiosk with a pyramidal roof. The ambulatory runs forward and reaches the building next to the Buddha statue. It is a two-storied side hall with five doors and a gable and hip roof, indicating that the slope of roof in the Tang Dynasty is gentler than that of later periods, and the petal is less obvious. The bodhisattva and Buddha are on a stage surrounded by well-organized rails in an harmonious vermilion and indigo pattern. We can say that buildings in the painting are not only well-structured, but also depicted in considerable detail.

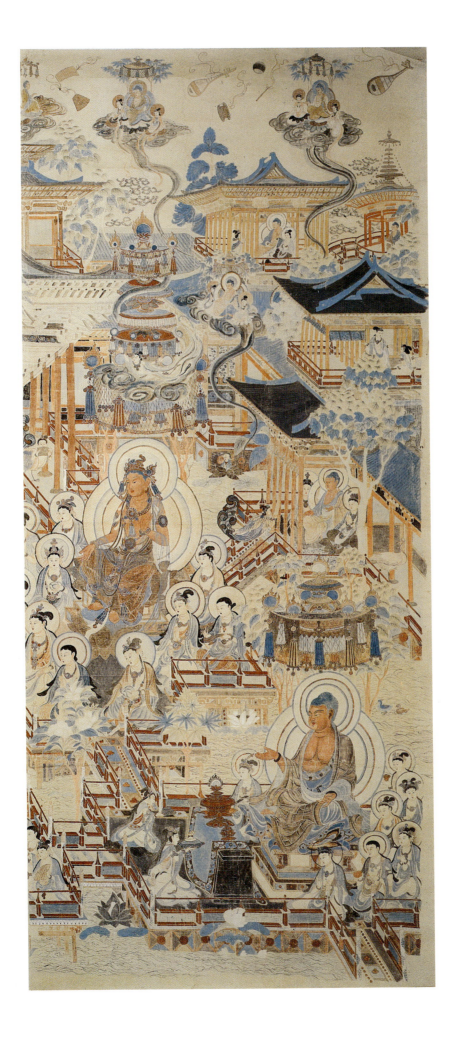

19
五臺山圖之一部
莫高窟第61窟 西壁北側
五代
壁畫臨本
238.0×373.5 公分
臨摹者：李振甫

Episodes from Mt. Wutai (East-Platform)
North Section of West Wall, Cave No.61, Mogao Grottoes
Five Dynasties
Copy, Wall Painting
238.0×373.5 cm
Copied by：Li Zhenfu

　　文殊菩薩道場的五臺山（山西省東北部）是我國四大佛教名山之一。中唐吐蕃統治敦煌時，五臺山圖的畫稿傳到西北，敦煌壁畫也開始繪製。小幅的五臺山圖多繪於文殊變的下方，場面比較簡單，到了曹氏統治敦煌時期，第61窟則出現了高3.42公尺、寬13.40公尺的巨幅五臺山圖。全圖可分為上、中、下三層，上層繪各種雲中幻現之景，中層為大小寺院伽藍、以及發生於此的故事遺跡等，下層則是進山諸道、朝山的香客、以及山下的城鎮等。由於第61窟建於宋初，圖中反映出晚唐、五代時的寺院形制。圖中央最高峰榜題為「中台之頂」，其餘東、南、西、北台各有標示，不但是主壁的背景，也是現存中國古代最大的地形圖。

　　本臨摹以五臺山壁畫右下角的「東台」為範圍，在描繪寺地形的同時，也闡說感應聖跡的內容。如榜題「大法華之寺」的上方，為佛陀波利與文殊逢於五臺山的故事，畫面上以荷擔的行腳僧和白衣老人表示；「大佛光之寺」則表現住持解脫禪師說教的場面；此寺是唐大中二年（857）所建，但畫面上二層樓閣與現今單層七間的大殿型態不符，應為會昌法難（845）前的建築形貌。古今對照，適足以提供珍貴的建築史料。

Wutaishan (the mountain of five platforms, in northeast of Shanxi Province), the home of Mañjuśrī, is one of the four major Buddhist mountains in China. When the Tibetans ruled over Dunhuang in the Mid-Tang Dynasty, the sketch of Wutaishan was spread to northwestern China and became one of the materials of Dunhuang murals. Small paintings of Wutaishan (Mt.Wutai) with the story of Mañjuśrī were often made in a rather simple manner. It was not until the Chao's ruled over Dunhuang that a huge painting, 3.42m tall and 13.40m wide, appeared in Cave no. 61. The entire painting is divided into three parts. In the upper part there are various illusions that appear in the clouds; in the middle part there are monasteries and temples of different sizes and narrative vignettes around them; and in the lower part there are the paths leading to the mountain with pilgrims and towns at the mountain foot. As the cave was built in the early Song Dynasty, we can see temple construction from the Late Tang and Five Dynasties. There is a cartouche on the highest peak at the center of the painting which reads, "Peak of Zhongtai" (Peak of the Central Platform); similar indications are found on the east, south, west and north platforms. These not only form the background of the mural, but constitute portions of the largest earliest topographical map in China.

The copy is made from the "Dongtai" (East Platform) at the lower corner of the right hand side. In addition to depicting temple grounds miraculous stories are also illustrated. For example, stories about the meetings of Buddhapala (the wandering monk with a carrying pole) and Mañjuśrī (as an old man in a white gown) on Wutaishan are illustrated near the top of the cartouche read The Temple of the Great Flourishing Dharma. The scene this temple depicts how the abbot gets rid of a dogmatic master. The temple was built in the 2nd Year of Taizong's reign in the Tang Dynasty (857); yet the style of the two upper stories of the temple is different from the modern one-storied hall with seven doors. In fact, the style of the temple looks more like that of temple built before the persecution of Buddhism in 845. It provides much valuable information on architecture.

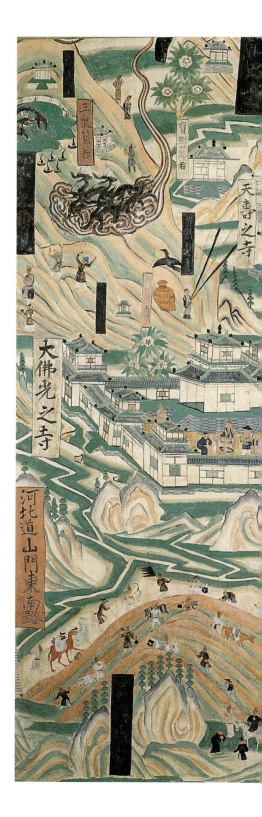

From the Forgotten Deserts :
Centuries of Dazzling Dunhuang Art

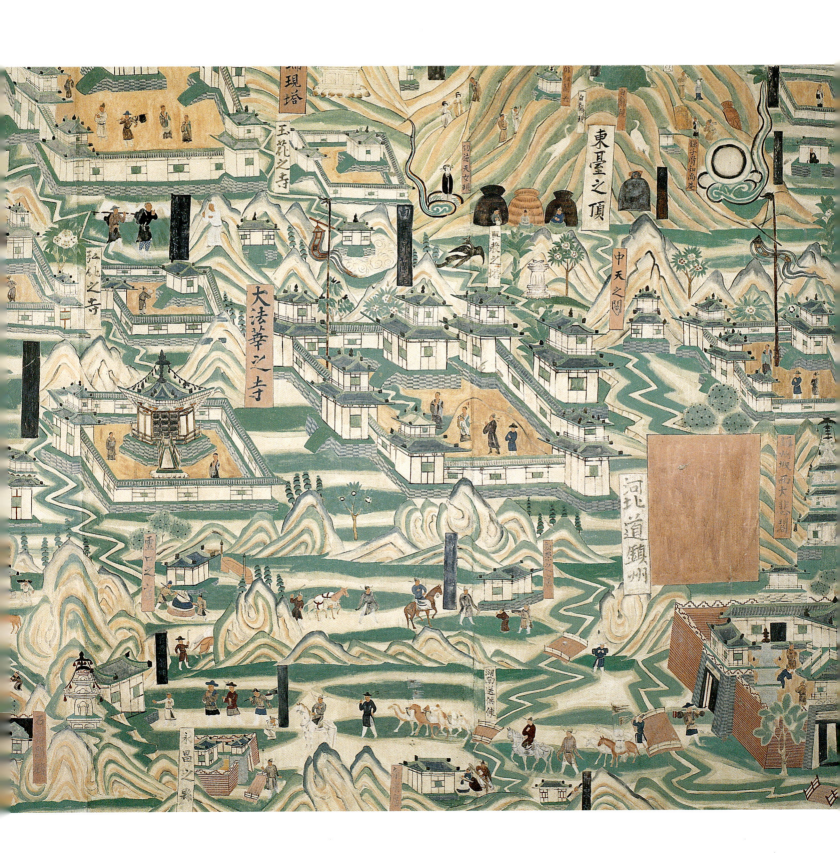

20
維摩經變之帝王圖

莫高窟第220窟 東壁北側
初唐
壁畫臨本
103.0×137.8 公分
臨摹者：李其瓊

第220窟東壁門北繪文殊菩薩、門南繪維摩詰，藉由窟門兩側凸顯〈問疾品〉中「維摩示疾，文殊來問」針鋒詰辯之勢。此圖乃以文殊菩薩下方的帝王為範圍臨摹。

圖中帝王頭戴冕旒、著深色的青衣朱裳、雙臂開展、昂首闊步，十分具有帝王尊貴昂然的氣勢；而身後一群簇擁的群臣則多著淺色白襦、動作顯得拘謹收斂。畫面色彩雖不多，卻配色巧妙，呈現絢麗的效果。再者，從構圖上的前後位置、人物大小，來突出帝王的形象，實為人物畫中的傑作。

第220窟是有記年的洞窟，建於唐貞觀十六年（642），與初唐畫家閻立本的名作歷代帝王圖中的帝王與群臣形象幾乎相同。這可做為敦煌與中原交流密切的證明。

Emperor and His Ministers from Vimalakīrtinirdeśa sūtra Illustration

North Section of East Wall, Cave No.220, Mogao Grottoes
Early Tang Dynasty
Copy, Wall Painting
103.0×137.8 cm
Copied by：Li Qiqiong

Mañjuśrī and Vimalakīrti are painted on the north and south sides of the east wall of Cave no. 220 to indicate their heated debate–Vimalakīrti presents the problem and Mañjuśrī queries about it- described in the scene "Inquiring After Vimalakīrtī's Illness." The copy features the king's figure below the statue of Mañjuśrī.

In the painting, the king wears a crown and a dark indigo gown and strides forward majestically with open arms. Most officials following the king, wear light color or white gowns and behave respectfully. Though the painting is not colorful, the effect is brilliant. Furthermore, the artist has skillfully employed the interplay of foreground and background and adjusted the size of the figures to emphasize the king's royalty; it is a masterpiece in figure painting.

The year of construction is indicated in Cave no. 220. It was built in the 16th year of Zengguang reign (642) of the Tang Dynasty. The figures are almost the same as that of the "Emperor Painting" by artist Yen Liben of the early Tang Dynasty. Therefore, the mural is proof of cultural exchange between Dunhuang and the Central Plains during the Tang Dynasty.

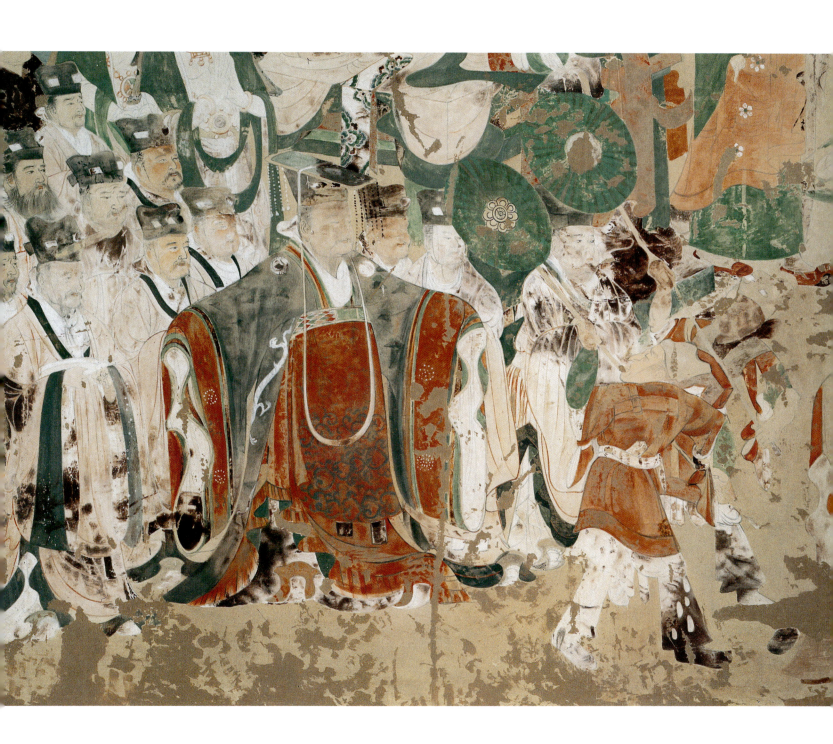

21
維摩經變之維摩詰
莫高窟第220窟 東壁南側
初唐
壁畫臨本
230.0×180.0 公分
臨摹者：鄧恒、趙俊榮

此臨摹作品為第220窟東壁門南側的維摩詰，手握羽扇坐於帳內，身體前傾，雖略顯病容，但經由面部細微的表情，仍透露出充滿自信、勝券在握之端倪。特別是維摩詰緊鎖的雙眉、深邃的眼神，精彩展現出文人的形貌。至於畫面上排列於維摩詰帳下形貌不一、膚色與服裝各異者，則為前來聽法的各國王子，是前來唐朝進貢的番王，顯示出當時交通往來之外域人士的面貌。

Vimalakīrti in the Vimalakīrtinirdeśa Sūtra Illustration
South Section of East Wall, Cave No.220, Mogao Grottoes
Early Tang Dynasty
Copy, Wall Painting
230.0×180.0 cm
Copied by：Deng Heng, Zhao Junrong

The copy is made of Vimalakīrti in the south side of the east wall of Cave no. 220. In the painting, Vimalakīrti is sitting in a tent holding a feathered fan, leaning forward. Though he looks ill, his facial expression conveys confidence, especially his furrowed eyebrows and shining eyes that express the typical temperament of an ancient scholar. People of different complexions and appearances wearing different costumes in the same tent are princes from different countries coming to listen to Vimalakīrti sermons. In fact, many are kings paying tributes typical in the Tang Dynasty. From the painting, we can see the type of foreigners traveling to the Central Plains at that time.

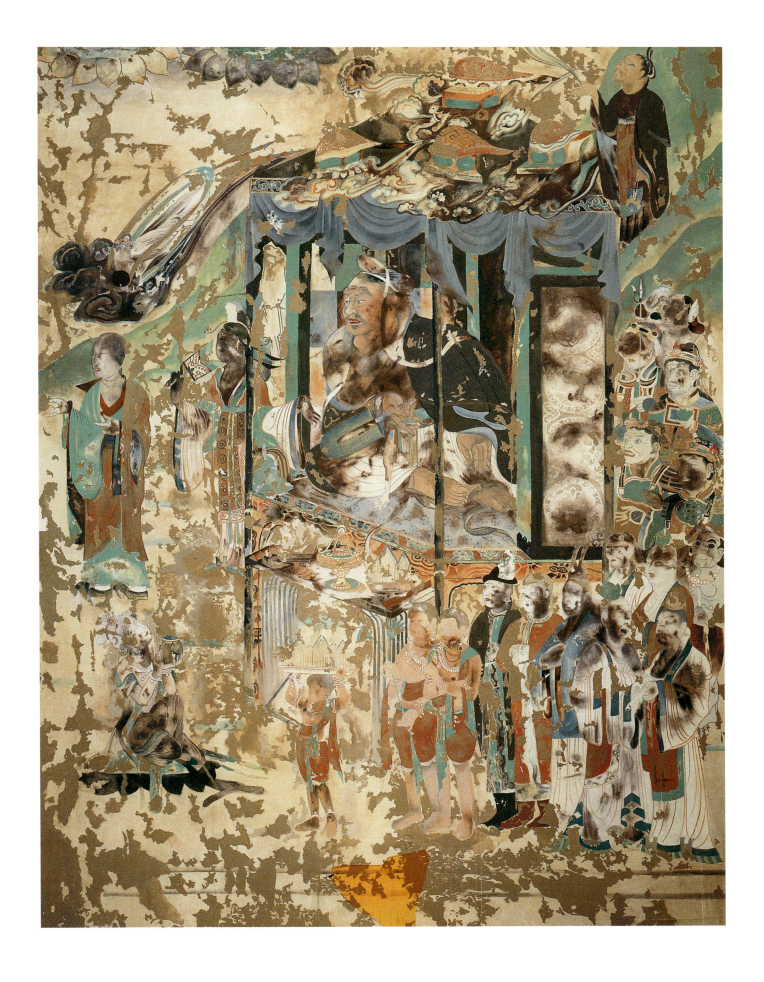

22
維摩詰經變之帝王圖
莫高窟第103窟 東壁北側
盛唐
壁畫臨本
116.5×104.0 公分
臨摹者：李其瓊

Emperor and his Ministers from Vimalakīrtinirdeśa sūtra Illustration
North Section of East Wall, Cave No.103, Mogao Grottoes
High Tang Dynasty
Copy, Wall Painting
116.5×104.0 cm
Copied by：Li Qiqiong

　　畫面上所表現的文殊菩薩下方的帝王圖，即是《維摩詰所說經》〈方便品〉中提到「長者維摩詰，以如是等無量方便饒益眾生，以其方便現身有疾，以其疾故，國王、大臣、長者、居士、婆羅門等、及諸王子、并餘官屬，無數千人皆往問疾，其往者，維摩詰因以身疾廣為說法」的內容。

　　穿戴袞冕前來聽法的帝王，藉由流暢明快的線條，勾勒出廣額豐頤、濃眉大眼、隆鼻美髯的堂堂儀表，尤其沈穩的神情與昂然開展的肢體，顯示出躊躇滿志的胸懷。如果說第220窟以線條與敷彩的方式來營造帝王的氣勢（圖錄號20），第103窟則更擅長使用線條來掌握人物的神情，一重設色、一重墨線，可說是以不同的風格卻同樣成功地揣寫帝王的神韻，為可資相互比較的佳作。

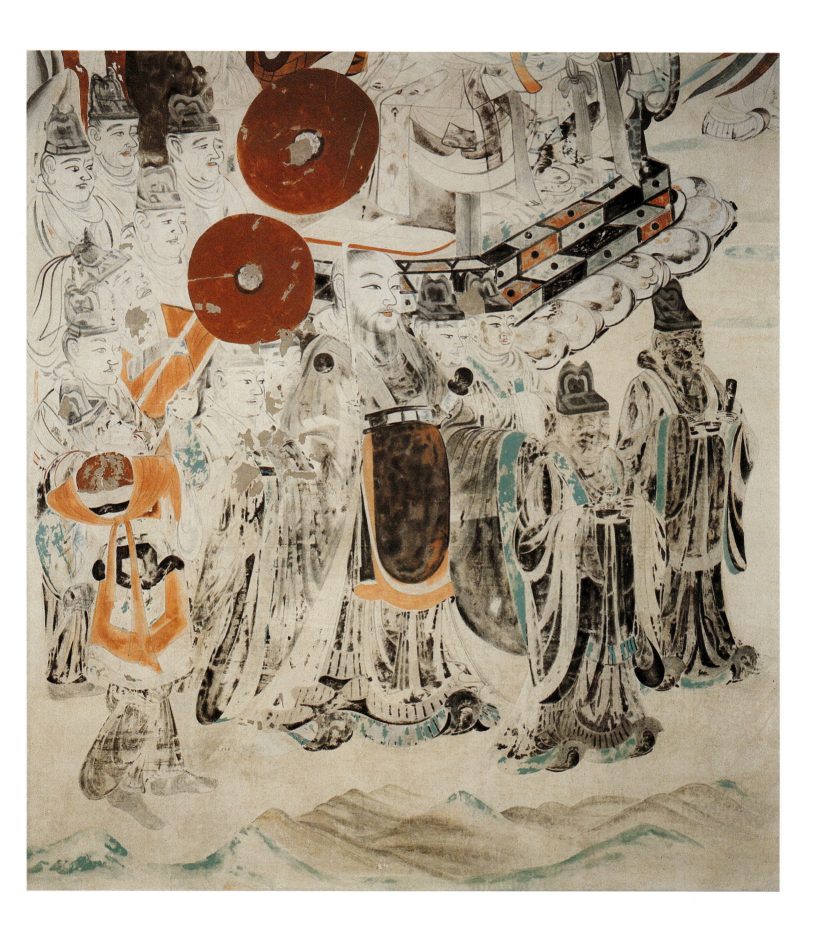

23
都督夫人王氏禮佛圖（復原）
莫高窟第130窟 甬道南壁
初唐
壁畫臨本
45.0×68.0 公分
臨摹者：段文傑

都督夫人供養像位於進入窟門的甬道南壁，其最前方的婦人旁有榜題：「都督夫人太原王氏一心供養」。而根據史書樂庭瓌於天寶十二年（753）前後，被任命為都督，駐守晉昌郡（瓜州），故可知此窟約略的營建時間。

都督夫人身形超過真人大小，雍容華貴，身後率有二女（榜題：「女十一娘光供養」、「女十三娘供養」、及九名侍女。無論從人物大小或服飾的設色與配置，都可以見出身份的尊卑等級；夫人身著花石榴紅裙，在半臂上披橙色帔帛，前胸綠色繫帶長垂，雲髻上簪花、並綴以釵梳；二女一梳高髻，一戴鳳冠，朱、白襦衣上罩橙、綠半臂後，再各披白、橙色的帔帛，但顏色質地明顯不及其母；身後九名婢女多著男裝圓領袍，或捧花、執壺、持扇、舉盒，形成一幅貴族婦女禮佛圖。

此鋪曾在宋代時被泥匠塗牆補土重修而覆蓋於下層，二十世紀40年代被剝出底層，但由於當時剝離的條件技術不佳而殘損，現今只能見50年代經過研究臨摹的作品。

Donor Portrait of Lady Wang from Taiyuan
South Wall, Cave No.130, Mogao Grottoes
High Tang Dynasty
Copy, Wall Painting
45.0×68.0 cm
Copied by：Duan Wenjie

This portrait of the wife of the Commissioner of Military Command is located on the south wall of the entrance passage. The cartouche next to this lead female donor indicates: "Lady of the Commissioner of Military Command, Madame Wang of Taiyuan devoutly donates this wholeheartedly." According to historic records, Yue Tinghuai, her husband, was appointed as the military command general to be stationed at Jinchang Commandery (Guazhou) around the twelfth Year of the Tianbao Reign; therefore the time of construction of the cave can be roughly estimated to 753 A.D.

The portrait of wife of the Commissioner of Military Command, Madame Wang, is larger than life size. She carries the elegance of elite society and is followed by two females with captions identifying them as the "Eleventh Daughter" and the "Thirteenth Daughter," and nine female servants. The sizes of the figures and the colors and accessories of their clothing clearly reveal their high social status. The lady is dressed in a red skirt with pomegranate design, an orange shawl over her short-sleeved outer garment; green lace hangs down low and flowery pins and decorative combs adorn her high bun. One of the two daughters also has a tall bun and the other wears a phoenix headpiece. Their upper garments are respectively topped with orange and green short-sleeved outer garments and then white and orange shawls of apparently lesser quality than their mother's. Most of the nine maids standing behind are in mannish round-necked robes. They hold flowers, carry an offering bottle, hold a fan, or present boxes, forming a contrast with the main figures paying respects to the Buddha.

Artisans had covered up this mural during renovation in the Song Dynasty. In the 1940 the outer layer was removed, but partial damage occurred due to inferior removing techniques at the time. What we see today is a restorative copy effort after studying the original in the fifties.

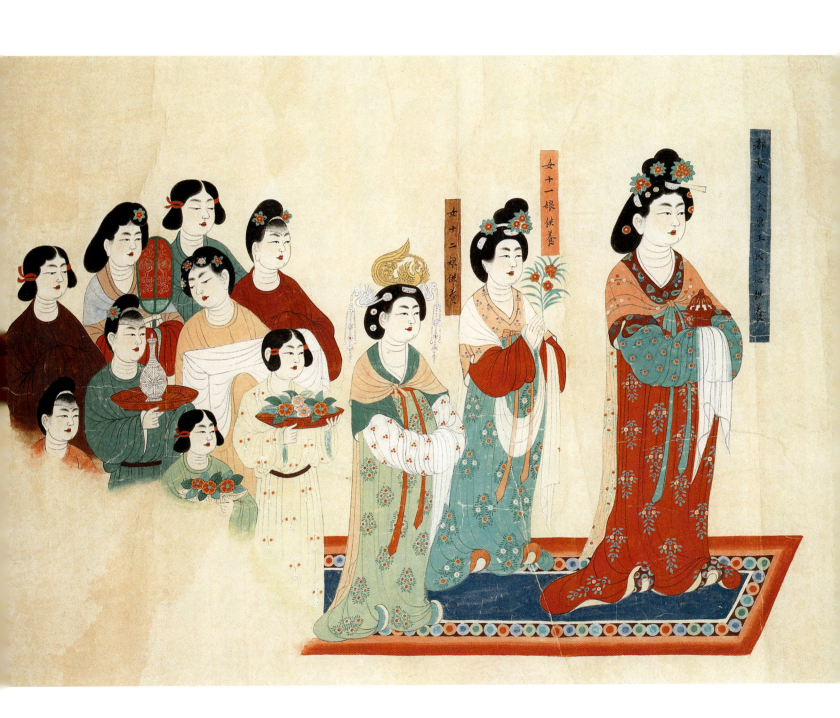

24
女供養人像
莫高窟第9窟 東壁
晚唐
壁畫臨本
82.0×142.0 公分
臨摹者：史葦湘

Female Donor Portrait
East Wall, Cave No.98, Mogao Grottoes
Late Tang Dynasty
Copy, Wall Painting
82.0×142.0 cm
Copied by：Shi Weixiang

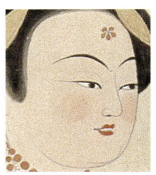 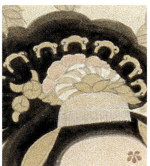

　　歷史上的晚唐是敦煌貴族爭權的時期，供養人也同樣競相將自己的肖像繪製於洞窟內。流傳下來的作品，提供我們認識當時人物服飾的最好實物。此圖即臨摹自東壁南側後面三身女供養人及侍童。

　　畫面上三位貴婦立於華麗的氍毹上，雙手捧供或合十，頂梳散成花朵狀之高髻，簪花與釵梳滿佈，並沿著雲髻外圍一圈插飾；面容頤圓，柳眉小嘴，胭脂輕扣，額貼花鈿；貴婦身材纖細，削肩而單薄，身著曳地的大袖襦裙，胸前裙帶拉高至領口、繫帶長垂，三位服裝樣式雖同、但花色互異，且團花的型態更是變化多端，加上纈染的帔帛，可謂極盡繁複華貴。最有趣的是人物間相互呼應，藉由轉頭、仰頭、返身等神態各不相同，使畫面顯得生動而自然。

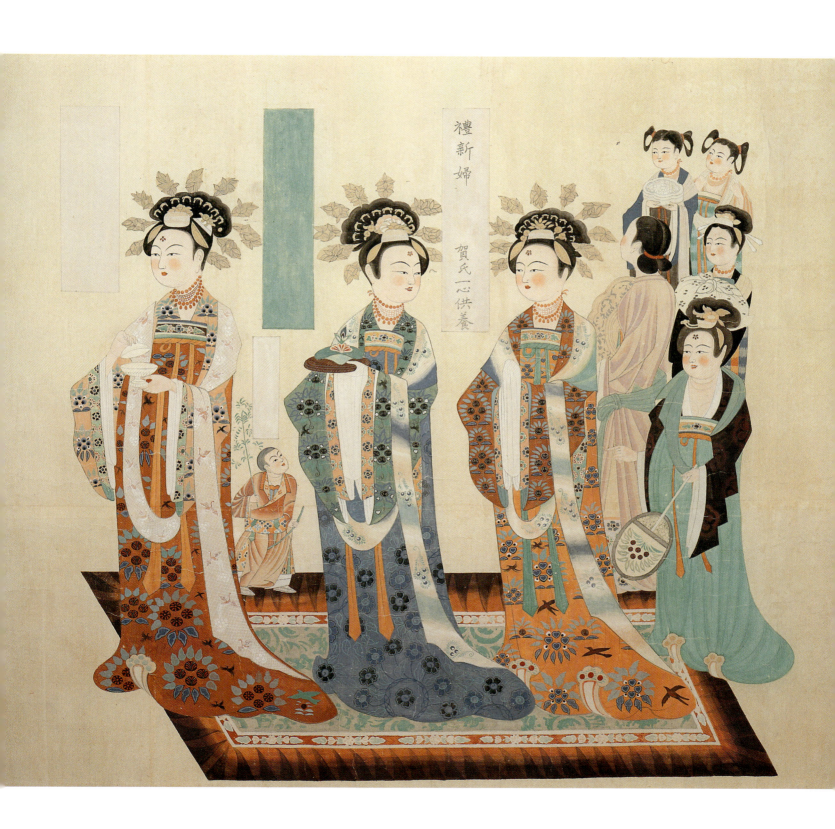

25
于闐國王李聖天供養像
莫高窟第98窟 東壁南側
五代
壁畫臨本
301.2×145.5 公分
臨摹者：馮仲年

Donor Portrait, Li Shengtian, Khotanese King
North Section of East Wall, Cave No.98, Mogao Grottoes
Five Dynasties
Copy, Wall Painting
301.2×145.5 cm
Copied by：Feng Zhongnian

　　此件作品像高2.82公尺，是莫高窟最大的供養人像，榜題為「大朝大寶于闐國大聖大明天子…即是窟主」，說明窟主為于闐國王李聖天。敦煌自張氏政權轉移至曹氏政權後，對內與中原相通，對外與外族通婚，成為安定社會的手段之一。第一任節度使曹議金的長女即嫁于闐國王李聖天，該畫像亦印證了這段歷史。

　　于闐國王左手持香爐，頭戴冕旒，身著鏽有日（鳥）月（樹）、龍等紋飾的袞服，大致符合天福三年（938）冊封李聖天時所記載的：「聖天衣冠如中國」(《新五代史》〈使于闐記〉)。在國王腳下有一從地湧出的半身女神承托其足，據傳于闐國王為北方毗沙門天王的後裔，天王像腳下多塑有地神，因此于闐國王亦享此護法殊榮。

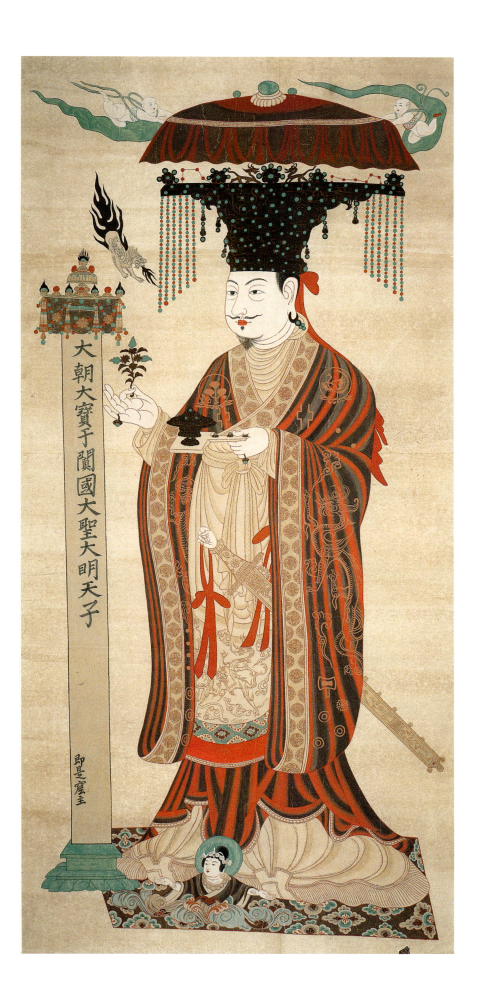

26
回鶻公主供養像
莫高窟第61窟 東壁北側
五代
壁畫臨本
202.5×249.0 公分
臨摹者：萬庚育、馮仲年

第61窟窟主為曹議金的兒子曹元忠，東壁門南的女供養人像皆為曹氏家族的女眷，本圖所臨摹的是第二、三、四身。畫中最左榜題：「故母北方大迴鶻國聖天的子勅授秦國天公主隴西李氏…」，故可知畫面左邊第一位是曹議金的回鶻夫人隴西李氏。夫人的裝束仍保持了回鶻特色，頭梳高髻（回鶻髻），戴桃形冠，兩側橫插一雲頭形簪釵，綴以步搖，髻間繫垂至身後標誌上層社會人物的飄帶，圓形環飾戴於耳，珠寶項鏈繞於頸；身著窄袖的石榴紅落地裙袍，領口呈V字形，翻折出青色、地飾鳥銜瑞草，袖口和領口相同；領內則露出紅色小花圓領錦衣；雙手捧香爐供養，足登翹頭軟錦鞋；面部豐潤，施胭脂、塗唇膏、貼花鈿、點面靨，這都是當時的時尚面妝。

五代時期，瓜州、沙州統治者曹議金與東邊甘州回鶻天可汗建立的姻親關係，在此壁畫中得到充分地反映。

Portrait of Uighur Princess
North Section of East Wall, Cave No.61, Mogao Grottoes
Five Dynasties
Copy, Wall Painting
202.5×249.0 cm
Copied by：Wang Gengyu, Feng Zhongnian

The patron of Cave no. 61, Chao Yuanzhong, was the son of Chao Yijin,. The female donors on the south side of the east wall entrance are female members of the Chao family. This reproduction covers only the second, third and fourth parts. The cartouche on the very left reads: "My deceased mother, entitled as Princess of the Jin Estate by King of Great Northern Uighur Kingdom, maiden surname Li..." We can therefore surmise that the first on the left is Chao Yijin's Uighur wife from Longxi (eastern Gansu), surnamed Li. Her attire has Uighur characteristics: including a peach-shaped headgear, hair wound into a high bun, a cloud-head hairpin on each side finished in dangling ornaments, a hair ribbon hanging down the back–an elite token–round earrings and jeweled necklaces. Her snug-sleeved, pomegranate-red long skirt contains the bird-holding, auspicious-grass design on the blue lapels of the v-shaped collar and cuffs. Inside the collar, a red round-necked silk shirt with small floral patterns is visible. Wearing soft silk shoes with upturned tips, she holds an incense burner. Applied on her well-groomed face are lipstick, blush and painted dimples, as well as decorative floral motifs on the forehead. These constituted cosmetic fashion at the time.

During the Five Dynasties, the commander of Guazhou and Shazhou, Chao Yijin established marital relations with the eastern Uighur ruler of Ganzhou. This mural demonstrates considerable evidence of this alliance.

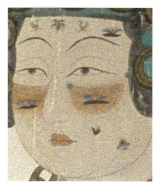
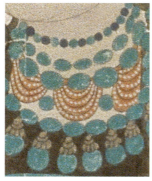

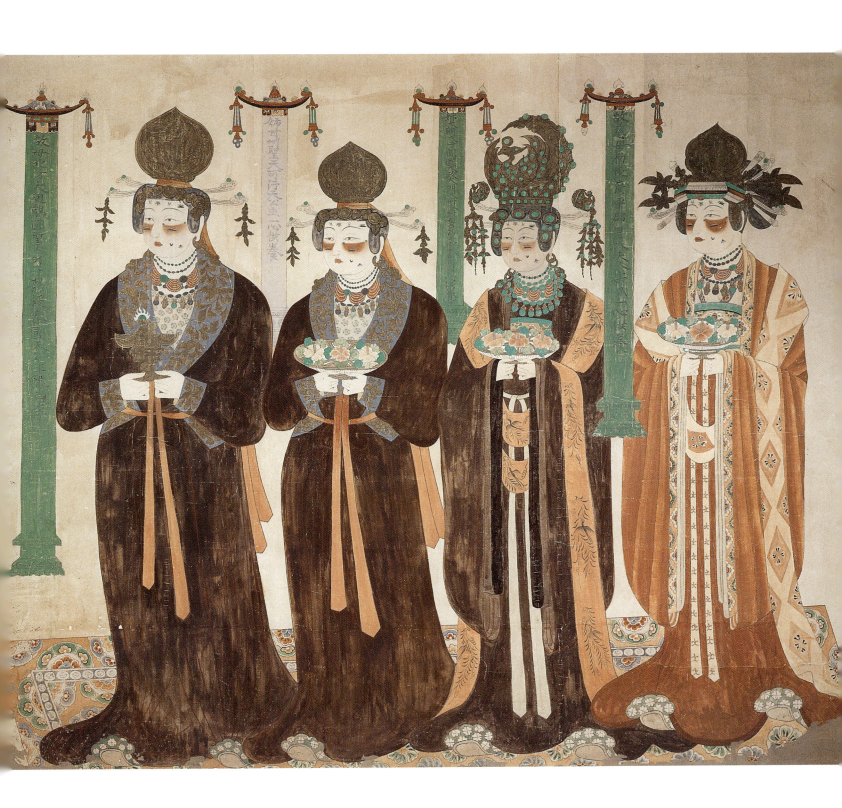

27
回鶻王供養像
莫高窟第409窟 東壁南側
西夏
壁畫臨本
226.5×169.5 公分
臨摹者：楊麟翼

　　此圖是西夏時期重繪於隋代第409窟東壁的供養人像，是重修此窟時的功德主，由於榜題殘損，因而身份難辨，但是特殊的造型與服裝，格外引人注目。此像頭戴高而尖的桃形雲鏤冠、冠帶垂至身後，面形渾圓，兩頰豐肥，柳眉細眼，八字鬍鬚，童子般的面貌顯得親切可人；身著圓領窄袖團龍袍，腰束革帶，並垂占鞢七事（打火石、磨刀石、解結錐等），腳穿白色氈靴，手執香爐供養。前方一少年，衣冠服飾大致相同，雙手捧供，應為其子。此像身後有八名侍從，一人張傘、兩人持龍紋翬扇，其餘或握寶劍、抱弓箭、背盾牌等。從服飾紋樣上多少顯示其不凡的身份；據新疆伯孜克里克石窟中回鶻王供養像，可知此為回鶻國王。

　　此鋪壁畫色彩，除龍袍變黑外，其餘則保存完好，暈染亦尚清楚，但線描則剝落許多，較細微的線條幾乎已不見，但透過臨摹讓我們可窺得其原貌。

Portrait of Uigur King
South Section of East Wall, Cave No.409, Mogao Grottoes
Western Xia Kingdom
Copy, Wall Painting
226.5×169.5 cm
Copied by：Yang Linyi

This is a depiction of a donor, which is part of the Western Xia repainted east wall of Cave no. 409. Due to the damage of the cartouche, the identity is difficult to ascertain. However, the appearance and costume appear unusual and attract attention. The person wears a tall peach-shaped hat with tassels hanging down his back. The round baby face with plump cheeks, long brows and narrow eyes, and the moustache imparts amiability. His round-necked, snug-sleeved robe with the circled-dragon pattern is secured at the waist with a leather belt with seven divining tools (flint stone, grinding stone, drill for untying knots, etc.). On his feet are white suede boots. He holds an incense burner to pay respects to the Buddha. In front, the young boy, similarly garbed with his hands in prayer, is most likely his son. Behind are eight attendants, one donor holds an umbrella, two carry fans with a dragon design, and the rest either carry a sword, a quiver and bow, or a shield. The markings on his clothes definitely reveal a high social status; the portrait of the Uighur king in the Beziklik Grottoes in Xinjiang helps verify this Dunhuang depiction as the Uighur king.

Aside from the darkened dragon robe, the rest of this mural is in pristine condition. The shading is still visible but the overdrawing has almost completely peeled off. The finer lines are nearly invisible. This reproduction restores the mural to its original appearance.

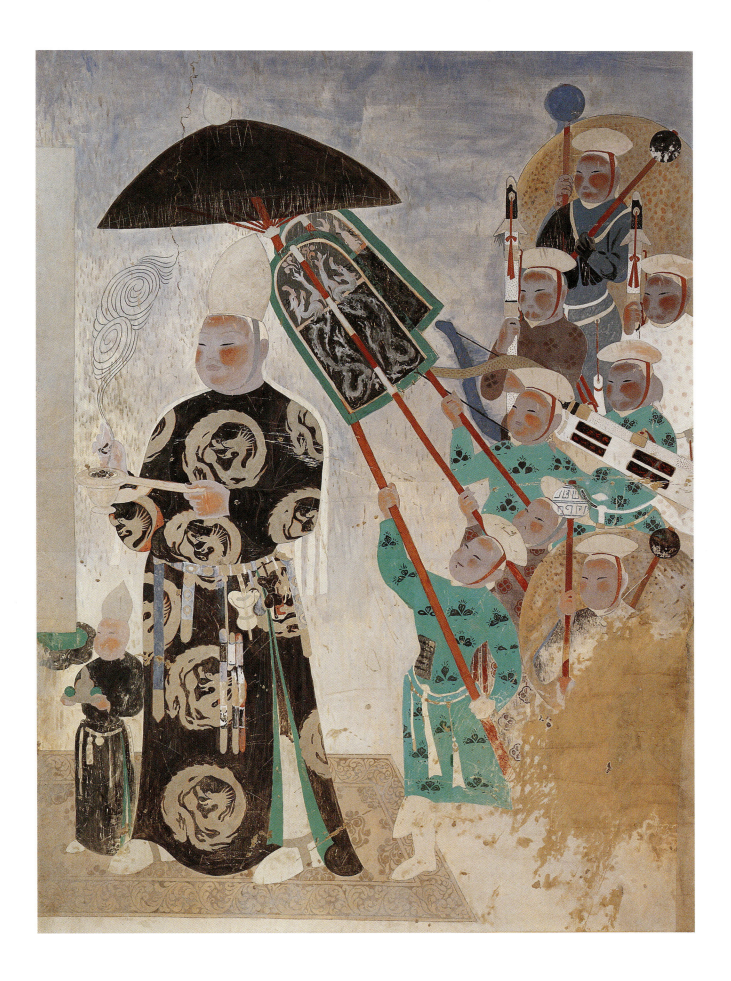

28
女供養人像
榆林窟第29窟 南壁西側
西夏
壁畫臨本
80.0×82.0 公分
臨摹者：霍熙亮

Female Donor Portrait
West Section of South Wall, Cave No.29, Yulin Grottoes
Western Xia Kingdom
Copy, Wall Painting
80.0×82.0 cm
Copied by：Hou Xiliang

　　黨項族所建的西夏王國於十三世紀時占據瓜、沙二州，以佛教為國教，因此留下大量珍貴的西夏歷史資料。榆林窟第29窟窟門南壁西側下層供養人是一僧人為前導，後有六身女供養人，本作品即臨摹前三身的女供養人。

　　三身女供養人的服飾顯然與漢族婦女不同，頭戴花釵冠，穿右衽窄袖開叉花衫，腳穿圓口尖勾鞋，身體顯得更為挺健豐碩，實為西夏貴族婦女的寫照，具有強烈的遊牧民族特色。西夏女供養人的冠帽與束袖長衫則呈現出一種俐落感，更具有男性氣質。根據榜題（西夏文字），此三位女供養人分別為當時瓜、沙二州監軍司官員的夫人、女兒、兒媳，在當時是極具身份地位的西夏貴族。

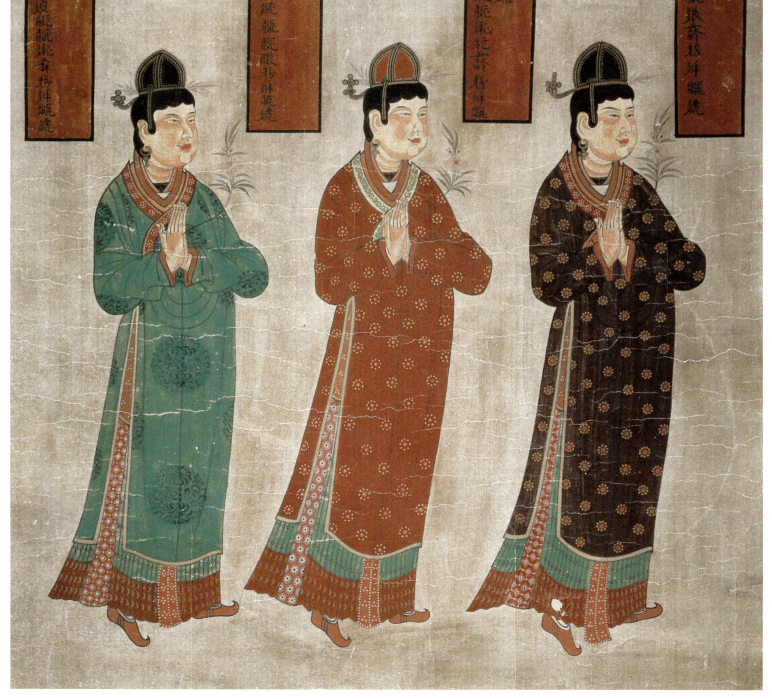

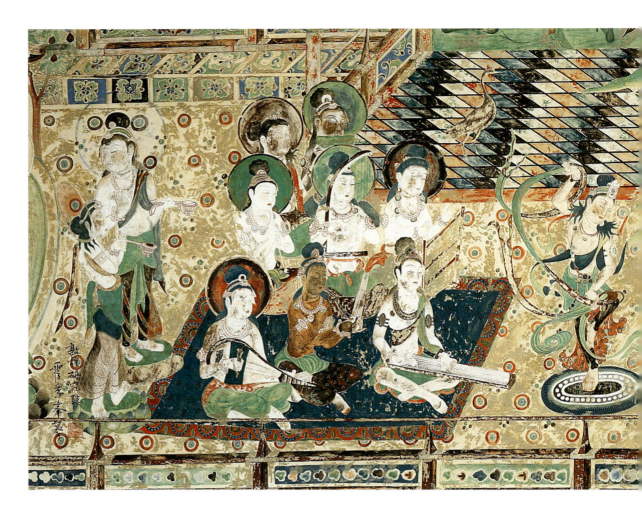

29
無量壽經變之舞樂圖
莫高窟第220窟 南壁
初唐
壁畫臨本
103.7×274.0 公分
臨摹者：霍秀峰

Dance and Music Scene Adapted
from the Sukhāvatī-vyūha Sūtra Illustration
South Wall, Cave No.220, Mogao Grottoes
Early Tang Dynasty
Copy, Wall Painting
103.7×274.0 cm
Copied by：Huo Xiufeng

　　第220窟洞窟內有初唐貞觀十六年（642）的題記，南、北壁通壁為大幅經變畫，南壁是無量壽經變，此作品即是臨摹其下方中央的樂舞圖。

　　樂舞圖在整體構圖上呈現對稱的型態，演奏的菩薩眾坐於氍上，兩側各八位分持不同樂器，左邊方氍上，前排內側依序為箏、笙、琵琶，第二橫排的方響、豎箜篌、簫，最後排的排簫和拍板；右邊方氍上，前排內側為羯鼓、腰鼓、雞婁鼓，中央排的橫笛，後排的答臘鼓、簫、塤，以及最後排的排簫。其中包括弦樂三種、管樂七種，打擊樂六種，幾乎網羅唐代的主要樂器。

　　中央則為舞蹈表演的空間，由兩位舞者相對而舞，一腳墊尖、一腳屈膝，從飄帶翻飛與旋捲的姿態，可知為唐朝時非常流行的胡旋舞。原本表現的是天上淨土中歌舞的景象，卻也反映出當時宮廷樂舞的風貌。

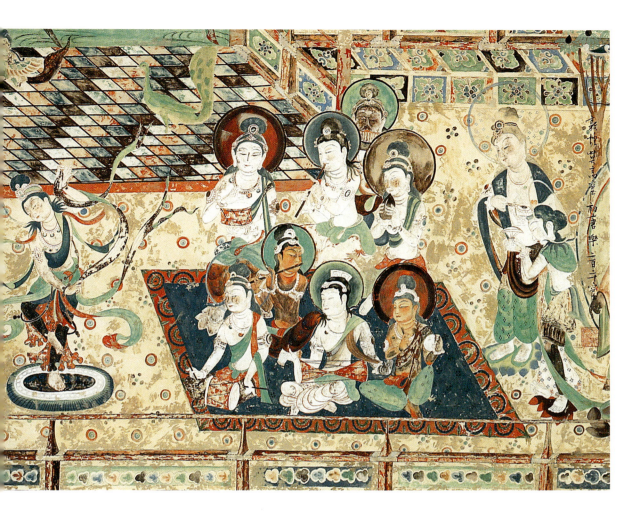

On both the north and south walls of Cave no. 220 are large scripture-inspired murals with captions dating them at the 16th year of Zhenquan (642 A.D.). The mural on the south wall is an adaptation from the Amitāyus Sūtra (Sukhāvati-vyūha Sūtra). This painting presented here is a reproduction of the dance and music scene at the bottom center of the mural.

The dance and music scene appears symmetrical. There are eight Bodhisattvas sitting on a square rug playing musical instruments on each side. On the front row in the outward order on the left are the zither, sheng and pipa. In the second row musicians have a fangxiang (xylophone), shugonghou (harp) and vertical flute. The last row features panflute and clapping boards. On the right, in the front row are a jie drum, waist drum and a chicken-basket drum. The second row a musician has flutes. On the third row are a dala drum, vertical flute and xun (earthen flute). The last row is panflute. Altogether there are three string instruments, seven wind instruments and six percussion instruments - just about all the major musical instruments used in the Tang Dynasty.

The center is the dance floor. Two dancers dance face to face, one perched on their tiptoes while the other bends at the knee. From the flowing sashes and the spinning posture, we know it's the Huxuan dance (High speed rotating dance) – very popular in the Tang Dynasty. Originally an expression of dancing in paradise, it also reflects a contemporary court dance scene.

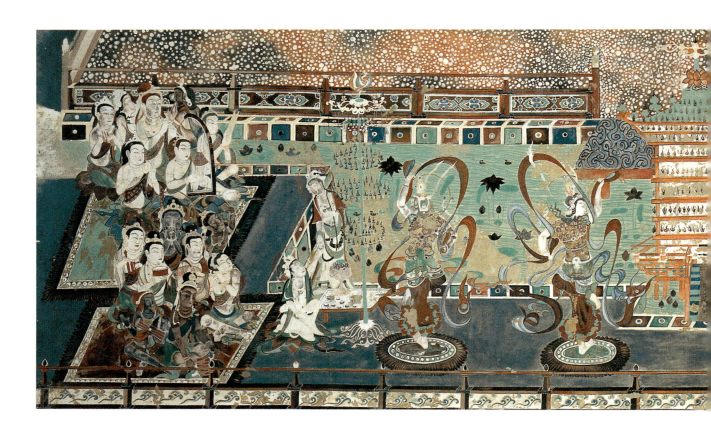

30
藥師經變之舞樂圖
莫高窟第220窟 北壁
初唐
壁畫臨本
117.5×423.0 公分
臨摹者：吳榮鑒、婁婕、侯黎明

Dance and Music Scene Adapted from
Bhaiṣajyaguru Buddha Sūtra Illustration
North Wall, Cave No.220, Mogao Grottoes
Early Tang Dynasty
Copy, Wall Painting
117.5×423.0 cm
Copied by：Wu Rongjian, Lou Jie, Hou Liming

　　作品是以藥師經變下方盛大樂舞場面為臨摹對象。樂舞會中央為燈樓，兩側亦配有燈輪，由天女燃燈供養。左右兩側各兩塊方氍上由二十八位樂家組成龐大的樂團，演奏來自中國或西域傳入的各種樂器，包括有羯鼓、細腰鼓、橫笛、雞婁鼓、答臘鼓、拍板、塤、豎箜篌、鈸、笙、花邊阮、篳篥、方響、簫、排簫、箏之樂器。
　　相較於對壁之無量壽經變，此圖的演奏樂家位置更靠邊側，使得中央的舞蹈空間增大，視覺焦點集中。舞者左、右側分別為兩男兩女，經由畫面上彩帶的飛旋與舞者髮絲的飛揚，充分說明旋繞的速度，也展現出優美的動感線條。藉由第220窟南、北壁之樂舞場景，可知初唐昇平之世的生活景象。

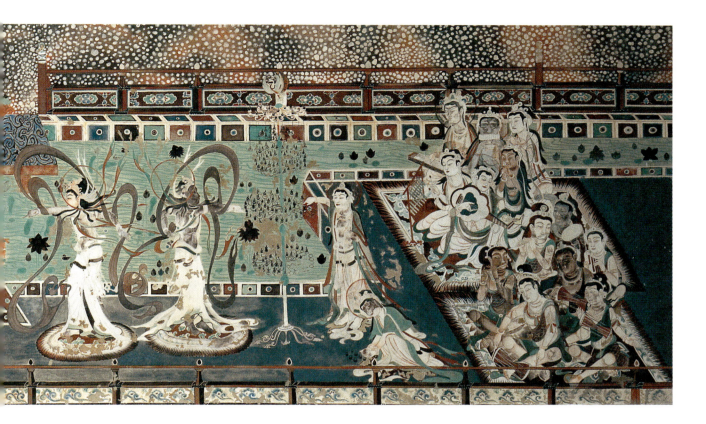

This is a reproduction of the vast dance and music scene at the bottom of the mural adapted from the Medicine (Bhaiṣajyaguru) Buddha Sūtra. A light tower stands in the middle, while on both sides light wheels are kept lit by goddesses. On square rugs on the left and the right, twenty-eight musicians form an impressive band, playing instruments that were introduced from either China or Central Asia. These include the jie drum, the thin-waist drum, flute, chicken-basket drum, dala drum, clapping boards, earthen flute, small harp, cymbals, sheng, huabianruan, bili, fangxiang, vertical flute, panflute and zither.

Compared to the mural on the opposite wall adapted from the Amitāyus Sūtra, the musicians are placed closer to the edge and a portion of the center dance floor is made larger and becomes the focus. There are two male and two female dancers. The ribbons and the hair of the dancers fly to show the speed of spinning as well as the beautiful lines of motion. These entertainment scenes on the north and south walls of Cave no. 220, reflect aspects of life during the peaceful period of the Early Tang Dynasty.

31
觀無量壽經變之破陣樂舞
莫高窟第217窟 北壁西側
盛唐
壁畫臨本
132.3×72.3 公分
臨摹者：關友惠

　　此臨摹作品是觀無量壽經變左側未生怨中破陣樂舞的場面，所描繪的是阿闍世太子逮捕父親頻婆娑羅王的戲劇性場面。王舍城城外，騎馬高高在上的是正檢閱軍隊操練的阿闍世王，阿闍世王面前是恭敬屈膝禮拜的臣子，身後則有數位隨侍撐起寶蓋；這和圖畫下方的父王雖然仍頭戴旒冕王冠，但傘蓋已被剝奪、兩位經過身邊的臣子也只舉笏不欠身的情況，成為截然的對比。而這個場面意外的保留了唐代訓練戰士破陣的型態，畫面上雖不見樂隊的佈局，但可以看見這些舞者（即戰士）的表現，隊形採兩兩相對，作打仗的態勢，舞者身披銀甲，一側是持戟，一側則掌盾，以往來擊刺動作為練習，動作相同而人物姿態表情各異，為當時的破陣樂舞留下生動的紀錄。

War Song and Dance Scene Adapted from the Amitāyurdhyana Sūtra Illustration
West Section of North Wall, Cave No.217, Mogao Grottoes
High Tang Dynasty
Copy, Wall Painting
132.3×72.3 cm
Copied by：Guan Youhui

This reproduction depicts the war song and dance scene in the "Enmity Before Birth" from the Amitāyurdhyana Sūtra on the left side of the mural. It shows the dramatic scene of Prince Ajātaśtru putting his father King Bimbisāra under arrest. Outside the castle, the prince sits up high on horseback to inspect the troops in training. In front of him are court officials paying respects, while a few servants hold the canopy to shelter the prince from behind. Although still wearing the crown, the king at the bottom of the picture has been deprived of the canopy and the two passing officials, without bowing, only hold their scepters up to greet him. The contrast between the father and the son is obvious. An added benefit is that a Tang Dynasty military training scene is preserved. The band does not appear in the picture but the dancers, the soldiers, are dressed in silver armor are paired up in battle stance. One side carries spears, the other shields. Their stance is the same but the soldiers' postures and expressions vary. This makes a lively record of period war song and dance.

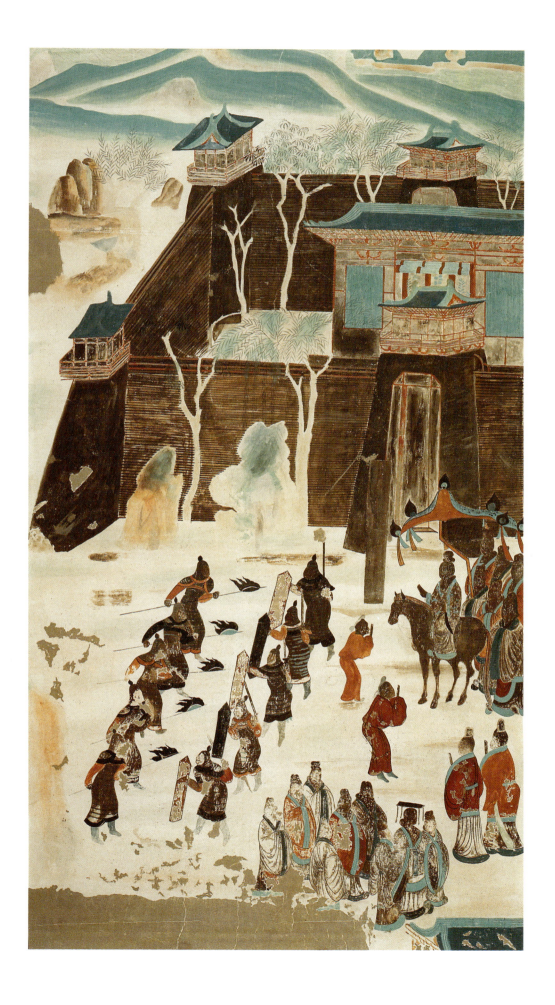

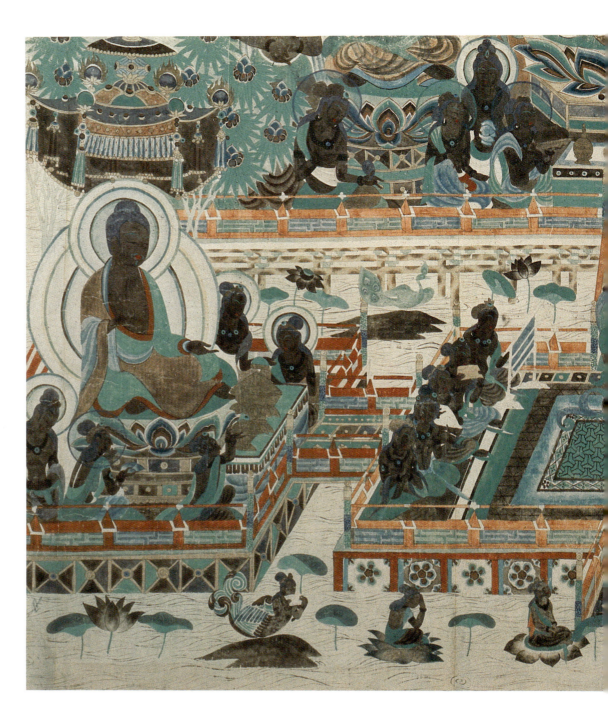

32
觀無量壽經變之部份
莫高窟第320窟 北壁
盛唐
壁畫臨本
113.3×207.5 公分
臨摹者：段文傑

Episodes from the Amitāyurdhyana Sūtra Illustration
North Wall, Cave No.320, Mogao Grottoes
High Tang Dynasty
Copy, Wall Painting
113.3×207.5 cm
Copied by：Duan Wenjie

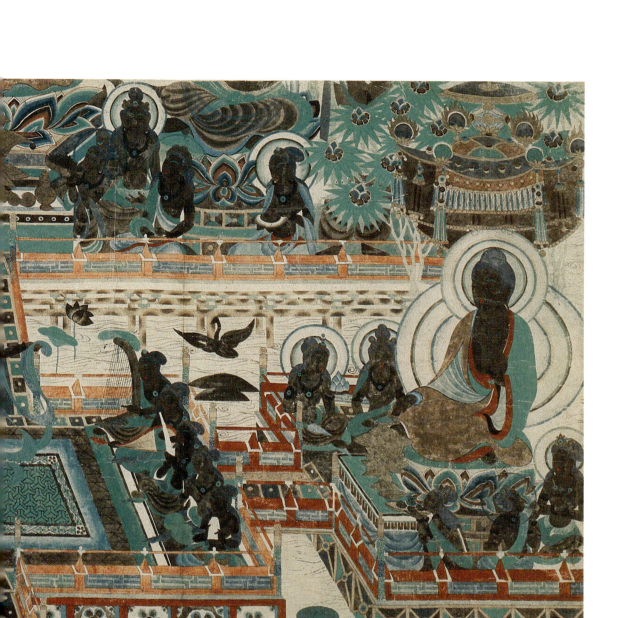

　　此臨摹作品是以觀無量壽經變中央說法圖之主尊下方為主要描繪的部分。說法圖下方是表現出連接三尊像的露臺，中央露臺兩側分別坐著左為持簫、笙、五弦琵琶、豎箜篌，右為橫笛、琵琶、排簫、方響的演奏者。正中央為一姿態曼妙的舞者，一腳曲膝勾起、一腳單獨著地，雙手一伸一曲舞弄彩帶，使原本頤長的彩帶隨著舞動而飄揚，同時亦突顯出舞者靈活柔軟的身段。兩側露臺上各有一佛、四周是數位菩薩眾。有趣的是池中蓮花中坐一童子，為蓮花化生童子，寶池兩側還有人首鳥身的迦陵頻伽，表現出極樂淨土的昇平景象。

　　畫面中諸尊像黧黑的肉身色，實為紅色系顏料含鉛氧化所致，然描繪尊像所使用的朱紅色，至今仍保有鮮明的色彩。

33
觀無量壽經變之舞樂圖
莫高窟第112窟 南壁東側
中唐
壁畫臨本
53.8×75.8 公分
臨摹者：吳榮鑒

相較於第320窟觀無量壽經變中的舞樂表演露臺（圖錄號32），在第112窟的樂舞露臺已升高至主尊下方，使得主尊、樂舞、與下方二佛的三個層次緊密呼應，並且突出中央樂舞露臺的視覺效果。此件作品即以寶池間的樂舞亭臺為臨摹範圍。

樂舞露臺上左、右兩側分別有三位演奏者，從左前方開始分持拍板、橫笛、雞婁鼓和鼗鼓；右前方始則分持琵琶、四弦西域琵琶、箜篌。其中最吸引人的莫過於中央反彈琵琶的舞者，其姣美的姿容，配合柔軟的身形，高舉琵琶擔負於身後，在一腳踮尖作為支撐、一腳彎曲配合身軀的舞動之下，不但維持曼妙的平衡，彩帶穿梭旋繞更說明了快速舞動下所顯現的靈活舞姿。事實上琵琶是無法反身撥弦彈奏的，作為舞蹈是一項表演的道具，舞者藉由高難度的琵琶反彈動作，展現出高超精湛的舞藝，吸引住觀者的目光。

Dance and Music Scene Adapted from the Amitāyurdhyana Sūtra Illustration
East Section of South Wall, Cave No.112, Mogao Grottoes
Mid Tang Dynasty
Copy, Wall Painting
53.8×75.8 cm
Copied by：Wu Rongjian

Compared to the dance and music scene in Cave no. 320 (Cat. no. 32), the stage in this picture is elevated to right under the main buddha and renders him in closer relation to the dance and music, and the two Bodhisattvas below. The center stage is also visually made more explicit. The reproduction is focused on the stages between the treasure ponds.

There are three musicians on each side of the center stage. On the left proceeding inward, there are clapping boards, flute, chicken-basket drum and the tao drum. On the right, players hold a pipa, moon lute, and harp. The most attractive of all is none other than the dancer in the middle playing the pipa behind her – the beautiful features, the supple body, the pipa raised behind the back, one foot pivoting on tiptoes while the other bends slightly with the body in motion to keep a subtle balance, and the weaving and spinning ribbons manifesting dexterous steps with the swift movements. In reality, the pipa cannot be played behind the back. It's employed as a prop; the difficulty of playing it behind the back emphasizes the superb dancing skills and attracts the attention of the audience.

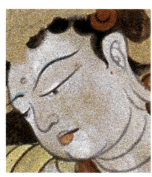 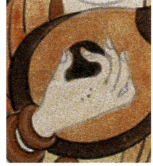

From the Forgotten Deserts:
Centuries of Dazzling Dunhuang Art

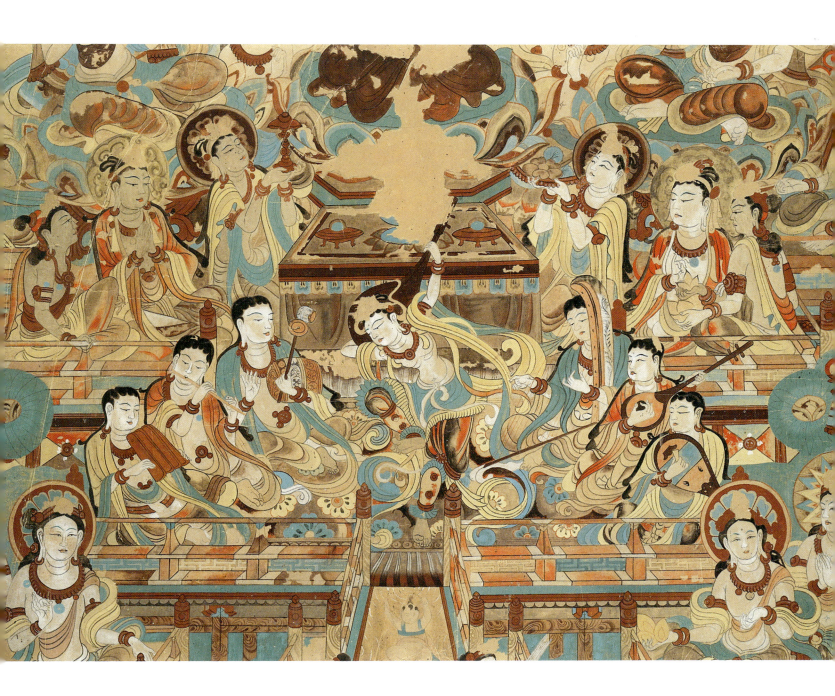

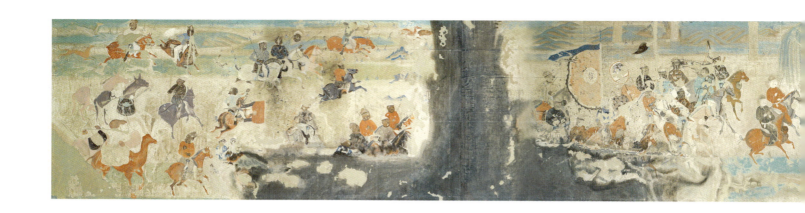

34
張議潮出行圖
莫高窟第156窟 南壁、東壁南側
晚唐
壁畫臨本
107.8×857.6 公分
臨摹者：關友惠、馮仲年、蘭州藝院

Military Governor Zhang Yichao and His Army in Procession
South Wall and South Section of East Wall, Cave No.156, Mogao Grottoes
Late Tang Dynasty
Copy, Wall Painting
107.8×857.6 cm
Copied by：Guan Youhui , Feng Zhongnian, Lanzhou Art College

　　第156窟為張淮深為紀念其叔張議潮所修的功德窟，繪於南壁和東壁南側下部的張議潮出行圖分前、中、後三段，中央身形最顯著的人物即張議潮，在此之前以軍隊、樂舞等儀仗為前導，分列兩側，最前者氈帽團衫，擊鼓吹角，以示開道，其後騎兵盔甲儼身，再後是文騎五對，而文騎之間為隨軍樂舞，樂師二人背大鼓、二人擊鼓，其餘琵琶、橫笛、篳篥、拍板、箜篌、腰鼓、笙、手鼓等，舞伎四隊兩行，一行戴頭巾，一行束雙髻，揮袖對舞，舞姿豪放；中段以身穿紅袍的張議潮為主體，白馬輕騎，威風凜凜，正欲縱馬過橋，前有將士護衛，後有僕從相隨，榜題為：「河西節度使檢校司空兼御史大夫張議潮統軍□除吐蕃收復河西一行圖」；後段主要是侍從、奴僕及子弟軍，最後以載用軍需的駱駝、馬匹、及狩獵隊為陣仗的結束畫面。畫中人物達兩百多身，十分宏偉壯觀。

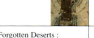

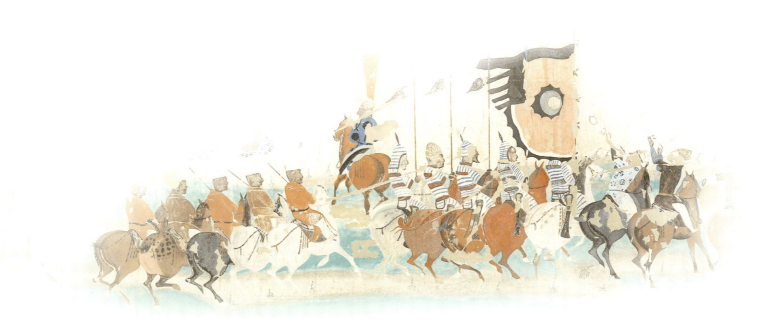

Cave no. 156 is a memorial cave built by Zhang Huaishen in memory of his uncle Zhang Yichao. The mural on the south wall and at the bottom of the south side of the east wall is divided into three sections. The prominent person at the center is Zhang Yichao. Before him troops and bands lead the way along the sides. At the front is the band in uniform clearing the way drums beating and horns blowing. Armored cavalries follow, and five pairs of non-military riders flank the musicians. Two carry big drums on their backs and two others beat drums from behind while the other members handle a pipa, flute, bili, clap board, harp, waist drum, sheng and hand drum. Four troupes of dancers appear in two rows, one wearing headgear and the other a double-bun coiffure; they dance vigorously between each other. The middle section centers on Zhang Yichao, a light-geared but lordly rider on a white steed, with guards in front and attendants behind, ready to cross the bridge. The cartouche reads: "*Commander of the Hexi Region and Censuor, General Zhang Yichao departs on the mission to eradicate the Tibetans and recover Hexi.*" The last section contains mostly attendants, servants and soldiers, followed by camels and horses laden with supplies, and concludes with a hunting party. The over two hundred figures in the painting make it magnificent.

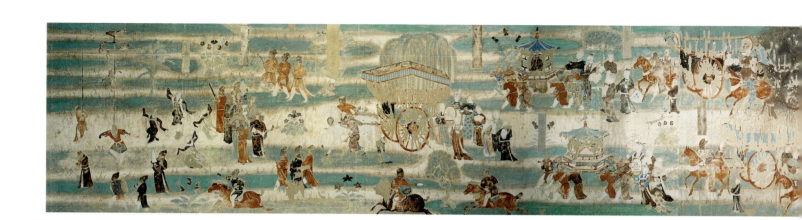

35
宋國夫人出行圖
莫高窟第156窟 北壁、東壁北側
晚唐
壁畫臨本
108.0×853.5 公分
臨摹者：史葦湘、蘭州藝院

Lady Song on an Outing
North Wall and North Section of East Wall, Cave No.156, Mogao Grottoes
Late Tang Dynasty
Copy, Wall Painting
108.0×853.5 cm
Copied by：Shi Weixiang, Lanzhou Art College

　　宋國夫人出行圖之榜題為：「宋國河內郡夫人宋氏出行圖」，即指張議潮夫人。此圖亦是人物眾多的巨幅繪畫，前導是歌舞與百戲的精彩表演，包括頂竿、長袖起舞、樂隊等好不熱鬧；緊接在後的是護衛、僕從、眷屬的豪華馬車、樓閣式的肩輿等，其間並穿插快馬加鞭的使者往來傳遞信息。中段是以宋國夫人為主體，夫人比畫中人物大且醒目，頭飾高髻，頂冠九釵，身披輕紗，白馬輕騎，左右各有侍女與馭手，充分展現出雍容華貴的氣度。畫面最後轉入東壁門北的部分，為龐大的馱運隊伍場面，馬、驢、駱駝等負重運輸，並有騎馬者看管之，與此同時，騎馬狩獵者正追逐前方奔跑的獵物。

　　宋國夫人出行圖的壁面位置與張議潮出行圖相對，後者肅穆森嚴、前者歡快輕鬆，可謂相得益彰的藝術表現。

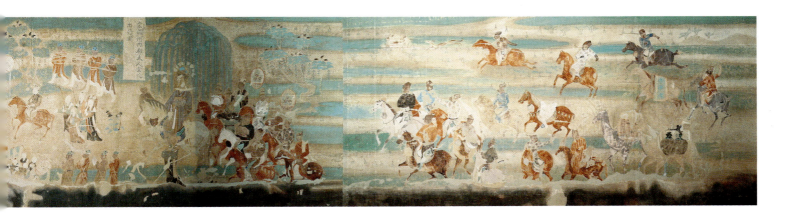

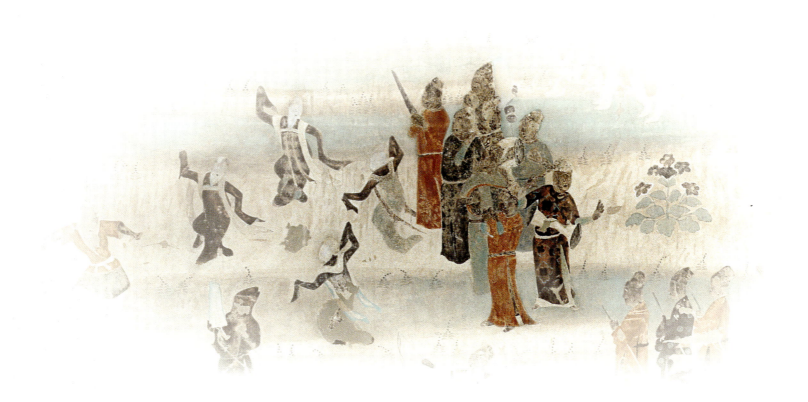

36
迎佛圖
莫高窟第323窟 南壁西側
初唐
壁畫臨本
78.0×107.0公分
臨摹者：李其瓊

本幅作品是描繪西晉時江南地區「石佛浮江」的故事。據《釋迦方志》記載，西晉建興元年（313）石佛在吳淞江口漂浮，漁夫以為是海神，乃延請巫祝迎接，結果引起更大風濤；道教徒則認為是道教始祖張天師，設醮壇迎接，結果風浪不減；後來吳縣佛教徒朱膺和東林寺僧、及佛教徒數人至江口稽首相迎，風浪才平靜，並發現佛像背面銘刻「維衛」、「迦葉」佛名，於是供奉於通玄寺。

畫面右邊可見一供壇，壇上六支三角旗幡飄揚，壇前有三人跪拜（此臨摹範圍至壇前一人為止），榜題為「石佛浮江天下希／瑞(請)□□□謂□／道來降章醮迎之／數旬不獲而歸」；表示當初石佛現於江上，道士以設醮迎接卻不成功的場景。畫面中央的一艘船中，兩尊石佛巍然而立，船上另有僧俗數人迎請護駕，前後船夫正撐槳而行，而江畔兩旁遠近信徒或合掌觀望、或跪拜禮迎，其中一婦人攜子乘牛而來，手上持花遠遠供養，場面顯得十分生動，榜題為：「靈應所之不在人事有／信佛法者以為佛降／風波遂靜迎送向通／玄寺供養迄至于今」；表現佛教徒正迎佛入通玄寺的場景。而畫面左上方岸邊，有數位僧人朝左凝望，則描繪迎請佛入通玄寺供奉的景象。

Welcoming the Buddha
West Section of South Wall, Cave No.323, Mogao Grottoes
Early Tang Dynasty
Copy, Wall Painting
78.0×107.0 cm
Copied by：Li Qiqiong

This is a depiction of the "Floating Stone Buddhas" story that took place south of the Yangtze River during the Western Jin Dynasty. According to "Śākya Chronicle," in the 1st Year of the Qianxing Reign of the Western Jin Dynasty, two stone buddhas were found floating at the Wusung River delta. The fishermen took them from the sea gods and called in shamans to welcome them. Nevertheless, it merely resulted in stronger winds and rougher waves. Taoists thought they were the founder of Daoism, the Heavenly Teacher Zhang, and set up the altar to greet him. The stormy waters remained unappeased. It wasn't until a Buddhist believer from Wu County in Zhu Ying, the monks from the Donglin Temple and other Buddhists came and bowed to bid welcome, did the winds and waves finally calm down. On the backs of the statues they discovered two carved Buddha names: "Weiwei" (Vipasyin) and "Jiaye" (Kaśyapa). Consequently the Buddhas were enshrined at the Tongxuan Temple.

On the right side of the painting is an altar with six triangular pennants fluttering on top. Three people kneel in front (the reproduction includes only the one closest to the altar.) The cartouche reads: "*It's rare to see stone Buddhas floating on the river. The Taoist monks were invited to perform a ritual to welcome the Buddhas. A long time went by but the ritual was to no avail. They therefore left.*" This means that the Taoist monks' ritual to coax the Buddhas to appear was to no avail. At the center of the picture two stone Buddhas stand tall on a boat on which there are also Buddhist monks and laymen to welcome and escort the statues. Boatmen both at the prow and the stern steer the vessel. On the two banks far and near, believers are either in prayer mudra watching or kneel to greet them. One woman and her child arrive on a cow; in her hand are flowers to pay her respects. The scene is very vivid. The inscription reads, "*The presence of the spirit is unrelated to secular affairs. Buddhists believe it is an appearance of the Buddha. After the storm, people swarm to pay respects. The icons continue to be worshipped at the Dongxuan temple today.*" This indicates that Buddhist devotees are in the process of devoted worship of the Buddha at the Tongxuan Temple. Further on the upper left side of the painting on the upper bank, several monks look left and they too are depicted paying their respects to the Buddha at the Tongxuan Temple in a similar scene.

37
彌勒經變之嫁娶圖
莫高窟第445窟 北壁
盛唐
壁畫臨本
56.0×68.5 公分
臨摹者：李其瓊

本作品是臨摹自彌勒經變中繪於中央下部左側的「女人年五百歲，爾乃行嫁」的場景。畫面上可見屋外空地搭起帷幕屏風，作為婚禮的會場，其中賓客區已高朋滿座，正聚精會神觀看場內的樂舞表演；屏風前是五人樂隊伴奏，一人中央獨舞、長袖正甩於頭頂；畫面右側新郎向賓客伏地行禮，髮髻高梳的新娘則在伴娘的簇擁下立於旁側，為當時婚禮「男拜、女不拜」的習俗；於此同時，場內侍者忙碌來去，場外屏風間還有人伸頭窺探，充分描繪出生動的現場。

根據唐段成式《酉陽雜俎》一書記載：「北朝婚禮，青布幔為屋，在門內外，謂之青廬，於此交拜…」、「拜閣日婦家親賓婦女畢集…」，所述與壁畫相仿，實為當時風俗情狀的縮影，為瞭解民俗的重要圖解。

The Wedding Scene Adapted from the Maitreya Sūtra Illustration
North Wall, Cave No.445, Mogao Grottoes
High Tang Dynasty
Copy, Wall Painting
56.0×68.5 cm
Copied by：Li Qiqiong

This piece is a reproduction of the "Woman Marrying at the Age of Five Hundred" adapted from the Maitreya Sūtra on the bottom central left section of the wall. In the picture, tents and partitions are erected outdoors for the wedding. The guest section is already filled up with invitees completely attracted to the entertainment. A five-piece band plays in front of the partition, while at the center a solo dancer performs, long sleeves over head. On the right, the groom expresses his gratitude in prostration to the guests. His bride, hair combed into a high bun and accompanied by her best maids, stands alongside. This concurs with the Tang custom of "only the male performs the courtesy, not the female." At the same time, waiters are busy inside and out. There is even a person peeking in from outside the partition. The whole scene is animated with action.

Tang Dynasty Duan Chengshi's Youyang Zazu records, *"Blue drapes are pitched up outdoors, called the blue house, for the wedding ceremony during Northern Dynasties..."* and *"All the female members from the bride's family attend the ceremony on the wedding day..."* Both descriptions coincide with the mural scene. They are consistent with medieval customs. This is an important pictorial reference for understanding the folk practices of that period.

38
觀音菩薩圖
晚唐
絹畫臨本
74.5×55.0 公分
臨摹者：李開福

Avalokiteśvara Bodhisattva
Tang Dynasty, 2nd Half of the 9th Century A.D.
Ink and Colors on Silk
74.5×55.0 cm
Copied by：Li Kaifu

　　表現在畫面正中央的觀音，繪以立姿形貌，身形巨大，面頰圓長，耳廓長大，細眉、長目，唇部上下繪有細微髭髯，神情莊重；身體厚實，胸廓的處理也呈現出飽滿的視覺感受，雙肩圓潤，腰身側邊略扭，右手上舉持淨瓶、左手下垂顯得臂長。整體而言，由於頂戴上的化佛與裝飾而顯得頭部比例拉長；菩薩身形對照拉長的上半身而使得整體顯得比例較短，具有一種壓縮感。
　　兩側頭梳雙髻的男童與及肩外擴兩髻的女童，皆面朝觀音，一人雙手合十、一人執花供養，顯示出對菩薩的尊崇。而在背景的部分，菩薩周圍飾以花葉，這些柔軟伸展的枝脈，不但有裝飾的功能，且與頭光旁蜷曲的雲氣及菩薩身上彎曲的飄帶，形成優美的呼應。
　　本絹原圖部分因經緯殘脫而致損壞，此件臨摹作品亦如實呈現出殘損現況，可見臨摹者仿真的繪畫功力。（原作品收藏於大英博物館，S. 21）

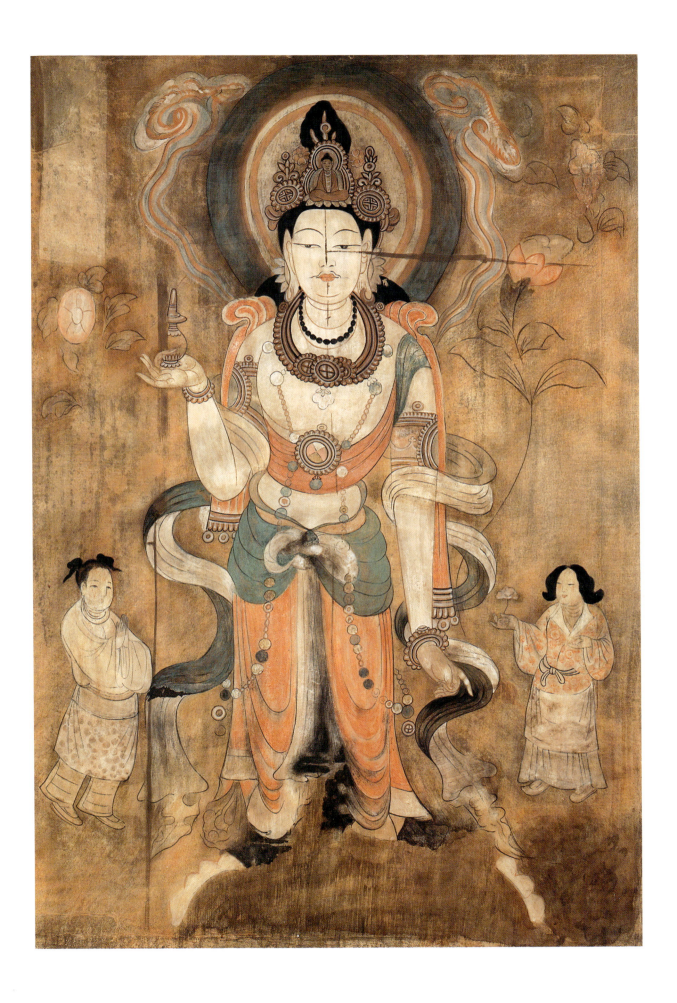

39
十一面觀音、地藏十王圖
五代
絹畫臨本
138.5×75.0 公分
臨摹者：邵宏江

Eleven-Headed Avalokiteśvara and Kṣitigarbha and the Ten Kings of Hell
Five Dynasties
Ink and Colors on Silk
138.5×75.0 cm
Copied by：Sao Hongjiang

　　地藏及十王所組成的地藏十王圖，是晚唐以來常見的題材之一，但是在地藏旁增繪十一面觀音者，是較少見的組合。

　　十一面觀音頂上有兩層小面、兩側兩面，共十一面，但加上本尊則成十二面；身有六臂，上二臂高舉，左手托日（三足鳥）、右手托月（月桂樹）；第二手在胸前位置，左手持火焰寶珠、右手捻楊柳枝；最下二臂於雙腿的附近，左手撫膝、右手持淨瓶。而地藏菩薩左手舉托火焰寶珠、右手持錫杖，身著袈裟，頭頂上則是披帽的造型。除了十一面觀音的背光較為繁複外，兩菩薩有許多相似處，例如上方寶蓋處皆有吹樂或捧供的飛天翩翩起舞、皆有S型頭光，且頭光與背光最外圍皆呈火焰形、皆結跏趺坐於大朵寶蓮臺上。或許是臨摹者關注於十一面觀音與地藏的形象，因此原件中尚有道明和尚與化現為金毛獅子的文殊菩薩等皆不得見。

（原作品收藏於吉美博物館，P. 3644）

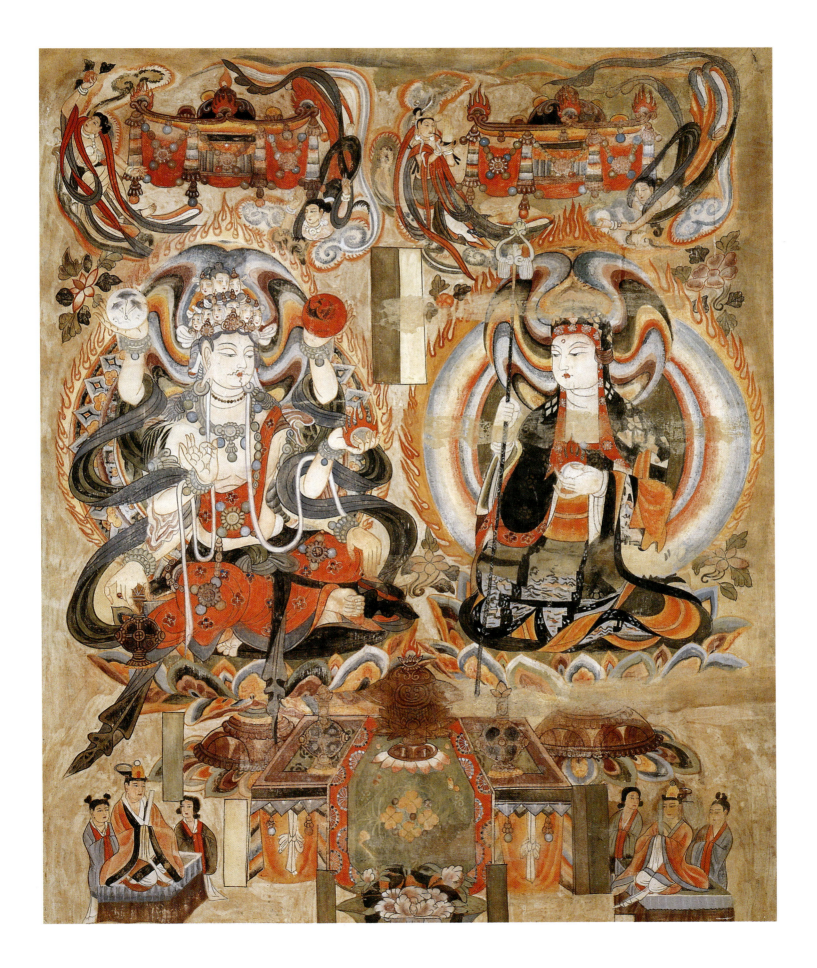

40
引路菩薩圖
五代
絹畫臨本
84.8×54.7 公分
臨摹者：婁婕

為接往生者前往西方淨土的引路菩薩，在敦煌藏經洞出土多幅，表現型態亦大致相同。

此幅引路菩薩左手執長柄香爐，爐上香煙氤氳；右手握長柄杆，頂端有鉤繫縛長幡，幡首的三角造型和幡身上的幡手、幡腳，與今莫高窟所出土的絹幡造型相仿。菩薩面龐圓潤，眉、眼、與唇的勾勒方式充滿女性溫柔的氣質，足踏蓮花乘雲而行，以幡招引身後的亡者。此幅亡者為一貴婦，面容小巧而精緻，身著華麗團花的寬袖長袍與披巾，雙手合袖跟隨引路菩薩前行，充滿沈靜恬美的氣質。

上方規律的橫線中整齊交錯穿插著建築物，為菩薩引領亡者前往的淨土。關於淨土的表現，在此次來展的法藏引路菩薩圖（圖錄號75）中，將建築物繪於雲霧掩映中，是較自然的呈現方式，此圖則略具裝飾性、而非意義性。（原作品收藏於大英博物館，S. 46）

Bodhisattva as Guide of Souls
Five Dynasties
Ink and Colors on Silk
84.8×54.7 cm
Copied by：Lou Jie

Many portraits of the Soul-guiding Bodhisattva, who leads the deceased to the Western Pure Land, were unearthed in the sutra cave in Dunhuang. The styles are more or less the same.

This one holds a long-handled incense burner from which smoke rises in his left hand. His right hand carries a long pole with a hook at the end to which a long banner is attached. The triangular portion at the head and the streamers extending from the main body are similar to the banners unearthed in the Mogao Grottoes. The roundedness of the face of the Bodhisattva and the lines of the brows, eyes and lips display a tender feminine quality. With the feet on lotuses, the Bodhisattva rides a cloud and guides the following deceased with the banner. The deceased appears to be an elite lady with delicate features, wearing a luxuriant long robe with loose sleeves and circular floral patterns and a shawl. Peacefully she follows the Bodhisattva with hands in prayer inside her sleeves.

The buildings amidst the regular lines at the top symbolize the Pure Land where the Bodhisattva is taking the deceased. Among the Buddhist treasures on exhibit, the buildings, half-hidden behind clouds in the Soul-guiding Bodhisattva (Cat. no. 75) are a more natural presentation. In this one, they are slightly decorative. (The original is in the collection of the British Museum.)

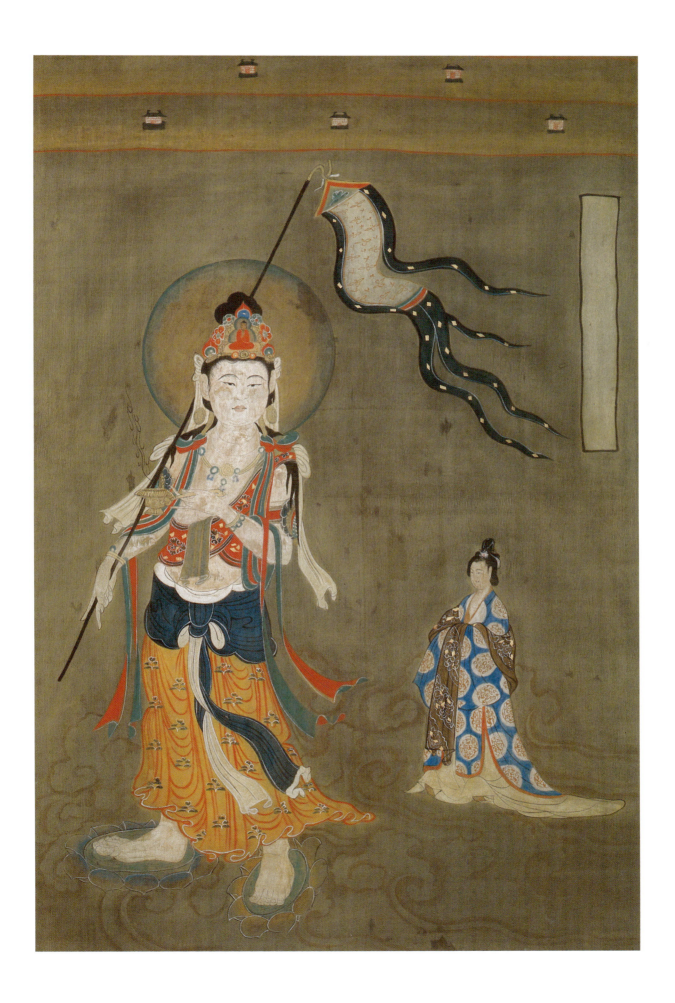

41
不空羂索觀音圖
北宋
絹畫臨本
84.0×64.5 公分
臨摹者：邵宏江

Amoghapāśa Avalokitaśvara
Northern Song Dynasty
Ink and Colors on Silk
84.0×64.5 cm
Copied by：Sao Hongjiang

　　一面八臂、頂戴化佛的不空羂索觀音，結跏趺座於蓮花上，左肩披著四個小白點一組的黑色鹿皮，主要雙手於胸前持有蓮花，其餘各手分持不同物，包括短頸水瓶、如意寶珠、長頸水瓶、「卍」字寶印、羂索等。

　　不空羂索觀音頭光之上有寶樹圍繞的傘蓋，其間綴以盛開的寶花，寶花沿著背光纏繞一圈，除了具有裝飾效果外，也突顯出主尊的印象。主尊兩側有眷屬或侍者，呈現左右相對的型態，最上方為天王，接著是僧人形貌的佛陀弟子，其下三層各一供養菩薩。而在最下方則為供養人，左邊二男子戴幞頭冠，右側二女子長髮釵鬢，皆呈現黑服、跪坐貌。本圖為圖錄號69之臨摹本。（原作品收藏於吉美博物館，P. 23076）

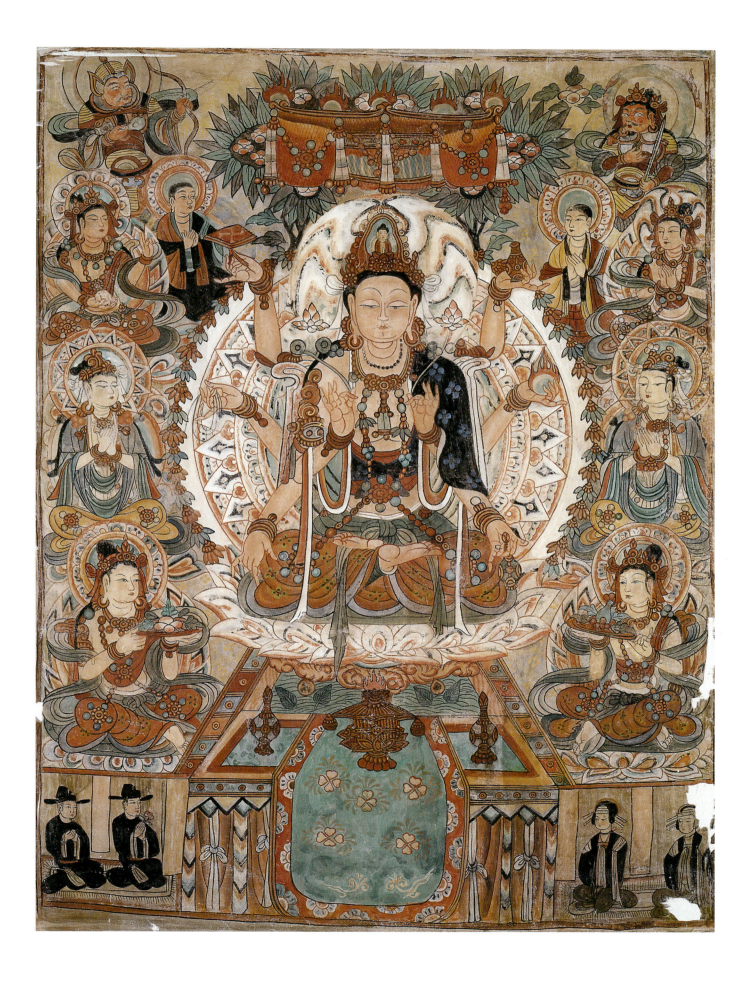

42
北涼石塔
北涼
文物
高98.0公分
Z. 1111

Stone Stūpa
Northern Liang Dynasty
Cultural Object
H. 98.0 cm

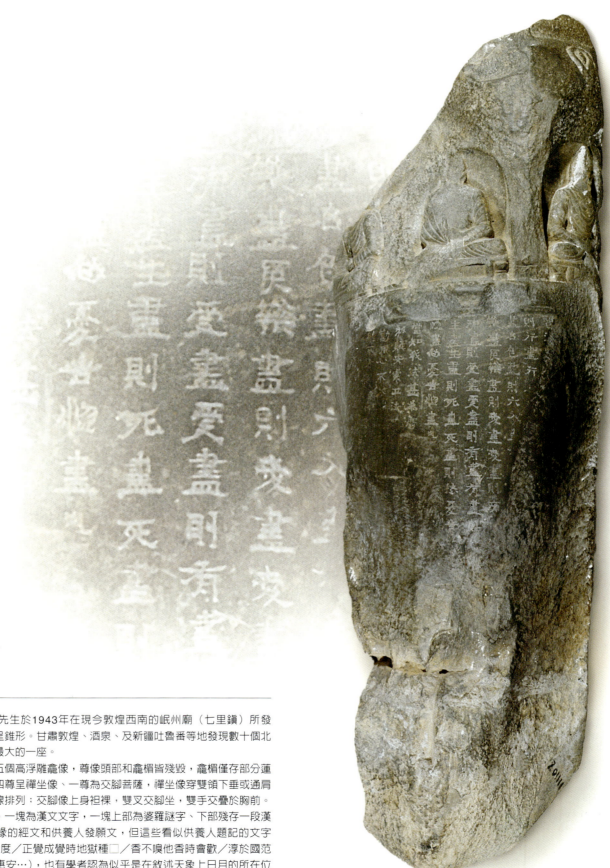

　　此石塔為向達先生於1943年在現今敦煌西南的岷州廟（七里鎮）所發現，底部塔基殘存呈錐形。甘肅敦煌、酒泉、及新疆吐魯番等地發現數十個北涼石塔，此為其中最大的一座。

　　石塔上端尚存五個高浮雕龕像，尊像頭部和龕楣皆殘毀，龕楣僅存部分蓮瓣紋飾，龕內造像四尊呈禪坐像、一尊為交腳菩薩，禪坐像穿雙領下垂或通肩袈裟，衣紋成橫弧線排列；交腳像上身袒裸，雙叉交腳坐，雙手交疊於胸前。塔腹殘存兩塊文字，一塊為漢文文字，一塊上部為婆羅謎字、下部殘存一段漢文，為說明十二因緣的經文和供養人發願文，但這些看似供養人題記的文字（日在角七月在角七度／正覺成覺時地獄種□／香不嗅他香時會歡／淳於國范始嚴□／□郭倫馬惠安…），也有學者認為似乎是在敘述天象上日月的所在位置。

　　從龕內造像的衣著形式、以及石塔的整體造形而言，與酒泉所發現北涼太緣二年（436）的程段兒塔近似，本石塔應為五世紀前半的作品。

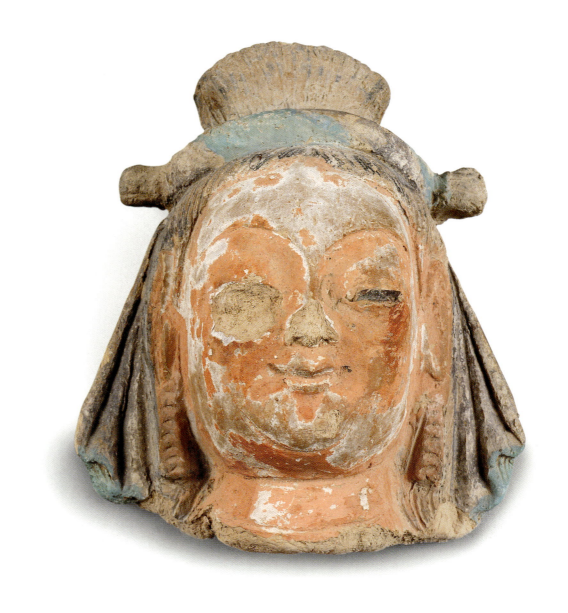

43
菩薩頭像
唐
文物
22.0×16.0×15.0 公分
Z. 0740

Bodhisattva Head
Tang Dynasty
Cultural Object
22.0×16.0×15.0 cm

　　1910年道士王圓籙將窟內殘損的塑像集中在莫高窟東岸的千相塔，1951年清理千相塔時，此像與其他多尊塑像一起被發現。

　　此件菩薩頭部多處泥皮剝落，眼鼻處殘損尤甚。菩薩頂梳高髻，額髮中分，髮絲以陰刻紋線整齊排列，兩側髮垂及肩。此菩薩頭像面龐寬圓，些微剝落的鼻處，可見玲瓏的鼻形塑造；鼻翼之上，兩道圓弧連接處直落鼻樑，以陰刻刀畫而形成圓弧的柳葉眉；唇型小巧強調上揚的嘴角。此菩薩面部有兩個特色，一是五官較為集中，特別是口鼻貼近的形塑；一為面龐較為扁平，這點可由眉骨與眼窩間僅輕微起伏、及面頰由正面轉至側面的骨架無法明顯區隔出邊線，使得此菩薩雖由其下巴處而得知面頰應有的幅員，視覺上卻顯出正面側面融混在一起的豐頤，為早期塑像的珍貴遺存。

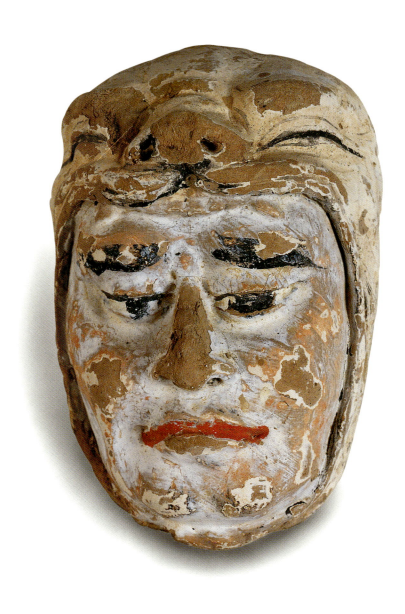

44
力士頭部
唐
文物
10.0×7.5×6.5 公分
Z. 0713

Head of Vajrapāṇibalin
Tang Dynasty
Cultural Object
10.0×7.5×6.5 cm

　　此件力士面形較長，雖多斑剝，但特徵依然明顯，頂上披有虎皮，虎眼緊閉，鼻端朝上，虎口處咧開覆蓋力士額際、沿著面龐雙耳至頸上，是仿造當時戰將的裝束。根據《舊唐書》〈吐蕃列傳〉，吐蕃中軍出其不意襲擊時，便著「虎豹衣」的裝束—敦煌中唐時期適值吐蕃佔領，或與此有些關連。

　　力士在佛教中的性格是具有威嚇色彩的護法神，然此力士在形塑之初並沒有誇張憤怒的表情，而是塑繪出較為凝重的神情；至於捍衛的意象，或許以頂所披戴的虎皮來連結宛如戰士的剽悍標誌。據悉吐蕃民族的虎崇拜和吐蕃王朝的大蟲皮制度有著密切的關係，而此件力士圖像特徵的實例，對於研究吐蕃大蟲皮制度有重要的參考價值。

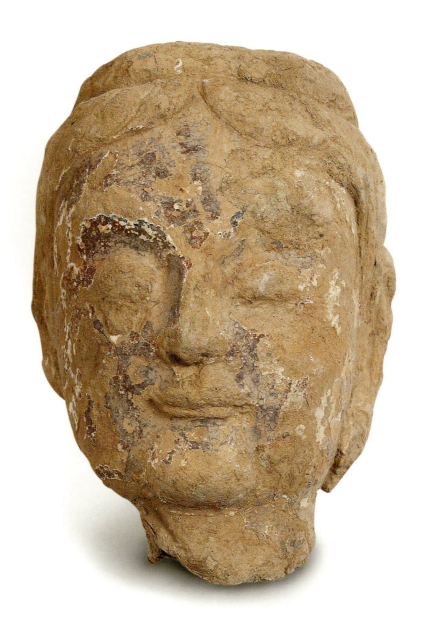

45
菩薩頭部
唐
文物
22.0×16.0×15.0 公分
Z. 0081

Head of Bodhisattva
Tang Dynasty
Cultural Object
22.0×16.0×15.0 cm

　　此件菩薩頭像彩繪部分殘脫嚴重，但面容型態大抵完整，仍可見其時代風格。菩薩面龐頤圓，依稀可見眉骨部分微微隆起，雙眉並非北魏以線刻的方式刀形出細眉、而是在泥塑時直接造形出自然弧度，眼窩殘部亦可見稍稍鼓突；眉眼至鼻樑處呈現出自然的連接，鼻翼玲瓏傳神；唇部輕薄短小，下唇邊緣作立體的處理，呈現出唇吻至下顎間細微的肌肉起伏，在唇部下接連頷部的部分亦可見到十分擬真的處理手法，這種掌握能力也同時表現在雙頰處，由正面至側面的自然角度，成功地拿捏容顏的擬真程度。

　　總體而言，此件菩薩頭像整體形塑手法嫻熟，面容生動逼真，傳神地表達出彿若「人」的面容，依其風格推測，似為初唐時期的作品。

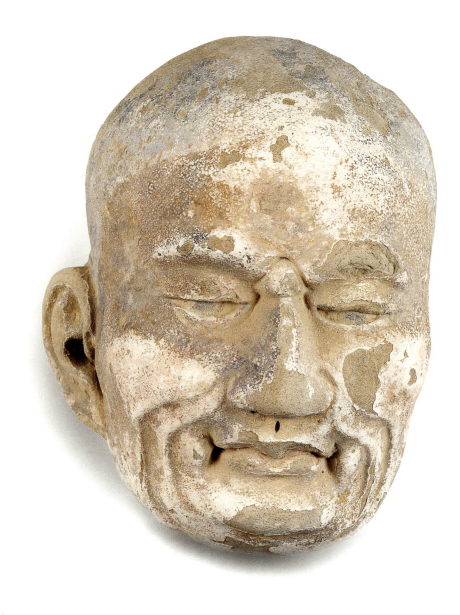

46
涅槃聖眾像頭部
唐
文物
18.0×13.5×14.5 公分
Z. 0080

Head of the Ārya in Nirvāṇa Scene
(Mahā-kaśyapa)
Tang Dynasty
Cultural Object
18.0×13.5×14.5 cm

　　此件頭像呈現出剃髮露頂的僧人形貌，眉頭深鎖，低垂的眼簾、緊抿的雙唇、深陷的嘴角，試圖傳達出哀戚心情；下頷嘴角旁一道道深刻的法令紋、呼應著上額雙眉間深深縐摺的鎖結，推測此件頭像或為佛陀涅槃時圍侍在側的聖眾像之一的大弟子迦葉尊者。此尊像面貌的形塑，顯現出內心的狀態為目的，這是此件塑像的最大特點；而其僧人形象，則似乎更能貼近真實「人」的性格。

　　此尊像雖色彩脫落，但保存狀況良好，特別是左眼上端、右耳廓內、及面頰處時有金色散落，依稀可揣度唐時代塑像彩繪中閃耀的貼金敷彩。

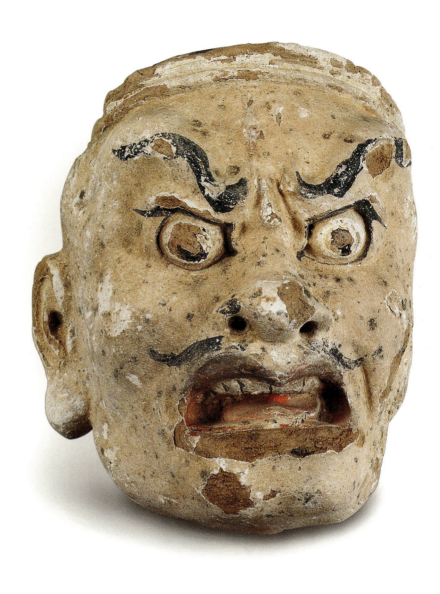

47
力士頭部
唐
文物
11.5×9.0×8.5 公分
Z. 0712

Head of Vajrapāṇibalin
Tang Dynasty
Cultural Object
11.5×9.0×8.5 cm

　　力士作為佛教護法神的地位，職司決定了其威武的性格，多呈現憤怒狀，以帶有嚇阻意味的姿態，表達出守護的精神。此力士頭像最大的特色在其生動的面部表情，特別是以立體球狀形塑出大睜的圓眼、以生動的線條勾勒出高高挑起的眉毛、以及種種形象逼真的表情面貌：怒蹙的眉頭、圓扁外張的大鼻、剛開露出牙舌的大嘴、以及唇邊怒張翹起的鬚髯等，成功地以誇張激烈的筋肉起伏，來傳達出力士的嗔面表情形象。

　　此頭像遺留了較多的彩繪，包括唇部的紅色，加強嘴角下拉的線條；眼眶四周的墨線，擴大眼部圓睜的表情；而最強調的莫過於眉毛的部分，上眼線繪出上挑的線條，而與之平行的眉毛則做出更誇張處理，焦點因此不得不聚集於此，由此可說明彩繪對於塑像立體效果的增進。

　　敦煌彩塑於造形時多使用摻有麥藁的粗土，然後附上混有麻布的中土，最上一層再裹以較為細緻的表土；此像下唇處有一片泥皮殘脫，顯示最後一層塗敷的細緻程度，由其殘處見諸製作的層次。

48
多臂菩薩立像
西夏
文物
124.0×36.0 公分
Z. 1095

Woodblock Standing Image of Many Armed Bodhisattva
Western Xia Kingdom
Cultural Object
124.0×36.0 cm

　　西方探險紀錄中提及，敦煌莫高窟的窟前木造殿堂中，曾發現為數不少的木雕佛像遺品—此件即為其中較大型之一例，自頭、身、至底部臺座一體雕刻成形。

　　菩薩面部因殘損而不能窺其面貌，手部也殘餘左右不一的數量，唯身上雕刻仍可見其形貌。菩薩胸前是一大串的瓔珞，從肩際開始、直達膝部，而在胸前交叉貫穿，貫穿處紐有一蝴蝶結，呈現出X字型的裝飾型態，是晚唐以後常見的菩薩形象。而此菩薩的左肩在斑駁中依稀可見披有殘損的鹿皮披肩—此乃一般作為瞭解不空羂索觀音的特徵；而由風格觀之，推測此木雕菩薩可能為晚唐到五代間的造像。

From the Forgotten Deserts:
Centuries of Dazzling Dunhuang Art | **285**

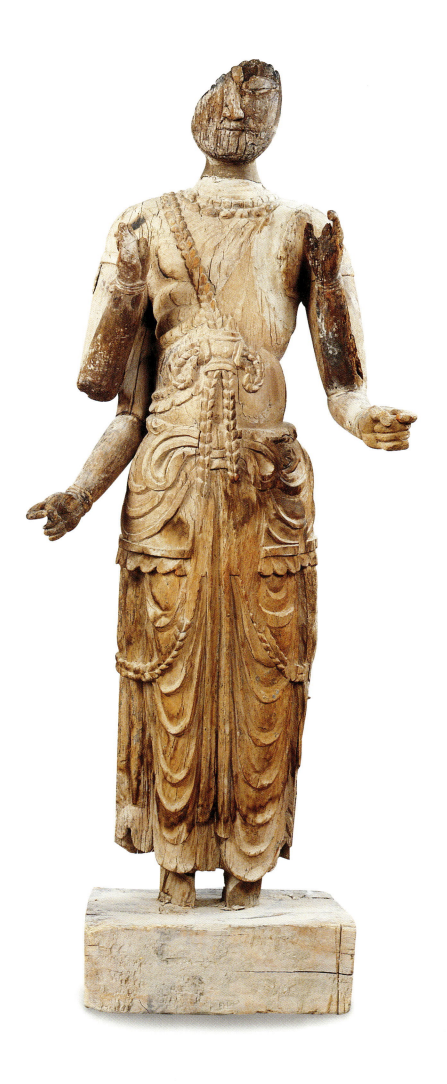

49
法華經變化城喻品
北朝
文物
24.5×66.0 公分
D. 251

Chapter on the "Parable of the City of Illusions," Lotus Sūtra
Northern Dynasties
Cultural Object
24.5×66.0 cm

藏經洞所發現的敦煌遺書中，大量的卷子都是佛教文書，最早的是前秦甘露元年（359）的《譬喻經》，最晚的是宋咸平五年（1002）的《大般若波羅蜜多經》，時間跨度長達七個世紀；其中以《法華經》最為常見。

此《妙法蓮華經》〈化城喻品〉寫經目前僅存四十行，一行字數從十九至二十四字皆有，字數多寡不一，首行經文之始為「復如是。爾時上方五百萬億國土諸大梵王皆悉自」；末行則止於「說是法時，六百萬億那由他人以不受一切法故，而於」，首尾殘缺的情況非常明顯。此寫經紙以淡墨色為欄界，黃紙上是墨色隸書體，紙質較厚，有單抄雙曬的痕跡。所謂單抄雙曬是古代製紙的方法之一，乃將紙漿抄出時趁濕疊在一起，兩層重曬而成。此種方法製成的紙質纖維較細緻，表面光澤、背面粗糙，適合用來繕寫經文。

此件寫經倒數第六行為「十二因緣」的部分，可以看到重複經文的繕寫方式，經文中原為「無明緣行，行緣識，識緣名色，名色緣六入，六入緣觸，觸緣受，受緣愛，愛緣取，取緣有，有緣生，生緣老死憂悲苦惱…」亦即上一句之尾與下一句之首為相同者，在此寫經上直接以「、」代替重複的經文，以減省紙張空間。

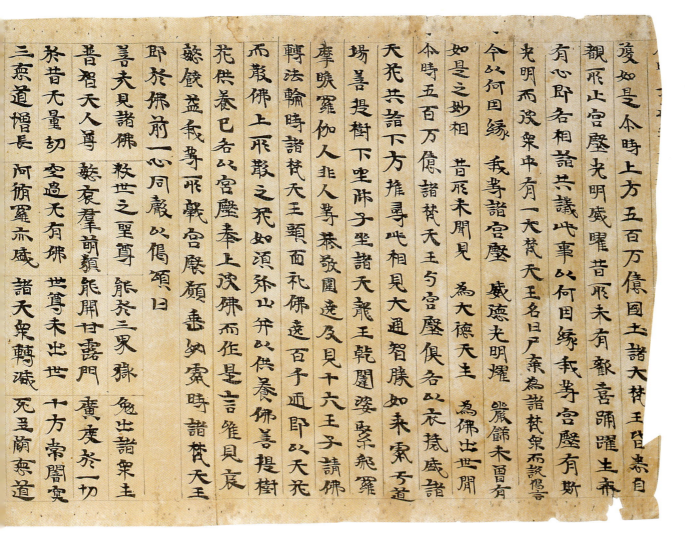

Most of the scrolls found in the sūtra cave are Buddhist texts. The earliest is the a sutra from the 1st year of ganlu in Former Jin (359A.D.). The latest is Mahāprajñāpāramitā Sūtra from the 5th year of xianping in Song Dynasty (1002 A.D.). The time span represented by these two manuscripts is almost seven hundred years. The Lotus Sūtra was the most common text found in the sūtra cave.

Only forty lines have remained from this scene of the "Parable of the Phantom City." There are nineteen to twenty-four characters to a line. The text begins with this way an except from the sūtra is provided. The beginning and the end of the text have been severely damaged. The dividing column lines were drawn in light ink. The characters are written in ink in clerical style on yellowish paper which is rather thick and carries traces of double sunning – an ancient paper technique which involves overlapping two layers of wet paper pulp to sun-dry and creating the paper with finer fibers. The result is a glossy recto and a coarse verso – ideal for scripture copying.

The twelve avadanas appear from the sixth line of the end of this manuscript. In this section we can see how scribes dealt with repetitive characters in transcribing a text. The text originally reads: "Avidyā results in samskāra, samskāra results in vijñāna, vijñāna results in nāma-rūpa, nāma-rūpa results in sad-āvatana, sad-āvatana results in sparśa, sparśa results in vedanā, vedanā results in tṛṣṇā, tṛṣṇā results in upādāna, upādāna results in bhava, bhava results in jāti, jāti results in jarā-maraṇa..." In the event that the character at the end of the last phrase is the same as the one at the beginning of the next phrase, the repeated character would be substituted by a " 、 " in the transcript, in order to save space.

50
法華經序品・方便品
唐
文物
843.0×23.0 公分
D. 0285

Chapter on Expedient Means, Lotus Sūtra
Tang Dynasty
Cultural Object
843.0×23.0 cm

　　晚唐及五代歸義軍時期，敦煌佛教日益世俗化，民間信仰與抄寫佛經的活動極為頻繁，敦煌藏經洞所發現的大量佛經多屬此時期，反映此時佛教發展的盛況。

　　此件寫經的內容為《妙法蓮華經》〈序品〉第一、及〈方便品〉第二，首尾完整，保存良好，卷首前端另紙裱裼包首，包首前端附有絲帶，方便捲收寫經，為橫展舒捲閱讀的手卷型態。此件寫經字跡優美，採深藍色用紙，配以銀色為欄界，書以金泥字體，輝映出對比強烈的璀璨色彩。事實上此種以金泥、銀泥、或金銀泥交互書寫於顏色濃重用紙（絹）上，為後代寫經廣泛採用的書寫手法。

　　根據敦煌遺書中《法華經》的研究顯示，唐王朝頒賜到敦煌的至少應有十部，而此件寫經為敦煌藏經洞發現之金泥寫經文獻中，評價最高的一件作品，推測應為宮廷寫經。

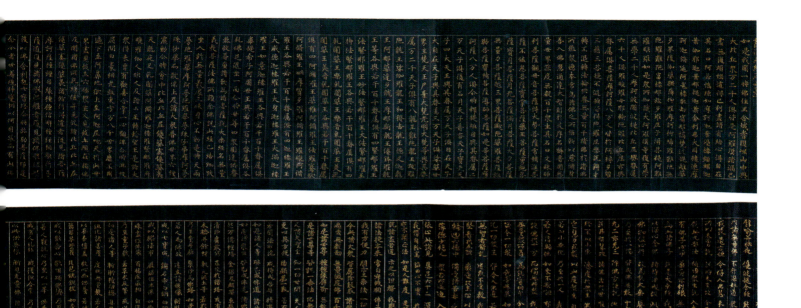

51
法華經方便品
唐
文物
前 25.3×96.0 公分, 後 25.6×128.3 公分
D. 269, D. 287

Chapter on Expedient Means, Lotus Sūtra
Tang Dynasty
Cultural Object
Front 25.3×96.0, Rear 25.6×128.3 cm

　　經過黃檗汁浸漬過的寫經紙其優點，是紙質瑩澈透明、質地堅韌，摹寫時不會污染範本，亦能防蟲蛀等害，適用於抄寫經典。

　　此件為黃檗所染的濃厚黃色寫經一紙為四十八公分、二十八行，一行則從16到18字不等，現存共一百二十三行經文；首尾有所欠缺，現所見者乃由兩件不同的編號經卷經辨識合綴而成，目前其中一紙有所殘損、後四紙則保存完好。首行經文之始為「…以何者…」；而末行則止於「辟之佛者。不聞不知。諸佛如來」，與現今流通的《大正新修大藏經》相校對，發現一字不差，確為《妙法蓮華經》〈方便品〉。此件寫經的墨色濃重，結構嚴謹，字體秀麗；且由與此件書體風格接近、又有明確題記時間的其他件寫經相較，推測此件寫經可能是初唐的宮廷寫經。

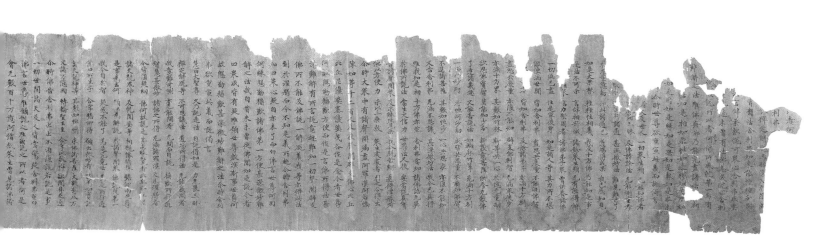

52
法華經普賢菩薩勸發品
唐
文物
198.0×26.1 公分
D. 0674

Viśvabbadra Bodhisattva Chapter, Lotus Sūtra
Tang Dynasty
Cultural Object
198.0×26.1 cm

　　此件經文首尾俱全，首行經文始於「妙法蓮華經普賢勸發品第二十八」，末行則止於「妙法蓮華經卷第七」，可以確知為《法華經》的抄寫；而在末行標明經名、卷數之後，尚有一行字：「天寶十五載八月廿日扈十娘為亡父母寫」，由此得知此經的謄寫時間、寫經人、及其為已往生的父母祈福而抄寫的目的；此外，在末行邊押方形紅印「敦煌縣政府印」一枚，可提供進一步研究當時印刷體制的重要線索。

　　此件寫經以細淡烏絲欄線為欄界，共有一百零三行，每行維持十七字，少數為十八字；墨色濃重烏黑，楷書字體工整，章法得宜，分佈均勻，行筆遒麗雄逸，是唐代寫經書體的代表作之一，特別是有明確的天寶紀年，對於寫卷的時代風格判定有不斐的研究價值。

妙法蓮華經普賢菩薩勸發品

爾時普賢菩薩白佛言世尊於後五百歲濁惡世中其有受持是經典者我當守護除其衰患令得安隱使無伺求得其便者若魔若魔子若魔女若魔民若為魔所著者若夜叉若羅剎若鳩槃茶若毘舍闍若吉遮若富單那若韋陀羅等諸惱人者皆不得便是人若行若立讀誦此經我爾時乘六牙白象王與大菩薩眾俱詣其所而自現身供養守護安慰其心亦為供養法華經故是人若坐思惟此經爾時我復乘白象王現其人前其人若於法華經有所忘失一句一偈我當教之與共讀誦還令通利爾時受持讀誦法華經者得見我身甚大歡喜轉復精進以見我故即得三昧及陀羅尼名為旋陀羅尼百千萬億旋陀羅尼法音方便陀羅尼得如是等陀羅尼世尊若後世後五百歲濁惡世中比丘比丘尼優婆塞優婆夷求索者受持者讀誦者書寫者欲修習是法華經於三七日中應一心精進滿三七日已我當乘六牙白象與無量菩薩而自圍繞以一切眾生所憙見身現其人前而為說法示教利喜亦復與其陀羅尼呪得是陀羅尼故無有非人能破壞者亦不為女人之所惑亂我身亦自常護是人唯願世尊聽我說此陀羅尼呪即於佛前而說呪曰

阿檀地 檀陀婆地 檀陀婆帝 檀陀鳩舍隸 檀陀修陀隸 修陀隸 修陀羅婆底 佛陀波羶禰 薩婆陀羅尼阿婆多尼 薩婆婆沙阿婆多尼 修阿婆多尼 僧伽婆履叉尼 僧伽涅伽陀尼 阿僧祇 僧伽波伽地 帝隸阿惰僧伽兜略 阿羅帝波羅帝 薩婆僧伽三摩地伽蘭地 薩婆達磨修波利剎帝 薩婆薩埵樓馱憍舍略阿㝹伽地 辛阿毘吉利地帝

世尊若有菩薩得聞是陀羅尼者當知普賢

神通之力若法華經行閻浮提有受持者應作此念皆是普賢威神之力若有受持讀誦正憶念解其義趣如說修行當知是人行普賢行於無量無邊諸佛所深種善根為諸如來手摩其頭若但書寫是人命終當生忉利天上是時八萬四千天女作眾伎樂而來迎之其人即著七寶冠於婇女中娛樂快樂何況受持讀誦正憶念解其義趣如說修行若有人受持讀誦解其義趣是人命終為千佛授手令不恐怖不墮惡趣即往兜率天上彌勒菩薩所彌勒菩薩有三十二相大菩薩眾所共圍繞有百千萬億天女眷屬而於中生有如是等功德利益是故智者應當一心自書若使人書受持讀誦正憶念如說修行世尊我今以神通力故守護是經於如來滅後閻浮提內廣令流布使不斷絕

爾時釋迦牟尼佛讚言善哉善哉普賢汝能護助是經令多所眾生安樂利益汝已成就不可思議功德深大慈悲從久遠來發阿耨多羅三藐三菩提意而能作是神通之誓守護是經我當以神通力守護能受持普賢菩薩名者普賢若有受持讀誦正憶念修習書寫是法華經者當知是人則見釋迦牟尼佛如從佛口聞此經典當知是人供養釋迦牟尼佛當知是人佛讚善哉當知是人為釋迦牟尼佛手摩其頭當知是人為釋迦牟尼佛衣之所覆如是之人不復貪著世樂不好外道經書亦

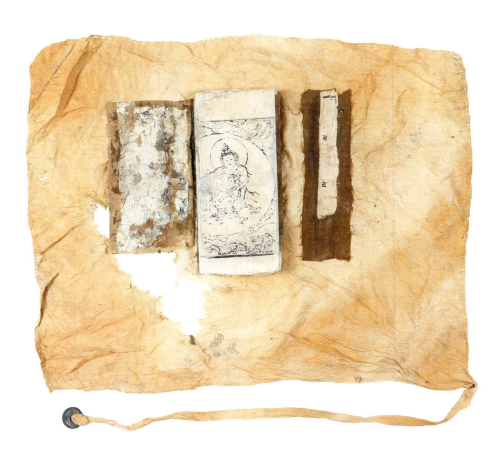

53
圖畫木刻本西夏本《觀音經》
西夏
文物
54頁,20.5×8.9公分
D. 0670

此件圖畫木刻本的《觀音經》為1959年3月在莫高窟宕泉河(大泉河)東岸的小型塔中發現。此《觀音經》為經摺裝的型態,整個經摺另包裹於40×50公分的方形色絹中,發現時色絹捆裹經摺的絹帶尾端尚結有一銅錢,為北宋元豐通寶時期所鑄。此作品內摺頁共計二百五十六行、二千四百二十三字。經文內頁是以上圖下文的方式製版印刷,上方四分之一空間圖畫為《妙法蓮華經》〈觀世音菩薩普門品〉中種種情節;其下四分之三空間則為小楷刻字的西夏經文,字體整齊規範。而扉頁繪刻一精美的水月觀音圖,木刻線條嫻熟流暢,觀音神態優美怡然,誠為不可多得的佳作。

據了解,西夏文的《法華經》成立於十二世紀前半。此作品中包括頁首的水月觀音,木刻的圖繪多達五十五幅,其中述及的人物高達一百六十六身之多,內容十分豐富。目前西夏文之觀世音菩薩〈普門品〉流傳並不多,此件作品為瞭解西夏版畫藝術與西夏文字的重要遺留。

Woodblock Carved Text, Avalokiteśvara Sūtra in Tangut (Western Xia) Language
Western Xia Kingdom
Cultural Object
54 pages, page leaf: 20.5×8.9 cm

This pictorial woodblock print of Avalokiteśvara Sūtra was discovered in the small tower on the east bank of the Dangquan River (also called Daquan River) at Mogao Grottoes in March 1959. The folding sūtra was wrapped in a 40x50cm piece of color silk. A silk string used to tie the scripture was attached to a coin minted in the Yuanfeng Reign of the North Sung Dynasty. The pages inside contain two thousand, four hundred and twenty-three Western Xia characters in two hundred and fifty-six lines. On every page, one-quarter of the space at the top is printed with a scene from the Avalokiteśvara Sūtra, and the neat and regular text takes up the lower three quarters. On the cover is a beautiful woodblock print of Guanyin (Avalokiteśvara) gazing at the moon over the water. The lines are smooth and skillfully drawn. Guanyin's expression exudes ease and elegance. A masterpiece like this is rare.

Accordingly, The Lotus Sūtra in the Western Xia language was completed in the first half of the twelfth century. This piece of artwork, including the Guanyin on the cover, contains more than fifty-five pictures in which there are as many as one hundred and sixty-six portraits. Not much of the Western Xia language has survived. These rich contents serve as an important heritage for the study of Western Xia woodblock printing and written language.

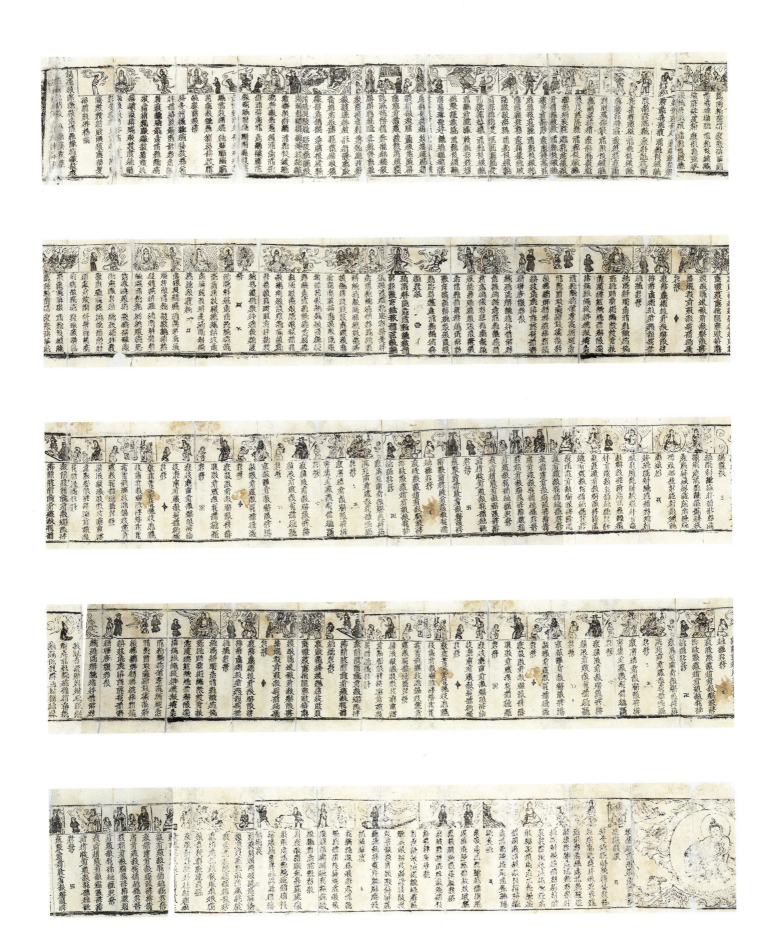

54
染纈絹幡
盛唐
文物
164.0×13.5 公分
Z. 0001

Dyed Silken Thread Banner
High Tang Dynasty
Cultural Object
164.0×13.5 cm

　　此幡為1965年莫高窟第130窟南壁壁畫表層下的岩孔中所發現。絹幡由三角幡首、六個花布綴成長條形幡身、及幡尾組成，首尾完整，保存良好。幡首為白色雙層印團花紋紗，鑲紅色絹邊，頂端幡緒為紫色平織絹；幡身由六片方格串接，綠、紫、黃色交錯排列，每格兩側綴以藍色的幡手，但現已殘失，僅剩下一點痕跡。

　　古代三纈是指蠟纈（蠟染）、絞纈（紮染）、與夾纈（鏤空防染），為我國古代三大染花技術。蠟染實際上是施蠟防染，先以蠟點繪花紋於織品上，再浸以染料，除蠟後現出因蠟防護的白色美麗紋樣，有單、複色兩種蠟染。幡身中黃色第三方格為蠟纈之雲頭花鳥紋為單色染，黃地上防染現出流雲、飛鳥、浮禽、花草等，描繪洗鍊，乃此中佳作。而綠、紫方格小圓點是以絞纈方式製作，有兩種方式，一種是單純以繩線紮束織物；一種是將小顆粒物包紮進織物內，然後浸染，此件即以此顯現出整齊的白點圖案。

　　唐代多樣的染織手法體現於此，細膩的圖案設計與和諧的色彩搭配，是莫高窟發現的絹幡中縫製最為細緻、色彩最鮮麗的一件。

55
綴花絹幡
盛唐
文物
78.0×9.5 公分
Z. 0002

Stitched Floral Silk Banner
High Tang Dynasty
Cultural Object
78.0×9.5 cm

　　此件絹幡亦為1965年發現於莫高窟第130窟南壁表層下岩孔中。綴花絹幡保存良好,整體幡形較小,三角形的幡首是以雙層白絹所縫製,幡身及幡尾則採用輕薄柔軟的深藍色絹製作,且其幡身與幡尾乃以同一塊絹分疊三段縫製成。全幡分佈黃色、淡紅色的八瓣花形,這些花形是由白絹經染、再裁減、縫綴至幡上。

　　事實上在敦煌莫高窟所出土的絹幡大致可以分為兩類:一類是藏經洞所發現彩繪的絹幡和幡蓋,這些是寺院所有,為裝飾佛教殿堂中的莊嚴佛國世界之用;另一類如第130窟所出土的絹幡,是一般民間信徒祈願、招福而獻予佛堂的供物—此為展現民間信仰面貌的實物。

56
拓印聯珠對禽紋幡首
盛唐
文物
13.0×8.0 公分
Z. 0024

Top of Rubbing of Banner with Rubbed Pearl Roundel, Double-facing Beast Motif
High Tang Dynasty
Cultural Object
13.0×8.0 cm

　　此件絹幡目前僅存外淡青、內深青拓印的三角形幡首、與一截黃地幡身。所謂拓印即是凸版印花，是先以木板雕刻出凸起的印花圖案，再把染料塗於印花版的紋樣上，然後鋪上織物進行拓印，織物便能顯出清晰的花紋。

　　此聯珠對禽紋絹的幡首外緣採用淡藍絹為邊飾，絹上有些深淺不一的染色痕跡，但原應為無圖案的單色絹面；而在幡首內部三角形區塊可明確見不同圖案的拓印技術的成果，一是聯珠對禽紋、一是聯珠捲草紋，這是將一件單面拓印的黑色聯珠對禽紋絹對折而成的。此件盛唐時期拓印聯珠對禽紋的發現，可說是東漢凸版印花技術消失後的重現，在中國染織史上意義不凡。

57
綠地團花蠟纈絹殘幡
盛唐
文物
47.0×52.5 公分
Z. 0033

**Green Ground Floral
Wax-resist Silk Banner**
High Tang Dynasty
Cultural Object
47.0×52.5 cm

　　此絹幡出土時幡首與幡尾已失，僅存兩段幡身，一為為紫地團花殘片，一為本作品黃絹染作綠地團。由於幡身兩側的邊幅保存完好，推測原絹幅面寬應即52.5公分，折合為唐尺一尺七寸，與文獻記載大致相符。以織紋密度而言，此殘絹因羅織的經線粗細不同，幡身正面呈現出平行條紋，其每公分52×33根的經緯線，為盛唐絲織品中所習見（一般經緯線為40-69、30-39根）。

　　以印染技術而言，此絹先染為黃色，再以鏤花夾板的蠟染方式染出綠地圓形和團花，此施蠟在絲織物上作為排染劑的顯花技法，所顯現的花紋邊緣整齊而清晰，因而能製作出諸如此件圖案精緻、結構工整、直徑甚達七公分的團花。此類團花表現在莫高窟盛唐窟之藻井或佛、菩薩塑像服裝上，但實物的出現為更直接體現織品的原貌，誠為考古發現中唐代蠟染的精品。

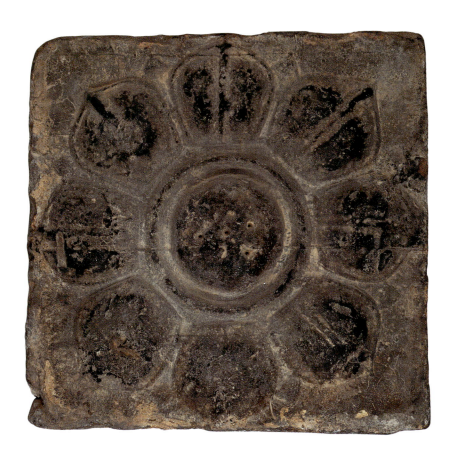

58
八瓣蓮花紋磚
隋
文物
38.0×38.0×6.5 公分
Z. 0063

Brick with Eight Trigram Lotus Floral Design
Sui Dynasty
Cultural Object
38.0×38.0×6.5 cm

　　敦煌石窟內部空間的地面（包括前室、甬道及後室）常以花磚鋪成，最早見於隋代第401窟；迄今莫高窟已發現的鋪地花磚包括隋、唐、五代、宋、西夏、元等幾個朝代。花磚的花紋是以八瓣蓮花為主，在已發掘的窟前遺址就出土了十八種之多。

　　此件蓮花紋磚出土於莫高窟的隋代洞窟，為灰色正方形磚，磚面中央以圓形代表蓮實，周邊配置八片蓮瓣，整個蓮花以淺浮雕的方式呈現，大而圓的花心仿蓮蓬造形呈現出細微穿孔，每一片蓮瓣厚實凸起，風格樸實而敦厚，與莫高窟隋代塑像或壁畫所呈現出的厚重感，有時代上異曲同工之妙。

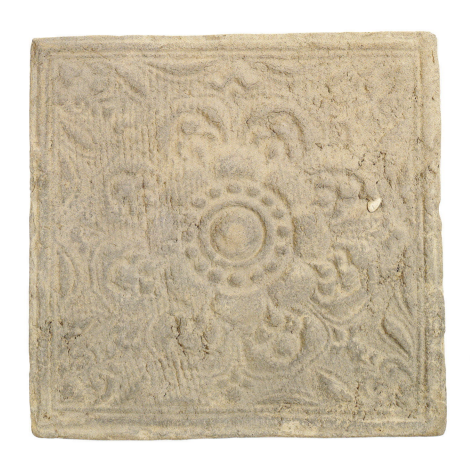

59
聯珠複瓣蓮花紋磚
唐
文物
34.5×34.5×5.0 公分
Z. 1123

Brick with Pearl String,
Double Trigram Lotus Floral Design
Tang Dynasty
Cultural Object
34.5×34.5×5.0 cm

　　此件聯珠複瓣蓮花紋磚,磚面呈灰色、方形,主體蓮花由兩層的八朵花瓣所構成,而中央的花心則是由聯珠圓所形構,內層蓮瓣仍有隋代蓮花紋的樸拙;而外層蓮瓣位於內層蓮瓣兩瓣尖處,形成錯落的層次,瓣面較大、雕琢也較複雜,因此十分具有立體感。另外在花磚的四隅,分別安排左右對稱的兩重葉形紋的圖案,葉形紋中間除了有三小花外,還有兩道內彎蜷曲的線條,以相映襯主體蓮花的繁複風格,在圖案紋樣的表現上有更形複雜化的趨勢。

　　此件敦煌唐代出土的實物,充分體現出唐代的紋樣風格,相對應於石窟壁畫的紋飾,呈現出同樣富麗的圖案。

60
桃心石榴紋磚
唐
文物
31.0×30.0×5.5 公分
Z. 0068

Brick with Peach-heart Guava Design
Tang Dynasty
Cultural Object
31.0×30.0×5.5 cm

　　此件桃心石榴紋磚為1965年於敦煌莫高窟第9窟的窟前遺址發掘時所出土。磚面方正，構圖以點與曲線為主，磚面中央以四瓣小花配合四朵雲頭紋，向四面開展形成十字型花朵，而四個角落對角線上是大朵桃形石榴形紋樣，形成佈局飽滿的構圖。同時，這些線條的組合喻含有所謂「榴開百子」的象徵。

　　關於石榴的紋飾，在唐代莫高窟、榆林窟壁畫中可見廣泛的應用；其以簡潔的線條而充實空間的效果，在磚面上也得到良好的運用。

61
寶相花紋磚
唐
文物
34.0×33.5×7.5 公分
Z. 1333

Auspicious Flower Design on Brick
Tang Dynasty
Cultural Object
34.0×33.5×7.5 cm

　　此件寶相花紋磚是1964年在莫高窟第98窟的窟前遺址所出土，為正方形的灰色磚。該件花磚紋樣：磚面正中央有一小圓點，周邊加上一些點綴，成一小團花；磚面上四朵蜷曲的是變形雲紋，分別向磚面四方伸展，以此形成一個「十」字；而此四朵較大的變形雲紋間，搭配較小的桃形雲紋；在磚面的四個角落，配置更小的雲紋，各種卷曲纏繞的線條，營造出豐富的寶相花紋，為由種種花形組合而成的一種裝飾圖案，實則無此植物型態。與桃心石榴紋磚（圖錄號60）相較，中央十字型放射狀型態相仿，但佈局較為疏朗，空間處理的意識不同，因此磚面邊緣餘留較多的空間。

　　而此類寶相花紋除了表現在石磚之外，在莫高窟唐代窟的佛龕或窟頂藻井的外緣部分也可見，是唐代流行的紋樣之一。

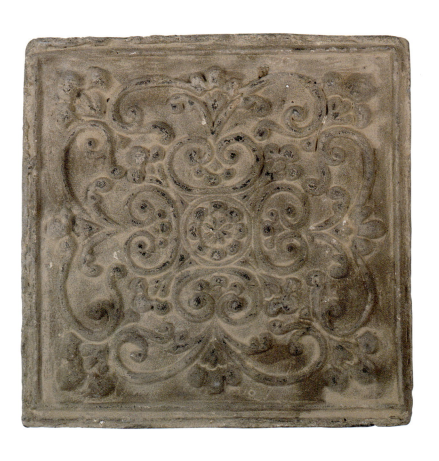

62
如意卷草紋磚
唐
文物
33.5×35.5×6.5 公分
Z. 1363

Brick with Ruyi Rolled-grass Motif
Tang Dynasty
Cultural Object
33.5×35.5×6.5 cm

　　此件為敦煌莫高窟唐代窟前遺址所出土的花磚,磚面紋樣為如意卷草紋。此磚面中央圓內為八瓣小蓮花,由中心四方向各伸展出一雲頭紋;在雲頭紋外層是如意卷草紋。這幾種花紋的組合形成有機的連結:如意卷草紋安排在雲頭紋蜷曲會合點的中心上方,形成相對、又似雲頭紋再延展出如意卷草紋的錯覺;此外花葉間隙、方磚的四隅,順勢開出一朵朵的小花紋樣,形成自然的連結。整體觀之,蜷曲的線條在有限的空間內傳遞流動的意象,呈現出生機盎然的趣味。
　　這種卷草紋盛行於唐代,是敦煌唐代圖案中主要的紋樣之一,廣泛運用於敦煌石窟中。

63
枝蔓蓮花紋磚
唐
文物
32.5×32.0×6.5 公分
Z. 1343

Brick with Lotus Stem Motif
Tang Dynasty
Cultural Object
32.5×32.0×6.5 cm

　　敦煌地區出土的唐代花磚紋樣繁複多變，蓮花紋磚繼隋代樸拙風格後，發展出許多變化的型態，「聯珠複瓣蓮花紋磚」（圖錄號59）、「蓮花唐草紋磚」、「大蓮瓣紋磚」，皆由蓮花紋飾發展而出；甚至組合圖案豐富的如「寶相花紋磚」（圖錄號61）、「如意卷草文磚」（圖錄號62）等。

　　此件枝蔓蓮花紋磚由蓮花紋樣進一步變化而來，磚面自中心向外作層層擴展分布，以莖蔓串聯，朝對角線的方向構築出「十」字形結構輻射，而在接近四角紐結出一蓮花圖案來。以枝蔓為連結圖案的型態，基本上奠定了曲折的意象，事實上此磚面上花紋真正纏繞處不多見，但整體顯得十分紛擾，概其以細長線條作為營造蓮花瓣的基本元素，盛開四方的效果，因而充滿流動不已的視覺現象。

　　此件花磚波形線條的紋樣，可說由單純以「花」為主體的蓮花紋飾，發展而為以「枝」為主蔓生相連的型態，體現出唐代圖案繁縟華麗的風貌、深富變化意趣。

64
天馬磚
唐
文物
20.0×42.0×10.0 公分
Z. 1122

　　絲綢之路與「天馬」傳聞密不可分，而位於絲綢之路上的敦煌，正是著名的「天馬故鄉」——相傳漢武帝時，敦煌南湖鄉渥洼池（現今的黃水壩）曾有兩次天馬從水中騰湧而出、並獻予天子。漢初深受匈奴之患，軍馬成為當時的需求，不但有漢武帝卜卦：「神馬當從西北來」，也有張騫出使西域帶汗血馬的記載。在絲路沿途，如武威東漢墓中足踏飛燕銅馬、酒泉十六國墓頂壁畫天馬、敦煌佛爺廟魏晉墓畫像磚翼馬、唐陵大型石刻翼馬、以及此件敦煌三危山老君堂塔廟所出土的唐代天馬磚等，隨時代演進敦煌地區天馬作品盛行不墜。

　　此長方形磚的天馬為馬身、鹿角、獅尾的綜合體。馬首高昂，四足狂奔，頸繫綬帶的飄舞與尾巴飛揚，說明了疾風而行的速度。《異物志》：「大宛馬有肉角數寸」，長沙漢墓出土的《相馬經》亦載肉冠大小與奔馳速度有關：長一寸、日行三百，長三寸、日行千里。不論天馬形象出於理想或事實，此磚的出土呼應了天馬曾經奔馳於絲路的不朽傳說。

Heavenly Horse Brick
Tang Dynasty
Cultural Object
20.0×42.0×10.0 cm

The Silk Road and the stories of Flying Horses are inseparable. Dunhuang, a town positioned on the Silk Road, is the celebrated "Home of the Flying Horses." Legend has it that during the reign of the Wu Emperor of Han Dynasty twice a flying horse sprinted out of the Wowa Pond (the present day Huangshui Dam) in the Nanhu Township of Dunhuang. They were captured and presented to the emperor. In the early Han Dynasty warhorses were in great demand because of incessant threats from the Huns to the north. The Wu Emperor consulted diviners and the answer was that "the Heavenly horse shall come from the northwest." There are also historic records of Zhang Qian returning from the northwest with blood-sweat steeds.

The artistic pieces of flying horses found along the Silk Road show evolution over time in the Dunhuang region. These include the brass horse positioned on flying swallows excavated from a East Han tomb in Wuwei, the flying horse mural in the Sixteen States burial chamber in Jiuchuan, the depiction of a winged-horse on brick from the tomb of the Weijin Dynasties period near Foye Temple in Dunhuang, the oversize stone winged-horse sculpture from a Tang Mausoleum, and this flying horse brick unearthed from the Laojuntang Temple Tower at Mt. Sanwei in Dunhuang.

This flying horse on the rectangular brick is made up with a horse's body, deer antlers and a lion's tail. The raised head and hooves and wavering rein and tail convey its galloping speed. The Yiwu Zhi (Book of Peculiarities), reads: "Horses from Dayuan possess fleshy horns of few inches in length." Xiangma Jing (Book of Horse Appraisal), excavated from a Han tomb in Changsha, also contains records related to the association between the size of fleshy horns and speed. "*Horses with inch-long fleshy horns can run three hundred miles per day; those with three-inch horns are able to cover a thousand miles.*" Whether all these were true or fabricated, the excavation of this brick embellished with this equine pictorial motif conforms to the everlasting myth that flying horses had once galloped on the Silk Road.

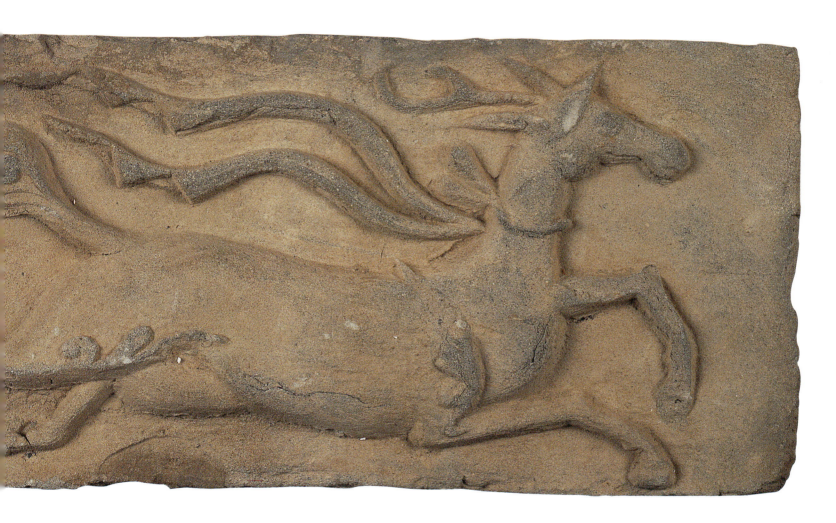

65
馴馬磚
唐
文物
34.5×33.0×6.0 公分
Z. 0064

Brick with Obedient Horse Motif
Tang Dynasty
Cultural Object
34.5×33.0×6.0 cm

　　歷代文獻多有馴馬資訊，根據《周禮》，周代宮廷中設有專門掌管馬匹的機關與職務，如「趣馬」一職掌管各種操縱馬匹的技巧訓練，調教馬匹包括按照行止、進退、馳驟等六種基本動作的學習，說明西周馴馬的技術已相當高超。而甘肅祁連山下大馬營草灘山丹軍馬場歷來為馴馬基地，隋唐時這裡曾畜養軍馬達十萬多匹。

　　此件形方正的馴馬磚上可以看出，馬匹前方有兩位馴馬人，分別立於馬的兩側，其中一位立於馬前吻部，左手彎曲握著韁繩駕馭；另一位較接近馬之頸項者，手臂彎曲緊握韁繩，前腳用力抵於地面、後腳似乎因為馬仍帶速度因此跟著前移而彎曲起來；而佔據磚面大半的馬身，背上配有馬鞍等馬具，馬身前高後低，四足抵地，後足微曲，似乎是正進行低下坐騎的動作。前方馴馬人費力的姿態與後方馬尾安靜垂下的模樣，此件畫磚不但在有限的磚面上表達出人馬的空間位置，並傳神地說明已調教成為溫馴良駒的意象。

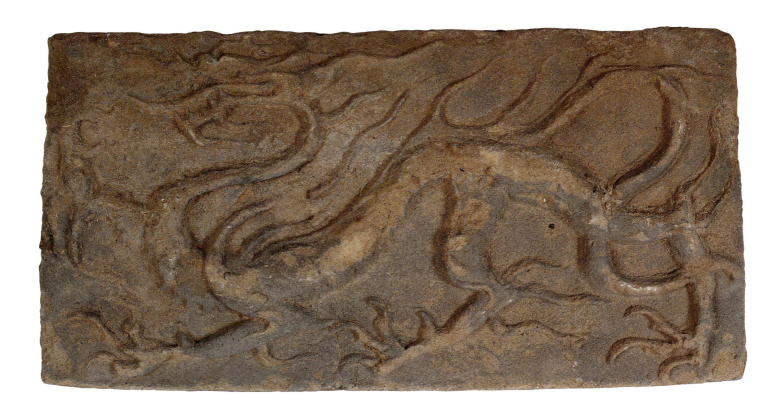

66
龍磚
五代
文物
26.9×52.0×9.0 公分
Z. 1388

Dragon Brick
Five Dynasties
Cultural Object
26.9×52.0×9.0 cm

　　龍是自古以來民間傳說流傳不朽的神獸，其形象是歷經時代漸次形成的。《說文解字》記載：「龍，鱗蟲之長，能幽能明、能細能巨、能短能長，春分能登天，秋分能潛淵。」千古以來，龍已然成為中華民族的象徵，以龍形為裝飾歷來都有表現，包括青銅器、石雕、磚瓦上屢見不鮮。

　　此件龍磚呈長方形，出土於敦煌三危山老君堂，為五代時期的地磚。磚上龍身曲折，細長彎曲的頸部之上為張口的龍首，口內尖銳的齒牙、以及口中長舌吐出似火焰條狀物，顯得十分生動。龍身經由曲折身軀的形塑、龍足厚實的處理與立體浮凸的技法，而顯得力道十足。此龍磚在經過塑形再燒製的工序後，能夠栩栩傳達龍形的靈活度，可謂技巧純熟；特別是龍之鬚與龍之爪，充分掌握住嶙峋與動感的線條，是最吸引注目之處。

67
鳳磚
五代
文物
26.5×50.3×10.0 公分
Z. 1121

此件鳳磚呈長方形,與龍磚(圖錄號66)同出土於三危山老君堂遺址。戰國以來,鳳即為祥瑞之鳥,其雄者為鳳、雌者為凰,並與「麟」、「龜」、「龍」合稱四靈瑞獸。《說文解字》:「鳳,神鳥也…鳳之象也,麐前鹿後,蛇頸魚尾,龍文龜背,燕頷雞喙,五色備舉。」鳳的形象是結合多種獸的形體而成其貌,在此件鳳磚上可以看見鳳體大致類似鳥身—特別是展開的羽翼,頂部至頸背髮昂揚;頸部細長彎曲,尾部呈現出魚叉尾形層層散開,形成優美的弧度。喙部尖銳,微張的口中含著雙折長索,所啣起的正是雙折點,並隨鳳身飄至鳳尾,這條在頸翅間與翅尾間分別結以蝴蝶形的綬帶,不但充分處理磚面上疏落的空間,並增添鳳之翼尾輕柔飄盪的視覺感受。

在莫高窟出土的龍磚與鳳磚往往位於寺觀建築下部,以成對的方式出現;這種配置在目前莫高窟宋代的慈氏塔中尚有實例遺存。

Phoenix Brick
Five Dynasties
Cultural Object
26.5×50.3×10.0 cm

This rectangular phoenix and dragon brick (Cat. no. 66) are both finds from the ruins of Laoquntang Temple at Mt. Sanwei. Since the Warring States Period the Phoenix has been an auspicious bird. The male is called "feng" and the female "huang." The four holy and auspicious animals in traditional culture are the phoenix, the qilin, the turtle, and the dragon. <u>The Shuowen Dictionary</u> indicates, "*The phoenix is a divine bird... As for its appearance, it looks like a qilin in front, and a deer in the rear. Its head looks like a snake and its tail like a fish. It has dragon patterning and a tortoise back. Its chin look like a swallow and its beak looks like a cock; the five colors appear in its feathers.*" The physical features of the phoenix are actually a combination of several animals. On this brick, it is easy to distinguish the body of a bird, in particular the spread wings. The bird forms a beautiful arc-the feathers on the nape fly, the long thin neck curves, and the tail fans in fishtail-shaped layers of feathers. The sharp beak holds a long, double-folded ribbon that floats along its body to the tail with a butterfly knot at both the end of the neck and the beginning of the tail. The handling of the ribbon not only requires manipulation of the limited space on the brick, but it also enhances the soft, flowing visual sensation of the tail.

At the Mogao Grottoes, the dragon and phoenix bricks often appear in pairs at the base of the religious buildings. Such combinations actually still exist in the same area in the Cishi Tower from the Song Dynasty.

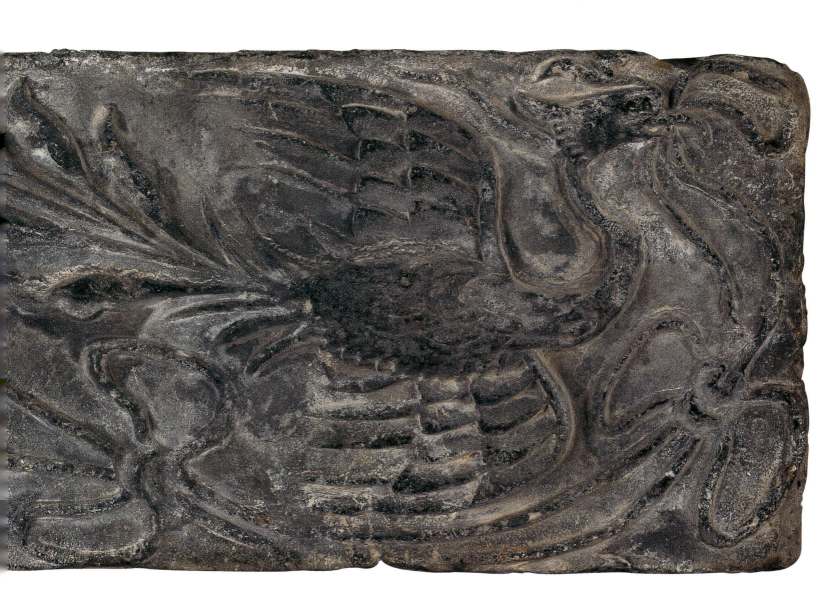

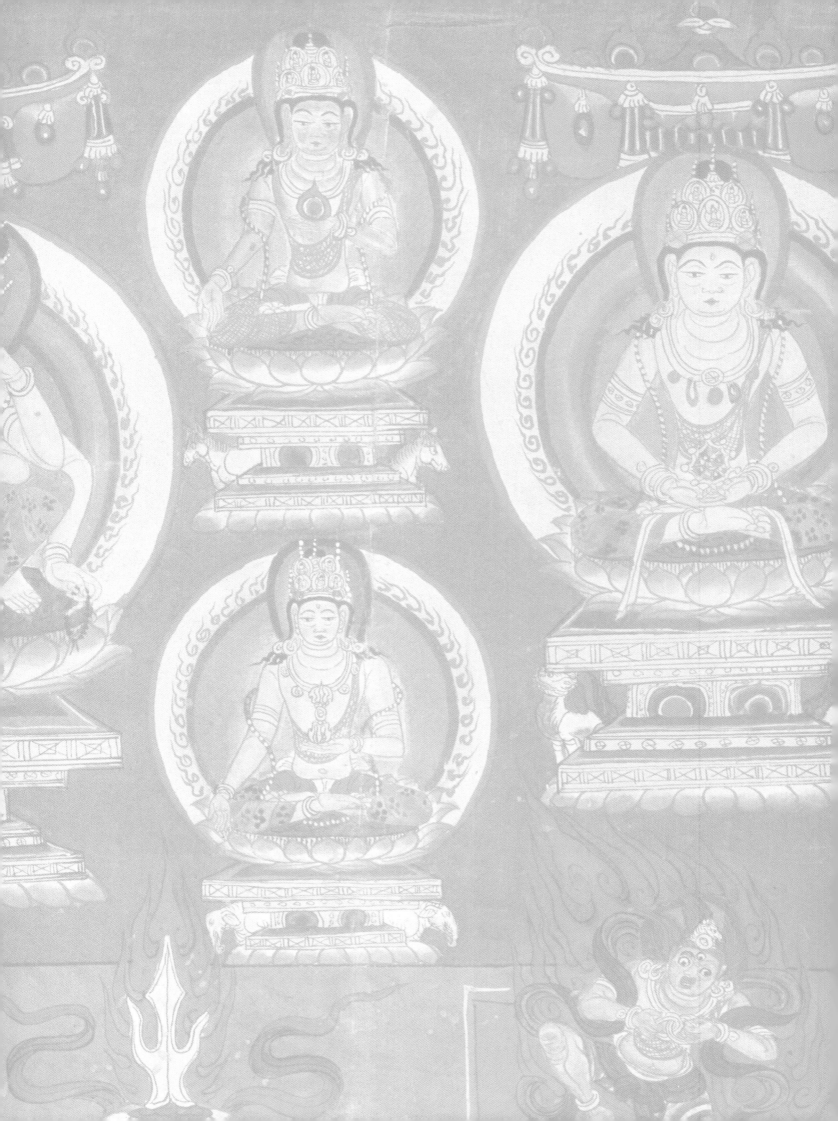

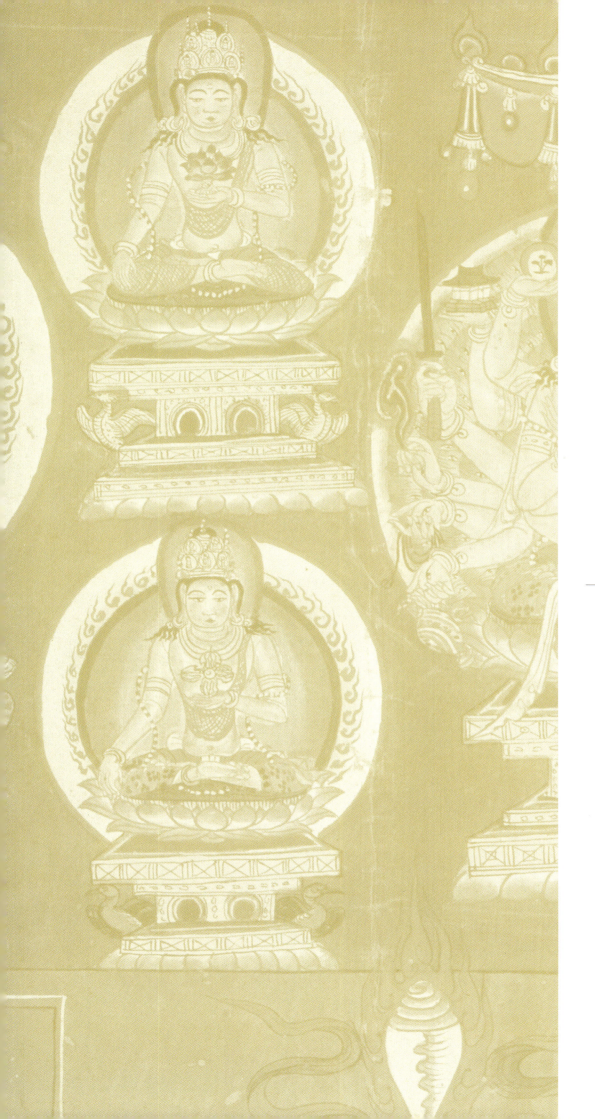

吉美博物館 典藏

Works from Musée national des
Arts asiatiques-Guimet

68
虎伴行腳僧像
掛幅畫
五代-北宋，10世紀
紙本畫
50.0×29.0 公分
伯希和中亞使命行，1906-1908，敦煌
法國國立亞洲藝術-吉美博物館，巴黎
MG 17683
RMN

在畫中央可以看到一位穿著涼履的僧侶。他由一隻老虎伴隨著，彷彿漫步在雲端。畫中的男子戴著一頂用兩條大繫帶繫著下巴的帽子。他穿著短上裝，上配著披肩。僧侶帶著拂塵及頂端呈瘤狀的木杖。在這位旅人的背上，可以很清楚地看到一些內書寫佛教經文的捲軸，繫在他扛的背架上。

在左上方，一尊在雲上的化佛伴隨著行腳僧。這圖像在此所表達的方式較絹畫來得更拘泥常規。另一幅藏在法國國家圖書館（伯希和中國4029）的紙畫與這一幅完全一樣。

P.L.M.

參考書目：吉埃，《中亞藝術，吉美博物館之伯希和收藏》，國家博物館聯合會，1996，第二冊，頁318，圖版 89。

Monk Accompanied by A Tiger
Votive Painting
10th Century
Paint on Paper
50.0×29.0 cm
Pelliot Mission in Central Asia, 1906-1908, Dunhuang
Musée national des Arts asiatiques-Guimet, Paris
MG 17683
RMN

At the centre of the composition is a monk wearing sandals. He is accompanied by a tiger and appears to be walking on a cloud. The man here wears a hat, held in place by a large ribbon tied under the chin. He is wearing a short tunic and a scarf. The monk carries a fly swat and a stick topped with a cross. Several scrolls containing Buddhist texts can be seen on the traveler's back, attached to a book cradle.

At the top left, a Buddha of transformation on a cloud accompanies the traveler's. This depiction is more conventional that those on the paintings on silk. Another depiction on paper, kept at the Bibliothèque nationale de France (Pelliot Chinois 4029) is identical to this.

P.L.M.

Bibliography: Giès, Arts de l'Asie centrale, Kôdansha, 1994 II., p 318, pl. 89.

Moine Accompagné d'un Tigre
Peinture Mobile
10ᵉ Siècle
Peinture sur Papier
50.0×29.0 cm
Mission Pelliot en Asie Centrale, 1906-1908, Dunhuang
Musée national des Arts asiatiques-Guimet, Paris
MG 17683
RMN

Au centre de la composition apparaît un moine, chaussé de sandales. Il est accompagné d'un tigre et semble marcher sur un nuage. L'homme est ici coiffé d'un couvre-chef, attaché sous le menton par un large ruban. Il est vêtu d'une courte tunique et d'une écharpe. Le moine porte un chasse-mouches et un bâton à sommet en crosse. Plusieurs rouleaux enfermant des textes bouddhiques sont visibles dans le dos du voyageur, attachés à un porte livres.

En haut à gauche, un Buddha de transformation sur un nuage accompagne le voyageur. La représentation est ici plus conventionnelle que dans les peintures sur soie. Une autre représentation sur papier, conservée à la Bibliothèque nationale de France (Pelliot chinois 4029) est parfaitement identique à celle-ci.

P.L.M.

Bibliography : Giès, Arts de l'Asie centrale, Kôdansha, 1994 II., p 318, pl. 89.

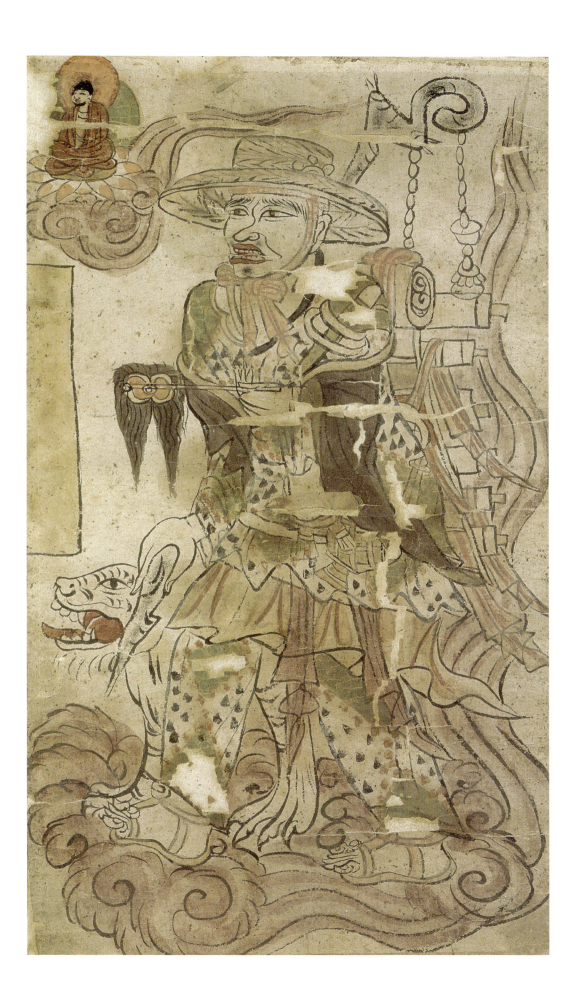

69
不空羂索觀音
掛幅畫
五代-北宋，10世紀
絹畫
84.0×64.6 公分
伯希和中亞使命行，1906-1908，敦煌
法國國立亞洲藝術-吉美博物館，巴黎
MG 23076
RMN

觀世音菩薩可由髮冠上之化佛辨認出其身份，在此係以「不空羂索」的型式出現。坐在蓮花寶座上的觀音有八隻手臂，各持不同的標誌：淨瓶、寶印、瓔珞、蓮花莖及有火焰寶珠。觀音具有頭光環及背光輪，頭頂上為飾有瓔珞和如意寶珠的華蓋。周圍，係由天王，比丘及菩薩所組成的眾會。寶座懸空飄在水池和供桌之上，後者上面放著淨瓶與香爐。在下方，所有的供養人均跪著。

羂索係此一型式的觀世音所擁有的特徵，是慈悲心的象徵，菩薩以此種心情接納所有的眾生。所有榜牌均無任何銘文。圍繞著觀音不同的人物也未命名。但是，我們能夠認出兩位天王，如持國天，為把著弓的東方王，及持劍的西方王廣目天。綠色底的畫，以三道線組成的菱形圖案來點綴，中間並飾以黃點。

P.L.M.

參考書目：吉埃，《中亞藝術，吉美博物館之伯希和收藏》，國家博物館聯合會，1996，第一冊，頁347，圖版78，圖33-34；《中印佛之土》，巴黎大皇宮特展目錄，1995/1996，210號。

Amoghapāśāvalokiteśvara Bodhisattva
Votive Painting
10th Century
Paint on Silk
84.0×64.6 cm
Pelliot Mission in Central Asia, 1906-1908, Dunhuang
Musée national des Arts asiatiques-Guimet, Paris
MG 23076
RMN

Amoghapāśa Guanyin is eight-armed, sitting cross-legged on the lotus, and wearing a Buddha reincarnation over the head. A piece of deerskin with lozenge patterns of four white dots is draped over the left shoulder. Of the eight arms, each of the two main hands holds a long-stemmed lotus before the chest; the other hands are respectively occupied with a short-necked water bottle, ruyi pearl (cintā-maṇi), long-necked water bottle, swastika seal(卍), the unerring lasso, and mudrā. The s-shaped halo of the main buddhas was often applied after Mid Tang in the murals of Dunhuang. Precious flowers blossom amidst the jewel trees surrounding the canopy above the halo. Below the back halo is the large lotus the bodhisattva sits on. New buds are ready to open in the precious lake underneath.

Amoghapāśa Guanyin's entourage stands by the two sides: the top left shows the bow pulling Dhrtarastra, guardian of the east and the sword carrying Virupaksa, guardian of the west, at the top right. Beneath are Buddha's disciples in the appearance of monks, followed by servant Bodhisattvas with both head halo and body halo. At the bottom of the painting are the patrons: two men wearing hats and two ladies with long hair and hairpins. From the hats and clothing and other decorative items, this painting was been made sometime during the North Song Period.

P.L.M.

Bibliography : Giès, Arts de l'Asie centrale, Kôdansha, 1994 I, p. 347, pl. 78, fig. 33-34/ Sérinde, Grand Palais, 1995/1996, n° 210.

Le Amoghapāśāvalokiteśvara Bodhisattva
Peinture Mobile
10ᵉ Siècle
Peinture sur Soie
84.0×64.6 cm
Mission Pelliot en Asie Centrale, 1906-1908, Dunhuang
Musée national des Arts asiatiques-Guimet, Paris
MG 23076
RMN

Le Bodhisattva Avalokiteśvara, reconnaissable au Buddha de transformation posé dans sa chevelure, est ici représenté sous sa forme "au Lacet infaillible" (Amoghapāśa). Assis sur un trône de lotus, il est muni de huit bras portant divers attributs: flacons, sceau précieux, lacet, tiges de lotus, perle flammée. Nimbé et auréolé, il est surmonté d'un dais à pendeloques et à perles précieuses, cintamani. Tout autour, l'assemblée est composée de rois gardiens, de moines et de Bodhisattva. Le trône survole un étang et une table d'offrandes présentant flacons et brûle-parfum. Dans la partie inférieure, les donateurs figurent agenouillés.

Le "lacet", caractéristique de cette forme d'Avalokiteśvara, est celui de la compassion avec laquelle le Bodhisattva recueille tous les êtres. Les cartouches ne portent pas d'inscription. Les différents personnages entourant Guanyin ne sont pas nommés. Cependant on pourrait identifier les rois gardiens comme étant Dhrtarastra, roi de l'est, porteur de l'arc, et Virupaksa, roi de l'ouest, porteur de l'épée. Le fond verdâtre de la peinture est orné de losanges à triple filet marqués en leur centre de points jaunes.

P.L.M.

Bibliography : Giès, Arts de l'Asie centrale, Kôdansha, 1994 I., p 347, pl.78, fig. 33-34/ Sérinde, Grand Palais, 1995/1996, n° 210.

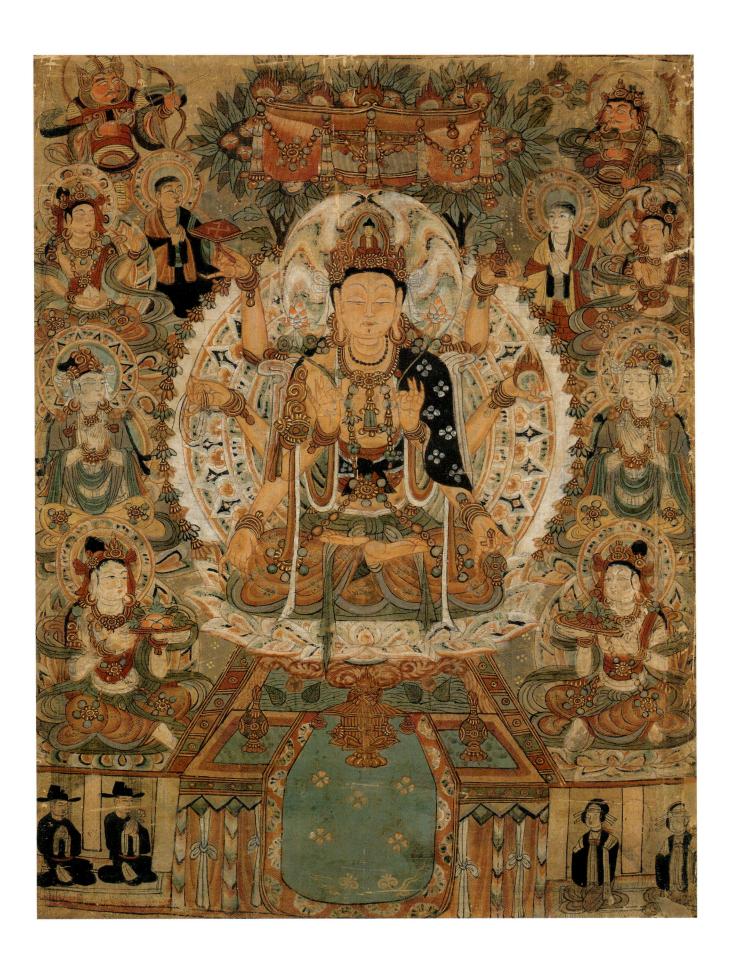

70
地藏王菩薩
掛幅畫
北宋，太平興國八年（983）
絹畫
229.0×159.0 公分
伯希和中亞使命行，1906-1908，敦煌
法國國立亞洲藝術-吉美博物館，巴黎
MG 17662
RMN

地藏王菩薩坐在蓮花寶座上，頭上戴著旅人披肩，有頭光和背光，頂上一纓絡寶蓋。祂右手持著錫杖，左手似乎缺寶珠。從環繞著地藏王菩薩的白色光環頂端，放出六條輪迴之道：右邊為人、阿修羅及地獄道；左邊則是天、畜牲及餓鬼道。圍繞在旁的十個王，每位都坐在一張桌子後面，身邊伴隨兩位童子。道明和尚與金毛獅子相對，並和四位判官位於寶座之下。圖的下方中央則繪一許願碑，碑兩旁分別是引路菩薩以及帶著僕侍的女施主。

白色的光環鑲有紅色的花邊，使得圖畫更顯莊嚴。引路菩薩指點往生者前進之路。榜牌中的銘文指明輪迴六道及十王的名稱，畫面下方中央有一長串的文字，提供了作畫的日期，女施主身邊則有一些難以辨認的回鶻文字。

P.L.M.

參考書目：吉埃，《中亞藝術，吉美博物館之伯希和收藏》，國家博物館聯合會，1996，第二冊，頁303，圖版 63，圖.26。

The Bodhisattva Ksitigarbha (Dizang)
Votive Painting
983
Paint on Silk
229.0×159.0 cm
Pelliot Mission in Central Asia, 1906-1908
Musée national des Arts asiatiques-Guimet, Paris
MG 17662
RMN

The Bodhisattva Kṣitigarbha is depicted seated on a lotus throne, with a traveler's shawl over his hair. With his halo, suffused with light, he is shaded by a canopy hung with pendants. In his right hanad he holds the khakkhara. The pearl seems to be missing from his left hand. Leading from the top of the white halo which envelops the Bodhisattva are the six ways of rebirth: to the right, those for humans, asura and deva-loka; to the left, the ways of the gods, animals and preta. All around, the Ten Kings are depicted, each one sitting behind a table and accompanied by two assistants. The monk Daoming, accompanied by a lion, and four clerks are placed at the foot of the throne. At the bottom, the Bodhisattva Yinlu (guide of souls) and the donator with her servants are depicted on either side of an inscribed votive stele.

The white halo with its red border gives a majestic feel to the composition. Bodhisattva Yinlu "shows the way" to the deceased. The inscribed cartouches clearly identify the six ways to rebirth and the Ten Kings. At the top of the painting, a long inscription in the centre tells the date of 983. Next to the donator is a hardly legible inscription in Uighur script.

P.L.M.

Bibliography: Giès, Arts de l'Asie centrale, Kôdansha, 1994 II, p. 303, pl. 63, fig. 26.

Le Bodhisattva Ksitigarbha
Peinture Mobile
983
Peinture sur Soie
229.0×159.0 cm
Mission Pelliot en Asie Centrale, 1906-1908
Musée national des Arts asiatiques-Guimet, Paris
MG 17662
RMN

Le Bodhisattva Kṣitigarbha est représenté assis sur un trône de lotus, coiffé du châle des voyageurs. Nimbé et auréolé, il est surmonté d'un dais à pendeloques. De la main droite il tient le khakkhara. La perle semble manquer dans sa main gauche. Du sommet du halo blanc qui enveloppe le Bodhisattva s'échappent les six voies de la renaissance: à droite, celles des humains, des asura et des enfers; à gauche, les voies des dieux, des animaux et des preta. Tout autour, les Dix Rois sont figurés chacun assis derrière une table, accompagnés de deux assistants. Le moine Daoming, accompagné du lion, et les quatre greffiers sont situés au pied du trône. Dans le registre inférieur, le Bodhisattva Yinlu et la donatrice avec ses servantes figurent de part et d'autre d'une stèle votive inscrite.

Le halo blanc muni d'un liseré extérieur rouge donne une grande majesté à la composition. Le Bodhisattva Yinlu "montre le chemin" à la défunte. Les cartouches inscrits identifient les six voies de la renaissance et les Dix Rois. Au registre inférieur, au centre, une longue inscription donne la date. A côté de la donatrice se trouve une inscription en ouïgour difficilement lisible.

P.L.M.

Bibliography : Giès, Arts de l'Asie centrale, Kôdansha, 1994 II., p 303, pl. 63, fig. 26.

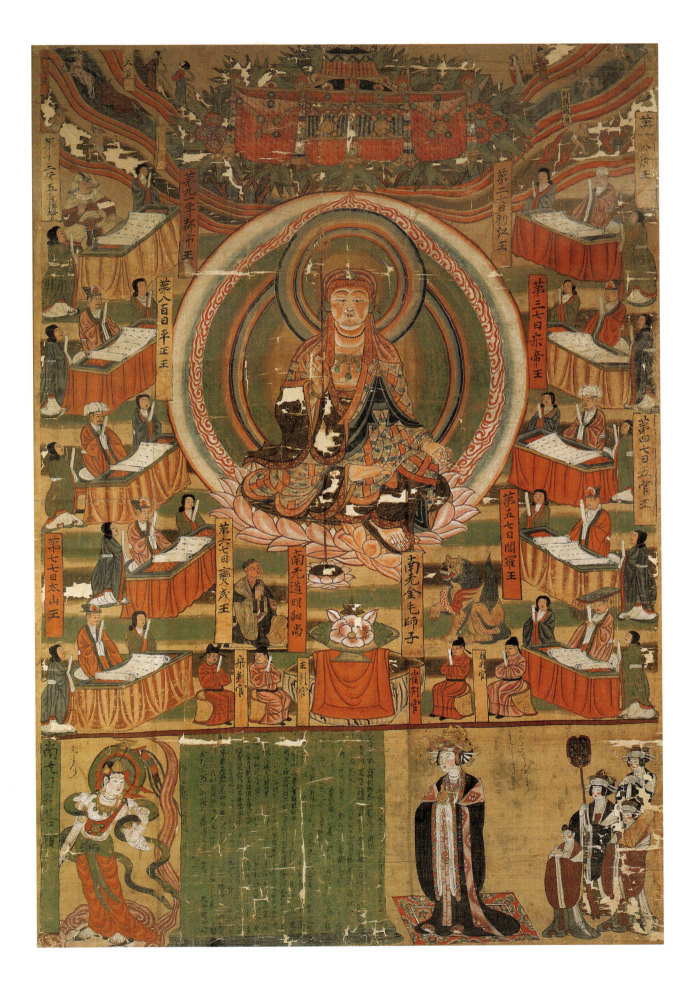

71
千手千眼觀音菩薩
掛幅畫
五代，天福八年 (943)
絹畫
123.5×84.5 公分
伯希和中亞使命行，1906-1908，敦煌
法國國立亞洲藝術-吉美博物館，巴黎
MG 17775
RMN

觀世音菩薩在此以擁有千手千眼的形象表達出來。坐在蓮花寶座上的觀音由池塘上升起，但池塘為一供桌所掩飾。祂具有頭光環及背光輪，戴著阿彌陀化佛寶冠。在背光輪及手心上均有眼睛。其成千成對的手臂結出不同的印契，並持不同的器物：太陽輪及月輪、三叉戟、斧頭、蓮花莖、淨瓶等等。在四周，不同的脇侍人物組群由榜書指認。從上至下我們可以看到四大天王、隱士婆藪仙、大辯才天女、難陀和拔難陀二龍王、兩位六臂金剛、兩位供養菩薩。在下方銘文的左側為女亡者及其女僕；右邊為一尊「水月觀音」。

「千手千眼」觀音，亦名大慈悲，在透明的月亮光中結金剛坐。千手在此僅以42隻手作象徵性的代表。印度女神中代表聰明、辯才無礙的大辯才天女則在此跪著，供奉可以滿足所有慾望的如意寶珠。兩尊供養菩薩像由榜題指認為「日藏」和「月藏」，這也是經常與觀音有關的主題。

P.L.M.

參考書目：吉埃，《中亞藝術，吉美博物館之伯希和收藏》，國家博物館聯合會，1996，第一冊，頁359，圖版 96，圖 39；《中印佛之土》，巴黎大皇宮特展目錄，1995/1996，268號。

Bodhisattva Guanyin with the Thousand Hands and Thousand Eyes
(Avalokiteś var Sahasra Bhuja-locana)
Votive Painting
943
Paint on Silk
123.5×84.5 cm
Pelliot Mission in Central Asia, 1906-1908, Dunhuang
Musée national des Arts asiatiques-Guimet, Paris
MG 17775
RMN

The Bodhisattva Avalokiteśvara (Guanyin) is depicted here in his form with the Thousand Hands and Thousand Eyes. Seated on a lotus throne, he is raised above a pond hidden by a table of offerings. With a halo and suffused with light, he wears a tiara containing the Buddha Amitābha. Eyes can be seen on the palms of his hands and in the halo. With his multiple pairs of arms, he sketches mudras and carries various objects, including: solar and lunar discs, a trident, an axe, lotus stems and vases. All around him, different groups of assistants can be identified from the cartouches. At the bottom of the top section we can see: the four guardian kings (Devarajas), the hermit Vasudeva, the goddess Sarasvati-devi, the dragon (Nagā) kings Nanda and Upananda, two vajrapāṇibalins with six arms and two praying Bodhisattvas. At the bottom, to the left of the inscription we find the deceased and his servant. To the right, Guanyin is represented in the form of "reflection of the moon in the water".

Avalokiteśvara with the Thousand Hands and Thousand Eyes, alias the Great Compassion, is pictured seated in the Diamond position in the translucent disc of the moon. The Thousand Arms are shown symbolicly by the number forty-two. Sarasvati-devi, Indian goddess of eloquence and Intelligence, kneeling, presents an offering of the gem which grants all wishes (cintāmaṇi). The two figures praying on either side of the altar, can be identified as the "Receptacle of the Sun" and the "Receptacle of the Moon", a theme often linked to Guanyin.

P.L.M.

Bibliography: Giès, Arts de l'Asie centrale, Kôdansha, 1994 I, p. 359, pl. 96, fig. 39/ Sérinde, Exhibition catalogue, Grand Palais, 1995/1996, n° 268.

Le Bodhisattva Guanyin aux Mille Mains et Mille Yeux
Peinture Mobile
943
Peinture sur Soie
123.5×84.5 cm
Mission Pelliot en Asie Centrale, 1906-1908, Dunhuang
Musée national des Arts asiatiques-Guimet, Paris
MG 17775
RMN

Le Bodhisattva Avalokiteśvara est ici représenté sous sa forme « aux Mille Mains et Mille Yeux ». Assis sur un trône de lotus, il s'élève au-dessus d'un étang dissimulé par une table d'offrandes. Auréolé et nimbé, il est coiffé d'une tiare avec le Buddha Amitābha. Des yeux apparaissent sur les paumes des mains et sur l'auréole. De ses multiples paires de bras il esquisse des mudra et porte divers attributs: disques solaire et lunaire, trident, hache, tige de lotus, vases...Tout autour, différents groupes d'assistants sont identifiés par des cartouches. De haut en bas nous pouvons distinguer les quatre Rois gardiens (Devarajas), l'ermite Vasudeva, la déesse Sarasvati-devi, les Rois dragons Nanda et Upananda, deux divinités vajrapāṇibalins à six bras, deux Bodhisattva orants. En bas à gauche de l'inscription se trouvent la défunte et sa servante; à droite, Guanyin dans sa représentation « aux reflets de la lune dans l'eau ».

Avalokiteśvara « aux Mille Mains et Mille Yeux », alias le Grand compatissant, est figuré assis en attitude du Diamant dans le disque diaphane de la lune. Les Mille Bras sont figurés ici au nombre symbolique de quarante-deux. Sarasvati-devi, déesse indienne de l'Eloquence et de l'Intelligence, agenouillée, présente l'offrande de la "gemme qui exauce tous les désirs" (cintāmaṇi). Les deux figures d'orants, de part et d'autre de l'autel, sont identifiés comme "Réceptacle du Soleil" et Réceptacle de la Lune', thème souvent lié à Guanyin.

P.L.M.

Bibliography : Giès, Arts de l'Asie centrale, Kôdansha, 1994 I., p. 359, pl. 96, fig. 39/ Sérinde, Grand Palais, 1995/1996, n° 268.

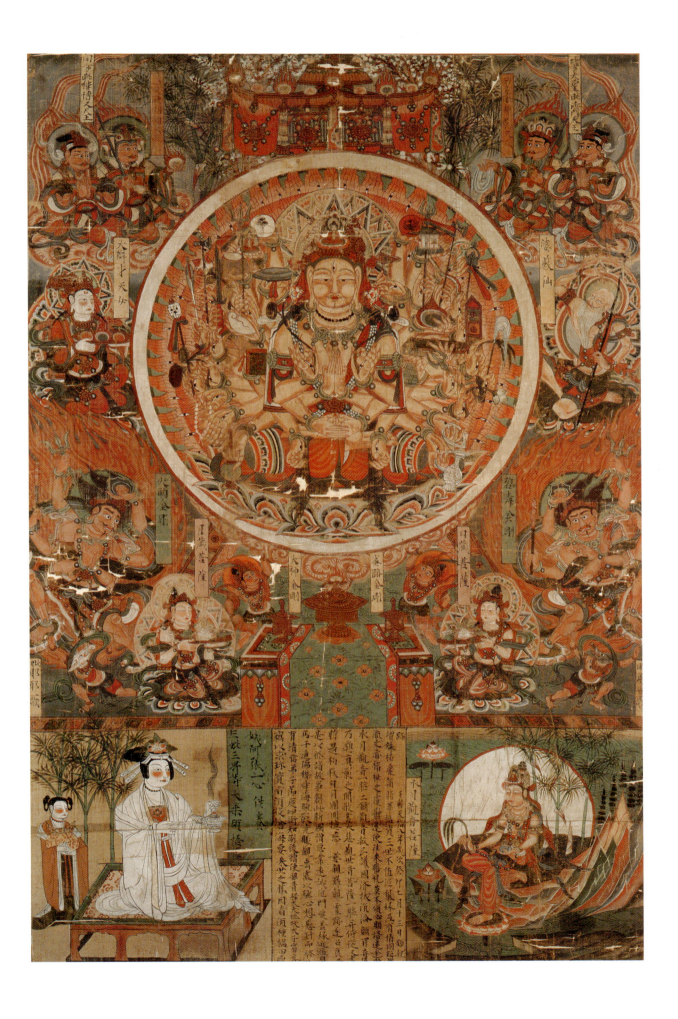

72
救苦觀音菩薩立像
幢幡
唐,九世紀下半葉
絹畫
183.2×58.0 公分
伯希和中亞使命行,1906-1908,敦煌
法國國立亞洲藝術-吉美博物館,巴黎
EO 1137
RMN

畫中觀音的體態是豐腴的,擁有較女性化的胸部。祂站在一個寶蓋下,雙腳踏在蓮花上。戴佩飾及穿著古印度緊身貼體式的裙裳,在他的髮飾中有一個化佛。菩薩擺出的右手係宣揚教義的手勢,即說法印,而左手施與願印。

此種形式的菩薩僅出現在禮拜儀式及許願的圖畫中。在光輪上,露出另一尊菩薩的下方,這顯示出系列製造的作畫方式,在一長條布上連續重複同一題材或成雙成對出現。位在上方右側的榜牌題書:「南无救苦觀音」。

P.L.M

參考書目:吉埃,《中亞藝術,吉美博物館之伯希和收藏》,國家博物館聯合會,1996,第一冊,頁339,圖版58,圖23;《中印佛之土》,巴黎大皇宮特展目錄,1995/1996,207號。

Bodhisattva Avalokiteśvara
«Saviour from Perils »
Banner
2nd Half of 9th Century
Silver Pigment on Vermilion Silk
183.2×58.0 cm
Pelliot Mission in Central Asia, 1906-1908, Dunhuang
Musée national des Arts asiatiques-Guimet, Paris
EO 1137
RMN

Bodhisattva Guanyin (Avalokiteśvara) is here represented with a rounded figure and a rather feminine chest. He stands under a canopy, with his feet resting on a lotus. Adorned and dresses with the Indian paridhāna, he carries the Buddha of transformation in his hair. With his right hand, the Bodhisattva makes the gesture of teaching, and with his left hand, the gesture of the gift (varada-mudrā).

This form of Bodhisattva only appears in liturgical and votive paintings. Above the halo, the lower part of another Bodhisattva shows that this type of paintings was probably produced in series, on a long strip or in pairs. The cartouche on the top right-hand side has the following inscription: "Homage to Bodhisattva Guanyin who saves from suffering."

P.L.M.

Bibliography: Giès, Arts de l'Asie centrale, Kôdansha, 1994 I, p. 399, pl. 58, fig. 23/ Sérinde, Exhibition Catalogue, Grand Palais Paris, 1995/1996, n° 207.

Le Bodhisattva Avalokiteśvara
« Secourable aux Douleurs »
Bannière
2ᵉ Moitié du 9ᵉ Siècle
Peinture sur Soie
183.2×58.0 cm
Mission Pelliot en Asie Centrale, 1906-1908, Dunhuang
Musée national des Arts asiatiques-Guimet, Paris
EO 1137
RMN

Guanyin (Avalokiteśvara) est ici tout en rondeur, la poitrine plutôt féminine. Il se tient debout sous un dais, les pieds posés sur un lotus. Paré et vêtu du paridhāna, il porte le Buddha de transformation dans sa coiffure. Le Bodhisattva esquisse de la main droite le geste de la Prédication, vitarka-mudra et de la main gauche, le Don du vœu (varada-mudrā).

Cette forme de Bodhisattva n'apparaît que dans les peintures liturgiques et votives. Au-dessus de l'auréole, la partie inférieure d'un autre Bodhisattva montre une exécution en série, sur une longue bande ou par paire. Le cartouche en haut à droite porte l'inscription : "Hommage au Bodhisattva Guanyin, secourable aux douleurs".

P.L.M.

Bibliography : Giès, Arts de l'Asie centrale, Kôdansha, 1994 I., p. 339, pl. 58, fig. 23/ Sérinde, Catalogue Exposition Grand Palais Paris, 1995/1996, n° 207.

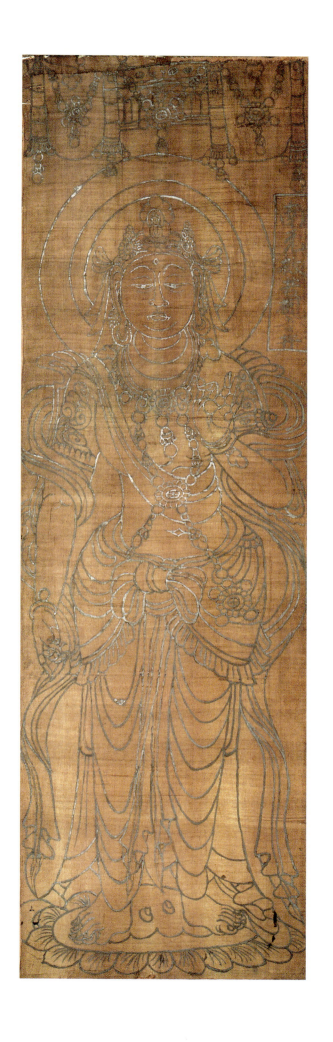

73
啣枝的飛鳥
幡幡
唐，8至9世紀
絹畫
78.0×22.5 公分
加上鑲框：高197公分；寬42.5公分
伯希和中亞使命行，1906-1908，敦煌
法國國立亞洲藝術-吉美博物館，巴黎
EO 3586
RMN

在橘紅絲製的中央部份，一隻鳥在喙中啣著一枝往下垂盛開花朵的軟枝。在上方，兩條並列的垂飾懸著兩個大鈴鐺。三角幡頭為藍色絹，裝飾有圖案化的花紋，但頂端則鑲了與主身同色的橘紅絹邊，作笠帽狀。銀畫的氧化可以從不同暗藍的色調顯示出。

在敦煌的發現中，此件作品與吉美博物館所收藏的另外兩件幡畫形成一種非常特殊的類別，鑒於它們所使用絲帶的品質精美-有些飾有織成的菱形花紋，細緻的木板裝飾，圖案生動優雅及銀畫的大量運用。它們可能於8世紀末在京城的一家工坊所製作而成的。

畫中所有的細節彷彿寓意處於西方極樂世界之無限幸福：一隻侯鳥飛上雲端，朝向天宮之門-門以垂飾的裝飾來暗示，另有鈴鐺象徵天籟之音。

L.F.

參考書目：吉埃，《中亞藝術，吉美博物館之伯希和收藏》，國家博物館聯合會，1996，第二冊，頁321，圖版97；《中印佛之土》，巴黎大皇宮特展目錄，1995/1996，287號。

Banner of Bird Holding Auspicious Flower in the Beak
Banner
8th-9th Century
Paint on Silk
78.0×22.5 cm
With frame: H. 197cm; L. 42.5 cm
Pelliot Mission in Central Asia, 1906-1908, Dunhuang
Musée national des Arts asiatiques-Guimet, Paris
EO 3586
RMN

The bird and flower design is sketched in silver on the light red and blue banner. The red parts include the bordering of the banner head, the body and the end of tails. The limbs of the banner are blue. Foliages appear on the triangular banner head and the end of tails; three leaves are painted on each of the two side arms and the three tails, with larger leaves on the latter.

In delicate silver lines on the light red main body a wing-spreading bird turns its head slightly to the right and holds in the beak a twig with leaves and flowers. Extended below are blossoming flowers of three and five petals, fully displaying the ornamental effect of florid extravagance. Same delicate silver lines depict flowers and grassy plants on the light blue parts. From the design and the techniques, it is reckoned to be a piece from the Prime Tang Period.

L.F.

Bibliography: Giès, Arts de l'Asie centrale, Kôdansha, 1994 II, p. 321, pl. 97/ Sérinde, Exhibition Catalogue, Grand Palais, Paris, 1995/1996, n° 287.

Oiseau Volant avec Une Branche
Bannière
8ᵉ-9ᵉ Siècle
Peinture sur Soie
78.0×22.5 cm
Avec Montage : H.197cm ; l.42,5 cm
Mission Pelliot en Asie Centrale, 1906-1908, Dunhuang
Musée national des Arts asiatiques-Guimet, Paris
EO 3586
RMN

Sur la partie centrale en soie rose orange, un oiseau tient dans son bec la tige souple d'un rameau fleuri tombant en cascade jusqu'au bas du panneau. A la partie supérieure, une double rangée de lambrequins supporte deux gros grelots. Le triangle de tête en soie bleue mais terminée par une bande de même soie rose en « chapeau de gendarme » est orné d'une composition floral très stylisée. L'oxydation de la peinture d'argent se traduit par un dégradé de tons en bleu noir.

Deux autres bannières conservées au Musée Guimet forment avec celle-ci un groupe très à part dans les découvertes de Dunhuang, par la qualité de la soie des rubans dont certains sont tissés de motifs en losange, le soin apporté à la décoration de la tablette de bois, l'élégance et la vivacité du dessin et l'emploi somptueux de la peinture d'argent. Peut-être furent-elles exécutées dans un atelier de la capitale à la fin du 8e siècle.

Tout semble indiquer la félicité des grandes scènes de paradis avec le choix d'un oiseau migrateur s'élevant au-dessus des nuages vers une porte de palais suggérée par le décor de lambrequin et la présence des grelots évoquant une musique céleste.

L.F.

Bibliography : Giès, Arts de l'Asie centrale, Kôdansha, 1994 II, p. 321, pl. 97/ Sérinde, Catalogue Exposition Grand Palais Paris, 1995/1996, n° 287.

74
經帙
唐,8世紀
絹及紙,五重組織錦,「緙絲」或「刻絲」
27.5×55.0 公分
伯希和中亞使命行,1906-1908,敦煌
法國國立亞洲藝術-吉美博物館,巴黎
EO 1207
RMN

　　這塊淺綠色絲質的長方形經帙內襯有紙,中央附有兩條紅絲線,可以綑綁經文卷軸。經帙的表面是精細的絲絹(原本是粉紅色),邊緣鑲著一圈織錦;織錦由數塊布隨意拼成,不在乎圖案的配合。其他來自敦煌的經帙上也曾發現同樣的織錦,目前保留在吉美博物館的伯希和收藏以及大英博物館的斯坦因收藏。毫無疑問,這條織錦是在中亞粟特國製造,花紋則受伊朗薩珊風格的影響。

　　經帙中央有兩條精美的緙絲帶,顏色是青綠色、綠色及橘色。唐朝時,這種技術在中國尚未流行,這件經帙可說是最古老、最少見的緙絲作品之一。經帙左上方用墨書寫「開」一字,依據《千字文》的原則,作為帙內所裝經書的編號。

<div align="right">L.F.</div>

參考書目:吉埃,《中亞藝術,吉美博物館之伯希和收藏》,國家博物館聯合會,1996,第二冊,圖 63;《伯希和使命團,敦煌的紡織品》,1970,頁221-224,圖版 43。

Sūtra-wrapper
8th Century
Silk and Paper, 5 Lats Worked Samite, Silk Tapestry Known as Gesi or Kesi
27.5×55.0 cm
Pelliot Mission in Central Asia, 1906-1908, Dunhuang
Musée national des Arts asiatiques-Guimet, Paris
EO 1207
RMN

This wrapper is made from a rectangle of lime green silk, lined on the inside with paper. In the center, two pink silk ribbons enable the text rolls to be fastened. The exterior of the cover is made from fine silk, once pink, edged with a band of samite composed of several fragments assembled without much concern for the pattern. This samite is found on other sūtra-wrapper found at Dunhuang and kept at the Musée Guimet in the Pelliot collection and also at the British Museum in the Stein collection. It was probably woven in Sogdiana and the motifs are of Iranian influence.

Two fine bands of turquoise, green and orange kesi are laid out at the centre. This is one of the rarest and oldest examples of this technique, which was not yet fashionable in Tang China. The kai (open) character traced in Chinese ink is placed on the upper left, on the background taffeta. It served to list the sūtra contained in the envelope, according to the numbering adapted from Qianziwen, the Book of a Thousand Characters.

<div align="right">L.F.</div>

Bibliography: Giès, Arts de l'Asie centrale, Kôdansha, 1994 II, fig. 63/ Mission Pelliot, Tissus, 1970, pp. 221-224, pl. 43.

Couverture de Sûtra
8ᵉ Siècle
Soie et Papier, Samit Façonné 5 Lats, Tapisserie de Soie Dite gesi ou Kesi
27.5×55.0 cm
Mission Pelliot en Asie Centrale, 1906-1908, Dunhuang
Musée national des Arts asiatiques-Guimet, Paris
EO 1207
RMN

Cette couverture est constituée d'un rectangle de soie vert tilleul doublé intérieurement de papier. Au centre, deux attaches de soie rose permettaient de lier les rouleaux de textes. La partie extérieure de la couverture est constituée d'une fine soie, jadis rose, bordée d'une bande de samit composée de plusieurs fragments assemblés sans grand souci des motifs. Ce samit se retrouve également sur d'autres couvertures de sûtra provenant de Dunhuang et conservées au Musée Guimet dans la collection Pelliot et au British Museum dans la collection Stein. Il fut sans doute tissé en Sogdiane et ses motifs sont d'inspiration iranienne.

Deux fines bandes de kesi bleu turquoise, vert et orangé sont disposées au centre. Il s'agit d'un des plus anciens et des plus rares témoignages de cette technique qui n'était pas encore en vogue dans la Chine des Tang. Le caractère kai (ouvrir) tracé à l'encre de Chine est placé à la partie supérieure gauche, sur le taffetas du fond. Il servait à répertorier le sûtra contenu dans l'enveloppe, selon la numérotation adaptée du Qianziwen, le Livre des Mille Caractères.

<div align="right">L.F.</div>

Bibliography : Giès, Arts de l'Asie centrale, Kôdansha, 1994 II., fig. 63/ Mission Pelliot, Tissus, 1970, pp. 221-224, pl. 43.

75
引路菩薩
掛幅畫
五代-北宋,10世紀下半葉
絹畫
94.5×54.0 公分
伯希和中亞使命行,1906-1908,敦煌
法國國立亞洲藝術-吉美博物館,巴黎
MG 17657
RMN

　　頭繞光輪及穿著印度緊身貼體裙服的引路菩薩以步行的姿勢站著,兩腳各踏著一朵紅蓮花。祂右手執幡杖,左手托香爐。菩薩前有一位侍者拿著一支三層幢幡。菩薩後跟著一位留著鬍子的男子,代表往生者,其雙手合什,穿著白色服裝及戴著一頂黑帽。在上方,三棟天宮樓閣清楚地出現在雲中。天宮的下方飄浮著七種繫上彩帶的樂器。

　　雖然我們在經文中可以發現指引靈魂的概念,但其中卻不曾出現引路的名稱。引路菩薩經常與具同樣角色的地藏菩薩混淆。在此引路菩薩身軀碩大,居高臨下,引導在雲道上的往生者靈魂,朝著極樂世界的方向前進。最初此幅畫係鑲上邊框的,但現在僅存留下方加縫上去的藍絹條邊。

　　位於上方左邊框牌的題銘,提及此幅畫是亡者的妻子—「女弟子康氏」,奉獻給名為薩詮的往生者—「奉為亡夫薩詮」。

P.L.M.

參考書目:吉埃,《中亞藝術,吉美博物館之伯希和收藏》,國家博物館聯合會,1996,第二冊,頁309,圖版 69。

The Bodhisattva Yinlu (Guide of Souls)
Votive Painting
2nd Half of 10th Century
Paint on Silk
94.5×54.0 cm
Pelliot Mission in Central Asia, 1906-1908, Dunhuang
Musée national des Arts asiatiques-Guimet, Paris
MG 17657
RMN

Adorned and dresses with the Indian paridhāna and the long thin banner held in the Soul-guiding Bodhisattva's right hand wavering backward suggests forward motion and the care for the deceased following behind. The bodhisattva's looking back also expresses the same concern. His red and green outfit with gold-leaf decoration makes a strong contrast with the white apparel of the deceased, except his black hat and belt. The latter looks devout and calm, holds his two hands together and follows the Bodhisattva in a peaceful atmosphere. Walking in front of the Bodhisattva is a young girl carrying the umbrella. The statuses of the characters are insinuated with the dimension each one takes up in the picture. At the same time, the buildings looming in the clouds at the top of the painting purport the allusion of the Pure Land, the paradise. The musical instruments flying in the air symbolize the welcoming notes from the heaven.

The caption at the upper left corner indicates: "With sincerity Disciple Ms. Kang has this Soul-guiding Bodhisattva painted for her deceased husband Sa Quan." Apparently a wife surnamed Kang had commissioned the painting in hope that the soul of her deceased husband could be led to the Western Pure Land.

P.L.M.

Bibliography: Giès, Arts de l'Asie centrale, Kôdansha, 1994 II, p. 309, pl. 69.

Le Bodhisattva Yinlu
Peinture Mobile
2ᵉ Moitié du 10ᵉ Siècle
Peinture sur Soie
94.5×54.0 cm
Mission Pelliot en Asie Centrale, 1906-1908, Dunhuang
Musée national des Arts asiatiques-Guimet, Paris
MG 17657
RMN

Le Bodhisattva Yinlu, auréolé et vêtu du paridhāna, se tient debout dans l'attitude de la marche, les pieds posés sur deux lotus roses. De la main droite, il tient la hampe d'une bannière; de la main gauche, un brûle-parfum. Le Bodhisattva est précédé par un petit assistant portant un parasol en trois parties superposées. Il est suivi d'un homme barbu représentant le défunt, les mains jointes, vêtu de blanc et coiffé d'un bonnet noir. En haut dans les nuages se détachent trois pavillons célestes. En dessous des pavillons sont disposées sept instruments de musique attachés à des rubans.

Le nom de Yinlu n'apparaît, semble-t-il, dans aucun texte de sûtra, bien que l'on y trouve l'idée de guide des âmes. Il a été souvent confondu avec Ksitigarbha qui a la même attribution. Le Bodhisattva Yinlu, dominant de sa haute stature, conduit l'âme d'un mort sur un chemin de nuages qui mène au paradis. Cette peinture était primitivement encadrée, il ne subsiste que la bande de soie bleue rapportée sur le bord inférieur.

L'inscription dans le cartouche situé en haut à gauche fait mention de l'offrande de cette peinture au défunt nommé Sa Quan, de la part de sa femme, « disciple de la famille Kang ».

P.L.M.

Bibliography : Giès, Arts de l'Asie centrale, Kôdansha, 1994 II, p. 309, pl. 69.

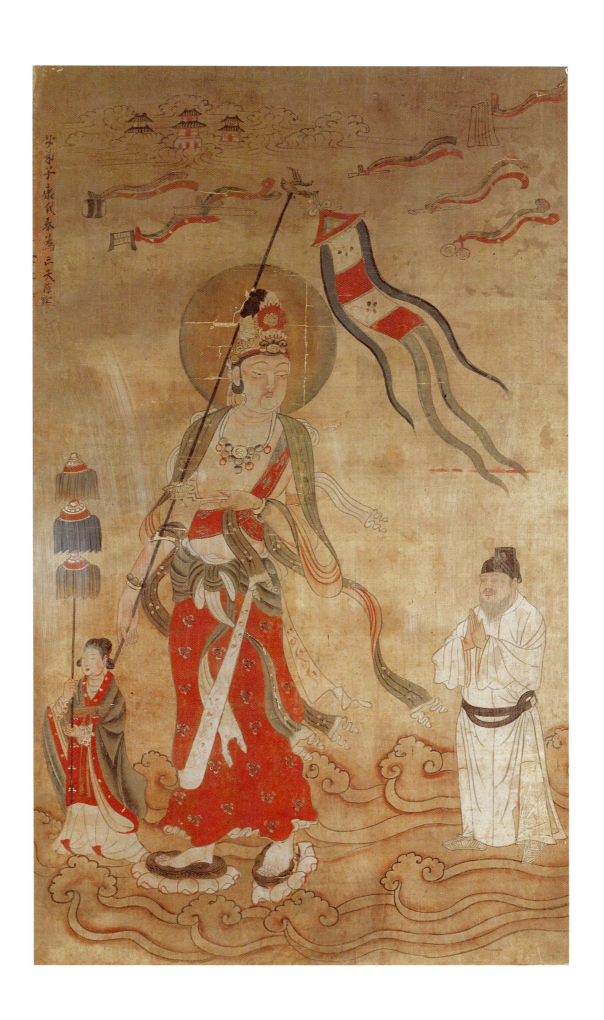

76
觀音經變相圖
掛幅畫
五代-北宋，10世紀下半葉
絹畫
84.1×61.2 公分
伯希和中亞使命行，1906-1908，敦煌
法國國立亞洲藝術-吉美博物館，巴黎
MG 17665
RMN

畫中的「觀音菩薩」係站在一朵池塘蓮花上。觀音戴著一頂形狀非常特殊的寶冠，額頭上有第三眼，眼睛皆作紅色。右手拿著蓮花莖，左手托著淨瓶。本畫的重點在於兩側的情景，由六道榜題辨認不同的禍害。我們可以看到火的災難及從金剛山及須彌峰高處跌落。同時也包括蛇、蠍子、老虎的災難，這一切均用圖像表達同一人物。在圖畫下方，施主及其女兒（比丘尼像）呈奉數樣供品。

此副畫具體描繪表現出《法華經》第25章〈普門品〉中所提到的多種災難之數例，如果一個人在其一生中禮拜觀音菩薩就可以逃避這些災難。此章節大受信徒的歡迎，在敦煌文獻中有大量的當地手抄本，以《觀音經》之名出現。

P.L.M.

參考書目：吉埃，《中亞藝術，吉美博物館之伯希和收藏》，國家博物館聯合會，1996，第一冊，頁343，圖版 72；巴黎大皇宮特展目錄，1995/1996，263號。

Bodhisattva Avalokiteśvara (Avalokiteśvara Sūtra Illustration)
Votive Painting
2nd Half of 10th Century
Paint on silk
84.1×61.2 cm
Pelliot Mission in Central Asia, 1906-1908
Musée national des Arts asiatiques-Guimet, Paris
MG 17665
RMN

The Bodhisattva Guanyin (Avalokiteśvara) is shown here standing on a lotus blossom rising out of a pond. He's wearing a very particular style of tiara. His red eyes and the third one in the forehead are also unusual. In his right hand he holds a lotus stem and in his left, a bottle. What is interesting about this painting are the scenes in the side panels, identified by the six cartouches and each showing different perils. You can distinguish between the perils of fire, the fall from the top of the Diamond mountain and the fall from the top of mount Sumeru; but also the perils of serpents, of the scorpion and of the tiger, all are depicted as one figure. The donator and his daughter, depicted as a female monk (bhikṣuṇi), present various offerings at the bottom of the painting.

This composition illustrates some of the many perils evoked in chapter 25 of the Lotus Sūtra, from which every individual can escape if, during his life, he offers homage to the saviour Guanyin. This chapter is very popular and is the subject of many independent copies in the manuscripts of Dunhuang under the name of Guanyin's Sūtra.

P.L.M.

Bibliography: Giès, Arts de l'Asie centrale, Kôdansha, 1994 I, p. 343, pl. 72/ Sérinde, Exhibition Catalogue, Grand Palais, Paris, 1995/1996, n° 263.

Illustration du « Sûtra de Guanyin »
Peinture Mobile
2ᵉ Moitié du 10ᵉ Siècle
Peinture sur Soie
84.1×61.2 cm
Mission Pelliot en Asie Centrale, 1906-1908
Musée national des Arts asiatiques-Guimet, Paris
MG 17665
RMN

Le Bodhisattva Guanyin est ici représenté debout sur une fleur de lotus qui s'élève au-dessus d'un étang. Coiffé d'une tiare d'un modèle très particulier, il porte un œil frontal et ses yeux sont rouges. Il tient dans sa main droite une tige de lotus et un flacon dans la main gauche. L'intérêt de la peinture réside dans les scènes latérales identifiées par les six cartouches et représentant les différents périls. On peut ainsi distinguer les périls du feu, de la chute du haut du mont du Diamant, de la chute du haut du mont Sumeru; mais aussi les périls des serpents, du scorpion et du tigre, tous figurés sur le même personnage. Le donateur et sa fille, représentée en moniale, présentent en bas de la peinture diverses offrandes.

Cette composition illustre quelques-uns des nombreux périls évoqués dans le chapitre 25 du Sûtra du Lotus, auxquels chaque individu peut échapper s'il en rend hommage durant sa vie au sauveur Guanyin. Très populaire, ce chapitre a fait l'objet de nombreuses copies autonomes dans les manuscrits de Dunhuang sous le nom du Sûtra de Guanyin.

P.L.M.

Bibliography: Giès, Arts de l'Asie centrale, Kôdansha, 1994 I, p. 343, pl. 72/ Sérinde, Catalogue Exposition Grand Palais Paris, 1995/1996, n° 263.

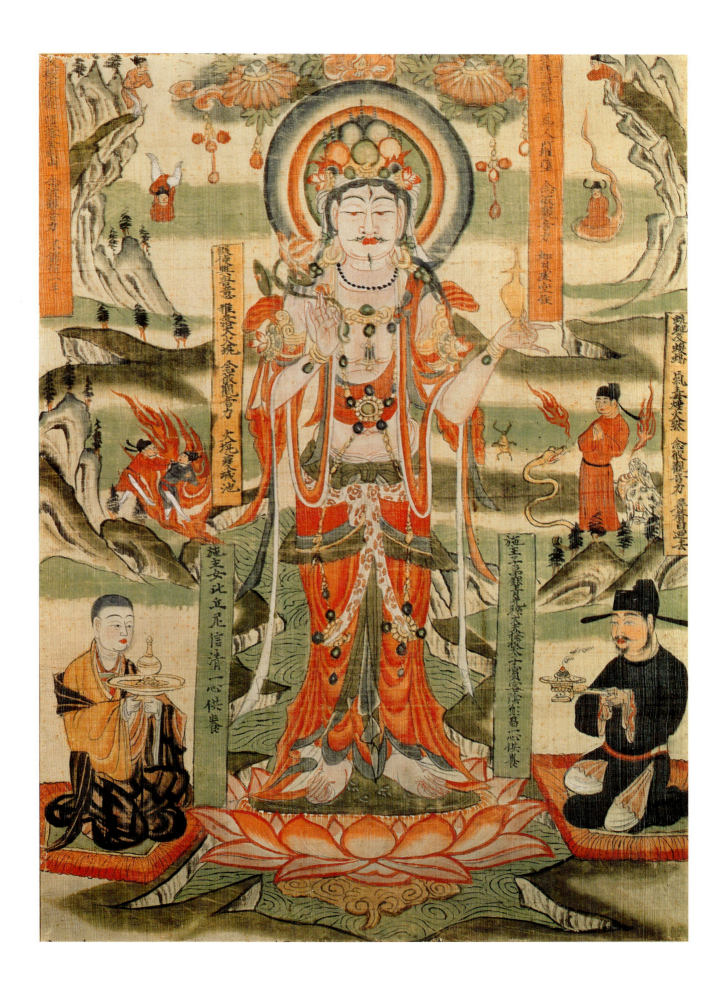

77

菩薩立像

幡幢

唐，9世紀末

絹畫

99.1×28.2 公分

伯希和中亞使命行，1906-1908，敦煌

法國國立亞洲藝術-吉美博物館，巴黎

MA 17651

RMN

　　菩薩面向右方的四分之三站立著。兩腳踏在蓮花上。其中一隻腳輕輕抬起，意味著移動的腳步。祂頭上環繞著光輪，頂上一寶蓋，穿著王子的服裝，為來自印度paridhana裳裙的模式。雙手交叉呈現出沉思的模樣。在下方，一菱形圖案的條飾展現出透視深度的效果。

　　此一幅畫的製作必須先用淡墨勾勒出草圖，然後上色，最後才使用深墨描繪所有的輪廓及外形。菩薩豪華的服裝係以飾有藍色半圓圖案的紅布做成。顏料的品質及畫工之精細使得此一作品屬於敦煌經典作之一。

　　本幅畫與吉美博物館所收藏的另一件作品極為相似（EO 1399 P.93）。此種情形也許可以解釋：畫師採用臨摹方式，根據同一模本，仔細地進行複製所致，或是使用另外一種還難以確認的手法著畫。

P.L.M.

參考書目：吉埃，《中亞藝術，吉美博物館之伯希和收藏》，國家博物館聯合會，1996，第二冊，頁286，圖版 11。

Standing Bodhisattva

Banner

End of 9th Century

Paint on Silk

99.1×28.2 cm

Pelliot Mission in Central Asia, 1906-1908, Dunhuang

Musée national des Arts asiatiques-Guimet, Paris

MG 17651

RMN

This piece originally had a triangular banner-head at the top and a triangular banner-tail at the bottom. The colorful main body is the only part left.

Standing on the lotus and turning a little to his right, the Bodhisattva's hands cross in front of the belly in a meditative gesture. His body tilts slightly forward but looks perfectly balanced. On the face, delicate and supple lines depict his brows, eyes and nose. Multiple layers of fine ink lines create the softness of his eye sockets, beard and sideburn. Furthermore, both the red shadowing technique applied on the torso and the red line along the inside of the black line that outlines his hands help increase the feeling of volume of the body. The finesse of the painter's artistic skills is also exhibited in the clothing: the blue and green design over the black cotton band on the chest, and light brown shadowing that shows the natural folds generated as the hands rest on the belly.

P.L.M.

Bibliography: Giès, Arts de l'Asie centrale, Kôdansha, 1994 II, p. 286, pl. 11.

Bodhisattva Debout

Bannière

Fin du 9ᵉ Siècle

Peinture sur Soie

99.1×28.2 cm

Mission Pelliot en Asie Centrale, 1906-1908, Dunhuang

Musée national des Arts asiatiques-Guimet, Paris

MG 17651

RMN

Le Bodhisattva est présenté debout, tourné de trois-quarts vers sa droite. Les pieds reposent chacun sur une fleur de lotus. L'un, légèrement relevé, indique le mouvement de la marche. Auréolé et surmonté d'un dais, il est vêtu du costume princier inspiré du modèle indien paridhana. Les mains sont jointes dans le geste de la méditation. En bas, une frise de losanges donne un effet de perspective.

L'exécution de cette bannière a nécessité la réalisation au préalable d'un croquis à l'encre pâle, puis l'application des couleurs avant que les formes et les contours ne soient soulignés à l'encre foncée. Le costume somptueux du Bodhisattva est réalisé avec un tissu rouge à motifs semi-circulaires bleus. La qualité des pigments et le soin apporté à sa réalisation classe cette œuvre parmi les belles de Dunhuang.

Cette bannière présente de fortes ressemblances avec une autre peinture conservée au Musée Guimet (EO 1399 P. 93). Ceci peut s'expliquer soit par la pratique de copies minutieusement exécutées à partir d'un même modèle, soit par un autre procédé encore difficile à établir.

P.L.M.

Bibliography : Giès, Arts de l'Asie centrale, Kôdansha, 1994 II, p. 286, pl.11.

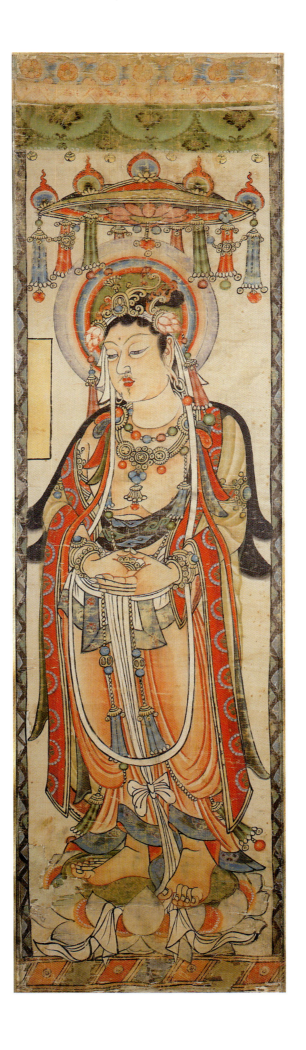

78
阿彌陀佛西方淨土圖

掛幅畫
五代，10世紀初
絹畫
141.0×84.2 公分
伯希和中亞使命行，1906-1908，敦煌
法國國立亞洲藝術-吉美博物館，巴黎
MG 17673
RMN

　　畫中央，帶著頭光和背光的阿彌陀佛結金剛坐。畫表現阿彌陀佛主持西方淨土的說法會，兩旁有脇侍菩薩，如慣例為觀世音菩薩及大勢至菩薩，並有四位聖僧與會。四周景物圍繞著阿彌陀佛：上有宮殿及樓閣，前為樂師演奏的平臺及接納化生靈魂的七寶池，以及諸佛觀水的天壇。畫下方第一橫條幅畫面同時呈現頻毗娑羅王的故事及韋提希皇后之觀想。第二橫條幅則由持著不同物品（瓶、經書）的數位僧人所組成，他們可能是定做本畫的施主。

　　中央三尊像重複出現以暗示西方極樂世界是無限度的，以及佛是無所不在的。化生的靈魂均以恭敬跪坐的赤裸童子為代表。本幅畫的特點係《觀無量壽經》變相圖之位置，位於畫下方而非側邊。此畫作工精細，我們特別可以從建築的結構中（中間樓閣的釘門，滾簾等）感受到。

<div align="right">P.L.M.</div>

參考書目：吉埃，《中亞藝術，吉美博物館之伯希和收藏》，國家博物館聯合會，1996，第一冊，頁320，圖版19；《中印佛之土》，巴黎大皇宮特展目錄，1995/1996，245號。

The Pure Land to the West of the Buddha Amitabha Sūtra Illustration

Votive Painting
Beginning of 10th Century
Paint on Silk
141.0×84.2 cm
Pelliot Mission in Central Asia, 1906-1908, Dunhuang
Musée national des Arts asiatiques-Guimet, Paris
MG 17673
RMN

In the centre, the Buddha Amitābha is seated in the vajrāsana position, suffused with light and encircled by a halo. He presides of the Assembly of the Pure Land of the West, assisted by his usual two Bodhisattva, Avalokiteśvara and Mahāsthāmaprāpta, and well as four holy monks. He is surrounded by a palace and pavilions, a terrace occupied by musicians, the Pond of the Seven Jewels, welcome reborn souls and a terrace occupied by Buddhas in contemplation of the water. The upper predella bears illustrations of both the legend of the king Bimbisāra and a depiction of the visions of the queen Vaidehī. The lower section is composed of monks carrying objects (such as vases and sūtra). These are probably the sponsors of the painting.

The central triad is repeated in order to suggest the immeasurability of the Sukhavāti and the omnipresence of the Buddha. The reborn souls are shown as naked children sitting on añjali（合什）. This painting is distinguished by the location of the illustrations of the Sūtra of the Contemplation of the Buddha Amitāyus in the lower section and not on the bands at the side. The care taken in the execution of this work is particularly apparent in the architectural structures such as the central pavilion with studded doors and rolled blinds.

<div align="right">P.L.M.</div>

Bibliography: Giès, <u>Arts de l'Asie centrale</u>, Kôdansha, 1994 I, p. 320, pl.19/ Sérinde, Exhibition Catalogue, Grand Palais, Paris, 1995/1996, n° 245.

Terre Pure de l'Ouest du Buddha Amitâbha Sūtra

Peinture Mobile
Début du 10ᵉ Siècle
Peinture sur Soie
141.0×84.2 cm
Mission Pelliot en Asie Centrale, 1906-1908, Dunhuang
Musée national des Arts asiatiques-Guimet, Paris
MG 17673
RMN

Au centre, le Buddha Amitâbha est assis en vajrasana, nimbé et auréolé. Il préside l'Assemblée de la Terre Pure de l'Ouest, assisté de ses deux Bodhisattva habituels, Avalokiteśvara et Mahāsthāmaprāpta, ainsi que de quatre saints moines. Il est entouré de palais et de pavillons, d'une terrasse occupée par des musiciens, de l'Etang des Sept Joyaux, accueillant les âmes renaissantes, et d'une terrasse des Buddha pour la contemplation de l'eau. La première prédelle du bas porte simultanément une illustration de la légende du roi Bimbisāra et une évocation des visions de la reine Vaidehī. La seconde prédelle se compose de moines portant des objets (vase, sûtra). Il s'agit probablement les commanditaires de la peinture.

La triade centrale est répétée afin de suggérer l'incommensurabilité de la Sukhāvatī et l'omniprésence du Buddha en tout lieu. Les âmes renaissantes sont représentées par des enfants nus assis en añjali. Cette peinture se caractérise par l'emplacement des illustrations du Sûtra de la Contemplation du buddha Amitāyus situées à la partie inférieure et non sur les bandes latérales. Le soin apporté à l'exécution est particulièrement sensible dans les structures architecturales (pavillon central à portes cloutées, stores roulés...).

<div align="right">P.L.M.</div>

Bibliography: Giès, <u>Arts de l'Asie centrale</u>, Kôdansha, 1994 I, p. 320, pl.19/ Sérinde, Catalogue Exposition Grand Palais Paris, 1995/1996, n° 245.

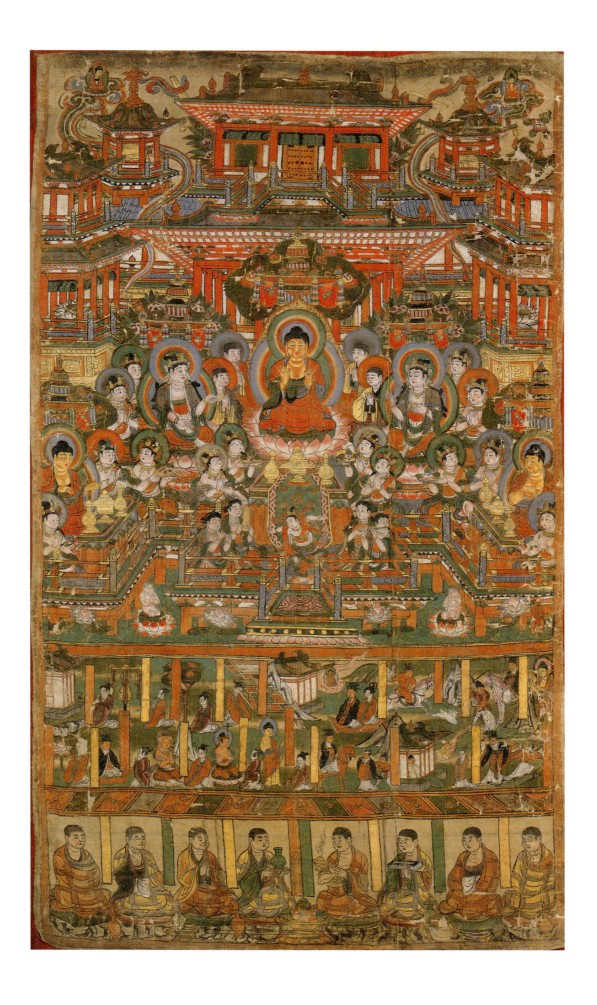

79

觀音曼荼羅
掛幅畫
五代‧10世紀
畫、顏色及絲金
115.0×65.0公分
伯希和中亞使命行，1906-1908，敦煌
法國國立亞洲藝術-吉美博物館，巴黎
EO 3579
RMN

　　畫面構圖區分為三個部分。在上方排列金剛界曼荼羅之五佛：毗盧遮那佛在中央，左右兩旁各一尊觀音菩薩，一位是千手千眼觀音，另一位則是能實現所有願望的如意輪觀音。在畫的中央可以看到一尊不空羂索觀音的主要圖像。菩薩擁有其獨特的持物。祂為其四種別相及四位供養菩薩所環繞。外面四周分散排列著供養菩薩，凶惡的門神，以及八吉祥[佛八寶]。在下方，供養人分成兩組，各在未書銘文的許願碑之兩旁。框邊的裝飾則是由金剛杵組成。

　　位於中央主要圖像的觀音，身配瓔珞、楊柳枝、蓮花及念珠。然而，此一觀音像未披鹿皮，無法確認是不空羂索觀音。基於其製作之品質及其所代表宗教圖像之重要性，此幅畫是從敦煌攜出最精美的作品之一。此一畫同時也為在敦煌對密教金剛界的信仰由吐蕃時期傳入直至10世紀初之具體見證。

P.L.M.

參考書目：吉埃，《中亞藝術，吉美博物館之伯希和收藏》，國家博物館聯合會，1996，第一冊，頁366，圖版99，圖41-42；《中印佛之土》，巴黎大皇宮特展目錄，1995/1996，284號。

Maṇḍala of (Avalokiteśvara)
Votive Painting
10th Century
Paint, Colors and Gold on Silk
115.0×65.0 cm
Pelliot Mission in Central Asia, 1906-1908, Dunhuang
Musée national des Arts asiatiques-Guimet, Paris
EO 3579
RMN

The composition is divided into three registers. At the top are the five Buddhas of the Diamond-world Maṇḍala: Vajar-dhātu, in the middle, is framed by two effigies of Avalokiteśvara, one with thousand hands and thousand eyes and the other with "the gem that grants all desires." At the centre of the painting we find the main image of Guanyin with the unfailing lasso (Amoghapāśa). The Bodhisattva is pictured with his particular attributes. He is surrounded by four of his aspects and four divinities of offerings. All around are pictured offering Bodhisattva, the terrible deities who guard the gateways, as well as the eight "prosperous objects." Below, the donators are placed in two groups on either side of an uninscribed votive stele. The surrounding decoration is made up of vajra.

The main figure of Guanyin in the centre has a lasso, a willow branch, a lotus and a rosary. However, this does not enable Amoghapāśa to be identified clearly. The antelope skin is missing. The workmanship and significant religious interest of this painting makes it one of the finest pieces brought by Paul Pelliot from Dunhuang. It is also evidence that esoteric Buddhism of the Diamond-world was practiced in Dunhuang up to the beginning of the 10th Century.

P.L.M.

Bibliography: Giès, Arts de l'Asie centrale, Kôdansha, 1994 I, p. 366, pl. 99, fig. 41-42/ Sérinde, Exhibition Catalogue, Grand Palais Paris, 1995/1996, n° 284.

Maṇḍala d'Avalokiteśvara
Peinture Mobile
10ᵉ Siècle
Peinture, Couleurs et or sur Soie
115.0×65.0 cm
Mission Pelliot en Asie Centrale, 1906-1908, Dunhuang
Musée national des Arts asiatiques-Guimet, Paris
EO 3579
RMN

La composition se divise en trois registres. En haut sont disposés les cinq Buddha du Maṇḍala du Plan du Diamant : Vajra-dhātu, au milieu, est encadré par deux effigies d'Avalokiteśvara, l'un « aux Mille mains et Mille yeux » et l'autre « à la gemme qui exauce tous les désirs ». Au centre de la peinture de trouve l'image principale de Guanyin « au lacet infaillible » (Amoghapāśa). Le Bodhisattva est muni de ses attributs particuliers. Il est entouré de quatre de ses aspects et de quatre divinités d'offrandes. Tout autour sont répartis des Bodhisattva d'offrandes, des divinités terribles gardiennes de portes, ainsi que les huit "objets fastes". En bas, les donateurs sont placés en deux groupes de part et d'autre d'une stèle votive non inscrite. Le décor d'encadrement est composé de vajra.

La figure principale de Guanyin au centre est munie du lacet, de la branche de saule, du lotus et du rosaire. Cependant elle ne permet pas d'identifier clairement Amoghapāśa. Il manque la peau d'antilope. Par son exécution et son intérêt religieux considérable, cette peinture est une des plus belles pièces rapportées de Dunhuang. Elle témoigne également de la pratique du bouddhisme ésotérique du Plan du Diamant jusqu'au début du 10e siècle à Dunhuang.

P.L.M.

Bibliography : Giès, Arts de l'Asie centrale, Kôdansha, 1994 I, p. 366, pl. 99, fig. 41-42/ Sérinde, Catalogue Exposition Grand Palais Paris, 1995/1996, n° 284.

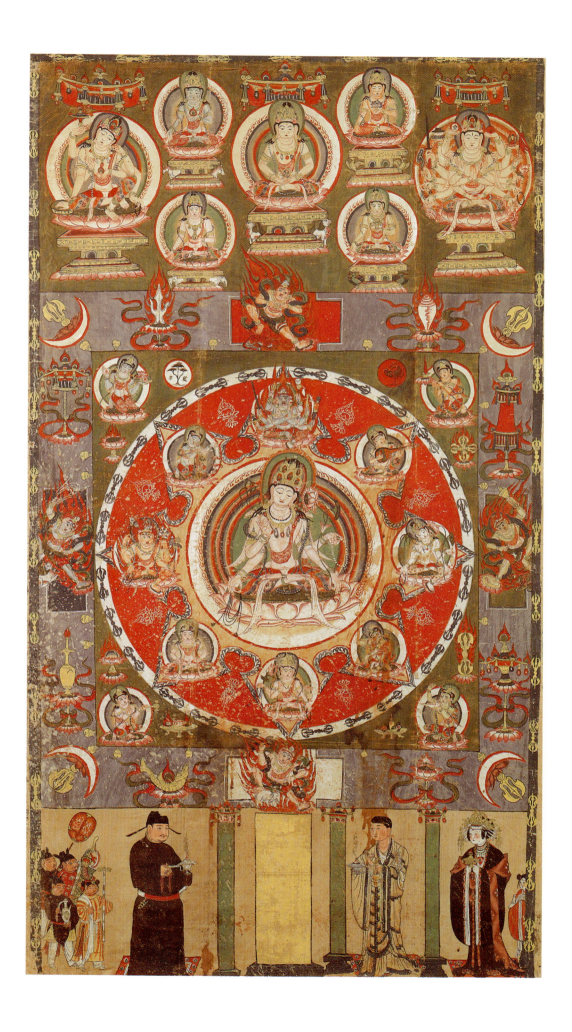

80
防染綾
織品殘片
唐，8至9世紀
生絲
49.0×26.0 公分
伯希和中亞使命行，1906-1908，敦煌
法國國立亞洲藝術-吉美博物館，巴黎
EO 1194
RMN

此件綾殘片係採用留白的方法作裝飾圖案：由藍底、綠色及赭石色的對稱花卉紋所組成。以輪廓彎曲的團花作主題，外為呈波浪起伏的蔓枝所纏繞界定，內則包含一大片圖案化的植物花紋。豐富的裝飾使此件帶鑲邊的殘片具備巴洛克華麗的風采。

此件作品採用大片留白的製作方式而取得裝飾圖案係極少見的例子。花紋裝飾的手法仍引起多項討論：這是使用鏤空版印花法抑或是防染的方式？根據中國專家高漢玉，中國西南部的民族早已知道使用蠟纈的技術（留白施蠟防染）。然而圖案採用留白的複雜技術也可能經由吐魯番盆地傳入，透過來自大唐帝國週邊的民族引入中國。此種類型的絹綾盛行於六朝及唐朝期間。

P.L.M

參考書目：吉埃，《中亞藝術，吉美博物館之伯希和收藏》，國家博物館聯合會，1996，第二冊，頁333，圖版125；《伯希和使命團，敦煌的紡織品》，1970，頁267-268，圖版 56。

Silk Decorated by a Resist Technique
Fragment of Cloth
8th-9th Century
Raw Silk
49.0×26.0 cm
Pelliot Mission in Central Asia, 1906-1908, Dunhuang
Musée national des Arts asiatiques-Guimet, Paris
EO 1194
RMN

This silk fragment has been ornamented using a method of resist dyeing. It presents a symmetrical floral motif in green and ochre on a blue background. Curvilinear sections, each containing a mass of stylized plant forms, are bordered by a series of undulating scroll-ended stems. The rich decoration gives a baroque feel to this edged border fragment.

This piece is a rare example of how patterns were created by leaving large areas of resist dyeing. The decoration process still ask many questions as to whether this done by printing with boards or resist technique. According to Chinese specialist, Gao Hanyu, the laxie technique, otherwise known as resist dyeing, was known among populations in the south-west of China. Elaborate dyeing techniques came in via the Turfan Basin, introduced into China by people coming from the very edges of the Empire. The loom used could have been a heddle loom.

This type of silk was particularly popular during the Six Dynasties and Tang periods.

P.L.M.

Bibliography: Giès, Arts de l'Asie centrale, Kôdansha, 1994 II, p. 333, pl.125/ Mission Pelliot, Tissus de Touen-Houang, 1970, pp. 267-268, pl. 56.

Soierie décorée par réserve
Fragment de Tissu
8ᵉ-9ᵉ Siècle
Soie Grège
49.0×26.0 cm
Mission Pelliot en Asie Centrale, 1906-1908, Dunhuang
Musée national des Arts asiatiques-Guimet, Paris
EO 1194
RMN

Ce fragment de soierie est orné par une méthode de réserve. Il comporte un motif floral symétrique, vert et ocre sur fond bleu. Des compartiments curvilignes, limités par des successions de tiges onduleuses à enroulements, contiennent de grandes masses végétales stylisées. Le riche décor offre un esprit baroque à ce fragment bordé de lisières.

La réalisation de dessins épargnant de larges plages de réserve se présente ici comme un exemple assez rare. Le procédé de décoration pose encore de nombreuses questions : s'agit-il d'une impression par planches ou d'une teinture à réserve. Selon Gao Hanyu, spécialiste chinois, la technique du laxie, ou teinture par réserve à la cire, était connu des populations du sud-ouest de la Chine. Des techniques élaborées de réserve ont pu pénétrer par le bassin de Turfan, introduites en Chine par les peuples venant de la périphérie de l'Empire. Le métier utilisé pourrait être un métier « à lisse ».

Ce type de soieries était répandu pendant la période des Six Dynasties et l'époque Tang.

P.L.M.

Bibliography : Giès, Arts de l'Asie centrale, Kôdansha, 1994 II, p. 333, pl.125/ Mission Pelliot, Tissus de Touen-Houang, 1970, pp. 267-268, pl. 56.

From the Forgotten Deserts : Centuries of Dazzling Dunhuang Art | **339**

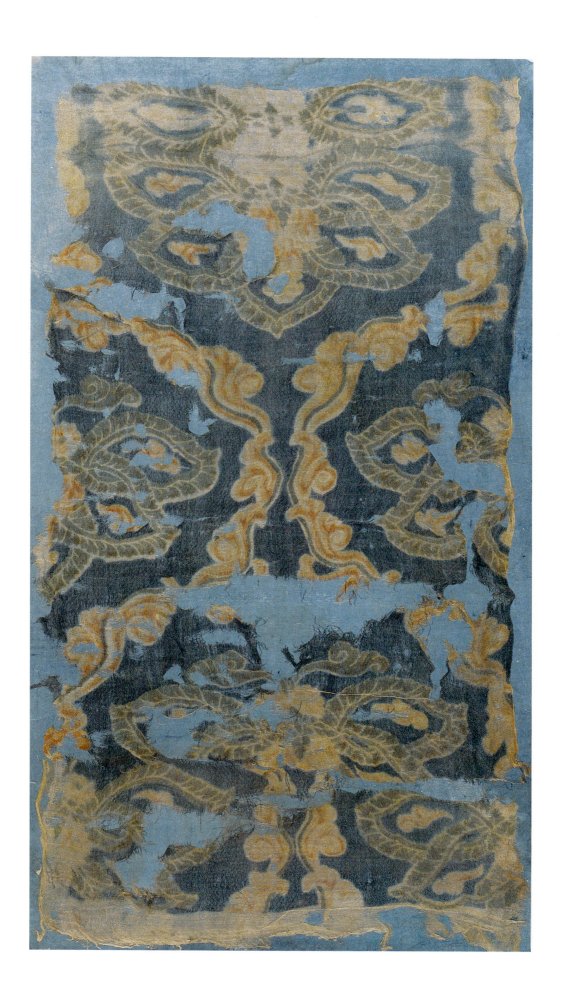

81
維摩詰菩薩
掛幅畫
五代，10世紀上半葉
紙本畫
70.0×33.8 公分
伯希和中亞使命行，1906-1908，敦煌
法國國立亞洲藝術-吉美博物館，巴黎
MA 6277
RMN

本畫的構圖前景係由吐蕃王組成，他由十二位隨從所陪伴。他同時也為其他的人圍繞著，其中一位深膚色的人托著一個香爐的貢品。根據肖像學的規範，維摩詰在此施宣揚教義的說法印。他坐在一張有華蓋的床榻上。在上方有一批乘著雲的獅群。

本作品描寫維摩詰所說經之內容：維摩詰的肖像。此一特殊的圖像主題也存在於某些敦煌石窟的壁畫中：第98號（伯希和編74號），103號（伯希和編54號）和61號（伯希和編117號）洞。

P.L.M.

參考書目：吉埃，《亞洲藝術》，1998年，頁73，插圖 19。

The Gṛhapati
Votive Painting
1st half of 11th century
Paint on Paper
70.0×33.8 cm
Pelliot Mission in Central Asia, 1906-1908, Dunhuang
Musée national des Arts asiatiques-Guimet, Paris
MA 6277
RMN

The king of Tibet is depicted in the foreground of the composition. He is accompanied by twelve figures belonging to his entourage. He is also surrounded by other figures one of whom with dark complexion is making an offering of an incense burner. Vimalakīrti is depicted according to iconographic rules, in a grand gesture of teaching (vitarka-mudrā). He is seated on a canopied four-poster bed. Above, lions are carried on clouds.

This is an illustration of the Vimalakīrti-nirdeśa Sūtra: A portrait of Vimalakirti. This specific iconography can be found in several wall paintings from Dunhuang in Caves no. 98 (Pelliot's 74), no. 103 (Pelliot's 54) and also no. 61 (Pelliot's 117).

P.L.M.

Bibliography: Giès, Arts asiatiques, 1998, p. 72, fig. 19.

Le Gṛhapati
Peinture Mobile
Lère Moitié du 11ᵉ Siècle
Peinture sur Papier
70.0×33.8 cm
Mission Pelliot en Asie Centrale, 1906-1908, Dunhuang
Musée national des Arts asiatiques-Guimet, Paris
MA 6277
RMN

Le roi du Tibet est représenté au premier plan de la composition. Il est accompagné de douze personnages appartenant à sa suite. Il est également entouré d'autres personnages dont l'un de carnation sombre présente l'offrande d'un brûle-parfum. Vimalakīrti est représenté selon la règle iconographique, en grande gestuelle de l'argumentation (vitarka-mudrā). Il est assis sur un lit à baldaquin. Au-dessus, des lions sont portés par des nuages.

Il s'agit ici de l'illustration du Vimalakīrti-nirdeśa Sûtra : portrait de Vimalakirti. Cette iconographie spécifique se retrouve sur plusieurs peintures murales de Dunhuang dans les grottes n°98 (Pelliot 74), n° 103 (Pelliot 54) ou encore n°61 (Pelliot 117).

P.L.M.

Bibliography : Giès, Arts asiatiques, 1998, p. 72, fig. 19.

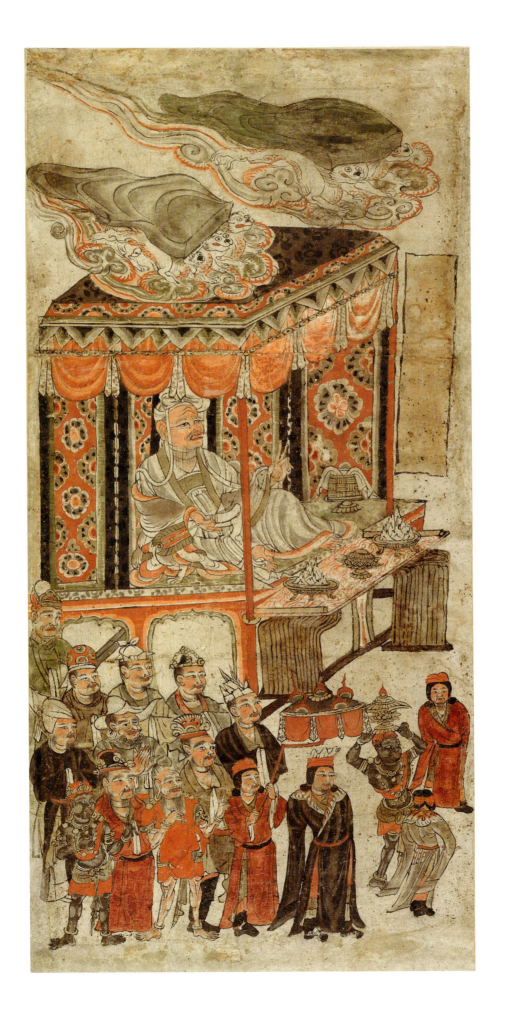

82
「千佛洞」諸洞窟的分佈圖

紙本墨畫，雙面
22.0×17.7公分
伯希和中亞使命行，1906-1908
法國國立亞洲藝術-吉美博物館，巴黎
圖書館，伯希和文獻
Pel. Mi 63
RMN

1908年2月12日，使命團抵達敦煌的綠洲。2月26日，伯希和在千佛洞的頭十個洞窟中渡過一整天[1]。面對其所必須完成的任務之重大，伯希和要努埃特描繪所有洞穴的位置分佈圖，同時以照相方式將遺址幾乎完整地攝影記錄下來。本圖以墨水畫在紙上（雙面半張紙），盡可能寫真地複製懸崖上洞窟及廟宇的實際分佈情況。伯希和並建立了一套特定的編號系統。某些洞窟的草圖還有伯希和親自加上的註釋，上面提及了「佛」、「天」、「供養人」，以及雕像和樓梯的位置。在某些例子中，註文同時還指出努埃特在洞窟中所拍攝相片的數目。

本文件並非使命團在滯留莫高窟期間所繪製唯一的草圖。其他的草圖同樣地也以墨水或鉛筆畫在不同的格式的紙上[2]，這提高了以下的推測之可信度：即當初基於安全措施，他們根據原始草圖而複製了數種稿本。

P.L.M.

1. 《保羅‧伯希和旅途筆記，1906-1908中亞使命行》，目前正由吉美博物館準備出版中。
2. 另一張分佈草圖已在法蘭西學院的出版中發表，參見《敦煌石窟，保羅‧伯希和使記，題記和壁畫》，第6卷，146a至182號洞及其他：莫妮克‧瑪雅爾序註，巴黎，1992，頁 100-101。

Plan of the "Qianfodong" (Dunhuang) Caves

Ink on Paper, Recto Verso
22.0×17.7 cm
Mission Pelliot, 1906-1908
Musée national des Arts asiatiques-Guimet, Paris
Bibliothèque, Fonds Pelliot
Pel. Mi 63
RMN

On 12th February 1908, the mission reached the oasis of Dunhuang. On 26th February, Paul Pelliot spent the day in the first 10 caves at Qianfodong.[1] Faced with the enormity of the task ahead, Pelliot instructs Charles Nouette to make a plan of the caves and to move on to the photographic recording of almost the whole site. This plan, shown here in ink on paper (half a page, recto-verso) is as faithful as possible in its reproduction of the condition of the caves and temples on the cliff. The specific numbering was established by Pelliot. Some of the drawings of the caves have annotations in the hand of Pelliot himself, mentioning figures of "Bouddha," "Gods," "Donors," as well as noting the location of statues and stairways. In some cases, other inscriptions indicate the number of photographs Nouette took in the caves.

This is not the only plan made during the time the mission was at the Mogao site. There are other sketches produced in ink[2] or pencil on paper, in various formats, substantiating the theory that copies of the original plan were made, doubtless as a security measure.

P.L.M

1. Travel Diaries Written by Paul Pelliot, Mission to Central Asia 1906 – 1908, publication pending. Musée Guimet.
2. Another plan has been published in a Collège de France publication: Grottes de Touen-Houang, carnet de notes de Paul Pelliot. Inscriptions et peintures murales. VI. Grottes 146a à 182 et divers. Notes préliminaires de Monique Maillard. Paris. 1992. pp. 100-101.

Plan des Grottes de « Qianfodong » (Dunhuang)

Encre sur Papier, Recto Verso
22.0×17.7 cm
Mission Pelliot, 1906-1908
Musée national des Arts asiatiques-Guimet, Paris
Bibliothèque, Fonds Pelliot
Pel. Mi 63
RMN

Le 12 février 1908, la mission atteint l'oasis de Dunhuang. Le 26 février, Pelliot passe sa journée dans les dix premières grottes du Ts'ien-fo-tong.[1] Face à l'ampleur de la tache qui l'attend, Pelliot charge Nouette d'établir le plan des grottes et de procéder à la couverture photographique quasi complète du site. Ce plan, ici réalisé à l'encre sur papier (une demi- feuille recto-verso), reproduit aussi fidèlement que possible la situation des grottes et des temples sur la falaise. La numérotation spécifique est établie par Pelliot. Certains dessins des grottes portent des annotations de la main de Pelliot lui-même, mentionnant des figures de «Bouddha», «Dieux», «Donateurs», ainsi que l'emplacement de statues et d'escaliers. D'autres inscriptions indiquent cans certains cas aussi le nombre de photographies prises par Nouette dans les grottes.

Il ne s'agit pas là du seul plan effectué lors du séjour de la mission sur le site de Mogao. D'autres croquis ont également été réalisés à l'encre[2] ou au crayon sur papier, de formats divers, accréditant l'hypothèse selon laquelle des copies du plan original auraient été faites, sans doute par mesure de sécurité.

P.L.M.

1. Carnets de route rédigés par Paul Pelliot, Mission en Asie Centrale 1906-1908, en cours de publication. Musée Guimet.
2. Un autre plan a été publié dans une publication du Collège de France : Grottes de Touen-Houang, carnet de notes de Paul Pelliot. Inscriptions et peintures murales. VI. Grottes 146a à 182 et divers. Notes préliminaires de Monique Maillard. Paris. 1992. pp. 100-101.

83
歐瑞爾・斯坦因爵士給保羅・伯希和的信

「吐魯番，1907年11月29日」
紙本墨書
20.0×28.0 公分
伯希和中亞使命行，1906-1908
法國國立亞洲藝術-吉美博物館，巴黎
圖書館，伯希和文獻
Pel. Mi 32
RMN

本封信為歐瑞爾・斯坦因於1907年11月29日給保羅・伯希和的致函。那時斯坦因正在吐魯番，已經待留過敦煌，在當地作了重大的發現並帶回眾多的手卷。而伯希和使命團係於1907年12月27日抵達吐魯番。當時斯坦因已離開了。當伯希和，努耶特及瓦揚一抵達，他們就住進一家小客棧，一位俄羅斯的僕人開始替他們服務。這位俄羅斯人交給伯希和一個盒子，而斯坦因在信中說明盒子中所裝的物品。然而，伯希和在其旅遊筆記中也提及同一件事情：「我在盒子發現我所寫有關烏齊蜜哈旺文章的五份樣本，這些樣本係因由喀什米市寄出，誤寄給斯坦因的，而斯坦因也在信中對於不能與我會面的事情表達遺憾之意，且不能向我證明甘肅曾是其最初計劃中意欲前往的地區。我相信他的說法，但卻從未收到有關說明此一事情的信件」[1]。這段文字反映出使命團一路旅途上所遇到接收信件和行李的問題。斯坦因或許低估了敦煌階段的重要性，這也是之後他為何嘗試輕描淡寫他的疏忽，但同時又希望還能獲買到敦煌的其他文物。

1月11日伯希和使命團離開吐魯番，於1908年2月抵達敦煌，較歐瑞爾・斯坦因晚了將近一年的時間。但是，伯希和的博學多聞將以另一種方式探解開千佛洞的神祕。

P.L.M.

1.《保羅・伯希和旅途筆記，1906-1908中亞使命行》，目前正由吉美博物館準備出版中。

Letter from Sir Aurel Stein to Paul Pelliot
"Turfan, Nov. 29, 1907"

Ink on Paper
20.0×28.0 cm
Pelliot Mission, 1906-1908
Musée nationale des Arts asiatiques-Guimet, Paris
Bibliothèque, Collection Pelliot
Pel. Mi 32
RMN

This letter written by Aurel Stein to Paul Pelliot is dated the 29th November 1907. Stein was in Turfan at this time. He had already spent time at Dunhuang, where he made brilliant discoveries and from where he brought back several manuscripts. The Pelliot mission arrived in Turfan on 27th December 1907. But Stein had already left. From the time of their arrival, Pelliot, Nouette and Vaillant lodged in a guest house where a Russian aqsaqal put himself at their service. This Russian gave Pelliot a packet, the contents of which was mentioned by Stein in his letter. Pelliot, in one of his travel journals, also made allusion to this event: "*I found five copies of my article on Utch Miravan which had been sent to Stein of Kachgar by mistake, and a letter in which Stein expresses his regret at not having seen me and not having been able to prove that the visit to Kan-sou was part of his principal plans. I do not doubt that it was, but the letter on this subject never reached us.*" This remark highlights the many difficulties faced by the mission during its journey with regard to correspondence and transport of luggage. Stein perhaps underestimate the significance of the Dunhuang stage, which he subsequently tried to play down, while envisaging acquiring other relics from the site.

The Pelliot mission left Turfan around 11th January. It reached Dunhuang in February 1908, almost one year after Aurel Stein. In spite of this, Pelliot's knowledge would help to shed light on the mysteries of the Qianfodong caves in another way.

P.L.M.

Lettre de Sir Aurel Stein à Paul Pelliot
« Turfan, Nov. 29, 1907 »

Encre sur Papier
20.0×28.0 cm
Mission Pelliot, 1906-1908
Musée national des Arts asiatiques-Guimet, Paris
Bibliothèque, Fonds Pelliot
Pel. Mi 32
RMN

Cette lettre adressée par Aurel Stein à Paul Pelliot est datée du 29 novembre 1907. Stein est alors à Turfan. Il a déjà séjourné à Dunhuang où il a fait de brillantes découvertes et rapporté de nombreux manuscrits. La mission Pelliot atteint quant à elle Turfan le 27 décembre 1907. Cependant Stein est déjà reparti. Dès leur arrivée, Pelliot, Nouette et Vaillant sont installés dans une auberge où un aqsaqal russe se met à leur service. Ce dernier remet à Pelliot un paquet dont le contenu est mentionné par Stein dans sa lettre. Cependant, Pelliot, dans un de ses carnets de voyage, fait également allusion à cet événement :«*J'y trouve cinq exemplaires de mon article sur Utch miravan qui ont été expédiés à Stein de Kachgar par erreur, et une lettre où Stein exprime son regret de ne pas me voir et de n'avoir pu par suite me prouver que le séjour au Kan-sou était dans ses projets primitifs. De cela je ne doute pas, mais c'est la lettre à ce sujet qui ne nous est jamais parvenue.*»[1]
Cette remarque fait état des nombreux soucis de correspondances et de réceptions des bagages qu'a connu la mission au cours de son périple. Stein avait peut-être sous-estimé l'importance de l'étape de Dunhuang, ce qu'il a tenté de minimiser par la suite, tout en prévoyant d'acquérir d'autres vestiges du site.

La mission Pelliot quitte Turfan et ses environs le 11 janvier. Elle atteint Dunhuang au mois de février 1908, soit près d'un an après Aurel Stein. Néanmoins, les connaissances de Pelliot vont participer à éclairer autrement les mystères des grottes de Qianfodong.

P.L.M.

1. Carnets de Route rédigés par Paul Pelliot, Mission en Asie Centrale 1906-1908, en cours de publication. Musée Guimet.

Turfan: Nov. 29. 1907.

Dear Sir,

The accompanying two covers addressed to you and Dr. Vaillant have recently reached me, having been forwarded with my mail from Kashgar evidently through an oversight of Mr. Macartney's office. As I learned during my short stay here that baggage of yours is deposited with the local Aksakal of Russian Turkestan traders, I have thought it best to leave the covers with him, trusting that they will safely reach you on arrival.

I greatly regret not to have had the good fortune of meeting you on my way back from the Kansu border; for what I know of your previous labours through common friends at Paris & Hanoi and through your publications in the BEFEO. has made me long eager for the chance of personal acquaintance. Had we met it would have afforded me some satisfaction to submit to you evidence showing that the extension of my journey to Lop-nor & Tun-huang was an essential feature of the programme which I submitted to the Indian Government in the summer of 1904 and to which I am bound to adhere. I understand from Mr. Macartney that he has already written to you on the point and, I hope, explained the circumstances.

Assuring you of my sincere regard for your scholarly achievements and wishing you continued success in your present labours, I remain

yours very truly,

M. A. Stein

Professor P. Pelliot.

84

敦煌石窟，120g 號洞窟的描述，
保羅・伯希和的筆記

紙墨，雙面
22.0×17.5 公分
伯希和中亞使命行，1906-1908
法國國立亞洲藝術-吉美博物館，巴黎
圖書館，伯希和文獻
Pel. Mi 75
RMN

本頁手稿來自保羅・伯希和親手所寫的中亞使命行筆記本中的第二冊。此記錄敦煌洞窟筆記的資料中，伯希和以三頁的篇幅（105至107頁）詳細說明120g號洞的佈局[1]。他描述一個「混合式風格」的小洞窟。前空門上有一尊毗沙門天的畫像，而走道門則以「知名的佛教造像」來裝飾，均為「一般式風格」。至於供壇及畫有「千佛」的窟頂，則被他稱為具「古風」，更仔細而言，供壇屬於「黃金時期」。至於描述天堂景象及觀音神蹟的部份則屬於稍後的時期。

伯希和進一步地探索供壇雕像重修的可能性，進行檢視，並記載其損壞及重新上彩的部份。他也談論到有關「具古風格的雕像黑化狀況」之技術問題，並作結論認為可能基於色彩混合，和「使白色變成黑色的化學作用（例如硫化）」所導致的結果。

有關題記部分，伯希和在洞窟內不同的壁上找到五處，其中包括洞窟底壁。這些中文的題銘及塗鴨為120g號洞窟中的圖像及日期提供了重要的線索。伯希和甚至解讀出一些已被刪去「大約十五個字母的西夏的文字」，這在當時還是一種鮮少人研究的文字，位於洞窟的前壁，即「入口的右邊」。

查理士・努埃特應伯希和之要求在洞內照了三張相片。這些相片展現兩側壁畫，右邊是阿彌陀佛樂土，左邊是救苦觀音菩薩。第三張照片則拍供壇上之窟頂，繪有釋迦與多寶二佛像[2]。

以上這些資料都由這位年輕的漢學家珍貴地記載下來，他以相當短的時間針對第120g號洞進行詳細的分析。伯希和編號第120g號的洞也就是敦煌學院所編第45號洞。

P.L.M.

1. 《敦煌石窟，保羅・伯希和使記，題記和壁畫》，第4卷，112a至120n洞，法蘭西學院，巴黎，1984，頁36-39及頁92-95及插圖。
2. 《敦煌石窟，查理・努耶特的照片，伯希和使命團》，巴黎，1921，第4冊，111至120n號洞，圖版 248 至250。

Dunhuang Grottoes, description of the 120g Cave,
Paul Pelliot's Note Book

Ink on Paper, Recto Verso
22.0×17.5 cm
Pelliot Mission, 1906-1908
Musée national des Arts asiatiques-Guimet, Paris
Library, Pelliot Collection
Pel. Mi 75
RMN

These manuscript pages in Paul Pelliot's hand have been taken from notebook B. In this book of notes on the Dunhuang Grottoes, Pelliot devotes 3 pages (105 to 107) to the layout of Cave no. 120g[1]. He describes a small cave in a "varied" style. He writes that the antechamber, bearing a picture of Vaiśravaṇa above the door, and the corridor, decorated with "famous Buddhist images" are "in the usual style". When it comes to the altar and the ceiling painted with the "Thousand Buddhas," he says they are of "an archaic style", and that the altar, more precisely, is "of the best age." The painted scenes of paradise and the miracles of Guanyin are of a later period.

Pelliot also wonders about possible repairs that could be made to the altar statues, noting the areas that have been damaged or repainted. He considers the technical problem of "the blackening of the archaic style figures" and concludes that a possible mixture of dyes and "a chemical reaction that would fade the black areas back to white (by sulphuration, for example)."

With regard to the inscriptions, Pelliot notes five different panels from the cave, including some from the back wall. These inscriptions and Chinese characters give an important indication of the date and the iconography of Cave no. 120g. Although it has been rubbed out, Pelliot deciphers "a Western Xia inscription of approximately fifteen characters", a style of writing that has so far not been the subject of much study, situated on the front wall of the cave "on the right hand side as you enter."

Charles Nouette took three photographs of the cave at the request of Pelliot. These show the two side panels illustrating on the right, the Paradise of Amitābha and on the left, the Guanyin Bodhisattva "Saviour from all dangers." The third photograph shows exclusively the painted ceiling above the altar, which has representations of Buddhas Śākyamuni d Prabhūaratna.[2]

All this information was carefully noted by the young sinologist who carried out a detailed analysis of cave 120g in a relatively short period of time. Paul Pelliot's cave number 120g corresponds to the Dunhuang Academy's number 45.

P.L.M.

1. Dunhuang Grottoes, Paul Pelliot's note book. Inscriptions and wall paintings. IV. Caves 112a to 120n. Collège de France. Paris. 1984. p. 36-39, and p. 92-95, and illustration.
2. The Dunhuang Grottoes Photographs by Charles Nouette. Pelliot Mission. Paris. 1921. Volume IV, caves 111 to 120n, pl. CCXLVIII to CCL.

Grottes de Dunhuang, descriptif de la grotte 120g, carnets de notes de Paul Pelliot

Encre sur Papier, Recto Verso
22.0×17.5 cm
Mission Pelliot, 1906-1908
Musée national des Arts asiatiques-Guimet, Paris
Bibliothèque, Fonds Pelliot
Pel. Mi 75
RMN

Ces pages manuscrites de la main de Paul Pelliot proviennent du carnet B. Dans ce carnet de notes sur les grottes de Touen-Houang, Pelliot consacre 3 pages (105 à 107) sur l'aménagement de la grotte 120g[1]. Il y décrit une petite grotte « de style mélangé ». L'antichambre, comportant une image de Vaiśravaṇa au-dessus de la porte, et le corridor, décoré « d'images bouddhiques célèbres » sont « de style usuel ». Quant à l'autel et au plafond peint aux « Mille Buddha », il les qualifie « de style archaïque, précisément « de la meilleure époque » concernant l'autel, et plus tardif pour les ensembles peint des scènes de paradis et des miracles de Guanyin.

Pelliot s'interroge plus loin sur la possible réfection des statues de l'autel dont il note les parties endommagées et les parties repeintes. Il aborde la question technique « des conditions de noircissement des figures de style archaïque » et conclut à un possible mélange des teintes et à « l'action chimique qui aurait fait passer le blanc au noir (par sulfuration par exemple) ».

En ce qui concerne les inscriptions, Pelliot en relève 5 sur les différents panneaux de la grotte, entre autres sur la paroi du fond. Ces inscriptions et graffito en chinois donnent des indications importantes sur les dates et l'iconographie de la grotte 120g. Même effacée, Pelliot déchiffre «une inscription Western Xia d'environ quinze caractères », écriture encore peu étudiée et située sur la paroi d'avant de la grotte, « partie de droite en entrant ».

Charles Nouette réalise trois photographies de la grotte sur la demande de Pelliot. Celles-ci montrent les deux panneaux latéraux illustrant, à droite, le Paradis d'Amitābha et à gauche, le Bodhisattva Guanyin « sauveur de tous les périls ». La troisième photographie est consacrée au plafond peint au-dessus de l'autel avec les images des *Buddha* Śākyamuni et Prabhuūaratna.[2]

Toutes ces informations sont précieusement notées par le jeune sinologue qui parvient à réaliser une analyse détaillée de la grotte 120g en un temps relativement court. La grotte n° 120g de Paul Pelliot correspond au numéro 45 de l'Académie de Dunhuang.

P.L.M.

1. Grottes de Touen-Houang, carnet de notes de Paul Pelliot. Inscriptions et peintures murales. IV. Grottes 112a à 120n. Collège de France. Paris. 1984. pp. 36-39, et pp. 92-95, et ill.
2. Les Grottes de Touen-Houang. Photographies de Charles Nouette. Mission Pelliot. Paris. 1921. Tome IV, grottes 111 à 120n, pl. CCXLVIII à CCL.

toute visuelle de toutes les mains extérieures, cette répétition des statuts grandes nature à la partie inférieure des parois d'Ouest, cette partie fait répéter ses gros à une étendue; je signalerai en bordure la décoration primitive.

Les deux petits panneaux de la paroi du fond, de chaque côté de l'autel, restent libres : on lui passe une ligne entière, de « l'époque du style nouvel (à ce début je dois un noté de même nature fait peint aux aspects peint de Nord); une inscription très pâle nous renseigne à ce sujet : 地藏菩薩一軀│清信弟子佛弟泊幸為先亡父母及法界│眾生作福一心供養 ǁ

Un peu plus tard dans l'histoire, quatre petits bodhisattvas furent peints aux pieds de la personnage grandeur nature, et une petite inscription porte: 女弟子武氏為在│蜀　皆寬能造暨供養 ǁ (Nous avions bien peint du suite nous avec la gette).

Sur le petit panneau de gauche fut peint un bodhisattva ayant un nom de la main gauche : Meng Li-chung, avec une inscription très petite: 清信佛弟子蜜譯周景奇……觀世音菩薩一軀一心供養 ǁ (Nous la formule qui rappelle celle de la gette 10, bien que le nom ne semble pas être ceux de la gette 10).

Enfin, sur la paroi d'ouest, partie à droite en entrant, qui doit également être libre, deux petits bodhisattvas furent peints, gelé à la même époque du style nouvel. Comme la partie inférieure est touchée, peut-être y avait-il — et ici des bodhisattvas d'ailleurs aussi disparus.

Tant sur cette partie de Nord du panneau d'avant que sur la bande définitivement plus tard une corniche et qui vient sur cette partie Nord, il y a un décor d'inscription aujourd'hui très effacés, entre autres, une inscription dix-huit d'environ 15 caractères, aujourd'hui inintelligibles; comme date, un 天至三年, une autre 乾德元號, une autre 15 jour du 8e(?) mois de l'année 泰定.

J'ai essayé de me rendre compte, à propos des peintures de cette grotte, des conditions de raisonnement des figures des style archaïque. Il est certain qu'il n'y a pas de grande différence de dessin entre le style archaïque et le début du style nouvel; la composition même se rapproche fort, et il n'y a rien d'aussi tranché que par exemple entre le style archaïque nouvel et le style ancien qui les précède; je n'en trouve plus maintenant, plus "archaïque" encore que l'archaïque que je dû baptiser de ce nom. Et la différence de couleur qui sépare notre le style archaïque finissant des débuts du style moderne n'est pas essentiellement tranchée; elle nous paraît aujourd'hui; je veux dire que les peintures archaïques étaient primitives, moins sombres que maintenant; on voit des figures qui sont aujourd'hui

──

Gette 120 f. (Il y a dessins ou retours nouveaux ?) du style nouvel. Quant aux souvent refaits modernes supposé cela elle est à il y a la relation de 97 transcription. De un qui primitif : le type 97 (et peut-être profond au lieu d'autel cas aux style nouveau, de son doit de même cercueil une chambre l'arête d'ouverte de la voûte même aussi, et à cette voûte correspond proviendrait du plafond peut-être, actuellement dit, où a un autel de la gette, la longue inscription Wei Ping — de l'époque des Pei-Ch'i-ong. Wei Ch'ing qui serait de l'époque du type 97.

Es l'antichambre, on

Gette 120 g
principles antichambre de style
supposé aff
principles type style
archaïque à ?

Vaiśravaṇa ou
l'antichambre on sépare
Coudre le style nouvel
simples bodhisattva debouts, remontée le Buddha et le bâton pour donner au retour

Le gette représente le meilleur exemple du style où même la partie archaïque d'un bonne à l'autel où du style archaïque, on prit une voûte inférieure et peignit sur la paroi droite la paroi gauche la même — cette même époque, un entrante de la paroi droite Wei-ch'ing qui serait à l'occasion d'une station

MUSÉE GUIMET

[Handwritten manuscript pages in French, largely illegible cursive notes. Contents not reliably transcribable.]

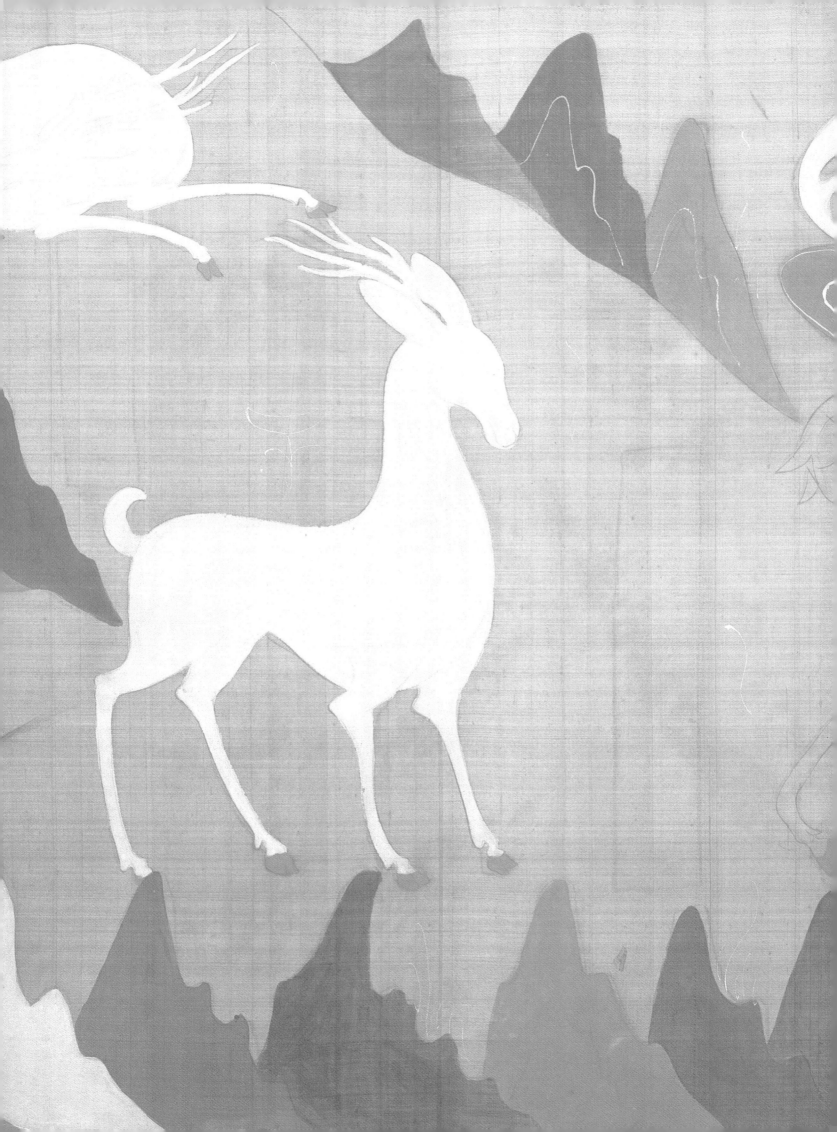

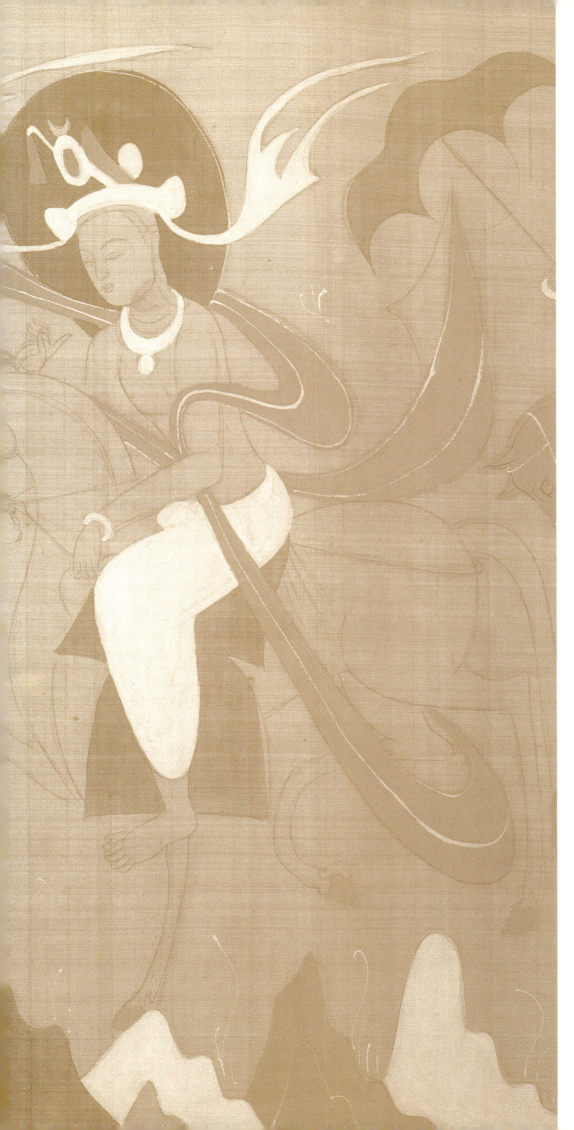

國立故宮博物院
國立歷史博物館 典藏
私人收藏

Works from National Palace Museum, Taipei;
National Museum of History, Taipei;
Private Collections

82
釋迦說法
摹自莫高窟第250窟北壁
北魏
本幅布本
145.5×127.4 公分
臨摹者：張大千
國立故宮博物院

Śākyamuni Sermon
Copied from the North Wall, Cave No. 250, Mogao Grottoes
Northern. Wei Dynasty
Scroll, Canvas
145.5×127.4 cm
Copied by：Chang Da-chien
National Palace Museum, Taipei

〈釋迦說法〉之繪畫題材在莫高窟各朝代之各窟中屢見不鮮，而此作繪於西魏早期，所描繪的形象特別高大，強調出說法之主題。北魏早期畫風比較富有粗獷的拙趣，但此作表現得靈巧多姿，尤其上方的飛天與週遭的脇侍菩薩都畫得十分生動有力，已逐漸邁入較成熟的藝術表現形式。

原畫色彩含有汞、硫的成分今多以氧化變成黝黑，而線條因色澤的斑剝變化而呈現沉鬱粗重的風貌，而大千卻以其個人之創作經驗與畫學修養將之恢復舊觀；亦即所謂「復原式」的臨摹，因此畫面形成色澤鮮麗與線條均勻的風格表現，其朱紅重彩之設色勾勒與原蹟風貌大為不同。兩者併觀，亦可謂饒富意趣。

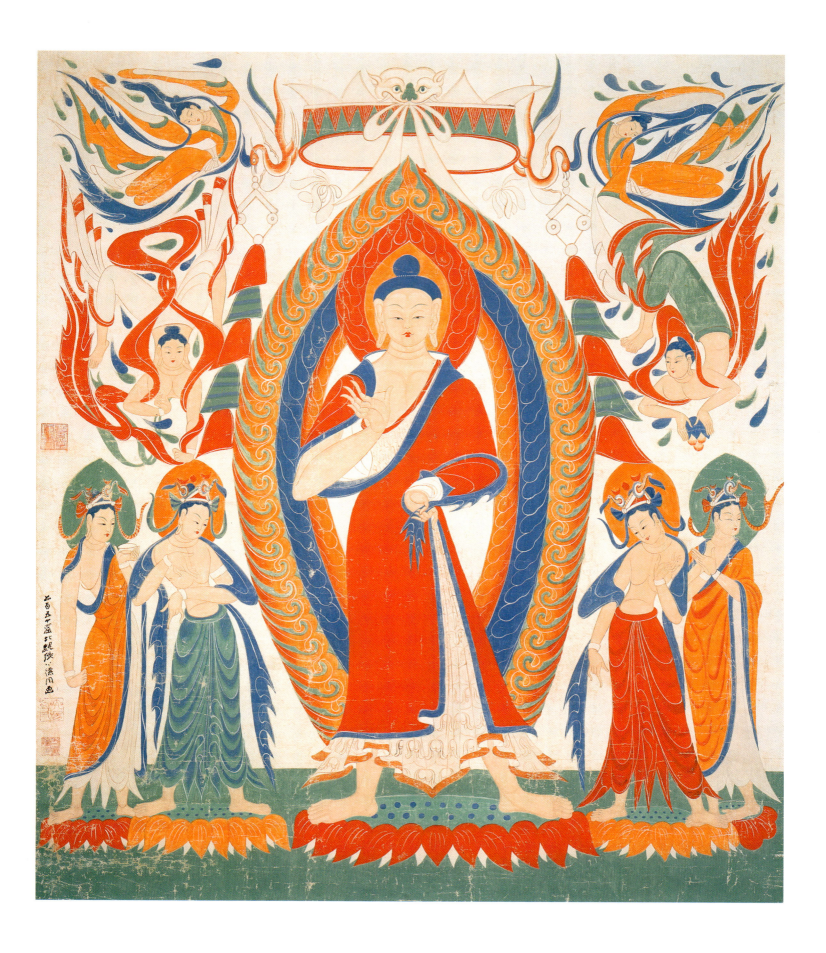

83
竹林大士像
摹自榆林窟第19窟
盛唐
本幅絹本
236.0×96.2 公分
臨摹者：張大千
國立故宮博物院

Veṇuvana-Mahāsattva (Bodhisattva with Bamboo)
Copied from Cave No. 19, Yulin Grottoes
High Tang Dynasty
Scroll, Silk
236.0×96.2 cm
Copied by：Chang Da-chien
National Palace Museum, Taipei

　　此幅尺幅高達兩公尺餘，描繪功夫特別精細繁複，且配飾造型亦十分特殊；即以大士頂上之寶蓋華飾以及圓光之描繪已無比精麗細緻，而身後之碧竹亦細細繪出，特有一股清逸之氣。菩薩合什身軀朝左，而法相卻向右迴視，造成一種動勢；面容開相與眉目手足之線條用筆無不生動柔美。菩薩足踏七彩寶蓮，而蓮花枝葉蓮蓬蔓生，生意盎然，造型尤特殊少見。畫上題識「番僧（喇嘛）昂吉同繪」，顯示畫家不掠人美的風範。

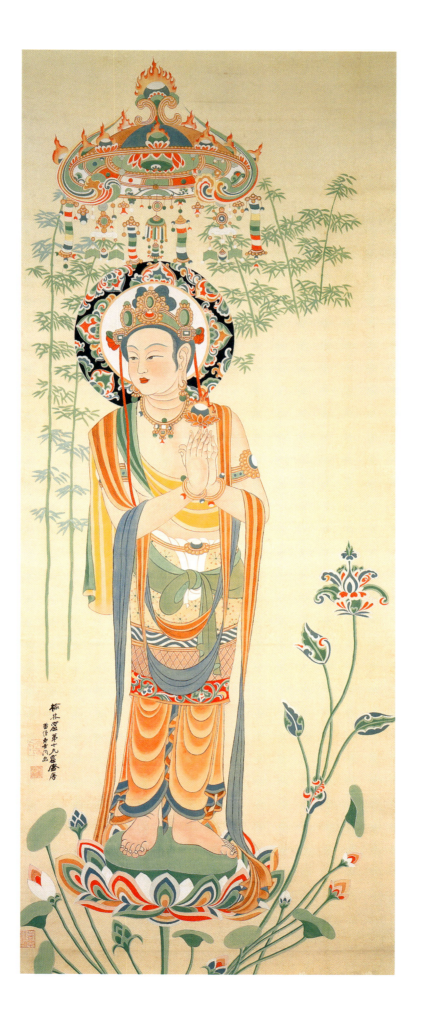

84
羅漢像
摹自榆林窟第9窟
北宋
本幅絹本
167.2×85.5 公分
臨摹者：張大千
國立故宮博物院

Arhat
Copied from Cave No. 9, Yulin Grottoes
Northern Song Dynasty
Scroll, Silk
167.2×85.5 cm
Copied by：Chang Da-chien
National Palace Museum, Taipei

　　此幅羅漢描繪亦精細，設色尤見鮮麗，羅漢法相典雅，身著紅綠華彩袈裟，頂後五彩圖飾圓光；足踏蓮花座，四周枝芽蔓生，花葉延展綻放，色澤妍麗生動，極富裝飾性。此作色調穠艷，卻具有一種清逸不俗的氣韻，有如瓷器的「鬥彩」，足見畫家於色彩一道別具匠心。

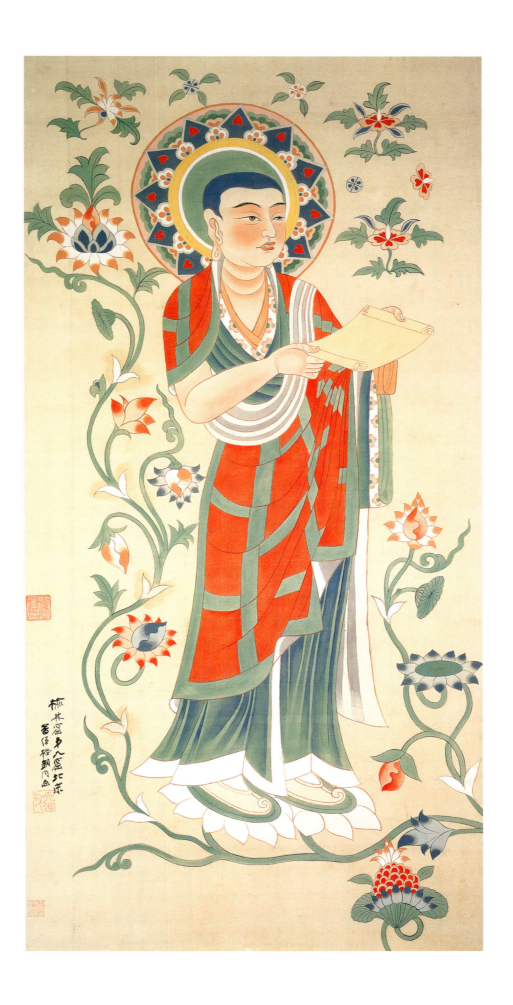

85
歸義軍節度使曹延祿供養像
摹自榆林窟第25號窟門南壁
宋初
本幅布本
186.4×89.6 公分
臨摹者:張大千
國立故宮博物院

Donor Portrait, Returning Commandery Commissioner Cao Yanlu
Copied from the South wall, Entrance Way to Cave No. 25, Yulin Grottoes
Northern Song Dynasty
Scroll, Canvas
186.4×89.6 cm
Copied by:Chang Da-chien
National Palace Museum, Taipei

　　晚唐張議潮於敦煌崛起,使河西地區重歸大唐版圖,張氏家族統治敦煌為節度使凡四任而止;五代初長史曹議金兄弟繼起統治敦煌地區,世奉中原正朔,曹延祿則為曹議金之孫,宋太平興國五年(980)授本(歸義)軍節度使,此為其供養畫像,寫實性相當高。
　　曹氏頭戴烏黑唐式幞頭,身著紅色官袍,足蹬烏靴,手持雕花香爐;眉目五官描繪精細,敷染醇厚,玉面朱唇,十分生動,顯得儀表不凡。畫面以高彩度的紅色硃砂構成主色調,搭配有黃、橙、青、綠等鮮麗色澤圖飾的華貴地毯,形成畫面豐富亮麗卻又色彩調和的安定視覺效果。

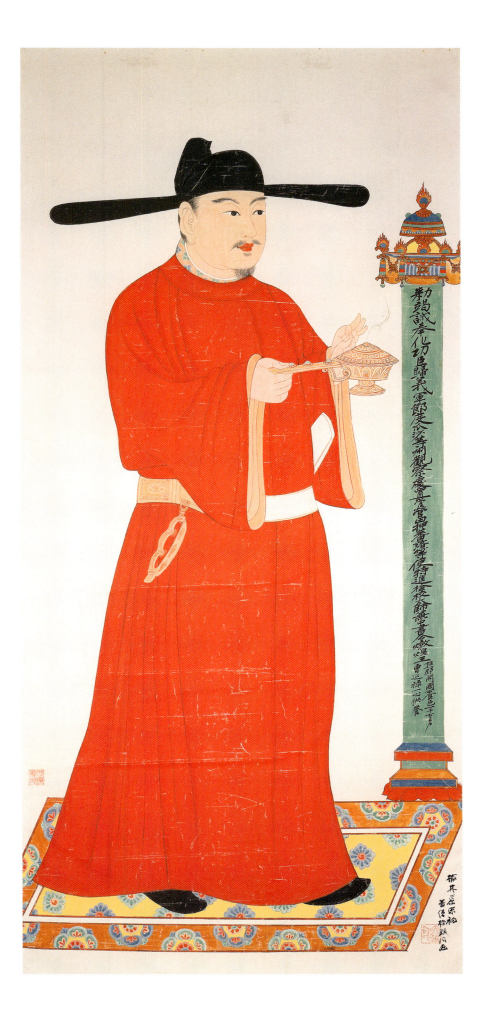

86
曹廷祿妻于闐公主李氏供養像
摹自榆林窟第25窟後洞北壁
宋初
本幅布本
184.3×88.2 公分
臨摹者：張大千
國立故宮博物院

Donor Portrait, Wife of Cao Yianlu;
Princess Khotanese, Li
Copied from the North Wall, Rear of Cave, Cave No. 25, Yulin Grottoes
Northern Song Dynasty
Scroll, Canvas
184.3×88.2 cm
Copied by：Chang Da-chien
National Palace Museum, Taipei

　　曹廷祿妻係于闐國第三公主，當時敦煌地區華夷併處，統治者為求邦國與社稷之和睦安定，常與各國貴族聯姻；此即為號稱「天公主」曹廷祿妻之畫像，「李氏」乃為賜姓。
　　貴婦身著朱紅繡鳳寬袖袍，頭戴鳳冠華飾，雙手持雕飾香爐，儀態明艷大方，表情虔敬莊重。衣紋與身軀之線條精準流暢，華表飾頭與地毯圖案描繪精細，色澤鮮麗典雅；紅、綠、黑諸色則形成對比強烈的畫面視覺效果。

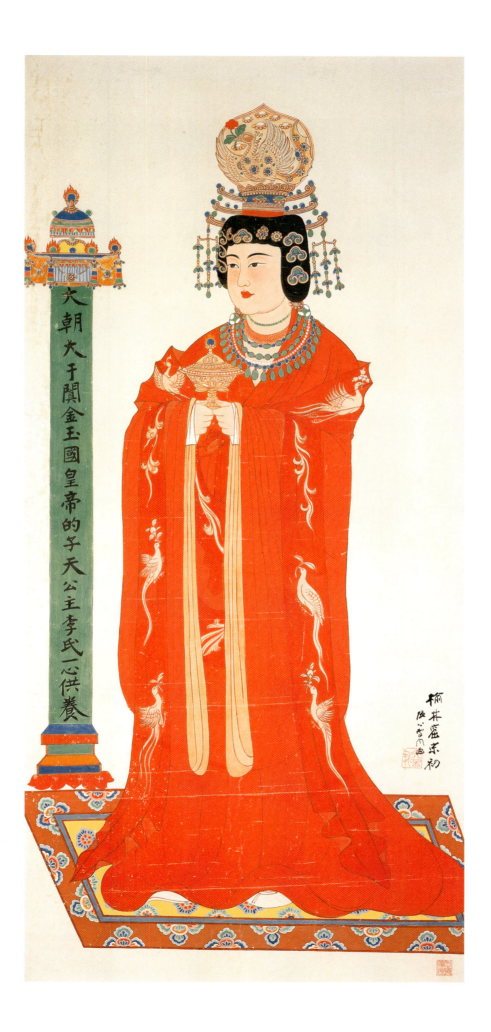

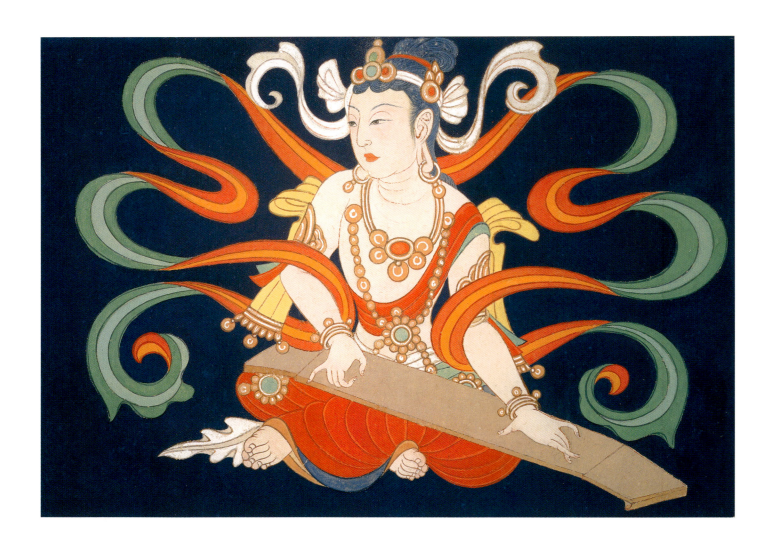

87-90

伎樂菩薩	Vādya Bodhisattva
摹自莫高窟第130窟	Copied from Cave No. 130, Mogao Grottoes
北宋	Northern Song Dynasty
本幅紙本	Scroll, Silk
50.5×72.5 公分	50.6×72.5 cm
50.6×72.5 公分	50.6×72.5 cm
50.6×72.4 公分	50.6×72.4 cm
50.6×72.4 公分	50.6×72.4 cm
臨摹者：張大千	Copied by：Chang Da-chien
國立故宮博物院	National Palace Museum, Taipei

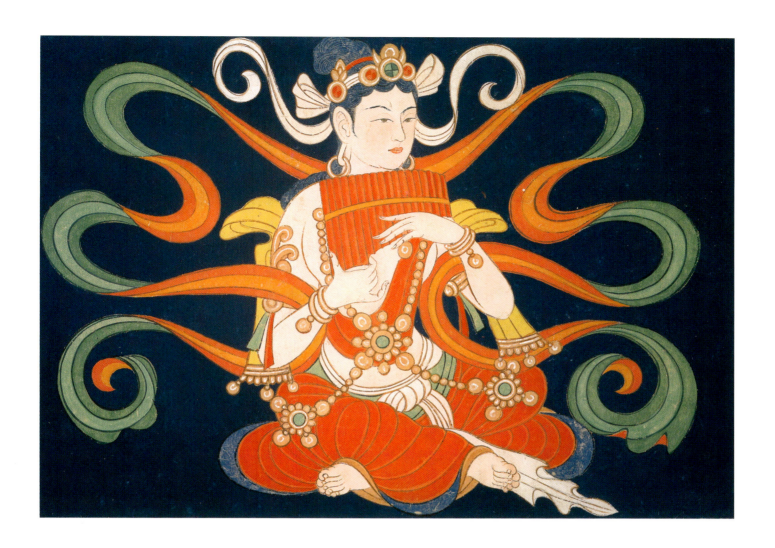

敦煌壁畫中描繪音樂舞蹈的題材處處可見，而大致可分「天樂」與「俗樂」兩類，前者意指「佛教世界」之仙樂，後者則是「人世間」的世俗音樂；其實兩者皆以現實世界為描寫之藍本，只是加以藝術的提煉與美化。

唐代的「伎樂天」多描繪於各舖淨土經變之中，皆已成為有龐大組織合奏的大型舞樂結構；晚期的「天樂」則多有畫在主尊佛像蓮座下方，如大千所臨〈伎樂菩薩〉之四幅連作，分別描繪演奏之樂器為瑟、管、笙、簫（疑為笛）。

畫幅背景作青地，菩薩身著朱紅法衣，佩帶瓔絡華飾，巾帶飛揚，而各具生動精妙之儀態丰神。此四幅連作用筆絕精，開相典雅，將菩薩伎樂端莊優美的儀容描繪的極盡動人；試觀其面目五官、手足、髮髻等細部線描最能見其非等閒之功力。此外，其敷染醇厚，設色鮮麗濃艷而脫俗，將菩薩的膚色暈染如真。原窟伎樂菩薩為十二尊，畫家擇其四而臨摹之。

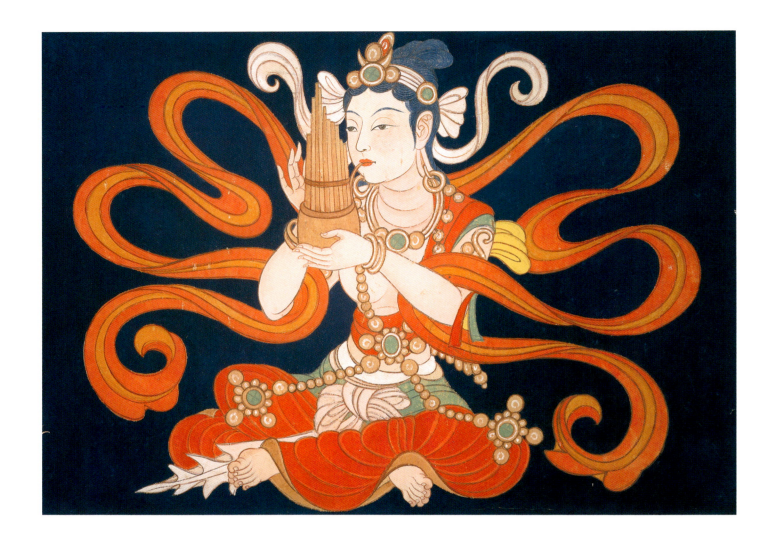

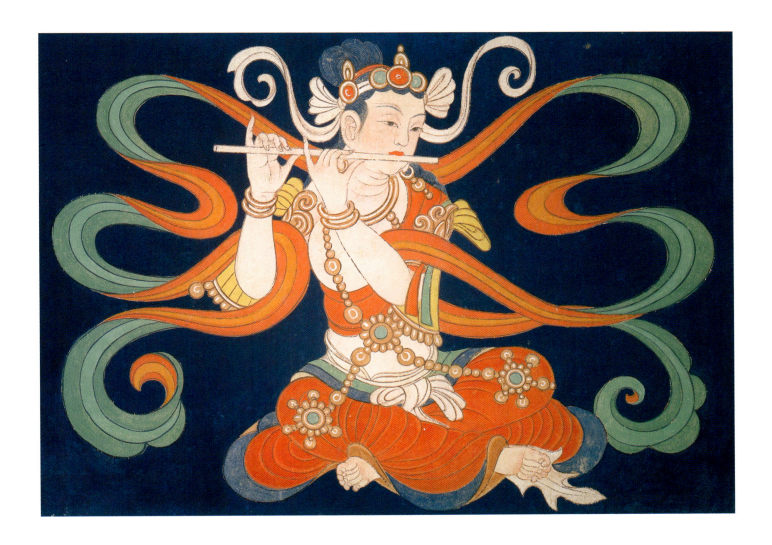

91
藻井
盛唐
75.5×74.2 公分
本幅絹本
臨摹者:張大千
國立故宮博物院

Ceiling Apex Design
High Tang Dynasty
75.5×74.2 cm
Scroll, Silk
Copied by:Chang Da-chien
National Palace Museum, Taipei

　　敦煌莫高窟的藻井圖飾變化繁複,初唐時期畫面中心方井較大,而盛唐以後則逐漸縮小,倒斗層次漸多,四周邊飾花紋有團花、半團花、聯珠、牡丹、蓮花、石榴、葡萄、寶相花、幾何紋、棋格紋、雲紋、山紋、流蘇等數十種以上。
　　本幅藻井四角對稱之角花沿襲初唐,中心以粉紅、朱色為地,飾以青、黃、橙諸色卷草;井圍倒斗層次花式增多,有石青、石綠、粉紅、赭黃諸色地,並分別飾以菱格、葡萄、寶相、牡丹等諸花紋。最外圍以黃色為地,並彩以各色紋飾,將全幅圖案裝點的富麗堂皇,光彩圓潤,呈現出大唐盛世昌茂繁榮的氣象。

92
藻井
盛唐
本幅布本
75.4×76.2 公分
臨摹者：張大千
國立故宮博物院

Ceiling Apex Design
High Tang Dynasty
Scroll, Canvas
75.4×76.2 cm
Copied by：Chang Da-chien
National Palace Museum, Taipei

　　本幅藻井飾倒斗形之四方花式，中心為紅地，繪丹、赭、青、綠套色四色蓮，再次為橙赭、粉黃為底，分綴對稱花飾；四周邊飾繪以敷彩卷草、各色花果，以及幾何菱格的圖案，最外圍則飾以紅底波浪布卷紋形，呈現出光鮮亮麗的華貴氣象。

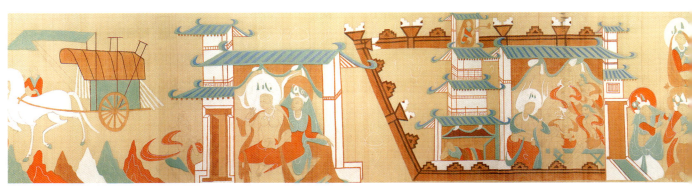

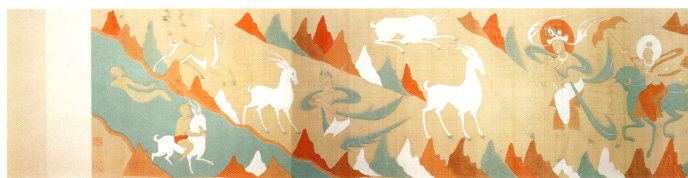

93

鹿王本生故事　　　　　The Jātaka Tale of Deer King
摹自莫高窟第243窟西壁　Copied from Cave No.243, Mogao Grottoes
北魏　　　　　　　　　Northern Wei Dynasty
本幅布本　　　　　　　Scroll, Canvas
61.5×607.4 公分　　　　61.5 ×607.4 cm
臨摹者：張大千　　　　Copied by：Chang Da-chien
國立故宮博物院　　　　National Palace Museum, Taipei

　　敦煌早期壁畫風格，係一種連環畫的佛經故事，描繪佛陀前生鹿王之因緣故事：首段左起畫九色鹿王從河中救一溺者，溺者感恩而鹿王囑之勿洩其蹤的畫面。次段右起畫王后夢見九色鹿，要求國王獵取為華裘以逞私慾。再中段繪溺者竟望恩負義向國王告密。構圖逐漸趨向中間畫面之核心，繪國王立即率眾入山獵鹿，鹿王於國王面前陳述救溺者之經過，國王深為感動，遂下令俟護鹿王，而溺者遭生瘡惡報。

　　畫面由兩方向逐漸趨中的連續時空情狀，構圖意念新穎活潑，呈現虔敬感人的情節發展。畫風帶有圖案性之意味，作品並沒有畫完，但造型優美流暢，線條生動精準；石綠、硃砂的對比色調鮮麗明亮，呈現出優雅，又帶樸拙趣味的早期敦煌壁畫風格。

　　依佛經所記載，鹿王見國王時雙膝跪地，狀頗哀憐；而這舖壁畫的原作者卻將鹿王畫得抬頭挺胸，且義正莊嚴地控訴溺者的負恩，是突破陳規而傾注個人情感的新創意，畫家匠心獨具之高度藝術境界令人動容。

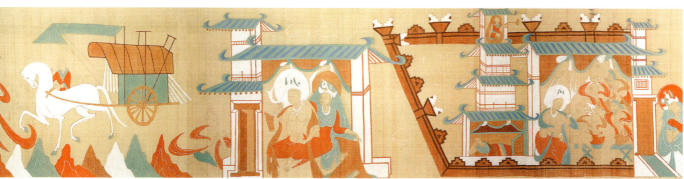

This early mural of Dunhuang was a Buddhist scripture story executed in a style similar to comic strips. It depicts the tale of cause and effect of one of the Buddha's past lives as a deer king. It begins from the left with the image of the nine-color deer king rescuing a man on the verge of drowning in a river. The rescued man was thankful and was enjoined never to reveal the deer king's whereabouts. The second section starts from the right. The queen dreams of the nine-color deer and asks the king to hunt it for its beautiful skin to make a coat for her. This is followed by the section in the middle describing when the rescued man ungratefully tells the king the deer's whereabouts. From this point the composition shifts toward the center as the king leads his men into the mountains to pursue the deer. Then the deer king tells the king the story of rescuing the drowning man; he is deeply touched and gives the order to protect the deer king; at this moment skin ulcers begin to grow on the rescued man as retribution.

The images move in toward the center from the two sides; this is a new and vigorous format producing a sincere and moving plot development. Although damaged, the painting has a compelling pattern — like design executed with elegant fluency and brisk linear precision. In spite of the unpretentious and amusing quality of paintings from the early period, the fresh and brilliant contrast between malachite green and cinnabar red shows elegance.

Buddhist texts have it that the deer king appears pathetic when kneeling in front of the king. Quite the contrary, the original artist of this mural depicted the deer king as standing upright and righteously accusing the ungratefulness of the man he had rescued from drowning. Breaking the old rules by infusing creative ideas with personal emotions bespeaks the high and unique artistic level of the painter.

94
文殊問疾 粉稿
185.0×109.5 公分
臨摹者：張大千
私人收藏

Draft copy, Mañjuśri Asking after Vimalakiirt's Illness
185.0×109.5 cm
Copied by：Chang Da-chien
Private Collection

　　維摩詰是在家修行的居士，素以狡點慧辯著稱；維摩詰稱病在家，佛世尊擬派弟子前往慰問，但諸弟子怕被捉弄而無人敢前往。最後乃由以智慧出名的文殊菩薩前往問疾，於是展開了一場佛學義理的精奧說法論辯，是佛經裏的一段著名故事。

　　畫面右方維摩詰高踞床褟，好整以暇地與左方正在發言的文殊菩薩展開論辯。雙方各有信眾弟子簇擁，有的虔敬向前聆聽，有的卻私下交換意見，似對雙方答辯毫無礙難的法力十分傾讚；上方尚有飛天環繞，場面氣氛營造地十分熱切，是盛唐壁畫中不可多得的精采傑作。

　　此畫以淡彩設色，雖是粉稿摹本，但大千以精鍊流暢的線條將原畫的生動傳神作了精準的傳達。大千的線描用筆沒有刻意於粗細一致，亦非亦步亦趨地描摹原蹟，而是自運筆法率性寫來：其將文殊菩薩、維摩詰、諸弟子信眾等眾多人物，各具表情姿態且鬚髮如生地表現出來，流露出畫家不凡的才情氣度。

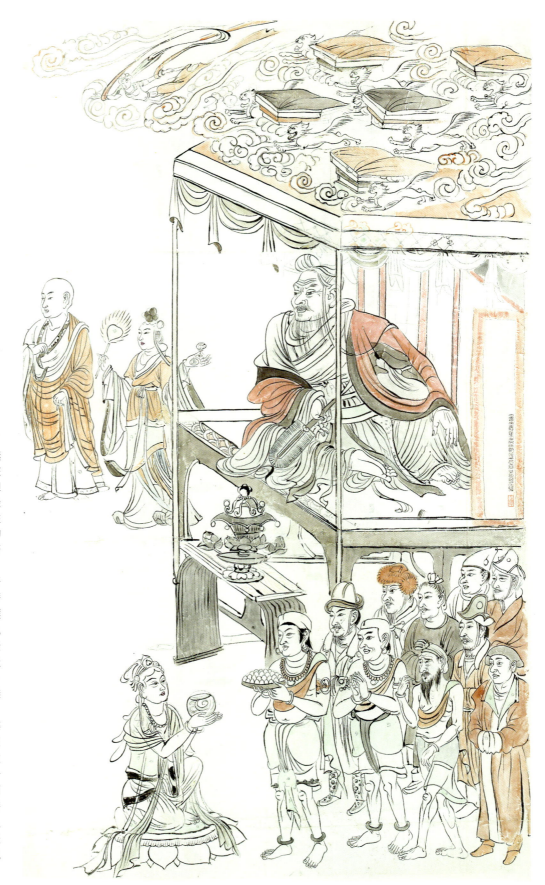

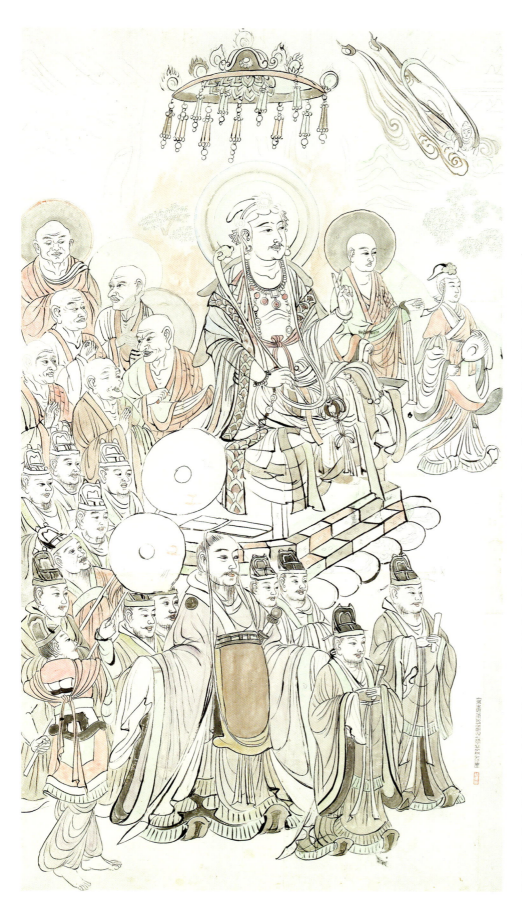

Vimalakiirt is a Buddhist layman famous for his clever debating. One day he claimed to be sick at home. The Buddha wanted to send a disciple to pay him a consolatory visit, but everyone turned down the mission for fear of getting teased by him. In the end Mañjuśri, renowned for his wisdom, made the trip. A profound debate over Buddhism resulted and became one of the celebrated stories from the Buddhist scriptures.

On the right side of the painting, Vamalakiirt sits up in bed and leisurely begins the debate with Mañjuśri, who's in the middle of speaking on the left. Fans and followers of both sides gather around. Some respectfully crane forward to listen, whereas others seem to be exchanging opinions in private and looking absolutely impressed by the eloquence of both debaters. The ambiance appears stimulating and flying goddesses circle above. It is one remarkable masterpiece among High Tang murals.

This painting basically employs light colors. Although they are only drafts, Chang Da-chien's refined and smooth lines have accurately transferred the vivacity of the original. His sketching was not intended to create lines of even thickness. Neither was it done methodically to produce an exact copy. It was spontaneously carried out to vividly depict the expressions and facial features of Mañjuśri Bodhisattva, Vimalakiirt, the disciples, and followers. It totally exhibits an outstanding artist's extraordinary talent.

95
瓔絡大士
113.0×65.5 公分
臨摹者：孫雲生
國立歷史博物館

Muktāhāra-Mahāsattva
113.0×65.5 cm
Copied by：Sun Yun-sheng
National Museum of History, Taipei

　　孫雲生（1918-2000）為大千門下高弟，長期追隨先生習畫，臨摹敦煌菩薩佛像臨本，上探隋唐高古之繪畫技法，頗得大風堂真傳。本館典藏孫氏佛畫臨本多幀，描繪功力精湛，於此遴選二幅一併展出。
　　此作摹於敦煌莫高窟晚唐第152窟，大士法相莊嚴，身著華飾天衣、環玉臂釧，頭戴寶冠，背飾火焰佛光，端作於青綠雙色蓮花寶座之上。通幅用筆嚴謹，色澤濃艷，敷染醇厚，再現了唐代畫家古典精麗之描繪技法風格。

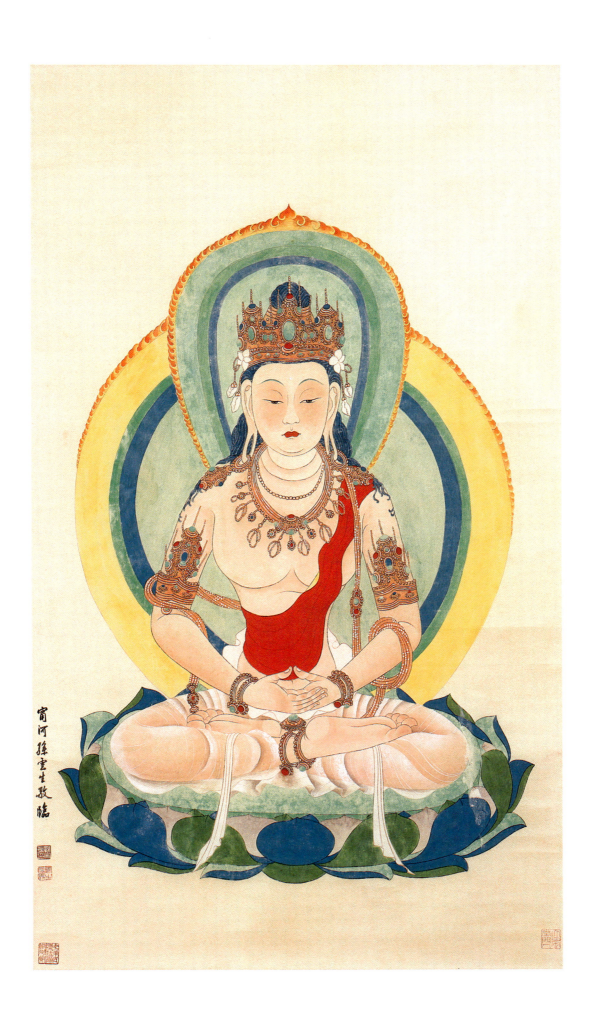

96
飛天
74.5× 40.5 公分
臨摹者：孫雲生
國立歷史博物館

Apsara
74.5× 40.5 cm
Copied by：Sun Yun-sheng
National Museum of History, Taipei

　　飛天係佛教壁畫中所常見圍侍佛菩薩的天女，猶如西方宗教畫中的「天使」。在敦煌大場面之壁畫雕塑中，尤常見「飛天」的身影飛繞在空中。此幅描繪飛天騰越雲霧之上，其一飛沖天之勢結合了「力」與「美」之雙重特徵，在佈局方面更是匠心獨運，構圖採取上實下虛的視覺效果，使畫面更生動而富於變化；用筆流暢，設色精美，是一張出色的摹本。

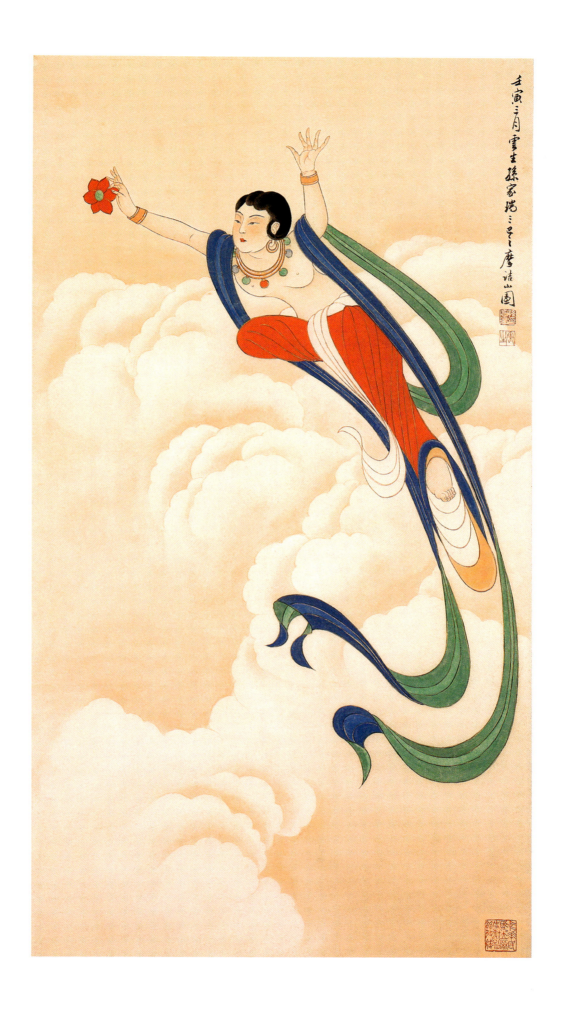

97
唐人寫經卷
25.0×288.5 公分
國立歷史博物館

Sūtra Scroll
Tang Dynasty
25.0×288.5 cm
National Museum of History, Taipei

　　清光緒年間敦煌石室發現大量藏經寫本後，書史大為改變。其內容豐富，包括西晉至北宋間墨跡，而唐代最豐，此為敦煌石室出土遺書之所傳世者，今藏台北國立歷史博物館。唐代寫經書體，源於前代。西晉經卷寫法便已粗具經卷體的規模，至南朝時，字體益趨端整，楷法漸備，寫經字體風格特色越發明顯；就是屬北朝之作品其風格亦與南朝相去不遠。此作書法近於唐楷，點畫妥貼，使筆輕重有致，保有鮮明的寫經特色。

加羅國王佛入涅槃經三七巳尒乃方知尒
時師伽那王佛入涅槃經三七巳尒乃方知
尒時波肩羅外道名王佛入涅槃經三七巳
尒乃方知即將臣從疾往拘尸既至拘尸即
見無數四兵之衆防衛拘尸繞無量重復見
城門有大呪師防山外難王問呪師佛涅槃
耶荅言佛涅槃未巳經四七當令大衆將分

城門有大呪師防山外難王問呪師佛入涅槃
耶荅言佛涅槃未巳經四七當令大衆將分
寶莊嚴安置七寶舍利金塔復見大衆悲哀
呪師聞巳即聽前入至四衢道見師子座七
至城欲入城礼拜供養如来舍利汝可開路
舍利王語呪師佛入涅槃我都不知故令晚
我都不知一何苦我不得見佛請衆與我一
分舍利還國供養衆言汝何来晚佛巳先説
分布法軷舍利皆巳各有所請愁夏不乐即礼
可還宮王及臣衆不果所請愁夏不乐即礼
舍利悲戀而還

大般涅槃經後分卷第卅二

98
五代人寫經殘卷
24.0×177.5 公分
國立歷史博物館

Scroll Fragment, Sūtra Copy
Five Dynasties
24.0×177.5 cm
National Museum of History, Taipei

安樂品

亦不親近　增上慢人　貪著小乘　三藏學者
破戒比丘　名字羅漢　及比丘尼　好戲笑者
深著五欲　求現滅度　諸優婆夷　皆勿親近
若是人等　以好心來　到菩薩所　為聞佛道
菩薩則以　無所畏心　不懷希望　而為說法
寡女處女　及諸不男　皆勿親近　以為親厚
亦莫親近　屠兒魁膾　畋獵漁捕　為利殺害
販肉自活　衒賣女色　如是之人　皆勿親近
凶險相撲　種種嬉戲　諸婬女等　盡勿親近
莫獨屏處　為女說法　若說法時　無得戲笑
入里乞食　將一比丘　若無比丘　一心念佛
是則名為　行處近處　以此二處　能安樂說
又復不行　上中下法　有為無為　實不實法
亦不分別　是男是女　不得諸法　不知不見
是則名為　菩薩行處　一切諸法　空無所有
無有常住　亦無起滅　是名智者　所親近處
顛倒分別　諸法有無　是實非實　是生非生
在於閑處　修攝其心　安住不動　如須彌山
觀一切法　皆無所有　猶如虛空　無有堅固
不生不出　不動不退　常住一相　是名近處
若有比丘　於我滅後　入是行處　及親近處
說斯經時　無有怯弱　菩薩有時　入於靜室
以正憶念　隨義觀法　從禪定起　為諸國王
王子臣民　婆羅門等　開化演暢　說斯經典
其心安隱　無有怯弱　文殊師利　是名菩薩
安住初法　能於後世　說法華經
又文殊師利　如來滅後　於末法中　欲說是經
應住安樂　行若口宣　說若讀經時　不樂
說人及經典過　亦不輕慢　諸餘法師　不說他
人好惡長短　於聲聞人　亦不稱名　說其過惡
亦不稱名　讚歎其美　又亦不生　怨嫌之心　善修
如是安樂心故　諸有聽者　不逆其意　有所難
問不以小乘法答　但以大乘　而為解說令得
一切種智　爾時世尊　欲重宣此義　而說偈言
菩薩常樂　安隱說法　於清淨地　而施床座
以油塗身　澡浴塵穢　著新淨衣　內外俱淨
安處法座　隨問為說　若有比丘　及比丘尼
諸優婆塞　及優婆夷　國王王子　羣臣士民
以微妙義　和顏為說　若有難問　隨義而答
因緣譬喻　敷演分別　以是方便　皆使發心
漸漸增益　入於佛道　除懶惰意　及懈怠想
離諸憂惱　慈心說法　晝夜常說　無上道教
以諸因緣　無量譬喻　開示眾生　咸令歡喜
衣服臥具　飲食醫藥　而於其中　無有所望
但一心念　說法因緣　願成佛道　令眾亦爾
是則大利　安樂供養　我滅度後　若有比丘
能演說斯　妙法華經　心無嫉恚　諸惱障礙
亦無憂愁　及罵詈者　又無怖畏　加刀杖等
亦無擯出　安住忍故　智者如是　善修其心
能住安樂　如我上說　其人功德　千萬億劫
算數譬喻　說不能盡

又文殊師利　如來滅後　於末法中　欲說是經
應住安樂　行者口宣　說若讀經時　不樂
說人及經典過　亦不輕慢　諸餘法師　不說他
人好惡長短　於聲聞人　亦不稱名　說其過惡
亦不稱名　讚歎其美　又亦不生　怨嫌之心　善修
如是安樂心故　諸有聽者　不逆其意　有所難
問不以小乘法答　但以大乘　而為解說令得
一切種智　爾時世尊　欲重宣此義　而說偈言
菩薩常樂　安隱說法　於清淨地　而施床座
以油塗身　澡浴塵穢　著新淨衣　內外俱淨
安處法座　隨問為說　若有比丘　及比丘尼
諸優婆塞　及優婆夷　國王王子　羣臣士民
以微妙義　和顏為說　若有難問　隨義而答
因緣譬喻　敷演分別　以是方便　皆使發心
漸漸增益　入於佛道　除懶惰意　及懈怠想
離諸憂惱　慈心說法　晝夜常說　無上道教
以諸因緣　無量譬喻　開示眾生　咸令歡喜
衣服臥具　飲食醫藥　而於其中　無有所望
但一心念　說法因緣　願成佛道　令眾亦爾
是則大利　安樂供養　我滅度後　若有比丘
能演說斯　妙法華經　心無嫉恚　諸惱障礙
亦無憂愁　及罵詈者　又無怖畏　加刀杖等
亦無擯出　安住忍故　智者如是　善修其心
能住安樂　如我上說　其人功德　千萬億劫
算數譬喻　說不能盡

國立台南藝術大學 典藏

Reproduced Music Instruments,
Tainan National University of the Arts

99
排簫
45.0×40.0×5.0 公分
竹

Panpipe
45.0×40.0×5.0 cm
Bamboo

管樂器
敦煌壁畫

排簫，屬古代編管樂器。文獻中也稱簫、比竹、參差、胡直等。敦煌壁畫中的排簫位置顯著，造型華麗，但型態不盡相同，其主要型制為二種：一為二端長、中間短，稱為底簫。二為一邊長、一邊短，稱為洞簫。敦煌壁畫中的排簫自北魏始，直至元代。

Panflute, an ancient wind instrument, it is sometimes referred to as a xiao (vertical flute), bizhu, cancha or huzhi, etc. in historical documents. In Dunhuang murals it stands out with its luxuriant design, but the shape varies. There are primarily two types: the first is long on the two sides and short in the middle, called dixiao; the second is long on one side and short on the other, called dongxiao. The panflutes in Dunhuang murals appeared from the Northern Wei to the Yuan dynasties.

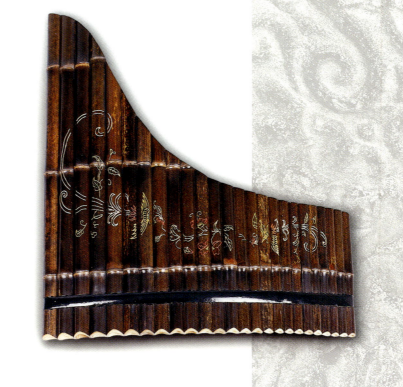

100
龍鳳笛
59.0×8.0×3.0 公分
57.5×6.0×2.5 公分
烏木

Dragon Flute and Phoenix Flute
59.0×8.0×3.0 cm
57.5×6.0×2.5 cm
Ebony

龍鳳笛，橫笛中的一種，為龍笛與鳳笛之合稱。即在笛之兩端，裝飾有龍頭龍尾或鳳頭鳳尾並加以彩繪。元史《禮樂誌》載有：龍笛，七孔，橫吹之，管首置龍頭，管末置龍尾。鳳笛，見之於榆林窟元代第十窟，是敦煌壁畫中一種變形的橫笛。

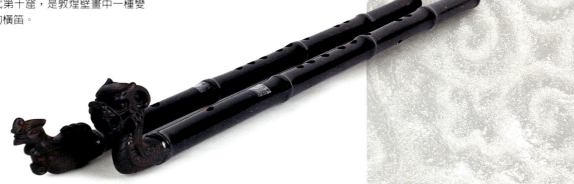

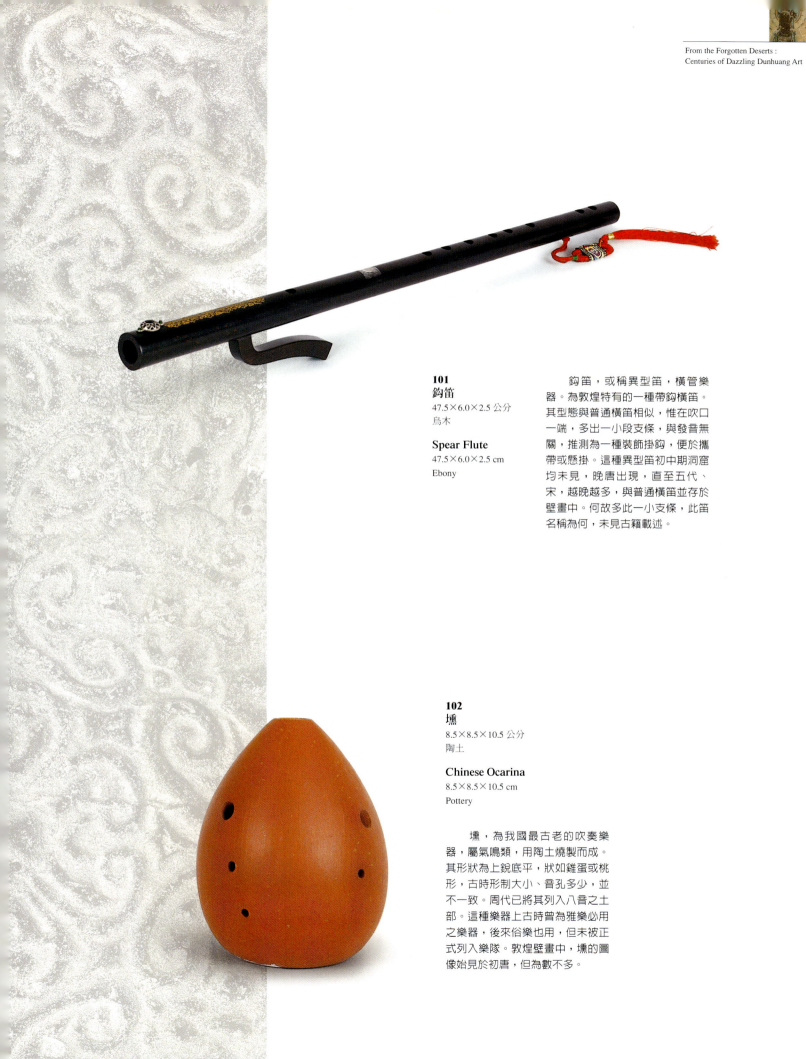

101
鈎笛
47.5×6.0×2.5 公分
烏木

Spear Flute
47.5×6.0×2.5 cm
Ebony

　　鈎笛，或稱異型笛，橫管樂器。為敦煌特有的一種帶鈎橫笛。其型態與普通橫笛相似，惟在吹口一端，多出一小段支條，與發音無關，推測為一種裝飾掛鈎，便於攜帶或懸掛。這種異型笛初中期洞窟均未見，晚唐出現，直至五代、宋，越晚越多，與普通橫笛並存於壁畫中。何故多此一小支條，此笛名稱為何，未見古籍載述。

102
壎
8.5×8.5×10.5 公分
陶土

Chinese Ocarina
8.5×8.5×10.5 cm
Pottery

　　壎，為我國最古老的吹奏樂器，屬氣鳴類，用陶土燒製而成。其形狀為上銳底平，狀如雞蛋或桃形，古時形制大小、音孔多少，並不一致。周代已將其列入八音之土部。這種樂器上古時曾為雅樂必用之樂器，後來俗樂也用，但未被正式列入樂隊。敦煌壁畫中，壎的圖像始見於初唐，但為數不多。

弦樂器
敦煌壁畫

琵琶，為弦鳴類樂器中之彈弦樂器。"推手向前曰琵，卻手向後曰琶，因以為名焉"，琵琶二字始自漢代之後，最早寫作枇杷或批把，後在字形上與琴瑟連類，故書為琵琶。古時琵琶為廣義之詞，文獻上將漢族和少數民族的各種彈撥樂器都泛稱為琵琶。漢代琵琶，指的是圓形的阮，東漢晚期已出現梨形的樣式，魏晉南北朝以後漸趨定型，但稱謂仍然混亂，直到唐代，琵琶之名始固定，圓形的稱為阮咸，梨形的稱為琵琶，敦煌壁畫中，琵琶的圖形最多，居所繪樂器之首位，凡畫有音樂形象處必有琵琶，具有音樂的象徵意義，從建窟之始，從未間斷。

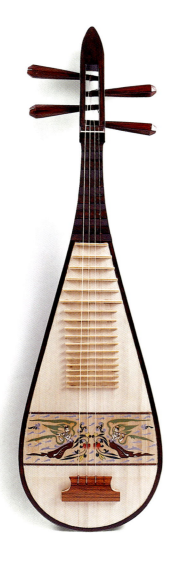

103
直項琵琶
109.0×30.0×11.0 公分
紅木

Straight Neck Pipa
109.0×30.0×11.0 cm
Rosewood

直項琵琶，共鳴箱為梨形，四弦，演奏姿勢早期為橫抱，明代以後，隨技巧之發展演變為豎抱。演奏手法為撥彈或指彈。

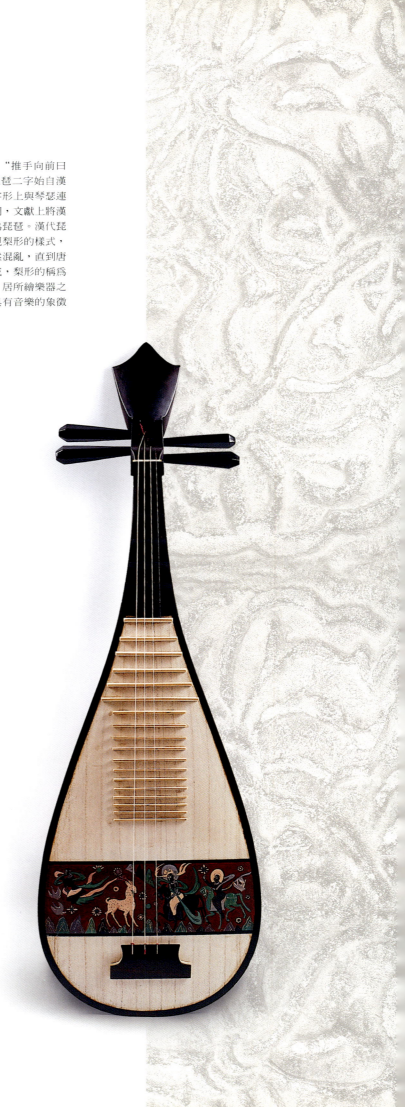

104
曲項琵琶
106.0×34.0×18.0 公分
紫檀木

Curved Neck Pipa
106.0×34.0×18.0 cm
Padauk

曲項琵琶，大約在南北朝時自波斯傳入，人們為了和中原的秦琵琶相區別，稱為曲項琵琶，梨形共鳴箱，橫抱，用撥子演奏。

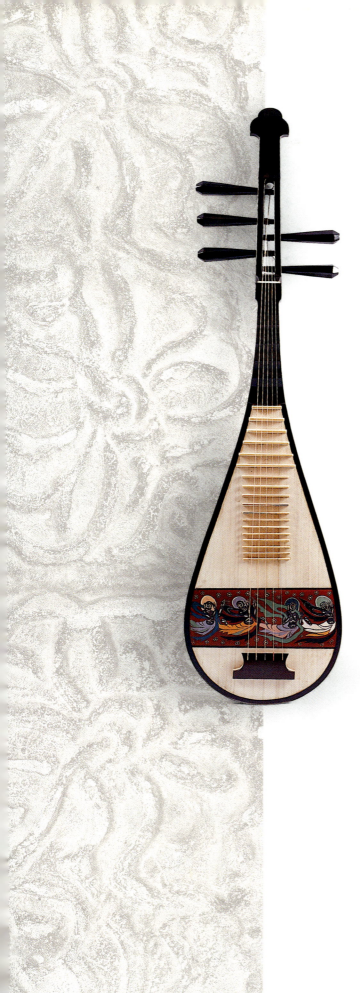
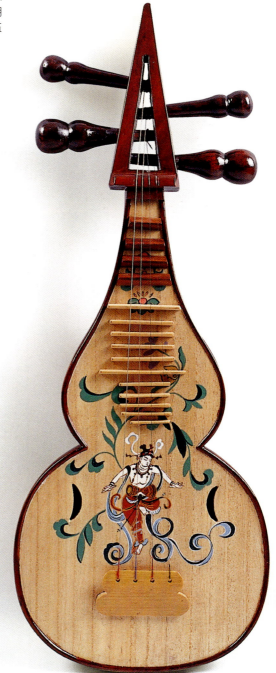

105
五弦琵琶
118.0×31.0×11.0 公分
紫檀木

Five-Stringed Pipa
118.0×31.0×11.0 cm
Padauk

　　五弦琵琶，也稱作五弦，是一種比直項琵琶多一條弦的樂器。文獻記載，五弦出現於北朝之後，隋唐樂隊的多部樂中，五弦列為正式編制。

106
葫蘆琴
72.0×17.0×11.0 公分
花梨木

Gourd Lute
72.0×17.0×11.0 cm
Jatoba

　　葫蘆琴，敦煌特有的一種葫蘆形彈弦樂器，屬於琵琶類，可能由琵琶演變而來。史書未有記載，見於莫高窟與榆林窟。

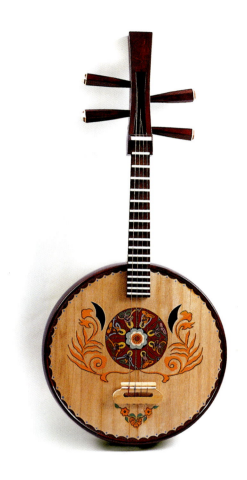

107
阮咸
94.0×41.5×12.0 公分
紅木

Ruanxian
94.0×41.5×12.0 cm
Rosewood

　　阮咸，因晉代竹林七賢之阮咸善彈此器而得名。唐代武則天以後，才有阮的名稱。其型態為正圓形共鳴箱，長柄，四弦或五弦。漢代畫像石刻、晉代墓葬中均有圖形可尋。文獻記載比琵琶的歷史還早，最初也稱做琵琶。敦煌壁畫中阮始自北魏，以後歷代均有描繪。

108
花邊阮
106.0×43.0×19.0 公分
紅木

Hua-bian Ruan
106.0×43.0×19.0 cm
Rosewood

　　花邊阮，是一種阮與琵琶造型合成的樂器，見於莫高窟，古時文獻及其他石窟中均未見此種形式。這種樂器應屬於低音的彈弦樂器，其特徵為形體較大，扁平花瓣形共鳴箱，長柄，四弦或五弦，琴頭似曲項琵琶，奏法應與阮咸相同。

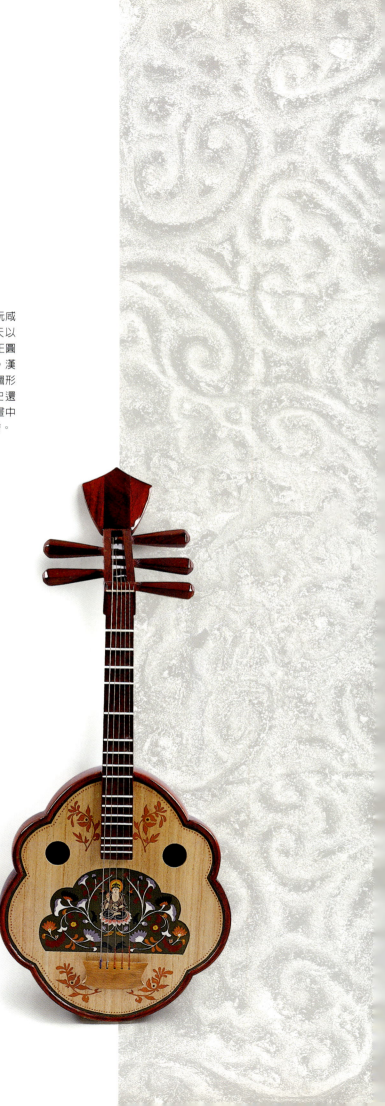

109
箜篌
77.0×35.0×125.0 公分
紅木

Konghou
77.0×35.0×125.0 cm
Rosewood

箜篌，古代框箱彈弦樂器。最初名為坎侯或空侯。為一種三角形框架，多弦的樂器。漢代以前未見，漢以後相當流行。南北朝以後的壁畫、石刻、樂舞陶俑等圖像資料中，多有發現。它屬於世界上的豎琴體系。唐代杜佑《通典》載："箜篌，胡樂也，漢靈帝好之，體曲而長，豎抱於懷中。"敦煌壁畫中箜篌相當多，僅次於琵琶。

Konghou, an ancient string instrument with a resonant box, was originally called kanhou or konghou. It has a triangular frame and many strings. It did not exist before Han Dynasty but was quite popular after the Han and was often seen in murals, stone carvings and clay figurines related to music and dance after the Southern and Northern Dynasties. It belongs to the harp family. Du You's <u>Tongdian</u> from Tang Dynasty, records: "Konghou, a northern nomad musical instrument, was well-liked by the Ling Emperor of Han Dynasty. It has a long and curvaceous body and is held vertically when played." A rather large number of konghou can be seen in the murals at Dunhuang, second in frequency only to the pipa.

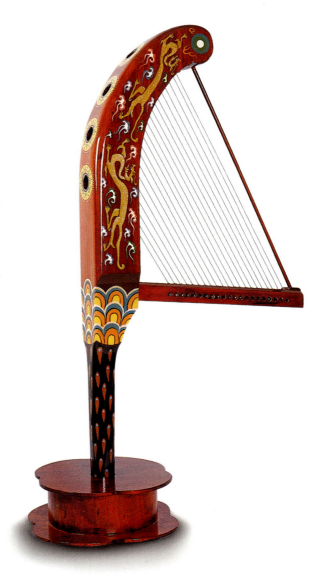

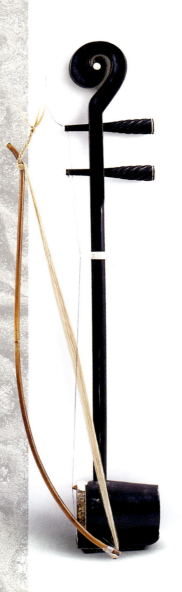

110
胡琴
82.0×16.0×9.0 公分
烏木

Huqin
82.0×16.0×9.0 cm
Ebony

胡琴，古亦稱奚琴、嵇琴。我國弦樂器中出現較遲的一個種類，文字見之最早是唐代，敦煌壁畫見於榆林窟。為一鼓形琴筒，琴杆插入小鼓中，有千金隔弦，有碼，二軫，二弦，筒側有一弓，直線。演奏姿勢為左手持琴，右手持弓。榆林窟胡琴的圖像，是我國壁畫中最早出現的拉弦樂器圖形，可以證實，在西夏至元代，胡琴在西北地區確已流行，此為壁畫中胡琴之最早者。

擊樂器
敦煌壁畫

111
羯鼓
78.0×40.5×40.5 公分
椴木、牛皮

Jie People Drum
78.0×40.5×40.5 cm
Basswood, Leather

　　羯鼓，古代膜鳴樂器。羯指古之月氏，羯鼓之名，始見於南北朝，盛行於唐。唐代羯鼓是樂隊首席，居指揮地位；當時羯鼓發達，曾有專用樂曲。文獻記載，唐明皇即善奏羯鼓，且傳為佳話。敦煌壁畫中羯鼓出現甚多，一般置於樂隊前列，或居於高處，統領樂隊。敦煌的羯鼓有兩種型態，一為直筒狀，一為直筒且縛以繩索，均橫置於小木架上。

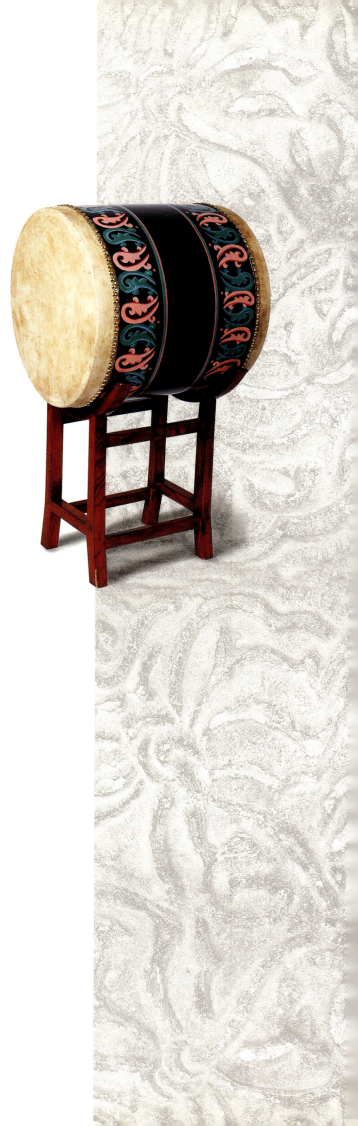

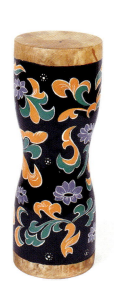

112
腰鼓
51.0×18.0×18.0 公分
椴木、牛皮

Waist Drum
51.0×18.0×18.0 cm
Basswood, Leather

　　腰鼓，蜂腰型膜鳴樂器，其特徵為細腰，鼓形狀如兩個碗，底部對接而成，兩端張以皮革，敲擊發音。腰鼓演奏方式是繫於腰間，或置於面前，踞地演奏，用手拍或杖擊。腰鼓在我國歷史悠久，種類變異甚多。最早可追溯到史前。敦煌壁畫中，從早期北涼至元代，一貫始終，從未間斷，而且形類繁多，幾乎每一只都有其特色。

113
都曇鼓
65.0×19.0×19.0 公分
椴木、牛皮

Doutan Drum
65.0×19.0×19.0 cm
Basswood, Leather

　　都曇鼓，古代腰鼓的一種，其名稱常見於文獻中。隋唐時期已廣為流傳，用於九部樂與十部樂中的天竺、龜茲、扶南諸樂中。唐代杜佑《通典》載："都曇鼓似腰鼓而小，以槌擊之。"即指外形細長，直徑較小的腰鼓。演奏時，將鼓橫置於身前，以槌敲擊兩端鼓面，在敦煌石窟壁畫中有此圖像。

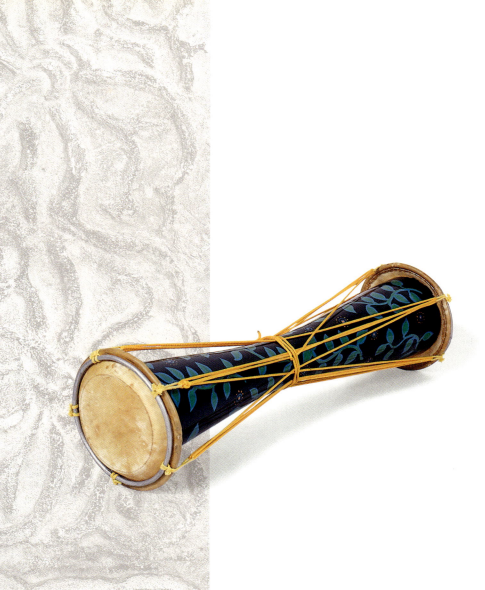

114
毛員鼓
68.3×40.5×40.5 公分
椴木、牛皮

Mauyuan Drum
68.3×40.5×40.5 cm
Basswood, Leather

　　毛員鼓，古代腰鼓的一種。名稱常見於唐代文獻，且於多部樂中將其列入編制，曾用於天竺、龜茲、扶南樂中。杜佑《通典》載："毛員鼓似都曇鼓而稍大。"即指外形較大，直徑略粗的腰鼓，莫高窟內有此圖像。據文獻記載，毛員鼓多以手掌拍擊，但莫高窟內所繪，手拍槌擊，兼而有之。

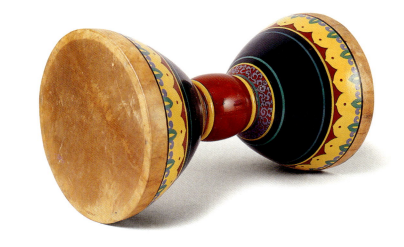

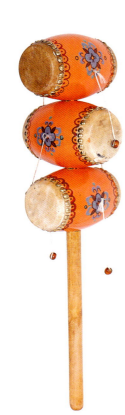

115
鼗鼓
62.0×16.0×16.0 公分
椴木、牛皮

Taur Drum
62.0×16.0×16.0 cm
Basswood, Leather

鼗鼓，古代膜鳴樂器。也寫作鞀鼓、鼗牢，即今日民間流傳之撥浪鼓。此鼓由來已久，《詩經》、《周禮》均有記載，鄭玄注："如鼓而小，持其柄搖之，旁耳還自擊。"敦煌壁畫所繪甚多，為一木柄，上串數枚小鼓，持柄搖奏。早期鼗鼓繪製簡單，後來裝飾彩色圖案，造型至為精美。

116
檐鼓
43.0×42.0×42.0 公分
椴木、牛皮

Yan Drum
43.0×42.0×42.0 cm
Basswood, Leather

檐鼓，古代膜鳴樂器。隋唐時用於西涼、高麗諸樂部，《舊唐書·音樂誌》載："檐鼓如小瓮，先冒以革而漆之。"鼓身木製，中腰較粗，兩端鼓面一大一小，蒙以皮革，用鼓釘固定，鼓身外表繪有圖案。演奏時，將鼓橫掛於腰間，雙手分別拍擊兩面。敦煌莫高窟出現數只，後來不復見。

117
扁鼓
67.0×60.0×60.0 公分
椴木、牛皮

Shortened Drum
67.0×60.0×60.0 cm
Basswood, Leather

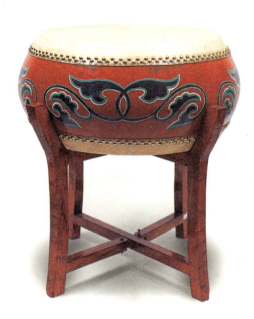

　　扁鼓，膜鳴樂器。鼓身扁圓，兩面蒙皮，周圍以小鐵釘固定。歷史久遠，歷代用於貴族宴饗、宗教音樂與各地民間音樂。目前出土文物最早為東周崖墓扁鼓，在楚墓中也多有實物可考。扁鼓是敦煌壁畫後期的樂器，只見於榆林窟西夏千手觀音圖中。

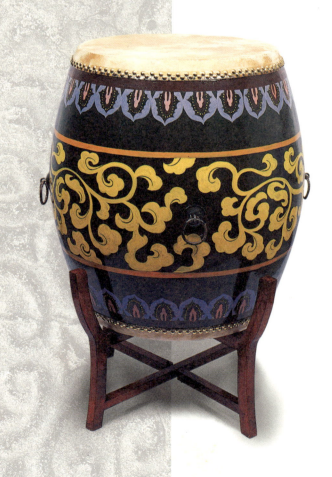

118
大鼓
96.0×66.0×66.0 公分
椴木、牛皮

Bass Drum
96.0×66.0×66.0 cm
Basswood, Leather

　　大鼓，膜鳴樂器。歷史悠久，古代用於軍事、儀仗、祭祀、宗教、報時與各地民間音樂。其外形為粗腰的枇杷桶狀，中空，木製鼓身。兩端開口尺寸相同，蒙以獸皮，用鐵釘固定，以棰擊之。唐代文獻中稱作大鼓，宮廷樂隊有此編制。大鼓未見於敦煌壁畫音樂圖像中，只見於經變畫裡，與鐘相對。

莫高窟大事紀

Chronicle of Dunhuang Grottoes

公元	朝代		大事紀
前111	前漢	元鼎六年	・設置敦煌郡。
前88		後元元年	・敦煌郡的戶數為11,200戶，人口38,355人（《漢書》二八地理誌）。
266	西晉	秦始二年	・敦煌的僧竺法護至長安，於青門內白馬寺口授《出三藏記集》。
366	前秦	建元二年	・沙門樂僔在莫高窟造窟一所，稍後又有法良禪師續造佛窟，自此濫觴一千五六百年間石窟藝術寶藏之歷代經營。
386	後涼	太安元年	・呂光據河西，建後梁，敦煌歸後梁。鳩摩羅什至涼州。
395		麟嘉七年	・居住在武威張掖以東的人西奔敦煌者數千戶。
400	後秦	弘始二年	・法顯等人西行求法，至敦煌停留月餘。
413	西涼	建初九年	・天竺僧曇無讖離開鄯善至敦煌。
421		永建二年	・西涼亡，敦煌歸北涼。
423	北涼	玄始十二年	・罽賓僧曇摩密多離開龜茲到敦煌。
442	北魏	太平真君三年	・敦煌歸北魏。
460		和平元年	・曇曜在雲崗石窟開鑿五窟。
487		太和十一年	・北魏廣陽王施刺繡佛像，在莫高窟第125和16窟窟前出土。
495		太和十九年	・北魏從平城遷都洛陽，開始營造龍門石窟。
525		孝昌元年	・孝昌元年之前，北魏宗室元榮出任瓜州赤使。
529		永安二年	・封瓜州赤使元榮為東陽王。
530		建明元年	・瓜州赤使，東陽王元榮造寫《仁王護國般若波羅蜜多心經》三百部，在此前後，元榮在莫高窟修造佛窟。
538	西魏	大統四年	・第285窟北壁供養銘。
539		大統五年	・第285窟北壁供養銘。
571	北周	天和六年	・在此前後，燕國公于寔為涼州大總管，其弟瓜州赤使于公義在莫高窟修造佛窟。
584	隋	開皇四年	・第302窟中心柱北面發願文。

公元	朝代		大事紀
585		開皇五年	・第305窟北壁發文。
601		仁壽元年	・全國各州建塔，瓜州崇敏寺建塔。
613		大業九年	・第282窟建成。
618~622	唐	武德元年至五年	・第390窟北壁「幽州總管府」供養銘。
642		貞觀十六年	・莫高窟今220窟建成。
675		上元二年	・第386窟南壁銘。
686		垂拱二年	・第335窟東壁發願文。
692		如意元年	・西千佛洞第7窟南壁銘。
695		延載二年	・營造第96窟北大像。
695~697		萬歲年間	・第123窟西壁龕下發願文。
698		聖曆元年	・第332（大周李君重修莫高窟佛龕碑）。
698~700		聖曆年間	・第335窟北壁維摩經變發願銘。
702		長安二年	・第335窟西壁銘。
705		神奄元年	・第217窟。
721		開元九年	・營造第130窟南大像。
726		開元十四年	・第41窟北壁下層壁畫題記。
748		天寶七載	・第180窟西壁題記。
749		天寶八載	・第185窟西壁題記。
746~755		天寶五載~十四載	・第130窟甬道供養人題記。
776		大曆十一年	・營造第148窟。
832~834		大和六年~八年	・第365窟建成，窟主為大番沙州釋門教授和尚洪䛒。
839		開成四年	・營造第231窟。
848		大中二年	・張議潮起兵逐吐蕃，率眾取沙州、瓜州結束了吐蕃在敦煌等地長達六十七年的統治。
851~862		大中五年~咸通三年	・營造第16、17窟。
865		咸通六年	・淮深營造第156窟。
862~867		咸通三年~八年	・翟法榮營造第85窟。
866		咸通七年	・重修第130窟。

公元	朝代		大事紀
870		咸通十一年	・第12窟建成。
871		咸通十二年	・第107窟西壁發願文。
888		文德元年	・第94窟建成。
890~892		大順元年~景福元年	・營造第9窟。
892~894		景福年間	・營造第196窟。
894		乾寧元年	・重修第148窟。
903		天復三年	・營造第92窟。
907	五代	開平元年	・營造第468窟。
924		同光二年	・曹議金掃義軍節度使，第98窟建成。
925		同光三年	・瞿奉達重修瞿家窟（第220窟）北壁，繪新樣文殊師利菩薩。
926		同光四年	・營造榆林窟第19窟（窟門上方發願文）。
936~942		天福年間	・曹議金的回鶻夫人隴西李氏營造第100窟。
953	北宋	廣順三年	・第469窟。
953~		廣順三年~	・曹元忠營造第53窟。
962~966		建隆三年~乾德四年	・曹元忠營造第55窟。
966		乾德四年	・曹元忠重修第96窟北大像。
970		開寶三年	・曹元忠營造第427窟木造窟。
974~976		開寶七年~太平興國五年	・第454窟（甬道南壁供養發願文）。
988		雍熙五年	・營造榆林窟第13窟。
1019		天禧三年	・永安寺等九寺共二十六僧結社於莫高窟對岸三危山下造塔一所。
1184	南宋	乾祐一四年	・榆林窟第19窟主室甬道銘。
1348		至正八年	・莫高窟六字箴言碑立。
1351	元	至正十一年	・8月，莫高窟皇慶寺重修。
1354	元		・至正十四年，設沙洲。
1404			・永樂二年，置沙洲衛。
1516	明		・敦煌陷於吐魯番。
1534			・元以後海上絲路興起，陸上與西域交通路線亦

公元	朝代	大事紀
		換，敦煌經濟交通樞紐地位盡失；莫高窟自此未再開鑿新窟，明代以後更形荒涼，敦煌遂走入歷史的黃昏。
1723~1725		・地方史官開始注意莫高窟。督修敦煌城的汪漋，發現＜李氏再修功德碑＞和敦煌壁畫，寫詩盛讚壁畫藝術。
1725	清	・於敦煌故城之東，築今敦煌城。設沙洲衛，遷內地五十六州縣民戶至敦煌屯田。
1820以前		・著名西北史地學者徐松遊歷莫高窟，記錄莫高窟碑刻文字，並探討莫高窟創建年代和歷史。
1831		・敦煌知縣蘇履吉修敦煌縣志，內載有關敦煌詩文及圖。
1878		・於此四年間，俄人探險家普魯氏（Przheval Skii）、克茲洛夫（Kozlov）；匈牙利賽切尼（Szechenyi Bela）等人陸續抵達敦煌，調查報告記錄記錄敦煌之地理環境、洞窟大佛、壁畫情狀等事要
1900		・6月25日，道士王圓籙（1850-1931）發現「藏經洞」（即莫高窟第17窟），在窟內發現古代文書、寫經、絹畫等文物數萬件。

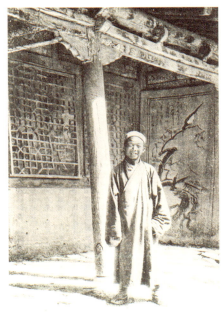

公元	朝代	大事紀
1903		・甘肅學台葉昌識得到藏經洞出土文物多件,建議敦煌縣令汪宗翰將全部文物運至省城蘭州保管,因經費難以籌措未能成行。
1904		・3月,甘肅當局令敦煌知縣汪宗瀚檢點藏經洞發現的經卷、畫像,責成王道士就地封存保管,後清點目錄卻為王圓籙所毀。。
1907		・3月16日,英籍匈牙利人斯坦因(Mark Aurel Stein, 1862-1943)首抵莫高窟訪王道士未遇;5月復來,騙購文獻經卷二十四箱,美術文物、絹畫5大箱等共近萬卷。
1908		・法國人伯希和(Paul Pelliot, 1878-1945)至敦煌莫高窟,耗三週時間精挑細選,攜走經卷文物、絹畫、雕像之精者約六千餘件,並剝除五十五洞窟壁畫。同年,清政府下令將殘存經卷妥為保管。

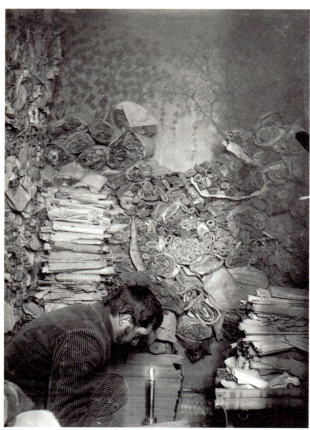

伯希和於藏書窟163號(1908年,查理・努耶特攝)

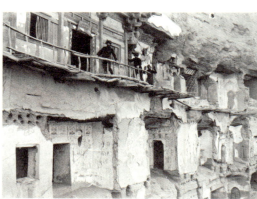

首訪千佛洞(1908年,查理・努耶特攝)

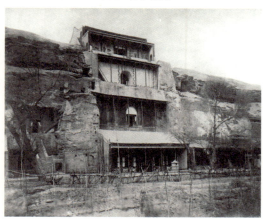

76-80號窟外觀(1908年,查理・努耶特攝)

公元	朝代	大事紀
1909		・伯希和將攜回北京的數十件敦煌寫經古物出示學界，士林譁然。羅振玉電告陝甘總督，建議組織敦煌莫高窟調查事宜，不得再將古文物流出。
1910		・清政府下令保護剩餘敦煌古寫本，所存經卷全部運往京師圖書館；途中仍為人所乘，散失不已，所餘不足九千卷。
1911		・日本大谷探險隊吉川小一郎、橘瑞超等人入敦煌，前後搜得三百餘經卷及絹畫等；又巧取塑像之精者二尊納入行篋，於翌年離去。
1914	民國	・斯坦因又赴敦煌，再度騙購寫經卷約六百卷。
1914~1915		・俄人奧登堡（S. F. Oldenberg）亦至敦煌，搜購經卷絹畫二百餘件，並全面搜尋南北洞窟，得寫經殘片達一萬數千頁；且剝離263窟等壁畫十餘處，竊走塑像數尊。
1920~1921		・白俄遊兵數百餘人盤據莫高窟，在洞窟內燒飯、住宿、塗抹、刻劃，壁畫慘遭浩劫。
1924		・哈佛大學美術館人員華爾納（Langdon Warner）至莫高窟，粘取壁畫26方，並竊走部分彩塑。
1925		・華爾納再至敦煌，企圖進行大規模之劫掠計劃未逞，而已造成壁畫巨大傷害；再竊走328窟供養菩薩彩塑一尊，並於敦煌區域各窟拍攝、記錄、編號。
1930		・史學家陳寅恪（1890-1969）總結了因敦煌藏經洞之發現，而興起的新學術領域；其謂「敦煌學者，今日世界學術之新潮流也」，由此確立了「敦煌學」於學術研究之重要發展地位。
1941		・畫家張大千（1899-1983）於敦煌臨摹壁畫，于右任（1878-1969）赴西北考察，兩人肇生維護國寶，成立「敦煌藝術研究院」之共識。
1942		・中央研究院西北科學考察團歷史考古組至敦煌、莫高窟調查。
1943		・3月16日，在向達、張大千、王子雲等藝學界人士之呼籲下，教育部接受于右任之建議，成立「敦煌藝術研究所籌備會」，張大千、王子雲等人任委員。

公元	朝代	大事紀
1944		・2月1日,國立敦煌藝術研究所於莫高窟正式成立,由常書鴻任所長。8月30日,莫高窟土地祠出土敦煌古書卷八十八件。
1950		・敦煌藝術研究所更名為敦煌文物研究所。
1961		・3月4日,敦煌莫高窟和安西榆林窟列為第一批全國重點文物保護單位。
1964		・再次對石窟展開編號,共計492號,並沿用至今。
1979		・莫高窟正式對外開放參觀。
1983		・第一次全國敦煌學術討論會於蘭州舉行,參加學者一百五十餘人,發表論文一百餘篇,出版學術論文集四大冊。
1984		・敦煌文物研究所擴大為敦煌研究院,院下設保護、考古、遺書、美術、音樂舞蹈等五個研究所以及行政相關部門,由段文傑、樊錦詩等人領導,分任院長、副院長。
1985		・香港商界邵逸夫捐款千萬港幣保護石窟文物,日本也對敦煌文物進行大規模維護整修的支援合作計劃。
1987		・10月,舉行敦煌石窟研究國際學術研討會,包括歐、美、中、亞等十餘個國家與地區之敦煌學者專家百餘人參加,發表論文七十餘篇,會後出版論文集兩大冊。12月,聯合國教科文組織世界遺產委員會將莫高窟列為「世界文明遺產」。
1992		・日本政府投資十一億日圓,無償援助敦煌建設石窟文物保護研究陳列中心奠基開工。
1994		・敦煌研究院創立五十週年,舉辦「一九九四年敦煌學國際學術研討會」,邀請各國專家學者與會,提交論文數量達一百四十六篇。9月,「敦煌研究陳列保護中心」落成開放。
1999		・敦煌文物首度來台,於台中科學館展出。
2005		・「荒漠傳奇・璀璨再現—敦煌藝術大展」在台展出,共彙集敦煌研究院、台北故宮博物院、法國吉美美術館等珍貴文物百餘件;其中法國來台展出佛幡絹畫,更是自伯希和於1908年自敦煌藏經洞攫出海外後,首歸兩岸華人地區之展出。

Year	Reign Period / Dynasty	Major Events
111 B.C.	Yuanding 6th Year, Early Han Dynasty	· Dunhuang County was established.
88 B.C.	Huoyuan 1st Year, Early Han Dynasty	· 11,200 households and a population of 38,355 people in Dunhuang County (Geography Section, The Chronicle of Han Dynasty)
266 A.D.	Qinqi 2nd Year, Western Jin Dynasty	· The Indian monk Dharmarakṣa traveled from Dunhuang to Changan and preached the Collection of Notes Concerning the Translation of the Chinese Triṇipiṭakāni at the Whitehorse Temple in Qingmen.
366	Jienyuan 2nd Year, Earlier Qin Kingdom	· Monk Yeujun built the first cave in Mogao. Monk Faliang continued the tradition later.
386	Taian 1st Year, Later Liang Kingdom	· Lu Guang occupied Hexi and founded the Later Liang Kingdom. Dunhuang became a part of the kingdom. Kumārajīva came to Liangzhou.
395	Linjia 7th Year, Later Liang Kingdom	· Thousands of households living to the east in Wuwei and Changyeh flee to Dunhuang.
400	Hongze 2nd Year, Later Qin Kingdom	· Han monk Faxian et al traveled to the west to pursue the dharma and stayed in Dunhuang for several months
413	Jienchu 9th Year, Western Liang Kingdom	· Indian monk Dharmarakṣa left Shanshan for Dunhuang.
421	Yongjien 2nd Year, Western Liang Kingdom	· The Western Liang Kingdom ended. Dunhuang became a part of the Northern Liang Kingdom.
423	Shuanze 12th Year, Northern Liang Kingdom	· Monk Dharmamitra of Kaśmīra left Kucha for Dunhuang.
442	Taiping Jenjun 3rd Year, Northern Wei Dynasty	· Dunhuang was returned to the Northern Wei Dynasty.
460	Heping 1 Year, Northern Wei Dynasty	· Monk Tanyao excavated five caves in Yuangan Grotto.
487	Taihe 11th Year, Northern Wei Dynasty	· Embroidery of the Buddha by King Guangyang was unearthed in front of Caves no. 125 and 26, Mogao Grottoes.
495	Taihe 19th Year, Northern Wei Dynasty	· The Northern Wei Dynasty moved the capital from Ping City to Loyang and started excavating the Longmen Grottoes.
525	Saozang 1st Year, Northern Wei Dynasty	· Yuanrong, a descendent of the royal family, was appointed the governor of Guazhou.

Year	Reign Period / Dynasty	Major Events
529	Yongan 2nd Year, Northern Wei Dynasty	· The title of King Dongyang was conferred upon Yuanrong, governor of Guazhou.
530	Jienyuan 1st Year, Northern Wei Dynasty	· King Donyang, Governor of Gua Zhou (today's Xian), made 300 copies of the Bhagavat Prajñāpāramitā Hṛdaya (The Buddha's Heart of Wisdom Gone Beyond. Yuanrong built Buddhist caves in Mogao Grotto around this time.
538	Datong 4th Year, Western Wei Dynasty	· Donor's inscription on the north wall of Cave no. 285.
539	Datong 5th Year, Western Wei Dynasty	· Donor's inscription on the north wall of Cave no. 285.
571	Tienhe 6th Year, Northen Zhou Dynasty	· Yu Shi, the Duke of Yan, was the commander-in-chief of Liangzhou; his brother, Yu Yi, governor of Guazhou, built Buddha caves in Mogao Grottoes area around this time.
584	Kaohuang 4th Year, Sui Dynasty	· Vows inscribed in the north of the center pillar, Cave no. 302.
585	Kaohuang 5th Year, Sui Dynasty	· The vowing speech on the north wall of Cave no. 305.
601	Renshou 1st Year, Sui Dynasty	· Pagodas were built across the country, and a pagoda was built at Chongmin Temple in Guazhou.
613	Dayeh 9th Year, Sui Dynasty	· Cave no. 282 was completed.
618-22	Wudeh 1st-5th Years, Tang Dynasty	· Donor inscription Yaozhou Governor Office on the north wall, Cave no. 390.
642	Zengguan 16th Year, Tang Dynasty	· Cave no. 220, Mogao Grottoes was completed.
675	Shangyuan 2nd Year, Tang Dynasty	· Inscription on the south wall of Cave no. 386.
686	Chuigong 2nd Year, Tang Dynasty	· Vows on the east wall of Cave no. 335.
692	Ruyi 9th Year, Tang Dynasty	· Inscription on the south wall, Cave no. 7, west of the Grottoes of the Thousand Buddha.
695	Yenzai 2nd Year, Tang Dynasty	· Built the colossal statue, car touche inscribed on the north wall of Cave no. 96.
695-7	Wansui years, Tang Dynasty	· Vows under the niche on the west wall, Cave no. 123.
698	Shenli 1st Year, Tang Dynasty	· Cave no. 332 (Inscription in niche cites renovation by Li of Zhou, Mogao Grottoes)

Year	Reign Period / Dynasty	Major Events
698-700	Shenli years, Tang Dynasty	· Vows inscribed as a part of the Vimalakirtī Sūtra, north wall, Cave no. 335
702	Changan 2nd Year, Tang Dynasty	· Inscription on the west wall of Cave no. 335.
705	Shenan 1st Year, Tang Dynasty	· Cave no. 217 built.
721	Kaiyuan 9th Year, Tang Dynasty	· Built the statue of the Buddha, inscription located on the south of Cave no. 130.
726	Kaiyuan 14th Year, Tang Dynasty	· Inscription on the mural at the lower part of north wall, Cave no. 41
748	Tienbao 7th Year, Tang Dynasty	· Inscription on the west wall of Cave no. 180.
749	Tienbao 8th Year, Tang Dynasty	· Inscription on the west wall of Cave no. 185.
746-55	Tienbao 5th-14th Years, Tang Dynasty	· Donor inscriptions located in the tunnel passageway of Cave no. 130.
776	Dali 11th Year, Tang Dynasty	· Built Cave no. 148.
832-34	Dahe 6th-8th Years, Tang Dynasty	· Cave no. 365 completed; organized by the abbot Hong Bian, leader of monks in Shazhou.
848	Dajhong 2nd Year, Tang Dynasty	· Chang Yichao led the opposition to take over Shazhou and Guazhou.
851-62	Dajhong 5th Year to Shientong 3rd Year, Tang Dynasty	· Built Caves no. 16 and no. 17.
865	Xiantong 6th Year, Tang Dynasty	· Chang Waishen built Cave no. 156.
862-7	Xiantong 3rd-8th Years, Tang Dynasty	· Zhu Fanrong built Cave no. 85.
866	Xiantong 7th Year, Tang Dynasty	· Cave no. 130 was renovated.
870	Xiantong 11th Years, Tang Dynasty	· Cave no. 12 was completd.
871	Xiantong 12th Years, Tang Dynasty	· Vows on the west wall of Cave no. 107.
888	Wendeh 1st Year, Tang Dynasty	· Cave no. 94 was completed.
890-2	Dashun 1st Year to Jingfu 1st Year, Tang Dynasty	· Built Cave no. 9.
892-4	Jingfu years, Tang Dynasty	· Built Cave no. 196.
894	Qianning 1st Year, Tang Dynasty	· Cave no. 148 was renovated.
903	Tianfu 3rd Year, Tang Dynasty	· Built Cave no. 92.
907	Kaiping 1 Year, Five Dynasties	· Built Cave no. 468.
924	Tongguang 2nd Year, Five Dynasties	· Cao Yijing mopped up the military officers, and

Year	Reign Period / Dynasty	Major Events
925	Tongguang 3rd Year, Five Dynasties	Cave no. 98 was completed at the same time. · Chu Fengda renovated the north wall of the Zhu Cave (Cave no. 220), and made a new painting of Mañjuśrī.
926	Tongguang 4th Year, Five Dynasties	· Built Cave no. 19, Yulin Grottoes (vows above cave door)
936-42	Tianfu years, Five Dynasties	· Madame Li from Longxi of Uyghur origin, wife to Chao Yijin, built Cave no. 100.
953	Guangshun 3rd Year, Northern Song Dynasty	· Cave no. 469
953-	Guangshun 3rd Year, Northern Song Dynasty	· Chao Yuanzhong built Cave no. 53.
962-6	Jianpeng 3rd Year-Qiande 4th Year, Northern Song Dynasty	· Chao Yuanzhong built Cave no. 55.
966	Qiande 4th Year, Northern Song Dynasty	· Chao Yuanzhong renovated the Buddhist statue Cave no. 96, inscription noted on north wall.
970	Kaobao 3rd Year, Northern Song Dynasty	· Chao Yuanzhong built Cave no. 427 with wood.
974-6	Kaobao 7th Year-Taiping Xingguo 5th Year, Northern Song Dynasty	· Cave no. 454. (Vows inscribed on the south wall of the passageway).
988	Yongxi 5th Year, Northern Song Dynasty	· Built Cave no. 13, Yulin Grottoes.
1019	Tianxi 3rd Year, Northern Song Dynasty	· 26 monks from Yongan Temple and other 8 temples built a pagoda on Sanweishan across from Mogao Grottoes.
1184	Qianyao 14th Year, Southern Song Dynasty	· Passageway inscription in the main hall, Cave no. 19, Yulin Grottoes.
1348	Qicheng 8th Year, Yuan Dynasty	· Erected the 6-character mentra inscription in Mogao Grottoes.
1351	Qicheng 11th Year, Yuan Dynasty	· In August, the Huangqing Temple of Mogao Grottoes was renovated.
1354	Qicheng 14th Year, Yuan Dynasty	· Established Shazhou.
1404	Yongle 2nd Year, Ming Dynasty	· Established the Shazhou Wei
1516	Ming Dynasty	· Dunhuang was occupied by Turfan.
1723~1725	Qing Dynasty	· Local officials noticed the importance of Mogao Grottoes Wang Long, the official supervising the restoration of Dunhuang City, discovered the Li Donor Merit Inscription for Renovation

Year	Reign Period / Dynasty	Major Events
		and Dunhuang Murals. So he wrote poetry to eulogize the mural art.
1725		· Built today's Dunhuang City in the east of the ancient Dunhuang City. Established Shazhou Wei, and sent citizens of 56 inland states and counties to cultivate Dunhuang.
Before 1820		· Xu Song, famous historian from northwestern China, visited Mogao Grottoes, recorded the inscriptions in the caves, and investigated the periods of construction and history of Mogao Grottoes.
1831		· Magistrate Su Luji of Dunhuang compiled historical and other records of the county, including poetry, writings and paintings.
1900		· Taoist priest Wang Yuanlu discovered the sūtra-cave (Cave no. 17, Mogao Grottoes) and found approximately 42,000 ancient documents, sūtras, paintings on silk and other objects.
1904		· Authorities of Gansu Province objects Magistrate Wang Zhonghan of Dunhuang to record the sūtras, scrolls and paintings found inside the sūtra-cave.
1907		· Marc Aurel Stein (1862-1943) of Britain stole 24 boxes of sutras and 5 boxes of paintings from Mogao Grottoes on his first visit.
1908		· Paul Pelliot (1878-1945) of France took pictures of Mogao Grottoes without permission and stole thousands of ancient documents,

Scene of Caves no. 101-103 (1908, photographed by Charles neuette, RMN)

Year	Reign Period / Dynasty	Major Events
		sutras, paintings and monuments from the caves. The Qing Government issued a protection for the surviving monuments in the same year. Pelliot Mission – Dunhuang IV (1908, photographed by Charles nouette, RMN)
1911		· Zuicho Tachibana and Yoshikawa Koichiro stole hundreds of sūtras from Dunhuang.
1914	Republic of China (ROC)	· Marc Aurel Stein（1862-1943）of Britain came again and robbed hundreds of sūtras.
1914~1915		· S. F. Oldenburg（1863-1934）of Russia surveyed and drew maps of the caves in the Mogao Grotto area, dug up monuments inside, took away the murals, and stole many sutras, paintings and monuments.
1920~1921		· Hundreds of White Russian soldiers gathered in Mogao Grotto area. They cooked and lived there and defaced and carved on the murals, causing great damage to the art.
1924		· Langdon Warner（1881-1955）of USA visited the Mogao Grottoes and took away twenty-six pieces of murals and painted statues.
1941		· Chang Da-chien went to the Dunhuang Grottoes to copied frescos.
1942		· The History and Archaeology Section of Northwest China investigation team of the Academia Sinica conducted an investigation in Dunhuang and the Mogao Grotto area.
1944		· The Dunhuang Art Research Institute was founded.

Year	Reign Period / Dynasty	Major Events
1950		· The institute was renamed to the Dunhuang Historical Monument Research Institute.
1964		· The Institute renumbered the caves again. 492 caves were numbered and the numbering is still in use today.
1979		· Officially opened the Mogao Grottoes to the public.
1984		· Dunhuang Historical Monument Research Institute was expanded to the Dunhuang Academy.
1987		· UNESCO officially included the Mogao Grottoes as a world cultural heritage site.
1999		· Premier exhibition of Dunhuang monuments in Taiwan.
2005		· Exhibition of "From the Forgotten Deserts: Centuries of Dazzling Dunhuang Art," organized by the Tainan National University of the Arts.

專有名詞對照表 Table of Term Comparison

凡例說明：

1. 本文所引之專有名詞包含英文與梵文，至於常見之對譯中文的部份，有些是直接取其音譯，有些則是字義的解讀，為使讀者釐清譯文的來源，故在名詞對照上將「音譯」與「字譯」並列，俾便查閱時之便利。
2. 在「原文」表列之檢索上，是以英文為主，梵文次之；如該字詞是來自梵文的英文形式化，則以「括號」補充梵文原文於下。
3. 部份梵文字詞在華人世界廣為流傳，因中文的語音已經被接受，是故「漢音」的形式亦頗為常見。在本表之中另以「*斜體*」的方式補充之，其發音是來自中文的音譯，而和原文字詞無關。

原文／音譯／字譯

A
- Abhayaṃ-dada mudrā／[]／施無畏印
- Abhaya-dāda／[]／施無畏
- Aerjin／阿爾卑斯山／[]
- Ajātaśtru／阿闍世／未生怨
- Akṣobhya／[]／妙喜國
- Akṣyamati; Bodhisattva Akṣyamati／[]／無盡意（無量義）菩薩
- Amitā-buddha／阿彌陀佛／無量佛
- Amitābha／阿彌陀（阿彌多婆）／無量光
- Amitāyus／阿彌陀（阿彌多叟）／無量壽
- Amitāyus Sūtra／[]／無量壽經變
- Amitāyurdhyana Sūtra／[]／觀無量壽經變
- Amoghavajra; *Bukong*／[]／不空（不空金剛）
- Amoghapasa Avalokitasvara (Amoghapāśa Avalokitaśvara)／[]／不空羂索觀音
- Ānanda／阿難、阿難陀／歡喜、無染
- Ancient Route, the Silk Road／[]／絲路古道
- ānimitta／[]／無相
- Añjali／[]／合什、合掌
- Apsaras／[]／飛天、樂天
- Arhat／羅漢、阿羅漢／應供、應真、不生、無生
- Architraves／[]／腰簷
- Asura／阿修羅／非天、非類、不端
- Avalokitesvara (Avalokitaśvara)／阿縛盧枳低濕伐羅／觀音、觀世音、觀自在
- Avalokiteśvara Pumenpin (Samantamukhaparivarto nāmā valoakiteśvara-vikurvaṇa-nirdeśa)／[]／觀世音普門品
- Avalokitesvara with 1000 Hands and Eyes (Avalokiteśvara-sahasrabhuja-locana) (Sahasra-bhujāryāvalokite śvara)／[]／十一面千手千眼觀音
- Avataṃsaka-sūtra; Avatauska-sūtra (Buddhāvataṃsaka-mahāvaipulya-sūtra)／[]／華嚴經（大方廣佛華嚴經）
- Belief and Understanding Chapter, The (Adhimukti-parivartah)／[]／信解品
- Simile and Parable Chapter, The (Aupamya-parivartah)／[]／譬喻品
- Aurel Stein／歐瑞爾‧斯坦因／[]

B
- Banner／[]／幡
- *Baoen* Sūtra／[]／報恩經變
- Beziklik Grottoes／[]／伯孜克里克石窟
- Bhaiṣajyaguru／[]／藥師如來、藥師佛
- Bhaiṣajyaguru Sūtra (Bhagavān-bhaiṣajyaguru-vaidūryaprabhasya pūrvapraṇidhāna-viśeṣa-vistara)／[]／藥師經（藥師琉璃光如來本願功德經）
- Bhaiṣajyaguru-vaidūryapratha／[]／藥師琉璃光
- Bhikṣuṇī／比丘尼／乞士女
- Bodhi Tree (Bodhi-druma, Bodhi-taru)／菩提樹／覺樹、道樹、道場樹
- Bodhisattva／菩提薩埵、菩薩／覺有情、道眾生
- Bodhisattva Avalokitesvara; *Guanyin*／[]／觀音、觀世音、觀自在菩薩
- Bodhisattva *Guanyin* with the Thousand Hands and Thousand Eyes (Avalokiteśvara-shasrabhuja-locana) (Sahasra-bhujāvalokiteśvara)／[]／千手千眼觀音菩薩
- Bodhisattva *Guanyin* with Eleven Faces (Ekādaśamukha Avalokiteśvara) (Ekadaśamukhāvalokiteśvara)／[]／十一面觀音菩薩
- Bodhisattva Kṣitigarbha; *Dizang*／乞叉底蘗婆／地藏菩薩
- Bodhisattva *Yinlu* (Guide of Souls) (Bodhisattva as Guide of Souls)／[]／引路菩薩
- Buddha／佛陀、佛／覺者、知者
- Buddha-kṣetra／[]／佛土
- Buddha Vairocana／盧遮那佛、盧舍那佛／[]
- Buddha Amitāyus／阿彌陀佛／無量壽佛
- Buddhapāla／佛陀波利／[]
- Bejeweled Pagoda, The／[]／見寶塔品
- Bodhi World, The (Jambu-dvīpa)／浮提世界、閻浮提／贍部洲、譫浮洲
- Brahmā／婆羅賀摩／梵天

C
- Cakravartin-rājan／斫迦羅伐辣底遏羅闍／轉輪聖王、轉輪王
- Candraprabha／[]／月光菩薩
- *Cao Yanlu*／曹延祿／[]
- *Cao Yijin*／曹議金／[]
- *Cao Yuanzhong*／曹元忠／[]
- *Cave, also see Grotto*／[]／洞窟
- Caves of the Thousand Buddhas／Qiangfodong／千佛洞
- Caityagṛha (Central Pillar Caves)／[]／中心塔柱窟
- *Chang Huaishen*／張淮深／[]
- Chapter on Expedient Means, The／[]／方便品
- *Chang Da-chien*／張大千／[]
- Charles Nouette／查理士‧努埃特／[]
- Caisson Ceiling／[]／藻井
- Ceiling／[]／窟頂
- Close-range Photogrammetry／[]／近景攝影測量
- Cotton and Mud Layer／[]／棉花泥層

Cressent Moon Lake／[]／月牙泉

D Daquan River／[]／大泉河
Daśabhūmika／[]／十地經、十住經
Depicting Prince Ajatasatru／阿闍世太子／[]
Devadatta／提婆達多／天授
Devarājan／[]／天王
Devas／提婆／人天
Deva-loka／[]／天道
Dhāraṇī／陀羅尼／總持、能持
Dhanyākara／福城／[]
Dharma／達摩、曇摩、曇無／法
Dharmarakṣa／[]／竺法護
Dhyana／禪／靜慮
Diamond Mountain／[]／金剛山
Dunhuang (Touen-Houang)／敦煌／[]
Dunhuang Academy, China (DAC)／敦煌研究院／[]
Donor Portrait／[]／供養像

E Early Tang Dynasty／[]／初唐
Eastern Han／[]／東漢
Eastern Jin Dynasty／[]／東晉
Efflorescence／[]／酥鹼
Ekādaśa-mukha (Ekādaśamukhāvalokiteśvara) (Eleven-Headed Avalokiteśvara)／[]／十一面觀音
Entry into the Dharma Realm／[]／入法界品
Enmity Before Birth (Ajātaśtru)／[]／未生怨
Elegant Gathering in the West Garden, The／[]／西園雅集
Eleven-headed Avalokitesvara Bodhisattva,The／[]／十一面觀自在菩薩心密言念誦儀軌經

F Five Hundred Yojanas／[]／五百由旬
Pañca śīlāni／[]／五戒
Five Dynasties／[]／五代
Flying Apsaras／[]／飛天
Four Guardian Kings (Catvāri Mahā Devarājan)／[]／四大天王

G Gable Ceilings, the／[]／人字披平棊窟頂
Gaṇḍvyūha／[]／入法界品
Gandhamādana (*Xiangshan*)／[]／香山

Gaṇeśa／[]／象頭神
Gateway Niche／[]／闕形龕
Geomembrane／[]／土工薄膜
Goddess Sarasvati-devī (Srīmāha-devī)／薩囉薩伐底、娑羅室伐底／大辯才天女、妙音天
Gobi Desert／[]／戈壁沙漠
Gośṛṅga; *Niujiashan*／[]／牛角山
Gossamer-thin Lines／[]／高古遊絲描
Grass and Mud Layer／[]／草泥層
Gṛdhrakūṭa-parvata／耆闍崛山／靈鷲山、靈山
Gṛhapati／[]／大商人
Gu Kaizhi／顧愷之／[]

H *Han* Dynasty／[]／漢代
Headdresses Mili／[]／冪䍦
Heaven Dress／[]／天衣
Hexi Corridor／河西走廊／[]
Hemp and Mud Layer／[]／麻泥層
Vasudeva (Hermit)／婆藪仙（隱士）／[]
High *Tang* Dynasty (Great *Tang* Dynasty)／[]／盛唐
Hong Bian／洪䛒／[]

I Irrités／[]／瞋

J Jade Gate／[]／玉門關
Jātaka／闍多伽、闍陀伽／本生故事、本緣、本起
Jin Dynasty／[]／晉朝
Jingang Sūtra (Vajracchedikā-prajñāpāramitā-sūtra)／[]／金剛經（金剛般若波羅蜜多經）
Journey to the West／[]／西遊記

K Karuṇa／[]／悲
Kaṣāya／袈裟／壞色、不正色
Kāśyapa (Mahā-Kāśyapa)／迦葉（大迦葉）／[]
Khotanese／[]／于闐
Khvarenah／靈光／[]
King Śibi／尸毗王、尸毘王／[]
King Bimbisāra／頻婆娑羅王／[]
King Moonlight／月光王／[]
King Pilengjieli／毗楞竭梨王／[]

原文／音譯／字譯

Kinnara Birds (kalaviṅka)／迦陵頻伽鳥／[]
Kṣitigarbha and the Ten Kings of Hell／[]／地藏十王
King Kuaimu／快目王／[]
Kumār／[]／童子
Kumārajīva／鳩摩羅什／[]
Kyzil／龜茲／[]

L Late *Tang* Dynasty／[]／晚唐
Śrī-mahā-devi (Lakshmi)／室利摩訶提毘／吉祥天女
Lasso (muktāhāra, hāra, keyūra)／吉由羅、枳由羅／瓔珞
Lenggie Sūtra (Laṅkāvatāra Sūtra)／[]／楞伽經
Lenggieli King Jātaka／楞竭梨王本生／[]
Li Shengtian／[]／李聖天
Lotus／[]／蓮花
Lotus Sūtra (Saddharma-puṇḍarīka Sūtra)／[]／法華經（妙法蓮花經）
Lohan (Arhat)／羅漢／[]
Lokapāla／[]／世王
Louis Vaillant／路易‧瓦揚／[]
Luoyang／洛陽／[]
Land-supporting Layer, The／[]／地仗層
Larger Sukhāvatī-vyūha Sūtra, The (The Sūtra Everlasting Life)／[]／觀無量壽經變

M Maitreya Sūtra／彌勒經變／[]
Mazong／馬崇山／[]
Mahakaruna (Mahākaruṇa)／[]／大悲行法門
Mahaprajnaparamita Sūtra (Mahāprajñāpāramitā-sūtra)／大般若波羅蜜多經／[]
Mahāsthāmaprāpta／金剛／[]
Maṇḍala／曼荼羅、曼陀羅／壇城、壇場
Māṇḍapa (Worship Hall)／[]／方形覆斗頂殿堂窟
Mañju／文殊／[]
Mañjuśrī (Bodhisattva Mañjuśrī)／文殊師利、曼殊室利（菩薩）／[]
Mañjughoṣa／曼殊瞿沙／妙音菩薩
Mādhyamika／[]／中觀派
Mawandui／馬王堆／[]
Métamorphose *Huagongdian*／化宮殿／[]
Medicine Buddha (Bhaisajyaguru)／[]／藥師佛
Mingsha Hill (Mt. Mingsha)／鳴沙山／[]
Mid *Tang* Dynasty, or Middle *Tang* Dynasty／[]／中唐

Ming Dynasty／[]／明代
Monk *Daoming*／道明和尚／[]
Monk *Daosheng*／道生和尚／[]
Mongolians／蒙古／[]
Mogao Grottoes, The／莫高窟／[]
Motifs in Roundel／[]／團花
Mt. *Wutai*; *Wutaishan*／五臺山／[]
Mt. Sumeru／須彌山／[]
Muktāhāra Mahāsattva (Muktāhāra Mahāpuruṣu)／[]／瓔珞大士
Mural Paintings／[]／壁畫
Musée national des Arts asiatiques-Guimet, Paris／法國國家吉美博物館／[]

N Nāga-puṣpa／[]／龍華樹
Nanda／難陀／[]
Narrative Paintings／[]／故事畫
Niche／佛龕／[]
Nilakanta (ka)-sūtra, The (Mahākāruṇikacitta-dhāraṇī)／大悲心陀羅尼咒／大悲咒、千手千眼觀世音菩薩大身咒
Nine Unnatural Deaths／[]／九橫死
Nirvāṇa／涅盤／[]
Northern Dynasties／[]／北朝
Northern *Liang* Dynasty／[]／北涼
Northern *Wei* Dynasty／[]／北魏
Northern *Zhou* Dynasty／[]／北周

O Open Niche／[]／敞口龕
Osadhi-parivartah／[]／藥草喻品

P Pañca-Śīlāni／[]／五戒
Parable of the Medicinal Herbs, The／[]／藥草喻品
Paraninvana Gathering／[]／涅槃聖眾
Paridhana／[]／緊身貼衣裙
Peak of *Zhongtai* (Peak of the Central Platform)／[]／中台之頂
Pennants／[]／幢
Pig-head God／[]／豬頭神
Paul Pelliot／保羅‧伯希和／[]
Prajñā／般若／[]
Preta／[]／餓鬼道
Protègent／[]／護持、護法

Puṇya／[]／功德
Pure Land Buddhist／[]／淨土宗
Pyramidal Roof／攢尖頂／[]
Putuoluo Shan／鋪陀落山／[]
Parable of the Phantom (Illusory) City, The (Purva-yoga-parivartah)／[]／化城喻品
Pratyeka／[]／緣覺
Prédication (Preaching)／[]／說法印
Prince Ajātaśatru／阿闍世太子／[]

Q Qiang (Xixia)／西夏(黨項)／[]
Qing Dynasty／清代／[]
Queen Vaidehī／韋提希皇后／[]

R Rājagṛha／曷羅闍姞利呬／王舍城
Receptacle of the Sun／[]／日藏
Receptacle of the Moon／[]／月藏
Relic-keeping Cave／[]／影窟
Rosary／[]／念珠

S Śrāvaka／舍羅婆迦／聲聞
Saddharma-puṇḍarika-sūtra (Saddharmapuṇḍarika-sūtra)／[]／妙法蓮華經
Sāgara-nāgarāja／裟竭羅龍王／[]
Śākyamuni／釋迦牟尼佛／[]
Śākya Chronicle／釋迦方志／[]
Śākyamuni Sermon／釋迦說法／[]
Samantabhadra; *Puxian pusa* (Viśvabhadra)／三曼多跋陀羅菩薩／普賢菩薩
Sanwei Mountain (Fire Mountain)／[]／三危山 (火焰山)
Saṃkakṣikā／僧祇支／掩腋衣、覆腋衣、覆肩衣
Sasanian Dynasty／薩珊王朝（波斯）／[]
Senmurv／神穆聖獸／[]
Serene Bodhisattva／[]／伎樂菩薩
Seven Treasures／[]／七寶
Scarf Dances／[]／巾舞
Screens of Ink Lotuses／[]／大墨荷通屏
Shallow Niche with A Pointed Arch／[]／尖拱券淺龕
Shichanatuo (Śikṣānanda)／實叉難陀／學喜、喜學
Sixteen Kingdoms Period／[]／十六國時期
Siyifantiansuowen Sūtra (Viśeṣacintabrahma-paripṛcchā)／[]／思益梵天所問經變
Soft Dance／[]／軟舞
Song Dynasty／[]／宋代
Southern Asia／[]／南亞
Southern *Tang* Dynasty／[]／南唐
Sogdiana／[]／粟特國
Śrīmahā-devī／室利摩訶提毘／吉祥天女
Śrāvaka／舍羅婆迦／聲聞
Stone Buddha Statue Floating on the River, the／[]／石佛浮江
Stories of Cause and Effect (Hetu pratyaya)／[]／因緣故事
Stūpa (Pagoda)／窣堵婆、素睹波、塔婆、浮圖、浮屠、佛塔／高顯處、大塚、塔廟
Streamer／[]／幡
Sui Dynasty／[]／隋代
Sukhāvatī／蘇訶縛帝、須摩提／極樂世界
Sukhāvatī-vyūha／[]／無量壽經
Sukhāvatīvyūha Sūtra (Sukhāvatī-vyūha Sūtra)／[]／無量壽經
Sukha-vihara-parivartah／[]／安樂行品
Sumagadhī／須摩提女／善賢
Śūnyatā／舜若多／空性
Sūryaprabha／[]／日光菩薩
Sūtra／修多羅／經、契經、正經
Sūtra of Maitreya's Descent／[]／彌勒下生成佛經
Sūtra Paintings／[]／經畫、經繪
Sūtra Illustration／[]／經變
Sukha-vihara-parivartah (Peaceful Practices Chapter), The／[]／安樂行品
Suvarṇaprabhāsottama-sūtra／[]／金光明經

T *Tang* Dynasty／[]／唐代
Tantric／[]／密教
Tathāgata／多陀阿伽陀、多他阿伽度／如來
Tented Niche／[]／帳形龕
Temple of the Great Flourishing Dharma, The／[]／大法華之寺
Three sermons of Maitreya, The／[]／彌勒三會
Tianqingwen Sūtra／[]／天請問經變
Tibet／吐蕃／[]
Tibetan Buddhist Art／[]／藏傳佛教
Triyana, The (the Three Vehicles) (Triṇi yānāni)／[]／三乘
Thousand-armed, Thousand-eyed Avalokiteśvara (Thousand-Handed and Eyed Avalokiteśvara) (Avalokiteśvara-sahasrabhuja-locana)／[]／千手千眼觀音像

原文／音譯／字譯

Triloka (the Three Realms) (Trayo dhātavaḥ)／[]／三界
Truncated Pyramidal Ceilings／[]／方形覆斗頂
Tongxuan Temple／通玄寺／[]
Turfan／吐魯番／[]
Tuṣita-bhavana (Tushita Heaven)／兜率天宮／[]
Twelve Great Vows／[]／十二大願
Two-Stepped Niche／[]／重層龕

U Uighur／回鶻／[]
Upasika (Upāsikā)／優婆夷／近侍女
Upananda／跋難陀龍王、婆難陀龍王、重喜龍王、大喜龍王
Upāya-kauśalya／巧方便／[]

V Vaiśravana／毗沙門／[]
Vajrapāṇibalin／婆闍羅波尼婆里卑／金剛力士
Vajrāsana／[]／金剛寶座、金剛座
Vajrapāṇi／[]／金剛神
Varadamudrā／[]／願印
Vajrapāṇibalins with Six Arms and Two Praying Bodhisattvas／[]／三頭六臂金剛
Vasu-Deva (Vasudeva)／[]／婆藪仙
Vādya Bodhisattva／[]／伎樂菩薩
Veṇuvana-Mahāsattva (Willow Branch Mahasamaprapta)／[]／竹林大士像
Vigorous Dance／[]／健舞
Viharas (Meditation Caves)／[]／禪窟
Vimalakīrtinirdeśa Sūtra, The (Vimalakīrti-nirdeśa Sūtra)／維摩詰(所說)經／[]
Vimalakīrti Sūtra／維摩經／[]
Vipasyin／維衛／[]

W *Wang Yuanlu*／[]／王圓籙
Water Moon *Guanyin*／[]／水月觀音
Weimao／[]／帷帽
Wavy scrolls with Plants／[]／忍冬草紋
Western *Han* Dynasty／[]／西漢
Western *Jin* Dynasty／[]／西晉
Western *Liang* Dynasty／[]／西涼
Western Pure Land／[]／西方淨土
Western Regions／[]／西域

Western Thousand-Buddha Grottoes／[]／西千佛洞
Western *Wei* Dynasty／[]／西魏
Western *Xia* Dynasty (Western *Xia* Kingdom)／[]／西夏
Western *Zhou*／[]／西周
Wrathful vajrapani with Three Heads and Eight Arms, The／[]／三頭八臂金剛
Wu-sung River／[]／吳淞江
Wu Zetian／[]／武則天

X *Xuanzang*／[]／玄奘

Y Yaśogupta／耶舍崛多／[]
Yuan Dynasty／[]／元代
Yulin Grottoes, The／[]／榆林窟

Z *Zhang Yichao*／[]／張議潮
Zhou Dynasty／[]／周朝
Zoroastrian God Ahuramazda／阿呼拉馬茲達神／[]

荒漠傳奇・璀璨再現—敦煌藝術大展= From the Forgotten Deserts: Centuries of Dazzling Dunhuang Art

國立臺南藝術大學藝術交流研究中心編輯/台南縣：南藝大，民94年 (2005)

ISBN 986-00-0597-4 (平裝)

1.敦煌-佛教藝術 2. 敦煌藝術-中華文化 3.敦煌學

荒漠傳奇・璀璨再現—敦煌藝術大展
From the Forgotten Deserts
Centuries of Dazzling Dunhuang Art

發 行 人	黃碧端，黃永川，侯王淑昭，李俊賢
策　　劃	張譽騰，李明珠，簡丹，黃培宜
主辦單位	國立臺南藝術大學，國立歷史博物館 橘園國際藝術策展股份有限公司，高雄市立美術館
出 版 者	國立臺南藝術大學，國立歷史博物館 橘園國際藝術策展股份有限公司，高雄市立美術館
展覽策劃	巴東（國立歷史博物館），蘇盈龍（高雄市立美術館）
展場設計	郭長江（國立歷史博物館），林榮隆（高雄市立美術館）
地　　址	臺南縣官田鄉大崎村66號
電　　話	(06)6930100-3
網　　址	http://www.tnnua.edu.tw
編　　輯	國立臺南藝術大學藝術交流研究中心
文稿校訂	曹慧中，Sarah Fraser
執行編輯	廖新田
助理編輯	洪千雅
創意總監	連清隆
美術編輯	葉貽琛
印　　刷	四海電子彩色製版股份有限公司
出版日期	中華民國九十四年三月
統一編號	97960503
Ｉ Ｓ Ｂ Ｎ	986-00-0597-4
定　　價	新臺幣2000元
展 售 處	國立歷史博物館文化服務處 地址：臺北市南海路49號　電話：(02)23610270 高雄市立美術館 地址：高雄市鼓山區美術館路20號　電話：(07)5550331

版權所有・翻印必究